S0-BNG-481

Hypnerotomachia Poliphili

FRANCESCO COLONNA

Hypnerotomachia Poliphili

The Strife of Love in a Dream

THE ENTIRE TEXT
TRANSLATED FOR THE FIRST TIME INTO
ENGLISH WITH AN INTRODUCTION
BY JOSCELYN GODWIN

WITH THE
ORIGINAL WOODCUT
ILLUSTRATIONS

Thames & Hudson

Translated from the Italian
by Joscelyn Godwin

Set in Monotype Poliphilus and Blado Italic

© 1999 Joscelyn Godwin

First published in the United States of America in 1999 by Thames & Hudson Inc.,
500 Fifth Avenue, New York, New York 10110

Reprinted in smaller format with corrections 2003

Library of Congress Catalog Card Number 99-70844
ISBN 0-500-51104-7

Printed and bound in the USA

CONTENTS

INTRODUCTION

T HE TITLE OF THE *Hypnerotomachia Poliphili* is compounded from the three Greek words *hypnos* (sleep), *eros* (love) and *mache* (strife). The sleep of Poliphilo, the narrator and protagonist, is the occasion for the erotic dream that comprises the entire novel. The 'strife' or 'battle' of the title refers not to any outward violence, but to the turmoil of Poliphilo's own emotions and to his desperate efforts to gain the love of Polia. He is eventually victorious in this – but only in his dream.

The name of Poliphilo signifies that he is a 'poli-phile', which certainly means a lover of Polia, but might also mean a 'lover of many', since his affection, as he ruefully admits on page 272, is set on many other things. He adores architecture, for instance, and gardens; he likes to poke around old graveyards and read the inscriptions; he delights in sculptures, bas-reliefs, and the products of goldsmiths' work. He has a passion for rich, colourful fabrics, especially when they are worn by nymphs; he revels in music, pageantry, ritual, and any other spectacle that induces a heightened state of consciousness. Most of all, Poliphilo is in love with Antiquity. Its shattered relics speak to him of an epoch infinitely wiser and more beautiful than his own. In the freedom of his dream he is able to reconstitute them in more than their original glory, erecting palaces, temples and theatres that lift him to a plane of ecstasy.

Poliphilo's dream of mental strife in the pursuit of love transports him to a pagan and polytheistic world. Sin has not yet entered in there, much less been linked to sex. The reason for Poliphilo's anguish is that his own tutelary divinities are Cupid and Venus, whereas Polia, with whom he has fallen in love, begins as a chaste votary of the goddess Diana. When Polia transfers her allegiance to the same goddess as he, his battle is won, and the rest of his dream is unmitigated delight.

There are few passages of the book that are not to some degree erotic, if we allow that Eros-Cupid-Amor is the god who fires us with the desire for beauty of every kind. When Poliphilo stands agape before the stupendous buildings of Antiquity, he seems to enjoy the same state of arousal as when he voyages to Cytherea in the company of Cupid, Polia and six exquisitely seductive sailor-nymphs. At every opportunity he indulges in an enumeration of detail that one might call fetishistic when he applies it to clothing or footwear, but which is no less obsessive when the object is an elaborate foun-

tain or an emblematic obelisk. This polymorphous eroticism is what gives the *Hypnerotomachia* its intensity and its atmosphere, saturated with the desire to gaze, to taste, and to consume.

If on one level Colonna has created a sustained erotic fantasy, it is not surprising that almost everything in the *Hypnerotomachia* is taken to excess. The book itself was produced on such a sumptuous scale, printed in folio and adorned with an unprecedented number of illustrations, that both the author and his patron suffered financially from it. The quality of the book as *objet d'art* has made the original edition the crown jewel of any collection of incunabula or early printing, to be leafed through admiringly by the connoisseur of typography and the graphic arts. How many bibliophiles have actually read it is another question, for its textual excesses are enough to deter most readers. The present edition is intended to restore some equilibrium to the admiration which the *Hypnerotomachia* has never lacked, by making it readable.

There has been only one previous attempt to translate the book into English. It is entitled *Hypnerotomachia The Strife of Love in a Dreame* (London: Simon Waterson, 1592 and reissues), and signed by 'R. D.', surmised to be Sir Robert Dallington (1561-1637), courtier and littérateur. He writes in his preface that he intended to dedicate his work to Sir Philip Sidney, but, the latter having died in 1586, commended it to the patronage of Robert Devereux, Earl of Essex. Dallington's version, however, is not only extremely loose, but is far from complete: it stops short about two-fifths of the way through Colonna's text, just in time to spare the English engraver the challenge of reproducing Poliphilo's most elaborate illustration, the Sacrifice to Priapus (see page 195). For four hundred years, English readers have had to be satisfied with this noble failure, which some of them must innocently have taken to represent the entire *Hypnerotomachia*.

French readers have been more fortunate in possessing an elegant translation ascribed to an anonymous Knight of Malta and revised by Jean Martin (*Le Songe de Poliphile*, Paris: Jacques Kerver, 1546 and various revisions and reissues). This abbreviates the original by about a quarter of its length, omitting many descriptions of non-architectural interest and thereby making Colonna's novel more attractive to some, though not all, of its potential readers. A new set of illustrations was cut for the Kerver edition, recreating the scenes in the more elaborate and manneristic style of the School of Fontainebleau. It is interesting to compare them to the original woodcuts, and to the instances in later French decorative art that bear witness to the great influence of the *Hypnerotomachia* in that land.

The first complete translation into any language was again a French one, made by Claude Popelin for the use of Gustave Popelin, a painter

(Francesco Colonna, *Le Songe de Poliphile*, Paris: Isidore Liseux, 1883, reprinted Geneva: Slatkine, 1994). Popelin doggedly hacked his way through the virgin forest of Colonna's syntax, so that future voyagers could travel it more speedily. But his readings of Colonna's intentions are often questionable.

The present translation leans most heavily on the critical edition and commentary by Giovanni Pozzi and Lucia A. Ciapponi (Francesco Colonna, *Hypnerotomachia Poliphili*, 2 vols., Padua: Editrice Antenore, 1968, reprinted with a new Preface and Bibliography, 1980), supplemented by the two volumes on Colonna's life and works (Maria Teresa Casella and Giovanni Pozzi, *Francesco Colonna. Biografia e opere*. Vol. I: *Biografia* [by M. T. Casella]; Vol. II: *Opere* [by G. Pozzi], Padua: Editrice Antenore, 1959). It would have been rash to attempt a translation of the *Hypnerotomachia* without being able to depend on the scholarship of this Italian team, and especially on Giovanni Pozzi's analysis of the language, his punctuation and correction of the text, and his exegetical notes to Book One. In architectural matters, the most helpful study has been Dorothea Schmidt, *Untersuchungen zu den Architekturekphrasen in der Hypnerotomachia Poliphili. Die Beschreibung des Venus-Tempels* (Frankfurt a. M.: R. G. Fischer, 1978).

Returning now to the theme of excess and superabundance that permeates the *Hypnerotomachia*, it is sadly true that the one aspect that cannot survive translation is the language, which is so strange and idiosyncratic that there is truly no parallel to it in literature. It could probably only have been forged at this particular time, in a climate of linguistic uncertainty. In the late Quattrocento it was still an open question whether Italian was an adequate language for literary use, or whether it was better to use Latin. The Italian works of Dante, Petrarch and Boccaccio were strong arguments that the vernacular could and should serve the loftiest purposes of verse and prose. But against that was set the new learning of the Humanists, who were conversant with much more Latin literature than had been known in the Trecento, and who prided themselves on the superiority of their own Latin to the debased style of the Middle Ages.

Colonna's originality lay in choosing a middle way, combining Italian syntax with a Latin vocabulary. He stretches his Italian constructions to the limit, with a breathless piling of clause upon clause that sometimes tumbles into incoherence. But they remain Italian, as do his lack of declensions, his use of articles and prepositions, and his verb-forms. His vocabulary, on the other hand, is not to be found in any Italian dictionary. Much of it consists of Latin words, the more recondite the better, which he adapts with Italian endings. A small but significant proportion of the words is Greek in origin. However, there is no substance to the oft-repeated rumour that the

Hypnerotomachia also displays a knowledge of Hebrew, Arabic and Chaldean. Hebrew appears only in two inscriptions; a few Arabic words, in one.

Colonna derived his Latin vocabulary not only from well-known authors – Ovid, not surprisingly, being his favourite source both of words and ideas – but from the later Latin writers whom the Humanists disesteemed. His most abundant source was Apuleius's novel *Metamorphoses, or The Golden Ass*, which is written in an extremely mannered style and filled with unfamiliar words, some of them unique to that writer. Apuleius's combination of eroticism with pagan religiosity, and the structure of stories within stories, make the *Golden Ass* one of the most direct ancestors of the *Hypnerotomachia*. Equally important to Colonna's project was the *Natural History* of Pliny the Elder, which served him as an inexhaustible source of words and anecdotes concerning plants, animals, minerals, technology, geography, history and curiosa.

The language of the *Hypnerotomachia* must have been almost as difficult for sixteenth-century readers as it is today. Fluency in Latin was much more common, but the standard education in the 'better' classics and the Latin of Catholic liturgy and the Vulgate cannot have been much help with Colonna's extravagant vocabulary. Neither did those readers have dictionaries on their shelves to compare with modern ones. Then there are the strange botanical names drawn from obscure passages in Pliny's encyclopedia, and the mass of classical references that are often even more obscure, coming at times from manuscript sources that betray themselves by corrupt forms of names. None of this was common knowledge. Colonna uses his erudition not to educate so much as to dazzle his audience, just as Poliphilo is dazzled by the highly-polished and over-decorated surfaces of the monuments he sees, and by the overweening sumptuousness of clothing, feasting and entertainment in the land of his dream.

The first principle of this translation is to honour every word of the original, however redundant the style may seem to modern ears. To have done otherwise would have only produced another abridgment. The only general exception to the principle is the omission of Colonna's constant superlatives and diminutives, which would have become very wearisome in English; and very occasionally the effort to match Aldus's typography has been made at the cost of a few inessential words. But if one were really to convey the spirit and style of the original language, it would have been necessary to do as Colonna did: to invent English words based on the same Latin and Greek ones, and to embed them in a syntax to match. Thus one might render the description of the Fury on page 249 as follows: 'In this horrid and cuspidinous littoral and most miserable site of the algent and fetorific lake stood saevious Tisiphone, efferal and cruel with her viperine capillament, her mes-

chine and miserable soul, implacably furibund.' While most readers will be relieved at the decision not to do so, something has been lost thereby. All the colourful patina, all the grotesque accretions have been stripped away from Colonna's language, leaving it comprehensible but bland. The only compensation lies in exploiting the rich double vocabulary of Latin and Germanic roots that is unique to English.

The reader should be warned that the author's mathematical errors have not been corrected here, nor have the architectural terms been standardized. Colonna's terminology has been preserved, even when it is ambiguous or does not agree with the illustrations. He was obviously a very well-informed amateur of classical architecture, with all the love and enthusiasm that the word 'amateur' implies, blessed with a power of fantasy that enables him to imagine buildings, inside and out, that are truly original. But when he deals with dimensions or geometrical constructions, he is soon out of his depth. A telling example of Colonna's strength and his weakness is the great pyramid-portal illustrated on page 26. Nothing like this had ever been imagined: a great rampart closing the gap between two mountains, pierced by a classical portal, topped by a stepped pyramid, and above that an obelisk crowned with a rotating statue. But reading the text and applying Colonna's measurements to the drawing, one discovers a large disparity between the written and the drawn versions. The block on which the pyramid rests is said to be 3600 feet long, yet it rises to only 120 feet above the pavement. The cube supporting the obelisk is 20 feet across, while the obelisk is a mere 35 feet high. If the edifice had been drawn to these proportions, it would look very ungainly. Colonna's intentions seem to be faithfully represented in the woodcut, but betrayed by his arithmetic.

Many of the descriptive passages in the *Hypnerotomachia* treat the architectural details for which Colonna uses the Albertian term 'lineamenta'. These include the various types of mouldings that finish off the edges of plane surfaces and provide the footings and headings of columns and other structures, as well as conventionalized vegetation and abstract motifs such as the egg-and-dart. Renaissance architects learned of these from two main sources: the surviving ruins of Roman antiquity, and the *De architectura* of Vitruvius (1st century B.C.). Leon Battista Alberti's *De re aedificatoria*, written about mid-century and circulated in manuscript before its publication in 1485, attempted to standardize the terminology, often using a different term from Vitruvius for a certain lineament. Colonna, reluctant to let slip any opportunity of enriching his vocabulary, draws heavily on both authors, sometimes applying the alternative terms to the same object. Both Giovanni Pozzi and Dorothea Schmidt find it impossible at times to understand exactly what the author had in mind, for his terminology is fluid and

picturesque, rather than rigorous. The *Hypnerotomachia* may be a landmark in the history of architectural writing, but it is not the manual of a practitioner.

The two books of which the novel consists differ from one another in many ways. Book One is devoted to Poliphilo's dream-pilgrimage, of which the main episodes are outlined three times in the preface (respectively in Latin verse, Latin prose, and Italian verse). This is where all the descriptions of monuments, ruins, gardens, palaces, temples, etc., are to be found. As a guide to Poliphilo's progress through the Isle of Cytherea, a diagram is included here on page 475.

Book Two is much shorter than Book One, and has no descriptions of works of art or architecture. Apart from its realistic illustrations, its interest is psychological rather than aesthetic, as it relates the thorny history of Poliphilo and Polia's love. The setting is not the timeless imaginal realm of Book One but the city of Treviso in northeastern Italy, in which the Temple of Diana is a scarcely disguised allegory of a convent. It is even dated. In the only overtly Christian reference in the entire work, we are told that Polia reached the flower of her age 'in the year of human redemption 1462' (page 386).

Whereas Book One is told entirely from Poliphilo's point of view, much of Book Two speaks in Polia's voice, and tells the woman's side of the story. Its structure is not that of a single narrative, as Book One is, but a series of stories, dreams, speeches and letters, nested in one another like a set of Chinese boxes, as can be seen from the schematic analysis that follows. The whole tone of Book Two is more worldly, and more closely related to vernacular literature such as Boccaccio's *Decameron*. The gross humour of Polia's nightmare of the two ruffians (pages 405-407), and her nurse's tale of the young woman married to an old man (pages 412-415), is poles apart from the aestheticism of Poliphilo's contemplations in Book One. At the other extreme, Poliphilo's interminable love-letters and speeches, which the reader (like the translator) may well find excruciating, are pure exercises in the art of rhetoric, and illustrate the gulf between what the fifteenth and the twentieth century found entertaining.

Each of the two books has its own climax. That of Book One takes place at the Fountain of Venus in the centre of the Isle of Cytherea, where Poliphilo uses Cupid's arrow to tear the curtain that conceals the naked Goddess (page 361), and is then pierced by an arrow himself. Superficially, this recalls the symbolic deflowerment at the end of the *Romance of the Rose*, but a closer analogy is the epiphanic Book XI of Apuleius's *Metamorphoses* in which Lucius, restored from donkey to man again, witnesses the Mysteries of Isis and Osiris and beholds the Goddess in her visible form.

Book Two of the *Hypnerotomachia* reaches its climax in the heavenly

realm, when Venus, besought by the soul of Poliphilo, bids Cupid wound Polia with his arrow (page 457), so that the woman will at last fall in love with the man who has died for love of her. After this, Poliphilo says: 'I beheld the open revelation of mysteries and arcane visions that mortal and material senses are rarely permitted to see.' (page 459) But when this episode is told, it is already past history within the economy of the story. Poliphilo, we are given to understand, is dreaming that Polia is recounting the story of Poliphilo's death and recovery, as she heard him tell it to the Priestess of Venus. The celestial and earthly events that led to her falling in love with him must have happened before his dream began. Yet at the end of the book he wakes alone, while the wraith of Polia vanishes. We then realize that every-thing in the dream has been Poliphilo's fantasy, including the detailed autobiography he has put into Polia's mouth, which we have read with every confidence in its objectivity. That is the way of dreams: while they are hap-pening, we believe in them absolutely.

The schematic analysis on page xviii is intended to guide the reader through the complexities of this structure.

The date of May 1st, 1467 appears at the end of the story, while the last page in the book, devoted to Errata and not included in this translation, alone bears the publisher's imprint: 'Most accurately done at Venice, in the month of December, 1499, at the house of Aldus Manutius.' Maria Theresa Casella and Giovanni Pozzi have shown that some essential parts of the *Hypnerotomachia* (including the descriptions of the Pyramid and the Temple of Venus) cannot have been composed before 1489, because they make use of Niccolò Perotti's *Cornucopiae,* published in that year (*Francesco Colonna. Biografia e opere*, Vol. II, p. 138). On the other hand, Colonna does not use Giovanni Bonsignore's edition of Ovid's *Metamorphoses* (Venice, 1497), which was illustrated by the same artist as the *Hypnerotomachia* (Ibid, p. 134). It seems from internal evidence that Book Two was written before Book One, perhaps many years before, and then incorporated into the larger work. (Our analysis shows how easily this adaptation could have been made.) The two dates given in the text, of 1462 for Polia's maturity and 1467 for the con-clusion of the story, may be significant for Colonna's biography, if we wish to believe that the *Hypnerotomachia* has any relation to the author's experience. But since there is no evidence whatsoever of Colonna's activities before his first appearance as an ordained priest in 1465, this belongs to the realm of speculation.

Before proceeding to a sketch of Colonna's life, it should be mentioned that several other people have been honoured with the authorship of the apparently anonymous *Hypnerotomachia*. Felice Feliciano has been proposed as the author by Lamberto Donati and Anna Khomentovskaia, Prince

Francesco Colonna of Palestrina by Maurizio Calvesi, Lorenzo de' Medici by Emanuela Kretzulesco-Quaranta, Niccolo Lelio Cosmico by Roswitha Stewering, Eliseo da Treviso by Alessandro Parronchi and P. Scapecchi, and Leon Battista Alberti by E. Kretzulesco-Quaranta and, independently, by Liane LeFaivre. The present translation follows bibliographical convention, and avoids futile controversy, by respecting the solid evidence of the acrostic formed by the initial letters of the 38 chapters distinguished by elaborate decoration and faithfully reproduced here: POLIAM FRATER FRANCISCVS COLVMNA PERAMAVIT ('Brother Francesco Colonna greatly loved Polia'). This ingenious signature was pointed out in a note written in 1512 in a copy of the *Hypnerotomachia*, whose writer added that Francesco Colonna 'now lives in Venice at SS. Giovanni e Paolo.'

Here, summarized from M. T. Casella's volume of documentary biography, are the principal known events of Colonna's life.

1433 Birth, conjectured from the record of his death in 1527 at the age of 94.

1465 Priest and religious of the Dominican Order at Treviso.

1467 Teacher of the novices at Treviso.

1473 Incorporated at the University of Padua.

1481 Awarded the degree of Master *per bullam*, i.e. by decree rather than by examination. Resident henceforth at the monastery of SS. Giovanni e Paolo at Venice, with occasional visits to Treviso.

1488, 1493 Preacher at St. Mark's, Venice. At some time, Prior of the monastery.

1496 Released from the post of Prior.

1498 Syndic and Procurator of the monastery.

1500 Granted permission to live outside the monastery. Asks for a refund of his expenses for making the doors of the Choir while he was Sacristan.

1501 Ordered to repay the sum provided by the Order for the printing of a book.

1501-1510 Probable period of the composition of Colonna's epic Italian poem *Delfili Somnium* (first published 1959 in Casella and Pozzi's *Opere*).

1504 Votes against the nomination of a Sub-Prior who is supposed to improve the morals and discipline of the monastery. Outvoted, Colonna walks out of the assembly.

1511 Commissioned to make a silver crown for an altar-statue of the Virgin.

1515 Leaves Venice, probably as result of economies forced on the monastery. Resides at the monastery of Treviso.

1516 Visits Venice, perhaps for medical reasons since he is often mentioned in monastery records as being ill. Issues an anonymous denunciation of four or five of his colleagues, accusing them of sodomy and other unspecified

things. Under investigation by the General of the Order, he confesses his authorship of the calumny and asks pardon. He is banished from Venice to Treviso for life, and forbidden to say Mass or hear confessions.

1516 Paid the usual fee for saying the first Mass of the day.

1519 Reinstated at SS. Giovanni e Paolo, Venice. Serves as Master of Grammar, Custodian of S. Nicolò, Procurator.

1522 Censured for administering the sacrament to a noblewoman against Apostolic Orders.

1523 Granted allowance of food and firewood on grounds of old age and poverty.

1524 Denounced on indeterminate grounds by Pietro Britti, a jeweller banished from the city.

1527 Dies, either in July or on October 2.

The entries just after the period of the *Hypnerotomachia*'s publication in 1499 are significant, if inconclusive. In the dedicatory Preface of the work, Leonardo Grassi states that he has had it printed and published at his own expense, but this does not eliminate the possibility that Colonna, or rather his monastery, had furnished some of the cost. According to Casella, the monastery of SS. Giovanni e Paolo was distinguished in Colonna's day by being 'unreformed', which meant that its members did not follow the strict rules of monasticism. Among other concessions, they might live outside the monastery (as Colonna did for years), and earn and retain money of their own. This explains the monastery's stern demand in 1501 that Colonna repay its loan to him. His effort to recoup his expenses in 1500 may bear on the same financial crisis.

The extravagant enterprise of commissioning Aldus Manutius to print the *Hypnerotomachia* lost money for all concerned. In 1509, Leonardo Grassi petitioned the Venetian Council of Ten for an extension of his copyright to the work, stating that because of the wars and other troubles he had not been able to distribute it abroad, and was still in possession of almost all the copies.

The range of possible commentary and research concerning the *Hypnerotomachia* is wide indeed. Doubtless a new wave of interest will be inaugurated by this 500th anniversary year, to which perhaps this translation will contribute. It is not aimed so much at scholars, who can and should read the original, as to the wider circle of those who are touched by its sensibility. Poliphilo's dream gathers up so many of the threads that would weave their way into the following centuries of European taste and aristocratic culture. These include a passion for ancient architecture, and for creating a new style based on Roman models. Irrespective of any direct influence, Colonna's

approach to architecture held good for the next two centuries: an erudite use of the classical vocabulary, recombined with a large element of fantasy. Where his influence was surely direct was in the formal gardens of France and Italy, which enchant the visitor with the combination of stone, water, topiary and flowering plants, to which Colonna gave supreme literary expression in his description of the Isle of Cytherea. In some instances the *Hypnerotomachia* seems to be directly quoted, as in the fountain of the sleeping nymph in the forecourt of the Villa d'Este, the Venus Grotto of the Boboli Gardens, certain monstrous sculptures in the Sacred Wood of Bomarzo, and the canals and marble colonnade of Versailles.

As regards interiors, Poliphilo's taste is for precious materials and dense and symbolic decorations. The Temple of Venus Physizoa has statues of Apollo and the Muses, with their attributes; the Palace of Queen Eleutheryl/ida has the seven planets and their correspondences. These fit within a long tradition of 'cosmic' interiors, beginning before the book was written with the astrological decorations of the Palazzo Schifanoia in Ferrara, and culmi/nating in the seven planetary rooms originally planned for the Palace of Versailles. The Roman residences of the Borghese, the Farnese and the Doria/Pamphilj must have come close, in the days of their prime, to Colonna's descriptions of interiors entirely lined with polished marble, mosaics (or paintings), and gold.

On a more delicate scale, the mood of the *Hypnerotomachia* seems to imbue the studioli, those exquisite private chambers that enshrined collections of precious objects and significant imagery. During the 1470s Federico da Mon/tefeltro, father of the book's dedicatee, constructed two such rooms in his palaces of Urbino and Gubbio. In the following century, no one could have been more Poliphilic than Francesco de' Medici, Grand Duke of Tuscany, with his wonderland garden at Pratolino full of grottos, fountains and automata, his gemlike studiolo in the Palazzo Vecchio of Florence, his experiments in alchemy and porcelain/making, and his notorious love/affair with Bianca Capello. Francesco was the first of a line of melancholy, art/loving monarchs, of which the last was Ludwig II of Bavaria, builder of fantastically decorated castles in which he led a life on the borderline between dream and reality. There is a fin/de/siècle quality about Poliphilism that res/onates with the era of King Ludwig, of Huysmans, Wilde, and Beardsley. It is obvious from Beardsley's drawings and from his erotic novel *Venus and Tannhäuser* that he knew and loved the *Hypnerotomachia*.

Colonna's connoisseurship, together with his encyclopedic scope, antici/pates the sixteenth century fashion for the Kunstkammer, which contained a microcosm of the most precious and extraordinary examples of nature and art. Collections like those of Archduke Ferdinand of the Tyrol in Schloss

Ambras, Emperor Rudolf II in Prague, or the Green Vaults in Dresden would have plunged Poliphilo into an ecstasy of admiration. In a sense, the *Hypnerotomachia* is itself a Kunstkammer, enclosing within its covers a minia-ture but self-consistent world of visual and verbal beauties and rarities.

To some, the most striking aspect of the book is its unapologetic pagan-ism, including parodies of prayers and of some quite obscure church rituals. The disparity between Colonna's religious profession and his literary work is a most telling example of the split in the European aesthetic consciousness. On the one hand were images and icons of the Christian faith that inspired the majority of paintings and decorative articles available for public view. On the other were the themes from Graeco-Roman mythology that the aris-tocracy almost invariably chose for their domestic use. Those who commissioned works of art for their private enjoyment evidently preferred to live surrounded by the images of pagan antiquity, especially the Loves of Zeus, the Labours of Hercules, the adventures of Odysseus and Aeneas, the Metamorphoses of Ovid, and the heroes of Roman history. Their churches were Christian, even if they resembled classical temples; most of them habit-ually heard Mass and went to confession; but their palaces and gardens were entirely pagan in inspiration. The *Hypnerotomachia* is like a bible of this heretic religion, which used the prestige of classical learning to excuse its indulgence in eroticism and the celebration of an unfallen Nature.

After this short Introduction, it remains only to thank the Colgate Uni-versity Research Council for a grant towards photographic expenses, and those at Thames and Hudson who have helped to realize this project, and especially Thomas Neurath for twenty years of encouragement.

JOSCELYN GODWIN

BOOK ONE

The first section takes us from the real world, where Poliphilo falls asleep, into the dream world, where he finds himself in a wood (11).

Poliphilo's dream. In the wood, he encounters the stream (15), the pyramid (20), the horse, the colossus and the elephant (30), the portal (47) and the dragon (58). In Eleutherylida's realm he sees the fountain of the sleeping nymph (68), the bath (79), the palace and the feast (94), and the chess-game, the obelisk and the three portals (117). Here he meets the nymph (141), falls in love with her (147) and sees other nymphs and their lovers (153), the triumphs of Europa, Leda, Danae and Bacchus (158) and the lovers of the poets (177). After an erotic crisis (181), he is present at other triumphs and sacrifices, enters the Temple of Venus and is ceremoniously united to Polia (189). He examines the ruins and the tombs of unfortunate lovers (225). He embarks on Cupid's boat (242), rowed by the singing nymphs (283), and arrives at Cytherea (290), where he sees the triumph of Amor (326) and the fountains of Venus (358) and Adonis. The nymphs now ask to hear Polia's story and this forms a separate narrative within Poliphilo's dream (369).

BOOK TWO

Polia's narrative. Polia tells her family history (381), the plague, her cure, consecration to Diana and meeting with Poliphilo, ending with Poliphilo's death (387), her vision and nightmare (398), the nurse's story (409), Polia's return to the temple and revival of Poliphilo (417), their appeal to the Priestess of Venus (428), Polia's declaration of love, and the Priestess's request to hear Poliphilo's story (432).

Poliphilo's speech to the Priestess. Within Polia's narrative the reported speech of Poliphilo forms yet another story-within-a-story. He tells of his first sight of Polia and first letter (436), his second (444) and third letters, after which he visits Polia again in the Temple of Diana and dies (448). In death he sees a vision, hears Cupid's speeches to his soul and to Venus, and sees mysteries (455). He awakes in Polia's arms.

The Priestess addresses the lovers and Polia concludes her address to the nymphs (461).

At the end of Polia's narrative the nymphs thank her for her story and depart, Polia and Poliphilo talk for the last time, they embrace and Polia dissolves (462).

Back in the real world, Poliphilo awakes from his dream to the nightingale's song (465).

THE original edition of the *Hypnerotomachia* was bound in 'signatures' of sixteen pages. There was no pagination, but as a guide to the binder the first page of each double leaf was given a letter and a numeral; a1, a2, a3, a4, corresponding to pages 1, 3, 5 and 7 in modern usage, and so on through the alphabet. This translation has been conventionally paginated, but since the text is familiar to scholars under its original divisions these have been added to the margin in square brackets, with an apostrophe denoting the verso of the page. Thus a1 is what we should call page 1, a1' page 2, a2 page 3, a2' page 4 and so on.

THE HYPNEROTOMACHIA OF POLIPHILO, IN WHICH
IT IS SHOWN THAT ALL HUMAN THINGS
ARE BUT A DREAM, AND MANY
OTHER THINGS WORTHY
OF KNOWLEDGE AND
MEMORY.
✳✳✳
✳✳
✳

I have always respected and admired you, unconquered Duke, for your singular virtues and your renowned name, and especially because my brother fought under your command at the Siege of Bibiena. Whatever favour was then bestowed by you on him – and he often recalls that it was great, mentioning your kindness and humanity towards him – we have considered as conferred on all the Crasso family. Whatever was given to one, we all accept from you; and we will not allow him to be any more yours than we all are. My brothers are eager for the opportu- nity to risk for you not only their goods but their very lives. For my part, I often think of revealing to you something of myself, and will think so until I do it; and now I have some hope of fulfilling my vows. For knowing that the gifts of Fortune can affect you no more than water poured into the sea, as they say, and that only letters and virtue have power over you, I have made a first attempt to approach you through letters. There has recently come into my hands a somewhat novel and admirable work of Poliphilo (for such is the name of the book), which, in order that it shall not remain in darkness, but be of timely benefit to mortals, I have had printed and published at my own expense. Lest this book, bereaved of its parent, should appear like a pupil without a tutor or guardian, we commit it to your present patronage so that it may flour- ish boldly under your name. While it serves as minister and herald of my love and respect for you, you may often use it as a companion to your studies and varied learning. For it contains not only knowledge, but, as you will see, more secrets of nature than you will find in all the books of the ancients. One thing is remarkable about it: that although it speaks our tongue, in order to understand it one needs Greek and Latin no less than Tuscan and the vernacular. The wise author thought that speaking thus would be the one way to prevent anyone lacking in forbearance from accusing him of negligence. But he also arranged it such that none but the most learned should be able to penetrate the inner sanctum of his teaching; yet he who approaches it with less learning should not despair. It is the case here that although these things are difficult by their nature, they are expounded with a certain grace, like a garden sown with every kind of flower; they are told in a pleasant manner, presented with many illustrations and images for the eyes. These matters are not to be exposed to the vulgar or proclaimed at the crossroads, but brought forth from the sanctuary of philosophy and drawn from the Muses'

springs with a novel refinement of speech, deserving thanks from all superior men. Therefore, O most humane Prince, accept our Poliphilo with the welcome that you always show to the learned. Accept him, and since this is the little gift of a grateful soul, may you read him with all the more pleasure as you remember Leonardo Crasso. If, as I hope, you will do so, this book will fear no censure after it has submitted to your own; and what is known to have been read by you will often be read by others. As for me, I will hope to have realized part of my ambition. Farewell, and count all the Crasso family as your own, along with me.

[2]

Giovanni Battista Scita, to the most famous Leonardo Crasso, Counsellor in Arts and Pontifical Law.

This marvellous new book,
Equal to those of our ancient ancestors,
Containing whatever lives in the world
That is rare and noble,
Merits as much thanks to you, Crasso,
As to its parent Poliphilo.
He gave it life; you also have given
Life, and keep it from harm.
For while it lay from its creation
Fearing the approach of oblivion,
You give it to everyone to read,
Sparing neither your cost nor your labour,
But, as a better parent, have raised
The abandoned child in your own cradle.
Once Bacchus had two fathers:
As regards this book, it has
Poliphilo as its father, but Crasso as Jupiter.

Anonymous Elegy to the Reader

Gentle reader, hear Poliphilo tell of his dreams,
 Dreams sent by the highest heaven.
You will not waste your labour, nor will listening irk you,
 For this wonderful work abounds in so many things.
If, grave and dour, you despise love-stories,
 Know, I pray, that things are well ordered herein.
You refuse? But at least the style, with its novel language,
 Grave discourse and wisdom, commands attention.

If you refuse this, too, note the geometry,
 The many ancient things expressed in Nilotic signs.
Here are pyramids, baths and vast colossi,
 And the ancient form of obelisks appears.
A novel pedestal shines forth, and various columns
 With arch, zophorus, epistyle,
Capital and beam, the square symmetry [2']
 Of the cornice, and all that makes a splendid roof.
Here you will see the perfect palaces of kings,
 The worship of nymphs, fountains and rich banquets.
The guards dance, dressed in motley, and the whole
 Of human life is expressed in dark labyrinths.
Read what is said here about the Thunderer's triple majesty,
 And of what befalls at the three gates.
See what Polia's form was like, and her dress,
 And the four heavenly triumphs of Jupiter.
Beside this, the book tells of the various states of love,
 And the works and furies of that god.
Pomona triumphs here equally with Vertumnus.
 Here too are the rites of the Lampsacian God.
Here is the vast temple, the perfection of all art,
 The many rituals of the ancients' worship.
Soon in another temple, gnawed by the teeth of Time,
 You will see much that will delight your mind:
The Tartarean domain, many epitaphs, and the boat
 By which Venus's boy crosses the wide sea,
And the high honours paid to him
 By all the divinities that the seas contain.
See here Cytherea, divided into gardens and meadows,
 In whose centre a round theatre appears,
Where you will be able to watch Cupid's triumph,
 The spring and the sacred form of the Paphian goddess.
You will read of how each year Venus and the Naiads
 Celebrate around the tomb of her lover Adonis.
This is the sequence of events in the first volume,
 These are the novel dreams of divine Poliphilo.
In the book that follows, Polia tells
 Of her birthplace, her race and parentage,
And who first founded the walls of Treviso.

4

Here is the whole tale of a long love.
Lastly, the book is adorned with a long appendix
 Which I do not think the reader will mind reading.
There are more things, but it is tedious to mention them all.
 Receive what this great cornucopia has offered.
Behold a useful and profitable book. If you think otherwise,
 Do not lay the blame on the book, but on yourself. The End

[3] Reader, if you wish to hear briefly what is contained in this work, know that Poliphilo tells that he saw remarkable things in a dream, hence he calls the work in Greek words 'the strife of love in a dream.' He repre⁄sents himself as having seen many ancient things worthy of memory, and everything that he says he has seen, he describes point by point in the appropriate terms and in an elegant style: pyramids, obelisks, huge ruins of buildings, the varieties of columns, their measurements, capi⁄tals, bases, epistyles or straight beams, bent beams, zophori or friezes, and cornices with their ornaments. There is a great horse, an enormous elephant, a colossus, a magnificent portal with its measurements and ornaments, a fright, the five senses represented in five nymphs, a remark⁄able bath, fountains, the palace of the queen who is Freewill, and an excellent royal feast. He tells of the variety of gems or precious stones, and their nature; a game of chess in a ballet with music in triple time; three gardens, one of glass, one of silk and one a labyrinth, which is human life; a peristyle of brick in whose centre the Trinity was expressed in hieroglyphic figures, that is, in the sacred engraving of the Egyptians; the three portals before which he tarried; Polia, her appear⁄ance and behaviour. Then Polia leads him to watch four wonderful triumphs of Jupiter, the women loved by the gods and by the poets, the various affects and effects of love; the triumph of Vertumnus with Pomona; the sacrifice to Priapus, in ancient style; a marvellous temple, artistically described, where sacrifices were made with miraculous rites and religion. Then how he went with Polia to await Cupid at the shore, where there was a ruined temple, at which Polia persuades Poliphilo to go inside and admire the antiquities. Here he sees many epitaphs and an inferno depicted in mosaic. How he was frightened, and left them to return to Polia. And as they were standing there, Cupid arrived with the boat rowed by six nymphs, on to which they both went, and Amor made a sail with his wings. Then honours were paid to Cupid by the sea⁄gods and goddesses, the nymphs and monsters. They reached the

island of Cytherea, which Poliphilo describes fully as divided into groves, meadows, gardens, streams and springs. Presentations were made to Cupid, and he was welcomed by the nymphs, then they went on a triumphal chariot to a wonderful theatre, all described, in the middle of the island. In its centre is Venus's fountain with seven precious columns. He tells of all that happened there, and how when Mars arrived they left and went to the spring where Adonis's tomb was; and there the nymphs tell of the anniversary that Venus kept in his memory. Then the nymphs persuade Polia to tell of her origin and her falling in love; and that is the first book. In the second, Polia tells of her ancestry, the building of Treviso, the difficulties of her falling in love and their happy conclusion. The story is filled with innumerable and suitable details and correlations, then at the song of the nightingale he awoke. Farewell.

Leonardo Crasso, my reverend teacher,
 prelate learned in liberal art,
 outstanding in every virtue, as I know,
Deserves high and immortal praise
 for the expense and responsibility that he has assumed
 in reproducing such a compendious work.
Then look, gentle reader, and look again:
 at the dreams told by Poliphilo,
 sent from heaven with much grace.
You will not waste your time extravagantly,
 but rather rejoice to have listened to
 a work abounding in various things.
If you sourly refuse the new erotic guest,
 do not despise the well-ordered sequence
 nor this fine, exquisite style.
If grave sermons and well-ordered learning
 are not to your taste, notice the ancient
 figures, in geometry that costs little.
Observe the many notes with their measurements
 concerning the Egyptian Nile,
 the pyramids, antique tombs,
Together with the obelisks erected upon them,
 the hot and cold baths, and statues of colossi
 that leave their beholders astounded.

Here on various pedestals and great arches
 are different columns proportional to them,
 together with their capitals and beams,
And the cornices with their squares,
 their symmetries, the zophori and architraves
 that the splendid roofs display.
There you will see magnificent and beautiful palaces
 of kings and lords, and the nymphal springs,
 and the guests appropriate to these.
You will see various games of chess,
 together with the game of guards, and human actions
 joined together in the darkness of a labyrinth.
Here you will read of the triple and significant
 actions and the majesty of the great Thunderer,
 and his wise counsellors, in the three portals,
Who Polia was, fair and triumphant;
 here you will see the four celestial
 triumphs of high, thundering Jupiter.
Then it tells you in various moods,
 not crude ones, of the amorous work
 and the wounds dealt to mortals by Amor.
Here is the joyous triumph of Vertumnus and Pomona,
 and the sacrifice to Priapus
 with the ass and his monstrous phallus.
Here is a great temple which is as perfect
 as when it was built, with marvellous art
 and many rites appropriate to it.
Another temple, eroded in many places,
 and all damaged by age,
 you will see in these pages,
And other things that will please you:
 the Tartarean realm, innumerable epitaphs,
 and the boat of Venus's son;
All the honours that are paid
 with the highest reverence by the gods
 of the seas, the rivers and the other shores together;
Meadows, gardens and Cytherean orchards,
 a beautiful theatre conspicuous in the centre,
 where he triumphs with Cupid's folk.

[4]

He reaches the fountain of the Paphian
 with her venerable and beautiful form,
 and the tomb of Adonis, bereft of life,
Whom she loved most in the world,
 so that his anniversary is now celebrated
 by the Naiads together with Venus.
This is contained in the first book
 of Poliphilo's excellent dreams,
 in a style that is light, transparent and varied.
Now the second tells of Polia's ancestry,
 her race and formation, and where she was born,
 and the first founders of Treviso;
Then, in this volume, she falls in love.
 It is a worthy book, and full of many ornaments:
 he who will not read it is dull of mind.
Various things are treated in it
 which it would tire me to relate; but accept
 the work which offers a cornucopia,
 emending it, should it be incorrect. The End.

Andreas Maro of Brixen. [4']

Say, Muse, whose work is this? — Mine and my eight sisters'.
 Yours? Then why is the name of Poliphilo given?
It deserves rather to be the nursling of us all.
 But I ask you, who is really called Poliphilo?
We do not wish to tell. — Why? — Certainly we must first see
 Whether rabid malice brings forth divine things.
If it should refrain, what then? — It shall be known. — If not?
 We would not deem ourselves worthy of Poliphilo's true name.
O how happy you are, unique among all mortals,
 Polia, who lives even better in death;
Whilst Poliphilo lies overcome with deep sleep,
 He keeps you awake through his virtues' wise words.

8

THE HYPNEROTOMACHIA OF POLIPHILO, IN
WHICH IT IS SHOWN THAT ALL HUMAN
THINGS ARE BUT A DREAM, AND
MANY OTHER THINGS WORTHY
OF KNOWLEDGE AND
MEMORY.

✳ ✳ ✳
✳

ANY A TIME, POLIA, I HAVE THOUGHT of how the ancient authors dedicated their works aptly to princes and magnanimous men, some for gain, some for favour, and others for praise. But it is for none of these reasons, except perhaps the middle one, that I offer this Hypnerotomachia of mine, for I can find no prince more worthy of its dedication than you, my mighty Empress. Your noble station, your incredible beauty, your highly regarded virtue and your outstanding behaviour, by which you hold first place above any nymph of our age, have inflamed me excessively with a noble love for you: I have burned and am consumed. O splendour of radiant beauty, ornament of all grace, famed for your glorious looks, receive this small gift, which you have industriously fashioned with golden arrows in this loving heart, and painted and signed with your own angelic image; it belongs to you as its only patron. I commit this gift to your wise and intelligent judgment, abandoning the original style and having translated it into the present one at your behest. Thus if any fault appear therein, and if you should find any part of it sterile and undeserving of your discriminating approval, the blame is yours, as the best operator and only possessor of the key to my mind and heart. But I cannot think of, nor hope for, any reward of greater value and price than your gracious love, and your kindly favour for this. Farewell.

POLIPHILO BEGINS HIS HYPNEROTOMACHIA
BY DESCRIBING THE TIME AND SEASON AT
WHICH HE SEEMED TO FIND HIMSELF IN A DREAM
ON A CALM AND SILENT SHORE, WILD AND DES-
ERTED. THEREAFTER HE ENTERED UNEXPECTED-
LY AND WITH GREAT FEAR INTO A DENSE AND
PATHLESS FOREST.

THE HYPNEROTOMACHIA OF POLIPHILO.

DESCRIPTION OF THE DAWN.

 HOEBUS WAS EMERGING FROM
the ocean waves, at the hour when Leu-
cothea's brow grows bright. The whirling
wheels slung beneath his chariot were still
out of sight as he appeared dutifully with his
flying horses, first Pyrois, then Eous, to tint
his daughter's pale quadriga with scarlet
roses and to speed after it without delay. His
curling hair was already sending its rays scintillating over the restless
blue waves. As he arrived at this point, hornless Cynthia was setting
opposite, urging on the steeds of her vehicle which was drawn by a
white and a dark mule. She reached the far horizon separating the hemi-
spheres and gave way, fleeing from the first star that heralds the day. It
was the season when the Rhiphaean mountains were calm; icy and
chilling Eurus was not blowing so coldly on their sides, setting the
tender twigs quivering, disquieting the waving rushes, sharp reeds and
bending cypresses, disturbing the flexible osiers, shaking the languid
willows and flattening the fragile firs beneath the horns of lusty Taurus,
as it does when it blows in winter. Likewise boastful Orion was ceasing
to pursue the seven weeping sisters who adorn the shoulder of the Bull.

In this same hour, the bright flowers were not yet afraid of the dan-
gerous heat of Hyperion's approaching child, while the green meadows
were still wet and bedewed with the fresh tears of Aurora. Halcyons
were appearing above the smooth waves of the tranquil and becalmed
sea and nesting on the sandy shores, whilst mournful Hero sighed
[a2'] ardently on the eroded shore for the sad and unwelcome departure of the

swimmer Leander. And I, Poliphilo, was lying on my couch, the timely friend of my weary body, with no one with me in my familiar chamber but the dear companion of my sleepless nights, Insomnia. She was consoling me after several conversations in which I had explained to her the cause and origin of my deep sighs; she kindly helped me to calm my uneasiness, then, realizing that the time had come for me to sleep, asked to leave. Left alone with my deep thoughts about love, I passed the long and tedious night sleeplessly, altogether disconsolate about my fruitless fortune and my adverse and evil star. I sighed and wept for my importunate and unsuccessful love, thinking over point by point the nature of unmatched affection, and how best to love someone who does not love in return. What protection can the unquiet soul have when it is unarmed, yet assailed with many a surprise attack and sur-rounded by hostile forces, especially when the battle takes place within it, and it is hampered by novel, unstable and insistent thoughts? I bewailed long and bitterly this miserable state of mine; my unsettled spirits were already weary of futile thought, and I of being nourished by a false and feigned pleasure, albeit one with Polia as object. She, without a doubt, was not mortal but rather divine – she whose holy image was deeply impressed within me, and dwelt carved into my innermost parts. The bright and twinkling stars were already starting to pale when my tongue fell silent, and my wounded heart impatiently called on this desired opponent who was the cause of such ceaseless warfare, and vainly begged for a helpful and effective remedy; but this did nothing but renew my cruel and unremitting torment. I brooded on the state of those wretched lovers whose desire to please others makes them opt for a sweet death; or who, to please themselves, live miserably, feeding their famished lust with nought but laborious and sighing fan-tasies. Thus, like a man exhausted by the labours of the day, with my sad complaint scarcely soothed, the source of my welling tears scarcely dried and my cheeks hollow with amorous pining, I now wanted my natural and timely rest. As my reddened eyelids began to close upon my wet eyes, I was between bitter life and sweet death. A gentle sleep invaded and occupied that part of me that is not united with my mind and with my loving and vigilant spirits, and cannot participate in their lofty operations. O high-thundering Jupiter, shall I call it happy, mirac-ulous, or terrible, this unheard-of vision whose memory makes every atom of my being burn and tremble? I seemed to be in a broad plain [a3] that was all green and adorned with a mass of various flowers. Despite a

gentle breeze, there was a certain silence: the keenest ear could hear no noise, nor the sound of any voice. But the sun's rays made the tempera- ture mild and pleasant.

As I wandered in this place with fearful wonderment, I said to myself 'No human being appears to the eager sight; no forest or wood- land creature, no beast, wild or tame, no rustic house, no peasant's cottage or shepherd's hut, nor even a tent is to be seen.' Similarly in the grassy places one could see no shepherd, goatherd, herdsman or groom, no wandering flocks or cattle accompanied by the rustic two-holed flute or the reed pipe. But reassured by the quietness and pleasantness of the place and thus feeling safe, I proceeded, looking here and there but seeing nothing but the tender leaves resting immobile. Thus I steered my ignorant course toward a thick wood that lay opposite. Scarcely had I entered it than I realized that I had carelessly lost my way, I knew not how. A sudden fear entered my hesitating heart, whose rapid beating spread it throughout my pallid limbs and drained all the colour from my bloodless cheeks. I realized that no track or side-path was to be seen in this thorny wood – nothing but dense thickets, sharp brambles, the wild ash that vipers shun, rough elms that suit the fruitful vines, thick- barked cork-oaks apt for woman's adornment, hard Turkey-oaks, strong roburs, acorn-bearing oaks and ilexes with their abundant branches. They did not allow the sun's welcome rays to reach the damp soil, but covered it like a vaulted roof with dense leaves that the nurtur- ing light could not penetrate. Thus I found myself in the cool shade, humid air and sylvan darkness.

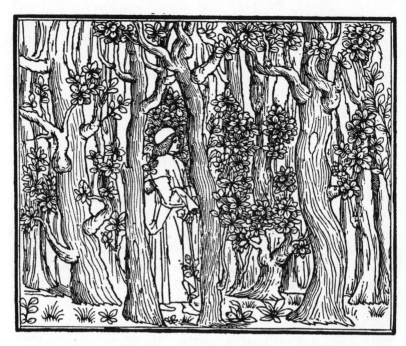

This made me suspect, not unreasonably, that I had arrived at the vast Hercynian Forest, where there was nothing but the lairs of dan‐gerous beasts and caverns full of noxious creatures and fierce monsters. I was defenceless and terribly afraid of suddenly being mauled by a bristly and tusked boar, like Charidemus, or by a furious and hungry wild‐ox, or by hissing serpents; I imagined howling wolves falling upon me and devouring my dismembered flesh. My fear made me waver, but I cursed my inertia and determined to lose no more time in finding an exit and escaping the imminent dangers. I forced my hesi‐tant and wandering paces to hurry on, often falling over roots pro‐truding from the earth, seeking at random now this way, now that, now right, now left, now forwards, now back again, not knowing where I was going. Thus I came to a woodland full of briars and brambles, a place of thorn‐bushes and prickly prunus whose rough berries scratched my face, while the sharp thistles and other spines tore my robe and held me back, delaying my attempted flight. Seeing no indication of a viable footpath or trodden way, I was much confused and dismayed and went even faster. Either my hurrying steps, or the south wind, or the motion of my body made me hot, so that my chilled breast was bathed in sweat. My mind, having no idea of what to do, [a4]

was bound and obsessed by terrifying thoughts. Echo alone offered a mocking reply to my plaintive voice, drowning my loud sighs among the twittering of dewy Aurora's noisy lover and the chirping crickets. At last, in this rough and pathless wood I prayed to the blessed Ariadne of Crete, who had given the ingenious thread to deceiving Theseus, so that he could kill her monstrous brother and come forth from the tangled Labyrinth, that she might likewise deliver me from this dark forest.

POLIPHILO, FEARING DANGER IN THE DARK WOOD, MADE A PRAYER TO JUPITER AND CAME OUT ANXIOUS AND THIRSTY. WANTING TO REFRESH HIMSELF WITH WATER, HE HEARD A SWEET SINGING WHICH HE FOLLOWED, NEG/LECTING TO DRINK, AND BECAME STILL MORE FRIGHTENED.

BSCURITY WAS ALREADY INVADING my mind, and clouds enveloping my senses, so that I did not know which choice to make: would I meet a hateful death, or could I hope for rescue as I wandered in the opaque and shadowed wood? Coursing hither and thither, I put my utmost strength and ingenuity to work for my escape; but my search only took me deeper in, and ever darker. I was becoming incapacitated by terror and fully expecting some wild beast to leap out of somewhere and begin to devour me; or else in my blindness I would stumble and fall into a deep ditch or trench, or into some vast cleft in the earth, then end my painful life like Amphiaraus and Curtius, swallowed up by the mephitic chasm, and fall even further than mad Pyreneus. Thus I wandered pointlessly and almost hopelessly, with my mind in confusion as I sought an exit, trembling like the loose leaves shaken by furious Aquilon in the vinous autumn, when they have lost their greenness and the sweet weight of their sap; and I prayed within myself: 'O Jupiter greatest and best, omnipotent and succouring, if mankind can merit divine favour through sincere prayer and deserve a hearing even when suffering a slight trouble, I call on you, supreme Father and eternal ruler of the higher, middle and lower powers, that you may deign in your measureless divinity to save me from these mortal perils and present

[a4']

horrors, and grant another and a better end to my uncertain existence.'
Thus I prayed, not unlike Achaemenides, who entreated Aeneas with
pleading words when menaced by the dreadful Cyclops, wishing
rather to die by human enemies than to perish so horribly. Scarcely had
I finished making my supplication, in a heartfelt, contrite and
impassioned manner, soaked with tears and believing firmly that the
gods answer a good intent, than I suddenly and unexpectedly found
myself outside that tangled, close and perilous wood, as if coming out
of the damp night into a new day. My eyes were clouded over and for a
while could not bear the welcome brightness; I was so pallid, dejected
and worried that I hardly seemed to have reached the light I so desired,
like one who comes out of the thick darkness of a windowless cell,
freed from the heavy burden of his chains. I was very thirsty and
scratched all over, my face and hands bleeding and blistered with
nettle-stings. I felt lifeless, and hardly seemed to recognize the gracious
light that was before me. My thirst was so great that the fresh breezes
could not cool me or satisfy my parched heart: I tried in vain to
swallow my own saliva, but that had dried up, too. But when I had
somewhat recovered, and my spirits began to revive a little within me,
though my breast was overheated by many sighs, by anxiety of mind
and exhaustion of body, I decided that I must at all costs satisfy my
burning thirst. Therefore I searched the tract carefully in the hope of
finding some water, and was very tired of exploring when a glorious
spring presented itself to me, gushing forth a great vein of fresh water.
Around it grew sweet-flags and half-concealed plantains, flowering
loosestrife and tufted imperatoria; and a clear stream arose from it that
wandered with its tributaries through the deserted forest in an
unkempt and winding channel. It increased as it received the outflow
of many other streams, till its swift waves dashed noisily against
obstructing rocks and tree-trunks. Then a great influx came to it from
the rapid and roaring torrents of melted snow that fell from the icy
Alps, which appeared to be not far off, whitened by Pan's frozen
monster. I had reached this stream several times in the course of my
fearful flight. I found the light rather dim, for the tall trees above the
muddy river allowed only a tattered sky to be seen where their tops [25]
separated into dry, leafy branches. It was a dreadful place for a man to
find himself alone in, with no way through, while the further banks
looked even darker and more impenetrable than the nearer ones.
Several times I was scared by the whistling of falling trees, by breaking

16

branches and the loud cracking of timber, whose terrible noise re-echoed down the long tract, amplified by the density of the trees and the enclosed air. I, Poliphilo, was terrified and anxious to escape from such horrors and to drink the water I longed for. I threw myself down on my knees upon the green banks, and with closed fingers and hollowed palms made myself a cup to drink from, dipping it into the stream and filling it with water to offer to my raving and panting mouth and to refresh my dry and burning breast. It was more welcome to me that the Hypasis and Ganges to the Indians, or the Tigris and Euphrates to the Armenians; more blessed than the Nile to the people of Ethiopia, or to the Egyptians when its flooding inundates the roasted earth. The Eridanus was not more acceptable or refreshing to the Ligurian people than this stream was to me, nor was Liber more grateful for the spring shown him by the fleeing ram. But just as I was raising my hands with the delicious and longed-for water to my open mouth, at that very instant a Doric song penetrated the caverns of my ears – I was sure that it was by Thamyras of Thrace. It filled my disquieted heart with such sweetness and harmony that I thought it could not be an earthly voice: it had such harmony, such incredible sonority and such unusual rhythm as I could never have imagined, and it certainly exceeded my power to describe it. Its sweetness and charm gave me much more pleasure than the little cup I was offering myself, so that the water began to run out between my fingers. My mind was as though stupefied and senseless, my appetite sated, as, powerless to resist, I loosed my knuckles and spilled it on the damp earth.

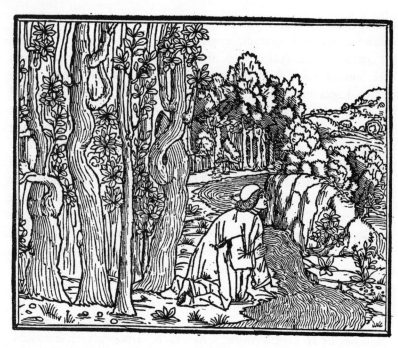

Now, like an animal distracted by a sweetmeat from noticing a
hidden snare, I postponed my natural want and immediately hurried
off toward this inhuman music. But whenever I thought that I was
coming close to it, I would hear it somewhere else; and as soon as I
reached that place, it would seem to have moved again. As its location
changed, so did the voice, its celestial concords becoming ever more
sweet and delightful. But I was becoming exhausted with this pointless
effort, and with running while I was so thirsty, so that I could scarcely
keep my tired body upright. My troubled spirits could no longer
support my gravely fatigued body, whether due to the fear I had suf-
fered, to my urgent thirst, long wandering, or else to my heavy anxiety
and the heat of the day, and I wanted nothing more than peace and rest
for my enfeebled members. I was astonished by what had happened to
me, stupefied by the mellifluous voice, and even more so by finding
myself in an unknown and wild region that was still quite pleasant; but
beyond that, I was distressed to find that the flowing spring I had sought
and found with such trouble and difficulty had disappeared and van-
ished from my sight. All this left me with baffling contradictions,
which I turned over and over in my mind. Finally exhaustion overcame
me; my whole body felt cold and torpid, and I stretched myself out on [a6]

18

the dewy grass beneath an ancient, furrowed oak. It was laden with clusters of acorns, despised by fertile Chaonia with its spacious and wheat-bearing fields, and with knobbly, spreading, leafy branches that made a cool shade above its hollow trunk. There I rested, lying on my left side, drawing the cool air in shallow breaths between my wrinkled lips, more desperately than the exhausted stag, wounded in the breast with an arrow and with the fierce hounds biting at its flanks, when its weakened neck can no longer hold up its head with the weight of its branching antlers, and it falls down on crumpled knees to die. As I lay there in similar agony, my mind ran minutely over the intricate weavings of infernal Fortune and the incantations of malefic Circe, in case she might have enchanted me with her verses or used her magic square against me. This only added to my fears, as I wondered, alas, where among these various herbs I might discover the black-rooted moly of Mercury to treat and cure myself. Then I said 'This cannot be so; but what is it, then, but a cruel deferral of a welcome death?' I remained in these painful agitations, my strength at its lowest ebb, finding no help but in the steady and frequent gasping of air, collecting it in my breast where a particle of vital heat still throbbed and warmed it, and exhaling it through my throat as though retching. I felt no more than half-alive as I took as my last comfort the damp and dewy leaves that lay beneath the fronded oak, pressed them to my pale, cracked lips, and greedily sucked the moisture from them to cool my parched throat. How I longed for Hypsipyle to show me, too, the spring of Langia, as she did to the Greeks! For I was beginning to suspect that I had been bitten in the vast forest, without noticing it, by the dipsas snake, so unbearable was my thirst. In the end, I renounced my weary and outlawed existence, abandoning it to whatever should chance. Stunned and mindless after my heavy thoughts, indeed almost insane, I staggered again beneath the oak-tree's shade and the comfortable spreading cover of its branches. An overwhelming drowsiness came over me, a sweet lassitude spread through my members, and it seemed to me that I slept again.

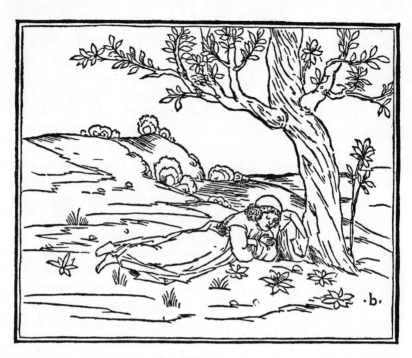

POLIPHILO TELLS THAT HE SEEMED TO SLEEP
AGAIN, AND TO FIND HIMSELF SOMEWHERE ELSE
IN A DREAM. HE WAS IN A VALLEY, BLOCKED AT
THE END BY A MARVELLOUS ENCLOSURE, WITH
A MIGHTY AND ADMIRABLE PYRAMID AND A
TALL OBELISK ABOVE IT. HE STUDIED THIS CARE-
FULLY, WITH DILIGENCE AND ENJOYMENT.

EAVING BEHIND THE TERRIBLE FOREST,
the dense woodland and the other previous places,
thanks to the sweet sleep that had bathed my tired and
prostrate members, I now found myself in a much
more agreeable region. It was not hemmed in by dread
mountains and cloven rocks, nor encircled by craggy peaks, but by
pleasant hills of no great height. These were wooded with young oaks,
roburs, ash and hornbeam; with leafy winter-oaks, holm-oaks and
tender hazels; with alders, limes, maples and wild olives, disposed
according to the aspect of the forested slopes. Even on the plain there
were pleasant copses of other wild shrubs and flowering brooms, and

20

[a7] many green plants. I saw there clover, sedge, common bee-bread, umbelliferous panacea, flowering crowfoot, cervicello or elaphio, sertula, and various equally noble herbs; also many other beneficial simples, and unknown herbs and flowers, strewn about the meadows. This entire happy region was copiously adorned with greenery. Then, slightly beyond the middle of it, I found a sandy or shingly beach dotted here and there with clumps of grass. A delightful grove of palms met my eyes, with the leaves shaped like pointed knives that are so useful to the Egyptians, and with a generous abundance of sweet fruit. Among these date-clustered palms some were small, others of medium size, and the rest straight and tall: the chosen sign of victory because of their resistance to heavy weight. In this place, too, I found no inhabitants, nor any animals. I was strolling alone among the palms, which were not crowded but neatly spaced, thinking that the groves of Archelais, Phaselis and Libya had nothing to match them, when look! – a hungry and carnivorous wolf appeared on my left, its jaws agape!

At the sight of it, all my hairs stood on end, and when I tried to [a7']
shout, my voice failed me. But it suddenly fled, and after a while I recovered myself. Lifting my eyes to the place where the wooded hills seemed
to meet, I saw far off an incredibly tall structure in the form of a tower,
or a high watchtower, next to a great building that was not yet fully
visible, but seemed to be a work of antiquity. I could see the pleasant
hills surrounding the valley rising ever higher as they neared this edifice,
and seeming to join it, so that it was connected with the hills on either
side and made with them an enclosed valley. I reckoned that it would be
well worth examining, and so without delay I set my hastening steps in
that direction. The more closely I approached it, the more it appeared to
be a huge and magnificent object, and the greater was my desire to
admire it; for now it did not look like a high watchtower, but rather a
tall obelisk resting on a vast mass of stone.

The height of this obelisk far exceeded the summits of the flanking
mountains, and would have, so I thought, even if they had been famous
Olympus, the Caucasus, or Mount Cyllene. As I hurried up to this
deserted place I was seized with an unexpected joy, and stopped to
admire at leisure the immensity and stupendous height of the structure,
which was such a bold example of the architectural art, considering
with astonishment the weight and density of this fragmented and halfruined building. It was of white Parian marble, with its square and
rectangular stones fitted without cement, placed equally and level,
smoothed and painted with red along their edges as exquisitely as could
be, so that the thinnest needle could not have penetrated into the borders
or cracks between one edge and another. I discovered there a colonnade
of the noblest form imaginable as to its decoration, design and material;
it was partly fallen, partly still in place, and partly undamaged. There
were the epistyles and capitals, excellently designed and roughly carved;
cornices, zophori or friezes and arched beams; huge, broken statues
missing many of their brass details; niches, shells and vases of Numidian stone and porphyry, ornamented with various marbles; great baths
and aqueducts, and a host of other fragments that lay shattered here and
there, nobly carved, but reduced, as it were, to their first elements, so that
one could not tell what they had been when whole. Many wild shrubs [a8]
had sprouted over and among the broken ruins, especially the unshaken
beantrefoil with its pods, both kinds of mastic, acanthus, dog'shead,
foetid silphium, coarse bindweed, centaury and many other plants that
grow among ruins. On the ravaged walls there grew many stonecrops

and the pendulous navel-wort, and briars full of stinging wasps. Some lizards were crawling among them, and more were creeping over the shrubby walls; several times, in these silent and deserted places, they made motions toward me which made me shrink with no small horror. In many places there were great broken column-drums of serpentine and porphyry, coloured like coral and other beautiful shades. There were various fragmentary scenes carved in the round, in high and in low relief, displaying an excellence that is lacking in our times, and showing that the perfection of this art is defunct. Next, on approaching the central face of this great and splendid work, I saw a conspicuous undamaged portal, proportionate to the entire building.

I could see that the stonework was continuous between the two mountains, interposed between two hanging promontories, and could estimate its size at six stadia and twenty paces. The equal wings of these mountains went perpendicularly from the summit to the ground, which made me stop and wonder what iron tools, what laborious handiwork, what numbers of men it had taken to achieve such a work by force: surely it had demanded great labour and a very long time. This admirable structure, then, was artificially joined to the mountains on either side, causing the valley, as I have said, to be protected by an enclosure such that no one could exit, return, or enter except by this open portal. Now, above this immense construction, whose height from the uppermost coronae to the footing and areobate I could easily estimate as a fifth of a stadium, there rested a monstrous pyramid, shaped like a pointed diamond. I had reason to believe that to invent and carry through such an incredible achievement must have taken incalculable expense and time, and a great multitude of mortals. If I had good reason to consider the very sight of such enormity an unbelievable and inconceivable thing (and it greatly tired my eyes and diluted the spirits of my other senses), how much more so was the making of it? I will try to describe each part of it briefly, as far as it was within the grasp of my intellect.

[a8'] Each face of the square base from which the steps of this admirable pyramid began, located on top of the building, was six stadia in length. Multiplied by four, this gave the ambitus of the pyramid's equilateral footing as twenty-four stadia. Raising a line from each corner equal to the base-line of the plinth, these four lines met above the centre to make a perfect pyramidal form. The median perpendicular above the crossing of the two diagonals of the plinth measured five-sixths of the ascending lines.

This immense and awe-inspiring pyramid rose stepwise with remarkable and exquisite symmetry, like a diamond, and was encased in 1410 steps or stairs, minus ten steps where its tapering stopped, whose place was occupied by a stupendous, solid and stable cube, of such monstrous size that one could not believe that such a thing could ever have been raised to this position. It was of the same Parian stone as the steps, and served as the base and support for the obelisk that I shall now describe. This giant among rocks, exceeding even the missile lifted by Titides, measured six parts along each descending side, two across the bottom, and one across its tapered top. It rested on the upper surface of the cube, which measured four paces on each side. Where the sides met, there were four harpy's feet of metal, with their plumage and clawed toes, firmly fixed in lead toward the angles of the great stone, above the diagonals. They were of proportional thickness, two paces high, and beautifully linked together by a marvellous conflation of foliage, fruits and flowers of appropriate size, which surrounded the lower base of the great obelisk. The latter rested securely on them; it was two paces wide and seven high, artistically tapered, and made from mottled red Theban stone, smooth and polished as bright as a mirror. Egyptian hieroglyphs were finely carved on its faces.

A firm base of orichalcum was placed with care and artistry upon the very top of the obelisk, and above this a revolving machine or cupola was fixed on a stable pin or spike. It held a statue of a nymph, elegantly made of the same material and such as to astound anyone who looked at it long and carefully, proportioned so that when one looked up at it in the air, it appeared to be of perfectly natural size.

Over and above the size of this statue, it was astonishing to consider [b1] the temerity with which such an object had been raised so high, indeed into the air. Its garments were blowing, revealing part of its plump calves, and two open wings attached between its shoulders showed that it was flying. Its beautiful face was turned towards the wings with a kindly expression, and its tresses floated loosely above its forehead in the direction of its flight, while the crown or cranium was bare and almost hairless. In its right hand it held the object at which it was looking: an elaborate cornucopia filled with good things, but turned towards the earth; and it held its other hand tightly over its bare breast. This statue revolved easily at every breath of wind, making such a noise, from the friction of the hollow metal device, as was never heard from the Roman treasury. And where the image's feet scraped against the pedestal

24

beneath them, it made a jingling unmatched by the tintinnabulum in the great Baths of Hadrian, nor by that of the five Pyramids standing in a square. This tall obelisk left me in no doubt that there was none other resembling or comparable to it, not even that of the Vatican, nor the Alexandrian, nor the Babylonian. It contained such a host of marvels in itself that I stood stupefied by the thought of them. Above all there was the immensity of the undertaking, and the exceeding subtlety, the extravagant and acute ingenuity, the great care and exquisite diligence of the architect. What bold invention of art, what power and human energy, what organization and incredible expense were needed to hoist this weight so high into the air, to rival the heavens? What capstans and pulley blocks, what cranes, compound pulleys, frameworks of beams and other lifting machines? It was enough to silence every other stru-cture, however large or incredible.

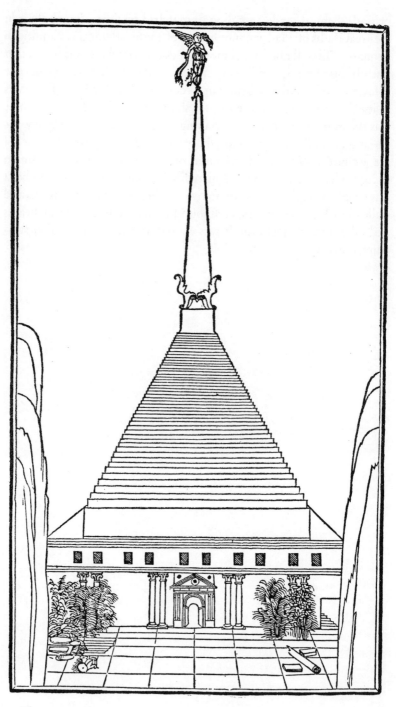

Let us return now to the vast pyramid, beneath which lay a single huge and solid plinth or square slab, fourteen paces high and six stadia in extent or breadth, which formed the footing of the lowest step of the massive pyramid. After careful reflection, I thought that it must not have been brought here from elsewhere, but that human effort had carved it out of the very mountain in this shape and scheme, and reduced it on the spot to this mass. The rest of the steps were put to-gether from separate blocks.

The vast square block did not join the mountains flanking the valley on the right-hand side, by which I passed, but was separated by ten paces on either side. In the middle of the plinth the serpentine head of terrible Medusa was boldly and perfectly carved, howling and snarling to show its fury, with frightful eyes sunk under lowering brows, the fore-head furrowed and the mouth gaping wide. The latter was hollowed out into a straight passageway with a vaulted roof which penetrated as far as the centre, or to the place where the median perpendicular dropped from the uppermost block of the ostentatious pyramid, giving easy access and entry. One climbed to this mouth-opening by way of the curling hair, which was formed with unimaginable cleverness and artistry, and extraordinary invention on the part of its maker, so that one could easily make the ascent to the gaping jaws by means of a regular staircase. Moreover, in place of the curling tresses with their large and lively spirals I was amazed to see vipers and coiling snakes wrapping themselves in a confusion of intricate whorls around the monstrous head. The face and the scaly serpents brawling around it were fashioned in so realistic a way that they caused me no small horror and fear. Their eyes were appropriately set with shining stones, and if I had not been certain that they were only made from marble, I would not have dared to go so near them.

The passageway that I have mentioned was excavated in the solid rock and led to the centre, where there was a winding channel with a spiral staircase by which one climbed to the highest point of this pyramid: the surface of the cube supporting the tall obelisk. Of all these splendid and striking works, I certainly judged this one to be outstand-ing, because this spiral was all brightly illuminated. The ingenious and gifted architect had displayed the highest degree of intellect by creating a number of lighting channels which corresponded to the movements of the sun, illuminating the three sections: lower, middle, and higher.

[b2'] The lower part was lit by the channels above it, the upper part by those

below it, which together with some reflection from the opposite walls gave sufficient light. The clever mathematician had calculated the exact placement of these in the East, South and West faces, so that at every hour of the day the winding stair would be brightly lit. These channels ended at various locations on the great pyramid, distributed widely and symmetrically.

I reached the opening of the mouth by climbing another solid and straight stair that led to the base of the building on the right-hand side. It was cut into the rock beside the mountain cliff, where there was the interval of ten paces, and I climbed up through it, perhaps with more curiosity than was permitted. After passing through the entrance of the mouth to the spiral stair, I climbed round and round to an unimaginable height, not without great fatigue and dizziness in my head. When at last I emerged, my eyes could not even see the ground beneath, for every object below me appeared blurred, and because of this I dared not leave the centre of the platform. Numerous metal posts, shaped like spindles, were elegantly placed and affixed around the circular opening of the upper exit or termination of the winding stair, spaced at intervals of one foot from each other and half a pace high. They were joined at their tops by a curved railing of the same material, and these posts went all the way round, fencing the edge of the opening at the top of the stair, except for the place where one came out on to the platform. I presumed that this was to prevent anyone careless from plunging into the opening of the winding chasm, in view of the fact that the extreme height caused one to stagger. A bronze tablet was set in lead on the underneath face of the obelisk with an antique inscription in our own lettering, in Greek and in Arabic, from which I understood that it was dedicated to the sovereign Sun. All the measurements of the massive structure were also noted and described, and the name of the architect written on the obelisk in Greek:

ΛΙΧΑΣ Ο ΛΙΒΥΚΟΣ ΛΙΘΟΔΟΜΟΣ
ΩΡΘΟΣΕΝ ΜΕ.
LICHAS THE LIBYAN ARCHITECT
ERECTED ME.

We return now to the base or slab beneath the pyramid, on the front of which I admired an elegant and magnificent sculpture of a brutal gigantomachy, marvellously carved, excellently worked and lacking only the breath of life. Its vast bodies had more movement and speed in them than I can ever describe. The imitation of nature was so well exe- [b3]

cuted that the eyes as well as the feet seemed to be struggling and striving as they eagerly swerved to this side or that. The horses looked no less alive: some were sprawled, others falling on the ground; many were wounded and battered, and seemed to be breathing their last; others, furious and unbridled, trampled carelessly with their hooves on the fallen bodies. The giants thrust out their weapons and grappled tightly with one another: some were dragged with their feet caught in the stirrups, others crushed under the weight of their own bodies. Some of them were crashing down with their wounded horses; others, lying on the ground, were still fighting beneath the protection of their shields. Many had daggers in their belts and swords on baldrics, and carried antique Persian blades and many other lethal-looking instruments. Most were on foot, fighting in a mêlée of weapons and shields, some with breastplates and helmets marked with various crests, and others naked, showing that their brave hearts mocked at death. Some were adorned with cuirasses and various noble military decorations. Many were shown as though shouting terribly, while others seemed immovable and furious. Many gave the impression of dying, true to nature in every detail, while others were already dead among the manifold unknown machines of war and destruction. They displayed their strong limbs and bulging muscles, allowing the eyes to see the workings of the bones and the hollows where the tough sinews pulled. This battle looked so frightening and horrible that you would have said that bloody and valiant Mars was there fighting with Porphyrion and Alcyoneus, and that it called to mind the flight of the latter when they heard the asses' braying. This entire image was much larger than life, sculpted in relief from the finest lustrous marble with the spaces filled by black stone, which showed up to perfection the beauty and grace of the white stone and the high relief of the carving. There was an infinitude of giant bodies, extreme efforts, resolute deeds, armoured dress, and death mingled with uncertain victory. Alas, such unremitting variety tired my spirits, confused my mind and disordered my senses, so that not only am I unable to tell of the whole, but cannot thoroughly describe even a part of this masterpiece of stone-carving.

Whence came this ostentation, this ardent desire to heap up jointed rocks in such an assemblage, such a mass, such a peak? What vehicles did they use? What sort of carriers, wagons and rollers served to carry off such an enormity of stones? On what support were they coupled and united? What mass of cemented foundations underlay the tall

obelisk and the immense pyramid? Dinocrates was no more ambitious
when he made his sublime proposal to Alexander the Great concern,
ing Mount Athos. Without a doubt, this extensive structure surpassed
even Egyptian audacity. The marvellous Labyrinth of Lemnos fell
silent beside it, the theatres were dumb, and the august Mausoleum was
not its equal. It was certainly unknown to him who wrote of the Seven
Wonders or spectacles of the world. Nothing like it was ever seen or
imagined in any age. Even Ninus's remarkable tomb is reduced to
silence.

Lastly, I considered particularly how solid and resistant the vaults
must have been to have ever sustained or supported such an intolerable
weight, and what kind of hexagonal and square pillars, what arrange,
ment of piers could have formed the foundations beneath. Thinking it
over rationally, I concluded that either a solid piece of the mountain had
been left underneath it, or else that it had been built on a compacted
mass of gravel and unshaped rocks set in cement. To confirm this suspi,
cion I explored inside the wide portal and saw that it was hollow inside,
and completely dark. In the next chapter I will describe something of
this portal with its marvellous and superb construction, worthy of ever,
lasting remembrance, and tell how excellently it was arranged.

AFTER POLIPHILO HAS DESCRIBED PART OF THE
IMMENSE STRUCTURE AND THE VAST PYRAMID
WITH THE WONDERFUL OBELISK, IN THE NEXT
CHAPTER HE DESCRIBES SOME GREAT AND MAR,
VELLOUS WORKS, NOTABLY A HORSE, A RECLIN,
ING COLOSSUS, AN ELEPHANT, AND ESPECIALLY
AN ELEGANT PORTAL.

AM FULLY JUSTIFIED IN SAYING THAT
nothing like these magnificent works has ever been
thought of or seen by the eye of man in the whole wide
world. I can state with confidence that human knowl,
edge, together with the greatest talent and capacity,
could not attain such audacity in the art and artifice of building, nor
even think of it. After looking at this so intently and concentratedly, my
senses were captivated and stupefied by an excess of pleasure that
excluded any other joy or comfort from the grasp of my memory. As I
marvelled at it and examined carefully every part of the beautiful

[b4] complex, examining these excellent and noble statues made from virgin stone, my emotions were suddenly so warmly aroused that I gave forth a sobbing sigh.

As my loud, amorous sighs resounded in the close air of this solitary and deserted place, I was reminded of my divine and immeasurably desired Polia. Ah, how short a time had this amorous and celestial ideal been absent from my mind, whose image was the perpetual companion of my unknown journey, in which my soul had established a nest for its contented repose, feeling as secure there as if it were deep within a fortress and immune from all fear! Having thus arrived at this place, my eyes were ravished and filled by the sight of a mighty and rare work of antiquity, and above all by a beautiful portal that was as stupendous and incredible in its artistry and elegant in its lineaments as ever could have been fashioned or finished. Without a doubt, I lack the knowledge that would allow me to describe it perfectly, especially since in our time the proper vernacular and native terms peculiar to the art of architecture are buried and extinct, along with the true men. Oh, execrable and sacrile‑gious barbarism, how you have invaded and sacked the noblest part of the Latin treasury and sanctuary! A once honourable art is now pol‑luted and lost, thanks to your accursed ignorance, which in league with raging, unslaked and perfidious greed has extinguished that supreme and excellent portion that made Rome the sublime Empress of the world.

First I should say that a four‑sided area was left uncovered in front of this noble portal. It was thirty paces across and admirably paved with marble squares a foot apart, with the interstices filled with mosaics in variously coloured woven and knotted forms. It had been damaged in many places by falling stones, and overgrown. At the edges of this area, on the left and right toward the mountains, there were two orders of columns at ground level, with the exquisite areostyle spacing dictating the proper distances of the columns from one another. The first row or order on either side began at the edge or extreme end of the pavement, at the metope or front of the great portal, and there was a space of fifteen paces between the two rows of columns. One could see the majority of the columns still intact with their Doric capitals, or else with cushioned capitals, their shell‑ or snail‑like volutes curling out from the echinuses with the astragals beneath, and hanging down on either side, exceeding the bottom of the capital by a third of their height, which was equal to half the diameter of the column beneath. The epistyle or continuous

straight beam lay on top of them, but most of it was fraﬅured and inter-
rupted. Many columns had lost their capitals, and were buried in the
ruins as far as their uppermost projeﬅions: astragal, hypotrachelia and
apothesis. Beside this curving colonnade ancient plane-trees were still
surviving, as well as wild laurel, coniferous cypresses and fragrant
blackberries. I suspeﬅed that it might have been a hippodrome, a xystus
or paradromides, a promenade or avenue with wide open porticos, or
the location of a temporary canal.

On this piazza, ten paces from its beginning toward the door, I saw a
prodigious horse like a winged steed, made of bronze with its wings
spread and of excessive size. One of its hooves covered a circle five feet
in diameter on the surface of the base, and from this circle at the bottom
of the hoof up to where the chest began, I found to be nine feet. Its head
was free and unbridled, with two small ears, one pointed forwards, the
other back, and a long, wavy mane falling down over the right-hand
side of its neck. Many children were trying to ride on its back, but none
of them could hold a firm seat because of the horse's great speed and
hard jolting. Some of them were falling off, others ready to fall; some lay
supine, others got up again and tried to remount. They grabbed the
dense mane and wrapped their hands in it, vainly trying to hold on to

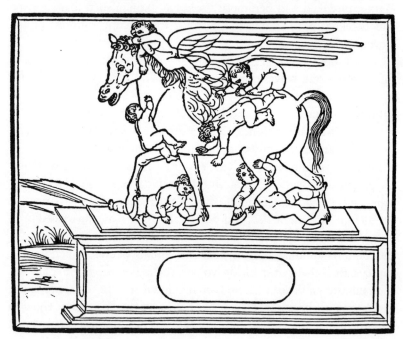

the long hairs. Some of the fallen were trying to rise beneath the body that had shaken them off.

[b5] On the surface of the base, a plaque of the same cast metal was set in lead, and the grounded hooves and the fallen children were fastened in the same way. It was a marvellous work of casting, for the whole com-position and mass had been made in one piece. One could not tell, in the end, whether this careless race-horse had satisfied any of his jockeys, but I doubted it, for the figures seemed sad and weary. If one heard no lament, it was only because they were not alive, for the imitation of nature was so perfect that they lacked only the breath of life. The great skill of imprudent Perillus or of Jewish Hiram would give way before it. It seemed to be bringing these maltreated children to the open portal.

The stage or base of the statue was a marvellous work of solid marble, of suitable depth, height, and length to support the structure fixed upon it. It had varicoloured veins waving through it, and spots confusedly mingled all over it, which gave great delight to the eye. On the front of this stone facing the portal I saw a green marble wreath depicting bitter parsley mixed with the fennel-like leaves of sulphur-wort, in which was set a round panel of white stone. This had the following inscription on it, in Latin capital letters:

Similarly, on the opposite face there was a wreath of deadly aconite leaves, inscribed as shown.

On the right-hand side there were several figures of men and damsels dancing, each having two faces: the one in front was smiling, the back one weeping. They were dancing in a circle with their arms linked man to man, and maiden to maiden. Each man had one arm

going under a woman's arm, and one going above, and thus it went on,
one after another, so that a happy face was always turned toward the sad
face of the next person. There were seven of each sex, carved in perfeĉt
imitation of their lively turning motions and wafting garments, so that
one could not reproach the noble sculptor of anything but having
omitted to give voices to some, tears to the others. This round-dance was
excellently carved within a shape made from two semicircles with a
space between them.

Under this semicircular figure I saw this word inscribed: TIME.
Then on the other side I saw a work by the same artist showing many
young people, perfeĉt in every regard and in the same shape as the other
carving, with beautiful wave-mouldings which in both cases were dec-
orated with exquisite foliage. The youths were busily gathering flowers
among many plants and shrubs, while a number of merry nymphs
were joking pleasantly and playfully snatching the flowers away. Just as
in the other carving, there were some capital letters inscribed beneath
the figures, spelling the single word: LOSS. They were fine, precise
letters, whose thickness was a ninth of their height, and whose width a
little less than its square.

34

I was quite amazed as I mused and gazed with delighted curiosity at this huge erection, cast in the form of an animal: a worthy tribute to human genius, in which every member shared impeccably in the noble harmony of the whole. My retentive memory brought to mind the unfortunate horse Sejanus.

As my mind was wandering about this mysterious artifact, a no less remarkable sight met my eyes: a great elephant, which I was hurrying toward with the utmost delight when suddenly I heard from another quarter a sickly human groan. I stopped immediately, with my hair standing on end and no idea of what to do; then hurried toward the groaning, clambering across a field of ruins covered with large frag-ments and chips of marble. I was advancing carefully when I saw a vast and extraordinary colossus, whose soleless feet opened into hollow and empty shins. From there I went with trepidation to inspect the head. I guessed that the low groaning was the result of divine ingenuity, caused by the wind entering through the open feet. This colossus lay on its back, cast from metal with miraculous skill; it was of a middle-aged man, who held his head somewhat raised on a pillow. He seemed to be ill, with indications of sighing and groaning about his open mouth, and his length was sixty paces. With the aid of his hair one could climb

upon his chest, then reach his lamenting mouth by way of the dense, twisted hairs of his beard. This opening was completely empty; and so, urged on by curiosity, I proceeded without further consideration down the stairs that were in his throat, thence into his stomach, and so by intri- [b6'] cate passageways, and in some terror, to all the other parts of his internal viscera. Then oh, what a marvellous idea! I could see all the parts from the inside, as if in a transparent human body. Moreover, I saw that every part was inscribed with its proper name in three languages, Chaldaean, Greek and Latin. Everything was there that is found inside the natural body: nerves, bones, veins, muscles and flesh, together with every sort of disease, its cause, cure and remedy. All the closely-packed organs had little entrances giving easy access, and were illuminated by small tunnels distributed in suitable places around the body. No part was infe- rior to its natural model. And when I came to the heart, I could read about how sighs are generated from love, and could see the place where love gravely hurts it. All this moved me deeply, so that I uttered a loud sigh from the bottom of my own heart, invoking Polia – and instantly heard the whole machine resonating, to my considerable fright. What an object it was, surpassing the finest invention, as even a man ignorant of anatomy could appreciate! O mighty geniuses of the past! O truly golden age, when Virtue went hand in hand with Fortune! But you have bequeathed to our own age only Ignorance, and its rival Avarice. As I came out at another part through the thickness of the colossus, I saw the forehead of a female head just visible among the ruins, the rest being buried by the great destructions. I surmised that it must have been a similar work, but omitted looking at it for fear of the rough and unsta- ble ruins; so I returned to the first place. Here, not very far from the great horse and on the same level, a huge elephant presented itself. It was made from a rock blacker than obsidian, thickly dusted with gold scin- tillae and silver specks that sparkled in the stone. Its extreme hardness was shown by the bright lustre which caused objects to be reflected in it everywhere, except in those parts where the metal had stained it with its greenish exudations. This was not surprising, for on top of its broad back it had a wonderful caparison of bronze held by two straps girt around its monstrous belly. Between these great straps, which were attached by rivets of the same stone, there was a square block corre- sponding in size to the width of the obelisk that was placed above it. For there should never be air or empty space directly beneath a weight, oth- erwise it will be neither solid not durable.

36

This square block had Egyptian characters beautifully drawn on three of its faces. The broad-backed monster was made with miraculous skill and precision, as well as could ever be done by following the rules of statuary, and the saddle which I have mentioned was decorated with many small figures, bosses, and little scenes and stories, with the obelisk firmly seated upon it. The latter was made from greenish Lacedaemonian stone, and the width of its equal faces at the lowest point was one pace. That, multiplied by seven, gave the height as it

[b7] tapered up to the pointed tip. A round ball was prominently fixed at its summit, made from shiny, transparent material. This great beast, so nobly carved, stood firmly on the flat surface of a vast base of hardest porphyry worked to a high polish, and was equipped with two large projecting tusks of a bright white stone. From hooks on its bronze saddle there hung a fine, ornamental pectoral of the same material, in the middle of which was written in Latin: 'The brain is in the head.' There was also a majestic collar encircling the neck close to the head, from which an ostentatious ornament of cast brass hung over the broad chest, made in a double square with elegant lineaments. On its surface, surrounded by wavy foliage, I saw some Ionic and Arabic letters, which spelled out this.

The beast's voracious trunk did not continue down to the level of the base, but rose up and hung in the air, pointing somewhat toward the front, while the great ears with their network of wrinkles hung down. This statue was no less enormous than the natural beast. Hieroglyphs or Egyptian characters were carved along the oblong surround of the base, which was finished properly with the requisite areobate, the plinth, gula, torus and orbiculo, its astragals or bindings, and a cyma reversa at the footing. The decorations above were no less proper, with the projecting cyma reversa and torque, trochili, dentils and astragals. It was made in symmetrical measures based on its thickness, such that its length, breadth and height were twelve, five and three paces respectively, and the ends were made in semicircular form. In the semicircular part of the base behind the elephant I found a small ascending stair carved out, with seven steps by which one could reach the flat surface, which, in my

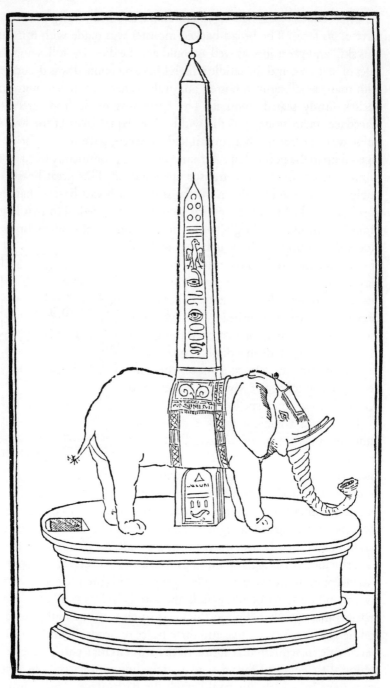

eagerness for novelties, I climbed. Then toward the square area beneath the caparison I saw a small doorway cut out, which I much admired, considering the hardness of the material, through which there appeared a cavity with some metal rungs fixed like a ladder, by which it was easy to ascend and enter the hollow viscera of the elephantine machine.

Strongly impelled by curiosity, I entered and climbed them, and [b8] found that the whole of the huge, prodigious monster was cavernous and empty, except that the same support as was visible underneath was also left inside, with a passage through it that allowed a man to pass easily between the head and the posterior. An inextinguishable lamp was burning, hanging by a bronze chain from the vault of its back and shedding a sepulchral light. This was enough for me to see in the back part an antique tomb made out of the same stone, with a perfect image of a nude man, of natural size and crowned, made from black stone, with his teeth, eyes and nails overlaid with shining silver. He stood on the rounded lid of the tomb, which was covered with imbricated work and other exquisite lineaments, and extended a gilded sceptre made from a bough in his right hand, while his left held a concave shield shaped like a horse's skull. It was inscribed in three languages, Hebrew, Attic and Latin, as follows:

אם לא כי הבהמה כסתה את בשרי
אזי הייתי ערום הפש ותמצא הגיחני

ΓΥΜΝΟΣ ΗΝ ,ΕΙ ΜΗ ΑΝ ΘΗΡΙ-
ΟΝ ΕΜΕΚΑΛΥΨΕΝ.ΖΗΤΕΙ.ΕΥ-
ΡΗΣΗ ΔΕ·ΕΑΣΟΝ ΜΕ.

NVDVS ESSEM,BESTIANIME
TEXISSET,QVAERE,ET INVE
NIES·MESINITO.

This unusual object amazed me not a little, and rather frightened me, so that I did not tarry long but retraced my steps. Thereupon I saw another lantern burning and shining like the first one, and, passing

through the opening of the support, I went toward the animal's head. Here I found another ancient tomb resembling the first in every respect, [b8'] except that the statue standing on it was of a queen. Her right hand was raised, with the index finger pointing to the place behind her shoulders, and with the other hand she held a tablet, which was made continu- ously with her hand and with the lid. On it was inscribed this epigram in three languages:

היה מי שתהיה קח מן האוצר הזה כאות ונפשך
אבל אזהיר אותך הסר הראש ואל תיגע בגופן

ΟΣΤΙΣ ΕΙ . Λ ΑΒΕ ΕΚ ΤΟΥΔΕ
ΤΟΥΘΗΣ ΑΥΡΟΥ, ΟΣΟΝ ΑΝ Α
ΡΕΣΚΟΙ. ΠΑΡΑΙΝΩ ΔΕ ΩΣ ΛΑ-
ΒΗιΣ ΤΗΝ ΚΕΦΑΛΗΝ . ΜΗ Α
ΠΤΟΥ ΣΩΜΑΤΟΣ.

QVISQVIS ES, QVANTVN
CVNQVE LIBVERIT HV-
IVS THESAVRI SVME AT-
MONEO . AVFER CAPVT.
CORPVS NE TANGITO.

This novelty was worthy of a marvellous tale, but I was left in utter ignorance about it and its riddles, which I re-read several times, and in much doubt about their interpretation and deceptive significance. I did not dare to do anything more, for I felt struck with fear in this place, so dark and ill-lit as it was despite the burning lamps. Nor did I lack the stimulus of a strong desire to contemplate the triumphal portal, which was a more legitimate cause than the other for me to delay no longer. Therefore without more ado I made a resolve to return there another time, after seeing the wonderful portal, and to look with more leisure at this magnificent invention of human genius. Thus I quickly reached the opening, descended the stairs, and exited from the hollow-bellied monster: an inconceivable invention, which must have cost incalcula- ble effort and human audacity! What kind of drill or other device could have been used to pierce such hard and resistant rock and to evacuate such a mass of unyielding material, so as to make the hollow interior correspond exactly with the exterior form? Having finally returned to

[CI] the piazza, I saw the following hieroglyphs engraved in suitable style around the porphyry base. First, the horned skull of a bull with two agricultural tools tied to the horns; then an altar resting on two goat's feet, with a burning flame and, on its face, an eye and a vulture. Next, a washing basin and a ewer; then a ball of string transfixed by a spindle, and an antique vase with its mouth stopped. There was a sole with an eye, crossed by two branches, one of laurel and the other of palm, neatly tied; an anchor, and a goose; an antique lantern, with a hand holding it; an ancient rudder, bound up together with a fruited olive-branch; then two hooks, a dolphin, and lastly a closed coffer. These hieroglyphs were well carved in the following graphic form:

After thinking over these ancient and sacred writings, I interpreted them thus:

FROM YOUR LABOUR TO THE GOD OF NATURE SACRIFICE FREELY. GRADUALLY YOU WILL MAKE YOUR SOUL SUBJECT TO GOD. HE WILL HOLD THE FIRM GUIDANCE OF YOUR LIFE, MERCIFULLY GOVERNING YOU, AND WILL PRESERVE YOU UN-HARMED.

41

I left this excellent, mysterious and unfathomable work and went
back once more to look at the prodigious horse. Its head was bony, thin
and proportionately small, and it gave a remarkable impression of
inability to keep still and impatience with waiting; I thought that I
could see its flesh trembling, looking more alive than artificial. A Greek
word was engraved on its forehead: ΓΕΝΕΑ There were many other
large fragments and pieces of lineaments among the great heap of
broken ruins, but out of it all, greedy and winged Time had been good
enough to leave intact only these four stupendous things: the portal, the
horse, the colossus and the elephant. O ancient artificers, our holy
fathers, what meanness infected your great virtue, that, as our inheri-
tance, you took such riches with you to the tomb?

I came, then, to this ancient portal of splendid workmanship,
marvellously constructed with exquisite regularity and art, and mag-
nificently decorated with sculpture and varied lineaments. I was
inflamed with the pleasure of studying and understanding the fertile
intellect and sharp intelligence of the wise architect; and thus I made
this careful scrutiny of its dimensions, its lineaments, and its practical
aspects.

I measured diligently the squares beneath the columns, which were
two on either side, and understood from this measurement the whole
symmetry of the portal, which I will run through with a brief explana-
tion. A four-sided figure, ABCD, divided by three equidistant straight
lines and three transverse lines, will become sixteen squares. Next, a
figure half the size is added to it, and when this added figure is divided
in the same way, twenty-four squares are to be found. (Such a figure
made from threads will prove very useful for foreshortening in mar-
quetry or intarsia work and in painting.) Now two diagonals are drawn
across the first figure ABCD, and then a straight and a transverse line,
intersecting one another, making four squares. Then in the space above
the equal-sided one the four median points are marked, and the lines
joining them constitute the rhombus.

After thus drawing the said figures, it was inevitable for me to
wonder what right the purblind moderns have to vaunt themselves in
the art of architecture, when they do not even know what it is. They
commit such enormities in regulating their faulty buildings, sacred and
secular, public and private, dishonouring the perfect symmetry of parts
through their negligence of nature's teachings. It is a golden saying and
a celestial adage, that virtue and happiness reside in the mean, as the

poet says. Deserting and neglecting this essential point will result only in disorder, and everything will be false, because any part that does not [c2] fit with its whole is wrong. Take away order and the norm, and what work can appear satisfying, gracious or dignified? Therefore the cause of such inharmonious errors arises from the denials of ignorance, and has its origin in illiteracy. Nevertheless, although perfection in this noble art does not deviate from the rule, the clever and industrious architect can adorn his work at will with additions and subtractions so as to gratify the sight, so long as the solid body is kept intact and conciliated with the whole. By 'solid' I mean the whole body of the building that was the architect's original thought, his invention, his prescience and symmetry, well studied and executed without any accessories. It is this, if I am not mistaken, that shows the quality of his talent, for it is an easy matter to decorate it afterwards. What is important is the distribution of it, so that the corona is not put at the foot but at the head, and the ovoli, dentils, etc., must all be in their proper places. The ordering, therefore, and the original invention is assigned to men of rare talent, while the more numerous common and uneducated folk can work on the ornamenta‑ tion. Thus the manual labourers are the servants of the architect; but the latter must never succumb to vile and accursed greed. Besides being learned, he should be well‑spoken, kindly, benevolent, mild‑mannered, patient, good‑humoured, hard‑working, a man of universal curiosity, and slow. Yes, I say slow, so that haste will not lead him into blunders; and that is enough of this.

Let us now take the three preceding figures that we have drawn and reduce them to a single one, including the part added to the sixteen‑ squared figure, and we get this one. Now we remove the rhombus and the diagonals, the three perpendiculars and the three horizontal lines, except for the middle one which ends where it meets the perpendiculars. In this way we obtain two perfect rectangles, one above and one beneath, each containing four squares. If we draw the diagonal of the bottom rectangle and re‑draw it perpendicularly toward the straight line AB, we can easily find from its additional part the width of the arch and of the jambs. Then the line AB will be the proper place for the extended or straight beam. The midpoint of the truncated line EF will be the point from which the arched beam bends in a semicircle. This should have as much added to its downward‑pointing horns as the semidiameter of its thickness. Otherwise it will defective and I cannot call it perfect; for this is how the best and most skilled of the ancients

43

made the beautiful, exquisite and diligent designs for their archings, so as to give the arch elegance and the requisite strength, and to avoid its being blocked by the projections of the abaci.

Now, under the double columns on either side, the square base, [c2'] arula, or podium began with a plinth one foot above the level of the paved area, which was in fact the continuous boundary. From this the reversed cymas, toruses and channels, with their astragals, rose in harmonious stages toward the podium, and thus constituted, with the proper and requisite mouldings, the socles or bases for the antiscolumns. Next there protruded from the top of the podium the cornice with its reversed cyma and other concurrent lineaments.

I found that between the line AB and the upmost line of the master square MN, the space was divided three times, i.e., into four parts, three of which were assigned to the straight beam, zophorus and cornice. This corona claimed a little more space than the beam and the frieze, such that if five parts were assigned to the beam, and the same to the zophorus, then the corona would claim six. It exceeded this limit all the more, since the discerning and clever architect had made a proclivity just above the limiting border of the cyma of the said corona, hollowing it out by half a foot. This was not done in vain, but so that the protrusion or prominence of the corona would not hide the bottom of the sculpture standing above it. He could have enlarged the ornamental part above, such as the zophorus, but that would have disturbed the symmetry assigned to it. A perfect square followed above this first crowning, with the following rule.

The zophorus projected above the perpendicular of the columns as follows: dividing it into two parts, one of these gave the thickness of the highest corona. There were two such squares, one on each side, and the remainder, in between them and perpendicularly above the opening of the portal, was divided in seven parts, the middle one being reserved for a throne or niche in which the statue of a nymph was placed. Three parts on either side were left for the flanking squares.

The amount of projection of the upper cornice was easily given: by making a square equivalent to its thickness and drawing its diagonal, the exact measure of its projection was found.

Now, adding together the entire figure of twenty-four squares, one obtains the sesquialter proportion that gives the figure OPQT, which clearly contains in itself a rectangle and a half. Dividing that half equally by straight lines into six portions, there will result five interstitial

44

lines and six partitions. The peak of the frontispiece occurs by rule at the midpoint of the fifth line up, from which the lines sloped down by [c3] the proper angle until they cut the lateral extension of the corona. Their extremities united exactly with the cymas of the projecting corona.

Finally, the frontispiece corresponded exquisitely with the linea- ments of the elegant cornice: its first order was taken from the plane of the projecting square, and its last from part of the dentillated cornice, within which the angular figure was contained.

This portal was diligently made from evenly-polished slabs of cut stone, with the undulating figures conforming to the closely-joined slabs, the inset work beautifully fitted, and the material bright and attractive. On either side of the doorway, separated from it by two paces, two large, superb columns stood still unshaken, buried up to their bases in broken fragments. I cleared the debris as best I could, and was able to uncover the bronze bases, excellently cast from the same material as the capitals. For my pleasure I measured the thickness of one base, and found that doubling it gave the lowest diameter of the column. By this measurement I found its height to be more than twenty-eight cubits. The two columns next to the door were of finest porphyry and lovely serpentine; the other two were of Cariatic marble, furrowed or fluted, and plainly visible. Beside these to left and right there stood companion- able pairs of columns with modest entasis, made from hard Laconic stone.

The semidiameter of the lowest circumference of the column gave the thickness of its base, which consisted of toruses, an orbiculo (also called scotia or trochilo) and a plinth. Dividing them by three, one part was taken by the plinth, whose width was one and a half diameters. Then, dividing the two remaining parts in four, the upper torus took one part, while the other three were assigned by halves to the lower torus and the concave trochilo, with the fillets taking a seventh part of the whole. I found that these measurements had been elegantly observed by the skilful builders. Above the regular capitals of these columns a splendid beam or epistyle extended, with its lower fascia ornamented with round whorls or berries, and its second fascia with a string of trun- cated spindles alternating with two compressed beads. The third fascia was beautifully decorated with flattened ears expertly carved among stalks of fine foliage. Above this was the zophorus of sinuous fronds, on whose ends or points were various large stems and flowers interspersed with tendrils carved in deep relief, on which many birds were nesting.

45

Above this was an order of exquisite mutules with spaces between
them, and above that, the inverted slope of a generous cornice. This
cornice was interrupted by breakage, so that beyond it could be seen the
greater part of the building, with the outlines or semblances of large
double windows surrounded by their ornaments, giving little indica-
tion of how the building had been when whole and perfect. Beneath the
beam that I have described was the cyma or pointed summit of the fron-
tispiece of the surviving doorway, making an area between its slope and
the beam in the shape of a scalene triangle, that is, one with unequal
sides. The beam was supported from beneath, in the space between the
columns, by marvellous mutules artistically spaced; and in the triangu-
lar figure described, where it could embrace the widest space, there were
carved two roundels imitating a platter with its edge surrounded by
undulations, gulas and scotias. The furthest protrusion among the
encircling lineaments was of a swelling torus nobly clad in closely
packed oak-leaves, overlapping one another and bound with fringed
ribbons, interspersed with acorns. Inside these circles were two venera-
ble images emerging from the hollow or concave surface from the bust
upwards, their breasts clothed with the pallium, knotted over the left
shoulder in antique fashion; they had full beards and laurels on their
brows, and were dignified and majestic in aspect.

In front, on the squared projection of the zophorus above the afore-
mentioned columns was the following sculpture: an eagle with
outspread wings perched with its taloned feet upon a swelling garland
of leaves and fruits, sagging in the middle and with its tapering ends
secured on either side by outstretched shoots, executed almost trans-
parently.

The open doorway was on a level with the flanking colonnades,
faced in smooth marble and arranged in the best possible way. That is
why I had first to describe the principal members of this magnificent
portal, and will continue in the next chapter by explaining its graceful
and beautiful ornaments. For to the serious architect, being comes
before well-being. That is to say, he must know above all how to arrange
the solid mass and to complete in his mind (as I said before) the entire
fabric, rather than the decorations that are accessory to the principal
matter. It is the first thing that demands the fertile skill of one rare man,
whereas the second needs numerous labourers or unschooled workmen
(whom the Greeks call 'doers'); and these, as I have said, are the instru-
ments of the architect.

AFTER POLIPHILO HAS SUFFICIENTLY DES-
CRIBED THE GREAT PORTAL AND ITS MEASURE-
MENTS, THERE FOLLOWS HIS BEST DESCRIPTION
OF ITS FINE AND SKILLED ORNAMENTATION, AND
OF ITS REMARKABLE COMPOSITION.

LTHOUGH I HAVE SPENT SOME TIME
on the preceding description, I hope that I have given
some small gratification even to the noble crowd of
those dedicated to the works of benign Amor.
Although hungry to learn what I intend to relate,
however bitter in itself, perhaps they can feed with
patient mind and contented heart on what is served here. For since
human affection is naturally mutable, let us not blame the bread that
suits simple tastes just because it sometimes displeases the jaded palate.
This is why I have spoken in several places about the proper goal of
architecture, which is its supreme invention: the harmonious establish-
ment of the solid body of a building. After the architect has done this,
he reduces it by minute divisions, just as the musician sets the scale and
the largest unit of rhythm before subdividing them proportionately into
chromaticisms and small notes. By analogy with this, the first rule that
the architect must observe after the conception of the building is the
square, which is subdivided to the smallest degree to give the building
its harmony and consistency and to make the parts correlate with the
whole. This is why the present portal was so beautiful in its admirable
composition and invention, and why it was so particularly elegant and
so faultlessly arranged, so that not even the most obscure element of it
could provoke criticism. Thus I think it now worthwhile to describe its
perfect ensemble.

On the right, first of all, there was a stylopodium or column-footing
beneath the bases of the columns. Its perfect square was bounded at the
top by a small cornice, and by moderate cymas at the bottom, thus
leaving a rectangular space broader than it was high. I must use the
vulgar speech, and not the Roman vernacular, because we are degener-
ate and lack that thesaurus by which we might explain all the details of
such a work; so we shall use whatever crude terms of this kind survive.

This altar, as I might call it, was adorned with gullets covered in
foliage, subtly incised in moderate relief. Between them there was a
transparent alabaster stone, whose well-proportioned reliefs were

protected by the edges of the square front that went evenly all around it. There was a carefully sculpted image of a man, somewhat past his virile years and ruddy like a peasant. He had a dense beard with strong, prickly hairs that seemed to break with difficulty through his thick skin.

He was sitting on a sculpted rock, wearing a goatskin whose shaved back parts he had knotted above his hips, while the neck hung with the fur inwards between his veined legs. In front, between his muscled calves, there was an anvil fixed in a knobbly tree-trunk, upon which he was busily forging a small pair of glowing wings, lifting up his hammer to strike his creation. Next to him there stood a noble lady who had two feathered wings inserted in her delicate shoulders, and held a naked infant, her son. As he sat with his little bottom on the plump maternal thighs, the Mother Goddess lifted him up so that his bare foot was placed on a rock that formed part of the seat of the hammering smith, like a hillock of stones. There was a furnace in a little cave, in which the coal fire was burning. The lady wore her hair combed forward over her broad brow and copiously encircling her head; she was so delicately represented that I could not see why the adjacent statues that also appeared in this work did not fall in love with her! One was an armed man with a furious expression, wearing an antique cuirass like the aegis with the frightful head of Medusa on the chest, and other noble and exquisite decorations. He wore a baldric across his broad chest, and held a spear half-raised in his muscular arm. His head was protected by a crested helmet, but his other arm was not visible, being blocked by the figures in front. There was also a youth, visible from the chest upwards and dressed in thin material, behind the inclined head of the smith.

The sculptor had diligently placed this scene against a background of coral-coloured stone, and inserted it within the mouldings framing the altar. The colour showed through the translucent alabaster and in the spaces surrounding the figures, imparting a look of pink flesh to the nude limbs and bodies. Every lineament of this column-support was [c5] repeated identically in the other, differing only in the scene.

Similarly, on the left pedestal was carved a nude man of virile age with a kindly face and signs of great speed. He was seated on a square bench decorated with ancient carvings, and wearing boots that were undone from the thigh to the calf, from which protruded two wings, one on each foot. The same lady was there, shown in her divine nudity with two small breasts standing out from her narrow chest, immobile in their hardness and roundness, and with ample thighs, so exactly as in

the other carving that they seemed to have come from the same mould. She was offering her own boy-child to this man for instruction, and the child, already winged, was stretching up on his little feet while the man was genially showing him three arrows. One could easily tell from this that the child was being taught how to use them, while his divine mother was holding the empty quiver and the unstrung bow. At the feet of this master lay a snaky caduceus. Here, too, were the armed man and a helmeted woman who held a trophy on a spear: it was made from an ancient cuirass, and on the top a sphere with two wings, between which there was this inscription: 'NOTHING FIRM'. She was wearing a loose dress that showed the upper part of her breast.

Two freestanding Doric columns of porphyry, seven diameters high, stood on each of these two squares that I have described. They were bright and polished, and dark red, randomly dotted with circles of a lighter colour. They were each fluted with twenty-four channels going exactly between the nextruli or fillets, but the lower third of them was filled in with a cable. I thought that the reason that they were carved thus, with the third part filled, might be because this excellent building or temple was ritually dedicated to beings of both sexes, such as to a god and a goddess, or a mother and son, a husband and wife, a father and daughter, or something similar. Then the wise ancient fathers would have attributed a greater part to the female sex (the fluted portion) than to the male (the filled portion), because the slippery nature of the former exceeds the latter in lasciviousness.

The reason that flutings were used for the temple of a goddess is that they represented the folds of feminine garments, while the capitals placed upon them with their hanging volutes indicated the braided hair of women and their ornaments. The Caryatids, which have a female head for the capital, were made for the temple of a rebellious people after their subjugation, because of their feminine inconstancy, whose perpet-
[c5'] ual memory was signified by columns thus constructed.

The fine, detached columns just described rested upon the support-ing plinths on bases of bronze, with their toruses or cymbias carved with oakleaves and acorns, tightly bound up with twisted ribbons. The capitals above them were of the same material as the bases, making the entire work suitably harmonious with itself. The over-refined Calli-machus saw nothing like them in the acanthus growing from the basket upon the Corinthian maiden's tomb, which he expressed in his charm-ing ornament. These capitals were topped by sinuous abaci or recurved

covers decorated in the center by a lily, with their vases excellently clothed in the Roman and Corinthian style with two rows of eight acanthus leaves. Out of these leaves issued the lesser volutes, turning toward the middle of the vase and bearing the lily, which was beautifully placed on the curve, after which the stems curled down beneath the protrusion of the abacus. Agrippa was right to place such columns in the pronaos of the wonderful Pantheon, adding to their height an entire diameter of the bottom of the column and observing the same symmetry in all the parts and accessories.

The threshold of the doorway was made from an immense leek-green stone, whose tough surface was marred with a scattering of white, black and grey spots and various other indistinct stains. The straight antis-columns rested on this, standing one pace from the edge of the threshold, with their inner sides smooth and lustrous but their outer faces notably carved. There was no sign of hinges either on the threshold or above, nor any indication of iron hooks retaining the half-capitals, which were of the same stone. Above this there curved the arched beam or semicircle, with the requisite lineaments and measured fascias of the beam, namely balls or berries and spindles, arranged by tens as if threaded on a string; dog's ears; sinuous or lappeted rinceaux in antique style, with their stalks. The spine, wedge, or keystone of the arch was worthy of admiration for its bold and subtle design and its elegant finish, which made it a splendid sight to see.

I then looked with amazement at an eagle, sculpted almost free-standing from a dense black stone, with its wings spread: it had amorously seized a sweet and delicate boy by his garments, taking care that its sharp and recurved talons did not injure the soft flesh. Thus it carried him with its claws through his clothing, bringing his feet up toward its swelling, arched breast and leaving the hanging child naked [c6] from the navel downwards, so that his tender buttocks faced the feathered thighs of the bird. This beautiful young boy, worthy of him who had seized him, showed by his expression that he was afraid of falling. He spread his little arms and grabbed with his plump hands toward the oar-bones of the spreading wings (that is, the bones that are connected by a mobile joint to the body), while his fat infant legs bent and kicked his feet out toward the broad tail, which descended beautifully beneath the soffit of the arch. The boy was carved with great artistry from a white vein of agate or onyx, and the bird from sard, which is the other vein that goes together with it. I stood stupefied by this exquisite cre-

ation, wondering how the artist's imagination had been so perspicuous as to use this stone for his purpose. I could guess from the way the eagle's feathers stood up somewhat around the beak, which was half open, revealing its playful tongue, that it was blatantly showing its libidinous intentions. Its back imitated the vault of the enclosure, and so, similarly, did the bent back of the child.

The remainder of the archway was arranged as a ceiling of small squares, excellently moulded, in the middle of which neat rosettes hung down carved in high relief. These squares were the same width as the capitals of the antis-columns, above which sprang the curved vault of the adytum or opening of the portal.

In the triangles made by the arch there was a noble sculpture of a Victory, made in the manner commonly known as cameo. The wafting garments clung to the virginal body and uncovered the beautiful calves, breast and shoulders; the hair was loose and the feet bare, as she held out toward the corner the trophy of victory. All this neatly filled the whole triangular area, with black stone to make the metal objects seem more real, while the nymphs were white as milk. The white slab of finest marble was to be seen attached behind the columns.

Above the beam rested the zophorus, in the middle of which was fixed a hooked tablet of gilded metal with an epigram in elegant Greek capital letters inlaid with refined silver, which read as follows:

[c 6']

ΘΕΟΙΣ
ΑΦΡΟΔΙΤΗΙ ΚΑΙ ΤΩΙ
ΥΙΩΙ ΕΡΩΤΙ ΔΙΟΝΥΣΟΣ
ΚΑΙ ΔΗΜΗΤΡΑ
ΕΚΤΩΝ ΙΔΙΩΝ
ΜΗΤΡΙ ΣΥΜΠΑΘΕΣΤΑΤΗΙ

That is: To the blessed Mother, the Goddess Venus, and to her Son, Amor, Bacchus and Demeter have given of their own (substances). The two sides of the brazen tablet were held by two putti or winged spirits, perfectly formed, such that the diligent sculptor of the famous putti that support the conch at Ravenna never saw the like. Their plump hands were joined to the tablet, and held it up to view. They were nude, and of the same metal, and well placed against a slab of blue stone, which was more beautiful in colour than that which is pressed into pastilles and squeezed till it gives forth a perfect azure, and as lustrous and translucent as glass.

On the front of the zophorus directly above the porphyry columns

51

there were trophies of cuirasses, coats of triple mail, shields, helmets, fasces, axes, torches, quivers, javelins and many other weapons of war for use in the air as much as on earth or sea. They were excellently made, and doubtless displayed on either side the victories, powers and triumphs that caused thundering Jupiter to change his shape, and mortals to perish in bliss.

The imposing cornice followed in due order, made with the lineaments that accord properly with the elegance of such a work. For just as in the human body, when one quality is discordant with another, illness ensues (because well-being consists only in the harmony of the compound, and when the parts are not distributed in their proper places, deformity follows) thus a building is no less dissonant and sickly when it lacks due harmony and proportionate order. The ignorant moderns confuse these things, knowing nothing about spatial arrangement. But our wise master likens a building to a human body with well-proportioned parts and decorously dressed.

Above this cornice with its inverse steps there were four protruding squares: two placed above the fluted or caryatid columns, and two contained in the central division. In between them was an excellent bas-relief of a nymph, made from orichalcum. She held two torches: one extinguished and pointing toward the ground, and the other lit, held up to the sun. The burning one was in her right hand, the other in her left.

In the square to the right I saw jealous Clymene, whose hair was [c7] turning into unmoving leaves. She followed weeping after Phoebus, who angrily spurned her, urging on the four coursers of his flying chariot with no less speed than that of a man hurrying to escape pursuit by a deadly enemy.

In the square above the left-hand column was carved an unusual scene, showing the disconsolate Cyparissus holding his delicate arms up to heaven, on account of his deer having been shot by an arrow; and Apollo was weeping bitterly.

The third square, placed next to the one above the sturdy columns, offered this beautiful sculpture: Leucothea, impiously slain by her own father, changed her white and girlish flesh into tender bark, shaking leaves and leaning branches.

The unfortunate Daphne was shown in the fourth square, about to yield her virgin flesh to the desires of the long-haired god of Delos, but sadly changing beneath the torrid skies into eternal greenery.

52

Now, in successive order above the cymatium (which is the name for the uppermost line of any lineament) of these scenes that I have described, a dentilled cornice stood out, and an ovolo with lightning-bolts or darts inserted in the gap between each pair of eggs; then foliage, and the tiles with their joints; niches and other images, and other fine carved work; also the mutules with the astragals, without any defect, and then the cyma, foliated with acanthus leaves and no visible joints. The carving of these things was so expert that, despite being cut in deep relief, there was not the slightest sign of the drill's teeth.

We return now to the frontispiece or pediment, which was arranged, as I have said, so that all the cornices beneath it were replicated all around it. It was aligned with the members beneath it so as to keep the rainwater off the uppermost cornice, which is harmful to that member.

We must now describe the triangular surface of this temple-front, which was worthy of admiring contemplation. The maximum space possible within it was taken up by a wreath of various interwoven leaves, fruits and stems, carefully made from green stone and tied in four places with knotted thongs that were interwoven with the wreath. Two semi-human Scyllae, whose lower parts were those of fish, held it in a suitable grip with one hand above and the other below. Their monstrous [c7'] fish-tails extended in ample coils into the angles on both sides above the cyma of the cornice, ending in scaly fins. They seemed like maidens, with their hair parted and twisted over the forehead and the rest arranged around the head in feminine style, leaving some to hang down in ringlets over their flat temples. From between the shoulders came spreading harpy's wings, stretching out toward the rings of their curling tails, and seals' flippers encircled their monstrous flanks. At the point where the scales began gradually to disappear, toward the end of the tail, they touched the wreath with the feet of sea-calves, which repel the celestial wrath.

Inside the wreath I saw a shaggy mother goat nursing a child, who sat beneath her with one plump leg stretched out and the other folded beneath him, holding his arms up to grab the rough, hanging hair, turning his face to the swollen udders and sucking on them. One of the nymphs was bending down kindly and holding one of the goat's feet in her left hand, while with the other she directed the heavy, distended udder to the sucking mouth of the nursling. Underneath one could read: AMALTHEA. Another nymph was standing at the animal's

53

head and dutifully encircling its neck with one arm, while with the other she gracefully restrained it by the horns.

A third nymph was standing in the centre, holding a branch in one hand, and in the other an ancient drinking-cup with exquisite handles. At her feet was inscribed: MELISSA. Two more nymphs, placed between the three already described, performed an agile leaping-dance with corybantic instruments, imitating the agitated movements in their nymphal fashion. Oh, how artistically the mystery of its magnificent execution had been accomplished! Such a faultless bas-relief was never made by the stone-carver Policleitus, nor by Phidias, nor Lysippus; pious Artemisia, Queen of Caria, was not offered such a splendid masterpiece of the chisel by Scopas, Bryaxis, Timotheus, Leochares or Theon. For its artifice surpassed all human skill and sculpture.

Finally, on the temple pediment or frontispiece, on the flat surface beneath the order of the topmost cornice, there appeared these two words in perfeét Attic capital letters: ΔΙΟΣ ΑΙΓΙΟΧΟΙΟ.

Such was the marvellous composition and excellent arrangement to be seen in this notable and speétacular portal. If I have not explained every detail of it separately, it is from fear of long-windedness and from lack of the proper vocabulary to encompass it. But since devouring Time had left it alone intaét, I could not pass it by without some description and treatment of it.

The remainder of the enclosure I have mentioned had evidently been [c8'] built up with great splendour on both sides, as could be seen clearly from some works that had been preserved intaét here and there, such as a few piers in the lower parts, made to resist immense weight; some other Corinthian columns with unfamiliar entasis, finished with a gentle swelling as symmetry demands and to satisfy the requirements of carving and ornamentation, and the artistic rules derived carefully and exaétly from the human body. For just as a man, for supporting heavy weights, needs large feet beneath robust legs, so a well-modulated building should have stout piers at the bottom, and then, for ornament, the graceful Corinthian and Ionic columns. Thus all the parts had the appropriate elegance according to the requisite harmony of the building, with coloured marbles suitably distributed and chosen for their contribution to the beauty of the objeét, including porphyry, serpentine, Numidian marble, alabaster, marble with fiery spots, Spartan marble, white marble, and others with undulating veins the colour of coals, stained with pure white spots, or with other colours confusedly min-

54

ΔΙΟΣ ΑΙΓΙΟΧΙΟΝ

gled. From their circumferences I calculated the height, using the rule drawn from their lowest diameters.

I also found a rare form of cushion-shaped base which had two trochili on the plinth, separated by hypotrachelias and astragals, with a torus above.

Various places were obstructed by a dense, hanging ivy growing from the ground in serpentine form; a cup made from its wood divides Bacchus from Thetis. Its scattered clusters were rich with black berries and downy growth; it occupied many crevices in the ancient building, together with many other wall plants. In the cracks grew the vigorous house-leek, and in other places navelwort sprouted forth, and erogen- neto (pleasant to those who bear its name) hung down to the ground. In other broken places there grew pellitory and diuretic chickweed, poly- podium, maidenhair and fringed spleenwort with its wrinkled underside; jointed lesser selenitis and other aizoi that love old walls and rocks; also polytrico and green privet, which frequent ruins. Many a noble work was clothed and covered with these and many other plants.

There were huge, tapered columns that had unimaginably fallen on top of one another, looking less like columns than like a confused heap of timber dashed to the ground. There were also statues visible among the ruins, representing various actions: many nudes, some with pleated [d1] or folded garments adhering closely to the naked form and showing the covered members; some resting on the left foot, some on the right, holding their heavy heads perpendicularly above the centre of the heel, and extending the other foot, free of all weight. (The foot was a sixth part of the overall height of four cubits.) Some of them were still stand- ing upright on their pedestals; others, more modest, were seated. I saw innumerable trophies, booty and spoils; endless ornaments of ox- and horse-skulls arranged at proper intervals; cornucopiae with the remains of leaves, apples, stems, pods and other fruits swelling their bodies, with putti playfully riding on them. From all of this I could well judge how fertile the learned architect's mind must have been; how careful, stu- dious and industrious he was, and how vigilant his inventive mind; how hard he had worked to achieve so voluptuous an effect; what eurhythmy had informed the subtleties of the stone-carver's work, and what artistry the sculptor showed in his stone. He displayed such facility that the material seemed to be of soft chalk or clay rather than hard marble, so exactly were the stones adjusted and fitted together at the joints, with perfect evenness and regularity.

56

That is what true art was, which reveals our confused ignorance, our detestable presumption and our common, damnable error. That is the clear light that graciously invites us to contemplate it, so as to illuminate our dimmed eyes; he who rejects it remains blind, even though his eyes be wide open. This is the accuser of that criminal avarice, rapacious and devouring of every virtue, the worm that continually gnaws at the hearts of those it has captured, the cursed obstacle and destroyer of gifted minds, the mortal enemy of good architecture, the execrable idol of our century, so unworthily and damnably worshipped. Oh, fatal venom! What misery is his whom you have wounded! How many magnificent works have been partly and completely ruined? This is why I was seized and overcome with pleasure and unthinkable happiness, and with such gratitude and admiration for holy and venerable antiquity, that I found myself looking around with unfocused, unstable and unsated gaze. I looked eagerly here and there, filled with wonder and overwhelmed in my mind as I thought over the meaning of the carved scenes I was examining, looking fixedly at these with the utmost pleasure and remaining for a long time with my mouth agape. Even so, I could not satisfy my hungry eyes and my insatiable appetite for looking again and again at the splendid works of antiquity. I was deprived and as though sequestered from every other thought, except that my beloved Polia often came graciously and helpfully into my tenacious memory. [d1'] But for all that, it was with a loud sigh that I painfully recalled her, then continued admiring these most welcome antiquities.

AFTER ENTERING THE PORTAL WHICH HE HAS
DESCRIBED, POLIPHILO SAW AGAIN WITH GREAT
PLEASURE THE WONDERFUL ORNAMENTATION
OF ITS ENTRANCE. WISHING TO GO BACK AGAIN,
HE SAW A MONSTROUS DRAGON, AND, INCREDI-
BLY FRIGHTENED, TOOK FLIGHT THROUGH UN-
DERGROUND PLACES. IN THE END HE FOUND THE
EXIT HE HOPED FOR, AND ARRIVED AT A PLEAS-
ANT SITE.

 IGHT IT NOT BE A GREAT AND PRAISE-
worthy thing, if one could easily describe, point by
point, the incredible work and unthinkable assem-
blage of this vast structure, the grandeur of the edifice
and of its beautiful portal, suitably situated in a lofty
and conspicuous place? The pleasure of contempla-
tion exceeded even my great wonder, because, by Jupiter, I thought that
its making would not have been difficult for higher beings; and I sus-
pected that no human art or science could have put together such
vastness or expressed such grand ideas, invented such novelties, orna-
mented them with such elegance, arranged them with such extra-
ordinary symmetry, and accomplished the splendid and unimaginable
ostentation of this structure without any addition or correction.

For this reason, I had not the slightest doubt that if the author of the
Natural History had seen or known of this, he would have disdained
Egypt and the industry and genius of its workmen who, scattered in
many different workshops, were commissioned by the statuaries to
carve one part and told its dimensions; then they joined together all the
pieces in perfect symmetry, to make a gigantic colossus that looked as
smooth as if it had been made by a single sculptor. The historian would
have had reason to think less of the brilliance of Satyros and other
famous architects, notably the marvellous work of famous Memnon at
Simandris, who carved three great statues of almighty Jupiter out of a
solid rock; one of these was seated, and the sole of its foot was seven
cubits long. The present work would likewise eclipse the stupendous
miracle of magnanimous Semiramis's effigy on Mount Bagistanus,
which was seventeen stadia high. We would hear no more of the proud
height of the pyramids of Memphis about which writers have written so [d2]
extensively. The famous theatres would be neglected, along with the

58

amphitheatres, baths, sacred and profane buildings, aqueducts and colossi; the marvellous and astonishing Apollo transported by Lucul/ lus, the Jupiter dedicated by Claudius Caesar, that of Lysippus at Taranto, the miracle of Chares of Lindus at Rhodes, those of Zen/ odorus in Gaul and in Rome, the colossal Serapis, nine cubits high, made from an incredible emerald; the famous Labyrinth of Egypt and the solid statue of Hercules at Tyre. The historian would have passed over them and, amending his eloquence, would have gloried in writing the highest praises of this one, as the greatest miracle of them all – even though there was an inestimable sight in the temple of great Jupiter: an obelisk forty cubits high, made from four pieces, four cubits broad on one side and two on the other.

I gazed insatiably at one huge and beautiful work after another, saying to myself: 'If the fragments of holy antiquity, the ruins and debris and even the shavings, fill us with stupefied admiration and give us such delight in viewing them, what would they do if they were whole?' And then I thought again, reasoning with myself: 'Perhaps inside there is the venerable altar of mysterious sacrifices and sacred flames, or even the statue of divine Venus and the holy of holies of Aphrodite and her Son, wielder of the bow and arrow.' And as I placed my right foot rev/ erently on the sacred threshold, I saw a white mouse run fleetingly in front of me. Suddenly, without any thought but curiosity, I went some way through the open entrance into the bright hallway, carefully exam/ ining what was there, as deserving my eternal respect. The walls to right and left were cased in glossy marble, and a large disc was attached to the centre of the wall, surrounded by a leafy coronet excellently carved. This, like the one opposite, was of the black stone that resists hard iron, and polished like a mirror. As I heedlessly passed between the discs I was filled with sudden fright at the sight of my own refle/ ction, but was reassured by an unexpected pleasure, for they offered a clear view of the scenes that were depicted there in splendid mosaic work. Low down on both sides, beneath the bright mirrors, there were stone seats along the walls. The floor was clean and free from dust, made from fine new tiles. Even the coloured ceiling was free from unwanted spiders' webs, because a fresh breeze continually blew there; the ceiling joined the panelled walls beneath the border, which was subtly designed to extend from the capitals of the straight pilasters as far as the [d2'] end of the hallway –a distance of twelve paces, as far as I could judge.

The ceiling began its upward curve from this smooth band, making

59

the arc of the vault conform to that of the doorway. The border was richly inventive and delightful, with excellent carving, being harmo-niously filled with little semi-human sea-monsters in an imitation of water and waves. There were women with curling fish-like tails seated on their backs, some of them nude, embracing the monsters with mutual intertwinings. Some played the flute or fantastic instruments, while others were seated in strange chariots drawn by tireless dolphins. Some were crowned with the cold flowers of water-lilies and clothed in the foliage of the same; others had many vases filled with fruits, and overflowing horns. Some were striking each other with bundles of sedges and flowers of wood-beard; others were girt with trivuli. The rest fought mounted on hippopotami and various other unfamiliar beasts protected with tortoise-shell. Here and there they were acting las-civiously, or playing various festive games. Their vivacious gestures and movements were carved and expressed to perfection, and the decoration ran all the way from one side to the other.

On the voussoirs of the portal I saw an elaborate vermiculate work, exquisitely made from vitrified tesserae with their surfaces gilded and attractively coloured. First there was a frieze two feet wide that went around the entire vaulted space above the band I have mentioned, then in a double course along the crest of the vault. Its colours were as lively as if it had only just been made, showing a natural foliage of emerald green with the reverses in scarlet, with blue and purple flowers, inter-mingled with graceful spirals and knots. I saw the following scenes depicted in the spaces enclosed by it.

Europa, as a young maiden, swimming to Crete upon the seductive bull; the command given by King Agenor to his sons Cadmus, Phoenix and Cilix to recover their abducted sister; they, not having recovered her, strenuously slew the scaly dragon at the gushing spring. Then, after consulting the oracle, they were told by Apollo to build the city with their companions at the place where the lowing heifer lay down; hence that country bears to this very day and eternally the name of Boeotia, after her mooing. Then Cadmus built Athens, the second brother Phoenicia, and the third Cilicia. This mosaic picture was very well arranged in the strict order of the fable, depicted in natural colours so to give the best expression to the actions, the places and the events.

On the part opposite this one, done in the same fashion, I admired the lewd Pasiphae inflamed with infamous passion and deceptively hiding herself in the wooden contraption, while the robust bull lascivi- [d3]

ously covered her, all unknowingly. Then there was the monstrously formed Minotaur, shut up and imprisoned in the difficult and devious labyrinth. After this, the clever Daedalus making ingenious wings for himself and Icarus to escape from their imprisonment; but the unfortunate son did not follow his father's command and example, and fell headlong into the Icarian waters, to which, dying, he gave his name. Last came the father, safe and sound, hanging up the oar-like device he had made from feathers in the temple of Apollo, in fulfillment of his solemn vow.

I gazed intently at this with my lips agape, my fluttering and mobile eyelids motionless, my soul enraptured, as it contemplated these scenes which were so beautiful, so well arranged and perfectly in order, depicted with such art and executed so elegantly, and preserved without the slightest damage. The cement was so strong that the glass squares were compacted and stuck there for ever, undamaged to this day and with not a single piece missing, because the brilliant artist had assembled this excellent work with the greatest of care. I moved along step by step, steadily examining the method of depiction that he had used for the calculated placement of his figures in their proper planes; how the seams of the material followed the objects; how in some places they seemed to vanish from sight, while in others the objects, at first imperfectly visible, came gradually to perfection, as if yielding to the eyes against their will. There were exquisite details of waters, springs, mountains, hills, woods and animals, whose colours faded with distance and opposing light; there were the appropriate reflections in the folds of garments and in other places, in no small emulation of nature's skill. I was so amazed and absorbed that I was as though lost to myself.

In this way I came to the end of the hallway, where the charming scenes ended, but beyond that there was such dense darkness that I did not dare to proceed. I was turning to go back when suddenly I heard a sound in the ruins like the breaking of bones and the cracking of branches. I stood stock still, my delightful recreation shattered, and then heard, closer to hand, a sound like the dragging of a great bull's carcase over the rough and ruin-strewn ground. As it grew ever louder and nearer to the doorway, I heard the deafening hiss of a giant serpent. I was stunned. Voiceless, and with my hair standing on end, I felt no reassurance in rushing for escape into that thick darkness.

Oh, how wretched and cruel was my fate! Suddenly there appeared on the threshold of the portal, not the lion that came limping to Andro-

cles's cave, but a frightful and horrific dragon! Its triple tongue trembled [d3']
in its jaws, which were full as a comb with sharp, serrated teeth. Its fat,
scaly body slithered over the tiled pavement, and as it glided, its wings
slapped its furrowed back, while its long tail wound itself in serpentine
fashion into tight, unstable knots. Oh, death! It was enough to frighten
warlike, armoured Mars, or to make Hercules, the feared protector,
tremble, despite the knotted club he got from Molorchus; enough to
deter Theseus from undertaking his bold enterprise; to terrify the giant
Typhon even more than the high gods were terrified by him; and to
make the most hirsute, stubborn and indomitable lose heart. Alas, if it
would have dragged sky-bearing Atlas from his post, what then of a
timid young man in these unknown parts, all alone, unarmed and
nervous about danger? I noticed that the monster was spewing out foul
smoke, which I immediately suspected to be deadly, but I had no way of
escape from this mortal peril. With my poor soul almost spiritless, in my
fear and trembling I devoutly invoked every divine power.

Without a moment's delay, I turned my back and entered in full
flight into the darkness, forcing my feet to go ever faster as I swiftly pen-
etrated the unknown interior of the darksome place. I fled through
many twists and turns, many devious paths, which made me think I [d4]

was in the inextricable maze of clever Daedalus, or of Porsena, because it contained so many baffling turnings and returnings, with frequent doors that led nowhere but sent one back to make the same errors again. I might have been in the chambered cavern of the dreadful Cyclops, or in the dark cave of furious Cacus. Although my eyes had become somewhat accustomed to the darkness, I was miserably unable to discern a single thing, but walked with my arms stretched out in front of my face to avoid striking my head on a pillar as I went. These did the office of my sightless eyes, just as a snail, carrying its house, stretches and shrinks its soft little horns to feel its way and draws them in at every obstacle. That is how I went, feeling so as not to bump into these massive foundations of the mountain and the pyramid. I kept turning toward the doorway to see if the cruel and fearful dragon was following me, but the light had totally vanished.

Here I was in the blind entrails and winding channels of the dark caverns, in greater fear and mortal danger than Mercury when he was turned into an ibis, Diana into the cholomene bird, Pan into double form, and Apollo exiled in Thrace; greater than that of Oedipus, Cyrus, Croesus or Perseus. I was in more deadly panic than Thrasileon, the robber in the bearskin; in worse anguish than Psyche, and greater danger than Lucius when he was an ass and heard the robbers deciding to kill him. Without any guidance whatever, I was truly ignorant and desperate. At this point, when all these fears, terrors and alarms had thoroughly scared and cowed me, my state was worsened by the flight of many bats around my head. Many times, the squeaking of these beasts made me believe that I was already between the sharp teeth of the venomous dragon, and firmly gripped by its crushing, saw-toothed jaws. I had no respite from this when the wolf I had seen came to mind, redoubling my grave fears and confirming me in my anguish. Could it perhaps have been an evil omen and the herald of my present miseries? I wandered hither and thither like a fruit-gathering ant that has lost the scent of its path, straining my ears to hear whether the repulsive monster was coming after me, wretch that I was, with its venom as poisonous as the hydra's, its hideous tongue and voracious appetite. Everything I encountered made me think immediately that it was at hand.

Finding myself thus naked, utterly helpless, in mortal fear and dissolving in misery, although I naturally did not think of hateful death as pleasant in the least, I reckoned that at this moment it would be

welcome. But try as I would, I could not wish for it, as I tried to face it [d4']
firmly in my uncertain, unhappy and timorous life. Ah, how I resisted
the dissociation of my spirit! I rejected death, refused its advantages and
regretted its noxious presence. For I was incensed when I thought of
how I might die without any consummation of my immense love, and
without enjoying any fruits of that sweet inflammation. If my loved one
had suddenly appeared before me here and now, I would have thought
nothing of death. But I returned to my fixed and habitual object,
weeping for the loss of two such dear things: Polia, and my precious life,
invoking her with a sighing and sobbing voice that resounded through
the thick air enclosed in the giant vaults and enfolded in the hollow
places, saying to myself 'If I die here, wretched, miserable and utterly
dispirited, who deserves to be the heir to such a precious jewel? Who
will possess such a priceless and golden treasure? What serene sky will
seek so bright a light? O miserable Poliphilo, how you are losing your-
self! By thus taking flight, do you expect to regain your heart's desire? It
would instantly interrupt and destroy all the charming pleasures that
your sweet love has planted in your mind. All your amorous and lofty
imaginings would be cut off and vanish in a trice. Alas, what evil fate
and malefic star has led you into this dangerous and oppressive dark-
ness, cruelly exposed you to many a mortal anguish and destined you to
die from the fierce appetite and violent maw of this terrible dragon?
Alas, what if I am swallowed whole to rot inside its foul, filthy and
faecal entrails, to be afterwards ejected by an unthinkable exit? What a
strange and tragic death, what a poor way to end my life! What eyes are
so barren, dried up and exhausted that they would not melt and well up
with great tears? But here am I at death's door, feeling the beast at my
back. Who has ever seen such an atrocious and monstrous reversal of
fortune? Here is woeful and pitiless death, and the supreme hour, the
accursed moment when in deep darkness my human body and flesh
shall nourish this terrible beast. What greater cruelty, what rage, what
misery can mortals suffer than the denial of the sweet and lovable light
to the living, and of the earth to the dead? But the calamity is all the more
hellish if I am to lose in this tragic and untimely way my beloved and
untouched Polia. Adieu, adieu, then, noble light of virtue and of every
true and genuine beauty: farewell!' Overwhelmed by such affliction
and distress and broken beyond belief, my soul reached utter exaspera-
tion. I realized that I must act immediately to escape the terrible danger [d5]
and save my poor, short life, or else expire in agonies from this irre-

64

sistible violence. I did not know what to do, being so confused from wandering through strange places and devious windings; my legs were dragging from weakness, and my bodily strength was all gone; I was fainting and losing my mind like one bewitched.

Having come to this pitiful pass, at the last resort I appealed out of my innocent soul to the high and omnipotent gods and my own good genius, beseeching them of their eternal goodness to take notice of my wretched state. And behold! I began to descry a faint light. Ah, how speedily I hastened toward it, till I saw a perpetual lamp burning before a holy altar, which as far as I could judge at such a moment was five feet high and twice as broad, with three golden statues upon it. I could not tell the nature of the light, and was struck by no small religious awe in this dim sanctuary. Despite the lamp, I could see little because of the thick, unhealthy air that is inimical to light. My ears were still alert, for I had lost none of my fear. Some dark statues were visible, whilst all around were vast and indiscernible corridors and fearsome subter-ranean passages beneath the mountain, supported on either side by great piers in endless rows, some square, others hexagonal or octagonal, scarcely discernible in the feeble light but of a size fit to bear the excessive weight of the pyramid pressing down on them. Having paused a moment here to pray, I could think of nothing more than to flee into the unknown; but no sooner had I run dispiritedly past the holy altar than I saw again a particle of blessed light that seemed to gleam through a narrow funnel-shaped tube. As I looked at it, how my heart leaped with joy! How I hurried joyfully toward it without another thought, faster perhaps than Anystis and Philonides; and as soon as I saw it, I felt such joy and desire that I gladly revoked my former contempt for my unpleasant and burdensome life, and calmed my unsettled mind and wavering soul. As I recovered somewhat, confidence began to return to my empty and loveless heart and filled it to the brim with burgeoning love, while its lost and exiled thoughts returned to their pristine state. Now, fixed all the more strongly on my beloved Polia, I tied myself to her with fresh bindings and resolved with firm and flattering hope that I would henceforth honour and adore her, whom I had thought tragi-cally lost to me through my premature death. O how extremely I tortured myself! I did not resist any of love's new boilings and burnings which my long-suffering and besieged heart might harbour, but, seeing every hampering obstacle removed and every assault ceasing, I opened myself to them and welcomed them freel in.

[d5']

65

Having been somewhat consoled by the blessed light, my depressed and discouraged spirits revived, and my debilitated energies recovered fully; I took courage and resumed my uncertain and pathless way, for the nearer I approached my goal, the more visible it became. Heaven's will accompanied me, with beloved Polia reigning supreme in my loving breast, as I eagerly arrived there, giving well-merited thanks to the gods, to complaisant Fortune, and to my golden-haired Polia. I finally reached the broad outlet and hurried out of it, without hesitating for a moment as I fled, while my arms, busied hitherto with avoiding collision with the stout pillars, turned themselves conveniently into oars to assist my flight. My efforts brought me out into a beautiful region, though I dared not stop and sit down for fear of the horrible monster, which had so impressed itself on my mind that I still thought I could feel it at my back. Such terror was not easily dissolved or instantly banished, for I thought it likely that it was still pursuing me. I felt agitated, even though everything invited me to proceed: first, the amenity of this beautiful place; next, my troubled soul spurring me to swift flight; but most of all my eternal desire to see and discover things that might be unknown to mortals. These motives urged me equally to enter this region and to get as far as possible from the exit; to find a place where I could quietly calm myself and regain peace of mind, letting my terrors pass into oblivion. My memory brought back the pleasant thought of the white mouse that had appeared at the doorway where I entered, and I took it as an encouragement to be of good cheer, for in the auspices this was always a happy sign and a good omen.

Thus I decided, as was fitting, to consign myself to benevolent Fortune, who had often offered me her hair as the generous dispenser of prosperity and good luck. Urged and pressed on by this, I began to move forward a little on my sluggish way, hampered only by my tired and aching legs. Yet as I entered this region I was still understandably [d6] worried lest my fortuitous arrival and hasty entrance into an unknown land might be against the law, and constitute a worse presumption and audacity than my entrance into the magnificent portal. Thus, with my heart steadily thumping and perplexity in my soul, I said to myself: 'Is there anything that would persuade me to turn back? Is it not easier here to flee and escape freely? I think it much better to risk exposing my life in the light and open air of this place than to perish brutally in that blind darkness. Besides, I would not know how to return to that opening by which I exited.' And at that moment groaning sighs arose from the

depths of my sad heart, as I recreated in my tenacious memory all the pleasure and delight of which my senses had been deprived; for it had been an astounding work, and full of marvels. As I remembered how I had been cruelly robbed of it, I imagined the brazen lions in the temple of the wise Jew, which scared men to the point of oblivion.

I wondered whether the dragon had caused something similar in myself. For I had diligently admired such elegant and marvellous objects, such stupendous inventions, that they appeared to be superhuman and most worthy of recall; yet now I had to admit that they had lightly fled my dried-up memory, and that consequently I could not have given a detailed account of them. I said to myself 'This cannot be. Yet I feel no lethargy, and all the recent events are in place in my intellect and memory, and indelibly depicted there. That savage beast was really alive and not an illusion, and so terrifying as was rarely seen by mortals, not even by Regulus.' And as I recalled it, my hair stood on end again and my rapid steps grew hastier. A little later I reflected and said to myself 'Without a doubt, to judge by the pleasantness of this site, even if humankind are lacking there may very likely be divine spirits here, tutelary heroes, various kinds of nymphs and ancient gods.' Then desire urged me forward on my chosen path, hastening my tardy steps. I was like a captive, continually goaded onwards, as my bold heart invited me to follow wherever frivolous Fortune led, even if I should collapse in the attempt.

As I considered this beautiful and pleasant country with its fruitful fields and fertile plains, and the pleasure it gave me, I rejoiced at this invitation and advanced somewhat, putting behind me my hindering fears and miserable apprehensions. But first I prayed to the divine light and the good genii to direct me on my arrival here, to be present as my companions while I wandered as a stranger, and to bestow their holy guidance upon me.

LAND HE HAD DISCOVERED AND ENTERED, IN
WHICH HE FOUND ON HIS WANDERINGS AN
EXQUISITE AND REMARKABLE FOUNTAIN; AND
HOW HE SAW FIVE MERRY MAIDENS APPROACH-
ING HIM, WHO, MUCH SURPRISED AT HIS ARRIVAL
THERE, KINDLY REASSURED HIM AND INVITED
HIM TO JOIN THEM AT THEIR RECREATIONS.

ORTH I CAME OUT OF THIS HORRIBLE
abyss, this intense darkness, this infernal place (not-
withstanding the holy Aphrodisiac sanctuary that was
there) to the welcome light and the friendly air of this
wonderful region. I turned to look back at where I had
emerged, where my life had not seemed worthy of the name, so troubled
and imperilled as it was. I could see an unknown mountain of medium
steepness, all wooded with green and pleasant foliage: acorn-bearing
roburs, beeches, and oaks – holm-oaks, Turkey-oaks, winter-oaks and
cork-oaks – beside the two kinds of ilex of which one is the yew, the
other the holly or prickly one. Further on toward the plain it was dense
with cornel-cherries, hazels, fragrant and flowering privets with their
perfumed blossoms of two colours, showing red to the north and white
to the south; hornbeams, ash, and burgeoning shrubs that looked
similar to these, which were wrapped in green climbing honeysuckle
and twining hops, giving a cool and opaque shade. Beneath these were
the sow-bread that hinders childbirth, frilly polypodium, triple-leaved
spleenwort, the two kinds of hellebore named after the shepherd, trifoli-
ate or triangular tora, sanicula and other shade-loving herbs and
woodland trees, some flowering and others not. Nevertheless, the place
was steep and rough, and thickly surrounded by trees.

The opening by which I had issued from that hidden lair was some-
what high up on the forested mountain and, as far as I could tell,
opposite the other gateway I have mentioned. I realized that this one had
once been as wonderful a work as the other, but that jealous and envious
age had overgrown it, concealing its entrance with climbing shrubs,
especially ivy and other such leafage, so that one could scarcely see any
exit or opening. The place served only for exiting, not for returning,
though it was easy enough for me to discern it, because it was all sur- [d7]
rounded by the thick, dark foliage that would prevent others from

knowing it was there. It was inside a dell with crags stretching above, perpetually dimmed by thick fogs that seemed darker to me than the one which concealed the divine birth on Delos. On departing from this leafy, obstructed portal I descended some way down the slope and came to a thick copse of chestnuts at the foot of the mountain, which I suspected to be a dwelling-place of Pan or Silvanus. I enjoyed passing through its damp grass and pleasant shade, till I came upon an aged marble bridge consisting of one fairly broad, high arch. On both sides of the parapet there were very convenient seats, but although they were inviting to me, tired as I was from my escape, I spurned them for the sake of my eager progress.

In the middle of each parapet, somewhat raised and directly above the keystone of the arch beneath, there was a rectangular panel surrounded by an elegant cyma with fine lineaments; one was of porphyry, and the opposite one was similar, but of serpentine stone. On the right-hand side of my path I saw some noble Egyptian hieroglyphs depicting the following: an antique helmet crested with a dog's head, a ox skull with two fine-leafed branches tied to its horns, and an ancient lamp. I interpreted these hieroglyphs (apart from the branches, which I could only identify as fir, pine, larch, juniper, or something similar), as follows:

PATIENCE IS THE ORNAMENT, GUARDIAN
AND PROTECTOR OF LIFE.

On the other side I saw this elegant carving: a circle, and an anchor around whose shaft a dolphin was entwined. I could best interpret this as ΑΕΙ ΣΠΕΥΔΕ ΒΡΑΔΕΩΣ: Always hasten slowly.

Beneath this antique, solid and noble bridge there rushed a broad [d7']
stream of fresh water, which divided into two running brooks, one to
the right and one to the left. They flowed, cold and murmuring,
through broken and eroded channels and between worn and
entrenched banks covered with rocks and shaded by trees. On these
banks one could see various roots laid bare, among which were hanging
spleenwort, maidenhair fern, navelwort and other woodland plants that
like to cover riverbanks. This cool and dense wood looked pleasant and
invited one to walk beneath its cheerful leaves, full of forest and moun-
tain birds. It extended a little beyond the bridge toward a pleasant plain
that echoed with their sweet songs. Lively squirrels were jumping
around, together with sleepy dormice and other harmless native
animals.

Thus the whole woodland region that I have described, bounded by
the forested mountains, was very pleasing to the eye, with its plain all
covered with various herbs, its fresh streams rushing into the valley from
the feet of the steep mountains, decked with bitter flowering oleander,
osiers, ground poplar and loosestrife, and shaded by tall poplars, both
black and white, and by riverside elders and rowans. On the mountains
one could see tall, single-stemmed firs, weeping larches and pines, and
similar species of noble, leafy trees.

As I considered this place, it seemed so pleasant, such a perfect
dwelling and resort for shepherds, and certainly conducive to singing
bucolic songs, that it caused me some surprise and uneasiness of mind
to see such a kindly homeland left unpopulated and fallow. Then as I
cast my eyes over the comely plain, carefully surveying the area I have
mentioned, I saw a marble building appearing beyond the trees with its
roof above their delicate tops. This thrilled me, thinking that I had at
last found a habitation and some place of refuge, and without a
moment's delay I hurried toward it.

I discovered an octagonal building with a rare and marvellous foun-
tain, whose invitation I did not refuse as I slaked the thirst that had
remained unsatisfied for so long. This edifice had an octagonal roof
covered with lead. On one face it had a stone of shining white marble
whose height was one-and-a-half times its width; I judged the latter to
be six feet. Two fluted pilasters were carefully carved in this noble stone,
resting with their bases above a straight cyma with a gullet, dentils and
cordings. Its capitals supported a small beam, zophorus and cornice, [d8]
above which another quarter of a square was assigned for the fron-

tispiece. All its lineaments were carved in the same single block and unadorned, except that I saw in the angular concavity or plane of the frontispiece a wreath containing two doves drinking from a little vase. The entire space bounded by the colonnettes, gullets and beam was cut back and hollowed out, and contained an elegant carving of a nymph. Beneath the cyma was the other quarter, which served as a pedestal with its wave-moulding, toruses, torques, scotias and plinth.

This beautiful nymph lay sleeping comfortably on an outspread drapery, part of which was beautifully wadded and folded to form a pillow for her head, while another part was made into a convenient cov-ering for that which should remain concealed. She lay on her right side, with the lower arm bent and its open hand beneath her cheek, lazily supporting her head. The other arm was free and extended along her left side with its hand open halfway down her plump thigh. The nipples of her small breasts were like a virgin's, and from them spurted streams of water, cold from the right-hand one and hot from the left. Both streams fell into a porphyry vase containing two receptacles side by side in the same stone, placed on a block of limestone six feet away from the nymph. There was a channel inserted between the two receptacles by which the waters flowed together, and the rims were grooved in the middle of each receptacle for the waters to escape, after which they mingled in a trough or gutter and ran down from there, each tempered by the other, to make all the vegetation grow. The hot stream shot up high enough so as not to impede or hurt those who placed their lips to suck and drink from the right breast.

The sculptor had made this statue so perfect and beautiful that I really doubted that Praxiteles had equalled it in carving his Venus, which King Nichomedes of Cnidos spent all his people's money to buy, so it is reported, and which was of such beauty that men burned with sacrilegious lust for it and ravished the statue by masturbating. But whatever it was worth, I judged that there had never been an image of such perfection made by chisel or knife, and wondered not unreason-ably whether a living being had been turned to stone in this place and thus petrified.

She held her lips slightly open so as to breathe, and the opening was carved and drilled out so that one could almost see her throat. Her loose tresses flowed over the cloth, with the finest hairs following the grooved or folded surface of the rumpled material. Her thighs were suitably fleshy, her plump knees slightly bent, showing her narrow feet which

[d8']

71

tempted one to reach out one's hand to stroke and tickle them; and the rest of her lovely body was enough to provoke even one made of stone, like herself. Behind her head was an arbutus tree with its evergreen foliage and many soft, round fruits, full of birds which seemed to be twittering and inducing the nymph's sweet slumber. At her feet there stood a satyr, all aroused in prurient lust: he had goat's legs, his lips adhered to his snub, caprine nose, and his beard divided at the chin into twin tufts of goatish curls. These also covered his flanks and his head, which had hairy ears and a wreath of leaves, and seemed to be a mixture of goat and human. I reckoned that for this immensely skilled work, the sculptor must have been able to summon up nature's own creation in his mind.

This satyr had violently seized the arbutus tree by its branches in his left hand and was gallantly bending it over the sleeping nymph so as to make her a pleasant shade. With his other hand he held the end of a curtain that was knotted to the branches near the trunk. Between the leafy tree and the satyr there were two satyr-children, one holding a vase and the other with two serpents wrapped around its hands.

I cannot describe adequately how delicate, how elegant and perfect this image was, to which was added the beauty of the stone, which was like polished ivory. Once again, I especially admired the fine pierced drill-work of the branches and ce-dar-like foliage, the birds with their little feet so precisely carved, and the figure of the satyr.

Below this miraculous sculpture, on the flat fascia between the gullets and the mouldings, I saw inscribed this mysterious saying in fine Attic characters:

ΠΑΝΤΑ

ΤΟΚΑ

ΔΙ

✳

ΠΑΝΤΩΝ ΤΟΚΑΔΙ

I could not say whether the temptation to drink came more from the burning thirst of that whole day and the one before, or from the beauty of the source, whose chill indicated that the stone was lying. Around this tranquil place and its babbling brooks flourished whortleberries, lilies of the valley, flowering lysimachia, sweet calamus and cedovaria, parsley and water sorrel, and other prized waterside herbs and noble [ei'] flowers. The channel that issued from the fountain entered and watered

a thicket or enclosure of no great height, made from rose-bushes in neat array, of various kinds and decked with fragrant blossoms; then the water ran away into a plantation of bananas, with their great leaves lac-erated by the breezes and their tightly-packed bunches of sweet fruit hanging down, and other delicious fruit-trees. There was also the arti-choke, beloved of Venus, and the green Egyptian bean with its shield-shaped leaves, and an infinite number of cultivated plants. Looking over the plain, I saw it blooming everywhere with varieties of plants distributed colourwise. For yellow, there were ranunculus and frogfoot or oxeye. For peacock blue there were satyrion, lesser centaury, crowned melilot and tiny euphrasia. For gold, there were scandix and flowering navew; and for azure there were chicory and the gladiolus that grows in the corn. There were flowering and fruiting strawberries, tiny-leaved achillea with its white flower clusters, serratula, cuckoo-bread, and countless other beautiful flowers. Lost in the wonder of the place, I felt consoled. Leafy orange, lemon and lime trees were planted here and there, elegantly spaced at regular distances and precise inter-vals with their equal branches hanging one pace from the ground. They were thick with foliage of a glass-green colour and were formed like cones, with long spires and rounded bases, rich in flowers and fruits and exhaling a delicious perfume. My contracted heart filled itself gen-erously with this, invaded as it had been by the pestilential stink and corrosive reptilian breath.

I stood thus for a long time, musing in suspense and wonder at having found myself in this present place which was so delectable to my senses, and in particular at having carefully examined the marvelous fountain. The variety of plants, the colour of the flowers, the plantation of trees, the noble and comfortable arrangement of the site, the sweet and unceasing bird-song, the temperature and purity of the air, would all have made me perfectly contented if only I had found some habita-tion. As I felt the urge to proceed further, the place seemed to please me more and more, even though my former terror was not yet utterly purged from the grasp of my memory. For this reason alone I stopped and looked from side to side, not knowing which way I should follow.

As I stood in this state of suspense, all unsettled by the thought of the terrible dragon and by having arrived I knew not where, there sud-denly came to mind the hieroglyphs on the left-hand side of the bridge, and I wondered if I was rushing into some troublesome accident. Such a monument had not been placed there for the passers-by in vain, [e2]

74

but was worthy of the golden inscription: ALWAYS HASTEN SLOWLY.

Suddenly I heard a great noise and din behind me, like the flapping of the dragon's bony wings, and before me, horrors! I heard the sound of a trumpet. Wretch that I was, I twisted frantically around and saw on one side a number of Egyptian carob-trees with their long, ripe fruits hanging down: they were shaking and striking together as they were blown by the wind. I quickly came to my senses and moved on, laughing at what had occurred.

For this reason, I now piously invoked the kindly god Jugantinus and the goddesses Collina and Vallona, praying that they would favour me as I passed through their sacred places. I wondered whether the sound of the trumpet betokened a military troop, but on reflection it had sounded more like a shepherd's bark-trumpet, which made me more reassured than worried. It was not long after this that I heard a company approaching which I guessed, from its tender young voices, to consist of comely and beautiful maidens, merrily taking their ease on the flowery grass and in the cool, pleasant shade, passing through the lovely flowers innocent of all suspicion and with great gaiety. The incredible sweetness of their harmonized song wafted to me on the temperate and dewy breezes and spread throughout the pleasant region, blending with the suave accompaniment of the lyre.

Curious about such a novelty, I crouched under the low branches and watched them approach with expressive gait. Their girlish heads were encircled with splendid ribbons of gold thread and crowned with flowering myrtle, wreathed and intermingled with many other flowers. The blond ringlets twisted and trembled on their snow-white foreheads, and their loose tresses, artfully composed with nymphal elegance, hung down behind over their white shoulders. They were dressed in Scarpantian fashion with three tunics in ornate silk of various colours and textures, one shorter and distinct from the others. The lowest one was dyed with conches, then followed one of green silk shot with gold, and the uppermost one of finest cotton crêpe, dyed with saffron, belted with a golden cord just beneath the rounded breasts. Their extended arms were clothed by the last of the tunics with generous cotton sleeves that allowed the colour of the flesh to show gracefully through them, and were tied near their plump hands with cords of fine silk knotted with little golden rings: an alluring device! Some of them wore double-soled sandals that were beautifully secured to their little feet with many laces

of gold thread and purple silk. Some were shod with half-boots of scarlet and green cloth; others had soft and comfortable leather on their bare feet, either polished or chamois and dyed in beautiful colours, concealing the toes.

These shoes, with their gilded eyelets, had a sinuous opening above [e2'] the snow-white ankle; they were tightly laced and fastened with leather thongs pierced by golden pins, or else with loops exquisitely knotted from gold cord. The hems surrounding their garments were decorated with unimaginable knotwork fringes, which were sometimes blown by the gentle breezes to give a glimpse of their rounded, ivory legs.

As soon as they noticed me, the nymphal step ceased and they stopped their song, suddenly interrupted by finding such a novelty as myself venturing into this place. They murmured curiously among themselves and looked me over silently, finding it extraordinary and unprecedented that a strange and foreign man should have chanced to arrive in this famous land. Thus they stood for a little while secretly whispering to one another, often looking at me and leaning forward to examine me, as if I had been a ghost. Oh, dear! At this point I felt all my entrails quiver like calamus leaves trembling in a strong wind. I had

76

scarcely recovered from my previous fear than I began to think, with good reason, that I had transcended the human condition (knowing no other) and was having a divine vision such as burned Semele to a cinder, after she had been tricked by the feigned form of Epidaurian Beroe. Alas, I began to shiver all over again, becoming more fearful than timid fawns when they see the tawny lioness roaring with hunger. I debated whether I should sink to the ground on my knees as a suppli-

[e3] ant, turn around and go away – for these gracious girls seemed more celestial than human –, or stand still where I was. In the end I decided to risk whatever danger might ensue, feeling confident that there could be no conceivable inhumanity or savagery in these people, and espe-cially because innocence carries its own protection. I thus aroused my timid soul, still dampened by embarrassment at having trespassed in this possibly sacred place and in the pleasant conclave of these delicate and divine nymphs. Moreover, I was not fully at ease in my mind about my arrival here: perhaps I had thrust myself with unwarranted pre-sumption into prohibited places and a forbidden land. As I was turning these thoughts over and over in my mind, one of them, more confident and bold than the rest, said pertly: 'Who are you, eh?' I was flustered with my habitual fear and sudden shame, not knowing what to say or reply, and with my voice and mind both paralyzed, I remained standing half-dead, like a statue. But these honest maidens, realizing that I was an actual human being, only fearful and timid, all ap-proached, saying: 'O youth, who, who are you? You have no need to fear our sight and presence. Do not worry in the least, for there is no savagery here; you will find nothing at all unpleasant. But who are you? Speak, do not be afraid.'

At this request I somewhat regained my voice, aroused by the allur-ing virginal figures and their kindly speech, and replied: 'Blessed nymphs, I am the most ill-favoured and unhappy lover that the world has ever seen. I love – but where is she whom I love so ardently and desire with all my heart? I know not, nor even where I am myself. I have arrived here after passing through more mortal peril than I could ever describe.' Already I had aroused tears of sympathy in their eyes, as I bent to the ground and prostrated myself at their virginal feet, bursting out with a sigh: 'Have pity, for the sake of God almighty!' Immediately their soft hearts were filled with pity and sympathetic sweetness, and they were moved, like me, to tears as they lifted me firmly by the arms and set me upright, saying to me with sweet and blandishing words:

'Poor man! We think there are few who manage to survive on the path that you were unfortunate enough to enter. But for all that, thanks to the divine power and your favourable stars, you have now escaped a great danger. At present you need fear no more adversity, no more assaults, for your journey may well have brought you to happiness. Sit down, then, and recover; console yourself. For this, as you can well see, is a region of pleasure and delight, not of pain nor of anything fearful, and so it has been throughout the ages, its site unaltered, its climate unchanged. Everything here is conducive to joy and graceful conviviality; it invites us to enjoy the perpetual leisure that it bestows. And you should also [e3'] learn this: if one of us is kind, the other will be even more so, and thus our delightful and mutual concord is cemented intensively and eter-nally.' Another commented: 'The other will eagerly induce her to enjoy the utmost pleasure,' and added, 'This is, after all, a wholesome land, broad in extent, rich in herbs and plants, charming to look upon, rich in every crop, graced with many hills, stocked with all the harmless animals, conspicuously equipped for every pleasure, abundant in every fruit, unversally fertile and adorned with the purest of springs.' Another said:

'All this is perfectly true, dear guest. This happy territory is more fertile than the northern slopes of Mount Taurus, which is famous, so they say, for having bunches of grapes two cubits long, and a fig-tree that produces seventy baskets of fruit.' A third added happily:

'This sacred plain is more fertile than the Isle of Hyperborea that lies in the Indian Ocean; it is unrivalled by Lusitania, or by Talge on the Mount Caspius.' A fourth continued, saying emphatically: 'The abun-dance of Egypt is vanity in comparison with our own, however much it is called the public granary of the world.' Immediately another one, whose looks surpassed all the rest, said with elegant diction: 'In this dear homeland you will find no marshes giving off harmful and noisome air; it contains no steep mountains, but only shapely hills, while on the outside it is surrounded and fortified by steep and impassable cliffs. In this way, all sorrow is excluded, while everything that can bestow plea-sure is here. It is the refuge of the gods, which gives blessed security to the soul. In addition to all these things, we are the subjects of an illustri-ous and noble queen, munificent and extremely generous, called Eleuterylida. Her kindness and mercy are remarkable, and she governs here with high and firm wisdom; she rules with the utmost authority, and reigns happily and blessedly to her redounding glory. She will be

78

greatly pleased when we lead you into her venerable and majestic pres-
ence. And if by chance others of us, who are her servants and courtiers,
should see you, they will crowd around to look at something that is
rarely seen here. So dispel and do away with every sorrow that afflicts
you, make ready your soul for joyful consolation with us, and give your-
self over to solace and pleasure, spurning every fear.'

POLIPHILO, CAPTIVATED AND REASSURED
BY THE FIVE NYMPHS, WENT WITH THEM TO THE
BATHS, WHERE THERE WAS MUCH HILARITY OVER
THE NOVELTY OF THE FOUNTAIN AND ALSO OVER
THE ANOINTING. HE WAS THEN LED TO QUEEN
[e4] ELEUTERYLIDA, AND SAW SOME EXCELLENT
THINGS ON THE WAY THERE AND IN THE PAL-
ACE, INCLUDING A REMARKABLE FOUNTAIN.

ECEIVED THUS AFFABLY AND THOR-
oughly reassured by the friendly nymphs, I felt my
weakened spirits considerably revived and comforted
by the flattering girls. I welcomed all their hints and
showed myself ready to please them, surrendering
myself as their devoted servant and friend. They were
carrying in their delicate hands alabaster unguent-jars, little soap-vases
of gold and precious stones, bright mirrors and golden combs, folded
veils of white silk and bathing-shifts. I offered to carry them, but they
declined, saying that they had passed this place because they were on
their way to the baths, adding immediately: 'We would like you to come
with us over there, opposite, where a fountain is playing. Haven't you
seen it?' I replied politely: 'Lovely nymphs, if I had a thousand tongues
I could not adequately express my gratitude and thank you for such
warm kindness, since you have opportunely restored me to life. There-
fore not to accept such a gracious and nymphal invitation would be to
seem vilely ill-bred, especially since I would count myself happier as a
slave here than as a master anywhere else. For as far as I can judge, you
are familiars and companions of all that is pleasant and truly good. You
should know that I have seen the marvellous fountain and examined it
carefully, and I must confess that no more wondrous work of art has
ever met my eyes. It allured me and utterly absorbed my mind as I
looked intently all round it; then I drank voraciously from it, healthfully

slaking my day-long thirst, but went no further in my explorations.'

One of them answered me gently, saying: 'Give me your hand: now you are safe and welcome. As you can see, there are five of us companions here. I am called Aphea, and the one carrying the boxes and white sheets is called Osfressia. The other one, who is the bearer of the shining mirror, our delight, is named Orassia. She who carries the resonant lyre is called Achoe, and the last one, bearing a vase of precious liquid, has the name Geussia. And we are all going to these temperate baths for recreation and delight. So, in brief, you can come too, since your good luck has fallen out thus. Come with us and enjoy yourself, then we shall merrily return all together to the great palace of our noble Queen. [e4']

'She is clemency itself, generous liberality and munificence, and you will obtain expert advice about your intense loves, ardent desires and lofty undertakings. Be brave and confident; let us go.'

They led me on with voluptuous movements, virginal gestures, engaging manners, girlish graces, lascivious looks and sweet words of comfort and flattery. I would have contented with everything if only my golden-haired Polia had been there to fill my cup of happiness and to make the company up to the perfect number of six. On the other hand, I was uncomfortable because my clothing did not match this delicious company. But I tamed myself sufficiently to begin dancing along affably with them, while they laughed sweetly, and I laughed with them. Eventually we reached the place.

Here I saw a miraculous octagonal bath-building, which had a pair of pilasters at every external angle. The areobates that joined them beneath began at the level of the ground. Then followed the pilasters, which protruded from the solid wall by a third of their width, and their capitals supporting the straight beam with a frieze above it, beneath a cornice that went unbroken all around. This frieze was decorated with rare sculptures, including some naked putti finely carved at equal intervals, whose hands were twined with nooses holding up plump swags of leafy twigs woven together and tied with ribbons. Next, an octagonal dome with elegant vaulting rose above the cornice, corresponding to the lower part. Between the angles it was perforated with miraculous skill with a thousand noble shapes filled with panes of pure crystal, which from afar off I had judged to be lead. The pinnacle rested on a high spire that followed the octagonal form of the cupola, immediately upon which was a sphere. From the top centre of this arose a fixed stylus that fitted into another mobile and freely revolving spire fastened to a wing.

Consequently, when any wind blew, the hollow spire turned, together with a ball at its summit that was a third the size of the lower one. On top of this a naked child rested on his right leg, letting his left leg hang freely. The back of his head was all hollowed out in the form of a funnel, pierced through as far as the mouth, to which a trumpet was attached. He was holding this with one hand close to the joint, and the other stretched out toward the end of the trumpet, perpendicularly above the wing. The whole thing was cast perfectly of thin bronze and brilliantly gilded. The wing easily impelled the ball and the child, shown with his mouth in the act of blowing, so that the back of his head faced the oncoming wind, and when this blew into it, the trumpet sounded. This was why I had heard the sound of a trumpet at the same time as the rattling of the Egyptian

[e5]

locust-pods. I laughed when I thought of this, and of how a man who finds himself alone and terrified in a strange place is easily scared by every little noise.

Now I saw the entrance, on the side opposite the beautiful nymph of the spring, with an exquisite doorway that I thought must all have been made by the same excellent sculptor as carved the sleeping nymph. On the frieze I read this title in Greek characters: ΑΣΑΜΙΝΘΟΣ. The Bath of Tacitus did not exceed this one in breadth. Inside there were four rows of seats all around made from continously jointed stone, using minute segments of jasper and chalcedony of every hue. The warm water covered two of these rows, and came up to the margin or surface of the third. In each angle there stood a round, detached Corinthian column of varicoloured jasper with undulating veins, more graceful than artful nature ever makes. The columns had suitable bases and the best designed capitals beneath a beam, above which lay the

zophoros. This was beautifully decorated by naked putti playing in the water in childish sports and contests with aquatic monsters, showing well the quick movements and games appropriate to their age. It was capped by a cornice. Above the order and projection of the colonnettes, directly above each one there stretched up to the top of the cupola a moderately swelling garland of oak-leaves, overlapping like pages, [es'] fringed and sinuous, made from green jasper and tied round with gilded ribbons. As these ascended, they followed the convex roof of the cupola and united at a roundel that was filled by a lion's head with a shaggy mane. It gripped a ring in its teeth, to which were entrusted chains of orichalcum elegantly knotted together. These hung down, suspending a smooth, shallow vase with a wide mouth of the same bright material two cubits above the surface of the water. The rest of the internal vault which was not filled with crystal was all coloured with Armenian blue and studded over with gilded bosses, rich and brilliant.

Not far away there was a fissure in the ground, continually vomiting fiery matter. They took this and filled up the vase with it, placing on it certain gums and perfumed woods so as to make an indescribable fumi-gation, as fragrant as the best pastilles; then they closed the double doors, which were of pierced metal filled with translucent crystal that gave a wonderful and multicoloured light. These piercings of transpar-ent knotwork illuminated the scented bath, while keeping the fragrance and the heat from escaping outside.

The flat wall between the columns was of black stone, resistant to metal and lustrous, framed by a rectangular band of coral-coloured jasper three inches wide, ornamented with a lineament of double gorgets or whorls. In the middle of each wall, between the columns, was seated an elegant nude nymph made from white stone with an ivory lustre, each with distinct gestures and attributes, firmly placed on suit-able pedestals with rounded lineaments created with the compass to match the bases of the columns. How I admired these exquisitely carved figures! Many times my eyes wandered from the real ones to rest on the imitations.

The paved floor under the water was inlaid with various emblems in hard stone, marvellously designed and variegated in colour. The limpid water was not sulphurous but fragrant, warmed without hypocaust or furnace, and pure beyond belief. There was no impediment between the eye and the object, so that the various little fish on the fronts and tops of the seats, which were artificially made with scales of mosaic in rivalry

with nature, looked as if they were alive and swimming. There were mullets, lampreys and many others, shown with a view to the beauty of the picture rather than to nature. The black stones of the walls were engraved and diligently supplied with an admirable composition of knotwork or ligatures of antique foliage, flowers and bright Venus-conches, which pleased the eye more than one could ever express.

[e6]

In a niche above the door I saw a dolphin of milk-stone arching over the placid waves, and a youth sitting on it playing a lyre. Opposite the trickster fountain there was another similar dolphin swimming, with Poseidon astride it holding his sharp trident. These little subjects emerged from frames of the same stone, and were affixed to the black background. Here my praises went deservedly to the distinguished architect, and no less to the sculptor. In addition to this, the graceful dignity of the charming and lovely girls was outstanding, such that I could not measure the distance between my former fear and my present unthinkable luck and well-being, but certainly found myself in a state of extreme pleasure and delight. Now that we had happily entered into such fragrance as could never have grown in Arabia, they spread out their silken garments neatly on the stone seats that served as dressing-room, tied up their blond hair beautifully in hairnets woven and knotted from gold thread, and unconcernedly let their shapely and delicate bodies be seen entirely naked in every particular, while keeping their virtue: flesh that was peerlessly delicate, mingling roses with seasonable snow. Alas, how my heart was agitated, opening itself up to be filled brimfull with voluptuous joy! I thought myself happy merely to behold such delights, for I certainly could not prevent the ardent fires from leaping up to assault me in my furnace of a heart. At times, for my own salvation, I did not dare to look at the arousing beauties in which these divine little bodies abounded; but the nymphs, noticing it, found girlish amusement in laughing at my bashful demeanour, while I remained sincere at heart and content to give them pleasure. Being in the grip of such ardour, I exercised no small restraint, but remained steadfastly modest and patient, knowing myself to be unworthy of such beautiful company. And when I was invited again, for all my reluctance and excuses I nevertheless did enter the bath. Like a crow among white doves I stood apart blushing, with my eyes wandering over these splendid and alluring objects. Then Osfressia said to me in teasing banter: 'Say, youth, what's your name?' And I replied politely: 'Poliphilo, Madame.' 'It's good enough,' she said, 'if the deed suits the

word.' And she added without a break, 'And what's your dear beloved called?' I replied obligingly 'Polia.' And she said, 'Oho, I guessed that your name meant "much loving," but now I see that it means "friend of Polia."' Then she added, 'If you found her now, what would you do?' [e6'] 'Madame,' I replied, 'I would do whatever suited her modesty and was worthy of your divine presence.' 'Tell me, Poliphilo, do you have a great passion for her?' 'Upon my life I do, alas,' I sighed; 'Beyond all the delights, riches, and precious treasures of the world, I carry and guard my love thrust through my seared and glowing heart.' 'Where have you left such a precious thing?' she said. 'I do not know, nor do I even know where I am.' She said with a smile, 'And if someone should find her for you, what reward would you give? But be of good cheer and give your-self to pleasure, for you shall find your beloved Polia.' And with these and similar gracious words the gentle and charming girls and I took much pleasure in bathing ourselves.

In the section opposite the remarkable fountain of the sleeping nymph outside, there was another fountain inside with statues made artfully from fine metals, shining with golden splendour. These were attached to a marble square, set back and framed with a frontispiece and two semicircular or half-columns, one on each side, with the miniature beam, zophorus and cornice carved out of a single stone. This admirable composition was of the finest artistry, like all the rest of the work, and an absolute miracle of invention. In the cut-out or hollowed part of the stone there stood two perfect nymphs, a little smaller than nature, showing a naked leg through a slit in the dresses which they wore, which wafted a little with their movements, and with their arms also bared to the elbow. The garments were thrown back from the arms with which they supported the little boy, who rode astride with one foot in the hand of each nymph. All three faces were laughing, as with their other hands the nymphs held the child's garment up so as to uncover him up to the waist or navel; and the child held his little member with both hands, pissing cold water into the hot bath, to make it tepid. I was entirely relaxed with joy and contentment in this delicious and excellent place, except that my prevailing pleasure was interrupted by the feeling that I might be contemptible: for beside such whiteness, like dew con-densed to hoar-frost, I looked as black as an Egyptian.

Then the one called Achoe said to me with a smile: 'Poliphilo, dear, take that crystal vase and bring me some of that cool water.' Being anxious to please, I lost no time in hurrying over there. No sooner had I

84

set one foot on the step to reach the falling water, than the little Priapus lifted his penis and squirted the freezing water in my hot face, so that I fell back instantly on my knees. At this, such a high and feminine laughter echoed around the hollow dome that as I recovered, I too began to laugh fit to die.

[e7] With a little thought, I saw through the designer's clever trick: the bottom step was movable, such that any weight would depress it and consequently raise the child's instrument. After careful examination and investigation, I found this machine and its curious device most gratifying. Moreover, inscribed on the zophorus in elegant Attic letters was the title ΓΕΛΟΙΑΣΤΟΣ.

After washing and bathing with much fun and laughter, and with a thousand sweet and amorous words, virginal jokes and blandishments, we all came out of the warm water. The nymphs jumped up the wet steps with much bouncing and gaiety, and anointed themselves with fragrant-smelling creams and perfumed liquors, offering me a jar, too, from which I anointed myself. This soothing unguent and healthy [e7'] washing were most opportune, because beside their wonderful sweetness they were especially good for my exhausted limbs after my recent perilous flight. When all had dressed, taking some little time over their nymphal toilet, doing up their clothes and arranging their ornaments, they set to work busily opening vases of delicate confections, which they and I enjoyed tasting, and afterwards came precious drink. When they had eaten enough they returned to their mirrors for a minute examination of the ornaments on their divine bodies and radiant brows, shaded with hanging ringlets of yellow hair, and rolled their wet hair in diaphanous veils. Finally they said to me cheerfully:

'Poliphilo, we are now going with joyful heart to our illustrious and sublime Queen Eleuterylida, where you will find greater delight still,' adding with a laugh, 'Ha, the water really hit you in the face!' And they began laughing sweetly and uncontrollably again, making merry at my expense and signalling to each other with meaningful winks and sly or sidelong glances. As they made their graceful exit, with me walking in the midst of the merry girls, they began to sing sweetly. It was a rhythmical song in the Phrygian mode about a facetious metamorphosis: a lover wanted to turn himself into a bird with magic ointment, but used the wrong jar and was transformed into a common ass. The moral was that no one should trust unguents to have a certain effect, because they may have quite another. I suspected that I was the motive for this, to judge by the mocking looks that they darted at me, but gave it no further thought for the present.

I had reasonably assumed that the ointment I had used was for the comfort of my exhausted limbs, but lo and behold! I suddenly began to be sexually aroused and lasciviously stimulated to the point of total confusion and torment, while these wily girls, knowing what had happened to me, laughed unrestrainedly. It increased so that I felt the irritation within me growing stronger at every moment. I do not know what curb or bit restrained me from flinging myself upon them like a raving, hungry eagle swooping down on to a flock of partridges: the urge to rape was no less strong in me. I felt this desire continuously

86

increasing, torturing me with prurience and lust, and was all the more venereally inflamed because I was offered such opportune and suitable victims. It was like the spreading of a pernicious plague, inciting me to desires I had never felt before.

Now one of these inflammatory nymphs, Aphea by name, said lightly to me: 'Poliphilo, what is the matter? A moment ago you were gaily joking, but now I see you altered and changed.' I said to her, [e8] 'Forgive me for twisting like a willow wand, but I am dying, if you'll excuse me, from the fire of lust.' At that they all burst out in unrestrained mirth, saying to me, 'Aha! and if your coveted Polia were here now, what would you do to her, eh?' 'Alas,' I said, 'by that goddess whom you obediently serve, I implore you not to add fuel to my incredible fire, not to heap torches and resin on it, not to daub pitch on my inflammable heart, not to make me burst, I pray you! For I am beside myself and totally consumed.' But my sad and lamentable reply only filled their coral lips with cries of mirth, so forceful and excited and growing so excessive that neither they nor I could walk any further for laughing. They tumbled down on the fragrant flowers and rolled on the grassy ground, breathless from laughter so violent that they had to untie and loosen their tight transverse girdles, then they paused, lying semiconscious beneath the shade of the leafy trees and the spreading roof of branches. I addressed them now with confident intimacy: 'O fiery maidens who use me so ill, what shall I do to you? Here I am being given a perfect chance to throw myself on you and do you a violence that is quite excusable.' And I made a move as if to assault them, boldly pretending to do what I would in no wise dare. But they with fresh laughter called on one another for help, leaving behind their shawls and gilded slippers as they fled, casting their ribbons to the fresh breezes and abandoning their vases among the flowers as they ran. And I ran after them, until I truly do not know whether they or I was more exhausted, as I spurned virtue and threw myself into a flood of desire, impatient from the excessive tension of the bowstring.

After this cheerful game and frivolous diversion had lasted for a while and fully satisfied my agitation, we collected the scattered slippers and other things and came to the damp green banks of a rushing stream. Their sweet laughter abated as they tenderly sympathized with me. There, on the banks adorned with low, bending reeds and wild nard, with floating victrix and many other vigorous aquatic plants, one of them, named Geusia, kindly bent to pluck a white water-lily, a root of

87

aron and one of star-wort, which were growing not far from one another. She offered them to me laughing, saying that I should choose from them whichever I liked, and eat it to free myself. I therefore refused the water-lily, rejected the aron for its caustic quality, and accepted the star-wort, which I was persuaded to taste after it had been cleaned. It did not take long to banish the venereal and lubricious urge and to extinguish my overwhelming desire. Now that the carnal enticements were restrained, the merry maidens calmed down and became gay and [e8'] talkative, so that we did not notice that we had come to a famous place of the utmost charm.

There was a road here, planted at regular intervals with tall, straight cypresses with their pointed, fissured cones and their foliage as densely packed as is natural to them, and the flat ground was covered all over with green periwinkle, rich in its little azure flowers. This attractive road was conveniently wide and led directly to a hedged enclosure four stadia long, whose entrance was as wide as the spaces between the cypresses. When we joyfully reached this enclosure, I found that it was equilateral, with three wings resembling perpendicular walls as high as the tall cypresses along the road, and all made from magnificent citrons, oranges and lemons with their lovely foliage closely pressed together and artificially connected to one another. I estimated their thickness at six feet. There was an archway in the middle, made from the same trees, which had been trained so skilfully by the gardener that nothing better could be done or described, and higher up there were windows at the appropriate places. Not a branch or twig was visible on the surface, but only the flowering fronds of charming greenery. Among the beautiful, dense and vigorous leaves were decorative clusters of white flowers giving off the sweet smell of oranges, while delicious ripe and unripe fruits were offered in abundance to the avid gaze. I admired with some astonishment the way that the branches had been masterfully arranged within the thickness of the hedge, so that one could conveniently climb through the entire structure supported by the connected branches, without the climbers being visible.

Now that we had entered this green and pleasant enclosure, very gratifying to the eyes and worthy of the mind's admiration, I saw that it formed an elegant cloister in front of a marvellous palace, of great size and magnificence and symmetrical in its architecture, which made a fourth wing for the leafy enclosure. It was sixty paces wide, and this was the dimension of the square open-air courtyard.

88

In the centre of this admirable area, I saw an extraordinary fountain spurting clear water through narrow pipes as high as the enclosing hedge. The water fell back into a wide shell of fine amethyst, three paces in diameter and three inches thick, diminishing to one inch at the rim of this excellent tub. All around it aquatic monsters could be seen, perfe‑

[fı] ctly carved in bas‑relief. The ancient craftsmen never managed to achieve such splendid work in hard stone as this admirable and complex ornamentation, nor could Pausanias boast of such when he dedicated his bronze crater at Hippari. This one was expertly fixed on a splendid pillar of jasper, with many veins beautifully intersecting one another, inlaid with diaphanous chalcedony the colour of turbid sea‑water. It was a noble artefact, made from two throated vases placed one on the other and separated by a narrow knot. It stood erect, fastened to the centre of a circular plinth of greenish serpentine. This plinth was raised five inches above the flat pavement, as was the surrounding rim of porphyry that was curiously decorated with fine wave‑mouldings. Beneath the basin and around the pillar, four golden harpies with rapa‑cious taloned feet rested on the surface of the serpentine plinth. Their back parts were against the pillar, one directly opposite another, and their unfolded wings rose toward the violet lip of the basin. They had the faces of virgins, and hair that flowed down their necks on to their shoulders, while their heads did not reach the underside of the basin. Their serpentine tails were curled up and turned at the end into antique rinceaux, joining the lower vase of the pillar not ungracefully, but with amicable union and interlacing. Inside the amethyst basin, at its navel and directly above the supporting pillar, there rose a well‑proportioned vase like a long inverted calyx, reaching as far above the surrounding rim as the basin was deep. Upon this was raised an artistic base that sup‑ported the three nude Graces, made from fine gold, equal in height and connected to one another. From the nipples of their breasts there flowed thin streams of water looking like rods of refined silver, polished and striated, as if it had been distilled from the white pumice of Taracona. Each one held in her right hand a cornucopia that reached a little above her head, then the mouths of all three horns met and made a single round, open form. An abundance of various fruits and leaves over‑flowed the opening or rim of the intertwined horns.

Six little spouts protruded among the fruits and foliage, from which the water flowed through minute openings. The clever metal‑sculptor had avoided having the elbows collide by having the statues make a

90

gesture of modesty, hiding with their left hands those parts that should be covered. The open basin's circumference reached a foot beyond that of the serpentine plinth below it, and well spaced around its rim were six scaly dragons of bright gold, resting on their reptilian feet with their [f2] heads high. They were remarkably made so that the water coming from the breasts fell directly into their hollow and open heads. Their wings were spread, their mouths wide open. The water was let out, or rather vomited through a channel so that it fell between the round serpentine plinth and the circle of porphyry, which rose an equal distance above the floor of the courtyard or open pavement, as already described. There was a channel between the serpentine plinth and this porphyry circle, one-and-a-half feet wide and two feet deep. The porphyry circle was three feet wide on its flat surface, with fine wave-mouldings toward the pavement.

The rest of the dragons snaked across the shallow basin, then all their tails came together and were transformed into antique rinceaux, making at the appropriate height a satisfying juncture with the support or footing of the three figures, and without deforming the hollow of the precious basin. The latter took on a wonderful colouring from the combination of the green orange-tree hedge, the translucent material and the pure water, so that it resembled a rainbow among the clouds inside the noble, proud and elegant vessel. There were also lion-heads with manes that stood out from the convex part of the basin, equally spaced between each pair of dragons on this splendid water-tub. With perfect aim, the lions spewed out through tubes in their mouths the water that fell from the six little pipes of the beautiful cornucopia. This water was driven with low pressure that made it fall between the dragons into the broad and resonant basin, so that its long fall made a lovely tinkling in the open vessel. It was a rare work, this proud fountain erected with keen ingenuity, with its perfect harpies and the rare dignity of the support for the three brilliant golden figures, all executed with the highest artistry and finish. I could never make a brief and lucid exposition of it, much less describe it all. It was no work of merely human skill, but I can freely testify, calling the gods to witness, that never in our age has there been a more graceful or admirable sculpture, nor even one to equal it. I was stupefied as I considered how hard and resistant the stones were that supported the great basin, namely the pillar which was made from two throated vases, one above the other, with as much ease and facility as though the material in question had been soft wax. It

would not have been easy to draw out these filaments and make these neat inlays, nor were such finely modeled flutings to be filed out without [f2'] resisting the hardest emery. No, they were done with special chisels and burins, tempered in a way that is lost to our modern craftsmen, to make them shine with peculiar brilliance.

The entire area, in whose centre this masterpiece of the famous and sumptuous fountain was erected, was paved with squares of fine marble of various colours and formations, inlaid with beautiful roundels of decorative jasper, somewhat smaller in diameter, precisely levelled and contrasting in colour. The remaining angles were attractively filled with curling fronds and lilies. Then I noticed wide stripes or bands between the squares, made in the best mosaic work from tiny stones, depicting green leaves with flowers of purple, blue, red and yellow, expertly assembled and firmly cemented together. I could never describe the artistic design, the extraordinary brilliance and the noble imagery of this diligent stone-work. Its colours were more beautiful than those of variously-tinted crystal struck by the sun's rays, because the environing colours were delightfully blended as they were reflected in this shiny stone. Not one piece of the mosaic, whether round, triangular or square, was uneven, but all were perfectly flat and level.

All these things left me stunned and in a senseless reverie, as I pored over this work whose utter splendour was beyond my experience. I would gladly have lingered to contemplate it more carefully, for crafts-manship of such dignity deserved a more protracted investigation, but I could not, because I had to keep following my talkative companions and guides.

However, my first encounter with this superb, sumptuous and mag-nificent palace, its ideal situation and its marvellous symmetrical design produced in me an extraordinary joy and gratitude, while the dignity of its construction made me want to look at more, for I had reason to believe that its skilful architect was preeminent over all who had ever built. What scaffoldings of beams and rafters, what arrangement of halls, chambers and passages, what walls covered and encrusted with precious panels, what a wonderful system of ornamentation, what unfading colours in the mural paintings, what proportion between columns and spaces! Compared to this, the Praenestine Road could not [f3] vaunt its Gordian structure, nor was this colonnade rivalled by that one, for all its two hundred columns divided equally into Numidian, Clau-dian, Synnadic and Carystean. What marbles, what sculptures I saw

there! There were the Labours of Hercules marvellously sculpted in high relief from translucent stone, beside spoils, statues, inscriptions and trophies miraculously carved. What a propylaeum or vestibule, what a royal portal! The Emperor Titus, with his Phoenician marble polished like a mirror, would have to give way to this. It was such that even the most gifted narrator would come to grief in trying to describe it. In addition, the dignified fenestration, the conspicuous doorway and the noble podium made it the highest expression of the architectural art. No less excellent was the wonderful ceiling which was beautifully pierced with little holes between the undulating and interwoven foliage: they were square and round openings with exquisite outlines decorated with pure gold and elegantly picked out in blue and gilt. Any other wondrous building was lost beside it.

Now that we had reached the opening of the splendid portal, the way was blocked by a marvellous and gaily-coloured curtain stretched across it, all woven from gold thread with a silken weft, showing two worthy figures: one was surrounded by all manner of tools, while the other lifted her virginal face to gaze intently at the sky. Such was their beauty that I am persuaded that no brush could have added to them, not even that of the famous Apelles.

Now my sweet, attractive and talkative companions each joined their right hands gently with mine, wanting to introduce and welcome me, saying: 'Poliphilo, this is the customary manner of entry into the venerable presence and sublime majesty of our Queen. This first and principal curtain will not allow any to enter unless he is admitted by a simple and vigilant maiden portress, called Cinosia.' And she, hearing us arriving, immediately appeared and courteously opened the curtain; and so we went in. Here there was a closed space divided by another curtain, nobly and artistically designed, dyed in every colour and embroidered in an unusual way with signs, shapes, plants and animals. As we came up to it, a similarly curious lady immediately presented herself, named Indalomena, who freely drew aside her curtain to admit us. There was the same distance between the second curtain and a third, extraordinary one, which was marvellously embroidered with speeches [f3'] and reasonings, and which depicted in vermiculate style a mass of ropes, nets, and ancient instruments for grabbing and grappling. Without delay, a third hospitable lady quietly presented herself to us and received us graciously; her name was Mnemosyna. She likewise summoned us and gave us free admittance. And here my companions

and I finally presented ourselves before the venerable majesty of Queen Eleuterylida.

POLIPHILO TELLS AS BEST HE CAN OF THE NOBLE MAJESTY OF THE QUEEN, THE CONDITION OF HER RESIDENCE AND THE ADMIRABLE APPOINMENTS; ALSO OF HIS KIND AND FRIENDLY RECEPTION, AND HOW SHE MARVELLED AT HIM. HE DESCRIBES SOMETHING OF THE SPLENDOUR OF THE BANQUET, WHICH SURPASSED HUMAN UNDERSTANDING, AND THE PLACE WHERE IT WAS GIVEN, WHICH WAS BEYOND COMPARE.

 S WE ARRIVED, THE FIRST PORTRESS looked at me with no small surprise, but after I had greeted her politely with due respect, she invited me in in a friendly and hospitable manner. So it was with the guardians of the next two curtains. Now I could see a high portico running the whole length of the palace. Its golden vault was decorated with green foliage punctuated by flowers, interlacing fronds and flying birds, made like a rare tapestry but in mosaic work. The floor was as clean as in the outside court, and the walls were encrusted with precious stones artistically arranged in vermiculate patterns.

At the last curtain, the lady Mnemosyna told me affectionately not to worry about anything, but to offer myself in strict obedience to the royal counsel and helpful advice of the Queen, and to persevere in following it, for then without a doubt things would turn out well. As she permitted me to enter, my eyes were struck by a sight of things more divine than human. It was a stupendous and spacious court, pompously appointed, joined to the side of the palace opposite the first one and perfectly square. I could see that the neat and precious pavement, set inside a surround of mosaic, was made from sixty-four squares, each three feet across. They were like a chess-board, alternately of coral-coloured jasper and of bright green with sanguine spots, so closely fitted that the joints were imperceptible. This was surrounded by a splendid frieze, a [f4] whole pace wide, subtly made from stone mosaic and assembled in tiny shapes like a beautiful picture made from precious stones. They were cut exactly and put together with no visible joints, then polished like a

94

mirror, and made so evenly with ruler and square that a spherical object placed there would never be at rest. Beyond this border was a marvellous work three paces broad: a noble interlaced design of jaspers, prases, chalcedonies, agates, and other conspicuous kinds of precious stone. I saw against the walls of this area a number of convenient seats of red and yellow sandalwood, carefully made and upholstered with green velvet, filled out like moderately swelling cushions with wool or some soft material that made a most comfortable seat. The silken velvet was attached to holes in the benches by means of round-headed golden nails passing through a long silver fillet or flattened cord.

I admired the splendid walls of the enclosure, which were all covered with plates of pure, lustrous gold, engraved in a manner appropriate to the precious material. The smooth, flat surface of these plaques was divided by small pilasters into a number of distinct rectangles of harmonious dimensions, with a circular wreath applied to the centre of each one. This swelled slightly in the shape of the torus of a column-base, and was of a depth to match the size of the space; it was made to resemble fringed leaves closely overlapping one another, and adorned to perfection by winding ribbons with waving ends. Fruits of various bright gems appeared harmoniously distributed among the leaves, admirably fashioned with various lineaments.

In the remaining spaces ringed by these swelling wreaths, I saw with great pleasure the seven planets with their innate qualities, perfectly represented in encaustic work. I admired the flat surfaces outside the circles, which were filled with innumerable elegant expressions of the goldsmith's craft and decorated with a seemly arrangement of many priceless gems. The left-hand wing or wall was divided similarly, with wreaths of the same form, number and ornamentation as I have described. Inside the seven circles were seven triumphs of the subjects ruled by the planets, very well executed in the same style as before. Likewise, I saw on the right-hand wall the seven harmonies of the planets, and the transit of the soul receiving the qualities of the seven degrees, with an incredible representation of the celestial operations.

[f4'] The fourth wall, adjacent to the palace, was arranged like the others, except that the middle space was occupied by the door. The other six spaces corresponded and matched the rest, containing wreaths which showed the operation of the planetary virtues, arranged symmetrically with the planets on the opposite wall. These virtues were represented in the form of elegant nymphs with the titles and symbols of their effects.

The seventh space, in the middle, contained the frontispiece or pointed arch above the door, and was directly opposite the seventh wreath that contained the planet Sol, which was raised above the others because that was where the Queen's throne was located. Every part corre⁄sponded with perfect accuracy as to material, number, form and lineaments, down to the smallest detail, so that the right⁄hand side matched the left, the front matched the back, in exquisite concord. Each wall of this superlative place was twenty⁄eight paces long.

This elegant and symmetrical open⁄air courtyard had canopies all around made from perfect gold: a wondrous and ineffable work.

The pilasters or semi⁄square columns were four paces apart, making seven equal divisions (the number most favoured by nature) and were of fine oriental lapis⁄lazuli, its colour delightfully enhanced by a scattering of tiny sparkles of gold. The fronts of the pilasters between the enclos⁄ing wave⁄mouldings were exactly proportioned as to width and height, and marvellously carved with a charming assemblage of candelabra, foliage, cornucopias, little monsters, heads with leaves for hair, putti whose extremities turned into scyllas, birds, baluster vases, all of extra⁄ordinary inventiveness and design, sculpted from top to bottom in relief as if detached from its flat background. Thus the pilasters intervened in a harmonious and pleasing manner between the well⁄spaced golden panels. The capitals were made in concordance with the rest of the work. Above them stretched the straight beam carved with the requisite lineaments, with cylinders or little rods intercalated between the down⁄ward spirals. Then came the ornate zophorus, which contained an alternating pattern: first, bucrania, knotted with waving ribbons to two branches of myrtle hung with berries, and secured across the middle with loose swags of material; next, dolphins, with leaf⁄like gills and the ends of their fins turning into leaves, their tails giving way to antique rinceaux, and putti holding on with their hands inside the curling tails. The dolphins' snouts were curved, with one part turning up toward the putto and the other curling inward toward an open⁄mouthed vase, and ending in a stork's head. The latter's beak was near the open mouth of a [f5] monster facing upward, and some beads were strung between the mouth and the beak. These heads had leaves for hair, and were placed in opposing pairs, making a leafy filling for the mouth of the vase. A linen cloth was tied to the handles of the vase and hung down, with its ends hanging freely beneath the knots. Everything was decorated in concordance with its placement and the material; and in the centre,

above the spirallings, was a child's face flanked by outspread wings.

The zophorus continued, decorated by these and similar lineaments. Covering it was a suitable cornice, very finely finished and artfully made, and on the surface above this, perpendicular to the projections of the quadrangular order, vases of antique shape were placed at regular intervals. They were over three feet high and made from chalcedony, agate, vermilion amethyst, garnet and jasper, alternating in colour and subtly carved in various excellent designs. The bodies of the vases were principally decorated with straight, concave grooves, and their handles were masterfully made.

Directly above each of the wreaths there were little squared beams seven feet high, suitably attached to the cornice and made from bright gold with spaces in between them. Similar beams were joined horizontally above these upright ones, going all around and serving as an ideal support for the regularly-spaced topiary work. The vases that stood at the angles of the walls held both a beam and a vine, whilst out of the remaining vases there issued alternately a vine or a convolvulus, made from different types of gold. They spread their many branches in all directions, supported by the transverse beams, weaving around one another in elegant friendship and graceful concord so as to cleverly [f5'] cover this entire courtyard. They formed an unbelievably rich ceiling with their variegated foliage, made from splendid Scythian emeralds that delight the eye (the one with Amymone carved on it was nothing to them) and with flowers of every season made from sapphire and beryl, distributed with great skill and artifice among the green leaves. There were also large gemstones shaped like various fruits, and bunches of grapes imitated by massed stones hanging down and coloured like the

97

natural grape. All these excellent and refulgent things, matchless in value, incredible and almost unimaginable, were precious not only for their wonderfully noble material but also for the grandeur and finesse of their workmanship.

I brooded on this marvellous thing, examining it studiously and following in my mind the wandering extensions and the proportionate widths of these intricate branches. What art, what bold ambition, what steadfast will had assembled them so perfectly? Was it done with sculptor's adhesive, or soldering, or hammering, or with the founder's art? It seemed to me impossible that a roof so wide and with such excellent joints should have been made by any of these three methods of metalworking.

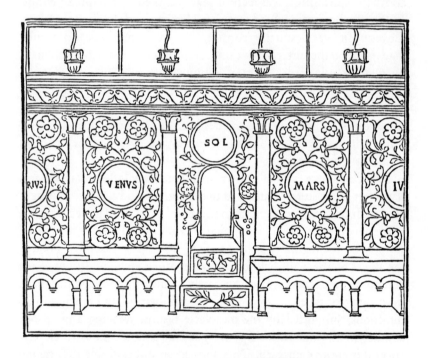

The Queen herself was sitting in the centre, right opposite our entrance, on a throne raised on steps and decorated with many designs of glowing gems, even more wonderfully made than the throne in the [f6] temple of Hercules at Tyre, which was of eusebes stone. Her Majesty appeared divine and remarkably magnanimous, and wore a material with a weft of gold drawn out into filaments. Her majestic head was

splendidly bedecked with a matronly and regal mitre of purple silk, edged with a mass of light, luminous pearls that framed her broad forehead. It rested on her black hair, more lucent than Indian amber, which descended in graceful disorder to oveflow her snowy temples. Her exuberant coiffure was parted on the crown into two tresses that were neatly plaited and trained, one on each side, over her small ears, then wonderfully reunited on the top of her head, where they were tied with a knot or bunch of great round pearls, such as the Perimula promontory in India cannot produce. Beyond the knot, the rest of her long, flowing hair was covered by a thin veil that was fastened to the knot or bunch by a golden hairpin, and flowed in waves over her delicate shoulders. In the middle of the mitre, near the pin on top of her head, there was a prominent and precious brooch, and about her rounded throat, coloured white as snow, there was a priceless collar with a pendant that hung down in the cleavage of her milk-white breast. It was made from a peerless diamond, table-cut in half-round or oval form, scintillating and of monstrous size, set in a golden frame ornamented with vermiculate work.

Her pierced ears were richly and exquisitely adorned with a pair of ear-drops made from two pure, large carbuncles, unrivalled in their refulgence. Her feet were shod in light sandals of green silk, tied through golden loops with many-jewelled laces, and they rested on a footstool or support consisting of a soft cushion stuffed with feathers, covered with crimson velvet with a surrounding fringe of orient pearls, such as would never be found in Arabia or the Persian Gulf. Four tassels hung at the four corners, with their knops covered with bright gems and their beards or braids twisted and intertwined from threads of gold and scarlet silk. To right and left were the ladies-in-waiting, seated modestly on the sandalwood benches with honest and unaffected gravity. Their garments of cloth of gold were so gorgeous that I think the world has never seen the like. Thus this illustrious and sovereign Queen was sitting in the midst with high pomp and ceremony and unspeakable splendour. The fringes of her stately robe were adorned with such an abundance of rich gems that you would have thought that Nature, in a fit of extravagance, had rained down all her finest kinds of brilliants.

[f6'] At this imperial and sublime sight I was filled with veneration and fell to my knees, and straightway all the ladies of the chamber and court rose from their seats, stirred and greatly wondering at such a novelty and

at the spectacle of myself present in such a place. But I felt my sad and unquiet heart swelling again as I anxiously thought over past and present events: I was embarrassed, filled with stupor, and altogether suf-fused by reverent awe and honest shame. Faced with this novelty, the seated ladies whispered curiously into the ears of my companions, quietly asking them who I was and qestioning them about this strange and unexpected event, causing all eyes to be fixed intently upon me.

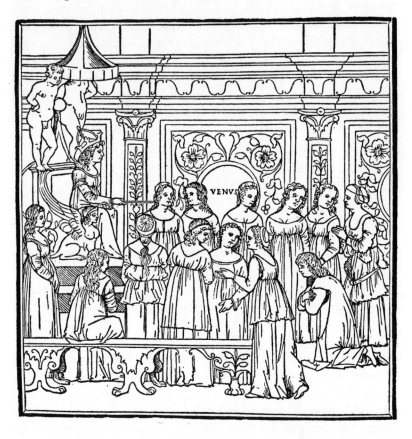

I felt very humble before this excellent and beautiful spectacle, and remained thunderstruck, as if bereft of spirit and shamefaced. When the Queen asked them about how I had succeeded in entering this place, my companions readily told the entire story. The kindly Queen was touched by this; she bade me rise, and, speaking my name, she began to address me in a friendly fashion: 'Poliphilo, be of good cheer! But come, tell me how you came here safe and sound, and how you escaped [f7]

the horrible dragon. How did you find the way out of that odious, dark and sightless cave? I have listened intently to everything, but am not a little astonished. For they are rare, indeed there are hardly any, who manage to come here by this route. However, since long-haired Fortune has chosen you to reach here in safety, I judge that nothing should prevent you from receiving my benign grace and favour, and grant you our generous and benevolent hospitality.'

Such a liberal invitation, such a regal response and welcome were more than I had ever known. I expressed my profound gratitude in devout and respectful words, then gave a brief and succinct account, point by point, of my flight from the formidable monster, and of how I afterwards hastened with great labour and difficulty to this blessed place (at which both she and the venerable ladies marvelled greatly); how the five companions found me terrifed and lost, and how my soul was then ravished by such magnificence and by extreme pleasure. After this she smiled gently, saying: 'It is worth noting that an evil beginning some-times gives way to a happy issue and conclusion. But now, before you proceed in search of your amorous and fixed idea and your hot desire, I wish that you would relieve your burdensome cares and join us at table for a convivial banquet. For your heavenly support has proved you worthy of our generous and kindly hospitality, and has led you under our triumphant roof. Therefore, my Poliphilo, do not hesitate to sit down here and take your ease; for you will have the pleasure of seeing a part of our magnificent ways and the copious variety of my more than regal delights, the outstanding elegance of my service and the splendour of my house, the lavish opulence, the inestimable value and the gener-ous effects of my goodwill.'

When she had ended her kindly and eloquent speech, I showed my humble obedience to this sincere and holy command, and immediately complied — with timid courage and feeble daring — by sitting myself down on those comfortable benches on the right-hand side, in my woollen toga still stuck over with burs and aperine seeds. I was seated among the five companions, placed second away from the Queen between Osfresia and Ochoe. Six other attendants were on the other side, as far apart from one another as to occupy the whole space; and the Queen came down from her high throne in the centre to sit with regal and august dignity above the lower step.

[f7'] The wreath above the throne contained an encaustic painting of a beautiful beardless figure with yellow hair and part of his chest covered

with fine cloth, above the open wings of an eagle that raised its head to stare fixedly at him. He wore an azure diadem decorated with seven rays, and at the eagle's feet on either side was a branch of deathless green laurel. I saw similar paintings in each of the other wreaths, showing the properties of the respective planets.

It so chanced that behind my back was the wreath containing the story of winged-footed Mercury; and by turning round, I could see how his benevolence is spoiled when he is placed in the malignant tail of the venomous Scorpion. Then, turning back, I thought of how abjectly dressed I was among so many sumptuous costumes, exactly as that deadly beast looks deformed and vile among the noble signs of the Zodiac.

Now as many noble ladies as could conveniently do so, sat down together on the magnificent benches, which went all around the walls to the right and left of the courtyard. They were richly adorned, with unusual and elegant head-dresses containing the world's most beautiful feminine inventions, and with their hair arranged in knots and tresses. Some had amber curls among their blond hair, tastefully and modestly waved above their shining rosy foreheads and flat temples. Others had hair as black as obsidian – not the Italian or Spanish kind, but the Indian – and were charmingly adorned with collars of priceless white pearls on their snow-white shoulders. They behaved with such polite-ness and attention that when the table-servants made their reverential bows, all the ladies arose simultaneously from their sumptuous seats and made a similar movement. They were all clothed in radiant gold cloth of marvellous texture and workmanship. The serving-maids did not remain at these tables.

The opening covered by the third curtain was opposite the tri-umphant Queen. It was a great and noble portal, not made of marble but of fine, hard, oriental jasper, artistically worked in the antique style [f8] and of great beauty and dignity. On each side of this excellent portal, near the ladies sitting at table, were the young musicians, six on each side, dressed in suitable, rich, nymphal costumes. At every serving or

102

change of courses they changed their music and their instruments, and while we were eating, others warbled sweetly with an angelic or siren-like song.

Now tripods of ebony with temporary tables were quickly set up, without noise or fuss, for each servant was expert at her appointed task, keen and attentive, with loving skill and total concentration on the duty commanded or entrusted to her.

First, a tripod of the following design was set up before the Queen. It had a round base of the best jasper with fine mouldings, holding three uprights. The latter, where they joined the base, turned into fierce lion's claws of gold with exquisite foliage that embraced the columns. Above that they were clothed in detailed foliage, and in the middle they had cherub's heads affixed to them, flanked by outspread wings. From one head to another there hung a swag of massed branches, swelling in the middle and supplied with various fruits. At their summits, the uprights had a projection made to support the round table-top before the Queen. This support never altered, but the round tables were quickly exchanged, just as the material of the vessels changed at each new course.

In the blink of an eye, this tripod was set with a round table of smooth gold, three feet in diameter and an inch thick; all the following ones were of the same shape and size. The ivory tables were each spread with a perfumed and smoothly ironed cloth of green silk, as long and wide as almost to reach the floor, and fringed at its edge with its own threads interwoven and mixed with gold and silver thread. This fringe hung below a band or frieze a sixth of its width, subtly embroidered and with many pearls fastened to it, hanging about a handbreadth above the pavement all the way around. All the borders of the table-cloths were fringed and decorated in this manner.

Next there came a fair and lively girl with a broad golden dish filled with flowers: yellow, white and amethyst-coloured violets, fragrant as in

103

springtime, which she immediately scattered over all the tables except that of the Queen, which remained empty.

Her royal Majesty had taken off her cloak of office – Lolia Paulina the Roman never saw the like – and remained in a sumptuous gown of crimson-purple velvet, embroidered all over with a host of birds and other small animals, fronds and flowers, symmetrical knotwork, and in part with stump-work of lustrous pearls. Over it she had a diaphanous blouse of silk, lightly tinted with crocus-yellow, which was thin enough for the embroidery and the crimson garment to be visible underneath. It was an extremely light, charming and imperial costume.

Now two elegant girls came in carrying an artificial fountain that flowed perpetually, ingeniously raising the water that had poured out. It was of bright gold, beautifully cast in shell-form; and first of all they placed it before the Queen. No sooner was it presented on the golden table, than they made a graceful curtsy together, bowing their ornamented heads in unison and genuflecting to within an inch of the polished pavement. These servants made similar reverences in time with each other as they continued their service, both before and after they offered anything, and when they removed it. Three other splendid adolescents followed closely after them, one with a golden pitcher, the second with a shining hand-washing basin, and the third with a delicate towel of whitest silk.

After the divine Queen had washed her hands, the one with the golden basin caught the water so that it did not return to the fountain, and the one with the jug poured in as much perfumed water as had been poured out; for this wonderfully designed fountain never emptied. The third one quickly dried her hands.

The broad open basin of this fountain was cleverly supported on four little wheels, allowing it to run [91] on the table-tops and thus conveniently wash the hands of all the reclining guests. The centre of the fountain rose up higher than the rim, which was studded with round gems and formed into gadroons, as was the hollow of the bowl all around, and there were other ornaments. A noble vase stood upon this central promi-

nence, and on that another one of a different design. The two vases were joined together by two handles that were exquisitely finished, elegantly worked and richly ornamented. Among the other inestimable decorations, the top of it was formed into a flower, above which was a diamond shaped like a pear with its pointed end fixed in the flower. It flashed all around, and was of a size never before seen or imagined. To judge by my sense of smell, the water was scented with rose mixed with sugar, lemon peel, and a little amber or benzoin, carefully proportioned to make a sweet and pleasant odour.

In the middle of this stupendous court there was exhibited a marvellous vase for fumigations, not only noble and perfect in its material, which was the best and purest gold, but by its noteworthy and antique workmanship. The base stood upon three taloned feet of the dreadful harpy, which were joined by foliage to a triangular support, copiously ornamented with little scenes such as that metal demands. Three naked genii stood above the protruding angles, made in proper fashion, two cubits high, standing close together with their winged shoulders adjacent to one another. They rested with the right foot on a corner of the base, and the other foot relaxed and free, near to the fixed foot of the next child. They all had their elbows raised, holding in each hand a baluster that was thin at the bottom and opened at the top into a broad, shallow bowl with a wide rim. There were six of these in a circle, each adhering to the other. In the space behind the backs of the winged boys, a column rose from the central point of the triangular base, finely modeled in the form of an antique candelabrum. At the top it held its own bowl, like the others, and of just the size to fill the space

[91'] left in the centre between the six other bowls. The servants had filled these bowls with burning plumstones and then covered them with ashes; and upon the ashes in each bowl a golden pot was boiling. These each held a compounded liquor, or rather a water that had been infused all day with perfumed substances. I suspected that each pot contained a

different water: perhaps one had rosewater, while others were scented with orange, myrtle, the tender leaves of laurel, elderflowers and other well-known substances in various combinations. And when they boiled, an extraordinary and delightful fragrance drifted over everything.

In the presence of the magnificent Queen, there were always three demure maidens at her service, furnished with overgarments of gold marvellously woven with silk. These delighted the eye by changing their colours along with the changing of the tablecloths, such that when they changed the cloths, the servants also changed their nymphal garments to the corresponding colour. An elegant swatch of material emerged from their tight belts to circle around the snow-white flesh of their shoulders and over their generous bosoms, which swelled moderately beneath it, revealing the valley of their breasts: it was so extremely voluptuous as to make the richest food seem meagre to the spectators. These costumes were luxuriously decorated with a thousand coils and cords of gold and silk, destined with feminine wiles to provoke the pleasure of free and amorous glances, sweet and delectable to a degree beyond that of any favoured and delicious dish. They wore shoes of gold with a moon-shaped opening above the naked foot, all voluptuously secured in the same way with golden clasps. Their abundant blond hair flowed down as far as their calves, and was encircled above their white brows with strings of great matching pearls. These three served before the Queen with especial devotion and reverence, very adroit in their performance of this duty and exceptionally prompt in its execution, serving none but this one table. At each changing of the tables, they all stayed standing after their service was done, with their arms folded in reverent fashion; and thus did all the others who succeeded them, always remaining the same in number.

Of the three servants ministering to each guest, the one in the middle presented the food, the one on the right interposed a plate beneath the food so that nothing should fall, and the third, on the left, elegantly wiped the guest's lips with a white napkin, soft and perfectly clean. After each action they promptly curtsied. The napkin was not reused in this service: the maiden dropped it on the pavement, whence it was promptly collected and taken away; and as many napkins were brought as there were morsels to be served. They were fragrantly scented, folded, and wonderfully woven from silk.

This table service was observed diligently for each of the guests, so [g2]

that no one touched any of the food, but was fed at will by the servant, except for the cup.

After the first course, everyone washed in the ingenious fountain that I have described, in which the fallen water was raised again by the force of the air that was received or enclosed. I pondered on this exquisite device, and was extremely gratified to realize, after careful investigation, that the vase was divided inside by means of two pipes of unequal bore, with an inserted plate perforated in the middle, and that the water was forced to ascend by its own impulse.

After everyone had washed, first the Queen and then all the rest, the refined serving maidens gave to each a pear-shaped pomander of gold, finely pierced and containing a mixed paste of marvellous fragrance, so that their idle hands should be busied with something, and the senses of sight and smell delighted with this ball or toy, with its decoration of precious stones.

Then, at every change of course, two beautiful table servants pulled into the middle of the royal court a stupendous buffet on four rolling wheels, with its front made in the form of a boat or drinking cup and the back shaped like a triumphal chariot. It was made of pure gold, decorated with many scyllas and little sea monsters and a host of other exquisite images miraculously worked, and wonderfully ornamented all over with precious stones in elegant arrangements. These scintillated so as to light the whole surrounding area, and their blaze met in every direction with the flashing of other jewels in various places, so that one might well have said that Phoebus was here with his radiant hair. There was a nymph sitting on it, whose face was no less fair than her bright eyes. One could add nothing, nor even find anything to equal the continuous lustre and splendour of these ineffable artefacts – not even the Temple of Babylon with its three golden statues.

The interior of the chariot was well stocked with all manner of condiments and sauces, suiting the needs of every kind of table. It contained tablecloths, flowers, cups, napkins, vases, forks, drinks, food and seasonings. This charioteer nymph prepared them and promptly handed them out for distribution.

When the tables were taken down for the change of course, everything on them, as described above, was returned to the buffet-chariot. This then departed, and the maidens immediately began to sound their curved trumpets – such as were never invented by Pisaeus, son of [g2'] Tyrrhenus, nor by Maletus, king of Etruria – and the flautists played

107

with them. Thus it was done each time the buffet went out: they played until it returned and then stopped. Whenever the tables were changed, the musical instruments did likewise; and when they ceased, the singers began in the Aeolian mode, so sweetly as to make the Sirens sigh, accompanied by reed pipes and double flutes such as Troezenius Dard-anus never invented. In this way one was always hearing lovely music, listening to gentle harmonies, harkening to delectable melodies, breath-ing delightful perfumes and receiving the most delicious satisfaction of the appetite. Everything came together faultlessly for the sake of dignity, grace and pleasure.

All the utensils or instruments at this supreme and splendid table were of fine gold, as was the round table in front of the Queen. Now a cordial confection was presented, which I think I am right in saying was a healthy compound made mostly of powdered unicorn's horn, the two kinds of sandalwood, ground pearls in brandy set alight so as to dissolve them completely, manna, pine-nuts, rosewater, musk and powdered gold: a very precious mixture, weighed and pressed out in morsels with fine sugar and starch. We were given two servings of this, at a moderate interval and without drinking in between. It is a food for preventing every harmful fever and for dispelling all sorrowful fatigue.

After this, everything was taken away in an instant: the fragrant violets were scattered on the ground and the table was stripped. No sooner was this done than the table was covered once more with a sea-coloured cloth, and all the servants were wearing the same. Then, as before, they covered it with fragrant flowers of citrine, orange and lemon, and then presented in vases of beryl (and the Queen's table was of the same stone, except for the forks, which were of gold) five cakes or fritters made from saffron-coloured dough with hot rosewater and sugar, cooled and finely sprinkled with the same musk-flavoured water and with powdered sugar. These globes were delicious to the taste and very various, having been carefully cooked in the following ways: the first one offered was in olive-flower oil; the second, in clove oil; the third, in jasmine-flower oil; the fourth, in finest benzoin oil; the last, in oil pressed from musk and amber. After we had tasted this delectable dainty and savoured it with avid and keen appetite, we were presented with a solemn cup made, together with its cover, from the stone already [g3] mentioned. There was also a fine silken veil covering it, embroidered in vermiculate work with silk and gold, which was then thrown over the shoulder of the bearer and hung down her back. All the drinking and

eating vessels were covered and presented in this fashion. This chalice was filled with a precious wine: I suspected without a doubt that the god who makes the vintage in the Elysian Fields had infused this sweet liquid with his divinity, for it was unrivalled by Thasian wine or by any other precious liquor.

After this welcome drink, the table was taken down without delay, and the fragrant flowers strewn on the shiny pavement. A tablecloth of purple silk was quickly laid, and a mixture of roses scattered on it: incarnadine or mallow, white, vermilion, musk, Damascus, four-leaved and Jebbedine. The new servants, dressed in the same cloth and colour, nimbly brought to each guest six cuts of fattened, blinded capon, moistened with its own fat, sprinkled with yellow rosewater mixed with orange juice, roasted to perfection and then gilded all over. With this came six slices of snow-white bridal bread, and beside it a sauce of lemon juice modified with fine sugar mashed with pine nuts and the capon's liver, to which were added rosewater, musk, saffron and choice cinnamon; and all these flavourings were compounded in special and exquisite proportion, and perfectly seasoned. All the dishes were made from topaz, and so was the round tabletop.

This third frugal and magnificent table was dismantled like the others, then without delay it was newly covered with a satin cloth of bright yellow (and the servers clothed in the same), and all flowered over with fragrant lilies-of-the-valley and narcissus. The food was straightway presented: seven pieces of partridge meat, roasted diligently at the fire, and as many mouthfuls of yeasty milk bread. The sauce was sharp, with crushed almonds, thrice cooked sugar, starch, yellow san-dalwood, musk and rosewater; the dishes were of chrysolith, as was the circular table. At the end they proffered the precious chalice, and so it was done in the succeeding courses.

When this fourth rich course was removed, the table was relaid for the fifth with a crimson silk cloth, and the nymphs clothed in the same. The flowers were yellow, white, and amethystine Cairo roses; the food consisted of eight morsels of choicest, succulent roast pheasant meat, and as many pieces of a light white bread. The sauce was thus: fresh egg yolks with pine nuts, orange water, pomegranate juice, Colossine sugar and cinnamon. The dishes were of emerald, and so was the table of the sublime Queen.

After this solemn course was cleared, there was no delay before spreading a cloth of violet silk, with matching garments for the

[g3']

nymphs. The flowers were the three kinds of jasmine: red, yellow and white. The food was nine mouthfuls of long-lasting peacock's breast, roasted in its juices, fat and well grilled. There was a sour green sauce with ground pistachio nuts, Cyrian sugar, starch, musk, wild thyme, white oregano and pepper. The dishes and the royal table were of blue sapphire.

After this seventh rich course, they brought in a sumptuous table all made from white ivory subtly pieced together, in which was set another one of precious aloe wood, well compacted with glue and engraved from one end to the other with a wonderful design of noble knotwork, with foliage, flowers, vases, little monsters and birds, filled in with a black compound made from musk and amber. I reckoned this, with good reason, to be a most elegant and luxurious thing, with an odour that was delightful to breathe. The cloth was fine and white, with ver-miculate embroidery of Carystian cotton, the same cloth as was worn by the serving maidens. The flowers were cyclamens together with every kind of carnation, excessively fragrant: I dare not express the delight to the senses caused by such sweet and varied scents in ever new combinations. The excellent confection was morsels made from date-pulp and pistachios ground with rosewater, sugar of the Isles and musk, mixed with precious powdered gold so that the entire thing seemed to be made of gold. Three of these were given to each. The dishes and the circular table were of hyacinth, a suitable stone for the excellent setting of the divine and magnificent table, and not subject to Licinia's sumptuary laws.

After we had delighted in tasting this marvellous confection and the flowers had been tipped on to the ground, without a moment's delay a great golden shell of regal magnificence was brought in. It was full of burning plum-stones, on to which the tablecloths and cotton napkins were all thrown and left long enough in the fire for them all to catch light. When they were taken out again and cooled, they seemed to be undamaged, purged and perfectly clean, as before. This was another remarkable and unusual spectacle. Soon the the tripods and tables were quickly dismantled and taken away.

The more I thought over all these excellent spectacles, the more igno- [g4] rant and stupefied I was; but the intense admiration of everything certainly gave me extreme pleasure, as I beheld so many great and tri-umphant things. There was such lavish luxury, such incredible expense and extravagance, that I think it better to hold my peace rather than

speak inadequately of it. I must say, though, that the banquets of Sicily, the ornaments of Attalus, the vases of Corinth, the delights of Cyprus and the Salian feasts were less costly. Nonetheless, the supreme and excessive gladness, the hearty enjoyment and the extreme pleasure that I felt during this entertainment was interrupted, checked and spoiled by one of those three nymphs who came to serve me at each change of course, because she seemed in every respect to resemble the beautiful image and sweet outward looks of Polia, as well as her lively gestures and her knowing and captivating glances. This added no small measure of sweetness to the great and superior delight of the rich, delicious flavourings and the lavish feast. But she gradually prevented my excited and ravished eyes from admiring all those precious gems that flashed everywhere with refulgent splendour, all that diversity of beauties never seen before, those conspicuous ornaments; it was as though I had surrendered them all to her, with my immoderate desire to behold in her the resemblance of that acme of all beauty. Finally, the tables were taken down in the order described, and a sign was made to me not to leave my place, because the pastries and rich, sweet desserts were to follow.

Now five comely servants, dressed in costumes of blue silk beautifully interwoven with a golden weft, presented themselves first to the venerable and divine presence of the Queen, and afterwards presented themselves with extraordinary dignity, all in unison, to each of us in turn. The one in the middle held an oversized bush of cinnabar-coloured coral, such as would never be found in the Orcadian Islands: it was a cubit high, and fixed so as to stand upon a hillock made all of emeralds. This hillock covered the mouth of an antique vase of pure gold, made in the shape of a chalice and the same height as the mountain and the branching coral, and full of marvellous artificial foliage, such as is not made in our times. The tapering foot and the bowl were perfectly connected by a pommel of indescribable workmanship. Both the base and the bowl had outstanding bas-reliefs of leaves, little monsters and double-tailed scyllas, more exquisitely made than any embosser could achieve, and proportionate to the round body. The dentillated surround of the hillock was studded with incomparable gems, and more of these were positioned to blaze like lightning from every [g4'] appropriate part of the base. Some open flowers shaped like the five-petalled rose were artfully attached to the branches of the bush, some made from lucent sapphire and others from lustrous hyacinth or beryl. Inside five of these flowers were five little apples – or rather sorbs, being

111

of that colour – fixed on a golden bee's sting that protruded from the centre of the flower with realistic effect.

This damsel curtsied reverently to the ground with her right knee, leaving the other raised to support this admirable coral. Beside the twigs occupied by the precious flowers, it had others with huge pearls attached to their tips.

Another maiden had the cup with the precious liquor, such as even Cleopatra never offered to the Roman captain. The three others executed their appointed tasks, as described above. Having plucked these little fruits (never before seen or known by me) one after another with golden tongs, they offered them for us to relish the taste. The unspeakable sweetness of taste that I felt was as though the ideal form had been dissociated from the gracious material. And now the pear-shaped golden pomanders, mentioned above, were given back.

Straightway there appeared a miraculous work of art: another perpetual fountain of skilful design, made from the same material as the first but of a different, noble form and invention, marvellously mobile and resting on a fixed axle around which the spinning wheels revolved. On this axle was placed an unequal rectangle, three feet long, two feet wide and a third of a foot high. At each corner there sat a harpy with both its wings extended upwards toward a vase, which was placed in the very centre of this rectangle. It had a cornice of gullets, cymas and small fruits that made a perfect sur-

[g5]

round for the top. Each face of this table was divided into three, and the middle part framed with wave-mouldings, to contain a bas-relief carving of a triumph of satyrs and nymphs, with trophies and exquisite scenes. But the front and back faces, which were moderately curved, contained instead of the square lineament a circle outlined with a wave-moulding. Inside this a small sacrificial scene was marvellously sculpted, showing in each panel an ancient altar with several figures and actions. The parts remaining empty were well covered by the harpies' bifurcated tails, which were neatly transformed on either side into spiral fronds. In the centre of the original rectangle, a beautiful ancient vase rose up out of antique foliage, not exceeding in its circumference the limit of the flat rectangle beneath it. Both this and all the remainder of the construction was thoughtfully proportioned as to height, width and depth, made with the lineaments proper to vases, diligently filed and polished, and finished with absolute smoothness. From its stopped mouth there grew a shell, wider than the vase below it, ornamented all around with grooves, wide mouthed and broad rimmed, such as no turner could ever turn on the lathe.

Another vase of incredible workmanship rose from the central point of this shell. The bottom third of it had shingles protruding outwards, then a row of various priceless, navel-shaped gems, brilliantly arrayed in alternating colours; and above this a monstrous male head, whose hair issued on all sides in the form of exquisite foliage and filled the whole space as far as the head on the opposite side, gracefully decorating the capacious body of the vase.

On the projecting rim perpendicularly above the head there rested a ring, from which festoons hung to either side; they contained a mass of leaves, flowers and fruits, swelling as they hung down, with both ends neatly tied to the rings.

Above the midpoint of the curve, the head of a little old man was affixed beneath the projecting rim, with his beard turning to leaves and [85'] a pipe in his mouth from which the water of the fountain was made to fall incessantly into the shell beneath.

From the mouth of this vase there arose a precious mound, marvellously compounded of innumerable globular gems heaped closely on top of each other and irregularly or roughly fashioned. They made the mound look delightfully rocky, with its different colours brilliantly flashing and its well-proportioned height. On the top or peak of this mound there grew a pomegranate bush whose trunk or stem and

branches were, like this whole assemblage, of shining gold. The leaves attached to it were of scintillating emerald; the fruits distributed over it, of natural size. The golden pomegranates were split wide open, and in place of the seeds there were bright rubies glowing beyond compare, and as large as beans. Then the ingenious artisan of this inestimable work, out of his fertile imagination, had separated the seeds with a membrane made from thin silver leaf. In addition, he had realistically made some of the split pomegranates showing immature seeds, which he had made exquisitely from large pearls of orient whiteness. Then again, he had cleverly imitated the pomegranate flowers in perfect coral, with their calyxes full of golden bees. Above and beyond this, the stem was hollowed like a tube, and out of it issued a freely turning rod. The bottom of it was fixed in a socket, pivoting or rather fastened to the middle of the axle, and it ascended through the hollow trunk.

Firmly fastened to the top of this rod was an admirable vase of topaz,
of antique form, its bottom broad and gadrooned, its mouth admirably
encircled by a cornice, flanked above and below by a fillet. There were
four winged cherubs' heads attached to this belt at equal intervals, with
four running pipes in their lips. The remainder of the vase was twice as
high as the bottom width, and culminated in a reversed leaf-form that
[g6'] blocked its mouth. Placed above this was another small, roundish vase
covered with delicate foliage, with little cornices and an artistically fash-

ioned mouth. The flowered tail of a dolphin descended from the bottom of this vase, connected for a while with the tapering part of the vase beneath, then joined its leaf-finned head to the encircling belt where the cherubs' heads were attached. With a moderate outcurving near the head and an incurving toward the tail, these dolphins formed elegant handles. This descending part displayed an exquisite finish and the best lineaments.

The vase attached to the summit had been made so perfectly that when the chariot was in motion, the rod began to spin together with the vase, and the water sprayed out beyond the tree, stopping when the wheels did so. This is how I understood it: the power came from the motion of one of the wheels, which contained another, toothed wheel facing the turning spindle. This had holes for the teeth, and moved the stem of the vase. The wheels were half covered with a shrouding resembling two spread wings facing in opposite directions and decorated with scyllas. This marvellous device passed in front of everyone, wetting their hands and then their faces and making everything emit an unexpected fragrance: for when I rubbed my hands together, there was a perfume such as my senses had never known before. And thus the appointed maidens operated it. After this sprinkling with perfumed water, the house servants made a singular show of generosity by offering us a golden boat of sweet nectar. The sovereign Queen drank first, saluting us all with especial friendliness, then each of us in order drank solemnly with reverent, grateful and mutual courtesies. It was the conclusion and seal of all the libations and delicious food that we had received.

Lastly, all the fragrant flowers were diligently swept up and collected, and all the crumbs removed, leaving the floor bright and shining like the surface of a polished mirror that rivalled the surrounding spectacle and the lustrous gems. With everyone seated in her own place, the nymph of the fountain departed. Finally the high and magnanimous Queen commanded an unusual dance or ballet to be performed on the squares of jasper, which were smoothed, polished and finished with the ultimate in skill, such that mortals have never seen or imagined the like.

POLIPHILO CONTINUES BY TELLING OF THE
ELEGANT BALLET IN THE FORM OF A GAME THAT
WAS GIVEN AFTER THE BANQUET, AND HOW THE
QUEEN ENTRUSTED HIM TO TWO NOBLE GIRLS
WHO LED HIM TO LOOK AT GREAT AND DELIGHT-
FUL THINGS, AND SPEAKING PLAINLY TO HIM
RESOLVED CERTAIN DOUBTS. FINALLY THEY
REACHED THE THREE PORTALS, AND
HE REMAINED IN THE MIDDLE ONE
AMONG THE AMOROUS NYMPHS.

O DESCRIBE IN ALL ITS DIGNITY THIS superabundance, this incomparable glory, these tri-umphs, and the incredible treasury, delicious foods, high ceremonies, solemn feasting and sumptuous ban-queting of the serene and opulent Queen would be beyond my powers. But this should not surprise the curious public, because if even one endowed with the keenest mind and the richest and most eloquent language could not give a satisfactorily clear and connected account of it, how much less could I, who suffered continu-ally in the secret parts of my heated heart from the ceaseless attack of my lady Polia, who though absent sapped all my valour and left me in dev-astation? The many surpassing and unheard-of wonders, the endless parade of priceless and superhuman novelties confused my mind and left all my senses equally distracted. Their spectacular variety and the excessive contemplation of them made me incapable of describing them point by point and displaying them adequately. Who could ever conceive of the rich accoutrements, the exquisite ornaments and the curious customs, the conspicuously perfect and exalted beauty free from every defect, the lofty wisdom, the Aemilian eloquence, the more than regal generosity, the splendid architectural arrangements and the firm symmetry of this absolutely faultless building, the nobility of the marble masonry, the placement of the columns, the ornamentation of the walls, the variation of stones, the royal vestibule and the ample peri-
style? Who could believe in pavements of such luxury and ex-travagance, decorated and strewn with precious carpets; in the high and spacious atrium and the ostentatious interior rooms: bedrooms, drawing rooms, baths, library and picture gallery, all solemnly arr-anged, furnished and decorated with majestic richness?

I admired there bold and marvellous conceptions incurring incredible expense, to the great praise of the noble artist who had ensured that everything was defined and assembled with suitably refined lineaments. I took special pleasure in admiring an example of coffered joinery decorated with supreme skill, which extended horizontally and was beyond all comparison. It was a superb ceiling, divided into variously shaped compartments of precise and regular dimensions, which made a fine design, being walled off by protruding mouldings decorated with the proper lineaments of a cornice: small fascias, gullets and egg-mouldings, berries or rosehips uniformly threaded, and acanthus leaves in the angles of the squares and the adjacent rectangular coffers; roses in high relief with a double row of petals, all open and sinuous, with the inner row smaller and duly separated from the larger one. All this was covered or rather gilded with the finest glossy gold, and coloured with rare dark blue, together with various other decorative figures and similar lineaments. The beams of Salauces, king of Colchis, were nothing to it.

Add to this the luxurious amenities of tidy lawns, orchards, watered gardens, playing fountains, rivulets running in marble courses enclosed and channeled with incredible workmanship; dewy plants forever fresh and flowering, gentle summer breezes and springtime airs, the mixed chorus of birds; the pure serenity and perpetual temperance of the sky, clear and pure in the healthgiving breeze. Here were no rocky or stony places, swept by harsh and freezing winds or burned by the intemperate heat of the sun, but everything enjoyed kindly and benign weather and a moderate degree of sunshine. The fields were fertile and yielded all their produce without labour; there were sunny hills and cool, leafy copses with dense, comfortable shade.

Then there were the priceless furnishings, the efficient attendants with their many elegant duties, the many girls in the flower of their youth, the gracious presence of maidens of the vestibule, the hall, the chamber and the royal service; the venerable and majestic appearance of the Queen, with her exquisitely decorated raiment, her extraordinary ornaments and the proven charm of her own beauty, which were more than anyone could describe or imagine.

The high priest Hircan would have nothing to boast of in the face of these infinite riches, supreme delights and immense treasury, nor would Darius or Croesus, nor any other human wealth or condition. As for [g8] myself, I was so overcome at this point that I can say nothing more in conclusion than that I was left senseless and vacant of mind; I lingered

in the utmost pleasure, neither averse to the things presented nor satiated by them, but above all, as I have said, outside myself, brooding on the fate that had destined and led me to these blessed realms. But later I found myself again among such a mass of glories and in this holy place, this happy land, this beatific entertainment, and at a worthy and triumphant feast such as Clodius the tragedian never gave, exempt from the Tapullian or Licinian laws, refreshed without excess and safely reassured by royal favour of the success of my longed-for love. Then I was consoled, and contemplated inwardly everything that had happened and been shown to me, joyfully giving thanks to Fortune for it all.

The mighty Queen now wished to make a greater exhibition than hitherto, to show that she was first and greatest in the world for excellent and rare magnificences. Each sat in her own seat, after the miracle of the sumptuous feast, then without further ado the Queen ordered a game for the spectators, worthy not only to be watched but to be remembered for ever. It was a splendid dance, or rather a ballet, which proceeded thus.

Thirty-two young maidens entered through the curtains, of whom sixteen were dressed in golden material. Eight of them were uniform. One of the sixteen was dressed in gold in the costume of a king, and another in the costume of a queen. There were two guards of the fortress or citadel, two confidential attendants or secretaries, and two knights. An equal number were dressed identically in silver material, with the same courtiers. All of them were set out according to their ranks on the squares of the pavement, sixteen dressed in gold on one side and sixteen in silver on the opposite side.

The musicians began to play on three instruments of strange invention, very well in tune and in ensemble, with sweet chords and melodious intonation. At the rhythmical beat of the music the dancers moved on their squares, agile as dolphins, as the king directed: they turned around, duly honouring the king and queen, then jumped onto another square, making a perfect landing. As the music began again, the silver king ordered the one in front of the queen to move forward. She proceeded with the same reverent gestures, made her landing, and stood there. In the same fashion, following the rhythm of the music, [g8'] they changed places or else stayed dancing on their own squares until they were attacked or captured and departed, always at the king's command. When the music marked a certain beat, the eight uniform pieces would take the time of that beat to move to another square; they

could not go backwards unless they had managed to move unharmed to the row of squares where the king had his residence, nor could they advance except in a diagonal line.

A secretary and a knight covered three squares in one beat: the secretary in a diagonal line, and the knight by two straight squares and one to the side; and they could do this in any direction. The guardians of the citadel could traverse many squares in a straight line, covering three, four or five squares by keeping time and increasing their pace. The king could move to any square that was not blocked or rather guarded; he could also capture, but he was forbidden to enter a square on to which another piece could leap, and if possible he should avoid it through prior warning. But the queen could go through any square of the same colour as her original seat, and it was good if she always followed at her husband's side.

Sometimes the ministers of one king or the other found one of their adversaries without guard and protection; then they would take it prisoner, both of them would kiss, and the vanquished one would exit. In this way they made a wondrous game into an elegant ballet, dancing and gaily playing in time with the music, with the result that the silver king was the victor, to the delight and applause of all. This solemn performance with its skirmishes, retreats and defenses lasted an hour. It involved rhythmical circulations, obeisances, pauses, modest restraints; and it filled me with such pleasure that I might well have thought myself transported to the heights of Olympus to taste a felicity I had never known before.

When the first ballet game was finished, all moved back to their own squares, and just as it had been done the first time, so the second time, as soon as they had returned to their appointed places, the musicians speeded up the beat and the movements and gestures of the agile dancers went faster. They followed the rhythm of the music so well and with such appropriate and artistic gestures as to be beyond criticism. The skilful maidens wore their copious hair bound at the head with a wreath of fragrant violets, then falling down over their delicate shoulders and over their backs, so that it moved in time to the music; and when one of them was captured, she lifted her arms and clapped her palms together. Sporting and turning in this fashion, the first side was [h1] victorious once more

All were positioned in their places for the third ballet, then the musicians played in a still faster tempo and in the exciting Phrygian mode,

the one supposedly invented by Marsyas of Phrygia. The gold-clad king made the maiden in front of the queen move to the third square, counting in a straight line from the first one, and a battle immediately ensued. It was a delightful tournament with quick and sudden movements: they bent down to the ground and then leaped up opposite each other, spinning like a lathe with two revolutions in mid-air, then landed without a break with the right foot on the ground, spun round three times, and then suddenly turned in the other direction on the other foot. All this action took only one bar, and was accomplished with such peerless ease and agility, complete with deep bowings, complicated jumps, facile leaps and graceful gestures, that nothing resembling it has ever been seen or even attempted. None ever impeded another, but whenever one was captured, she never left the game without instantly giving her capturer a succulent kiss. And when only a few were left, one could better appreciate the wiles with which the two sides deceived one another. They displayed such discipline and faultless order that if the rhythm of the expert musicians briefly accelerated, all the dancers would do no less with their movements, owing to the consonance of harmony with the soul; for it is chiefly and principally through this that there exists the concord and agreement by which the body is sympathetically disposed. For this reason I thought warmly of the power of Timotheus, the most skilful of musicians, who with his singing forced the army of the great Macedonian to take up arms, then, changing his voice and the mode, made them all lay their weapons aside and calm down again. In this third match, the king clothed in gold triumphed gloriously.

Now this gay festival concluded amidst great joy and immense pleasure, and everyone sat down. Then they made me rise, and I made a profound reverence before the venerable seat of her divine Majesty, and as I duly knelt, she spoke to me thus: 'Poliphilo, henceforth you should consign to oblivion your past misfortunes, and put away your painful thoughts and all that has happened, because I am certain that by now you are fully recovered. Therefore, since you are bravely bent on pursuit of the amorous flames of Polia, I think it best for your attainment of her that you go to three portals, where the old queen Telosia dwells. In that [hɪ'] place, above each of those doorways you will see its name and title indicated and inscribed. Choose carefully! But for your guidance and protection, I will give you two of my joyous and experienced handmaidens, who will lead you safely and never leave you. So go with a

light heart and a happy outcome.' And straightway, with royal largesse, she drew from her ring finger a golden ring set with an ananchitis stone. 'Take this,' she said, 'and wear it joyously in memory of my friendly generosity.' I was dumbstruck at this exhortation and this precious gift, and could find nothing to say to match my gratitude. But she kindly noticed this and turned in a motherly fashion, with natural superiority and royal gravity, to two noble girls next to the imperial throne to the one on the right, and spoke her command.

'Logistica, you shall be one of those to go with our guest Poliphilo.' Then in a holy, religious and reverent fashion she turned to the left, saying: 'Thelemia, you will also go with him; and both of you will give a clear indication of the portal in which he should remain. Then, Poliphilo, they will present you to another queen, a very splendid and venerable one. If she acts kindly and helpfully toward you, you will be blessed; if the contrary, you will be unfortunate. Nevertheless, one can tell nothing from her face, for sometimes she seems to be showing well-bred urbanity and agreable jollity, and sometimes malice, ill-will and contempt, with unstable humour. It is she who terminates everything, and for this mysterious reason she is not undeservedly called Queen Telosia. She does not dwell in such a pompous and opulent mansion as you have seen me inhabit. But I wish you to know that neither the almighty Creator nor orderly Nature herself could have shown you a greater treasure than to reach my divine presence and ample munifi-cence. For skilful Nature could not heap up greater riches than to obtain and follow my benign grace and to be a participant in such blessings. Thus you can judge accurately that no treasure in the world could possi-bly compare with that which you truly find in me: a celestial talent veiled from mortals. But Queen Telosia lives in a darksome, cloudy place, and her dwelling has its exits blocked because she will never permit herself to be seen by men, beautiful as she is. For it is not allowed for divine beauty to appear to bodily eyes, and for this reason one can never see her approaching; but in her desire not to be manifest, she has the remarkable habit of transforming herself into many shapes. When [h2] the ancient doors are opened to you, she will appear before your eyes in each one of them, yet you will not know her unless modest prudence, together with sincere and right judgment, allow you to glimpse her, because she transmutes herself with ambiguous dress and looks. This duplicitous quirk of hers often leaves a man irrevocably disappointed in his expectations.

'Take note, then, O Poliphilo, that these two girls of mine whom I consign and confide to you will suggest which portal you should enter and abide in. Whichever companion you prefer to listen and hearken to, you may follow her advice unreservedly, thanks to the free and excellent gift and the permission I have granted to you; for each of them has some notion of what to do.' And when she had said this, she nodded to both Logistica and Thelemia, who did not hesitate to show themselves her humble servants. And I made a gesture of gratitude for her great generosity, since I neither dared nor knew what to say in so sublime a presence.

The two companions took me gaily with unceremonious speed and virginal gestures, one by the right hand and the other by the left, and after taking reverent leave, first of the Queen then of all the others, led me out through the same curtains and doorways. Still eager and unsated, I turned round at the splendid portal to survey the whole ensemble of the palace, which was an admirable and perfect example of architectural art. The subtlety of this work was beyond imitation even by the most inventive of mortals, so that I suspected that the architect's sagacity had created many delightful things to admire in the hidden parts of his work, for the sake of comfort, utility, grace, decoration, and in order to make it forever firm, constant and enduring. For this reason, I very much wanted to stop and tarry awhile, but was unable to do so, since I was following my assigned guides and companions. Still, I stole a quick glance at the frieze or zophorus of the portal, and saw this inscription written there: Ο ΤΗΣ ΦΥΣΕΩΣ ΟΛΒΟΣ

When my excellent senses had rapidly grasped it, I found it very satisfying and felt such extreme pleasure as would never be believed. O happy they to whom it is granted to dwell forever in such a place, either as natives or as sojourners!

When we had reached the area enclosed by the hedge of orange trees, Thelemia said to me very affably: 'Beside the excellent and marvellous things that you have already seen, Poliphilo, there are four more sights for you to admire.' Then she led me into a gorgeous orchard on the left side of the incomparable palace: a tremendous creation demanding vast [h2'] expense, time, and ingenuity, and equal in ambitus and area to the place where the royal palace stood. All around it were were flower beds, attached to the enclosure and protruding from it, in which instead of living plants, everything was made from clear glass, surpassing anything one could imagine or believe. There were topiary box trees

moulded of the same material with golden stems, alternating with cypresses no more than two paces tall, while the boxes were one pace high. The beds were filled with a marvellous imitation of various simples, elegantly trimmed as in nature, and with gaily varied forms of flowers in distinct and delightful colours. The flattened edges of these square open beds, or rather containers, were adorned with a little cornice of gold, finished and decorated with subtle lineaments. Its beautiful fascia was of glass plaques gilded on the inside and curiously decorated with wonderful engraving, enclosed and gripped by golden frames; and these continued around, with the lower socle two inches high. This orchard was fenced by carefully spaced, swelling columns of the same material, clothed with convolvulus flowers; and on either side of them protruded square, fluted pilasters of gold, arching over from one to another, with the requisite beam, zophorus and cornice projecting the proper distance above the glass capital of the round column. The body of the latter, beneath the vines, was an imitation of jasper with many bright colours, while the vines stood out a fair distance from the solid surface. The vaults of the arches were filled with transparent glass lozenges a third as long as they were wide, similarly enclosed in doublegrooved frames and surrounded by various encaustic paintings, very gratifying to the senses.

The whole site was paved with small glass roundels and other appropriate and supremely graceful figures, fitted together and cohering firmly. It had a gemlike radiance, without any addition of foliage. A remarkable fragrance emanated from the flowers, which had been rubbed with an ointment and watered.

Sweetvoiced Logistica now made an eloquent speech with penetrating remarks in praise of the splendid craft, the nobility of the material, the artistry and the invention (such as one would not find in Murano), but disparaging its nature and saying 'Poliphilo, let us go up to this fine tower near the garden.' Leaving Thelemia behind, we leapt nimbly up the spiral staircase to the flat top, where she showed me, and explained with divine eloquence, a wide circular garden made in the form of a complex and intricate labyrinth. Its circular paths were not walkable but navigable, for in place of streets there ran rivulets of water. [h3] This was a mysterious place with salubrious meadows and rich soil, pleasant and fertile, supplied with an abundance of sweet fruits and ornamented with generous springs, rejoicing in flowering greenery, and offering everywhere solace and recreation. Logistica said: 'I think,

Poliphilo, that you do not understand the conditions that obtain in this marvellous site. Listen: whoever enters cannot turn back, but, as you can see clearly, these towers placed here and there divide seven circuits from one another. The great danger run by those who enter is that a deadly dragon, voracious and invisible, dwells in the open entrance of that central tower; and the worst of it is that he lurks now in one place, now in another, yet one cannot see him, and, horror of horrors, cannot escape him. He flies to the entrance or to further on, where he has his lair, and devours those who enter; but if he does not kill them between one tower and another, they can pass the sevenfold circuit safely as far as the nearest tower.

'You can see on this first tower the title written in Greek, and take heed of it: ΔΟΖΑ ΚΟΣΜΙΚΗΩΣ ΠΟΜΦΟΛΥΣ. Those entering here travel on their boat with a following breeze and no trouble or care; fruits and flowers fall into their vessel, and they cover the seven revolu⁄ tions as far as the second tower with the utmost delight and jollity. Now notice, Poliphilo, the clarity of the air in this first part: how it increases as far as the middle tower, then gradually declines toward the centre until it becomes dark and lightless.

'In this first tower there dwells and presides eternally a pious matron who is kind and generous; firmly placed before her is an ancient and fateful urn, ornamented with these seven Greek letters: ΘΕΣΠΙΟΝ. It is crammed with future fates, and she gives one to everyone who enters, politely and freely, without respect to their condition but according to what will eventually happen to them. After receiving these, they go forward and begin to sail in the labyrinth, whose channels are divided by roses and fruit⁄trees. When they have completed the first long circuit of the seven revolutions, which are navigable to the very end of the spiral, and reach the second tower, they find innumerable girls of all conditions who ask them all to show them their futures. After these have been shown them, the girls easily recognize one particular destined future and, embracing him, welcome him as a guest and invite him to travel the second seven circuits with them. Each one is led as far as the third tower in a manner and speed conforming to his inclinations. If anyone wishes to proceed through this place with his companion, she will never abandon him; but since other, more attractive maidens are to [h3'] be found here, many repudiate the first and join up with a new one. As they leave this second tower to go to the third, they find the water some⁄ what contrary and have to make use of oars. After they have arrived at

the third and set out toward the fourth, they find the water more con-
trary, although in these seven oblique courses great pleasure can still be
found, albeit variable and inconstant. On attaining the fourth tower,
they find different maidens who are athletic and aggressive, and these,
after examining their original futures, admit the suitable ones into their
activities and allow those who are unlike them to remain with their own
women. The water in these circuits is even more rough, demanding
great effort and heavy exertions in rowing.

'When they land at the fifth tower they find the water smooth as a
mirror, in which they admire the beauty of their reflections, and, with
their minds riveted by this pleasant and satisfying entertainment, they
succeed only with difficulty in passing through. It is here that one
clearly understands the motto and golden saying, 'Blessed are they who
keep to the mean' – not the linear or local mean, but the mid-point in
time between what is past and the end. A sincere examination reveals
this mean, at which one gathers the happiness or blessings either of
intelligence or of riches; but if one does not have them, it is more diffi-
cult to acquire them in what follows.

'As they travel onward from there, the water in the tortuous circles
begins to lessen its speed, right up to the final centre; thus they are carried
with little or no rowing to the sixth tower. Here they find elegant ladies
with chaste and modest looks, intent on religious observance, whose
divine appearance captivates the guests, making them reject their previ-
ous companions and turning their love to nausea. They enter into
tranquil relations with the new ones, and calmly traverse the seven revo-
lutions.

'Once these are past, a rapid voyage ensues through foggy air and a
very uncomfortable and difficult route, for as the revolutions of the
channels approach the centre, they grow ever shorter, and one flies with
irresistible speed between the slippery banks to the whirlpool of the
central tower. With great affliction of soul, one recalls the beautiful
places and the company left behind, and is all the more aware of being
unable to reverse or turn the prow of one's boat, because the prows of
the other boats are continually at one's stern. Thus one comes with great
suffering to the frightful inscription over the entrance of the central
tower, carved in Greek letters: ΘΕΟΝ ΛΥΚΟΣ ΔΥΣ ΑΛΓΗΤΟΣ.
And considering this disagreable motto, they regret having ever entered
this labyrinthine orchard, which includes so many delights but submits
them to such miserable and inevitable necessity.' Logistica then smiled,

adding as though inspired, 'Poliphilo, in this voracious mouth there sits a severe judge; she holds a scale and judges those who enter, scrupulously weighing their actions on the balance. By this means they obtain a better or a worse fate. And because it would take too long to tell you all, this is enough to say for the present. Let us go down to our companion Thelemia.' When the latter asked what had delayed us, Logistica replied: 'It was not enough for our curious Poliphilo simply to see, but I had to give him information about that which matter cannot penetrate, so that at least he could know it by hearing my interpretation.' And after that, Thelemia said:

[h4]

'Let us walk to the other garden adjoining the right wing of the great, proud and royal palace, which is no less full of pleasures and delights than the glass one.' And when we came into it, I stood astounded and amazed to see a work not only difficult to make, but also to describe. It was the same size as the glass garden, with a similar arrangement of containers edged with elaborate cornices and a golden socle, except for the construction of the dividing walls and the material, for this was all excellently made from silk. There were silken box-trees and cypresses with golden stems and branches, appropriately seeded with gems, and the containers were filled with simples that Mother Nature would have envied, flowering and most desirable with every exquisite colour, and fragrant just like the glass flowers. The surrounding enclosures were all astonishingly made, with incredible expense, from pearl. I could see that all the surfaces were covered with a crowded mass of clear, medium-sized pearls tightly cohering, while creeping green ivy was growing over them out of the containers, its leaves hanging down in front of the pearls. The golden stems were artificially bent into serpentine forms, and the slender tendrils crept around the pearls with the most exquisite refinement, while gemstone berries were attached to the clusters. The enclosure was splendidly divided by square pilasters, with their golden capitals and a masterly sequence of beam, zophorus and corona of gold.

The faces of the containers were embroidered in Arras-work with scenes of love and hunting done in gold, silver and silken threads, unequalled in its imitation of painting. The ground of the level area appeared to be of green silken velvet, like a lovely meadow, and in its centre there stood a round enclosure with a tall cupola, made from golden rods and covered in a distinctive manner with flowering rose-bushes of the same material, so that I would have said that they were

more acceptable to the senses than real ones. Beneath this roof was a circle of seats made from reddish jasper, and the entire area inside it, right to the edge, was a solid circle of yellow jasper, marked by a confusion of colours that harmonized beautifully together. It was so lustrous that every object was reflected in it. [h4']

We rested a little, sitting beneath this bower, and amiable Thelemia took the lyre she was carrying with her and began to sing, with heavenly melody and unheard-of sweetness of voice. She sang of the origin of all these delights and of the empire of her Queen, and of what an honour it was for her to have the companionship of her friend Logistica. I was surprised that Apollo himself did not come to listen, so excessively harmonious was her performance; and for the present, I had no desire whatever for anything else. As soon as the divine poem was over, the god-beloved Logistica took me by the hand and led me out of there, saying 'Poliphilo, I want you to know that things perceived give more enjoyment to the intellect than to the senses alone. For this reason, let us go into this place so as to satisfy both modes of perception.'

Then, with her noble companion, she led me into another garden near the former one, where I saw an areostyle arcade all made from bricks, five paces high from the ground to the top of the arch and three in breadth, and all tiled so that the rain ran to the outside. It was a continuous circle, beautifully covered and overgrown with green ivy so that not the slightest vestige of wall was visible, and there were a hundred arches, enclosing a flowering orchard. In each of the arches there was a red porphyry pedestal of the best lineaments, on which stood a golden statue of a divine-looking nymph, all varying in their garments, head-ornaments and actions, and each making a reverent gesture toward the centre of the garden.

Right in the centre there was a mysterious thing: a cubic base of translucent chalcedony, and upon this, contained within the square, a cylindrical stone of bright-red jasper, two feet high and a pace and a half in diameter. Next, placed on this and fitting within its circle, was a black, triangular stone a pace and a half in height, whose three angles extended to the limit of the plinth beneath it. On each of the flat, polished faces of the triangle was attached an admirable image, divine, grave and venerable in aspect, with its feet resting on the part of the cylinder uncovered by the triangle. These figures were as tall as the black stone to which they adhered at the back; they extended their left and right arms to the angles, holding a cornucopia affixed to the dulled or

128

curtailed points, which were cut off by their fingers at a distance of one foot, two inches. The horns, ribbons and statues all shone with pure gold, and the hands were looped with loose and sinuous ribbons that seemed to fly through the surface of the stone; and they were dressed as nymphs. It was no human work, but divine: even the sepulchre of Zarina, queen of the Sacians must give way before it.

[h5]

On the flat, square faces of the lower figure, Greek letters were carved, first three, then one, two and three, thus: ΔΥΣ Α ΛΩΤΟΣ On the circular stone I saw three hieroglyphic characters directly under the feet of each statue: first the form of the sun was traced, then an antique rudder, and lastly a dish containing a flame.

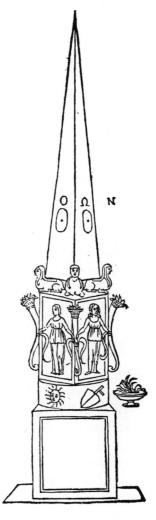

Above each angle of the dark stone I saw an Egyptian monster of gold, four-footed and recumbent. The first had an altogether human face, the second half-human and half-beast, and the third was completely bestial. They had a fillet around the head, two ribbons hanging down covering the ears and touching the neck and breast, another one descending over the back, and the body of a lion with its head raised.

Then, rising from the backs of the three, there was a massive, triangular pyramid of gold, five times as high as its lower face or diameter. Each of its faces was carved with a plain circle, and above that a Greek letter. On the first was an O; on the second face, a circle and above it a letter Ω; on the third plane, a circle and above that a letter N.

God-inspired Logistica now began to prophesy, and said, 'The celestial harmony is in these figures. Take note, Poliphilo, that these figures, with their perpetual affinity and conjunction, are noble antique monuments and Egyptian hieroglyphs, whose hidden message tells you this: TO THE DIVINE AND INFINITE TRINITY, ONE IN ESSENCE. The lowest figure is

consecrated to the Divinity, because it is produced from unity, and mea-
sures one on every side. It is the primary foundation of every other
figure, and stable and permanent on its base. The circle upon it has no
beginning or end. The surface around it contains three symbols, directly
below the three images and showing their proper attributes. The sun,
with its joyous light, has power over everything, and its nature is attrib-
uted to God. Second is the rudder, which expresses the provident
government of the universe by infinite Wisdom. Third is the flaming
vase, meaning a participation of Love. And although the three images
are distinct, they are a single thing that is at the same time complex, uni-
fying in its embrace, and eternally joined in one. It generously confers its
gifts, as you can learn from the cornucopias at the statues' elbows.'
Prophetic Logistica continued, saying:

'At the image of the sun, notice this Greek word: ΑΔΙΗΓΗΤΟΣ; at
the rudder, look at this Greek notation: ΑΔΙΑΧΩΡΙΣΤΟΣ; and
beneath the fire has been carved ΑΔΙΕΡΕΥΝΗΣ. It is for these reasons
that the three animals are lying beneath the golden obelisk that rests on
them, for these forms represent three great and famous opinions. And as
the human form predominates over the other two, even so does the cor-
responding opinion. On the pyramid there are three flat surfaces
decorated with three circles, one representing each division of time:
past, present and future. Understand that no other figure could contain
these three circles except this unchanging one; and no mortal could per-
fectly discern or see simultaneously two sides of this figure, but only one
at a time, and that is the present. That is why these three letters ΟΩΝ
have been wisely engraved here.

'Do not think my explanation prolix, Poliphilo, but rather brief.
Understand that the primary figure at the base is known only to itself.
Although it seems somewhat transparent to humans, it is not totally
clear to us. Next, someone endowed with intelligence will ascend and
carefully consider the coloration of the figure. Searching further, he
ascends to the third figure whose coloration is dark and opaque, and
which is surrounded by these three golden images.

'As he climbs higher, he considers lastly a figure of triple form and
contemplates it rising and tapering to a point. Here even the best
informed can learn no more than that the thing is; but as to what it is,
they remain ignorant, impotent and incompetent.'

After Logistica, with her absolute knowledge, had made this out-
standing exposition of these proven principles, ingeniously extracting

them from the rich bosom of divine Nature, I began unhesitatingly to
[h6] feel a greater pleasure than in any other marvellous work that my eyes
had enjoyed. I thought the obelisk so mysterious, so ineffable in its
upright symmetry, so solid and eternal in its firmness and persistence,
forever in equilibrium, unbreakable and incorruptible. It stood perma-
nently in this large, circular space, surrounded by a flowery meadow
and with evergreen fruit-trees bulging with every fruit that is sweet to
the taste and wholesome, sited and arranged in regular ranks for the sake
of beauty, charm and ornament, miraculously made in perfect and stu-
dious imitation of nature, and shining everywhere with precious gold.

When Logistica had finished, they both took me by the hand and
we happily passed through the gap or opening of one of the arches and
out of the ivy-walled precinct, with myself well contented to be
between them. As we left there, Thelemia said cheerfully, 'Now let us
go to the proper doorways.' As we made our way briskly through the
pleasant tract of countryside, I admired the sky, entirely clear of dark
clouds. Delightful, witty and peculiar arguments filled my mind, and I
longed to know all of the inestimable riches, the unimaginable joys and
the incomparable treasures of the unspeakably sacred queen – greater
even than those of Osiris, maker of the two golden temples, one to celes-
tial Jupiter and the other to the King. So I asked this little question:

'Tell me, blessed maidens, if my curious petition pleases you.
Among all the precious stones that I have been able to see clearly, there is
one which I think is incomparable for its great weight and price, and
precious beyond count. It surpasses even the jasper that was engraved
with the armoured image of Nero, or the brilliant topaz of the statue of
Arsinoe, the Arabian queen, and is more valuable than the gem for
which Nonius the senator was proscribed. It is the splendid and
incomparable diamond, of such unheard-of beauty and size, that
was hanging from the rich collar on to the snow-white breast of our
divine queen. What intaglio was carved on it? Its refulgence was such,
and I was so far away that I could not make it out perfectly. It is only this
that keeps my mind in suspense and anxious to know the answer.'

Logistica, understanding my honest request, immediately replied,
saying 'Know, Poliphilo, that this gem is engraved with the image of
almighty Jupiter, sitting crowned on his throne, while under his majes-
tic and holy footstool are the vanquished giants who wanted to reach his
high threshold, to seize his sceptre and to be equal to him; and he struck
them with lightning. In his left hand he holds a flame of fire, in his right

he has a cornucopia filled with good things, and he holds his arms [h6'] apart. This is all that is contained on that precious jewel.' Then I said, 'What is the significance of these two such different things that he holds in his divine hands?' Thelemia replied knowingly, 'Through his infinite goodness, immortal Jupiter indicates to earthlings that they can freely choose from his hands whichever gift they wish.'

Without hesitation, I added, 'Since our pleasant conversation has taken this course, gracious friend, my ardent wish to under⁄ stand is not yet satisfied; and if my boldness does not offend you, I pray you tell me this. Before my horrible fright, I saw a stone monster of formidable size and craft, which was an elephant. On entering into its hollow belly I dis⁄covered two sepulchres with ambiguous writings on them about finding a treasure: they said that I should spurn the body and take the head.' Logistica's quick reply required no forethought. 'Poliphilo,' she said, 'I know all about what you are asking, but I want you to know that this huge device could not have been made without the most admirable human ingenuity, intense study and incredible diligence, so as to perplex the mind that would understand its divine idea. Know that the ornament that hangs from its brow, with that double inscrip⁄ tion, means in the maternal and common tongue "Labour and Industry"; because he who wants treasure while living in the world must put away idle ease, represented by the body, and take the decorated head, which is this inscription; and if he works industriously he shall have treasure.' No sooner had she finished her clear and kindly words than I understood it all, and thanked her for being so good as to oblige me. However, I was still keen to investigate everything that I had hith⁄ erto understood imperfectly; so, having ingratiated myself thus far, I made a third request. 'Wisest of nymphs,' I said, 'on my exit from the underground caverns I came upon an elegant antique bridge, which had benches made from porphyry stone on one side and from serpentine on the other. I saw some hieroglyphs carved there, and was able to inter⁄ pret both of them. The only things I did not understand were the

branches that were tied to the horns, and why it was made from por-
phyry and not from the same stone as the other side.'

[h7] She answered me straightway, without a second thought: 'One of
the branches is spruce, and the other is larch. It is the nature of these
woods that one of them does not easily catch fire, while the other, when
fashioned into a beam, does not bend. They therefore signify patience,
which is not readily inflamed to anger nor gives way in adversity. The
stone of porphyry is related to this image through a well-known
mystery, because it is said to be of such a nature that not only does the
furnace not damage it, but it also protects the other stones that are
nearby. Thus true patience is depicted, which not only remains unin-
flamed but puts out the fire of others' wrath. Serpentine stone also has
its well-known property that accords with the words written there.

'Thus I commend you, Poliphilo, because you are so eager for such
knowledge, and because it is praiseworthy to search out, consider, and
evaluate everything.' Thereupon I praised the wisdom of the eloquent
lady, giving her countless thanks.

With such open and admirable conversation we arrived happily at a
charming river, on whose banks I saw a lovely grove of plane-trees
together with other green
shrubs and water plants,
well placed and arranged
with lotuses between them.
It was crossed by a proud
stone bridge of three
arches, which had its heads
on solid foundations on the
banks and its piers keel-
shaped on both sides, to
support the firm structure,
and a noble parapet.

On the central arch of
the bridge, above the key-
stone, a polished square
of porphyry stood out on
either side, containing
hieroglyphs sculpted in re-
lief. On the right as we
went, I saw a lady wreathed

with a serpent, sitting on only one buttock and lifting the opposite leg. On the side on which she was sitting, she held a pair of wings in her hand, and in the other, a tortoise. On the opposite side of the bridge, two little spirits held a circle, with their breasts facing inwards.

Here Logistica said to me, 'Poliphilo, I know that you do not understand these [h7'] hieroglyphs, but they are very important to one who is going to the three portals, and an opportune reminder to passers-by. The circle means "Blessed are those who hold to the mean", and the other one "Control speed by sitting, and slowness by rising." Now think that over thoroughly.'

The bridge sloped gently and showed the careful thought, the skill and ingenuity of the clear-sighted maker and inventor. It was commendable for its eternal solidity, unknown to the myopic pseudo-architects of today who lack literature, measure and art, decking their work with pictures and lineaments while leaving the fabric inharmonious and ill-formed. It was all beautiful Hymettus marble.

Now that we had crossed the bridge, we walked beneath the cool shadows, gladdened by the sweet twitterings of many birds. We reached a rocky and stony place where the high mountains rose up steeply, and then came to an abrupt, impassable and jagged peak. It was all eroded and full of rugged outcrops, rising to the sky, circled with thorn bushes, devoid of any greenery and surrounded by treeless mountains. And here were the three brazen portals, crudely hacked into the living rock: an ancient work of incredible antiquity in the utter desolation of this site.

Above each of the doors I found the title that the divine Queen Eleuterylida had predicted and foretold, in Ionic, Roman, Hebrew and Arabic characters. The first portal had this word carved above it: THEODOXIA; above the second, this saying: EROTOTRO-PHOS; and the third was thus entitled: COSMODOXIA.

Now that we had arrived, my maiden companions immediately began learnedly interpreting and elucidating these titles, then knocked resoundingly on the closed doors of the right-hand portal, all corroded with verdigris, which were instantly opened.

135

Behold! an aged dame with a spinsterish air appeared before us, emerging with matronly modesty from the narrow door of a reed hut with a smoky roof and smoke-stained walls. Above the door was written PYLURANIA. Her cottage was in a lonely place, on a dull and decaying outcrop of bare, flaking rock. She was in rags, squalid, skinny, poor, with downcast eyes, and Theude was her name. She was accompanied by six companions, her house-servants, who were fairly ill-clad and wasted. One was called Parthenia, the second Edosia, then Hypocolinia, the fourth Pinotidia and beside her Tapinosa, and lastly Ptochina. The venerable matron pointed with her bare right arm to high Olympus. She dwelt at the entrance to a stony road, difficult to travel and obstructed with thorns and brambles; it looked like a rugged, disagreeable place with narrow passes, beneath a troubled, rainy sky and looming dark clouds.

Logistica, sensing that I was appalled by the first sight of this place, said to me almost sadly, 'Poliphilo, this path is not known until the end is reached.' Then the holy and venerable lady Thelemia added knowingly, 'O Poliphilo, the love of this laborious woman is not yet for you.' I nodded in agreement to Thelemia, and we came out of there. Then, closing the door, they knocked on the left-hand one.

The door was opened without hesitation, and after we had gone in, a
matron with a golden sword approached us. Her eyes were fierce, her
face set, and the sword trembled and glittered in her raised fist. The
middle of the blade passed through a golden crown and a palm-branch
which were suspended from it. She had arms fit for Herculean labours,
and her carriage was haughty, with a flat stomach, a small mouth and
strong shoulders. She showed by her face that that no arduous or diffi-
cult task could daunt her, and that her soul was that of a ferocious giant.
Her name was Euclelia, and she was accompanied by six noble and
respectful young maidens of whom the first was called Merimnasia, the
second Epitide, then Ergasilea; the fourth was called Anectea, and
Statia was the name of the fifth; the last was Olistea. The location and
site seemed very rough to me. Logistica, noticing this, immediately took
the lyre from Thelemia's hands and began to sing and to sweetly play in
the Dorian mode and tone, saying 'O Poliphilo, do not shrink from
manly combat in this place, for when the labour is past, the reward
remains.' Her song was so vehement that I was already agreeing to lodge
with these maidens, no matter how laborious their way of life appeared.
Suddenly Thelemia, gentle and caressing, said to me with a charming
expression, 'It seems to me sensible, Poliphilo my little pet, that before

you stay here you should at least look at the third portal.' I agreed, and so
we left this second one and latched its brazen doors. Thelemia knocked
at the third and central door, whereupon the bolt was instantly drawn
and the door opened. As we entered, we found before us a noble lady
whose name was Philtronia. Her looks were wanton and capricious,
and her joyful airs seized and captivated me with love at the first sight of
her. She dwelt in a voluptuous place, its grounds clad with green herbs
and flowers; a place of abundant solace and ease, running with clear,
gushing springs and loud with the noise of meandering brooks. It was a
delicious, well watered place, with open meadows and the cool, almost
cold shade of the leafy trees. Like the others, Philtronia had with her six
beautiful serving-maids, all of the same age and attractive in looks,
dressed with the greatest luxury, adorned with amorous ornaments and
conspicuous in their loveliness. The name of the first one was Ras-
tonelia, the second was called Chortasina, the third Idonesa and the
fourth Tryphelea; the fifth one was Etiania, and the last Adia.

As they presented themselves to my steady gaze, they seemed
supremely gracious and lovable. But honest Logistica, seeing me so
readily disposed and diverted into a servile love of them, said to me in a
sad voice:

'O Poliphilo, theirs is a feigned and cosmetic beauty, deceitful,
insipid and vain! For if you were to examine them from behind, you
would be sickened to realize how indecent and despicable they are, how
disgusting and abominably stinking, worse than a great rubbish heap.
Here both pleasure and shame are forever fleeing and dissolving, leaving
nothing but a life burdened with perpetual tears and anxious sighs. O
delight adulterated by misery, containing as much bitterness as the
honey that drips from the leaves of Colchis! O foul and meanest of
deaths, how sweet is your poison! What dangers and mortal perils,
what foolish cares the blinded lovers suffer as they plunge headlong,
while you are standing right before their eyes, yet the wretches see you
not! O how many sorrows, what bitter pain and torture you bear with
you! O depraved, impious and accursed desire, O detestable madness,
O defrauded senses, which you seduce with the selfsame bestial pleasure
for the ruin of miserable mortals! O sordid love, O mindless fury, O
wild and vain desire that causes such errors and torments to take up res-
idence in the afflicted hearts! O evil and deadly ruin of all good things,
O savage monster who cleverly veils and befogs the eyes of unhappy
lovers! O tragic and unfortunate ones, who let themselves be lured by so

slight and poisonous a pleasure and by deceptive goodness into a morass of evils!'

Logistica spoke these and similar words in vehement agitation, with angrily wrinkled brow, then threw her lyre to the ground and broke it. Thelemia, alert and unperturbed by this tirade, smiled and made a sign that I was not to listen to Logistica. The latter, as soon as she grasped my wicked intentions, was filled with contempt; she turned her back, sighed, and ran speedily out and away.

I was left there with my dear, victorious Thelemia, who flattered me with cheerful words: 'This is the place, Poliphilo, where it will surely not be long before you find the thing you love most: the thing that is yours, the one thing in the world which your obstinate heart unceasingly thinks about and hopes for.' As I considered this carefully, I found nothing engraved on my unhappy heart, nothing I thought about or desired, except my sunlike Polia; therefore I was cheered by these kindly and divinely comforting words, and very much reassured. Thelemia

[i2']

139

could see that this lady pleased and suited me, together with her atten-
dants, her place and its conditions, and that she was well-disposed
toward me; therefore she gave me a loving kiss and embraced me tightly,
then asked to take her leave of me.

The metal doors were closed, and I was left inside with these noble
nymphs, who began to banter with me in a familiar and lascivious
manner, and began to provoke me, captured as I was by their volup-
tuous band, to seductive, enticing and tempting desires. I felt the itch
beginning as these wanton looks kindled the amorous and exasperating
fire. Perhaps even the frigid and scrupulous Xenocrates, assaulted thus
by the love of Phryne, would have melted, trembled and fallen into
wantonness. He would not have accused her of being a statue if she had
been one of these, with their lascivious looks, their pert breasts, their
flattering eyes playing and sparkling in their rosy faces, their excellent [i3]
figures, engaging costumes, girlish movements, mordant glances and

splendid ornaments. Nothing about them was false, but all was perfect and exquisitely finished by nature; nothing deformed, but all concordant and harmonious. Their heads were yellow as the sun with their blond hair; their tresses were most beatifully wound with cords and knotwork of interwoven silk and golden threads, exceeding all human skill, and wrapped around their heads in splendid arrangements held with hairpins. Their foreheads were overhung and shaded by curly ringlets that moved provocatively; their elegant garments were designed with inexhaustible charm, and they all gave off a musky perfume and an unfamiliar fragrance. Their speech was fit to force and break down any reluctance, any resistance of untamed and averted hearts, and to lead the holiest into depravity. They could capture any free spirit, reform any rustic crudeness and crumble even the hard flint-stone. Therefore my heart was totally inflamed with new desire and condemned to the intense fires of concupiscence, while my hasty and headstrong appetite overwhelmed me with love and longing. I found myself suddenly invaded and infected by the fiery contagion that was waxing and burgeoning within me, and thus I did not notice when the amiable ladies left me alone, all aroused, in this pleasant plain.

AS HE WAS LEFT ALL ALONE AND DESERTED BY THE LASCIVIOUS GIRLS, AN ELEGANT NYMPH CAME TO MEET HIM. POLIPHILO DESCRIBES AMOROUSLY HER BEAUTY AND HER GARMENTS.

XCESSIVELY WOUNDED IN MY TENDER heart by the pricks of love, I do not know whether I was delirious as I stood there, stupefied by the way my graceful company had vanished instantly before my very eyes. I was beside myself and in a kind of rapture as I raised my eyes a little, and saw before me an artificial pergola of flowering jasmine, its high arch decked all over with fragrant flowers, with the three colours mingled together. I went into it, gravely worried by the unexpected disappearance and thinking over the various stupendous things that had happened. Above all, I held on firmly to the high hopes confirmed by the royal and fateful promise: that I would find my golden-haired Polia. 'Alas, Polia!' I
[13'] sighed to myself, and the amorous sighs engendered inside my inflamed

heart echoed beneath the green bower. Thus agitated by my anguish and absorbed in myself, I came without noticing it to the other end of the flowery shelter, where, looking out, I saw an innumerable crowd of young people. They were making merry together with loud voices and the melody of various instruments, with charming and playful dances and clappings: a troop assembled in a broad open space, mightily enjoying themselves. This pleasing and unexpected novelty made me stop there in admiration, hesitating to go any further forward.

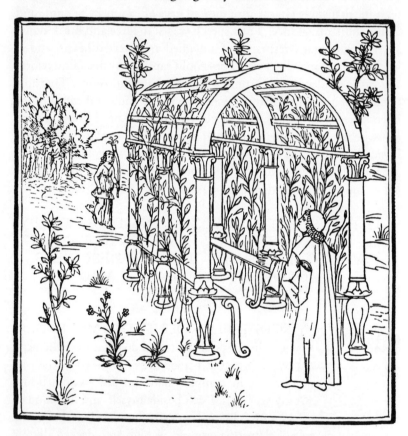

But look! a noble and festive nymph had separated herself from them and was coming toward me with her burning torch in her hand. Since I could tell plainly from her virginal walk that she was a real and genuine girl, I did not move, but awaited her with relief. She approached me with girlish haste and modesty, starry-eyed and smiling even though she had never been near me before. She had such presence

[i4] and charming elegance that perhaps even amorous Idalia did not appear thus to warlike Mars, nor the handsome shepherd Adonis to her, nor the delicate Ganymede to almighty and inflamed Jupiter, nor beautiful Psyche to ardent Cupid.

If I had seen her beside the three rival goddesses as a fourth, and if almighty Jupiter had appointed me as judge, like the Phrygian shepherd beneath the shady woods of Mesaulon, without a doubt I would have found her more admirable in beauty and incomparably more worthy of the apple and its inscription, and would have rightly judged her so with no regard to the others. I was almost certain on the first sight of her that she was indeed Polia, but the unfamiliarity of her clothing and of the location dissuaded me; on judicious reflection I doubted it and remained in respectful suspension of judgment.

The sun-like nymph had dressed her virginal and divine little body with the thinnest material, of a green silk weft woven together with a warp of gold, like the lovely colouring of the feathers on a duck's neck. She wore this over a white tunic of silk crêpe next to her delicate flesh and milk-white skin, such as the inventive Pamphila, daughter of Platis on the island of Cos, could never have woven. The graceful tunic seemed to contain white and scarlet roses, while the dress above it, elegantly fashioned in tiny pleats or wrinkles, clung to the ample hips and was tightly secured around the little breasts with a golden cord, stretching out the pleats of the fine cloth over the delicately swelling bosom. The superfluous material of the long dress was pulled up above this first belt, leaving the fringed edge to fall evenly around the fleshy heels.

This stuff was then gathered again and secured to the original golden cord by holy Cynthia's sacred girdle, so that it was raised in bunches and sinuous folds that made an elegant surround to the chaste womb, and swelled charmingly over the firm and tremulous buttocks and the small, round belly. The rest of the clothing hung loosely in minute wrinkles down to the milk-white heels, wafting in the breath of the suave, mutable breezes and with the motions of her body. Sometimes the gentle puffs of wind lifted the garments to reveal the trim and modest figure, which did not trouble her in the least. It was not presumptuous to suspect that she was not of human seed. Her extended arms with their long hands, ornamented with rounded and delicate [i4'] fingers with longish, pink, translucent nails – such as were never dedicated to Minerva – seemed little more than bare through the transparency of the sleeves; and at the exit of each arm, the white flesh was

beautifully ringed with a fringe of netted gold, decorated with many bright gems.

All the fringes of her clothing were made in the same way, with tiny spangles of gold leaf loosely attached in many places, to charming effect. Beneath the ribs on either side the clothing was unstitched or slashed, and fastened in three places by three buttons made from big pearls tied on with blue silk, such as Cleopatra would never have dis⁄solved in her drink. This gap was fastened in such a way as to show the undergarment in the spaces between the pearls.

An artistic collar of drawn gold encircled her straight and milk⁄white neck, then divided over her virginal bosom, narrowing considerably, and rejoined itself crosswise. It was richly decorated with vermiculate work and precious gems. Beneath this garment, as already mentioned, was her tenuous, pleated tunic of white silk of the most minute weave, which covered that precious flesh like crimson roses in the division of her broad and delicious bosom. It was more pleasing to my eyes than cooling streams to the exhausted and hunted deer, or as the little fishing boat of Endymion was to Cynthia, or the melodious lyre to Orpheus.

The sleeves of this blouse were comfortably wide, gathered near the wrists by a little golden border and each buttoned with two large union pearls of oriental whiteness. Moreover, all these delightful things gave ample cause for the furtive and busy gaze to relish voluptuously the pert and swelling nipples, impatient of their suppression by the filmy garment. Not unreasonably, I judged that the creator of so dignified and admirable a work could only have formed it for himself and for his own extreme pleasure; that he had made it so beautiful with all diligence and with all the strength of his affection. Perhaps even the four golden birds tied to the royal basilica of Babylon and called the Tongue of the Gods could not incline souls to greater love for the King than I felt, alas, at these breasts; they would scarcely have filled the hollow of my hand, and the space between them was the most beautiful living thing that nature ever made.

A precious necklace ringed her throat, more white than Scythian snow: I doubt that that of Caesar's doe equalled it, nor even the one that [15] degraded the wicked Eriphile to the point of revealing Amphiaraus's hiding⁄place. This necklace displayed an exquisite arrangement of strung gems and round pearls. At the lowest point, toward the division of her white bosom, was threaded a brilliant round ruby between two

144

great pearls, and flanking these, two flashing sapphires, then two more oriental pearls. Two glowing emeralds followed, one on either side, then two more pearls and two bright jacinths. All these gemstones were perfectly spherical in shape and as large as berries, spaced in the most agreable manner.

Her blond head was rich with curly, glossy hair, its loose locks tumbling over her shapely neck and looking like nothing so much as fine filaments of gold with a changeable lustre. The hair on her crown was fastened by a garland of fragrant amethystine violets, hanging down slightly over her joyous brow and forming an irregular triangle, as attractive as any offering to the Genius. The curly hair issued tidily from beneath the garland, some of it giving a tremulous shade to her beautiful temples but leaving her little ears uncovered and fairer than anything ever dedicated to Memoria. Then the rest of the yellow hair spread out behind her shining neck and hung over her round shoulders, flowed irregularly down her shapely back, extended beyond the joints of her knees and blew in gentle waves. It was more beautiful than when Juno's peacock spreads its many-eyed tail; nor did Berenice consecrate such hair for the sake of her Ptolemy in the Temple of Venus, nor Conon the mathematician see its like united in a triangle.

On her smiling brow were two fine, black, semicircular and disjunct eyebrows, such as were never seen among the Abyssinians of Ethiopia, nor even those which Juno had in her power. Beneath these there shone two festive and radiant eyes, fit to turn Jupiter into a rain of gold, filled with bright light with the dark iris covered by the milk-white cornea. Next to these were the rounded, crimson cheeks, decorated with extraordinary charm by two laughing dimples: they were the colour of fresh roses gathered at dawn and placed in vases of purest Cypriot crystal, for they seemed to me no less in their brilliance, so transparently did the vermilion shine through them.

Beneath her straight nose, a sweet little valley led to her small, demurely formed mouth, with lips that were not thick but moist and tinged with crimson, covering a regular array of small ivory teeth. Not one of these stood out from its fellows, but all were tidily arranged, and Amor constantly breathed his redolent scent over them. It seemed to me, as I mused on it, that these lovely lips concealed nothing less than lucid pearls for milk-white teeth, warm musk for fragrant breath, and Thespis with her nine daughters for sweetness of speech.

I was thoroughly seduced by all these things, so that my senses were

[15']

145

kindled and my appetite disordered and enflamed, and a great uprising and bitter contention was born in me such as had never arisen during the previously related events, for all their extravagance and variety. My idle and roving eyes commended one part as being much more beautiful than the others, whereas my appetite was enraptured by another part of the divine little body, and preferred that one. The cause of all the trouble, all the perturbation and contentious commotion, was my insatiable and unquiet eyes; I felt that it was they that had planted and nurtured the seed of this noxious struggle in my poor wounded heart, their arrogance that was now completely ruining me. Nevertheless, without them I could achieve no satisfaction whatever. My grumbling appetite praised the delicious bosom as beyond compare; my voluptuous eyes agreed, but said 'If only we could see everything!' Thus they wandered about, and then, violently drawn to her gorgeous appearance, found the height of pleasure in that. Thereupon the appetite strongly disagreed and murmured thus: 'You will never persuade me that a head could ever rejoice in more copious hair, voluptuously arranged and wound into extraordinary masses and amusing curls, to decorate so beautiful and radiant a brow, ever spiralling in ringlets like pinewood shavings.

'Hesperia of the streaming hair never appeared to Aesacus like this. Her head and brow are more beautifully ornamented with her two bright, darting eyes, like morning stars shining in the cloudless sky, than ever was warlike Necus of the Accitanians with his splendid rays; and my heart is deeply wounded by them, as if by an arrow shot by angry Cupid. Therefore I dare say, in conclusion, that even when Delos ceased its roving, it produced no lights more bright or more welcome to mortals than these celestial works of art, placed beneath a divine brow, [16] refulgent and amorous!' Thus my poor heart was besieged with such altercations and such disagreable arguments of the appetite, as if they harboured a twig of that laurel that stands on the King of Bibria's mound, which causes ceaseless quarrels until it is thrown away. In the same way, I thought that this strife would never cease unless the pleasure she caused were removed from my heart – which was impossible. For this reason, no firm agreement was possible between the voluptuous and insatiable desires of the one and the other. I vacillated like a starving man faced with an abundance of various foods, desiring them all but not fully satisfied with any of them, and thus left a prey to his hunger.

THE BEAUTIFUL NYMPH REACHES POLIPHILO,
AND, CARRYING A TORCH IN HER LEFT HAND
AND TAKING HIM WITH THE OTHER, INVITES HIM
TO GO WITH HER. POLIPHILO BEGINS TO
GROW WARM WITH A TENDER LOVE
FOR THE ELEGANT MAIDEN,
AND HIS FEELINGS
CATCH FIRE.

EGARDING THE GENUINE OBJECT
from close quarters convinced me that this was the
most magnificent presence, divine in its appearance,
endowed with a superfluity of beauties, and of a more
than human loveliness. I now deemed all the priceless
treasures, the opulence and the high pomp that I had hitherto witnessed
as worth nothing in comparison to this. Happy is he who confidently
owns such a treasure of love ! But not only is the possessor happy, as I
truly believe, but also he who humbly submits to all her desires and
commands, and is thus altogether owned and possessed by her. O
almighty Jupiter, here is the stamp of your divine image left in this noble
creature, such that if Zeuxis had only her to contemplate, he would
have praised her above all the girls of Agrigentum, and of the whole
globe, and chosen her as uniting absolute perfection within a single
example. This beautiful and heavenly nymph hurried toward me and
[16'] approached with joyous haste, revealing her rare beauties to my eyes,
while I remained seized and dumbstruck as I gazed at the revelation at
close quarters.

As soon as her amorous appearance and graceful presence had
descended, by means of my eyes, to my inmost parts, their advent awoke
my memory and aroused my heart. They offered and presented to it the
cause of all its trouble: that which had filled it full as a quiver with
piercing arrows, and made it into the house and home of her sweet
image. It was she who had long consumed my tender years in a hot and
violent first love. Already dislocated by this, I could feel my wounded
breast ceaselessly thumping like a noisy drum. And so she appeared to
me in all her beauty and worthiness, with her blond tresses and the tight
and tremulous ringlets sporting around her brow: my golden-haired
Polia, passionately loved. Not for a moment had my life been able to
escape from those burning flames, or to fluctuate in its affections. Never-

theless, her superb nymphal garments were unfamiliar to me, and the place unknown, which left me greatly in suspense, doubt and hesitation. For her part, she was carrying a lighted and burning torch in her left arm which rested against her snow-white bosom and rose somewhat above her golden head. She gripped the narrowest part of it closely in her fist, and courteously stretched out her free arm to me. It was whiter than ever Pelops's was, and the fine cephalic and basilic veins appeared on it like a sandalwood line drawn on immaculate papyrus. With her delicate right hand she compliantly took my left, then with broad and radiant brow, and smiling mouth scented with cinnamon and dimpled, she addressed me thus, in eloquent words and gently flattering tones: 'O Poliphilo, you can safely come along with me, and have no fear.' I felt my spirits stunned, being astonished that she knew me by name; my inward parts were overthrown and seized by a fervent amorous flame, and my voice was paralyzed between fear and awed embarrassment. I had no idea of how to respond to her appropriately, and could only show my respect for this divine little virgin by quickly offering my clumsy and unworthy hand.

✳ ✳ ✳
✳ ✳
✳

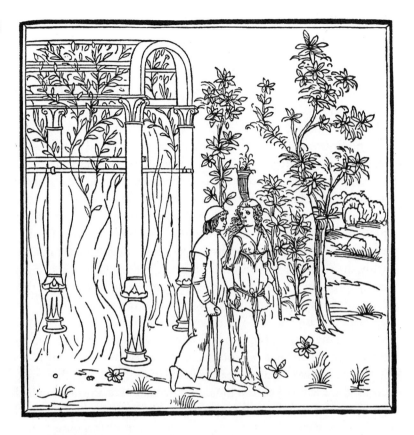

As I placed it in hers, I felt grasped between warm snow and solid milk, and it seemed to me slightly – no, altogether – as though I were touching and holding something beyond the human condition. After I had done so I remained very agitated, shaken and suspicious, not understanding things unknown to mortals, nor what might follow from this. I judged my plebeian garb and my incongruous and common dress unfit for her and an unsuitable match for such company; it seemed forbidden for a mortal and an earthling to taste such delights. Thus blushing and filled with diffident admiration, which consoled me somewhat for my appearance, I became her pupil.

Finally, even though my spirits were not fully recovered, my fear and perturbation began to lessen, since I reckoned that so beautiful and divine an object, and such a place as this, must lead to a happy issue. Her noble looks would have been enough to drag lost souls out of the eternal flames and to rejoin them with their bodies in the tombs.

Bacchus would have renounced the famous intoxication of the Gau- [17']
ranian, Faustian, Falernian, Pucinian or Pictanian vintages in order to
have the constant spectacle of her. Following behind her with my heart
fluttering and unsettled by love, I was shaking like the wagtail bird, and
was as powerless as the timid sheep when the rapacious wolf drags it off
by the throat.

I now felt myself touched by a pleasant warmth, growing little by
little and beginning to heat and melt my frigid fear, and adjusting the
heat to the proper degree for genuine love. Already almost overcome
and conquered by the provocative appetite within me, I gave myself
over to a silent debate, saying first: 'O happy above all other lovers is he
who is coupled to this person, if not wholly, at least in part!' Then,
reproaching my improper desires, I argued the contrary: 'Alas, I cannot
possibly believe that such nymphs condescend to those who are inferior,
earthly, and in every respect unlike them. On the contrary, this one is
worthy to be embraced by the supernal gods, who, putting off their
divine forms, would transmute and personify themselves, lured from
high heaven by love of her.' On the other hand, I consoled myself that I
had offered my amorous soul to her (having no more suitable gift), and
although divine, she had not spurned it, just as Artaxerxes King of the
Persians had bowed to drink water offered in the hands. At this, full of
warm sighs, I felt shaken and moved to the bottom of my heart, which
eagerly consented to this and prepared to take fire, just as the little spark
in a dry reed, blown by Eurus, begins at first to spread vigorously, then
suddenly bursts into flame.

I felt just like this as I experienced a flame, at first tame and harmless,
growing and spreading over the fuel prepared for it. Her amorous
glances had now become pernicious and deadly blows, just as flashing
thunder causes hearty oak-trees to split beneath its sudden blow. And
now I dared not look at her bright eyes, because whenever I did so, I was
overcome by the incredible beauty of her lovely face; and if her radiant
eyes had chanced to meet mine, everything would have appeared
double for a while, until I could control their blinking and restore their
original clarity.

All this left me totally vanquished, plundered and captured, so that I
was ready to grasp a handful of fresh grass and offer it to her as a suppli-
ant, saying 'I give up.' My mind had already tacitly agreed to allow the
rent in my soul to be spread wide for free access, and my heated breast
had humbly opened itself like the red, ripe fruit of the mordica or caran- [18]

150

cia which opens gradually when first cracked, then bursts. It felt within itself sporadically the familar warmth, and its well-worn and broken hearth recognized this fervour and this fire, as she penetrated its inflammable entrails with her virginal looks, decorated with unimaginable elegance. As soon as the first sign of amorous fire was introduced into the mind, gently but as doom-laden as the Trojan horse, it unleashed a shocking and implacable conflict in my faithful and simple heart, which would never cease. So easily seduced by a lovely face, my heart lost no time in bursting open, letting in a host of amorous attackers and incendiaries to join in the conflagration, and willingly submitting to their domination.

These continuous inner fires reinforced a familiar excitement that was already latent in me, which seemed to me the best help I could get at present – as indispensable as Castor's star and Tiphys's mighty rudder are to the hollow ships, which sail in heavy weather on the rapidly surging waves of the much-travelled sea. It was more welcome than that which smitten Adonis received from Mylitta, or Aphrodite from the compliant nymph Peristera; more than the dittany plant of Ida with its purple flower, brought by the daughter of Dione to heal pious Aeneas's wound. As I felt my breast, already filled to bursting with its silent, inner pains, gathering its scattered thoughts and brooding on the burden of its love, the incurable wound grew ever greater. Gathering my few, weak spirits, I almost plucked up the courage to tell her of my intense fervour and amorous thoughts, as though, lost in blind desire, I could no longer repel the assault of the invaders or resist the searings and boilings; thus I would cry with a loud, excited voice: 'O delicate and divine maiden, whoever you may be, stop using these powerful torches to burn and consume my sorry heart! I am being goaded by an incessant fire, and feel the soul within me transfixed and penetrated by a sharp, flaming dagger.' And saying this, I would beg her to uncover the hidden fire and to mitigate my suffering a little, because this terrible, raging inflammation of love was greatly aggravated by being concealed. But I waited patiently, and thus repressed all these grave and fervid agitations, these bold thoughts, these lascivious and violent desires, considering how I looked in my sordid robe, which still had the hooked seed-pods from the forest stuck to it. Like the peacock which lowers its circular tail if it sees foul and ugly feet, I suppressed all my voluptuous urgings, my insolent desires and vain imaginations as I considered how ill they suited so divine an object.

[18']

151

For this reason I was firmly resolved to employ all my energies in overcoming and stifling my dissolute and wandering appetite and my wavering mind, and conquering my immodest desire, thinking that from henceforth it must be otherwise. At last, in my reflections, I began to think in the depths of my inflamed heart that my present and continuous pain must resemble that of wicked Tantalus, when his arid and thirsty mouth was offered pure, cold, delicious and refreshing water, and in his hunger, sweet fruits came almost close enough to gratify his open lips; yet he was left unfed, bereft of both.

Alas for me, that a beautiful nymph, noble in form, in the flower of youth, dressed in a more angelic costume than one could describe and outstanding for sincerity should present herself with good will before my eyes! This visitation surpassed the most exquisite and delicious contentment possible to man, and I was beside her! She was filled with everything that might joyously arouse love and desire, drawing the mind away from every other thought and concentrating it solely on herself, yet she did not satisfy my panting and voluptuous desire.

Since she did nothing to extinguish my ardent concupiscence, I did my best to calm my languishing and overheated heart, steadying it with comforting hope, telling it that there is no coal so extinguished that it will not readily flare up again when brought to the fire. But since my eyes were unbridled, at every moment her extraordinary and divine beauties inflamed my heart, impotent as it was to resist, with ever more insolent desire. My sweet pleasure increased marvellously as she seemed to become ever more beautiful, elegant, charming, desirable, and extremely ripe and ready for love.

Then I thought sincerely to myself: 'If perchance the high gods notice my desire, my wicked appetite and longing for forbidden pleasures, which are very likely prohibited in this holy place and toward this person, might it not easily happen to me as it did to many other profanators who impudently offended them, as when their cold and unbending anger descended on bold and confident Ixion?

Similarly, the Thracian would not yet have discovered Neptune's [k1] deep throne if he had not presumed to mix pure and savorous Bacchus with watery Tethys, and unworthily trespassed on their divine states. Nor would Galantides, the royal handmaid, have had her womb transported to her mouth if she had not deceived Lucina. This divine nymph must surely be reserved for her genius or some other sublime hero, and I, attempting such sacrilege, would deserve to have such

anger directed against me.' Reasoning in such appropriate terms, I reck-
oned that those who easily become overconfident, easily perish, for
deception and failure are not difficult for them. Moreover, deceptive and
playful Fortune does not always favour the bold, as they say; and besides,
it is difficult to penetrate another's heart. Just as bashful Calisto, feeling
her womb swelling within her, departed from the presence of chaste
Diana, so in shameful agitation I withdrew from this impulse, curbing
my voluptuous and inappropriate desires. Instead, I examined the
beautiful nymph closely and constantly with lynx-like eye, feeling
immense pleasure and wonderful emotion as I devoted myself with
unfailing constancy and firmness of soul to the blissful love of her.

POLIA, STILL UNKNOWN TO HER LOVER POLIPH-
ILO, REASSURES HIM WITH HER COURTESY AND
FRIENDLINESS, WHILE HER MARVELLOUS
BEAUTY TURNS HIS MIND TO LOVE. THEY
ARE PRESENT TOGETHER AT THE TRI-
UMPHS, WHERE HE IS DELIGHTED
TO SEE INNUMERABLE
YOUTHS AND GIRLS
IN THEIR FEST-
IVITIES.

ORCIBLY CAPTURED BY CUPID THE
archer-god, I felt him reigning as a tyrant in my heart
and strongly binding me with solid chains of love. As
I submitted to his harsh but pleasant laws, I felt direly
wounded and attacked by their cruel and fiery bite.
Filled with a double affection, I sighed exceedingly and languished as I
melted. The noble nymph, splendidly arrayed, lost no time in reassur-
ing me with flattery and with firm and persuasive words from her
mellifluous crimson lips, banishing all the fearful thoughts from my

[k1'] mind, refreshing me with her Olympian looks and cooling my over-
heated soul with her lucid eloquence. With a flirtatious and amorous
glance and a graceful smile, she said:

'Poliphilo, I want you to know that true and virtuous love has no
regard for external things; therefore your garments do not detract from
your soul, which may be magnanimous, noble, and worthy of these
marvelous and holy realms, and deserve to witness the wondrous tri-

umphs. For this reason you should not allow the slightest fear to enter your mind, but watch carefully what realms are possessed by those crowned by holy Venus: those who have fought manfully and perse⁄vered in her amorous service and her holy fires, and who have thereby made themselves worthy to receive her ready blessings.' And as she con⁄cluded her wise and kindly discourse, we continued our walk together, neither hurried nor lingering but at a moderate pace. I debated inwardly with myself, saying:

'O mighty Perseus, for such a one as this you would have striven even harder with the horrible monster to obtain her sweet love than you did for your Andromeda.' Then I added:

'O Jason, if you had been offered legitimate marriage with this one, I swear by Jupiter that you would have braved a much greater peril than that of your quest for the Golden Fleece. I truly think that you would have laid that aside and fought ferociously for her, prizing her as pre⁄cious beyond compare and valuing her above all the jewels and rich treasures of the wide world, even those of the divine Queen Eleuteryl⁄ida. Hour by hour she grows more beautiful and appears more sublime in her magnificent ornaments. An abundance of gold did not seem more desirable to Hippodamia, nor is it to rapacious and anxious misers; nor, to sailors, is the entrance to a safe and tranquil port, and being tied up to a mooring⁄post or bollard in the winter storms. A shower of rain was not more welcome to the pyre of Croesus than the offer of this delicious nymph as the perfeçt objeçt of my love. I rejoice in her and cherish her more than furious Mars does his bloody battles, Dionysus the first vintage of Crete, and long⁄haired Apollo the elo⁄quent lyre. She is even more welcome to me than fertile soil, thick ears of corn, the sacred first⁄fruits and the Thesmophoria are to Demeter.'

On we went, joyfully and side by side, over the grassy plain with its growth of green and flowery plants. Sometimes my inquisitive eyes stole a curious glance at her delicate feet, perfeçtly fitted with shoes of scarlet leather and swelling voluptuously within their tight enclosure. [k2] Sometimes I saw her white legs moving, as the gentle breeze lifted her silken garment a little, wafting above her virginal limbs and revealing their lovely and exquisite form. I sincerely believed them to be tinçtured with fine cochineal, such as is never colleçted in the Peloponnese, com⁄pounded and coagulated with white milk and fragrant musk.

All these deleçtable things bound me inextricably with chains of violent affeçtion, harder to unloose than the knot of Hercules or the one

154

that Alexander the Great undid with his sword. I was netted and entangled in amorous meshes; my surrendered heart was bound in a straitjacket of ardent thoughts and fervent desires, restraining me wherever I turned, so that I felt more stabs and punctures in my loving heart than faithful Regulus, carried off to Africa and enclosed in a nailed cask. Nothing came to cool my wretched spirits, exasperated by amorous smouldering and exquisite torment as they burned in my noisy breast, than what I could swallow in my constant sighs, gasping like a hunted deer. Being thus plunged into a legion of cares and altogether ravished by my violent love of her, I said to myself:

'O Poliphilo, how could you abandon a love that was once kindled exclusively for your sweet Polia for the sake of any other woman?' And therewith I tried with all my strength to disentangle myself from this painful bondage, which gripped me faster than the pincers of a crab; but I only found my tortured soul bound all the tighter by my affection for this one, who resembled my sweet Polia in every fibre of her body, in the charm of her face and the refinement of her gestures. Above all else, it tormented me atrociously to think that I could give up my beloved Polia; and my moist eyes welled with hot tears at the thought, for it seemed to me both arduous and despicable to renew my afflicted heart, and to banish its former lord by admitting one who was new, unknown and impious. Then I said, to console myself, 'Perhaps this is she, according to the divine oracle and the high and truthful promise of Queen Eleuterylida; but she does not reveal herself. Yet if I am not mistaken, it seems that she is unmistakably the same.' And during this amorous and discursive thinking, this persuasive guessing, I abandoned all other desire, dwelling with my heart and mind only on this noble nymph. My great love of her seized me tightly, and I felt strongly com

[k2'] pelled to keep looking at this unknown figure with unusual admiration. My eyes turned into whirlwinds, gulping in and absorbing her incomparable virginal beauty, and after they were exhausted by the heat and excitement caused by the utter sweetness of this kind and lovely presence, they took on eternal strength, and the resolve to unite for this voluptuous task with all my other captivated feelings, and agreed that I would beg her, and her alone, for the refreshment and delight peculiar to my burning flames. While I was thus painfully suffering from the exasperations of love and staggering in my affliction, we came toward the righthand side of the wide field.

This place was planted regularly all around with green, dense

leaved fruit trees, full of sweet flowers and leaves of many kinds, ever green and delighting the heart of the viewers.

The fascinating nymph stopped and stood there, as I did. As I looked with half my vision over the pleasant plain, being unable to dis- engage it altogether from its object of affection, I could see nearby a large chorus formed by a dense crowd of fine and delicate adolescent youths. They were making merry, dancing and leaping, with their uncut and uncombed hair curling slightly in unstudied ringlets, wearing garlands and aureoles of manifold flowers: scarlet roses, leafy myrtle, and purple amaranth mingled with melilots. With them was a great multitude of beautiful girls, more fair and delicate than would ever be found in Sparta. Both sexes were dressed in splendid materials: not in Milesian wool, but in rich garments of silk and of watered taffeta (not subject to Oppio's laws). Some were shot with different colours, so that one could not tell the true one; some were of select purple from the murex shell, and others of linen finer than any produced in Egypt: a thin, white, crinkly stuff, minutely woven and of innumerable colours. There were sky-blue, Phoenician red, many greens and purples, ver- milion and dark blue, all richly delightful. There was a saffron tincture such as neither Corycus or Centuripino ever produces, most grateful to the sight and interwoven with gold thread, with an extraordinary deco- ration of bright gems attached by pure gold to the extreme fringe above the ankles. Some here and there were wearing the sacred diadems of a divine and pontifical cult, while others were in hunting costume.

Most of these distinguished nymphs had their blond hair mounded [k3] up and tied to voluptuous effect in exquisitely twisted triple knots. Others let their loose and mobile tresses spread out behind, falling effu- sively over their milk-white necks. Some had their copious locks wrapped in tenuous veils, leaving their uncovered brows charmingly shaded by incurling hair with a finesse that owed no thanks to art, but only to Mistress Nature. They also had ribbons woven from cloth of gold fringed with shining pearls. Others had their hair adorned with rich and voluptuous head-bands, and sumptuous collars and precious necklaces round their straight throats. They wore armlets and bracelets, and their little ears had beautiful pendants of various jewels. Their coif- fures were extravagantly ornamented, and around their foreheads were strings of great, round pearls. All these excellent things, combined with their elegant persons, would easily have transformed the most wild, ferocious, stubborn and inhuman heart.

The white breasts were left voluptuously open as far as to reveal the round nipples. The little virginal body rested on straight legs and little feet, some of them bare within antique sandals that were held on by golden thongs that passed between the big and the middle toes, near the little toe and right around the heel, to join neatly above the instep in an artistic bow. Some were in shoes, tightly fastened with golden hooks; others wore boots with soles of crimson and other gay colours, such as were never seen on Gaius Caligula, the first to wear them. Some had high boots slit around their white and fleshy calves; others, slippers with masterly fastenings of gold and silk. Many wore antique Sicyonian shoes, and a few had fine silken socks, with golden laces decorated with gems.

Then again, there were some whose heads were wound with flying veils woven by the clever spider, leaving their faces free. Their piercing and joyful eyes were brighter than stars shining in the cloudless sky, beneath thin curved eyebrows, and the little nose between the apple cheeks, red as the fruits of autumn, was duly equipped with its smiling dimples or creases. The incisors and the eye teeth, regularly spaced like all the others, were small and coloured like refined silver, between juicy lips like fine coral. Many of them were playing on sonorous instruments such as would never be found in Ausonia or in the hand of Orpheus, making the flowery meadows and level plains rejoice with sweet music and singing odes with their lovely voices. They were also dancing and, [k₃'] for their greater glory, making amorous skirmishes with one another.

With such recreations and merriment the joyful round-dancers celebrated four superb and divine triumphs, the like of which mortal eyes have never seen, to sincere and delectable applause.

IN THE PLACE DESCRIBED, POLIPHILO SEES THE FOUR TRIUMPHANT SIX-YOKED CHARIOTS, ALL MADE FROM VARIOUS GEMSTONES AND PRECIOUS JEWELS, AMONG THE CROWD OF BLESSED YOUTHS REVERENTLY PRAISING JUPITER MOST HIGH.

REASON TEACHES US THAT NOTHING is difficult for the high gods: they are able to achieve any effect at will, in any place and upon any created thing, for which reason they are rightly called omnipo-tent. Perhaps you will sometimes be greatly astonished at the marvellous, stupendous, and indeed divine works that you will hear me relate. For art does all it can to imitate natural things, but divine things are certainly impossible for any created genius and intellect to copy or emulate without divine help and inspiration. For this reason none should let himself be swayed by doubt, but should calmly take note in his mind that things unknown to us are possible to the higher ones, as I saw for myself.

DESCRIPTION OF THE FIRST TRIUMPH.

The first of the four divine triumphs had its four rapid wheels made of a fine stone of the greenest Scythian emerald, flecked with copper-coloured spots. I was astonished to see that the rest of the carriage was all made from panels, not of Arabian or Cypriot but of Indian diamond with its iron-like gleam, which defies hard emery and conquers steel, comes unhurt and contemptuous out of the blazing fire, but becomes soft and malleable in hot goat's blood, thanks to the magical art. These panels were divinely worked, engraved with scenes in intaglio, and wonderfully framed and enclosed in pure gold.

On the right-hand panel I saw depicted a noble and regal nymph in a meadow, with many others of her age, crowning the victorious bulls with many garlands of flowers; and the one beside her seemed to be peculiarly tame.

[k4]

The left-hand panel contained the same nymph, who had confi-dently mounted the tame white bull; and he was now carrying the frightened maiden across the swelling sea.

SECOND, ON THE LEFT

On the front, I saw Cupid with an innumerable crowd of wounded people, astonished that he was aiming his bow at high Olympus. On the back, I admired Mars lamenting before the throne of great Jupiter that the latter's son had pierced his impenetrable cuirass; and his good lord was showing him his own wounded breast and holding in his other outstretched arm the inscription: NO ONE.

159

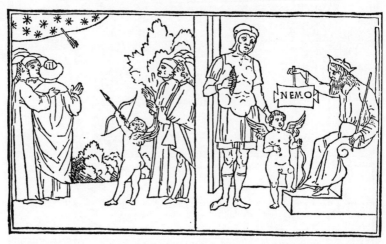

This carriage was formed as a rectangle of two perfect squares, six feet long, three wide and as much high, with the necessary cornice above and the plinth below. Above it was a slab a foot and a half high, two and a half feet wide, and five and a half long, sloping down to the cornice and covered with scales of precious stones arranged in alternat-ing colours. Inverted cornucopias were attached at the four corners, with their openings pointed downwards over the projecting angles of the cornice and crammed with many fruits and flowers made from numerous large gems, sprouting among the variegated golden foliage. I saw that these horns were excellently carved with a covering of poppy leaves and with twisting grooves, and that they curled upwards, taper-ing, toward the edge of the slab, where they broke out into antique rinceaux that recurved beautifully over the backs of the elegant horns, made from the same material. On each corner between the plinth and the cornice was affixed a harpy's foot, with a moderate curve and a strik-ing metamorphosis on either side into acanthus leaves.

The wheels were contained inside the carriage and only half visible; and the plinth, which was the lowest part of this machine, rose up slightly at the front near to the harpies' feet, tapered smoothly and turned into a snail-shell volute, to which the ropes or tethers for pulling were conveniently attached. Where the axles turned in their fixtures there were tapering struts attached beneath the plinth; they were twice as wide at the top, where they joined the plinth, as the distance from there to the axle. Two exquisite leaves arose from there which divided and curved

under the plinth, and at the mid-point of their divergence a five-petalled rose protruded moderately, in the centre of which the axle rotated, as shown in the first illustration.

Now upon the slab that I have mentioned there lay a fateful, tame, white bull, decked with many flowers and ritual ornaments of conse-cration. A royal virgin was sitting upon its broad back, holding fast as a crab and embracing its pendulous dewlaps with her long bare arms. She was exquisitely dressed in fine cloth of green silk and gold — a mar-vellously woven nymphal garment — and girt with a veil whose extremity just covered her nipples. Her jewels were both many and various, and she wore a crown of gold on her hair, which was elegant and golden, neat and lustrous.

Six lusty centaurs, sons of the fallen seed of presumptuous Ixion, drew this triumph with flat chains of gold on their strong horsy flanks, exquisitely articulated and held by golden clasps, with the links joined by overlapping one another and connected to the attached rings, running different ways so that all six pulled equally: the same method as Erichthonius invented for harnessing the wild horses to his speedy quadriga.

The centaurs were ridden by noble nymphs, mounted with their backs to one another. Three turned their admirable faces to the right, and three to the left, and they played musical instruments in heavenly harmony together. Their abundant yellow hair spread downwards over their white necks, and their heads were decorated with garlands. The two nearest the triumphal car were clothed in dark blue silk, like the rare, glowing colour of the feathers around a peacock's neck.

The two in the middle wore blazing scarlet, and the leading pair wore emerald-coloured satin, lacking no nymphal adornments and decorations. They sang with their rounded mouths, making so sweet a melody as would serve as food to keep the soul alive for ever.

The centaurs were crowned with tree-ivy, and the two nearest the carriage carried vases in antique style, with one hand beneath the vase and the other arm embracing it. These were made from Arabian topaz with its brilliant golden colour, a favourite stone of Lucina and able to calm the waves. They were thin at the bottom, swelled gradually in the middle to a fair size, then tapered again toward the mouth. They were two feet high, had no handles, and were of marvellous workmanship; and a cloud of smoke escaped from them, diffusing a priceless perfume. The next two centaurs were sounding golden trumpets which had

161

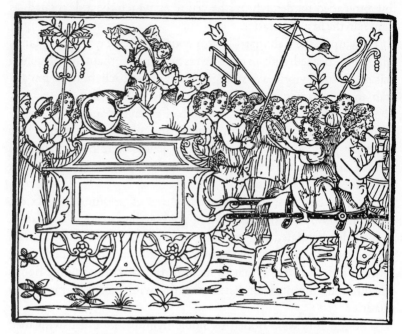

pennons of fine silk woven with gold, tied in three places to the tube of the instrument. The other two had ancient horns, which they played together and with the instruments of the riding nymphs.

Beneath the triumphal six-yoked chariot was the axle, fixed to the centres of the turning wheels which had baluster-shaped spokes that tapered from the axle and finished with a pommel at the circumference. The pole was of fine, heavy gold, resistant to corrosive rust and to fiery Vulcan, but a deadly venom to virtue and peace. The revellers cele-
brated by leaping up and making a rapid, controlled spin, and with
solemn acclamations. Their garments were secured by flying
ribbons. And the nymphs sitting on the centaurs sang
with high exaltation in amorous praise of the
sacred event and the divine mystery,
with harmonious voices
and prophetic
songs.

✳︎ ✳︎
✳︎

162

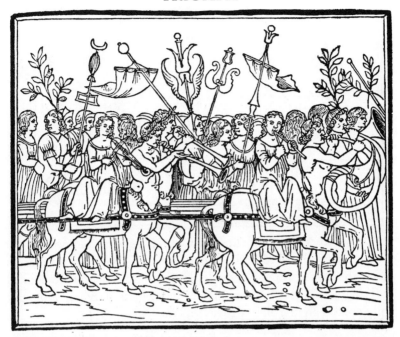

THE FOLLOWING triumph was no less marvellous than the
first, for it had all four wheels – spokes, hub and all – made from dark
agate beautifully variegated with white veins. This certainly outdid
King Pyrrhus's agate, which nature had impressed with the nine Muses
and Apollo playing in their midst.

The axle and the form of this one resembled the first, but its sides
were made from dark⁄blue oriental sapphire sprinkled with gold flecks,
well suited for magic and most acceptable to Cupid when worn on the
left hand.

On the right⁄hand panel I saw a carving of a noble matron who
had given birth to two eggs in the royal bedchamber of a
marvellous palace. To the astonishment of the midwife
and of the many other matrons and nymphs
present, there issued from one egg a little
flame, and from the other
two bright stars.

✳ ✳
✳

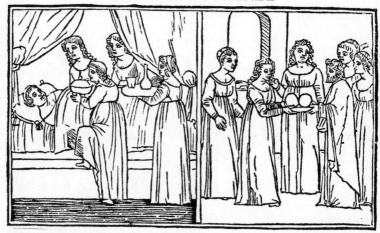

On the other panel, the curious parents, not understanding this new prodigy, devoutly asked at the divine statue in Apollo's temple for an oracle about its cause and its result. The bounteous divinity responded thus enigmatically: 'One loves the sea; the sea loves the other.' After this ambiguous reply, the pious parents kept the eggs

LEFT-HAND PANEL

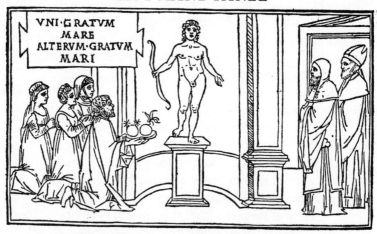

On the front side one could see Cupid as a beautiful little boy lifted up to the aether and violently drawing on the starry sky with the sharp point of a golden arrow various animal forms: quadrupeds, reptiles and birds. People were standing on the ground marvelling that a fragile arrow could have such an effect. On the back, great Jupiter set up a

164

clever shepherd as judge in his place, having woken him where he slept
[k7] near a gentle spring, and made him judge of three beautiful naked god-
desses; and the shepherd was seduced by busy Cupid to award the apple
to his amiable mother.

FRONT AND BACK PARTS

This triumphal carriage was appropriately drawn by six white ele-
phants yoked two by two, such as would not be found in the Abyssinian
country on the Gandaros, nor yoked to the African triumph of Pompey
the Great, nor even drawing the triumph of Liber Pater after the con-
quest of India. Their trunks were armed with deadly ivory tusks, and
they trumpeted softly. They were harnessed with cords of fine dark-blue
silk, beautifully intertwined with a mixture of gold and silver threads,
tightly knotted and woven in squares patterned like the ears of wheat of
Mount Gargano. Their golden pectorals bore a multitude of different
blazing gems, and were fitted with golden rings through which the har-
nesses of all six elephants passed. Six tender girls again rode them, in
the same manner as the first ones, with different kinds of instruments
blending in a magnificent consort; and whatever the other group did,
these did likewise. Two were dressed in Phoenician red, two in brilliant
yellow like the colour inside the ranunculus flower, and two were in
violet. The harnessed elephants were pompously decked out with a cov-
erlet of gold fringed with great pearls and other gems. They had large
round jewels encircling their necks, and hanging above their broad fore-
heads was a swinging ball of marvellous pearls, with a long tassel of
various silks and golden threads that shook as they moved.

I saw upon this superb and triumphal vehicle a white swan in amorous embrace with Theseus's daughter, an illustrious nymph of unbelievable beauty. The swan was kissing her with its divine beak; its wings were down, covering the bare parts of the noble lady, as with divine and voluptuous pleasure the two of them united in their delect⁄ table sport, with the godlike swan positioned between her delicate, snow⁄white thighs. She was lying comfortably on two cushions of cloth of gold, softly filled with finest wool and with all the appropriately sumptuous ornaments, and was dressed in a thin virginal dress of start⁄ lingly white silk with a weft of gold, elegantly adorned in suitable places with precious stones. Nothing was lacking to contribute to the increase of delight. This triumph possessed all the features that were described in the first one, and gave especial pleasure to the onlookers, who responded with praise and applause.

✳

THE THIRD celestial triumph followed with four rolling wheels of Ethiophian chrysolith, flecked with flaming gold, which repels malignant demons when threaded on an ass's hair, and is lucky when worn on the left hand. Everything about the wheels was the same as those described above, and the panels of the carriage, attached all around as on the others, were of green Cyprian heliotrope dotted with drops of sanguine. This stone has power over the heavenly lights, renders its wearer invisible and bestows divination.

The right-hand panel was carved thus: a man of high regal majesty was praying to the statue of the god in a holy temple and asking what would happen to his beautiful daughter. The father learned that she would be the cause of his banishment from the kingdom, so to avoid anyone impregnating her, he made a fortified structure consisting of a high tower, in which he imprisoned her under strict guard. But while she was sitting idly there, she was extremely happy to see drops of gold falling into her virginal lap.

✳

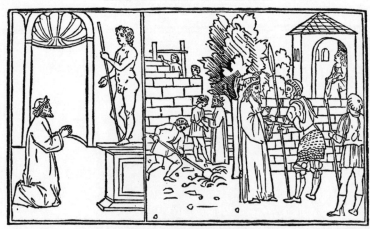

On the other panel was engraved a noble youth who with great solemnity was receiving a crystal shield for his protection. He bravely decapitated a terrifying woman with his sharp, curved sword, and proudly held up the severed head as a sign of victory. From its blood a winged horse was born, which flew up to a mountain peak and with its hoof made a mysterious spring gush forth.

SECOND PANEL, ON THE LEFT

On the backside, powerful Cupid was visible, shooting his golden arrow up to the starry sky and making an amorous rain of golden drops, at which a huge crowd of all sorts of wounded people stood stupefied. Opposite, I saw Venus angered, freed together with an armed man from a fateful net. Taking her son by the wings, she wanted to have her revenge by plucking his feathers: she already had a fistful of them, and [l1]

the boy was crying. Another panel showed winged-footed Mercury sent by Jupiter seated on his throne on high, to rescue the child unhurt from his mother's violence, after which he presented him to Jupiter. And Jupiter the succourer was saying to him in the Attic tongue, excellently carved opposite the divine mouth, ΣΥΜΟΙ ΓΛΥΚΥΣΤΕ ΚΑΙ ΠΙ‑ΚΡΟΣ, and covering him with his celestial mantle.

FRONT AND BACK PARTS

This triumph was pompously drawn by six dreaded unicorns with their horned deer‑like foreheads, sacred to frigid Diana. They were har‑nessed around their strong, equine chests with a golden ornament rich in precious jewels, and with twisted cords of silver thread and yellow silk artistically tied together. Six virgins, resembling the others in conduct and splendour, sat upon them, dressed in cloth of gold with a weft of fine dark‑blue silk embroidered with various flowers and leaves; and all six played in consort on marvellous antique wind instruments, with incredible breath‑control. On the platform of the carriage, in the middle, there was a precious bench of green jasper, preferable to silver for helping in childbirth and as a medicine for chastity. It was hexago‑nal at the foot, and tapered as it rose beneath a shell‑like seat, the bottom of which was deeply grooved for half of the way, then smoothly undu‑lated up to the beaded rim. Its seat was slightly hollowed out for comfort in sitting. On it sat a beautiful nymph in a gold and dark‑blue garment of girlish style decorated with a host of gems, her flowing hair crowned with a diadem of gold. She showed her affectionate delight as a mass of celestial gold fell into her lap, and, like the others, she received solemn homage and joyful applause.

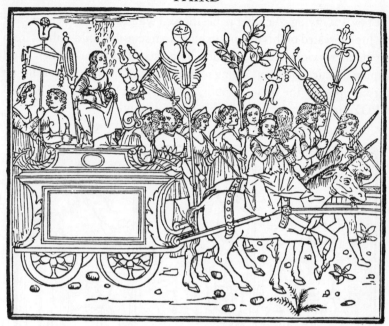

THE FOURTH triumph was carried on wheels of ferrous Arca-
dian asbestos, which once lit resists extinction. The rest of the carriage
was carved from glowing troglodytic carbuncle which fears not the
thickest darkness. Many things could be told about it, but one would
have to consider in what place and by what craft such works were made.

The right-hand face showed a scene of a venerable pregnant lady to
whom almighty Jupiter was appearing in his divine form, as he does
only to Juno, with such thunders and lightnings that she caught fire and
burned to ashes. A divine child was extracted from the combustion.

RIGHT-HAND PANEL

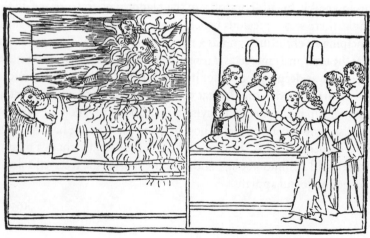

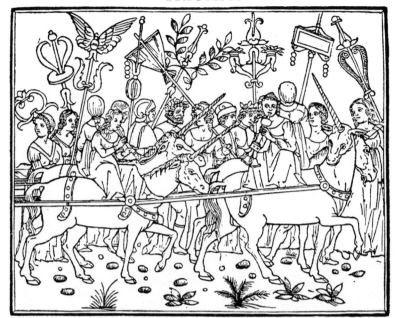

On the other side I admired Jupiter the succourer handing the same infant to a celestial man with winged heels and a caduceus; and it was then entrusted for nursing to many nymphs in a cave.

SECOND, ON THE LEFT

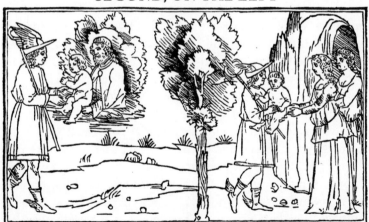

On the square in front I saw Cupid watched with amazement by a great crowd of both sexes who had been struck with arrows: he was shooting with his noxious dart to the high heaven so as to draw Jupiter down from his divinity to contemplate a mortal girl. Opposite, on the back, great Jupiter was to be seen sitting as a judge on a throne, and

Cupid limping and calling his divine mother to judgment. Cupid was complaining bitterly that, thanks to her, he had wounded himself with love for a beautiful maiden, and that a spark from a lamp had scorched his divine little leg. The accused nymph was also present with the lamp in her hand, and Jupiter, smiling, was saying to Cupid 'You can bear a spark, you who set light to heaven and to everything else!'

FRONT AND BACK PARTS

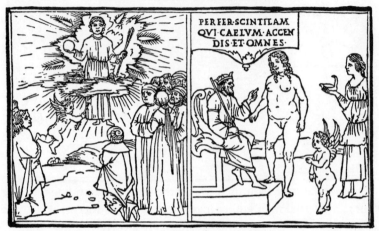

PERFER·SCINTILAM
QVI·CAELVM·ACCEN
DIS·ET·OMNES·

This verse was carved in our letters on a tablet before the face of the venerable god. The rest was like the other ones. This mysterious triumph was drawn by six swift and agile Hyrcanian tigers, dappled with spots of bright yellow. They were beautifully harnessed with flexible shoots of the fertile vine, adorned with tender leaves, curling tendrils and vermilion bunches of grapes, and drew it at a measured pace.

Above the middle of the platform there was a golden basin, one foot, three palms in diameter at the base and three palms in height. One portion was assigned to the circular plinth at the bottom, and half as much to the cyma reversa and the nextrule. The remainder was taken up by the trochlea and the cyma reversa with their accessory nextruli and cords. On the surface of this plinth, a circle was left open in the centre into which the tails of four eagles descended as they stood on the flat surface. The base was made from precious red eagle-stone from Persia, and the eagles stood with their backs opposite one another, their curved golden claws fixed on the base, and their wings raised and joined to each other. They were well matched by a marvellous vase of Ethiopian hyacinth, clear and resistant to the chisel, which rested on the elbows of their wings. This vase was an incredible thing, encrusted

172

with emerald and many other veins of gemstone; it was two and a half feet tall and rounded in form, the diameter at the widest point being a foot and a half, and the circumference thrice the diameter. The base was a third of a foot high, and a frieze one palm wide encircled its

[l₃] maximum width at the top. From this frieze, it was one palm to the beginning of a ewer contiguous and integral with it. The entire height was a foot and a half. The ewer emerged above it: this was a foot high, and for the first palm and a half it swelled. The upper half-palm was devoted to an exquisite frieze of intertwined leaves and flowers, almost detached from the hyacinth body; and the diameter was two palms and a half. Beneath this frieze was a circle of gadroons in moderate relief and gently rounded, thick at the top and diminishing to nothing at the base; and the two and a half palms up to the mouth were beautifully fluted with spiral grooves. The opening was like a shell, its mouth narrower than the width of the ewer; it had an elegant cyma, and joined the vase with twisted gullets, cymas and toruses. At the frieze of the ewer were two broken circles or half rings let into its body on opposite sides, which were held in the jaws of two lizards or small dragons, made from a vein of perfect emerald; they rested with their four little lizard feet on the lid of the lower vase. It was one palm's distance from the bottom of the ewer to the rim of the lower vase, and in between there was a sloping lid of hyacinth in the form of a reversed cyma, diligently covered with scales. All that was left of the vein of emerald was the two dragons, with their serpentine bellies and their four feet joined to the scales. These dragons followed the slope of this lid as far as the moulding of the cornice, with their tails turned up toward their spines to make a spiral loop; and these spirals served as the handles. At the bottom, the tails divided into two, one part going in each direction and mutating into marvellous fronds. These fronds, carved free of the body, allowed one to see the base or surface of the hyacinth vase beneath. The whole circumference was garlanded with these fronded tails. It remains to be said that the body within them was a foot and half across. I judged the body of this vase to be a stupendous work, and certainly divine. The whole vase was covered with a vine carved in relief, whose stems were full of tendrils, their spirals accommodated to a vein of topaz, such as is not to be found in the Ophiades Island. The leaves were of finest emerald, the

[l₃'] grapes of amethyst. What a joy to both eye and mind! The solid body beneath was brilliant hyacinth, more polished than any lathe could achieve. Only beneath the leaves had a thin ligature been left to connect

173

the free, pierced foliage with the hyacinth base, from which it was raised an inch. The sinuous leaves were formed in bold rivalry with nature, and the fruits, sprouts and wandering tendrils no less so. This marvellous work was not equalled by the drinking-vessels of divine Alcimedon, nor even by the cup of Alcon. The vase was full of fine and sacred ashes.

Returning to the encircling garland or frieze of the precious vase: in the space between the tails I saw two scenes worthy of the highest admiration, sculpted in the same fashion. On the front side of this vase I saw an excellent relief of high-thundering Jupiter, holding in his right hand a sharp golden sword made from a brilliant vein of Ethiopian chrysolite, and in his left a blazing thunderbolt made from a ruby vein. His threatening face was a vein of galactite, crowned with stars sparkling like lightning and standing on a sacred altar of sapphire. His divine and tremendous majesty was being celebrated by a chorus of seven nymphs dressed in white, with indications of solemn singing and reverent applause. They then transformed themselves into green trees of transparent emerald, covered with bright blue flowers, which bowed devoutly to the high god. The last one was entirely turned to a tree, her feet becoming roots; the next, all but her feet; the third, all but the part from the waist to the arms; and so on, successively. But the tops of their virginal heads showed that the metamorphosis would happen to each in turn.

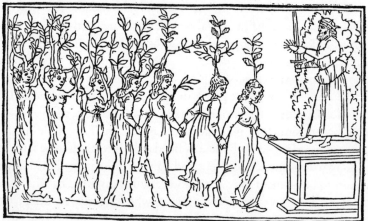

On the other side was a relief of a jolly divinity resembling a deceitful girl, crowned with two long, tangled serpents, white and black, tied in squirming coils. He lounged beneath a fruitful vine, on whose trellis some beautiful little nude spirits were climbing with laughing faces and [14]

174

picking the heavy, ripe bunches of grapes. Some of them were offering them in bowls to this divinity, who, on seeing them, accepted them pleasantly; others were lying on the grassy ground in a sweet sleep caused by the grape-juice. Some were busy with the work of the autumn vintage, while others were amusing themselves, singing and playing on stretched drumheads. They were carved in the appropriate colours, which were those of the natural veins of the precious stone opportunely brought out by the craftsman. Although these scenes were small, there was not the least defect in them, not even in the smallest detail: everything was perfect and clearly discernible.

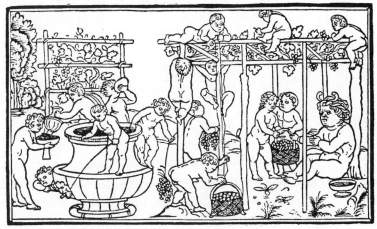

A leafy vine of gold rose from the vase that I have described, with its curling stems generously laden with clusters made from purple granules of Indian amethyst. The foliage was of the sacred green selenite of Persia which is unaffected by the lunar motions and pleasing to Cupid, and keeps the wearer safe. It overshadowed the six-yoked carriage.

Upon each corner of the triumphal car was a shining candelabrum, resting on three horn-shaped feet of branching coral. This repels lightning and storms, and protects one when worn as an amulet. Perseus found none such beneath the Gorgon's head, nor is the like to be found in the sea at Erythrae, in Persia, or in Drepana. One of them was all of sky-blue Lusitanian ceraunite, a stone friendly to storms and especially dear to Diana. It swelled and tapered in longish balusters and knobs, adorned with vermiculate work, and two feet high. The second was of fine Dionysian stone, black with reddish stains, which when pounded smells like the god .

[14'] The third was of best Medea stone, dark in colour with gold veins

175

and tasting of nectar. The last was of precious nebritis,

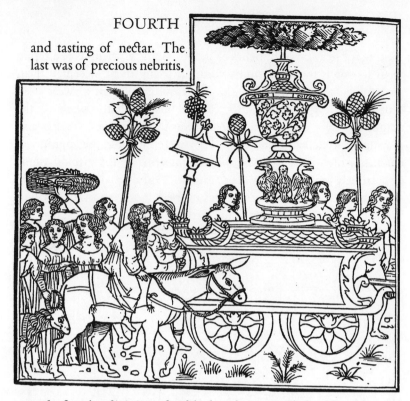

named after the divinity, of a black colour mingled with white and green. On the bowl of each candelabrum, a pyramidal flame of inex‑tinguishable fire was continuously burning.

The light from these made luminous flames appear reflected in all the detailed carvings, making it impossible to look steadily at them.

A great host of Maenad nymphs surrounded this divine triumph. They had loose, dishevelled hair; some were naked, with their nymphal garments hanging off their shoulders, and others wore dappled fawn‑skins. None of the other sex were present. They played cymbals and flutes, and celebrated the sacred orgy with shouts and Bacchic hymns, as at the triennial festival. They bore thyrsi wound with the needles of coniferous trees and with vine‑leaves, and garlands and wreaths on their naked bodies, and they leapt as they went. There followed the triumph of little old Silenus, mounted on his ass; then a hairy goat adorned for the sacrificial rite; and one nymph, acting as its bell‑wether, bearing a wicker winnowing‑basket. Thus with disorderly laughter and violent gestures the fourth triumph celebrated this ancient rite, as all the Mimal‑lones, Satyrs, Bacchantes, Lenae, Thyades, Naiads, Tityri and nymphs followed in exultant confusion, shouting the words 'Evohe Bacche!'

[15]

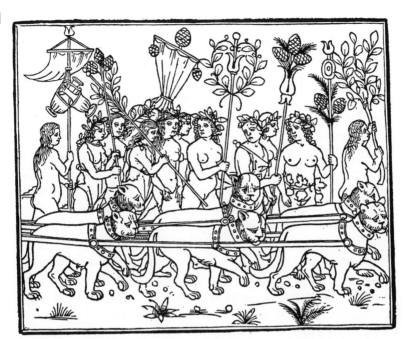

THE NYMPH ELOQUENTLY EXPLAINS TO POLI⁄
PHILO THE CROWD OF YOUNG LOVERS AND DIVINE,
AMOROUS GIRLS, AND TELLS HIM ABOUT THOSE
WHO WERE LOVED BY THE GODS; AND HE SEES THE
CHOIRS OF THE DIVINE POETS SINGING.

NYONE, NO MATTER HOW TIRELESS his eloquence, would fail in the adequate description of these divine arcana, for he could never succeed in finding words sufficient for the full and detailed narra⁄ tion of the sacred pomp, ceaseless triumphs, eternal glory, gay festivity and happy dancing that took place around these four extraordinary six⁄yoked carriages, most memorable to behold – to say nothing of the distinguished youths and the dense crowd of innumer⁄ able happy nymphs, prudent and wise beyond their tender years, making delicious and light⁄hearted merriment with their chosen pubes⁄ cent and smooth⁄cheeked lovers (though a few were sprouting the first shining down of manhood). I saw many with their torches kindled and burning, while others were carrying caskets, or long lances decorated [15'] with ancient spoils, and trophies nicely arranged and ordered. Their

mingled, joyful throng preceded the mysterious triumphs, making loud jubilations echo to the sky. Some were playing brass instruments of various shapes and demands on the breath, with bent or straight tubes. There were also loud wind instruments, while others sang to stringed instruments with heavenly melody, singing of ineffable pleasures and endless delights exceeding all that the human mind could imagine. They glorified the eternal triumphs as they circled around on the blessed, flowery earth and the green fields of this happy land, this holy place dedicated to the blessed ones. No shrub grew to obstruct or trouble it, but the whole flowery ground was a level meadow of fragrant grass with an infinitude of blooms of every colour, more beautiful in their various forms and more sweet in their perfume than one could ever express. These meadows did not fear the burning assaults of Phoebus, for in this pleasant place he did not drive with his speedy horses toward a new Hesperia. The air was always pure, and unveiled at all times by clouds and mists so that the clarity of the day never varied. The earth was forever adorned with the scented flowers of spring, which stood unfading as in a painting, with their dewy freshness and their colour unmarred by time. There were the four sorts of violets, primula, melilot, blue anemones, gith, cyclamen, ranunculus, aquilegia, lily of the valley and amaranth; horse-mint, spikenard, Celtic nard, ambrosia, marjoram and mint; also the basils – lemon, clove and the other tiny ones – and many other sweet-smelling and flowering herbs. All the species of pinks were there, together with miniature Persian rose-bushes covered with fragrant hundred-petalled roses of every colour, and innumerable others, including all the scented and attractive herbs. They were all uncultivated, scattered in beautiful array by noble Nature herself, with no human assistance. Their greenery and flowers never faded, and they delighted and gratified the senses with unfailing loveliness.

Here among the noble and well-bred girls, famous for their beauty, I saw Calisto of Arcadia, daughter of Lycaon, together with Diana whom she ignored; Antiope of Lesbos, daughter of Nycteo, with her revered satyr, who bore the musician Amphion and the countryman Zethus; Isse, daughter of Macareus, with her beloved shepherd; Antichia, daughter of Echo, and the adolescent Canace. The daughter of Athamas was also there, as was Asteria, born from the Titan Coeus; likewise Alcmene rejoicing merrily with the imitation of her husband. After these I saw Aegina, loved both by the clear river and by the divine fire, enjoying the height of bliss; the mother of Phyllis, and Meneph-

ron's mother, who let him play the part of his father; Deolis, with her lap filled with beautiful flowers, revering the coiled serpent; and the noble maiden who no longer mourned her sprouting horns. There were [16] Astyochia and Antigone, daughter of Laomedon, voluptuously rejoicing in her plumage; Coriphe, inventor of the first quadrigas; the nymph Garamantides, whom a crab held by the little toe while she was washing her delicate feet on the bright banks of the Bagrada. Then I watched a quail pursued by an eagle's talons. Erigone was also there, whose white bosom I could see filled with juicy grapes; the daughter of King Aeolus with a strong, placid bull; the wife of Enipeus, pleased with her transmuted husband; the mother of Bisaltis quietly enjoying herself with a hirsute, woolly ram; the virgin Melantha with the swimming monster; and Phyllire, daughter of ancient Oceanus, with the father of Chiron. After these I saw Ceres the lawgiver with her brow wreathed with yellow wheat, embracing the scaly serpent in voluptuous delight; beautiful Lara, the nymph of the Tiber, in the embrace of Argiphontes; the lovely nymph Iuturna, and others too many to name.

Now, stupefied though I was, I took excessive pleasure in the detailed survey and the careful study of these divine triumphs, thronged round with such choirs in these delicious meadows. They would have been totally unknown to me except as amorous mysteries, had not the divine nymph, my faithful companion and guide, noticed my ignorance. With sweetly eloquent words, and without being asked, she said considerately: 'My Poliphilo, do you see this one?', pointing out to me one who in ages past had been ardently loved by almighty Jupiter, and similarly with another of his loves. In this way she also enumerated for me his royal progeny, and in her kindness told me helpfully all the names I did not know. After this she delighted in showing me a venerable crowd of young virgins, presided over by three holy women who led the way, bearing divine ritual objects. Somewhat changing her angelic voice, she added amorously: 'My Poliphilo, I want you to understand that no mortal woman can enter here without her torch being lit either by ardent love and extreme labour, as you see me carrying my own, or else by the safe company of these three ladies.' And with a hearty sigh she added 'I must take this torch, lit by your love, to the sacred temple, and, as you will see, offer and extinguish it there.' When she spoke thus, and with this information, it pierced my inflamed heart, for it was so welcome and delectable to me that she was calling me 'My Poliphilo': it made me very suspicious that she was indeed Polia. On this account I

felt a supreme sweetness from head to foot that altered me inwardly and revived me, while my battered heart took flight to her alone. This vehement effect was betrayed by my face and my submissive sighs, as she [16'] astutely noted, interrupting this new development by saying to me, in a kindly and comforting way, 'Oh, how many would long for a glimpse of that which you now see clearly! However, raise your mind to higher things and look carefully, Poliphilo, at how many other illustrious and noble nymphs are behaving in a suitably companionable manner, acting politely and generously to their youthful lovers. They and their tireless lovers are praising each other with sweet, amorous songs and rhythmic verses, and taking great pleasure in ceaseless celebration, while the air is filled with the sweet and varied twittering of many birds.'

In the first choir, then, were the sacred Muses led by their divine lyrist, joyfully singing the high praises of the first carriage. After this celestial triumph there followed an elegant Parthenopean maiden called by the name of Leria, whose brow was crowned with immortal laurel. She was accompanied by a particularly lovely girl, Melanthia, who was embracing her divine father; her garments and voice indicated that she was a proud Greek. It was upon her that the great Macedonian always rested his heavy head when he slept. She carried a resplendent lantern that lighted her following companions, and she was sweeter than the others in voice and melody. Next the excellent nymph showed me ancient Iphianassa, then the ancient Himerian father, moved to mellifluous song with his beloved daughters. Joined to these was the prolific and facile Lichoris, and a lady singing between two Theban brothers, with the beautiful Sylvia. All these and others preceded the first triumph in pomp and splendour, singing tunefully with lyres and dulcet instruments and dancing neatly.

At the second glorious triumph were noble Nemesis with Corina, Lesbia, Delia, Neaera and many other amorous and lascivious ones, offering loud and immortal praises together with Crocale of Sicily. The smooth-skinned nymph explained the third pompous triumph to me, saying 'Do you see that one? Quintilia and Cynthia Nauta are melodiously pouring out their delectable verses; and see the virgin Violantilla with her dove, and the other one weeping for a swallow.'

The fourth triumphal chariot was preceded and praised by noble Lida, Chloe, Lydia and Neobola, with lovely Phyllis and beautiful Lycea, Tyburna and Pyrrha, singing voluptuous hymns with the resonant cithara. Then after this fourth triumph, a distinguished maiden

followed among Maenads singing to amorous Phaon about how she wished that his head were adorned with horns. Last of all, she showed me a worthy lady dressed in white, and another one in immortal green, who were singing behind all the other singers.

[17]

Thus they circled gaily around, all over the pleasant and flowery plain, some wearing laurels, others myrtles, and decorated with many and various wreaths, making solemn prayers and devout, divine and triumphal discourse without break or end, without boredom or fatigue, but with the utmost enjoyment of every glorious pleasure, admiring each other's divine beauty and enjoying their blissful and eternal possession of the blessed kingdom and sacred homeland.

THE NYMPH, HAVING SUITABLY EXPLAINED TO HER POLIPHILO THE TRIUMPHAL MYSTERIES AND THE DIVINE LOVE, INVITES HIM TO GO FURTHER, WHERE HE IS ONCE MORE DELIGHTED TO SEE INNUMERABLE OTHER NYMPHS WITH THOSE WHOM THEY LOVE SO MUCH, ENJOYING A THOUSAND PLEASURES AMONG THE FLOWERS, THE COOL SHADOWS, THE FRESH BROOKS AND LIMPID SPRINGS; AND HOW POLIPHILO, AGITATED BY LOVE SO STRONGLY THAT HE WAS MADDENED, CALMED HIMSELF AGAIN THROUGH HOPE AND BY ADMIRING THE SWEET FACE OF HIS BEAUTIFUL NYMPH.

OT ONLY WOULD HE DEEM HIMSELF fortunate, but blessed above all others, to whom it was granted by especial grace to behold the divine ceremonies, the celestial triumphs, the glorious games, the charming places, together with these gods, demigods and decorous nymphs of incredible beauty and elegance; to consort with them in person and to have the perpetual sight of them. But he would be happy above all to have this noble nymph of extraordinary beauty, with her exquisite, virginal and divine garb, as his close and boon companion and as his leader and trusty guide. And I did not consider this a lesser or a slight part of my happiness. After I had actually seen these things, I remained a long time in thought, joyful beyond imagining and astonished beyond measure. Then my tender and deli-

cious damsel guide spoke beguilingly to me: 'Poliphilo, let us go further on now.' We departed without delay, directing our leisured steps toward the shady brooks where the flowing streams made circles around the flowery meadows, surging forth from the lively springs that poured out their crystalline waters in graceful wavelets. The purple-flowered son of the nymph Liriope was ardently admiring himself in these pure waters, above the tender leaves and the red, aquatic mint, while here and there the gladiolus was flowering, and all the beautiful banks were full of other admirable flowers, growing among the cheerful greenery of the grass. This blessed place was wide in circuit, and edged with mountain shrubs. There was much green laurel, fruiting arbutus, high bushy pines and firs, and low white myrtle; and the three-leafed water lotus was thriving inside the clear channels with their beds of sand and gravel, in which the rapid water ran with a soft murmuring, as well as in some places where the ground was of yellow sand.

There was a host of delicate and divine nymphs here, of tender years, redolent with the bloom of youth and beautiful beyond belief, together with their beardless lovers who were the perpetual inhabitants of this worthy place. Some of these nymphs, charming with their pert faces, were enjoying themselves in the pure waters: they had gathered their thin silken dresses, bright with many attractive colours, and bundled them up in their snow-white arms, showing the elegant form of their solid thighs, and revealing their white legs and their rounded calves as far as the fleshy knees, while the limpidly running water ba-thed their shapely heels. I felt that this had the virtue of converting anyone, even one inept in love and extinct in desire. Where the wavelets were still, the water reflected the extreme whiteness of their snowy limbs and their celestial faces as in a shining mirror. Where there was a slight current the waters seemed to divide and to break against their little feet, leaping up and curling back in their noisy coursing. Some were amusing themselves by running briefly through the water with the tame, web-footed swans, then scooping up the water in the hollows of their hands and merrily splashing each other. Others were standing outside the flowing streams on the soft grasses, busily weaving garlands from the fragrant, varicoloured flowers which they then presented familiarly to their favourite lovers, not refusing them afterwards the addition of succulent and savorous kisses. On the contrary, they kissed each other more tightly and mordantly than the suckers of an octopus's tentacles; more than the shells that adhere to the Illyrian rocks or to the

Plotae Isles. They kissed with juicy and tremulous tongues nourished with fragrant musk, playfully penetrating each other's wet and laugh-ing lips and making painless marks on the white throats with their little teeth. Others had sat themselves down comfortably among the green grass and coloured blooms on the banks, which were adorned not with reeds but with various flowers. The waters flowing through were clearer than those of the River Axios in Mygdonia, and splashed loudly at the feet of the red oleander. And beneath the shady arbours they were clinging to one another like the vipers in Medusa's hair, in delectable embraces more intricate than bindweed and tighter than the ivy that snakes around antique elms and ancient buildings. The nymphs were not cruel or resistant to their revered lovers, but purely benign and affable in their reciprocal affections, consenting to their desires by exposing their naked and generous breasts, for which the youths appeared extremely grateful, to judge by their gestures, which were more delectable and welcome than flowing tears are to cruel and impious Cupid; much more so than the fresh brooks and the daybreak dewfall are to the grassy meadows; and still more than the desire of matter for form.

Some were singing amorous verses together, their halting voices interrupted by sighs from their inflamed bosoms, full of soft accents that would have made hearts of stone fall gently in love, or tamed the hostil-ity of impassable Mount Caucasus. They would have achieved everything that the lyre of Orpheus could do, or the accursed face of Medusa, and rendered every horrible monster benign and tractable, even calming the ceaseless motion of raving Scylla. Some of the youths were lazily resting on the chaste bosoms of the seated girls, telling them the merry fables of mighty Jupiter, while the nymphs dexterously wound their curly hair with garlands of fragrant flowers and scented herbs.. Likewise, some of them made amorous play of feigning reje-ction and pretending to flee from one with whom they were in intense and mutual love; then the girls would run after them with their mouths wide with laughter and womanish clamour, their blond locks flying loose over their milk-white shoulders, shining with golden threads and tied with green myrtle shoots. Some girls had taken nymphal care in tying elegant flying scarves, while others had interwoven their hair with golden vines ornamented with gems. Then they would join together again and, bending down, gather the beautiful flowers, filling their plump hands, and in amorous play would scatter them in each other's

[18']

183

lovely faces, enjoying themselves with much jesting and merriment. Others, when the tightly laced bodices were opened, courteously added flower to flower, putting in roses without leaves and following this with a succulent kiss; then sometimes they fought with their harmless hands, without causing wounds or bruises, giving gentle blows on the dimpled cheeks and growing as red as shining Phoebus on the wheels of cool Aurora. They fought the most novel and unheard⁄of battles that Love has ever devised, with festive, lively and altogether delightful provoca⁄ tions, with girlish gestures and motions of virginal simplicity, entangling in sincere love without any offence to honoured virtue, free from any disagreable events and from the rivalry of turncoat Fortune. All this took place beneath the temperate shade of the weeping sisters of imprudent Phaeton, of the immortal Daphne, of pines with their coifs of tiny, needle⁄shaped foliage; also beneath the tree stained with the inflamed blood of the unhappy Babylonians, the tall cypresses and green orange trees, cedars, and other admirable trees abundant in leaves, flowers and fruits. These were all eternally green, beautiful and fragrant beyond imagining, and regularly arranged at moderate intervals on the pleasant stream⁄banks and upon the plain. In between was the grassy ground, filled and clad in green periwinkle with its sky⁄blue flowers. Oh, what heart could be so frigid and frozen as not to warm with excitement at the sight of such regal and delectable rites of reciprocated love? I suspected with good reason that even the huntress Diana would easily have been incensed, as well as icy Helice whom she pursued. I might even have dared to propose, in jest, that the infernal spirits suffer no torment except that of envying these who live endlessly in delights and triumph, taking an extreme pleasure in the present moment without becoming either bored or satiated. Thus many a time my heart was warmed through the extreme sweetness that entered through my eyes and, growing into a great fire, lifted my amorous soul almost as far as my hesitating mouth. My mind remained fixed on these delightful pleasures, and as I watched with curious gaze the sucking kisses and the abundant rewards of winged Cupid, I seemed truly to feel my enflamed soul making its transition and gently migrating to the extreme limits of bliss. Thus I found myself wavering, absolutely beyond myself, stupe⁄ fied as though drugged, as I thought. My persistent memory presented me with the unguents of malevolent Circe, the potent herbs of Medea, [m1] the noxious songs of Byrrenna and the sepulchral spells of Pamphila, because I judiciously doubted that bodily eyes could see superhuman

things, or that the humble, ignoble and gross body could go where the blessed immortals reside.

On emerging from my anxious thoughts and fantasies, I recalled all the wonders I had seen, and concluded that they were not deceptions or magic tricks, but rather things imperfectly understood.

Now, as I looked intently on the most excellent of these nymphs, who was at my side and almost touching me, her eyes stirred up my vague and wandering thoughts, gathered them together and concentrated them on her, reviving my dying soul with a vigorous rekindling of its original fires. I suffered bitterly from not daring to ask whether she was my divine and much-desired Polia, seeing that she had already given me a certain ambiguous and suspicious hint. I feared that my rude and uncultured manner of speech would offend her, and for that reason I repressed my ardent voice many a time when it rose to my reticent lips. But be that as it might, I found myself enwrapped and suspended in a strange stupor (like Sosia deceived by the false Atlantiad), closely observing the celestial operations with subtle gaze and weighing them in my heart, filled with burning desire and beside myself with longing, saying to myself: 'How I long to be accepted here as a perpetual citizen! If only it were possible, I would expose my dear and precious life without another thought, not refusing the hard and weighty choice of the two doors that was given to Amphitrion's son; I would consume my sweet youth and my best years in the mortal perils of the cruel sea, and would voyage in the frightful regions of Trinacria, enduring worse burdens and terrors than wandering Ulysses when he was in the dark and imprisoning cave of the horrible Cyclops, Polyphemus son of Neptune, and in the transformation of his company by Calypso. I would not grudge my dear life to anything whatever, but would bear harder and longer servitude than the amorous Hebrew shepherd endured, or more dire than that of the slave Androcles, because when love is raging, all pain is blotted out. I would submit to the trial of

[m1'] amorous Minalion and Ileus for the beautiful Atalanta, and would fight no less than muscled Hercules for his beloved Deianira, when he struggled manfully against powerful Achelaus and won. I would do no less in order to obtain such delights and to enter for long years into these holy and fertile places that are readied for every voluptuous pleasure, and above all to pursue my precious love and to obtain the goodwill of this one whom I have longed for every day: this one who is incomparably more beautiful than Cassiopeia, fairer than Castianira, and who, alas,

holds my death or life at her command. And if perchance I seem unworthy of this companion and of an amorous relationship, at least let me be permitted, as a special gift, privilege and grace, to gaze on her eternally.' And after this, still speaking to myself, I said: 'O Poliphilo, if the heavy and painful weight of this love should daunt you, the sweet⁄ ness of the fruit invites you to endure every sorrowful burden; and if the looming dangers terrify you, your hope for the protection and help of this nymph ought to invigorate and encourage you.' Then my uncer⁄ tainty immediately vanished, and I said: 'O great and almighty gods, and you, supernal goddesses of more than mortal powers, if this one whom I behold is that beloved Polia – whom I have cherished from the first years of my love until this moment, and carried inside my burning and faithful heart, with her image indelibly fixed there – I am content with everything and will now ask for nothing more. I make only this one supplication: that you bind her in love as fervent as my own and make her burn with the same consuming fire as I have fed on so bitterly for her sake, so that she may burn and love equally. Either bind us both together, or set me free alone, for I can no longer conceal and disguise the effort I am making to hide the growing fire. Already I am dying, though alive, and feeling no life in my living being. I am sorrowing in my joy, and am in torment without suffering. I am consumed in the flame which nurtures me, and as the flame is used up, it increases. I burn like gold in the hard rock, yet find myself solid ice. Alas for my misery! This heavy love crushes me more than Inarime Island on top of Typhon; it tears me apart more than the rapacious vultures in the tangled intestines of Tityus; it confuses me more than the windings of the Labyrinth, troubles me more than the cloud⁄bearing winds over the tranquil sea, and besets me more than the snapping dogs chasing after Actaeon. Sweet life perturbs my spirits more than horrid death; my tormented heart is gnawed more perilously than the entrails of the crocodile when seized by the ichneumon. My spirits hammer on my heart with incredi⁄ ble and incessant blows, worse than the Ceraunian Mountains that are often struck by celestial lightning. And it is all the worse since with all the power of my intelligence I cannot think or fathom what part of the world I am in, except that I am in the perpetual presence of a sweet fire [m2] which consumes me without bodily harm, emanating from that demigoddess whose abundant yellow hair is to me a knotted noose made to stretch around my heart. Her broad and enwreathed brow, white as lilies, constricts me like a stem tied into the garland; her darting glances

put my life in the balance, arousing sweetnesses in order to afflict me; those rosy cheeks invite me gently to exasperation; that cinnamon mouth makes me long for a sweet torture. Then the delicious bosom, shining white as winter snow on the Hyperborean peaks, although extremely lovely in itself, is a cruel and biting scourge to me; her super-human appearance and her graceful person arouse my appetite to a fantasy of pleasure, but mercilessly destroy me. My heart can offer no further resistance to the assault of these torments and this perilous agony, nor to impious, insidious Cupid, armed with all these provoca-tive members of her smooth little body. Despite all my efforts to act the resolute athlete, I find myself like Milon before her, drained of all strength and torn apart. Nor can I escape from thence, any more than if I had rashly entered the Babylonian marshes. One effective remedy alone, one present and opportune medicine could be proffered: that I should be accepted, with all these bitter and intolerable pains of mine, by this goddess who, being Polia, has enflamed me in disguise, so that I am blazing up in my whole being with the flames of rigid Cupid, just as Minerva burned the statue of Prometheus, who stole with his slender rod the ardent fire from bright Phoebus's whirling wheels. O Tityus, you will not convince me that my torment is any less than yours, when the ravening vultures rent your warm breast and straightway tore the heart out of it, still alive and reeking, then gripped it in their taloned feet, cruelly dissected it bit by bit with their hooked beaks, and devoured it; then in a little hour, after it had been restored by none other than the executioner himself, they quickly returned and the tragic butchery began again. Similarly, when my inflamed breast is closed up again, my amorous heart is pitilessly destroyed by two ravaging eyes that rend it, and after rending it, bite it bitterly and devour it. But it does not take long for their joyful looks to cure it as though it has never felt a wound; then in a moment they return once again to their wounding.' Alas, after I had said this to myself I began to weep miserably, and as I sighed, my tearful eyes overflowed with their usual abundance, as I found myself again wishing for hateful death. For a while I was rabidly aroused with excessive and morbid desire, which made me shake uncontrollably in [m2'] my pain and tortured me with a fervent heat and with pitiful sighs. While I was in such anguished confusion, my soul often tempted me to shout at the top of my voice: 'O more than fairest of nymphs, my goddess and my only hope, have pity on me now and come to my aid, for I am on the very point of death!' But in a moment I changed my

187

mind, thinking it a mistake and rebuking it as a false and frivolous idea; then instantly my mad and raging spirit was stirred up, and I said in my perplexity: 'Why do you waver, Poliphilo? Death in the cause of love is praiseworthy. It must be my sad and malignant fate that my dolorous adventure, my grave misfortunes and my noble love of this nymph must be told to the hollow earth, after which maybe the thin, flexible reeds will grow, and their sound shall make manifest my ever more perilous amours.' Not excluding such foolishness from my erring thoughts, I said: 'Perhaps she is as she appears to be, a venerable goddess. Thus talkative Syrinx of Arcadia, in the marshy bed of the River Ladon, would not have been given over to tremble at the stimulus of bold Eurus, tumultuous and chilly Boreas, strong and cloudy Auster, and turbulent and rainy Notus, if she had curbed her importunate speech in the presence of the goddesses. Responsive Echo would not have taken on a new voice if she had spoken fittingly. And for all that the gods are kind in themselves, such contempt and unthinking presumption makes severe avengers of them. For this reason even the companions of dawdling and inquisitive Ulysses would have escaped the mortal peril of shipwreck, if they had not impudently stolen the fateful cattle of Apollo, guarded by the nymphs Phetusa and Lampetia. And similarly Orion would not have suffered horrible revenge if he had not insolently approached frigid and chaste Diana. The headstrong son of burning Phoebus was struck by lightning and relegated for eternity to the Stygian waves for using the peony plant. Thus if I should give any sign of indecency toward this divine nymph, the like, and worse, might easily happen to me.'

At last I emerged from all the commotion of my argumentative mind, and, feeling great satisfaction, I sat down and consoled myself by looking at the ornate elegance of this noble and excellent nymph, and contemplating her lovely form. She contained within herself every per-fection that could be amorously cherished and tenderly loved, and gave off such sweetness from her glad eyes that the worrying and unbridled thoughts were driven out of my troubled mind, and it became quite calm. The loud sighs retreated, and with flattering hope (O food [m3] beloved of lovers, often mixed with a draught of tears!) I tied a tight rein around my excited thoughts. With such musings and with feigned pleasure I took extreme delight and solace in admiring that gracious and genial body, those rosy cheeks, those white and brilliant members. Through these rare things I comforted my fierce desires, calmed my

raving, escaped from the excessive heat and from the amorous hearth, though being so close, they were always ready to catch fire again.

THE NYMPH LEADS AMOROUS POLIPHILO THROUGH OTHER BEAUTIFUL PLACES, WHERE HE SEES INNUMERABLE NYMPHS CELEBRATING THE TRIUMPH OF VERTUMNUS AND POMONA AND HOLDING A LIVELY FESTIVAL AROUND A SACRED ALTAR. THEN THEY CAME TO A MARVELLOUS TEMPLE WHOSE ARCHITECTURE HE PARTIALLY DESCRIBES; AND HOW AT THE SAME TEMPLE, FOLLOWING THE INSTRUCTION OF THE PRIESTESS, THE NYMPH EXTINGUISHED HER TORCH WITH MUCH CEREMONY, SHOWING HERSELF TO POLIPHILO AS HIS OWN POLIA. AFTER THIS SHE ENTERED THE HOLY CHAPEL WITH THE SACRIFICING PRIESTESS, AND INVOKED THE THREE GRACES BEFORE THE DIVINE ALTAR.

ELESTIAL ASSAULTS WERE MORE THAN I could resist! Thus the elegant nymph had amorous and irrevocable dominion over me, her unhappy lover, as, imitating her small paces, I followed her like a led beast while she guided me to a broad strand contiguous with the flowery and enclosed valley. This shore marked the end of the fertile slopes and vinebearing hills, which closed and encircled this golden land brimming with incredible delights. There were woods of great density in which the trees had been set out in an orderly fashion: the Cyrnaean and the Arcadian yew, the unfruited and resinous wild pine, straight silver firs refusing to bend and indifferent to weight, inflammable pitch pines, the fungusbearing larch and airy torch pines. These hills were beloved, celebrated and cultivated by the joyous Oreads. We went together through the verdant and flowery
[m3'] plain, the noble nymph leading and myself enwrapped in amorous fire. We passed by the tall cypress, by spreading beeches, leafy oaks full of new acorns in their cups, which are beloved of thundering Jupiter; by hard roburs with their rough bark, pungent junipers that love eternity, fragile hazels, lancemaking ash, berried laurel, shady winter oaks, gnarled hornbeams, and limes that tremble in the breath of sweet

Zephyr, who scatters his gentle blows among their tender branches.

These trees were not densely packed together, but placed at suitable distances and all duly arranged with regard to the place and aspect. They greatly delighted the eye, and were green with leaves. The country nymphs frequented this place, and the wandering dryads who wreathed their agile little bodies with soft and malleable branches and wore their hair hanging over their broad foreheads. With them were the horned fauns, crowned with hollow reeds and pithy stalks and girt with prickly pine, and the leaping, lascivious and agile satyrs: they had all come out of this sacred wood to celebrate the rites of Faunus. The foliage was more fresh, I think, than the wood of the goddess Feronia, which bur-geoned after the inhabitants brought her image there after the fire.

We now arrived at a place where there were equal square areas sur-rounded by broad, straight paths meeting at right-angles, one pace broad, edged with cynacanth or thorny grape and ground juniper, and with dense boxes cut precisely at wall level, which contained the squares of damp, flowering meadow. I saw, planted symmetrically along these hedges, the high palms of victory with their fruitful bunches of dates hanging out of their shells, some black, some red and many yellow, such as would never be found in dewy Egypt; nor does the dabulan palm of the Scaenite Arabs produce the like, nor even the date palms of Jericho. They alternated with green citrons and oranges, sorb-apples, pistachios, pomegranates, quinces, tree-myrtles, medlars, sorbs, and many other noble, fertile and ornamental fruit-trees, in fields renewed by spring.

Here, upon the greenery of the flowering meadows and in the cool shades, I saw a great crowd gathered together of extraordinary people, such as are rarely seen. They were mingling merrily, clothed rustically in skins: some wore fawn-skins, spotted with white and painted, and others wore the skins of lynxes and panthers. Some wore the leaves of the banana tree over their naked flesh, others those of the flea-bane and Egyptian bean, the mixe, the greater ground-poplar, and other fronds with their various flowers and fruits. They had boots made from sorrel leaves with flowers woven in, and they were celebrating with religious dancing, clapping and jubilating. These were the Hamadryad nymphs [m4] and the vigorous Hymenides with their fragrant flowers, who were merrily leaping in front of flowered Vertumnus and on either side of him. His brow was encircled with crimson and yellow roses, and his lap was full of those sweet-smelling and beautiful flowers that love the season of woolly Aries. He sat upon an aged carriage drawn by four

horned fauns, harnessed with ropes of new boughs, with his beloved
and beautiful wife Pomona sitting beside him. She was crowned with
fruits, and her blond hair hung down elegantly. At her feet there lay an
earthenware funnel, and in her hands she held a cornucopia filled with
flowers and ripe fruits, with leaves mixed in with them. Preceding the
carriage, near the fauns who were drawing it, was a vanguard of two
lovely nymphs, one carrying a spear with a trophy of mattocks, hoes
and sickles, on which hung a sign-board with this inscription:

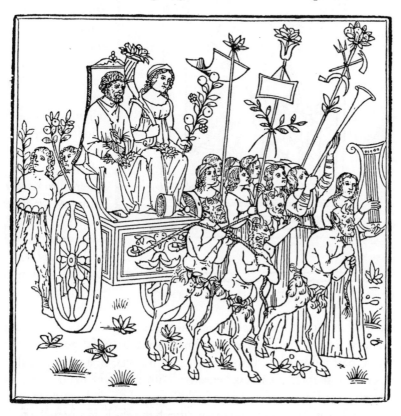

I OFFER TO MY WORSHIPPERS WHOLENESS OF
BODY, HEALTH AND LASTING STRENGTH, THE
CHASTE DELIGHTS OF THE TABLE AND
BLESSED SECURITY OF SOUL.

The other one carried a trophy with some shoots and green sprigs tied around rustic tools. They were dancing according to an ancient rite, clapping, solemnly turning and circling around a sacred quadrangular altar that was set up religiously in the middle of the grassy, flowery field, which was watered from clear springs. This altar had all the exquisite lineaments finely carved with excellent skill in shining white marble, and on

TO FLOWERING SPRING.

each of its faces there was an incredible carving showing an elegant scene as though in full relief. The first was a beautiful goddess with flying hair crowned with roses and other flowers, in a fine tunic that traced the shapely members beneath. With her right hand above an antique sacrificial vase that gave forth flames, she was devoutly scattering flowers and roses; and in the other hand she held a branch of scented myrtle with its berries. Beside her stood a handsome winged child, smiling, with his wounding attributes, and there were also two doves. Beneath the feet of this figure was written: 'Sacred to Flowering Spring'.

[m5] On the next side I saw a marvellous carving of a maiden with a virginal face but displaying the majesty of a lady, which did great honour to the sculptor. She was crowned with ears of wheat, and her hair hung down elegantly over her nymphal garments. In her right hand she held a cornucopia full of ripe grain, and in the other three stalks with wheat-ears; and a tied sheaf lay at her feet, with this inscription: 'Sacred to Yellow Harvest.'

On the third side was a divine image made with remarkable skill and artistry, of a nude infant crowned with clusters of grapes, laughing lasciviously. He held in his left hand a bunch of fruiting vines, and in the other a cornucopia full of grapes, their leaves and tendrils spilling out of its mouth. At his feet there lay a shaggy goat, and the inscription was thus: 'Sacred to Autumn Vintage.'

The last part had an outstanding sculpture of a regal figure, red-faced and stiff. In his left hand he grasped a sceptre and looked toward the sky, which was dark, turbulent and stormy, while with the other he touched the hail-bearing clouds (for the air here was also rainy and cloudy). He wore on his naked body a garment of skin, and was shod in antique sandals. The title beneath was thus: 'Sacred to Winter Winds.'

TO YELLOW HARVEST.

TO AUTUMN VINTAGE.

193

The oustanding artist had carefully chosen the marble of this noble work, so that beside its whiteness it was veined with black at the appropriate places, to depictthe dark and lightless air and the clouds with their falling hail. On the surface of this venerable altar there arose, firm and rigid, the rude image of the pro- tector of gardens with all his decent and proper attributes. A domed bower, sup- ported by four posts driven into the ground, shaded the mysterious altar. These posts were lovingly decorated with flowery and fruited greenery, and the roof was covered all over with a host of flowers. A burning lamp was hung from each post at the edge of the opening or gap in the bower, and golden plates were

TO WINTER WINDS. suspended around them which made a metallic rattling whenever the fresh spring breezes stirred them. Before this image, with great reverence and ancient rural and pastoral ritual, they were breaking a number of glass bottles or flasks, spattering the foaming blood of the sacrificed ass, warm milk and sparkling wine; and thus they made their libations with fruits, flowers, fronds, festivity and gaiety. Now behind this glorious triumph they led little old Janus, harnessed with ancient woodland ceremony, girt with strings and twisted tresses of many flowers. In rustic style they sang nuptial and bawdy songs, and played their peasant instruments with the utmost joy and glory, celebrating with jumping, leaping and earnest applause,and with loud female voices. These solemn rites and festive celebrations gave me as much pleasure, delight and astonishment as the pre- ceding triumphs had aroused my ad- miration.

✳

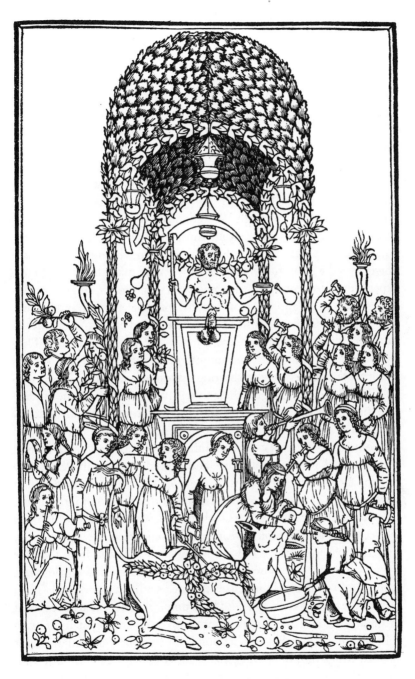

After this we walked on together for a while, and as we went, I had the unspeakable pleasure of seeing again, by the clear, fresh springs of the pleasant, grassy fields and shady woods, the nymphs of the watered dells choiring, the pleasant Naiads playing, and the marine Nereids singing. Some of them were wearing the skins of the sea-cow, which is immune to the anger of almighty Jupiter, and holding large shells of food in their hands, filled with fruits and flowers. They had come thither from the gravelly shores and were making merry at their leisure with various amusements. Many of them were holding green thyrsi in their hands, their ends packed with orange flowers with soft leaves, yellow Egyptian and Persian roses, narcissi, and handfuls of scarlet flowers redolent of cyclamen. Woodland Pan of Arcadia was there, and the demigods of forest, mountains, oak-woods and many others. There was Zephyrus with his lover Chloris, to whom he had granted power over the beautiful flowers; and there were many lively shepherds, expert at singing contests and armed with their crooks, singing praises with shouts and clapping, some serious, some playful and some in jest. They had old-fashioned instruments of reed and cane, and in place of trumpets, flutes of bark in serpent-form with a strange sound. They were glorifying amorous and omnipotent Jupiter and the blessed country life, and devoutly celebrating the festival of Flora.

Let he who can imagine these things judge what voluptuous plea-sure they gave me. Overflowing with incredible joy, I and my graceful companion continued on our happy journey and our amorous stroll; but sometimes my eyes escaped a little from their sweet captivity and bondage, as if it were forbidden – and behold! looking above the deli-cate foliage and the green tops of the frolicsome trees, I spied a high turret above a rounded roof. I guessed that this stood not far from the whispering shore to which she was happily leading me, and which was the terminus of the rapid streamlets that encircled the valley. They rushed down from the feet of the ornamental hills and from the little mountains, partly meadowed and partly wooded, one flowing down on each side through sparkling channels lined with grass and sand. Then beyond the turret I saw a splendid high dome which seemed to be roofed in grey lead, and had at its summit an octagonal cymatium with columns, and above that another dome. Then came eight square pillars covered with a roof in baluster shape, above which was a pinnacle with a perfectly rounded sphere fixed on it, shining splendidly with gold.

This sight gave me so much pleasure that I was moved immoderately
[m7] by the ardent desire to see it properly from close to, suspecting with good
reason that it was a grand and ancient structure. Then, as if this wish
had been a request to my kind guide to lead me thither, we walked
straight toward the place. But I reproved this desire, saying to myself
'Alas, I dare not ask for this thing which drives me with such sharp and
constant longing, though I am certain that once I obtained that which I
desire so much and pursue with so fixed a mind, it would make me con-
tented above any lover. But if I suppress, stifle and condemn so vain and
improper a notion, asking for no more help in that long torment than
my daily fare of heartfelt sighs, how could I beg for something much
less important to me? Alas, my unquiet heart, who are partially and not
wholly mine, why do you insist on following the fierce eagle which robs
you of your life?' Such petulant, ensnaring, and unwholesome thoughts
excited me unpleasantly and inflamed my breast with ceaseless throb-
bing, just as the plaintive pheasant's wretched heart beats when it is
forced to fly from cover by the cruel falcon. While I was much agitated
by these amorous reflections, we were proceeding at a brisk pace, and
my revered nymph was chatting freely and talking with easy eloquence
about the marvellous things that I would see plainly, by divine grace.
Thus at last we approached the resounding shore, washed by the pleas-
ant waves of the unquiet sea. In this well-situated place we found a very
ornate, well-made, and ancient temple of antique workmanship and
great richness, sumptuously made and consecrated to Venus Physizoa.

This sacred temple was built by the architectonic art in the form of a
rotunda, carefully inscribed within a square figure on the flat ground, so
that the diameter was the same length as the height of the square; and
within this circle on the ground was drawn another square. The space
between one of its sides and the circumference, following the diametral
line, was divided into five parts, and a sixth part was added toward the
centre. After drawing another circular figure through this point, the
learned architect had raised the principal part of this extraordinary
structure, this superb edifice, with all its modules, dimensions, ambitus,
contents, the thickness of its walls and of the outer columns, between
one circle and the other; that is, between the principal wall and the
colonnade or peristyle surrounding the open, roofed space. Then he
drew ten radii or divisions from the centre to the circumference, cutting
[m7'] the inner circle. These lines governed the ten arches, resting on columns
of serpentine; and applied against the solid support, between the arches

197

on either side that formed the interior circular wall, a hewn and polished Corithian column of clear porphyry stood out for a distance of two feet. This was as tall as the Ionic order, that is, nine diameters in height excluding the capital. With its bronze capital it supported a horizontal beam that circled around, with its zophoros and cornice carved integrally with it, and passed above the top of the curved beam or arch.

All of these – beam, frieze and cornice – projected as far beyond the solid body of the Corinthian order as the perpendicular line of the porphyry column required. The bases and capitals of refined metal were fire-gilt and brightly shining, with elegant entasis or swelling. This order, with its projections regularly observed, was uniform and equal throughout all the porphyry columns, each one standing upon its own pedestal, connected to the pillars. But the distinguished architect had made the intercolumniation open, in order to leave more of the floor free.

The curved beams rested their ends on the serpentine columns, which were rounded, smoothed, and polished. Each end descended to an appropriate slab or plinth on top of the capital, which gave them a solid, not an airy footing, through the covers inserted over the capitals. And beneath them there was a half-altar which served as the pedestal, on which the bases of all the serpentine columns rested firmly.

Each Corinthian column stood on a subcolumn, or rather a base in the form of a half-cylinder, neatly attached on either side to the half-pedestals. It was made by taking two squares, each as wide as the lowest diameter of the column. A third of it was used for the residue of wave-mouldings, toruses, gullets, astragals, cymas and similar lineaments above and below, conveniently arranged and nicely joined to the free-standing bases mentioned above.

Each arch was decorated elegantly on its keystone with putti alternating with shells, and flowery foliage, and in each triangle there shone like a mirror a roundel of variegated jasper, its frame splendidly encircled by a cyma covered with foliage and radiantly gilded.

On the pillar of the arch behind the Corinthian column, a fluted [m8] square pilaster protruded for a third of its width, with its base standing on the pavement, and faced another one, similar in every respect, attached to the wall beneath the arch that divided the vaults. The intervals from one to another were made by the radii drawn to the circumference in line with the outermost pillars. Above the half-capitals of these there went a circular moulding of graceful workmanship.

198

The half-cylinders and semi-pedestals were of lucent alabaster, beautifully ornamented with curving ropes or garlands of many leaves and fruits – spurges, medlars and poppy heads – swelling toward their sagging centers, hung from tendrils woven into them and knotted fast to rings.

Underneath the circular moulding mentioned above, between the square fluted pilasters of the outside wall, was a rectangular window of a square and a half, as required in the ancient temples. The opening or light was artfully filled with a transparent or diaphanous slab of Segovian stone, which does not fear age. There were eight windows in all, because the door of the temple occupied one bay, and directly opposite the main entrance there was a bay containing the golden doors of the retro-chapel or sacred adytum. The description of this will be given more conveniently elsewhere.

Beyond the square columns that I have mentioned as being attached to the first circuit of walls, there were pillars projecting on the exterior by exactly the same distance from the wall as the wall itself was thick. The distance between them was determined by the radii of division drawn from the center to the circumference. Dividing this distance, one portion was for the breadth of the pillar, and the other portion was again divided into two parts: one was assigned to a pilaster on one side, one on the other, which served for an arch in the solid wall, or rather a blind arch between one pilaster and the next. If the projection or salience of the pillars were divided by three, one part would be taken by the protrusion of the arch from the surface of the curved wall, and two by the protrusion of the two small pilasters. Wall, arch, and pilasters were all made in a solid piece. The finest architects favoured this exquisite practice, because it did not make the wall so crudely thick as to obscure the windows; it made the crude and superfluous solid transparent, and adorned the exterior. These arches curved round in an arc, joined perfectly to one another, with the proper mouldings, the same width as the pilasters, beautifully girding the whole and making it uniform from one bay to the next.

[m8'] The windows were carved out of the empty space between the pillars, or rather in the flat wall-surface remaining beneath the curves of the arches. The same distance separated the arch from the pillar as from the first exterior cornice that ran around the first roof. There were ten pillars, truly the bones of the building, and as many engaged arches on the outer wall, minus the bay to which the chapel was attached.

That cornice embraced the circular chapel and joined it to the temple, then above this moulding rose the chapel roof, which was a closed dome, distinct and free from the larger one.

We return now to the interior moulding above the circular colon-nade or peristyle, consisting of the straight beam, fascia and cornice. Perpendicularly above the porphyry columns, where each projection of the moulding emerged, there were square, fluted half-colonettes of fine serpentine. Above their half-capitals ran a cornice of remarkable linea-ments, from which point the springing of the high dome began.

Beneath each of the square half-columns, as just described, I saw a well-proportioned and well-positioned window, closed by a pane of glass from Bologna in Gaul, placed in a gilded field of fine mosaic work. In these spaces, equally distributed and partitioned, I admired a marvellous depiction in vermiculate mosaic of the months of the year with their properties and attributes. Above them ran the Zodiac, with the movements of the sun and the system of the moon's monthly phases from new to horned, half and full, and its orbit by which the months are measured. There were also the courses of the wandering sun, the winter and the summer solstice, the changes of night and day, the fourfold pro-cession of the seasons, the nature of the fixed and errant stars with their influences. I suspected that such a work of art must have been designed by the noble mathematician Petosiris, or else by Necepso. The sight of these things induced the viewer to inspect them minutely and admir-ingly, to his extreme delight; they were a rare spectacle, elegantly designed and with the figures charmingly arranged in a finished picture full of colour and shading. The modelling of the bodies and the proper lighting were pleasingly done, with an excellent representation of the attributes that had a laudable and joyful effect on the senses of the soul. It was a work as surely deserving of study as any ever seen. In one divi-sion the content and meaning of the things I have mentioned were elegantly written in ancient characters. The spaces between the square half-columns were surrounded by fascias carved in beautiful work.

The remaining walls of the temple, with manifold and various [n1] symbols, were laboriously encrusted with precious marbles, such as the knowledgeable architect imagining so magnificent a structure knows how to apply; there was probably nothing like it at the Temple of Ammon. Above the order of Corinthian columns was a perfect sculp-ture of fruitful Apollo sitting and playing his lyre, and above every other column in the circle, made in one piece with its suitable pedestal, was a

Muse of pilates stone with her appropriate gestures and attributes, carved exquisitely to the great praise of the sculptor. They were located on the projections of the surrounding moulding, as mentioned above.

The huge dome displayed the greatest evidence of workmanship more nearly divine than human; but if it were human, it aroused astonishment that human ingenuity should make such an ambitious attempt in the founder's craft: for I judged that its great vastness had been made in a single solid fusion and casting of metal. I was astonished and overwhelmed by what I deemed to be impossibile. Be that as it may, this bronze work consisted wholly of a vine sprouting from beautiful vases of the same material that were ranged perpendicularly above the columns. Thence they spread out branches, sprouts or shoots, and tendrils of dizzying intricacy, perfectly fitting the convex curve of the dome and all of the appropriate thickness. There were leaves, bunches of grapes, infants climbing and plucking them, flying birds, lizards and snakes, all modelled exactly from nature; and in between it was all transparent.

The works I have described were made in such a way that they appeared to be of natural size when viewed from the ground. Everything was brightly gilded with pure gold, while the openings or interstices between the leaves, fruits, and animals appeared to be conveniently covered by crystalline plaques of various colours, like transparent gems.

The exterior moulding bore witness to the overall consistency of the structure and the integrity of its harmony, for it corresponded to each binding element of the interior. The outside pillars continued the areobate footing with the odd number of three steps, embracing the whole bottom of the temple and lifting it as high above ground level as the floor inside. Upon the areobates, or stylobates, or rather footings, the temple's base was encircled by an ornate band with toruses, fascias, gullets and quartercircles; and there was a corresponding one inside the sanctuary. Its lowest projection was based on the human foot, as was that of the pilasters above. The interiors of these were drilled or perforated with channels, so that the water falling from the gutters or roof would rush
[nɪ'] down through these tubes until it reached the ground. They were very well joined by tonguing each one into the other. The reason that stairs, gutters and rainpipes should not be located on the outside of buildings is, firstly, because of the danger of their falling off, and secondly, because he who pisses too close to his feet spoils and dirties his shoes. Another

nuisance to be avoided is that in heavy rain, an uncovered gutter digs out the ground, and all the worse if it hits a stone beneath, because the water damages the footing and the walls just as much by splashing up against them.

It is very damaging and expensive if water is blown against the walls by the force of the wind; it soon makes them rotten and friable, and when it attacks through the windows, all the mortar is loosened and washed away. Where there is dampness, weeds grow in the joints: cotyledons or cimbalaria, maidenhair ferns, house-leeks, pellitory and polypody appear, then even saplings like the wild-fig. It is the ruin of the wall, as their many vigorous fibres and roots render the masonry cracked and unstable.

Let us resume. The height of the first or exterior wall was derived from the tops of the bent beams or arches above the columns, and from the vault of the wall facing the Corinthian columns. On top of this wall, above the moulding of the surrounding cornice, there was a hol-lowed-out channel whose inner edge formed the termination of the tiled slope of the gilded bronze roof. The highest part of this roof began above the vault on a level with the top of the interior cornice, frieze and beam. When it rained, the waters ran down the sloping roof to this channel hollowed out of the cornice, then down the drain-pipes inside the pillars. Thus the streams of rain quickly fell to the ground and flowed through hidden pipes or subterranean channels into the cistern, which had an overflow through which the superfluous water ran away, leaving sufficient for ritual use.

The faces of the pilasters, between the fine lineaments of wave-mouldings, were decorated to perfection with candelabra, leaves, fruits, flowers, birds and various other rarities, done with great skill. These pilasters continued above the top of the wall for a height equal to the dis-tance between the interior cornice marking the plinths or pedestals beneath the Muses, and the uppermost moulding above which the great dome began to curve; and the descent from this height to the top of the pillars was as steep as the shingled, tiled and gilded roof. The golden [n2] Capitol of Catulus could not equal it, nor did the Pantheon have such a tiling. Thus between the opening of the wall beneath the cupola, and the extension of the pilaster directly above the outer surrounding wall, there sprang a wide, open arch with the same lineaments as the beam. The ends of it rested respectively on the wall and on the pilaster: the former end, on the capital of a square half-column inserted in the wall,

of which a third part protruded opposite the interior column of serpentine; the latter, on the extension of the pilaster. In the outside face of the extension of the pilaster was a niche or frame, and inside the niches, perpendicularly above the pilasters, were noble statues showing various actions. To left and right of them were lineaments of the same kind as on the faces of the pilasters beneath. The lowest point of the exterior arch was on a level with the top of the pilaster.

The descent of the arch began from the circular moulding just beneath the exterior springing of the dome, and came down as far as to the extended pilaster. It was connected to all the lineaments that were on the circular moulding beneath the cupola; and by resistance to this descent, the arch was created. The moulding consisted of a corona with dentils and echinuses or eggs, together with the circular, hollowed-out eaves with leaves of cinquefoil wound round the joints, perfect in the ensemble of its lineaments.

Upon the upper surface of this band or corona on which the dome rested, a channel was cut into which the water from the dome ran down. Then, falling through the holes, it gurgled noisily down through the pilasters.

On top of the slope that started at the dome and ended at the cymatium or top of the pilaster, there was a volute or scroll-shaped covering made from two contrary spirals. One curled downwards, touching the dome, while the other curled upwards in the shape of a snail-shell, touching the pillar. From the curls there sprouted pods or husks teeming with beans or lupin seeds. The pods were covered with elegant scales, and above the upward volute an artichoke leaf unrolled, falling down on the scaly, undulating pods. This shell-shaped spiral can be drawn easily and decoratively by means of a compass. Fix the point, then draw a semicircle; next, putting the point of the compass between the drawn semicircle and the original point, open the compass and match the drawing-point with the far end of the semicircle, then draw another semicircle. By opening the compass and moving the starting point again, this figure is drawn precisely.

[n2']

Finally, above the highest level of each well-made pilaster there stood a candelabrum of lustrous orichalcum whose mouth opened like a shell, in which an inconsumable material was burning with an inextinguishable flame that could not be put out by wind or rain. These miraculous candelabra looked uniform in their proportions and of equal height, with suitable handles.

From the handle of one to that of the next there hung a garland, chained and knotted in many places with the highest artistry, made of fronds, flowers, and diverse fruits, and duly swelling as it sagged in the middle, bound and carved in pierced work. Above the coffered binding around the central swelling there brooded a lifelike eagle of hollow work, perching with its wings spread, which when viewed from ground-level appeared as perfect as nature itself. It was made from the same material as the candelabra, entirely hollow and extremely thin, and well weighted with sand; and all the leaves, hollow fruits, florets, and the rest were made with equal delicacy. The vaulted ceiling of the interior, between the colonnade and the outside wall, was of vermicu-late mosaic work with golden tesserae, showing images of great artistry in the appropriate colours.

As regards the height, it is not sufficient merely to state the universal rule that the diameter of a round temple should equal its height. The correct procedure is to find the height of the moulding above the peri-style, that is, the uppermost line of the cornice, because the line drawn from the centre to the circumference of the outer circle should give this height. One then divides the entire diameter into six parts, four of which, drawn perpendicularly, will likewise give the topmost surface of the highest moulding.

The rule for the slope of the roof should not be neglected. One takes the space between the walls where the sloping roof is to be, and fills this space with two squares. By drawing the diagonal of the resulting rec-tangle, cutting the line between the two squares, the exact slope is given.

The illustrious architect had made this marvellous building univer-sally symmetrical, with mouldings matching inside and out. One could show in much greater detail the rules by which everything was related to the solid figure, and what figures on the ground determined the height of the walls, which stood not leaning but upright, as straight as could be. Their thickness, and every particle and line was without error, [n3'] down to the smallest shaving. Oh, how unhappy is our own time and age, when the moderns (to use the convenient term) are ignorant of so beautiful and worthy an invention! No one should imagine that beams, friezes, coronas, bases, capitals, columns, half-columns, pavements, plaster-work, walls, floor-joists and all the joints, dimensions and parti-tions can be laid out without an inkling of how the eminent and skilful geniuses of antiquity and early times studied and understood them, to say nothing of their extraordinary smoothing of marble, such as neither

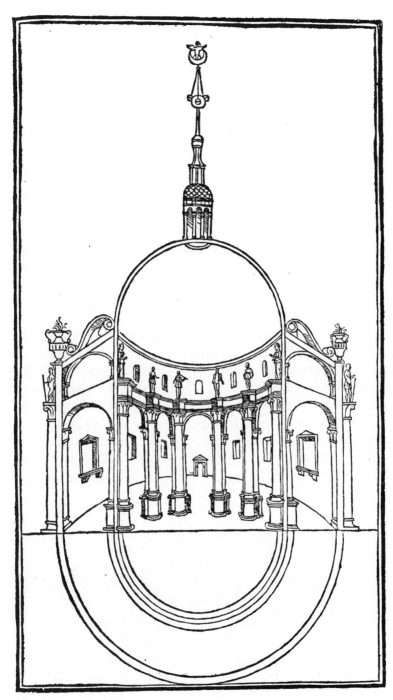

the spume of heated tin nor calcined lead can achieve. In the center of
the temple there stood the well-head of a fateful cistern, with a lively
choir of nymphs carved around it in relief, who seemed to lack nothing
but breath. They were sculpted in alabaster as well as ever the chisel can
do, with their floating garments and veils.

At the centre and summit of the interior of the lofty dome there was
a decoration of dense leaves belonging to the metal vine, mentioned
above, which ended at the top of the vault, as perfectly and closely inter-
woven as one could ever imagine. They left a circular space, of the same
size as the opening of the reversed ewer, which was beautifully filled by
the snaky head of furious Medusa, skilfully cast from the same material
as the dome. Her tangled serpents, gaping mouth, manic expression
and furrowed brow were at the centre, directly above the cistern, and
from the corners of her mouth there issued a half-ring, to which was
connected a forged chain that descended perpendicularly, suspended
above the mouth of the well.

This chain, all of pure gold, ended at the bottom with a ring, which
was fastened to another ring attached to the thin end of an inverted
shell, which with its opening downwards and its wavy base upright
tapered to a point at the ring. Its recurved lips were about a cubit across,
and attached to them were four hoops or pins, fastened to four hooks.
From these there hung four equal chains that held a circular plate
exactly at the horizontal. Carved around its upper edge were four mon-
strous female figures with loose hair and wreathed brows, cast with rare
workmanship. Each one was divided at the groin, whereupon her fleshy
thighs separated and were transformed into antique fronds with acan-
thus leaves. These curled in opposite directions, tapered, then spiralled

206

toward the belly or flanks, where the spirals were grasped in clenched fists. Harpy-like wings were attached behind the shoulders and extended toward the chain. At the place where the sinuous and fringed leaves of one girl met those of another one, a small curved hook was attached at the back. The outsides of the spirals touched one another and joined, and out of the connecting band there rose some ears of corn, seeded and half open. Beneath this ligature were three seedpods, four bands, and four little hooks like scorpions' tails. From these there hung four more chains suspending the marvellous lamp, which was shaped like a sphere and an ell's length around.

The round plate mentioned earlier had a circular hole in the middle, and exactly on the diameters between one maiden and another were four round holes of less than two palms across. In these hung four hollow globes that had mouths or lips that turned outwards, thus keeping them in the holes. They were artfully made so that almost all of their round part was free and hung downwards, all equally. These small lamps were carved from precious stones with incomparable workman-ship: one was of balas ruby, the second of sapphire, the third of emerald and the fourth of topaz.

The larger lamp, as mentioned above, was spherical and of purest crystal, made with a finesse and hollowed to a degree of thinness that could not be achieved on the lathe: an exquisite work of incredible [n4'] manufacture. Near its mouth it had four ringlets evenly spaced in four places, by which the bowl hung on the chains, and its opening was half an arm-length across. Into this aperture was inserted another vase, shaped like a urinal or rather a gourd, and similarly of purest crystal.

This vessel was carefully inserted, and hung down so that the light of the lamp shone in the centre. Then the whole body of the larger lamp was filled with ardent spirits, five times distilled. I suspect that it was this placement of the lamp at the midpoint that made the whole spherical body seem to be alight, making it impossible for the eye to dwell long on it, as with the sun. The material was of extraordinary transparency and thinness.

This also showed that the incombustible fluid in the gourd-like vessel was extraordinarily transparent. The same fluid burned in the four upper lamps, whose lovely gemstone colours were reflected in the larger lamp, and its light in theirs. The whole hallowed temple was filled with this flickering splendour and by its reflection in the highly polished marbles, such as even the sun does not paint with Iris after the

rain. But the most marvellous thing of all was the decoration of its interior, where the adept sculptor had engraved or excavated the body of the crystal lamp with a lively combat of infants mounted on swift and swelling dolphins with spiral tails, showing manifold and varied attitudes and childish enthusiasm, just as nature would have made them. They did not seem to be carved out, but rather to be raised in relief, and made so true to life that they seduced my eyes even from so delectable an object as my companion nymph, while the vacillating light seem-ed to set the sculpture in motion.

[n5]

Finally, to conclude this miraculous temple structure, it remains to say briefly that it was built from blocks that were partly of Augustan marble and partly from the alabaster already mentioned, wedded perfectly without iron or car-pentry. Our times can neither achieve nor imagine such subtle knowledge of masonry, nor could even the Apis temple of Egyptian Psammeticus equal it.

On the primary enclosure or wall, the square pilasters were linked by a contin-uous moulding at the bottom and a similar one at the top surrounding the capitals. Beneath their bases on the flat pavement was a band or fascia of the finest porphyry, as wide as the bases were high; and next to it, without any gap, another band of serpentine. Beneath the footing of the columns was a circular band of porphyry of the same width as they, flanked by two of dense serpentine, following the circle of the peristyle. A similar one was to be seen on the floor

around the opening of the cistern, with one band of porphyry and another of serpentine.

The rest of this splendid pavement between the well and the peristyle was marvellously decorated with tiny tesserae of fine stone, making rings that elegantly framed ten separate roundels, each a foot across and of a particular colour and type of stone. Two of them, opposite each other, were of red jasper, most beautifully mottled with various stain,ings. Two were of lapis,lazuli, dusted with specks of gold no larger than glowing atoms. Two were of green jasper, veined with chalcedony and spotted with red and yellow. Two were of agate, with milky threads mingled and undulating through it. The last two were of transparent chalcedony. And as the lines narrowed toward the cistern, the circular figures diminished.

Under the vault, in the 'unswept floor' style of vermiculate design, were depicted foliage, animals and flowers, carefully made with tiny tesserae of cut stone and very evenly polished or carved. Such art was found neither in the pavement of Zenodorus in Pergamum, nor in the mosaic of the Temple of Fortune in Praeneste.

Let us turn now to the peak or pinnacle of the magnificent dome, which was made from the same metallic material and laboriously gilded. Above the stupendous domed roof eight fluted columns rose proudly upwards: they were void, or rather hollow, and stood on noble bases divided from one another by windows interposed all around, with little arches in between supported on flanking pillars. Above these, obeying the harmonious sesquialter proportion between height and lin,eament, ran the beam, zophorus and cornice, with the projections exactly above the columns beneath and a tiled dome resting upon them. Directly above each supporting column I could see the statue of a Wind, elegantly depicted in accordance with its nature, with its wings open and stretched out from its shoulders. These figures were neatly fixed to the roof with a movable pin or pivot, so that when any wind blew, all eight looked for their hats, swivelling round to face the opposite direction to the breeze.

On the summit of the cupola just described there rose eight more little pilasters of the proper height of two squares, and an inverted ewer with its mouth above them. The whole elevation was exquisitely mea,sured and mathematically proportioned from the observers' point of view.

The base of this ewer (as I call it, on account of its shape) was beau,tifully roofed with seed,shaped tiles. A spire of the same metal rose from

[n5']

209

it, beginning as wide as the base and tapering moderately upward; and when the spire had become half as high again as the vase, it held a great hollow ball that was expertly fused to it.

This ball had a round hole on top, and at the bottom was pierced in four places. After pondering this, I concluded that it was carefully designed so that water, entering in the form of rain or ice, would not overload it and prevent it from functioning. The spire or spindle rose up through the hole on top of this sphere, free from its edge, and tapered to a sharp point. From where it emerged up to its summit, it was as long as from the bottom of the vase to the ball.

Attached to the point of the spire was a bronze moon, as wide as it looks on its eighth day, with its horns to the sky. On its hollow or curve there perched an eagle with its wings spread. On the spire underneath the moon were four firm and solid hooks holding four chains of the same metal, cast out of bronze like all the rest and displaying the abun-dant genius of its maker. [n6]

One can well imagine what ingenuity it required of the clever founder to cast or compound a whole chain without soldering, by making a suitable mould divided in four parts, and leaving an open space in the centre, by which the first ring was cast. After threading the first ring into it, the next one could be made, and so on, easily making one after another ad infinitum.

These chains hung down equal distances above the swelling middle of the brass ball, each being linked at the end to a brass bell. These bells had comb-like fissures from the middle to the bottom, and each enclosed a bead of fine steel that produced a tinkling sound. When the winds shook them sufficiently, the bells bumped against the body of the hollow ball, mingling their high-pitched tinkling with the booming of the metal sphere and making a pleasing sound, sweet and loud. It was a curious invention, created with much thought; and the sound of it perhaps surpassed that of the Temple in Jerusalem, which had brass vases hung by chains from the top to scare away the birds.

I will conclude by giving the one rule for understanding all the dimensions of this celebrated temple. The wall containing the eight windows was a foot and a half in thickness, and so was the nave or the part that surrounded it. The pilasters projected by the same amount, and excluding the cornice they took up a fourth of this entire thickness, which was three feet on each side. [n6']

The portal of this holy and stupen-
dous temple displayed a frame that was
Doric in form and decoration, and all
of the best jasper; and on its high fascia
this inscription was affixed in ancient
Greek capital letters made of pure
gold: ΚΥΛΟΠΗΡΑ.

The gilded doors were ornamen-
ted with bright metal and beautiful
pierced work, so beautiful than one
could never make anything like them.
They were brilliantly polished and
closed on the outside by a bolt, which
the nymph guiding me did not dare
touch before the High Priestess of this
venerable and holy temple should rev-
erently unlock it, together with the
other acolytes. These were holy and
upright virgins, seven in number, who
celebrated the sacred offices most duti-
fully before the Priestess and Diviner of
the Sacrifices, and it was fitting that
they alone should confer the right of
entry. After these holy virgins had
kindly greeted us, they received us in
friendly and flattering terms, and when
they heard from the nymph, my faith-
ful guide, the reason for her and my
arrival, they were thorougly welcom-
ing and gracious to us. With friendly
expressions they made us climb with
them to the splendid portal, up seven
steps of porphyry which joined the
surrounding base of a magnificent and
elegant propylaeum.

Here we found a noble resting-
place or landing of a single block of
black, unbreakable stone, such as is not
found in the Euganean country, uni-

formly and brightly polished and inlaid with beautiful emblems. Facing it, the holy threshold of the consecrated doors was all carved, and where the panels met there were Venus conch-shells, and the most beautiful carved lineaments that could ever have delighted human eyes. Everyone stopped here, including the two of us, and the holy Priestess began to make a prayer. The nymph and I bowed in reverence, but I certainly do not know what the Priestess was saying, because as I bent my head, straightway my quick and wandering eyes lighted on the unseen whiteness and smoothness of my companion's lovely feet, and even spied a shining white portion of her right calf – for as she moved slightly, her filmy garment was displaced, revealing the white hoarfrost of snowy and tingling Boreas.

A pure admiration immediately assuaged my heated recollection. [n7] The whiteness naturally disturbed the visual sense, which was grasping and absorbing the whole sight with the greatest pleasure; it not only hurt it, but also afforded it the solace and extreme delight of clasping such a precious object inseparably to itself.

Meanwhile the holy lady concluded her devout prayers to the gods Forculus and Limentinus and the goddess Cardinea, and the fair nymph stood up, I alone remaining with my eyes fixed on her volup-tuous actions; and I would have made no movement through all of this if the flimsy cloth had not returned to cover up the blessed delights.

Then suddenly the bolt was shot open by the chalice-bearing lady, and the twin doors sang – not with a creaking noise, nor with a deep groan, but with a pleasant and melodious murmur that whispered echoing round the vaulted temple. I noticed how this occurred on seeing, at the bottom of the heavy door on either side, a little polished cylinder turning on an axle fixed to the door which rolled along a smooth and level flagstone of hardest serpentine, making by its friction a most agreable tone.

Beside this, I was naturally puzzled that the two doors had opened by themselves without any pressure. So, after everyone had gone inside, I stopped then and there without looking anywhere else, wishing to investigate whether these doors were opened at such a steady speed by counterweights or by some other mechanism. Thus I discovered a sublime invention, for at the place where the two doors joined, tonguing into one another, there was a plate of fine, highly polished steel attached to their metal on the inside.

There were, moreover, two slabs of the best Indian lodestone, a third as wide as they were high, and no different from the adamant that points to Calisto, heals human eyes, is made impotent by garlic and is especially useful to sailors. They had the proper cerulean colour and were smooth and bright, fixed flush in an opening within the thickness of the marble wall, at the place in front contiguous to the ingenious door. Thus the steel plates were forcefully attracted by the power of the magnets, and the doors opened slowly by themselves. It was an excellent and precise piece of work, not only pleasant to see but more especially for subtle study, however improper it may be to pry into the artist's work.

On the lodestone tablet to the right of the entrance was carved in exquisite ancient Latin letters this famous saying of Virgil: Trahit sua quemque voluptas. (Let each follow his own pleasure.) On the left I saw that the tablet was elegantly inscribed in old Greek capitals: ΠΑΝ ΔΕΙ ΠΟΙΕΙΝ ΚΑΤΑ ΤΗΝ ΑΥΤΟΥ ΦΥΣΙΝ (Let each do according to his own nature.)

I raised my eyes, my curiosity excited by the magnificence of so great a temple and by the vastness of the extraordinary, heaven-like dome. All its parts were most precisely made with proud and peerless workmanship, devised by an inspired mind, superbly executed and wonderfully designed with its marvellous lineaments, stupendously ostentatious and miraculously built. But more marvellous by far, I thought, was the incredible beauty of the divine nymph who captured my gazing eyes and possessed my whole soul, such that any part of her that one consid-

ered deserved to be singled out for attention and contemplated with amazement and wonder. Therefore forgive me, reader, if I have not written at full length about every detail.

Now the holy Priestess entered the temple with the noble and illus-trious nymph, and I followed them closely, together with all the other holy maidens, whose abundant hair fell decorously about their milk-white necks. They were dressed in choice purple robes, covered with somewhat shorter or briefer surplices of the thinnest cotton, and they led us devoutly and festively to the fateful mouth of the mysterious well.

As I have said, no water entered this except that which flowed
from the channels and gutters at the top of the temple
through the hollow pilasters, without damage to
the structure. The High Priestess now made
a sign to the virgins, and they retired to
a sacristy by the entrance, leav-
ing us three alone.

✳ ✳ ✳

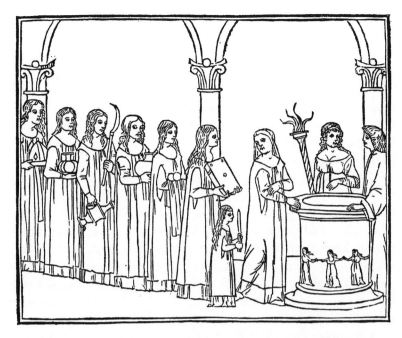

In due course they came out again with great solemnity, each virgin distinguished by a garland on her comely head. One was bearing in prescribed form the book of ritual, duly bound in dark-blue silken velvet, padded and nobly embroidered with round pearls in the form of a flying dove, with clasps of gold. A second one carried two diaphanous veils with golden ornaments and two purple hats. The third had the sacred salt-water in a golden vase. The fourth was holding the sickle with a long ivory handle, round and solid, joined with a silver and gold collar and nailed with copper, and also a bronze vase. The fifth carried a most attractive water-pot of hyacinth, filled with spring water. The sixth was charged with a golden mitre with sumptuous ribbons hanging down, all copiously ornamented with precious and brilliant gems. A girl acolyte went before them with an unlit candle of white, refined and virgin beeswax. These delicate virgins were instructed in the holy and divine offices and scrupulous in their ministry, more skilled even than in the Etruscan rite and capable of performing the hallowed sacrifices in the ancient manner. They presented themselves obediently
and with devout veneration to the High Priestess.

Now with extreme devotion and time-honoured ritual the Diviner-Prophetess first took a veil, then tying up her hair she placed upon it the superb mitre, attaching to its center the diaphanous veil that covered her sacred head.

She gave the other mitre and veil to the nymph, who forthwith covered her blond head with the mitre and put the veil on top of it. Both veils were gathered into pleats and fastened with a stupendous jewel, the one assigned to the nymph being of bright and strongly-coloured sapphire, but that of the Priestess of ananchitides.

Thus devoutly apparelled, she made me approach forthwith to the mouth of the mysterious cistern, then, taking a gold key, she reverently unlocked the well-cover. The acolyte gave the white candle to the virgin who had carried the mitre, then took the book of ritual and opened it, placing herself before the High Prophetess. The latter began to read something quietly in the Etruscan language, then she carefully took the consecrated salt-water, and with many a priestly gesture poured it with her right hand into the echoing cistern. Then she caused the pure candle to be lit from the burning torch that the nymph was holding.

Thereupon she caused the burning torch to be inverted with its flame in the middle of the opening, and questioning the nymph she said: 'Daughter, what is your wish and desire?' The nymph replied: 'Holy Priestess, I ask grace for him, that together we may attain the amorous kingdom of the divine Mother, and drink of that sacred fountain.' Likewise she said to me: 'And you, my son, what do you ask?' I replied humbly, 'Most sacred lady, I not only beg the efficacious grace of the supernal Mother, but above all, that she whom I believe to be my most desired Polia should keep me no longer vacillating in such amorous torment.' The divine Priestess said to me: 'Son, take now this torch, lit by her pure hand, and holding it thus, say thrice after me: "As the water extinguishes this burning torch, so let the fire of love be rekindled in her cold and stony heart."'

I said this with the holy ritual and the proper words, just as the Hierophant had told me. When it was finished, all the virgin priestesses, expert in their venerable ministry, responded 'So be it.' The last time, she had me immerse the torch reverently in the cold cistern.

No sooner had I obeyed this holy command than she took the pre-
cious hyacinth ewer, and with a cord of gold and crimson and green
silk made for that purpose lowered it into the cistern, filled it with the
holy water and offered it religiously to the nymph alone, who drank it
with ready devotion. Immediately after this, the hieratic Priestess dili-
gently locked the cover of the cistern with the golden key, reading over it
certain holy and efficacious prayers and exorcisms; then she continued
to the nymph, telling her to recite these words thrice before me: 'May the
divine Cytharea hear your prayer, and may her Son support what I ask.'
And the virgins responded: 'So be it.'

When this ceremony was religiously concluded, the nymph rever-
ently prostrated herself at the Priestess's sandalled feet, shod with
crimson interwoven with gold and ornamented with many gems. Then
the fearless nymph turned to me, with her placid and charming pres-
ence showing every sign of kindness, and with a sigh uttered hotly from
the bottom of her inflamed heart she spoke thus: 'Dearest and best
beloved Poliphilo, your ardent and excessive desire and your constant
and persistent love have altogether stolen me away from the college of
chastity, and forced me to extinguish my torch. Up to now, though you
have reasonably suspected who I am, I have not made it manifest.

Nevertheless, it has cost me no small fire to keep it hidden and con-cealed in me, and so long suppressed. Be that as it may, I am without a doubt your Polia, whom you love so much. A love so worthy should not be left unrequited and denied equal reciprocation and recompense; and consequently I am all prepared for your inflamed desires. Look: I feel the fire of fervent love spreading and tingling throughout my whole being. Here I am, the end of your bitter and frequent sighs. Here I am, dearest Poliphilo, the healing and instant remedy of your grave and vexing pains. Here I am, a ready consort for your amorous and bitter suffering and a sharer in everything. Here I am with my profuse tears to quench your burning heart, and to die for you promptly and most devotedly. And as proof of it, take this!' She hugged me close and gave me, mouth to mouth, a luscious biting kiss full of divine sweetness, and also a few pearls in the form of tearlets, wrung by singular sweetness from her starry eyes. Inflamed from head to foot by her charming speech and by the mouth-watering and delicious savour, I dissolved in sweet and amorous tears and lost myself completely. Likewise the sacrificial President and all the others, moved with sudden emotion, could not contain their tears and sweet sighs.

My barren and feeble tongue could neither collect itself nor find suit-
able words to express even a little of that sweet flame that played over
every part of my burning heart: thus I remained dumb, as if struck by
epilepsy. Finally, after these amorous and sacred acts and ceremonial
rites, performed with such singular and extreme sweetness and with the
incredible pleasure of love, I felt as though I were in the unhoped-for
condition of dying contented.

The Hierophant said: 'Let us continue, Polia, by completing the
sacrificial secrets of the rite that we have begun.' Now everyone moved
in order towards the dark, circular chapel situated directly opposite the
door of the magnificent temple and artfully connected with it. The
chapel was of antique and unusual construction, and made from rare
materials.

It was wonderfully built, all of diligently squared stones of precious
phengite, and roofed with a round dome made from a single, solid piece
of this stone, more marvellous even than the chapel of Chennim Island
in Egypt or the famous sanctuary of Ravenna. This stone is of so mirac-
ulous a nature that, although there were no windows and all was closed,
with doors only of gold, it was all brightly illuminated. In a way
unknown to us, this stone absorbs light, and perhaps takes its name
from this. Two of the virgins who had been relieved and bidden to go
out returned to the middle of the sanctuary. One was carrying with
heartfelt veneration a pair of white male swans suitable for the auspices,
and an antique ewer of sea-water. The other had a pair of white
turtle-doves, tied by the feet with red silk, placed on a wicker
basket full of red roses and oyster shells. They set them
down devoutly and reverently on a square
sacrificial table near the
golden doors.

Now the golden doors were opened again, and they entered together. But I waited on the sacred and hallowed threshold, and with watchful eyes gazing fixedly at their best-loved object, I saw Polia, fragrant as a perfumery, kneeling at the prayer-leader's command on the sumptuous pavement, and with sincere devotion veiling herself.

This pavement was marvellous, all made of precious stones placed in circles with subtle workmanship, neatly distinguished with complex and elegant knotwork. It was fine tessellated work with an arrangement of green leaves, flowers, birds and other animals, following the opportunities offered by the lovely colours of the brilliant gemstones. It was perfectly smooth, so that those who had entered appeared mirrored in it.

Upon this pavement my brave Polia knelt with consummate elegance, reverently baring her milk-white knees. The Misericordia never saw more beautiful knees dedicated to it! Meanwhile I stood and waited attentively with sealed lips, and since I did not wish to interrupt the sacred sacrifices, contaminate the offerings, interrupt the solemn prayer and the mysterious ministry, or perturb the altar ceremonies, I duly imprisoned the wanton sighs of my vigorous and flaming love.

Now she remained humbly kneeling before an elaborate consecrated altar situated in the middle of the chapel, which burned with a divine flame.

[03] I will briefly describe this altar, for I admired its outstanding design and its unusual construction. The bottom of it, resting on a marble step, was a circular block, above which ran an undulating band of highly polished leaves, ear-shaped, lappeted and finely stalked, whose widen- ing ended at a little string, or astragal, or reglet contained above the block. Similarly, where the surrounding foliage began there was another string, and between the two a trochlea, moderately hollowed out, and above them a small cornice. Above the table or plane of the trochlea there was another circular reglet, then a gullet that contracted to a smooth, plane surface. At the centre of this there stood a fluted pier, gradually increasing in proportion toward its base upon the plane. Dividing the diameter of the bottom of this pier, one portion was assigned to the projection around it, and two to the top of the pier, with the surrounding gullets which were duly absent from the bottom. The pier was topped by a circular, inverted plate, extending as widely as the edge of the trochlea below and ornamented above its rim by an inward- sloping cyma of beautiful foliage that neatly turned into a fine little corona. The circle enclosed by this corona filled the opening of an elegant flower of baluster shape, its petals shining on the surface and opening charmingly into four acanthus leaves. Another leaf was art- fully carved beneath this, where it showed through the lappets. At its upper extremity, after the appropriate lineaments, there was an exquis- itely formed knob, then, fixed upon this, there arose an antique dish of pure gold with a largish rim and a shallow bowl. Its flattened rim dis- played a marvellous arrangement of matchless diamonds alternating with carbuncles, cut in pyramidal form and of incredible size. The cup of powerful Hercules, the cantharus of joyful Bacchus and the drinking-vessel of immortal Jove would all give way before this.

*

Fixed to the edge of the inverted plate were four equi-distant and beautiful handles, rising out of the trochlea and solidly attached to it. Their volutes started below the in-verted plate and ended above the trochlea, and the shell-like form swelled out to the same point as the supporting block; then they curved mod-erately inwards beneath the plate, and outwards below, so that the top volute turned downwards and the bottom one upwards.

This wonderful sculpture was made entirely from a single piece of finest jasper, with many colours mixed and beautifully combined, and worked with incredible and exquisite lineaments on its every part. It was surely not worked with chisel or knife, but marvel-lously made through some unknown artifice.

The height from the marble step to the beginning of the pier was one cubit, and that of the pier the same. The rest, up to the golden dish, was a foot and a half, and from there upwards, a quarter of a foot. Gold threads were suspended from one upper volute to another, on which were strung longish beads of pierced, coruscating balas rubies, fulgu-rating sapphires, scintillating diamonds and verdant emeralds, arranged with a pleasing and harmonious alternation of colours, together with priceless and monstrous pearls, doubtless exceeding those offered by Octavian to Capitoline Jupiter.

Below the curved rim of the golden dish were suspended four pen-dants of round gems, pierced so as to be strung on a gold thread tied to a ring, and hung on an open hook. They were bigger than filbert nuts, and seven to a thread. At the end of the thread was an elegant tassel made from a mixture of silk, gold and silver threads. Gold threads [04]

hung from hook to hook in the same manner and arrangement but with nine gems on each, drooping in the middle with a graceful curve. The dish was richly decorated inside and out with fine chasing in low relief showing putti, monsters, flowers and fruits. The whole object displayed magnificent and miraculous workmanship.

Now, before this most holy altar that I have described in all its in‑
credible expense and artistry, the dutiful little acolyte suddenly but
reverently presented herself before the sacrificer (Polia) with
the ritual book opened. Everyone except the High
Priestess knelt down on the sumptuous, richly
gleaming stone floor; then I heard this
famous and solemn blessing as
she read, with humble and
tremulous voice, the fol‑
lowing invocation to
the three divine
Graces:

'O joyous Aglia! O verdant Thalia! O delectable Euphrosine!
Divine Graces and best beloved daughters of thundering Jupiter and of
Eurydomene, faithful followers and constant companions of the
amorous Goddess! Pray leave the waters of the Acidalian Spring of
Boeotian Orchomenus and the blessed seats where you attend beside the
holy throne of Apollo, and as divine Graces, be altogether propitious to
my devout prayers, that in her divine sight and venerable majesty she
may be pleased to accept my religious offerings, my pure and votive sac-
rifices, and to hear my many supplications with maternal love.'

After this holy and heartfelt prayer, all sang the responsory, 'So be
it', and I, having listened very closely and reverently and having clearly
heard the holy oration, attended with the utmost sincerity of heart.
Entirely restored to myself, I stood immobile and beheld these mysteries
with scrupulous attention and observant eyes. I knelt like the others,
and noticed the High Priestess's expertise in these ancient and sacral
ceremonies, but above all I commended the elegance and promptitude
with which Polia adapted herself to this kind of deep mystagogy, and
waited with close attention for what would follow.

POLIA PIOUSLY OFFERS UP THE DOVES, FROM
WHICH A LITTLE SPIRIT FLIES OUT. THEN THE
HIGH PRIESTESS SPEAKS THE ORATION TO DIVINE
VENUS. AFTER THAT, SHE SCATTERS THE ROSES
AND SACRIFICES THE SWANS, FROM WHICH A
ROSE-BUSH GROWS MIRACULOUSLY WITH FRUITS
AND FLOWERS. THE TWO LOVERS TASTE THESE.
AFTERWARDS THEY COME HAPPILY UPON A
RUINED TEMPLE, WHERE POLIA TELLS POLIPHILO
WHAT ITS RITE USED TO BE AND PERSUADES
HIM TO GO AND EXAMINE MANY ANTIQUE
EPITAPHS. FRIGHTENED, HE RETURNS
TO HER, RECOVERS AND SITS DOWN.
ADMIRING THE IMMENSE BEAUTY
OF POLIA, HE BECOMES ALL
INFLAMED WITH LOVE.

✳

CANNOT BELIEVE THAT SUCH RITES, ceremonies, and sacrifices were performed even by Numa Pompilius or by Cerites of Tuscany; never in Etruria, nor by the holy Jew; neither were the priests of Memphis so religious in their observations as they made sacrifice and oblation to Egyptian Apis and immersed the golden dish in the Nile. Nor, again, was the cult of Rhamnusia venerated so religiously in the city of Rhamnus in Euboea, nor the cult of Jupiter Anxurus with such awe. Such rites were not to be found at Feronia, where they walk unharmed on burning coals, nor did the Edonides, the Clodanes, or the god-inspired Mimallones display such Thracian inspirations as were shown in the present cere-mony. I could well guess, from what I had lately seen and from the preparations and god-fearing actions, what would ensue, for the golden-haired nymph Polia was worthy of her office, imbued with holy matters and initiated into them. No sooner had she seen the sign given by the director of the ritual than she rose immediately and reverently from the polished pavement without a word or a sound (none of the others moving); then the holy director led her to a wonderful urn of hyacinth set apart in the chapel, of such artistry as even Mentor was incapable.

As for me, I watched her attentively, minutely observing her every act. Her aspect, as I saw it, was like shining Phoebus tinted by the fresh dawn colours. And there she poured out ceremoniously with her ready and fearless hand a fragrant liquid, and gracefully anointed her face, milk-white and vermilion, exhaling crimson roses, also wetting her del-icate hands. Thus devoutly purified, with more sincerity than the virgin Aemilia, she approached the step of the sacred altar, where stood a wonderful golden candelabrum. It was most beautifully and carefully made, elegantly surrounded and studded with large gemstones; on its summit it opened out, as required, into a circular shell-form or dish, less than an arm's length around.

In this was deposited the soft ambergris of huge whales, odoriferous musk, crystalline and fugitive camphor, fragrant gum from great Crete, thymium and mastic, the two types of storax, amygdaloid benzoin, weighty aloe of Byzantium (also called Indian unguent) and the blessed seeds of Arabia. All these precious substances were measured out in the appropriate quantities. The careful Polia approached with exquisite [05'] diligence and veneration and touched the burning candle to them, then

after she had lit these aromatics, she immediately extinguished the candle and set it aside.

Into the little smoky flame, which gave off an incomparable fragrance, she put a twig of dried myrtle, then touched it, burning, to the sacrificial altar whence it came, setting alight all the other twigs gathered there. Then, attentively and well-schooled, she threw into this fire the pair of white doves, which had previously been diligently plucked and their throats cut upon the sacrificial table, opened dorsally with the knife, and tied together with knots of golden thread and purple silk, the warm blood being preserved with great veneration in the special vessel. After the sacrificed doves had been cast into the fragrant flame and burned, the diviner acted as precentor of the rubricated rites, starting to chant and to play, then all joined in alternation. The High Priestess now led the dance, preceded by two virgins playing sweetly on Lydian flutes and in a Lydian mode and tone, such as even Amphion could not have composed; then Polia and the others joined in one after the other, each holding in her hand a branch of fragrant and flowered myrtle. They danced following the tempo, the steps and the positions, equally spaced from one another and leaping like solemn and religious Bacchantes, harmonizing their voices with the instruments and producing from their virgin breasts an incredible symphony that echoed beneath the domed cupola. Circling the burning altar, they intoned rhythmically: 'O holy, fragrant fire, Let hearts of ice now melt. Please Venus with desire, And let her warmth be felt.'

As they sang and fluted in this mysterious fashion, circling elegantly in their round-dance, the sacrifice was consumed and the little flame went out, smoking slightly. I think that those unguents were for covering up the smell of scorching flesh, which they certainly did. No sooner was the fire extinguished than all but the High Priestess silently prostrated themselves on the pavement. In no time at all, I saw unmistakably a most beautiful little god-sent spirit emerge from the holy smoke, superhuman in form and more beautiful than learned discourse and searching imagination could ever conceive. It had a pair of curved wings on its divine shoulders, and shone with an unfamiliar and uncanny light. I stared at it so hard that my eyes hurt; but I truly felt my heart stop when it made an explosion greater than that of any thunder created from water, fire, cloud and wind. The sacrificer noticed me and [06] made a sign that I was not to fear, but to keep silent.

This lovely infant held in one chubby fist a myrtle wreath, and in the

226

other a dart burning with a sparkling fire, while around its divine head of fine golden hair was a precious crown of splendid diamonds. It flew thrice around the glowing and smoking altar, and the last time dissolved untouched and vanished like cloudy smoke in air, disappearing incontinently from eyes that were blinded by the brightness of its lightning-flash.

I beheld with fear and trembling these mystical and divine things, marvellous to view, and for a while I considered them in my mind, remaining pensive and filled with holy dread. Soon after this the intrepid director caused all the virgins to rise, and taking a golden rod in her purified hand she commanded my precious Polia to read from the ritual book, held open to her by the acolyte, and, following the proper rubrics, to gather the ashes that remained from the burnt offering. These Polia took up with great veneration in a golden sieve prepared for this purpose, and skilfully sifted them from it on to the venerable step of the altar, as readily and neatly as if she had been devoted to this practice elsewhere. Then the learned director had her curl the fingers of her left hand and extend the ring-finger, then draw in the sacred ashes certain characters, with care and precision just as they were painted in the volume of pontifical ritual.

When the diligent Polia had done this, the prophetess-director caused her and all the others to kneel humbly once more upon the precious pavement, and, looking carefully at the ritual book, she likewise drew certain mysterious and superstitious figures in the same ashes with the golden rod.

All this stupefied me and reduced me to witlessness: I was so frightened by everything that not a hair of my head stayed down. My mind was in great suspense, wondering whether in this solemn and holy expiation my Polia might be stolen away like Iphigenia and replaced by some animal or other maiden, causing me to lose in an instant all that I desired. My heart pounded, and all the spirits within were as though devoid of vital force. I was shaken like the mobile reeds in the impetuous breezes; I was more unstable than a rowing-boat; my mind vibrated more than the thin sedge-grass in the marshes blown by violent winds. [o6'] But whatever happened, I never let my eyes wander from my Polia as she performed the sacrifice, but observed her closely with attentive admiration, noting what she and the High Priestess were doing so adeptly together.

The latter took the ritual with its many symbols, and with her innate

227

sanctity exorcized all those things that served as obstacles and harms to pious love. And taking a sacred sprig of rue handed to her by one of the assistants, she dipped it in the hyacinth urn, in the liquid with which Polia had washed her fair face, and sprinkled everything and everyone, including myself. After the holy aspersion, the sprig of rue was gath⁄ered with the other branches of myrtle, and one of the ministrants, receiving the golden key from the High Priestess, opened devoutly the cover of the well⁄head. Then she dropped the branches into it, together with the feathers of the sacrificial doves, holding the cover open and watching it. The Priestess read certain holy execrations over the well and the sacred ashes, blessing them again. Then with deliberate cere⁄mony she gathered into a heap those ashes in which characters had been traced, with a brush of fragrant hyssop tied up with gold thread and purple silk, and with solemn reverence put them into a hand⁄reliquary, while Polia and the others solemnly processed after her to the open mouth of the sacred cistern.

While the nymphs sang rhythmic hymns and offered fitting obla⁄tions and censings, she immersed this reliquary, and when it had disappeared she closed the cistern mouth. With this immersion sin⁄cerely performed, all returned in procession and order to the marvellous chapel, where she struck the divine altar thrice with her sacrificial wand, with many arcane words and conjurations. She made a sign that all should again prostrate themselves on the pavement, she alone remaining standing, and with the pontifical held open by the acolyte devoutly kneeling, she spoke in our language, haltingly and with a low voice, saying:

'O most holy Goddess, kind mother of Eros, forever renowned as
the strong protector of ardent and holy loves and of amorous fires, and
tireless helper of sweet unions, may the merits of these two reach your
divine holiness. Let their excessive ardours and devoted hearts be gra-
cious and acceptable to you. Be persuaded by their many orations, full
of affectionate and religious vows, and hear their urgent prayers, recall-
ing those exhortations and divine arguments made on your behalf by
Neptune to furious Vulcan, and the snare of Mulciber's chains by
which you were caught together with amorous Mars. Hear me in your
supernal and kindly clemency; show yourself favourable to the fulfil-
ment of the firm vows and burning desire of these two. For, thanks to
your blind and winged son, this maiden has been dedicated since her
tender and budding youth to your holy and laudable service and to your
sacred ministry. Once separated through Diana's coldness, she has now
regained her own nature and is altogether prepared with utter and com-
plete devotion for your amorous and divine fires. Already her soul is
pierced by that much-wounding son of yours, and her tender heart,
torn from her chaste breast, feels that it cannot resist, but waits patiently
inclined, with sincere religion and proven devotion for the divine fire

sent out from your sacred altar, and offers itself thereto with particular sincerity, inflamed without remission. And now, feeling the amorous weight that urges and presses on her singed heart through the violent passion of this young man, she consents with determination and unswayed courage to open herself with proper dignity to your delectable and honorable ardours, and so much the more fervently, as your divinity may hear her and show her favour. For these two lovers are most desirous to obtain your rewards, to feel the holy graces, and to behold your most sacred divinity, O mother Amathusia! By the present prayer I beseech, supplicate and adore you on behalf of them both, in this good and sincere service, that they may be able to take ship and cross the sea, through the mediation of your powerful Son, to your delicious, triumphal and glorious realm. And through me as mediatrix and religious celebrant of the mysteries, may they satisfy their urgent and goading desires, extinguish their boiling passion, and succeed in reaching the goal ordained by your venerable sacrament. Be moved now, O most pious Goddess of this place, tireless mother of mortals, benign redeemer, and hearken to our devout prayers, just as you hearkened to those of Aeacus, Pygmalion and Hippomenes as they humbly prayed before your divine altars. Remembering them, show yourself generous and gracious with your natural kindness, as you showed it affectionately to the shepherd-youth when he was struck by jealous Mars, and through that divine blood that you then sprinkled on to a rosy flower.

'Lest our merits and supplications be unworthy in the sight of your high majesty, may your loving clemency mercifully supply our weakness with sacred flames. Know that these two are inseparably linked, with firm mind and singular promptitude of heart, and warmly vowed to each other with indissoluble promises. They are strictly tied with absolute obedience to the sedulous observance of your venerable and sacred laws, without ever deviating in the least. For several days now, this young man has continued to bear witness that he is a fearless and vigorous competitor, and she scrupulously professes the same, with wondrous hope of attaining your divine and efficacious patronage and sure refuge. Therefore I intercede for them, beseeching your high holiness and sublime power that you may munificently grant the desired gifts, O Cyprus-born, through those amorous fires with which you are pleased to inflame the beloved Mars, by your furious husband and your striving Son, who live with you eternally in the supernal delights and [08] glorious triumphs.'

At the end of this all the holy virgins responded with a loud voice: 'So be it!'

The holy lips were scarcely closed upon this sacred oration and pious petition than the High Priestess, adept in ritual, took the fragrant roses that had been prepared, together with some seashells or marine oyster-shells, and filling her pure hands with them, scattered them ceremoniously around the firebox on the altar. Then, using an oyster-shell, she sprinkled the whole divine altar with sea-water from the ewer.

Next, the two swans had their throats cut with the ritual knife on the sacrificial table, and their blood was mixed with that of the burned doves in the golden charger, with devout ceremonies and loving prayer, while the virgins sang rhythmical odes. The High Priestess, reading softly, directed that the immolated swans, drained of blood, should be burned as a holocaust in the sanctuary provided for the purpose, and that the ash be collected in an pyx and cast into an opening beneath the altar.

Taking the holy charger containing the two bloods, the sacrificer stood before the consecrated altar on the smooth and shining pavement, and with great reverence and care wrote many arcane characters with

her index finger dipped in the crimson blood, and summoning Polia had her do the same. The virgins continued their sweet singing of the [08'] lovely odes.

When this was completed, the noble bowl-bearer washed the holy blood quickly and carefully from the Priestess's and Polia's hands, because no other contact was permitted. The acolyte poured out pure water from the golden pitcher, and the sacred fluid was received in the golden bowl.

Then Polia, instructed by the adept High Priestess, wiped those bloody characters clean away with a virgin sponge, and squeezing it into the liquid with which she had purified her hands, she carefully washed it.

Then as they all turned their faces to the ground, the President stirred this washing-water and with a reverent gesture poured it over the firebox. Immediately a smoke leaped forth, rising gradually to the hollow vault of the dome. No sooner had it risen than it fell back to the ground, and behold! I instantly felt the solid earth stir and shudder beneath my rounded knees. There was a strange noise in the air, and a dreadful thundering in the temple: it was exactly like hearing a huge mass suddenly fall from high heaven into the sea. The groaning hinges

of the golden doors sounded beneath the vaults like a thunderclap trapped in a sinuous cavern.

[p1] Full of astonished terror and trembling with fear, I silently invoked some divine protection and kindness. Scarcely had I opened my frightened eyes a little to look at the altar, than I saw a verdant rose-bush miraculously issue out of the pure smoke, grow and multiply. Its many branches filled a great part of the sanctuary, reaching to the ceiling and bearing a host of vermilion and red roses, together with somewhat rounded fruits of marvellous fragrance that were white tinted with red. They tempted the taste to an even greater degree than those which approached the famished mouth of Tantalus, and were more beautiful than those desired by Eurystheus.

Next, three white doves and some small birds appeared upon this fruiting rose-bush, flitting in their flocks among the branches, joyfully hopping and sporting, and singing sweetly. By this apparition I guessed that a divine being was present, and suspected that the holy Mother herself was concealed in this species.

Now the sacrificing Priestess rose with ladylike dignity, and so did Polia, who appeared with her signal beauty more lovely to my eyes than ever before, and her expression sweet and smiling. They both reassuringly invited me to enter the hallowed sanctuary, and reverently to approach the divine altar. While I knelt between the Priestess and Polia, the Priestess plucked three of the fruits in an ancient ritual manner, and keeping one to herself, she offered the other two respectively to me and to Polia, which we all three ate with the prescribed ritual and the deepest sincerity of heart.

✳

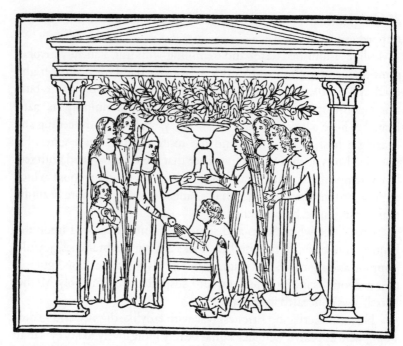

No sooner had I tasted the miraculous and sweet fruit than I felt my crude intellect renewed, my anxious heart revived in amorous joy, just as when someone dives into the depths of the sea, going with pressed lips and pent-up breath to the very bottom, and then returns to the surface and, gasping avidly, revives himself with the blessed air. This caused even more amorous flames to burn incontinently within me, and I seemed to be transmuted with the sweeter torment of novel qualities of love. I began to know directly and actually to feel the graces of Venus, the power that they wield over earthlings, and the joyful reward of those who battle their way boldly into those delicious realms through victory in the amorous battle. Finally, after the devout and sacred communion of the prophetic fruits, the divine plant disappeared, vanishing from view without lingering for a moment. Then the Priestess went out of the sacred chapel, as did Polia, myself, and all the rest.

Now that the mystic sacrifices were concluded in this order, together with the libations, immolations and the divine service, they both took off their sacred vestments and deposited all those mysterious and pontif- ical objects in the sanctuary, in compliance with the customs of the temple. There the noble High Priestess, with especial majesty, spoke to [p2] us in friendly and measured tones: 'Now, my children, purified and

blessed by me, go your way on your amorous undertaking. I will again pray the divine Majesty to show herself compassionate toward your amorous hopes, wishes and adventures. May she be merciful, favorable and propitious. And from henceforward, imprison those deep and fre⁄quent sighs, and leave your lamentations behind you. Flee from all sorrow, for owing to my entreaty, this present hour will be fortunate and favorable to you. Therefore incline your souls to my wise commands, so that she in her sweet affection will grant you a happy issue.'

After the holy President had spoken this kindly address, we gave her our undying thanks and took reverent leave with mutual farewells, showing by our damp cheeks how much this parting grieved us. We went out of the magnificent temple still saying our good⁄byes, then my golden⁄headed Polia was informed of our path, and at last we left.

'O blessed companion, daily desired! O happy ending and escape from sorrows! Now with my heart infused with an inner sweetness and its hurtful fires quenched in celestial dew, I do not falter for a moment, since this is clearly and plainly my much desired Polia, my tutelary goddess, the genius of my heart. I owe her my gratitude for all her service to the divine Mother, and for demonstrating such love for me.' I was saying these words to myself when Polia, noticing that I was talking in a low voice, fixed on me her two joyous eyes, burning with love. Brighter than the shining stars when horned Cynthia is absent and they glitter in the serene sky, brighter than white⁄hot steel sparking between hammer and anvil, thus a multitude of sparks invaded my breast. And as she spoke with angelic accents, her fragrant, crimson mouth a treasury of orient pearls and a seed⁄bed of dulcet words, she laid to rest all my mental inquietude. Such speech would doubtless have pacified the frightful face of Medusa, mitigated the dread cruelty of furious Mars and despoiled him of his bloody weapons; it could have purloined fair Ganymede from the crooked talons of the eagle, and soft⁄ened, broken, and shattered into tiny fragments the hardest of marbles, flintstones, jagged rocks, even the adamantine cliffs of Persia and the inaccessible cloud⁄capped mountains of Atlas that face the Ocean; it could have calmed or tamed the fierce beasts of Libya, and restored life to the dust and ashes of the dead. Thus she spoke:

'Poliphilo, my dearest' (taking my hand) – 'now we are going to the [p2'] roaring shore, and I hope, believe, and firmly hold that we shall happily attain the place that our heart ardently desires. It is for this cause that I have extinguished the torch of surrender to the painful laws of Diana,

made solemn sacrifices, supplications, immolations and oblations, poured out my humble prayers and tasted the miraculous fruits, so that expiated, cleansed and purified we may be worthy to behold the divine presences that are not vouchsafed to the unclean sight of mortal men.'

Thus the noble Polia and I, suffused alike with measureless sweet-ness and linked in earnest love, went on our way hand in hand, while I brooded on these arcane ideas, ever more filled with happiness, as we came to an ancient building surrounded by a sacred wood.

This was built upon the washed and wave-resounding shore of the ebbing sea. What remained of it was a great ruin of walls or enclosures, structures of white marble, and nearby a broken and sea-dashed mole of the nearby harbour. In the fissures thereof I saw growing the salt-loving littoral cock's-crest, in some places ox-eye, much saltwort and the fra-grant sea-wormwood, and on the sandbanks iringo, purslane, sea-cole-wort and other well-known simples, characias and myrtites. From the port many odd-numbered stairs led to the footing of the temple gateway. Due to devouring time, the decay of age and negligence, this building had collapsed onto the damp earth, leaving here and there a shaft without a capital, or a headless trunk of some immense column of Persian stone with its red granulations, sometimes alternating with Mygdonian marble. Some were broken at the joints: one could see neither hypothesis, nor hypotrachelia, nor astragal. I also saw some of such marvellous artistry as even the temple of Gades could not boast; but everything was exposed to the sky and gnawed by decay and old age.

My wise and beloved Polia said to me: 'My sweet Poliphilo, look at this noble monument! Once so great, it has been left to posterity lying in ruins, jagged and gaping, a mere heap of broken stones. Once, in its prime, it was a noble and wondrous temple around which solemnities were held, and each year a host of mortals assembled to perform specta-cles, for it was famed far and wide for its elegant structure and for the sacrifices celebrated there, and held in high veneration by the inhabi-tants. But now it has fallen, its dignity forgotten, and look how it lies broken, ruined and abandoned. It was called the Polyandrion Temple.

'In it, Poliphilo my dear heart, there are many grave-pits in which were buried the mouldering corpses of those who yielded to a dark and miserable death through base, unfortunate and unhappy love. It was dedicated to infernal Pluto; and each year on the Ides of May all those who were indulging the pleasures of love used to come here, both men and women, with ancient and solemn ceremonies. They came here for [p3]

236

the solemn assemblies from many regions, from bordering provinces and from their remote homelands, offering to the divinity of three-bodied Pluto that they might not fall, from impiety, into awareness of their own untimely death. Hence they sacrificed dark victims or black sheep that had not yet known the male, on a burning brazen altar, the males to the god and the females to the goddess; and they held this feast for three nights. Afterwards they covered the fire and flame with a mass of roses and extinguished it with water consecrated to Hades. That is why you can see great rose-bushes of every kind still left here. To pluck the roses was forbidden at the time, but the priests trafficked in them.

'After the sacrifice was consumed, the priest, adorned on his breast with a mysterious golden clasp decorated with a precious synochitis stone, gave some of the holy ashes to each person with great reverence, using a golden ladle. After receiving the ashes, they went out of the temple in a crowd, and then to the rush-grown shores of the nearby sea, Then they placed the holy ash in a reed and blew it out to sea with religious awe, shouting with loud and raucous voices mingled with the womens' howls, and saying "Thus perish those who are knowingly the cause of their lovers' death!"

'After they had thus thrown the ashes into the sea, they spat thrice in the sea, and thrice they said "Fu, fu, fu!" Then they returned merrily with more roses which they strewed throughout the temple, and especially on the tombs therein, singing funereal laments and lugubrious and doleful songs, accompanied by the sacrificial Milvine flutes.

'Immediately afterwards, everyone joined his countrymen and set out in a circle the tables, the banqueting things, and whatever they had brought to eat, communicating as at the banquets of the Salian priests. Having finished this funerary feast, they laid the leftovers on the tombs, invoking the spirits; and in addition to this anniversary, they held the Secular Games.

'Then the banqueters issued forth from the temple, and each one bought a garland and put it on his head. Taking in their hands a branch of funereal cypress, they followed the Salian priests, the prophetic sacrificers, and the dance-leaders bearing the sacred objects, and danced the ancient Sicinnium together with the women, with loud clapping and jubilations, accompanied by many and various wind and stringed instruments. They danced three times about the circuit of the temple to placate the three fatal Parcae, Nona, Decima, and Morta, the stewardesses of high-thundering Jupiter. They circled briskly like semi-

Bacchantes, then returned to the sacred temple, where they all hung up their cypress branches in separate places. These branches, fixed here [p3'] and there, were religiously preserved until, in the following year, the holy ladle-bearers gathered up all the dried branches and burned them in a sacrifice. At the end, after all these offices of the dead had been performed with great festivity and rectitude, after the prayers had been said in the services and cult of the gods, and every evil spirit driven away, the high priest and first Curion pronounced the final word: "Begone!" Everyone could now return joyfully to his own country and happily come home.'

My magniloquent Polia told me about all these admirable observances with such charming words, that I felt thoroughly educated. Meanwhile we had reached the broad and sandy shore, beaten by the gentle ebb and flow, where the ruined and deserted temple stood.

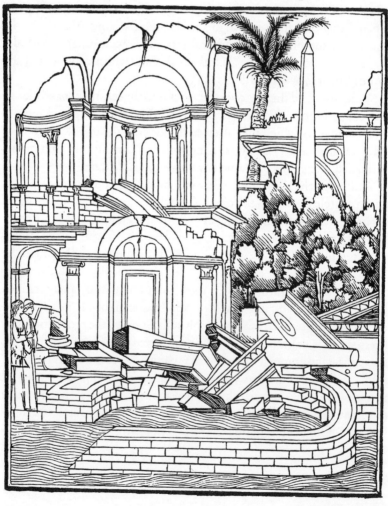

[p4] We happily sat ourselves down on the fresh and flowering grasses. There I was, with my eyes insatiably fixed on her face, contemplating such a harmonious host of beauties in one perfect and inviolate little body, refusing to look away from so lovely an object though it exceeded the grasp of my eyes, and still unsated. New thoughts came thronging into my ardent heart, rekindling it with a silent joy; and, rejecting vulgar and common follies, I considered rather their intelligible effect. The serene sky, the healthy and gentle air, the delicious country, the ornate greenery, the pleasant and temperate hills ornamented with dark woods, the clement weather and pure breezes, and the charming and comfortable place, well watered by streams flowing through the wooded valleys beside the rounded hills, running gently to left and to right and falling into the sea; the fertile meadows rich with turf, filled with many trees and the concerts of little birds: all this surpassed the rivers and fields of Thessaly. We sat here together amongst the burgeon-ing and fragrant flowers and the roses; I held my eyes fixed firmly and with such delight on that celestial effigy, concentrating all my senses upon so fair and rare a creation and so divine an image. The vexatious attacks of heat in my soul became more pleasurable, melting into sweet-ness; I was stupefied, anxious, tense and curious, wondering with astonishment how and why that crimson fluid turns pure milk-white when one presses the precious flesh of the rounded wrist, and for a little while does not return. No less did I wonder by what artifice Madame Nature had formed this lovely body, and flooded it with all the perfume of Arabia. With what diligence had she fixed upon that starry fore-head, its golden threads curving in unison, the most beautiful region of the heavens with its Heraclean splendour!

 Then I turned my attention to those neat and slender feet, admiring the tightly fitting scarlet shoes, with moon-shaped openings above the ivory instep and serpentine perforations, secured with golden eyeholes and blue silken strings and tightly laced. They were fine instruments for disturbing one's life and for the excessive torment of a heart aflame! After this my lascivious gaze returned to the long neck encircled with orient pearls, unable to distinguish one or the other for whiteness; then it descended to the dazzling bosom and delicious breast, where two rounded apples stood forth, resisting their clothing and striving obsti-nately against it. Without a doubt, Hercules stole nothing like these from the orchard of the Hesperides, nor did Pomona ever see the like in her garden. They rested unmoving and fixed on the rosy bosom like soft

and lucid snow, in the season when Orion sets beneath the fishlike body of the gentle monster, Pan. I admired voluptuously between them a delicious little cleft that was the delicate tomb of my soul, such as Mau⁄ solus could not have built, for all his wealth. In this, then, I was content, and my anguished heart knew that my eyes were saving it from death. Nonetheless, I could not altogether hold back those amorous sighs, nor reprove them in time to prevent their feigned sound from escaping.

As if touched by this and attacked by amorous contagion, she forth⁄ with turned her wanton glance (enough to make the sun jealous) placidly upon me. I felt a burning irritation spreading through my body, causing an itching in its lowest and inmost parts and spreading through all my capillaries. As I contemplated her matchless being, a honeyed sweetness waxed deliciously within me. And sometimes, assailed by insatiable appetite and heavily oppressed by a burning and inopportune passion, I beseeched her inwardly with plangent words full of suave and vehement prayers, secretly longing for kisses: sweet, moist, and vibrant with the snake⁄like motions of the succulent tongue. I imagined myself tasting the extreme delight of that savorous little mouth, breathing its fragrant airs, its musky spirits and its untainted breath, and pretending to penetrate into the hidden treasury of Venus, there to steal, like Mercury, the precious jewels of Mother Nature.

'Alas,' I sighed, finding myself besieged by that divine Mother and assailed by her flame⁄bearing Son. Obsessed by that fair face and infečted by the charms with which she was adorned, inveigled by that golden head whose every hair held me captive, chained in its snare and bound in its twisted knots, allured by the abundance of such pleasant food and amorous sweets, I could by no guile resist the fiery assaults, the invasions and irritating thoughts. Love with his arrows had filled my whole being with such unbearable and inextinguishable heat, driving my patience to its limit, so that reječting all reason and ripe counsel, I was tempted, in this solitary place, to the Herculean audacity of vio⁄ lently possessing the divine and untouched nymph. But first I spoke to her with sighing and pleading voice and with beseeching piety:

'Alas, heaven⁄born Polia! I reckon it an eternal honour to die for you, and find death more tolerable, more sweet and more glorious if my last end can be dealt me by these delicate little hands of yours. For my soul is hemmed round with so many tormenting ardours, and they grow more savage by the hour. This long scorching, without respite and without pity, lets me spend not a single quiet hour in peace.'

By such means and method I hoped to put a stop to this sharp and vexatious urging, for no sooner had my heart scarred over than it felt itself cruelly burned all over again. 'Oh, Poliphilo, what will you do now? Think for a moment of the violence done to Dejanira, to the chaste Roman maid and to many others, which was evil and unhappy in its results. Consider that the omnipotent gods have received rebuffs in their love of earthlings, while you are but an abject rag of a man! Remember that everything comes to him who waits: even wild lions can be tamed by daily training, and so can any other wild animal. The grain-bearing ant, though tiny, by assiduously following its path leaves its footprint in the hard flintstone; so even a divine form enclosed in a human body ought to show the imprints of fervent love.' With this observation I reproved and confounded my vexatious passion, just as it was hoping to obtain the amorous fruits, the rewards of desire and the triumphant ecstasy; I searched my memory for the holy orations, sacrifices and libations, and the extinction of the torch: divine offices that she had performed for her Poliphilo and especially celebrated with commendatory prayers. Thus I deemed it better to seek while suffering for a more efficacious reward, recompense and realization of my desire, than to assuage my bitter anguish with a dangerous crime, so losing all hope.

The nymph Polia noticed that my face was changing colour even more than the famous tripolion, or teuthrion, whose flower changes its colour three times a day. Seeing me thus altered and hearing such hot, stifled sighs issuing forth from the depths of my love, she looked at me with her flattering gaze, tempering my impetuous motions and violent agitations. Not otherwise did she urge my soul, burning in those continual flames and scorching pains of love, to the patient hope that, like the Arabian phoenix on its aromatic branches lit by the coming of the ardent sun, hope might be reborn from its arid ashes.

POLIA PERSUADES POLIPHILO TO GO AND LOOK AT THE ANCIENT EPITAPHS IN THE RUINED TEMPLE. THERE POLIPHILO SEES MARVELLOUS THINGS, AND FINALLY, READING OF THE RAPE OF PROSERPINE, WONDERS IF HE HAD CARELESSLY LOST POLIA, AND RETURNS TO HER FULL OF FEAR. THEN THE GOD OF LOVE COMES AND INVITES THEM TO ENTER THE BOAT. CALLING ON ZEPHYRUS, THEY SAIL AWAY HAPPILY, AND THE SEA GODS PAY GREAT REVERENCE TO CUPID

EEING MYSELF ASSAILED TO NO SMALL [p5'] degree by the most unimaginable and exquisite tor/ments of love, yet having the desired, healing and present remedy to hand in my own physician, I was stu/pefied to think that against all natural law, she was the disease that was killing me, and that whenever I found her elegant manner, ornate eloquence and seductive looks about to give me the healing I craved, they rebuffed me. Hence the urge grew ever stronger not to show myself ungrateful and cowardly in the face of this provoca/tive opportunity: a welcome gift to ravishers! As a furious and snarling dog growls when he reaches his prey in the alpine passes, so I was mad with greed to satisfy myself utterly with my own desired game.

Accustomed as I was to a continuous and familiar death from love, I did not recognize the atrocity of this urge, nor what would come of it, but persuaded myself that every violation, however damnable, was per/mitted. My ready/witted Polia noticed this dishonorable condition of blinded love, and seeking to dampen so importunate a fire and to break it off for a while, she came to my rescue as my only saviour and said to me gently: 'Poliphilo, my best/beloved, I am well aware that you are extremely fond of looking at the works of antiquity. You might well use this interval while we are awaiting the Lord Cupid to go and admire these deserted temples which have collapsed through the ravages of time, or have been consumed by fire, or shattered by old age. Take your pleasure in looking at these, and examine the noble fragments that remain, which are worthy of admiration. And I will wait for you, con/tentedly sitting in this place, watching for the arrival of our Lord, who shall take us to his mother's holy and desirable realm.' After the other wonderful works I had seen, I was greatly eager for a careful and percep/tive examination of these, and so I rose from my comfortable seat beneath the mild shade of laurel and myrtle, surrounded by largish cypresses. All around this place was the honeysuckle, painted with its fragrant flowers; a bending jasmine covered us with a dark and pleasant shade, dropping on us masses of its white blooms, now at the height of their fragrance. Without another thought I left Polia's side and came to these out/of/the/way mounds of vast, lofty heaps and ruins, mostly covered with ground/ivy and ground/creepers and tangled with thorns. I conjectured, after some thought, that this had been a magnificent and marvellous temple of rare and superb construction, just as the virtuous and excellent nymph had aptly prophesied to me. It appeared that there [p6]

had been tribunes around the circular temple, for some parts were still left half-preserved, or half-ruined: great fragments of pillars with archivolts and roof-cornices, and numerous columns of various types of stone, including Numidian, Hymettian, Laconic and others, most graceful and with pure and accomplished lineaments. I could easily deduce from the disposition of the tribunes that the tombs had been in this place.

I observed first of all, at the rear of this ancient temple, a great, tall obelisk of reddish stone. On its squared support I saw the following hieroglyphs carved: first, in a circular figure, there was a pair of scales, between which was a plate. In the triangles between the beam and the edge of the plate there was a dog on one side and a serpent on the other. Beneath it was an antique coffer, from which an unsheathed sword arose. Its point went beyond the bar of the scales and passed through a royal crown. I interpreted it thus:

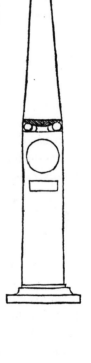

LAWFUL JUSTICE, UNSHEATHED
AND FREE FROM LOVE AND HATE,
AND WELL-CONSIDERED LIBER-
ALITY FIRMLY PRESERVE THE
KINGDOM.

Then beneath this in another rectangular figure I saw an eye, two ears of wheat tied crosswise, an antique scimitar, then two wheat-flails crossed over a circle and beribboned, a globe, and a rudder. Then there

was an ancient vase, out of which sprang an olive-branch adorned with fruits. There followed a broad plate, two ibises, six coins in a circle, a chapel with an open door and an altar in the centre, and lastly two plumb-lines. I interpreted the figure in Latin as follows: [p6']

TO THE DIVINE AND EVER-AUGUST JULIUS CAESAR, GOVERNOR OF THE WHOLE WORLD, FOR THE CLEMENCY AND LIBERALITY OF HIS SOUL, THE EGYPTIANS HAVE ERECTED THIS FROM THEIR PUBLIC FUNDS.

Similarly, on each face of this squared block was a circular figure like the first one, of the same kind and size. On the first one on the right I admired some elegant hieroglyphs. First there was a caduceus with serpents, and at the lower end of its rod, to either side I saw an ant growing into an elephant. Similarly at the upper end there were two elephants diminishing into ants. Between these on one side was a vase containing fire, and on the other a shell of water. I interpreted it thus:

THROUGH PEACE AND CONCORD, SMALL THINGS INCREASE; THROUGH DISCORD, GREAT ONES DIMINISH.

244

Opposite this there was another circle in which I observed a finely-wrought design; there was an anchor crossing it sideways, with an spread-winged eagle perching on it and a rope wound around its shaft. Beneath these images sat a warrior surrounded by weapons and looking at a snake that he was holding. I made this interpretation of it:

MILITARY PRUDENCE OR DISCIPLINE IS THE STRONGEST BOND OF THE EMPIRE.

After contemplating with extreme pleasure the noble ideas that were conceived and expressed in such figures, I looked at the fourth one, opposite the first circle. I saw a triumphal trophy, with two crossed palm-branches at the bottom of its lance. Two horns of plenty rose up, also tied to it. In the middle there was an eye on one side and a comet on the other. This was to say:

THE RICH TROPHY OR INSIGNIA OF THE VICTORIES AND SPOILS OF THE DIVINE JULIUS.

As for the magnificence of this obelisk, I thought that the like had never been transported to Thebes nor erected in the great circus. After this I returned to the ancient part of the temple and found the propylaeum all in ruins. At the entrance of the broken doorway I saw a fallen fragment of the beam, the zophorus and part of the cornice, carved

D. .M. .S.
CADAVERIB. AMORE FVRENTIVM
MISERABVNDIS POLYANDRION

from a single piece. On this zophorus I saw the above inscription ele-
gantly written in capital letters.

This noble and admirable fragment, still in one piece with a portion
of its gable-end or frontispiece, had preserved its fine lineaments. On its
triangular surface I could see two images carved, but not entire: there
was a headless bird that I thought was an owl, and an ancient lamp, all
of perfect alabaster. I interpreted them thus: DEATH-BEARING
MESSENGER TO LIFE.

Soon afterwards I reached the middle of the temple, which I found
somewhat free and clear of debris. There again, consuming time had
spared only one work demanding description. It was all of reddish por-
phyry, six-sided, with its base on a solid serpentine stone of the same
shape and resting on the pavement. It had six small columns, six feet
apart, with the epistyle, zophorus and cornice devoid of any lineament
or figure but simply polished and pure. The mouldings followed the
shape on the outside, but inside they were circular. Above the table of
the corona there rose a cupola, marvellously made from a single solid
rock, which tapered toward the top like a narrow and hollow
chimney. It covered an underground cavity, lit by a
circular opening that was blocked by a fine grille
of cast metal. Thus I found this admirable
and highly finished ciborium.

Looking through the grille, I seemed to see a kind of square beneath. Possessed by an inquisitive desire to go down there, I rummaged through the debris and ruined fragments, searching for some passage, and behold, I found a gap in a marble pillar, no more than two feet wide, obstructed by a strong creeping ivy which almost completely filled the opening of a little doorway. Led on by excessive curiosity, without another thought I care-lessly entered it. As I descend-ed by a dark stairway, it seemed from the first moment to be a horrible hole, dark with mist, but after a little my eyes be-came accustomed to it and

began to see, and I perceived a large and spacious underground place hollowed out in a circle, unresonant because of the dampness. It was propped and supported by piers situated directly beneath the superstructure of the cupola, with arches spanning openings of the same size as those contained by the six columns above. This whole place was vaulted from the piers upwards and of white marble, the polished blocks cemented together so that one could barely see the joints. Much saltpeter or borax had dribbled out there. I found the pavement to be beautifully cut and shaped, smooth and flat, but fouled by the presence of owls.

A double-square altar stood on the floor between the piers: it was all of orichalcum, six feet long, half as high including the base and cornice, and hollowed out like a tomb. But in the opening, two inches below the surface, I saw a grille or grid cast integrally from the same material. On one face I saw a little window, and thought that the sacrifi-cers thereby tended the fire for burning the offering and removed the sacred ashes. I also guessed that the things to be burned were placed upon this grid, in order to consume the animal, because the top of the

opening appeared rather sooty. I judged that the smoke of the sacrifice rose up and passed through the channel of the porphyry cupola to dis- [p8'] perse outside, and suspected that the tholos or central peak of the temple had perhaps been open, as in the Egyptian rite, so that the vapour and burning smell of the sacred smoke left without troubling the temple. On the other side of this altar I found this inscription exquisitely carved in Roman letters, reminding me of the altar found at Valesium near Tarentum.

INTER NOPLOTONI TRICORPORI
ET CAR AE OXORI PROSER PINAE
TRICIPITIQ_.CER BERO.

As I circled this earthy or subterranean place, I saw no other handi- work except seats joined to the walls and of the same material. After admiring all these things diligently with measureless delight and singu- lar devotion, I returned to the surface, where I wondered at the preservation of that splendid work, the ciborium. It confirmed my sus- picion that the temple had had an open roof, because the ruins had piled up around it while leaving this part undamaged. Now I cast my eyes about and saw that one of the tribunes was almost intact. Straightway my feet followed my eyes, and I hastened to it. In its ceiling an elaborate picture had been preserved, subtly executed with incredible skill and expertise in coloured mosaics.

One vault here was painted to represent a cavern darkened by dense fog, showing a huge, mournful, and terrible cave full of holes like a per- forated or fistulous pumice-stone, and giving way toward the middle of the left-hand side to a rough, impassable, rugged, iron-coloured cliff, in which one could see an open cleft. Opposite this end there was a steep, storm-eroded mountain of tufa, hollowed out and perforated like the

248

one opposite. At a medium height between the two, a double bridge was thrown across; this was of iron, glowing hot towards its centre but elsewhere seeming to be of the coldest metal.

[91] Beyond these steep and crumbling rocks, the division between the two sides appeared to be all on fire: it was a place of searing heat, full of fiery flying sparks running about, and glowing ashes falling like dense atoms in the sun's rays and crackling in the flames. A boiling fiery lake was also skilfully depicted, and many vents appeared between the rocks.

In the front part was shown a dark and muddy lake, frozen hard; and on the right there was another echoing mountain, sharp, rough, jagged, and sulphur-coloured, which vomited from various apertures a foul, black smoke that reacted against the active fire, immediately gushing forth a purulent igneous matter. This vomiting gave forth a rumbling, or rather an explosion like that of a compressed vapour forced to expand and diffuse, and the noise re-echoed through the tubular passages. And when this was not shown in one place, another place supplied the indication of it. There was a rough fissure making a deep cavern with cruel, solemn and Avernian shades, gouged out like the Taenarian Cave, with a brazen door rudely forced into that burned and porous rock. And beneath this echoing and vaulted cavern sat sleepless three-headed Cerberus, his black fur damp, capped with frightful snakes, horrific and terrifying in aspect, and panting heavily. He kept watch over those metal doors, spying with sleepless vigilance, his eyes ever open in perpetual sight.

On this horrid and sharp-stoned shore, in this miserable region of the icy and foetid lake, stood fell Tisiphone, wild and cruel with her vipered locks and implacably angry at the wretched and miserable souls who were falling by hordes from the iron bridge on to the eternally frozen lake. Rolling through the icy waves, they hastened to escape the painful and deadly cold, and so reached the frigid shore; and as they came out, avoiding the Tartarean Fury, the unfortunates passed over a difficult, laborious and rugged bank on the left. They fled quickly with throats agape, brows furrowed, and reddened and tearful eyes, indicating cries, wailings, and pitiful sobs and moans. Overcome with the horror, they pushed and trampled one another, and threw themselves violently into the deep and cold Avernus. Those who escaped from the precipice found in the rough cavern the second horrible Fury, Megaera, who prevented them from throwing themselves into the licking flames and forced them to ascend to the burning bridge. I guessed that a similar

arrangement was on the other side, because baleful Alecto, sister of the other two and daughter of Acheron and hideous Night, furiously prevented the souls condemned to eternal flames from flinging themselves into the icy lake. Terrified by the ghastly Fury, they ascended and met the others on the accursed bridge. And thus it appeared to me that the [q1'] souls who were condemned to the burning fire hoped to escape to the ice, whilst those who were sentenced to the frigid lake, colder by far than the Stygian marshes, wanted desperately to enter the accursed and ardent flames. But they were all compelled to follow the wrong route, for the burning pathway was divided by fatal decree so that the souls doomed to inextinguishable fire fell back into their eternal abode, and similarly, those who tried to evade the inevitable cold fell from the bridge to be submersed once more in the icy depths. Then, by virtue of divine justice, their journey started again from the beginning.

Other miserable souls were trying ceaselessly to achieve their vain and impotent desire, but by no means could they attain the desired result. Some wretched souls therefore hastened restlessly, shaken with furious horror and rage, to escape the burning flames and take solace by cooling themselves in the ice, but could not. Others likewise tried repeatedly to flee the biting cold and enter the ardent flames, but, frustrated in their greatest want, were unable to do so. And as their pain became inescapable and unceasing, and their yearning ever greater, they lost all hope. Their longing increased still more when they came face to face with one another on the bridge: as each neared the end of his course, the burning ones felt the reflection of the cold, and the frozen ones felt the heat, and this caused the greatest aggravation of pain and torment.

I saw that this picture, with its resolute art of colouring and of representing gestures and expressions, had been done with a perfection as exquisite as could ever be achieved and demonstrated. Its explanation was inscribed above it: those condemned to the burning flames were the souls who had killed themselves because of overheated love, and those plunged in the horrible ice were those who had showed themselves frigid and unyielding toward love, and had stubbornly rejected it. Lastly I admired the representation of the ghastly, terrifying and repulsive Barathrum. Here, where the freezing and the burning lakes met, their contrast must have caused an eternal conflict and given forth a terrible thundering, seeing that after meeting they both plunged over a steep precipice and poured into a dark, vast and bottomless cleft and an

immense abyss. Its depth was so artistically represented by the craftsman with his colouring that the picture actually deceived one into seeing a devouring chasm. Such were the marvellous imitation of colours and the measured lines of perspective, the elegance of figures, fertile invention, artistic arrangement and unbelievable subtlety, that the famous painter Parrhasius of Ephesus could not boast of having been the first to create its like.

While examining this picture in detail I could easily grasp its sense, since the artist, overflowing with mastery and outstanding intelligence, had shown the souls exquisitely in their bodily form. These shades could not have been visible without condensing and concretising their airy nature in this way. Many souls were blocking their ears, while others covered their eyes with their hands, not daring to look into the terrific, engulfing abyss filled with various frightful and terrible monsters. Some were pale, with their arms hugging their breasts to show the numbing cold; others were breathing out smoky breath to indicate their heat. Yet others demonstrated their bitter sorrow and doleful pains by

[q2]

251

weeping and wringing their hands. On the narrow bridge there was a transverse joint where the two hordes ran together. Here the leaders rammed into each other, but could not turn back because of the pres- sure of those following, whereupon the bridge separated by eternal and fatal decree, forcing everyone back to his own place, then, as it returned and rejoined, others ceaselessly tried to climb it. Some of the miserable, despairing souls were hoping to find a horrific death, but even ghastlier [q2'] than this frightful place with its dreadful Furies was their inability to achieve it. Thus this unhappy and sickening Erebus was depicted in all its detail, so as to fill the viewer with no small terror.

In this place I saw a square altar, on whose face or front I discovered this inscription carved in perfect capital letters:

This cheered me greatly. Leaving it, I found among the ruins a noble squared stone of marble, damaged on one side but with the major part intact. On one face, between wave-mouldings, was a central section of two small squares with an arch, and on either side a longish oval figure, one having the letter D and the face of a mask, and the other an M and another head. The cyma was somewhat pointed, but truncated, and on top of it stood an ancient brazen vase, open and coverless. I thought that the ashes must have been kept in it. The rest of the lineaments were intact, and this was the inscription:

Nearby I saw this elegant epitaph on a tablet of porphyry, lying on
the ground. I guessed that there had once been a magnificent sepulchre
here, because it appeared continuously broken on either side, and thus
had not been a simple tablet. But this part of the lineaments remained
undamaged, together with its lettering, around which
Iberian cress was growing.

```
        D.                    .M.
GLADIATORI MEO AMORE CV
IVS EXTREME PER VST A
INMORT. LAGVOREM DECVB.
AT EIVS CRVORE HEV ME MISE
RAM IMPIATA CONVALVI. D.
        FAVST. AVG.
PIE MONVMENT. RELINQVENS
VT.Q. ANN.SANG. TVRTVR. IN
TER SACRIFICAND. ARC. RELIG.
HANC INTINGIEX. L ⊞ ACCEN.
FACVL. ET COLLACHRYMVLAN
TES PVELLAE SOLVERENTVR
LVCTVMQ. FVNERAL. OBTAN
TI INDICIVM DOLORISDEVEL
LAT. CRINIB.PROMISSISRVSSA
RENT PECTORA FACIEMQ . DI
EM INTEGRVM PROPITIATIS
MAN. CIRCA SEPVLCRVM SAT A
GERENT ANNVALITER
        PERPETVO REPE
        TVND.
        EX.T.     F.l.
```

After I had carefully read these two epitaphs and looked at them with great pleasure, I cast my eyes searchingly around me, and what should I see but a figured tomb? I was not idle in approaching it. There was a small altar attached to the front and carved integrally with it, on top of which, wonderfully made, was the head of a wild goat, with a little old man holding it by one of its horns. The hair of his head was in disorderly curls, in the antique manner, and his nakedness was covered by a pallium thrown over his right shoulder, coming down below the left one, returning up to the right and then hanging down behind. Near him was one clothed in goatskins, one before and the other behind his back, with the feet of the two skins knotted together over his shoulders, and the remaining feet hanging down between his thighs with the rough hair turned to his flesh, belted with a wreath or rope made from wild grape or black bryony, with its leaves.

254

This man was playing two rustic flutes, with his cheeks bulging, as he leaned against a knotty trunk of pitted wood, all hollowed and split from age and with only a few meagre branches and leaves. His hair was uncombed and decked with leaves. Between the two men, a naked infant was dancing. On the other side was a man bearing on his strong shoulders a ritual wine-vessel, holding its mouth downwards and pouring the unmixed wine onto the horned head. By his side was a woman with her hair let down; and she and the wine-pourer were naked. She tearfully held a torch with its flaming end downwards. Behind these two a satyr child appeared, grasping a many-coiled snake in his hand. Following them was an little old peasant-woman carrying a basket, her nakedness covered by a ragged garment girt above the hips. On the crown of her unadorned head she had a pad, and upon this an osier basket full of fruits and leaves, while in her other hand she held a long-necked earthenware vase. These figures were excellently and sharply sculpted. The little altar was inscribed as shown. I was much excited by so many comely monuments; then as I searched around, a Roman epitaph inscribed most elegantly in stone presented itself to me, with this delightful dialogue and these ornaments:

✳ ✳

255

Leaving this, after viewing it with great pleasure, I entered a broken and ruined tribune. Here again I found part of a fine picture in bright mosaic, in which I could see a lady prostrated on a burning pyre and cruelly slaying herself, with nothing visible around her but some women's feet in shoes and some broken parts with a few draperies. All the rest had been destroyed by insatiable and greedy time, by antiquity, by winds, rains and burning sun. The altar in this place was broken; the largest piece was the one with this inscription, which I discovered face downwards when I returned to it. Nearby I found an antique vase lying on the ground, made of alabaster stone, a pace and a half in height, with one of its handles missing and its body partly broken up to the mouth and partly whole. It stood on a semi-cube or plinth, a foot or four palms

high. It was inscribed on one face, on the same side as the break, and similarly where it was damaged there remained some fragmentary and some whole letters. On the lower body, beneath the girdle and toward the bottom, where the handles had been attached, on the broken side was this remarkable inscription:

Leaving these shattered monuments, I came to a ruined tribune which contained a few fragments of mosaic. Here I saw a picture of a man troubling a maiden, and a shipwreck; also a little youth swimming to a deserted shore with a girl riding on his back. And part of a lion was visible, and these two rowing in a boat, but the rest was destroyed, and even these parts were damaged in many places. One could not understand the whole story. However, let into the pavement of inlaid marble was a brass tablet with Greek capital letters that had this epigram inscribed on it, which when I had read this sad tale in my own language provoked such feeling in me that I could not contain my tears, cursing and blaming fortune. After reading it over many times, I was able to turn it thus into Latin:

257

HEV SVIATOR PAVLVLVM INTERSERE. MANIB. ADIV
RAT. PRODITVM. AC LEGENS POLYSTONOS METAL
LO OSCVLA DATO ADDENS . AH FORTVNAE CRVDE-
LE MONSTRVM VIVERE DEBVISSENT. LEONTIA PVEL
LA LOLII INGENVI. ADVLESCENT . PRIMARIA AMORIS
CVM INTEMPERIE VRGERET . PATERNIS AFFECTA
CRVCIATVB. AVFVGIT. INSEQVIT. LOL. SED INTER AM
PLEXANDVM A PYRATIS CAPTI INSTITORI CVIDAM
VENDVNT. AMBO CAPTIVI NAVEM ASCEND. CVM NO
CTV SIBI LEONT. LOL. AVFERRI SVSPICARET . ARREP-
TO GLADIO NAVTAS CVNCTOS TRVCIDAT. NAVIS
ORTA MARIS SAEVIT. SCOPVL. TERRAM PROPE COL
LISA MERGIT. SCOPVL. ASCEND. FAMIS IMPVLSVLE-
ONT. HVMERIS ARRIPIENS IMPONO. FAVE ADES DVM
NEDT. PATER INQVIENS. NOS NOSTRAMQ. FORT. TI
BI COMMITTO. TVNC DELPHINEO NIXV BRACHIIS SE
COVNDVLAS, AT LEONT. INTER NATANDVM ALLO-
QVIT. SVM NE TIBI MEA VITA MOLESTIAE? TI PVLA LE
VIOR LEONT. CORCVLVM, ATQ. SAEPICVLE ROGANS
SVNT NE TIBI VIRES MEA SPES. MEA ANIMVLA? AIO.
EAS EXCITAS, MOX COLLVM AMPLEXATA ZACHARI
TER BAIVLANTEM DEOSCVLAT. SOLAT. HORTAT.
VRINANTEM INANIMAT, GESTIO, AD LITT. TANDEM
DEVENIM. SOSPITES. INSPERATO INFREMENS LEO, AG-
GREDITVR, AMPLEXAMVR INVICEM, MORIBVNDIS
PARCIT LEO. TERRITI CASV, NAVICVLAM LITTORI V
NA CVM REMIGA LIPAL MICVLA DEIECTAM FVGITIVI
ASCEN. VTERQ. ALTERNATIM CANTANTES REMIGA-
MVS. DIEM NOCTEMQ. TERTIAM ERRANT. IPSVM
TANTVM VNDIQ. COELVM PATET. LETHALI CRVCIA-
MVR FAME, ATQ. DIVTINA IN EDIA TABESCENTIB.
RVIMVS IN AMPLEXVS, LEONTIA INQVIENS AMABO
FAME PERIS? SAT TECVM ESSE LOLI DEPASCOR, AST IL
LA SVSPIRVLANS MI LOLI DEFICIS? MINIME INQVAM
AMORE SED CORPORE, SOLIS VIBRANTIBVS ET MV-
TVIS LINGVIS DEPASCEBAMVR DVLCITER. STRICTI-
VSQ. BVCCIS HIANTIBVS OSCVLIS SVAVE INIECTIS HE
DERACITER AMPLEXABAMVR, AMBO ASTROPHIA
MORIMVR, PLEMMYRIIS NEC SAEVIENTIB. HVC AVRA
DEVEHIMVR, AC AERE QVAEST VARIO MISERI IPSIS IN
NEXI AMPLEXVB. MANES INTER PLOTONICOS HIC SI-
TIS VMVS, QVOSQ. NON RETINVIT PYRATICA
RAPACITAS NEC VORAVIT LEONIA IN-
GLVVIES, PELAGIQ. IMMENSITAS
ABNVIT CAPERE, HVIVS VRNVLAE
ANGVSTIA HIC CAPIT AMBOS,
HANC TE SCIRE VOLEBAM
INFOELICITATEM.
VALE.

* *
*

I left this, wandering ever more avidly over the heaps of ruins, and found another four-sided altar which was resting on the ground without a plinth but with a base made from a gullet, a fillet, and then a torus. Beyond this it was flat. Upon this smooth part rested a plinth or slab which made a wave from corner to corner, gradually curving inwards by a quarter of its square figure. The projection of its corners did not exceed the limit of the torque or torus beneath. On this abacus-like plinth rested the circular base of a vase, whose circumference did not extend beyond the angles of the plinth. This vase swelled as much at its mouth as it did at the bottom, where its throat rested on the base.

Its mouth or lip was as thick as its wall, and turned down upon it-self. On the altar I saw this epigram:

Leaving this, I found a noble fragment of finest porphyry carv-ed with two horse skulls, from each of which iss-ued a ribbon tied across two branches of myrtle and hanging down. The crossing-point was knot-ted with a wavy binding, admirably made. Between the two skulls, above the myrtle fronds, I saw this inscription in beautiful Ionic capital letters. The rest of the inscription was destroyed along with the stone.

INFER·D· DEAB· Q·:
C.VIBIVS ADVLESCENS
INTEMPERATO AMORE
PERCITVS PVTILLIAE
SEX.P VELLAE GR·A
TISS.QVOD ALTERI VL
TRO TRADIT NON SV
STINENSCR VENTO GLA
DIO SIBIMET MORTEM
CONSCIVIT VIX.ANN·
XIX. M.II.D.IX.HORAS
SCIT NEMO.

TIMOKOYPHI
LAPKIA
APTEMEIΣ

ΛΟΝΙΧΟ

Greatly excited by the loveli‑ [96']
ness of so many monuments, I
was searching around and
found a rather perplexing ep‑
igram in white marble. Only
the inscribed part of a little altar
remained, while the rest lay
shattered on the ground.

Admiring these beautiful frag‑
ments with much delight and
pleasure, I was still avid to search out
new finds. I roamed like some animal
always seeking better pasture over the
heaps of ruins and the huge columns,
some in pieces, others whole.
Wishing to know their type, I mea‑
sured one that was lying on the
ground and found that its shaft, from
the socle to the thin end, was seven
times the diameter of its bottom.
Nearby I found a very ancient sepul‑
chre without any inscription, inside
which I could see through a crack
only the petrified funeral garments
and shoes. I guessed that this effect
was due to the sarcophagous stone
from the Troad in Asia, and won‑
dered if it were the body of Darius.

D. M.
LYNDIATHA
SIVS PVELLA
PVER HIC SVM
SINE VIVERE
NOLVI MORI
MALVI
ATSINORIS
SATEST
✷VALE✷

Close by, I saw among the woodland shrubs a noble tomb of
porphyry, exquisitely sculpted, which offered me an elegant epitaph
to read. It had a lid in the form of a splendid temple roofed with
tiles, one part remaining above the chamber and the other
lying broken inside it, and it bore this important
inscription:

260

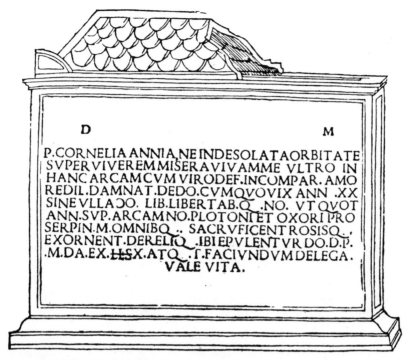

D **M**

P.CORNELIA ANNIA NE INDESOLATA ORBITATE
SVPER VIVEREM MISERA VIVAMME VLTRO IN
HANC ARCAM CVM VIRO DEF.INCOMPAR. AMO
REDIL.DAMNAT.DEDO.CVM QVO VIX ANN .XX
SINE VLLA OO. LIB.LIBERT AB.Q .NO. VT QVOT
ANN.SVP.ARCAM NO.PLOTONI ET OXORI PRO
SERPIN.M.OMNIBQ .. SACR VFICENT ROSISQ .
EXORNENT.DERELIQ .IBI EPVLENT VR DO.D.P.
.M.DA.EX.HSX.ATQ .I.FACIVNDVM DELEGA.
VALE VITA.

I left this. Next, beneath a wandering and fruited ivy that was hanging, dense-leaved, down a pitted wall, there stood an attractive chest-tomb of a stone resembling ivory, most of it still smooth and bright. I looked curiously into it through a crack or chink in the flat lid and saw two corpses entirely preserved, from which I guessed immedi-ately that this sepulchre must have been made of chernites stone. On its face I saw these Egyptian hieroglyphs incised; and inside there were also many glass bottles, pottery vessels and some statuettes in the ancient Egyptian style. From the top of the cover there hung an elaborate antique metal lantern, suspended by a woven chain and still burning. Near the heads of the deceased were two coronets. I judged that these things were of gold, but dark-ened by time and by the smoke of the lamp. This was how I interpreted them:

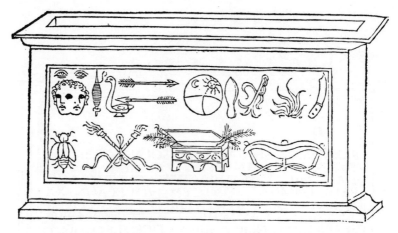

TO THE BLESSED SHADES. DEATH SPURNS ALL
LIFE'S CONTRARY AND RAPID THINGS. IT GIVES, IT
TAKES, IT CONSUMES, IT DISSOLVES. HERE IT HAS
SWEETLY UNITED TWO DEAD ONES WHO LOVED
MUTUALLY, STRICTLY, AND ARDENTLY.

Rejoicing with incredible happiness at such a variety of antiquities
and magnificent works, my soul again felt the insatiable desire to
wander on and investigate fresh novelties. But if at first I had been
moved to tears by that Greek epitaph of the two miserable lovers who
died of hunger, how much more was I moved when presented with a
magnificent but tragic monument of two other unhappy lovers, carved
on a great standing stone adorned with these lineaments: it was a square
extended to the height of its diagonal, containing two small pil-
asters with a small corona and a quarter-circle arc above
them. Between them, a tablet hung from the angles
of the arc, on which I read this
miserable epi-
gram.

262

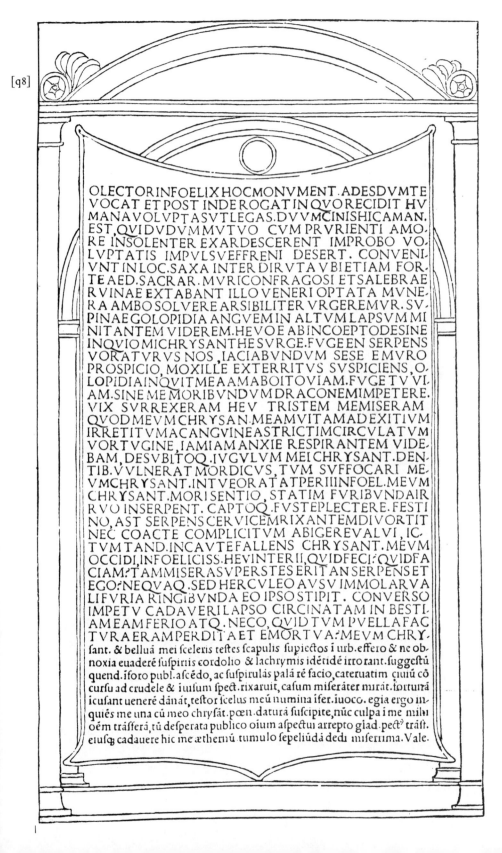

OLECTOR INFOELIX HOCMONVMENT. ADESDVMTE
VOCAT ET POST INDEROGAT IN QVO RECIDIT HV
MANA VOLVPTAS VT LEGAS. DVVM CINISHIC AMAN.
EST, QVID VDVM MVTVO CVM PRVRIENTI AMO-
RE INSOLENTER EXARDESCERENT IMPROBO VO-
LVPTATIS IMPVLSVEFFRENI DESERT. CONVENI-
VNT IN LOC. SAXA INTER DIRVTA VBI ETIAM FOR-
TE AED. SACRAR. MVRICONFRAGOSI ETSALEBRAE
RVINAE EXTABANT ILLO VENERI OPTATA MVNE-
RA AMBO SOLVERE ARSIBILITER VRGEREMVR. SV-
PINAE GOLOPIDIA ANGVEM IN ALTVM LAPSVM MI
NITANTEM VIDEREM. HEVO E AB INCOEPTO DESINE
IN QVIO MICHRYSANTHE SVRGE. FVGE EN SERPENS
VORATVRVS NOS, IACIABVNDVM SESE EMVRO
PROSPICIO, MOXILLE EXTERRITVS SVSPICIENS, O-
LOPIDIA IN QVIT ME AAMA BOITO VIAM. FVGE TV VI-
AM. SINE ME MORIBVNDVM DRACONEM IMPETERE.
VIX SVRREXERAM HEV TRISTEM MEMISERAM
QVOD MEVM CHRYSAN. MEAMVITAMAD EXITIVM
IRRETITVMAC ANGVINEASTRICTIM CIRCVLATVM
VORTVGINE, IAMIAM ANXIE RESPIRANTEM VIDE-
BAM, DESVBITOQ. IVGVLVM MEI CHRYSANT. DEN-
TIB. VVLNERAT MORDICVS, TVM SVFFOCARI ME-
VM CHRYSANT. INTVEOR AT PERII INFOEL. MEVM
CHRYSANT. MORI SENTIO, STATIM FVRIBVNDA IR
RVO INSERPENT. CAPTOQ. FVSTEPLECTERE. FESTI
NO, AST SERPENS CERVICEM RIXANTEM DIVORTIT
NEC COACTE COMPLICITVM ABIGERE VALVI, IC-
TVM TAND. INCAVTEFALLENS CHRYSANT. MEVM
OCCIDI, INFOELICISS. HEV INTER II, QVID FECI? QVID FA
CIAM? TAM MISERA SVPERSTES ERIT AN SERPENS ET
EGO? NEQVAQ. SED HERCVLEO AVSV IMMOLARVA
LIFVRIA RINGIBVNDA EO IPSO STIPIT. CONVERSO
IMPETV CADAVERI LAPSO CIRCINATAM IN BESTI-
AM EAM FERIO ATQ. NECO, QVID TVM PVELLA FAC
TVRA ERAM PERDITA ET EMORTVA? MEVM CHRY-
sant. & belluä mei sceleris testes scapulis supiectos i urb. effero & ne ob-
noxia euaderè suspiris cordolio & lachrymis idétidé irrorant. suggestü
quend. iforo publ. ascédo, ac suspirulás palá ré facio, cateruatim ciuiú cõ
cursu ad crudele & iuisum spect. rixaruit, casum miseráter mirát. iorturrä
icusant uenerè dánát, testor scelus meú numina iser. iuoco. egia ergo in-
quiés me una cú meo chrysát. pœn. daturá suscipite, núc culpa i me mihi
oém trásserá, tú desperata publico oium aspectui arrepto giad. pect⁹ trást.
eiusq̃ cadauere hic me æthernú tumulo sepeliúdá dedi miserrima. Vale.

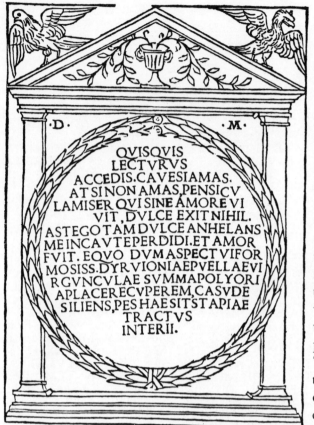

After reading in this excellent epigram the sympathetic story of the unfortunate lovers, I left well con-tented. I had not taken many steps when I came upon a noble tablet of marble, rec-tangular and with some-what of a pediment. There were two small columns, one on each side, freely and expeditely drawn, and nearly all the rectangular area was carefully carved out to make a leafy crown or wreath, inside which I read this inscription. The stone lay cast on the ground, but with the worked surface uppermost. The variety of these elegant works afforded no small pleasure to my soul.

I was feeling ever more enthused by the investigation of these pre-cious antiquarian objects when I met with a ruined tribune that still retained its right-hand wall. Here I saw with excessive pleasure a tomb of porphyry of the very best design and workmanship in its sculptural art. On either side near the edges, two small squared columns protruded by a third of their width. They had straight flutings and stood on a footing joined to the base. Perpendicularly beneath was a pedestal with three elegant nymphs in mourning, turning toward the centre and weeping together, and the other side was similar, carved half out of the

264

solid. An ornate epistyle lacking none of the proper and requisite linea-
ments extended above the two capitals, and above it was placed the
[11] zophorus, decorated with lovely convoluted leaves and flowers and
topped by a seemly corona.

Between the two square pilasters, a throne or niche with regular flut-
ings stood forth somewhat from the surface. On both sides of its
opening small pilasters protruded, each with capital and base, and an
arched beam sprang from them. They protruded from the level or plane
surface by as much as remained in the interior part, that is, a tongue's
width beyond the mouth of the niche. At the level of their capitals was
a curved moulding around the niche, and above it the half-dome.

These small pilasters were excellently ornamented with carving.
There was a projecting pedestal beneath each one, ornamented in the
same way as the small pilaster standing above it, and between these two
projecting pedestals or sub-columns I saw a Greek inscription, by
which I knew that this was the monument of the pious Queen of
Caria. It said: ΑΡΤΕΜΙΣΙΔΟΣ ΒΑΣΙΛΙΔΟΣ ΣΠΟΔΟΝ. The
whole was well bound and united with socles, coronas, cymas and
gullets.

On the inside floor of the niche was a plinth of the same material,
beautifully ornamented with carving, on whose surface were fixed four
equally-spaced lion's paws of gilded mental supporting an antique
chest with lineaments of remarkable design. On its lid was a stool,
whose covering was an imitation of cloth woven of silk and fringed
around.

Sitting on this was a matronly queen with royal trappings and a
majestic cloak pinned at the breast over a silken dress. A ribbon passed
from her collar down over the breast and transversely around the belt,
swelling over the belly in the form of a quatrefoil, that is, a figure of four
semicircles. This was inscribed in Greek capital letters: ΜΑΥΣΩΛ-
ΕΙΟΝ ΑΤΙΜΗΤΟΝ

With her right hand she held a chalice to her mouth as though
drinking, and in her left hand a rod or sceptre. Her profuse hair was
ringed upon her head by an indented crown, then by another coronet
with points, and was combed gracefully down from her neck.

Above the keystone of the arched beam there rose a flat, oval figure
reaching to where the cyma of the cornice projected, on which I saw a
face of regal majesty, crowned and with a full beard and curled hair: I
thought that it was the true image of the queen's husband. It was held

on either side by two nude, winged spirits, sitting on the outside circum⁄ference of the archivolt.

They had one arm outstretched, and held in their free hands a brass cord drooping in a curve, with some round beads threaded on it, and also in the same hand a perpendicular string of branches and berries, all well gilded. [11']

On top of the cornice there rose a much⁄ornamented plinth that sloped slightly. On top of that, in the front and centre, a circle of metal rested, enclosing a deep black stone like a mirror, in which I could see written in Greek capital letters: ΕΡΩΤΟΣ ΚΑΤΟΠΤΡΟΝ. The sur⁄rounding metal frame was a palm's breadth all round and beautifully decorated with bosses. On its uppermost edge there stood upright a perfect nude statue of gilded metallic material, holding a small spear in its right hand and an antique shield in the other, carved with excellent lineaments. Flanking this circle, one on each side, two winged boys sat on the plinth with their backs against the mirror, each holding a lighted torch toward the side.

Similarly, sitting on top of the cornice with their backs against the sides of the plinth were two nude, winged infants, holding in their visible hands a small fruit, with the other arm around an ancient brass candelabrum of bright gilded bronze, in the form of a vase with dolphin handles. These handles consisted of a pair of dolphins placed upright, with their mouths on a fillet and their tails attached to the body of the vase, which tapered up to its shell⁄like mouth, with two more fillets toward the opening. Regularly spaced around the latter were four sharp points fixed on the lip, and another one in the middle, taller than the rest. The feet of the vases were between the infants' shins. This whole cast sculpture rested on a square block of serpentine rising from the pavement, free of lineaments except for a carving in the middle, where I saw a maritime or naval trophy that I thought to be the monu⁄ment of the victory achieved over the Rhodian fleet. There was a rostrum, or part of the beaked prow of an ancient ship, in the middle of which stood a tree⁄trunk whose branches were hung with a military cuirass. Out of the arm⁄holes came two truncated branches, from one of which a shield hung by its handle, and from the other a naval article. Beneath the cuirass, across the trunk, hung an anchor and a rudder, and on the top of the trunk, which came out of the collar, was placed a beautiful crested helmet. One would not believe how all these objects, though asymmetrical, were depicted exquisitely, with great skill and all

ΕΡΟΤΟΣ
ΚΑΤΟΠ
ΤΡΟΝ

ΑΡΤΕΜΙΣΙ
ΔΟΣ
ΒΑΣΙΛΙΔΟΣ
ΣΡΟΔΟΝ

the proper lineaments, finely finished, worthy to be seen and never to be forgotten. Its measurements had been perfectly drawn up by one who understood the sequialter proportion. I suspected that it had been exe-cuted by one of the sculptors of the Mausoleum.

It is not easy for me to express the glee with which I examined [r2']
minutely such memorable and venerable works; my mind was ever
more stimulated by discovering new things. Scarcely had my eyes left
this supremely magnificent sepulchre than, carefully surveying
the jumbled heaps of ruins,I found another elegant stone.
On this one, I admired the incredibly finished carv-
ing of two nude boys drawing back a pair
of curtains, one on either side, and re-
vealing two beautiful heads, one
of a youth, the other of a young
maiden, with a sad tale
as their epitaph, writ-
ten thus in perfect
lettering:

*

* *

*

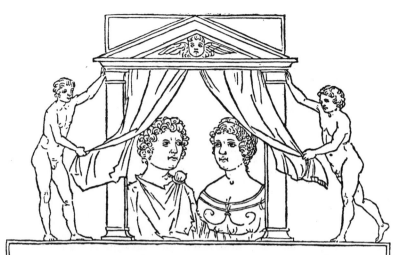

ASPICE VIATOR.Q.SERTVLLII ET DVLCICV
LAE SPON.MEAE.ᗡ.RANCILIAE VIRG.SIMVL
AC.POST INDE QVID FACIAT LICENTIOSA
SORS LEGITO.IN IPSA FLORIDA AETAT.CVM
ACRIOR VIS AMORIS INGRVER. MVTVO CA
PT.TAND.SOCERO.E.ET.M.SOCR.ANNVEN
TIB.SOLENNI HYMEN.NVPT.COPVLAMVR.
SED O FATVM INFOEL.NOCTE PRI.CVM IM
PORT.VOLVPTATIS EX.L.FAC.EXTINGVERE
ET.D.M.V.VOTA COGEREMVR REDD.HEV IP
SO INACTV DOM.MARITALIS CORRVENS AM
BIAM EXTRE.CVM DVLCITVDINE LAETISS.
COMPLICATOS OBPRESSIT.FVNESTAS SO
ROR.NEC NOVI QVID FECISS.PVTA. NON E.
RAT IN FATIS TVM NOSTRA LONGIOR HO.
RA.CARI PARENTES LVCTV NEC LACHRYMIS
MISERA A CLARVATA NOSTRA DEFLEATIS
FVNER A NE REDDATIS INFOELICIORA
AT VOS NOSTROS DIVTVR
NIORES VIVITE ANNOS
OPTIME LECTOR
AC VIVE TVOS.

269

I was moved to sighs by reading this unhappy tale. Not far away I found another impressive and noble monument with two fluted columns, one on either side, carved in the half-round from the solid stone of whitest marble, with bases, capitals, beam, zophorus, cornice, and pediment. Inside the triangle formed by the latter, two white doves were drinking together from a small vase. In the space between the fluted columns was an arched soffit carved in low relief, with voided cofferings equally distributed, each one occupied by a cinquefoil drawn in perspective, the design diminishing as it stretched into the distance. Beneath this an artistic coffer projected somewhat, with two little door-ways. Nude figures were going in at one of them, and nude children coming out of the other. By the inscriptions contained in the cen-tral part, I conjectured it to mean that this world is a coffer with two portals: one enters it to die, and comes out of it to be born, weeping in both cases. The coffer stood on two harpy's feet that turned into foliage, and one unornamented foot in the middle. Be-neath the band of the shallow vault I admired this epitaph describing an impious and desperate case; and I saw these characters in the remaining part:

✳

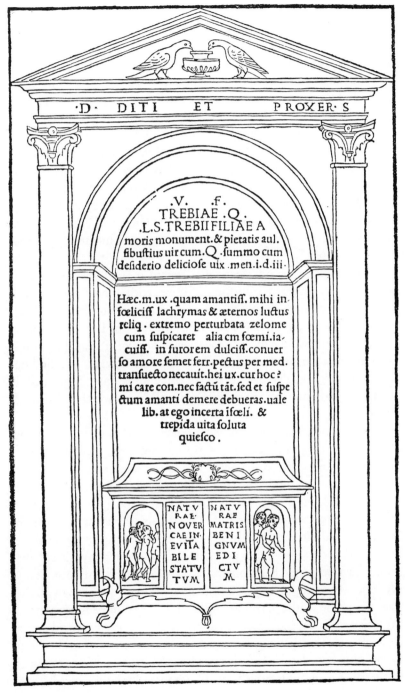

·D· DITI ET PROXER·S

.V. .f.
TREBIAE .Q.
.L.S.TREBII FILIAE A
moris monument.& pietatis aul.
fibuſtius uir cum.Q.ſummo cum
deſiderio delicioſe uix .men.i.d.iii·

Hæc.m.ux .quam amantiſſ. mihi in
fœliciſſ lachrymas & æternos luctus
reliq. extremo perturbata zelome
cum ſuſpicaret alia cm ſœmi.ia⸗
cuiſſ. in furorem dulciſſ.conuer
ſo amore ſemet ſerr.pectus per med.
tranſuecto necauit.hei ux.cur hoc?
mi care con.nec factú tát.ſed et ſuſpe
ctum amanti demere debueras.uale
lib. at ego incerta iſœli. &
trepida uita ſoluta
quieſco .

NATV
RAE
N OVER
CAE IN
EVITA
BILE
STATV
TVM

NATV
RAE
MATRIS
BENI
GNVM
EDI
CTV
M

271

Leaving this with joy and gratification, and burning with the
inquisitive desire to see more, I hurried toward a half-standing tribune
where I admired some other exquisite remains of a mosaic picture made
in vermiculate work. I could find no tomb in this place, but the glass
fragments of the picture showed with perfect clarity Proserpina with
Cyane and the Sirens, plucking flowers on burning Mount Etna. Pluto
had unlocked the fire-laden crater of the flame-breathing mountain and
was snatching her voluptuously for his love, while Cyane was weeping
in sympathy for being unable to help her. Here I found scattered the
huge stones of a decaying and gaping wall, with astercum and pellitory
growing in the cracks. The great root of an aged wild fig-tree had
gripped and demolished the wall just as if a wedge had been inserted in
it, and its other roots, springing up everywhere like serpents, had
destroyed the tessellation and forced the joints apart, making great gaps
in the enclosure.

Hence I could see only part of a stream into which a vestige of
human body appeared transmuted, done with incredible art and
admirably expressed, so that the like was not found in the Temple of
Minerva on the Capitol, in the picture of the Rape of Proserpine made
by Nicomachus. While my mind was pleasantly concentrated on this, I
suddenly heard behind me the falling of some tesserae, and finding
myself solitary, in a deserted and silent place, I was quite frightened. I
quickly turned round and saw a gecko or wall-lizard which had caused
this accident.

I was not a little annoyed at being unable to admire the work in its
entirety, for the greater part of it was demolished, broken up and
damaged by being left in the open. But as I thought about the violent
manner in which Proserpina had been rapidly abducted, a sudden dire
thought struck me cruelly in my loving heart, and I said: 'Alas, you
imprudent and unhappy wretch! Oh, how importunate is my research
and unbridled curiosity about things of the past, my quest for these
broken stones that I have been pondering, if by so doing my fairest Polia
should have been snatched from me, and I should have lost through my
carelessness a thing more precious than anything here, or than all the
treasures in the world!' And instantly a blow even more bitter pierced
my dejected heart, like a strong, sharp shock, as my confused mind
remembered the tragic and lamentable case in which the fugitive from
his burning homeland carelessly lost his dear Creusa. The onslaught of
this terrible memory troubled me all the more because I had left my

beloved Polia solitary and far out of my reach, sitting alone on the sandy
[r5] shore, so that trident-bearing Neptune might have done her violence, as
he did to Medusa. Alas, at this point I certainly felt what affliction of
the spirit is, and the quality of true lovers! I found myself far more
tremulous, terrified and stupefied, and in greater fear and more
wretched trepidation than when I saw myself about to suffer the final
ruin of being swallowed and digested by the dreadful, gaping jaws of
the venomous dragon. I was in such terror as I imagine the priest to have
been when the image vanished from the Pelenean temple. All peace had
fled from my soul, and at every moment the dolorous fear increased in
my fluttering heart.

Driven by these seething cares and urgent worries, I lost no time but
ran like the wind, abandoning this noble and distinguished quest, this
praiseworthy peregrination and learned recreation. I hurried through
the tangled and dangerous clumps and sharp bushes, through the rough
place crammed with rocks and thorns, through the fallen marbles and
the formless heaps of broken fragments, awkward pointed stones, sting-
ing-nettles and pathless ruins, speeding on my frenzied way through
rough paths and countless obstacles, not caring that my long robe was
torn here and there by being caught on spiny leaves, filled with burrs,
thistledown and seeds, goat's-beard and sow-thistle, and stuck every-
where with the grasping seeds of hound's-tongue. I firmly believed that
I had come to my last misery and fearful end, to the final and fatal depri-
vation of my hopes. When I reached my sweet and lovely Polia, I was
no longer alive but half dead, panting like an asthmatic or as if I had
breathed the heavy odour of the Babylonian gulf, with my eyes
bedewed with tears, and dashing up to her in a spasm of incredible pain
and anguish.

And she, her soft heart touched, with brow serene and kindly
expression, calmed this pale and afflicted being: she pitied the racing
pulse in my sickened breast, the bloodless pallor trembling in misery,
with loving kindness if not with astonishment. She took me gaily into
her sweet embrace, and with her natural tenderness wiped the abundant
sweat from my face with a delicate yellow kerchief. Lightly stroking me
with loving care, she carefully and tenderly dried it. She was eager to
know the cause of such bitter and turbulent anguish, and softly sooth-
[r5'] ing me she comforted me with fitting and persuasive words and calming
eloquence, speaking so as best to bring me back to myself, and fit to
resuscitate a body deprived of its formative principle. As I revived

somewhat and felt the prostrate forces stirring a little within me as I lay on her blessed bosom, I surrendered all my dread, and told her with sighs and groans of the cause of my fears; while she smiled pleasantly and lovingly kissed me with ready reassurances, saying in well-chosen and soothing words that she was now expecting the holy God of Love, Cupid, and exhorting me with tender persuasion to be patient and await my pleasure, since suffering is often the cause of noble results.

As my fair Polia consoled me, I felt my half-departed life returning to me, so long as I stayed close by her; my complexion, pale as boxwood, regained its colour, and the terror that had filled me dissolved into a feeling of great magnanimity. But next to my divine Polia I looked like an ash-coloured cadaver or a dusty, rotting corpse, scarcely yet restored to the company of the living. Still my eyes kept returning, as ever, to seek their comfort and peculiar nourishment, and to fix them-selves on her.

Suddenly the admirable Polia arose from her pleasant seat beneath the shady fronds, with courtly gestures and modest movements, with a face joyous as the heavens, with her native manners, adorned with a beauty worthy of eternal contemplation and reverence, with her talents, her form, her distinguished modesty, her quick but composed mind, and all the rest. With reverent forbearance and appropriate devotion, and without any other movement, she knelt with pious reverence, her face blushing more scarlet than red Claudian apples.

I did not know the cause of this action because I had not seen it, my eyes being constantly and sedulously occupied by the contemplation of her immense beauty. I could not tear them away nor bestir them, nor allow them to fall, and so I did as she did, quickly dropping to my knees on the ground by her side.

And behold! Without my noticing it, the divine Cupid had appeared before us in the form of a lovely child, his beautiful naked body uncovered, sailing in a swift boat with his eyes unveiled toward the whispering shore where we had sat waiting for him. And as the bow reached the ancient pier, worn away by jealous age, my eyes could in no wise bear to gaze on the celestial form unless I pressed my eyelids together, so disproportionate to my vision was the splendour that radi-ated from this divine and childlike face. I began to think that I myself was no longer among mortals but must truly be among the divine heroes, seeing that it is unusual and rare for a heavenly, spiritual and formless body to show itself to the material eyes. Thus my soul beheld

[r6]

274

with utter astonishment this head with its golden curls and finest hairs, these two great luminous eyes, awe-inspiring in their lordly majesty, whose light not only disturbed but mortified my feeble perception. Also the chubby round cheeks, suffused with crimson roses, were, like all the other parts, so beautiful that I reckoned that one had reached the height of felicity by merely knowing them, not depicting them. Moreover, being a flying god he had two wings attached to his sacred shoulders with feathers of gold, sparkling with rose, peacock hues, bright blue and the colour of mallows.

My generous mistress Polia and I remained kneeling until the winged god began to speak. I guessed that he was admiring the wonderful rarity of Polia's beauty and was astonished by the greatness of her virtues and beauties. It seemed likely, I thought, that he was comparing her in his mind with his beautiful Psyche, and, not without concupiscence, was finding her more lovely, more distinguished, and more eminently perfect. And then, with a language of heavenly inspiration and a voice fit to restore every dissolute thing, to easily wake the sleeping corpses out of the humid earth, to bring them forth from the eternal sepulchres and even out of their first matter — a voice that could restrain the passion of insatiable Vulcan, calm the turbid tumult of the dreadful waves, the unquiet swelling of the intemperate sea, silence the groaning shores, quiet the frothy and eroded cliffs, and arouse every chaste being to holy Venus and to her pleasant servitude, thus he spoke these winning words:

'Nymph Polia, and you Poliphilo, as keen followers of the amorous rites and the stainless cult of our venerable Mother, you have been intrepid devotees of my flaming fires. Your pure accomplishment of sacrifices and your zealous mediations, your devout prayers, dedicated service and chaste vows have reached her divine presence, and thus your ardent desires have deservedly attained the goal that you have pursued in your prayers. Come then with your inseparable companion into the sure protection of my boat, for none can make the crossing to my Mother's realm, to that destined isle, unless I transport him as his own captain and fare.' And with this divine discourse he gaily invited her to embark.

Without hesitation Polia quickly seized my hand and rose silently but promptly, with elegant energy, profound reverence and polite curtsies, then she and I leapt on to the fateful boat. She settled comfortably in the bow, and I, without delay, at her side. The divine nymphs, rowing as expertly as with a single hand, pulled away from the eroded shore.

[r6']

The little ship was a hexireme, that is, a boat that is not woven but rigid, with a complement of six oars. It was wonderfully caulked on the outside, neither with boiled pitch nor with pitch mixed with wax, but with a precious liquid composed of almond-benzoin, ladanum, musk, amber, civet and both kinds of storax, in carefully measured quantities. This precious mixture had been spread all over the vessel, which was excellently crafted of fragrant white and yellow sandalwood and a heavy and solid wood, rubbed with a marvellous and unheard-of perfume and joined with golden nails whose knobs or bud-shaped heads shone with precious gems, inset with wonderful skill. The deck and cross-benches were of sanguine sandalwood. They made the heart rejoice exceedingly.

This admirable and extraordinary vessel was expertly rowed by six very capable and masterful girls. The oars, including their blades, were of shining snowy ivory, not like a white radish but naturally glossy. The rowlocks were of gold, and the ties of many-coloured twisted silk. These maidens were luxuriantly dressed in transparent material that waved and wafted in the brisk and gentle breezes. Girdled against the wind, it danced and revealed with voluptuous ostentation that the members to which it clung were in the flower of their youth. Some had their heads adorned with a tangle of abundant, pale blond hair, while others bore copious glossy locks blacker than Indian ebony. How lovely it was to see the contrast of these two extremes! The flesh of their faces, shoulders and breasts was perfectly white, and generously encircled with their black hair arranged in curls and tresses and lasciviously bound with silver threads, knotted and netted so as to be more pleasant and grateful to the senses than any voluptuous vision, and apt to draw one away from any other sight. They wore massed orient pearls around their necks, surpassing the one that Julius bought for his dear Servilia. [17] Some also had attractive wreaths of roses and other flowers wound into the curly hair whose ringlets shaded their bright foreheads. Around their straight and milk-white throats they wore sumptuous necklaces of conical gemstones in various matching colours. Moreover, they were tightly belted crosswise close below their firm little breasts, which presented an obstinate obstacle to their blouses; for although imprisoned, at the slightest nudge they returned briskly to their places. The collars of these blouses had an ornate embroidery in gold, woven with great skill from fine threads and circlets of regular, round pearls; and evenly spaced around the hem there sparkled precious gems.

276

I cannot properly describe everything that I was kindly permitted to participate in by watching. As I turned my mind carefully over all these things, I was filled with amorous thoughts, and rehearsing them in my memory, I felt a sweet enjoyment in my soul, obtaining a sensuous pleasure from the image of such beauty. Now two of these maidens, Aselgia and Neolea, were lasciviously arrayed and preciously adorned in Attalic style, with damask material whose warp was of gold, its woof of blue silk. King Attala could have found nothing like that in Asia. Two others, Chlidonia and Olvolia, had luxurious Babylonian garments of a precious sea-green material with a variegated weave. The last pair, Adea and Cypria, were dressed in a splendid honey colour, with a loose and intricate weave pierced by numerous tiny slashes, with gold leaves placed underneath at the outer fringes. Where the arms joined, there was a sideways opening in the garment from which issued the naked ivory arms, showing as white as curdled milk, with all the requisite ornaments and nymphal accessories. The fresh and wanton breeze revealed, according to its motions, now the form of the rounded, firm and chaste belly and the pretty pubis, now the plump hips, and now the tremulous buttocks. Then it revealed the shoes on their long, slender feet, tightly laced with little horn closures. These were exquisitely crafted of blue, green and red silk, with a moon-shaped opening above the instep, minutely bordered and neatly latched with golden hooks and eyes. Some had gilded sandals or slippers with silken laces tipped with [17'] gold and threaded alternately around flat, round golden buttons; and there were many other ornaments of lascivious and virginal ingenuity, invented to gladden the senses with elaborate pleasure. All these rare things presented themselves at our amorous mystery with such grace and beauty that they were like fat to the burning flame, sulphurous matter to Vulcan, the vigilant guarding of the Tartarean abyss to thrice-throated Cerberus, or mortal terror to Megera and her sisters; like burgeoning youth to amorous Cupid, and comfortable retreats to his Mother.

When the sandy shore was left behind, these divine sailor-nymphs neatly shipped their ivory oars on the gunwale running beneath the rowlocks, and with majestic reverence they all turned their beautiful faces toward the naked lord standing on the prow, and their white shoulders to us. Polia spoke to clarify what was in my own mind, saying: 'My Poliphilo, beloved above and beyond all things, I wish you to know and understand that these six noble young virgins are the lord's loyal attendants, ministering readily to his pleasant service.'

When these consoling, fair and noble nymphs were sitting down two by two on the sandalwood benches, turning their faces to the divine lord and their delicate backs to us, the divine helmsman unfolded and spread his light wings, then summoned gentle and sweet-breathed Zephyrus and offered his sacred pinions to the wind. They flashed brighter than burning coals glowing in bright torches, and as their feathers filled with the flower-scented air, we began to leave the muttering shores and to sail upon the deep and spacious sea, dead calm and tranquil. Being in a state of great and awed veneration and singular sweetness and gladness, my amorous and stubborn heart pressed on me, and trembling I conversed with my own genius, wondering if there could ever be a heart so inhuman, or one so hard, so violent and rebellious – a heart as rough as the scales of a chimaera's paw –that these beautiful events, desirable presences and divine objects would not quickly convert it to kindliness, tenderness, softness, weakness and passivity?

And what imprisoned and extinguished desire, what glacial and depraved appetite would not have had its strong locks and painful bars vigorously shattered here, completely restoring it by these pleasant, beautiful and amorous sights? Would it not have turned to a flaming Etna? Would Diana have spurned such benign fires, fit to seduce chaste [18] Hippolytus and to turn modest Orithia to lust! But how much more could they be felt by those who were altogether ready, near at hand, and disposed toward them! I felt like the little fish that is born in boiling water: when it is taken out and put into other waters to boil, it never cooks. Moreover, I admired to stupefaction this little divine spirit and the way that his golden wings, on which fluttered some tender and delicate down like that of a bird that has not yet flown its nest, flapped against the dew-bearing winds. How beautiful and charming to the senses were these little wings of gold and red! Some feathers were blazing with that gold and red colour, while others were glaucous, bright emerald, mauve, light blue, and yellower than the oriole, which went together wonderfully with the gold and made a harmonious design all over the divine wings.

I might well have thought that all fertile nature's jewels had been spread out to flash on these wings, because some thin mobile flakes of pure gold were radiating as though suspended in the air when the wind blew in the bright sunshine. The water, too, was gracefully tinged with these delightful colours, which were then broken up by the unstable and curling wavelets to form a great circle. I also admired the incomparable

beauty of the divine compound that was Polia, who appeared more delicious and charming by the hour. I admired the pure, serene air, the temperate and placid climate, and the blue salt water through which I could see right to the bottom, as through a clear crystal. Here and there were many wooded cliffs and scattered islands decked with spring greenery, thick with green leafy bushes and pleasant shade. Many lovely places were lost to sight in the distance, appearing like smears on the even surface of the waves. Similarly, there were leafy trees casting their shadows on the sea-shores, and their green reflections looked as clear as the originals in the bright mirroring water.

Thus we proceeded on our delightful and triumphant voyage, under the empire and divine monarchy of all-powerful Amor. Here dwelt that lord whose extreme sweetness is austere, and whose austerity is so sweet; whose pleasure is so painful, and whose pain turns out to be so pleasurable. Happy are they who sail beneath his prosperous and favourable wings! Thus I found myself as though under two welcome rulers, one inflaming and the other consuming me. Now the sea-gods [r8'] arrived. Nereus, with lovely Chloris and their children Ino and Melicerta, came dashing in their chariots over the foamless waves to worship the divine child. Then wave-born Melantho or Poseidon with his shaggy azure beard and his sharp trident, drawn by great seals; and the blue Tritons, trumpeting with their sonorous shells whose bellow-ing clangour resounded through the aether. Then came a troop of Dircaean nymphs, and the Nereids mounted on speedy and out-stretched dolphins, those followers of the North Wind, carriers of Arion, who favour the name 'Snub-nose.' And there were whales, and the monstrous Cephiso.

Now ancient Father Ocean came, and presented in order his wife Tethys and their children Erate, Ephyre, Phillyra, Hippo and Prymno; and the daughters of Nereus, with mournful Aesacus, sad-voiced and clothed in dark and dirty coal-coloured garments on account of his beloved Epiriphe, who was bitten by a poisonous snake. Alcyone hurried up on the wing, lamenting his dear, awaited Ceyx. There was Proteus, drawn by hippocamps, and Glaucus the fisherman with his lover Scylla, and the other fishlike monsters with many sea-horses and mermen. They dived into the tide with an astonishing slap, creating a wash as they broke the turbulent white water and submerged, then they burst out again in their monstrous fishy forms, and made due reverence and solemn homage with tremendous cries to the elect voyagers. Next

there came a flock of shore-birds and white swans, some swimming and others flying in the air, to add the charming concert of their high voices. All gave praise and glory as subjects of the omnipotent gods, paying grateful and abundant homage, making a joyful noise as they moved nimbly in the water, breathing through their gills, dancing and leaping with their fins and flippers and whistling with a wondrous din. I was delighted beyond measure by such a variety of sea-gods, nymphs and monsters as I had never seen before, capering so earnestly and showing such honour to the divine child. I stood amazed, feeling as though I were enjoying a Roman triumph, no less; and seeing myself receiving such favour, by the grace of the gods, I deemed myself happier than lucky Polycrates.

My heart was now resting in a comforting heat, filled to the brim with pleasure and delight. In addition to all these memorable spectacles, being close to my dear and divine Polia I smelt a refreshing fragrance, redolent of the greatest purity and luxury. Falling into a deep reverie, I said to the genius within me: 'See, this very day I have victoriously [51] obtained that which I ardently desired. I see it plainly, and hold in my embrace that saving power which I yearned for so long. My delight and voluptuous reward are no less than those which shining Cynthia enjoyed with her beloved Endymion, when she left the supernal realms and searched over the shallow waters by the flaking cliffs for his light, unstable fishing-boat. Paris could glory no more in his litigious judg-ment, nor in his elopement with Leda's daughter when Auster's breath swelled his sails. Nor could Jason with the malefic and deceived Medea, nor Theseus abducting Minos's daughter, nor the Roman captain with the ambitious Egyptian woman. The daughters of tall Atlas could not have prided themselves so much when their ancestor supported the starry heaven on his strong shoulders; nor the painter Apelles over the amorous gift that Alexander the Great made to him; nor is the harvest as welcome to yellow Ceres as it is for me to have my divine Polia by my side. Her beauty would make tardy Saturn hasten, or arrest hasty Phoebus; it would still the caduceus-bearing Cyllenian, inflame frigid Diana, and make even the gods serve it.'

As we sailed on with the light and gentle pressure of the brisk breezes, I looked with curious, searching and shifting glances that I could not restrain, now at one and now at the other. But I was unable to discern any difference between the two of them except that of divinity. Thus strongly compelled by an unimaginable sweetness, my soul freely

abandoned itself to both of them: to the power of a little commander who was able to grant its amorous vows, and to the will of noble Polia, who in her goodness could also give her consent. I was bold and confident enough to believe that no other outcome than ardent love could transpire in such a majestic and venerable presence, and that now she could no longer escape from his triumphal boat, nor turn back. I was all the more hopeful for the fulfilment of my extreme desire because of the amorous hieroglyphs on the wind-filled sail of this glorious boat of divine and powerful Cupid. I exulted in being transported with such honour, basking and glorifying in being blessed with such excellent company and mutual love. It seemed to me that Apollo could not have gloried more in decorating his quiver and lyre with the laurel leaves, nor Policrates in the finding of his ring, nor Alexander the Great in the victories he won and the trophies he raised. I thought myself just as glorious, finding myself in such a triumph. Nevertheless, I was astonished at the incredible way that such an active and powerful fire could be engendered and contained in that divine little body: at this miraculous fire which kindled and inflamed the universe, penetrating the solid heavens and descending undiminished to the depths of the abyss, such that neither watery Tethys, nor old father Oceanus, nor trident-wielding Neptune could offer it any resistance. What is this fire, by which mortals, dying in utter sweetness, are nourished and enlivened? An even greater miracle put me into a stupor: how could it burn serenely and grow crimson roses among the snow-flakes of Polia's delicious bosom? I thought with emotion of how it also burned in those white lilies, full to overflowing with sweet and milky humour. I felt unable to analyze how it flamed up so violently in those brilliant roses blooming among the wintry frosts of numbing Capricorn. Nor did I know how the breath of Aeolus could kindle such a burning fire in the gay eyes of lovely Polia, with so much seductve power. Those leonine rays with which the Gaditanian fleet burned up King Theron's ships were no hotter than the rays with which those eyes penetrated my heart. I knew even less how Pyragmon and his fellows could had made themselves at home there with their thunderbolt factory! But one thing surpassed all the rest: my intelligence was absolutely incapable of fathoming by what virtue I had been exhausted, battered, mortified and utterly prostrated by so many unfair attacks and hailing blows; how my thunderstruck heart had been vanquished and taken captive, surrounded by hostile pleasures and held siege by burning yet pleasant flames, which alas,

[s1']

contrary to their nature, could not even burn up the thorn-bushes and the cruel, sharp thistles that were sticking into my heart – and all liber-ally sown there by the placid eyes of the faithful dispenser of mighty Cupid's sacred treasure. 'O sweet winged one,' (thus I said, turning to the god) 'how pleasantly you have nested in my soul!' Then, turning to the starry eyes of Polia: 'O charming and sweet executioners, how could you have made of my sad heart a quiver, filled full of arrows, to be hung and belted on the divine flanks of Love? Yet never have I found you more gracious and desirable, never wished for you with more ardour, incomparably more than long-eared Lucius, in his noxious pains and deadly fatigues, when he sought out the vermilion roses. You are more welcome and opportune to me than the grain-bearing ant which aided unhappy Psyche; than the swallow's warning, the eagle's help, or the painless prick of Cupid's arrow.' For all these reasons I could not retrieve my ardent soul from the delicate arms and voluptuous embrace of my fair-tressed Polia, in which my insatiable desires had firmly and et-ernally imprisoned and exiled it; and as we sailed, they divided and shared this per-petual prize with the high Lord. Meanwhile I felt intense pleas-ure and delight merely to have been invited to this blessed cele-bration and triumph.

[s2]

POLIPHILO TELLS OF HOW THE NYMPHS, HAVING SHIPPED THEIR OARS, BEGAN TO SING PLEASANTLY. AND AS POLIA SANG WITH THEM, HE WAS FILLED WITH THE GREAT SWEETNESS OF LOVE.

ELEBRATING THIS STRANGE TRIUMPH with auspicious, proud and elaborate pomp, with inconceivable joy and voluptuous amusement, I felt the pricking darts painfully stuck in my scarred heart, which was the fixed target of Polia's amorous glances and of Cupid's frequent arrows. Though it was burning like a furnace, I was still avid to increase the heat by the dutiful ministry of my insatiable and impatient eyes, for which I justly pardoned them, considering what was making them desirous, and what they constantly sought and rested upon. Just as the statue of Apis always turns to face the sun, so my eyes were aimed at the conspicuous and thrilling apparition of that beautiful, radiant face, whose equivalent it is impossible, nay, forbidden, to find anywhere in the world. But more hurtful and far more iniquitous and vexing were the elusive and wandering thoughts caused by this valiant lord: they were expert inquisitors in such a matter, skilled adepts at forging from fire and flames such sweet torment, such a worshipful idol, such a comely image and such a beautiful shape in the workshop of my imagination, and at feigning consolation. Oh, how hard and contrary to my temperament it was to refuse to give in! These unbridled and blatant assassins of my peace and quiet showed themselves insatiable and raging at the rare beauty of my golden-haired Polia. They were sometimes sweet, at other times bitter; joyful betimes, but more often sad; many a time desirable, and as frequently driving me to flight. What forces would have been strong enough to imprison my incontinent senses? By struggling they grew discordant, by discord they grew resistant, by resistance they repelled, and by repulsion they rejected any obstacle or barrier to that pleasant meadow, flowered all over with singular and rare delights, that was Polia. Like humming bees, they gathered there an abundance of sweetness and ecstatic pleasure which permeated my inward parts or violently invaded me, leaping up restlessly in serpentine flames. Therefore I thought it neither worthy nor proper that the amorous and glowing heart, vigorously exercised in such matters, should suffer itself to be upset and exhausted by its trou-

[s2']

bles, but rather that I should bear this burden quietly, since I had entered into this trouble of my own free will.

Now we maiden-voyagers sailed on under our fateful captain without bow-crest or rudder, in this unimaginable craft wherein all the mysteries of love respired. It had a stern for a prow, and a prow for a stern, and had been furnished for Cupid by his Mother with such apt and exquisite art as ever the most fecund tongue or the most accom- plished orator could express; and through expression, reflect on it; and through detailed reflection, investigate it. In the middle of the boat, in the mast-hole, there was raised a golden lance with a triumphal and imperial banner of fine silken material dyed blue, smoothly em- broidered on both sides with gems of appropriate colours and white pearls. These depicted many leaves in elaborate dec- orative shapes and three hieroglyphs: an antique vase, in whose open mouth a flame burned; then the world; and a little branch linking the two together. This banner waved and fluttered in the gentle breath of spring-like and helpful Zephyrus. Thus I interpreted it: Love conquers all.

✳

AMOR VINCIT
OMNIA.

I would have made every effort to keep my eyes reverently and modestly fixed on the divine pilot; and although my feeble sight could not easily support so incommensurate an object, by half-closing my eyelids I was able to see something of the divine boy of many shapes. Sometimes he appeared to me in a double form, sometimes triple, and again at other times he showed himself in countless images. Together with Polia, he made our journey fortunate, blessed and glorious. And on the way, amorous Cupid in the prow spread out the sacred feathers of his wings, between which Canens, the lover of Pico, sported. They flashed brighter than refined gold with various cheerful colours, making a turning circle on the waves that was even more beautiful and charming than Euclid's triangular prism of crystal, when brought close to the eye.

Now the sailor-nymphs began to sing, with sweetest notes and heavenly intonation quite different from human ones, and with a vocal skill beyond belief, a lovely concert with harmonized voices and bird-like melody. I felt that I would expire from excessive sweetness, because my beating and wounded heart was so stirred from its place by the beauty that it seemed to be escaping from my lips. The nymphs continued, fluttering their tongues against their sonorous palates and dividing and trilling even the shortest flagged notes into two or three. First they sang in pairs, then in threes, then in four parts and lastly in all six, their tremulous, rosy little lips opening moderately and closing neatly. They performed the well-modulated airs in musical rhythm, with a voice that was honey to the hot and swooning heart and its tiring postponement of love; and sometimes their voices sighed and gently sobbed, so as to make one forget and neglect one's natural desires. They sang to stringed instruments, celebrating the benefits and qualities of love, the merry affairs of great Jupiter, the soothing heat of holy Erothea, the lascivity of festive Bacchus, the fecundity of nurturing, yellow Ceres, the dainty fruits of Hymen, performing them rhythmically in poetic modes and metrical melodies.

I was firmly persuaded that this surpassed the music that saved Eurydice from the eternal flames after Pluto's speeding chariot had borne her

to the dark infernal seat. Nor did Hermes lull to sleep the many-eyed shepherd with such music as played on the pure air, breathed forth from their precious coral mouths. One could see the vocal spirits passing through their white throats, for this was celestial flesh of divine compo- sition, as transparent as crystalline, refined camphor tinted with scarlet.

If music like this had reached their ears, Phoebus would not have come to redden the morning dawn with his flashing rays; he would have forgotten to paint colours on the flowers and to renew the gracious day for mortals. Doubtless the archer Diana would have neglected her curved bows and fleet arrows, her familiar hunting and her dense forests; her cold spring would have grown warm, and she would not have resented the presence of the incautious huntsman and turned him into a horned stag to be torn by his own hounds. Wandering Selene would have stopped lighting the high heavens and the shady earth with her splendour; and dread Proserpina in her mournful kingdom would not have tormented her wretched subjects. Cheerful Bacchus would have resisted his lascivious games and neglected the Ogygian hills, Helos, Naxos, Chios, Mount Massicus and Mareotis, impoverishing the vinous delights of wine-bearing autumn. Bountiful Ceres would have kept the ears of wheat ever green, abandoning the abundant regions of Ausonia and never substituting for Chaonia's acorns the heavy four-eared stalks. The cloud-thundering eagle would not have felt the captured Phrygian cup-bearer escaping from his curved talons. So sweetly and concordantly did the nymphs sing, and each of them, can- tillating with my Polia, dispensed celestial melodies to expectant ears.

Such melodies would have lulled black, multiform and nocturnal Cerberus from surveying the metal doors of Tenarus with his unblink- ing eyes. Raging Tisiphone and her monster-bearing sisters would have become calm and kind to the suffering souls. Parthenope and her sisters Leucosia and Ligia, daughters of Achelous and Calliope, were never heard in such harmony as they sang on the Isles of Goats, near Pelorus, with voices, lyre and hollow tibia. My soul caught fire and was reft from its lodging by this joyous singing and playing, these beautiful figures, this company and this majesty. I could not recall it, so I resigned it to be tightly bound in the delicate arms and white bosom of Polia, surren- dered as a perpetual hostage, where it penetrated by delectable ways and voluptuous paths to secret delights; and from thence, with all my powers aroused, I could retrieve nothing but an imaginary and glorious comfort.

286

Thus abundant thoughts fed and rekindled my anxious soul, and with curious glances and wanton appetites I avidly admired the manifest and perfect beauty of Polia, such as is so rarely seen, refusing every other sight that might have diverted my attention. But now I was particularly charmed by her radiant bosom, miraculously painted with crimson roses and white lilies in their first blooming in tearful Aurora. They offered themselves to my eyes as a pleasing spectacle, revealed freely and without obstacle or intervening medium, but coloured like that most admirable object: her face. This was so enticingly and marvellously beautiful, comely and clear that Hippe never appeared thus with her ornaments in the pure skies. Her curly hair trembled on her pink forehead and smooth temples and flowed down very decoratively around her snowy neck and white shoulders, tossed to and fro by the lascivious spring breezes. Almighty Jupiter could never imagine giving more of himself to nature, or producing and creating anything better; nor could Apelles ever have painted the like, much less Aristides, who could imitate human souls with his brush. I could not sate myself with the sight, any more than buzzing bees are sated with thyme and starwort, or frisky goats with the flowers and tender leaves of clover. With willing soul and incredible pleasure, I would have unlocked my amorous heart, thinking nothing of it, and dissected it so that she could look inside and know the qualities one bears when one is in love, just as Antipater showed his scars to Caesar. And since my soul had been readily seduced and reduced to voluntary servitude by her sweet little face and noble presence, I would have made a window of my lacerated breast, just like the pious Egyptian Pelican that dwells in the solitude of the turbid and sourceless Nile: with her sharp, cruel beak she tears herself and eviscerates her pious maternal heart for the sake of her young when they are squalling with hunger. Not through Dionysus but solely through her perpetual and teasing excitement did sickly and Hydra-headed passions infuse my being: I formed in my consenting heart fiery desires and thrilling thoughts that united to consume me, and an ardent and eternal flame to destroy me, all of my own making. And more miraculously still, the lethal and deadly weapon that transfixed my wounded heart hung balanced, like the one that hung without any support in the Temple of Diana at Ephesus. But my soul was banished, and altogether unable to revivify me.

Deadly wounded in this way, I would have burnt up if her delecta-
ble glances had not refreshed me, her amorous signs comforted me, and

her calm and gentle words brought me back to life. She affectionately urged me to attend to the lovely songs of the rare and divine singers, and to enjoy the marvellous happenings with all my senses, turning my fixed stare and heartfelt attention away from her. But my beautiful Polia was more attractive than anything one could think of, and more comforting to my fervent flames than the rapid waters of the Xanthus and Simois to burning Ilium. Meleager's honourable gift of the bristly boar's head was not so welcome to Atalanta, nor benign Jupiter's gift to his beloved Alcmene. Nor was the timely arrival of the elephant at the water as welcome to Hannibal as Polia was to me, to my utter delight and contentment.

I persevered at the work thus begun, between sweet pleasure and hateful deferral, as constantly as heavy gold persists through every trial and the most penetrating fluids. Then I turned towards the divine child. 'O flame-bearing Cupid,' I murmured, 'O my master, you once wounded yourself with your own arrows, and attained the utmost limits of ardour for beautiful Psyche. You loved her extremely, as mortals do, and it pleased you to love her above all other girls. You were much hurt by the deceitful advice of the envious and lying sisters; in your pain you wept daily beneath the shady cypress-tree, and in your anger you rebuked her with lamentable complaints. Therefore use and exercise grace towards me, and consider, as one who has known it, the tender quality of lovers. Temper your burning torch a little, moderate your hurtful weapons and unstring your death-dealing bow, because I am altogether tortured by love.

'I think with good reason that though you were so cruel and pitiless as to injure yourself, your equability of soul will persuade you not to strike me pitilessly, and not to show yourself so severe and cruel towards me.' Thus I ventured in the heat of exasperation, and with various pleas and prayers, with elaborate complaints and false satisfactions, I somewhat blunted the violent attack and repeated assault of an immoderate and blinding love. But for all this, my burning heart did not receive the comfort it deserved, nor was my tormenting appetite really assuaged. So now I prayed to him in the hope that he would at least set a term to my daily suffering and to my grievous longing to leave my prison:

'It is true that the eagerness for future enjoyment is far more gratifying than pleasures that were had in the past; but since every unsatisfied love aims at its expected end, my Lord, cut short this waiting here and now!

End this unpleasant state which is more aggravating than a cloud of
[55] smoke to the bare eyes, a numbing pungency to the teeth, a delay when
help is needed, for hateful waiting and postponement of the goal are
grave torments to the desiring soul.' I then accused fecund Nature, and
with good reason, since she has ingeniously made everything work well
together, with one exception: appetite is not adjusted to capacity. Then
returning to myself, I wondered greatly, without being able to compre-
hend it, that so much durable material was to be found ready, like an
inconsumable Etna and a copious vapour-bath of such heat inside my
young and inflammable heart. In the end I contented myself with the
object of my vigilant attention – so rare, nobly elegant, complex and
ornate – and with absorbing with open ears the sweet consonances with
their heavenly intonation. With this ineffable recreation I gratified my
senses and received an intense pleasure.

Now our speedy hexireme ran in its extraordinary way, like a
weightless water-insect, over the still and level wavelets of the unfur-
rowed sea. The lovely oarswomen sang a jubilant song in the Ionic
mode, and divine Polia sang a solo cantilena, without the others, in the
slightly different but comparable Lydian mode. These were not the
laments of furious tragedy, nor the laughter of the satyr-play, nor deceiv-
ing comedy, nor tearful elegies, but they offered ornate poetry in elegant
language celebrating the supreme goodness of the holy Mother, Venus
Erycine, and sang of the lovable tricks of her Son, who was present.
And affable, beautiful Polia, well-dressed, polite and elegant, sang a
song of thankgiving for favours received, provoking admiration by her
energy and musicality. Blind Demodochus with his plaintive lyre did
not touch thus the ears of unhappy Ulysses. She felt no less happy to be
part of this gracious society, talking merrily and kindly sounding me
out to see how I was liking it: she named every rower-nymph to
me, and emphasized gently that perseverance alone would
win the victorious diadem. And so we sailed on
joyously, totally plunged and sunk in this un-
bridled desire, until our prosperous
voyage brought us to the deli-
cious Cytherean Isle.

HAVING ARRIVED HAPPILY AT THE MUCH DE-
SIRED PLACE, POLIPHILO MAKES KNOWN ITS
NOBLE AMENITIES, SUITABLY DESCRIBING ITS
PLANTS, HERBS, BIRDS AND INHABITANTS; BUT
FIRST THE FORM OF THE BOAT, AND HOW AT LORD
CUPID'S DISEMBARKATION MANY GIFT-BEARING
NYMPHS SPEEDILY PRESENTED THEMSELVES IN
HIS HONOUR.

VAUNTING HIS WIDE-OPEN WINGS, THE divine child was not driven by the rude winds of Ulysses' bag, but by the obliging and dewy breath of Astraeus's daughters and of rosy Aurora. Polia and I found ourselves of one mind, burning and driven with impatience to reach our destined goal, with a greater transport of love that ever human sense could feel or imagine, much less describe. However excessive it had been in our inmost hearts, it was nevertheless increased by the presence of the god, by the merry rowing nymphs and their lovely singing, and by the mysterious form of the solid and unbreakable boat. It was an instrument well fitted for love, with its pre-cious materials and the sweetness and amenity of the place, but above all with this ever-present flame which Polia, with her surpassing excel-lence, was blowing to a blaze in my flammable heart. For her amorous and refulgent eyes sent their lightning flashes into my inmost parts and seditiously set them into violent combustion. Melting in the heat, pros-trate from their wounds, they gushed forth with many a sob. Just as the pot placed on ardent and excessive heat boils over the top, even so the ebullient gasps of my fervent heart escaped with abundant and loudly resounding bubblings. Only the beauty of my guide, the lovely Polia, could dampen these importunate fires. But for all that, I was feeling such abundant pleasure that I was totally absorbed and consumed, though my tongue could never manage to express it as it deserves.

Finally we reached the much-desired island with joy, gladness and triumph in our superb and fair-oared hexireme. It was not ballasted, but rocked to and fro, and its form was as follows:

The boat was divided into four parts, of which two were occupied by the stern and the bow, both of identical design. The two other lengths were in the remaining hollow body. Both sides were edged with [56] a curved gunwale that ran from bow to stern, passing by the rowlocks,

dipped by a quarter of a foot, and continued slightly depressed until it rose at the other end. These horizontal scythe-shaped borders rose two feet above the decks. The three benches were fixed between the gunwales on either side, raised a foot and a half above the deck. The keel was covered with gold plating, as were the curved ribs that bellied out at front and back; at the tapered ends, it curled round into a graceful shape, called a dolphin from its appearance, forming an attractive volute that flashed with an ornament of large precious stones. After the volute, it turned back towards the deck of the stern or prow to form an antique leaf-shape, exquisitely made of finest gold, which spread its natural form over the deck, then expanded in serpentine fashion with moulded stalks, lappeted folds, incisions and fringes elegantly raised above the surfaces. A wonderful frieze emerged out of this volute and divided along the two sides, one palm's breadth wide, and traced the bend of the mouth, gunwhale or lip where the rowlocks were fixed; it was all of gold, and studded with gems of incredible price, admirably and harmoniously arranged. All the woodwork was assembled so diligently and with such extreme precision that the boards were joined like a breastplate, with no oakum in the joints or any nails, appearing smooth and compact as if it were made from a solid piece. In addition, the sides were caulked with a fragrant black pitch that shone like a mirror, with Syrian lineaments of gold leaf splendidly drawn, like all the other details I have described. It looked like this:

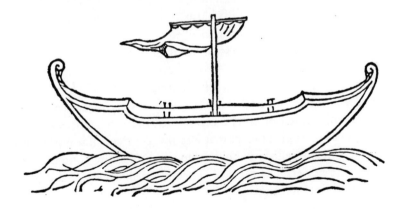

The serene air was filled with these amorous triumphs and with the [s6']
euphonious voices of the sailor-girls, and the blue sea with the confused
clamour of the sea-gods, in a medley of crashing waves, rejoicings,
caperings, strange gesticulations, festive joy and devout veneration, as
we disembarked in that delightful place. It was so benign and pleasing
to the senses, so delectable and beautiful with unusual ornamental trees,
that the eye had never seen anything so excellent and voluptuous. The
most eloquent tongue would feel guilty of poverty and parsimony in
describing it: any comparison with things already seen would be false
and inappropriate, for it surpassed imagination. This heavenly and deli-
cious place, all planted and decorated, combined a vegetable-garden, a
herbarium, a fertile orchard, a convenient plantation, a pleasant arbore-
tum and a delightful shrubbery. There was no place for mountains or
deserts; all unevenness had been eliminated, so that it was plane and
level up to the circular steps of the wonderful theatre. The trees were
sweet of scent, plentiful of fruit, and broad of branch. It was a garden
yielding incomparable pleasure, extremely fertile, decked with flowers,
free from obstacles and traps, and ornamented with playing fountains
and cool rivulets. The sky was not hard on it, but was temperate, wide,
transparent and luminous. There were no Avernian places with horrid
shadows; it was free from the changeable and inconstant weather that
troubles one with the assaults of unhealthy winds. It was not invaded by
hurtful wintry frosts, nor in summer by excessive sunshine or by torrid
drought, neither did freezing plague it, but all was springlike, and more
wholesome even than the air of that part of Egypt that faces Libya; it
prolonged health and well-being to all eternity. The place was planted
with lawns, and with an impressive wealth of leafy trees that presented a
wonderful display of verdure. Around everything there breathed the
incredible limpid air, redolent of flowers, for the whole area was
covered with grass and fresh rosemary, and flowery meadows. It was
unimaginably prolific of every pleasure and all nature's gifts. Coloured
fruits showed through a foliage that was always green; all was in friend-
ship and concord, with walks going among the plantings and many an
arching rose-bower. The plain of Themiscyra, however well watered
and planted, was nothing to it.

I reckon that even if one were endowed with genius, it would be
well-nigh impossible to tell of such a thing. But I will try to describe
briefly whatever my faulty memory has grasped and retained.

This holy place was dedicated by kindly nature (always compas-

sionate towards mortals) as a nursery of the gods and as a station and place of diversion for the blessed spirits. As far as I could ascertain, it was three miles around, with periodic inlets of limpid salt water. It was not troubled by hollow cliffs, gnawed by the insolence of turbulent and foamy waves into holes, and full of crevices like the broken Strophades. Nor was the rock of proud Niobe to be seen there, nor her tall and petri-fied daughters. But all was made from a shining mineral substance that was not frangible, friable or muddy, but translucent, whole and invio-late, like a transparent crafted crystal.

[57]

I carefully explored the shore, washed by friendly tides and pebbled with strewn gemstones that shone in various forms and colours. There was also abundant evidence of the fragrant coitus of monstrous whales, brought up by the fruitful tides. Beyond, this ornamental island was covered with lovely and ever-renewed perennial greenery, looking glori-ous over the whole plain.

But first I admired on the bare banks beside the shore the tall, uniform cypresses with their astringent, pitted cones, rising firmly to their heavy tops. Between their trunks, which are not tasty to the gnawing woodworm, there was a space of three feet separating one from the other. This regular order continued round in a circle, and was fol-lowed along the entire periphery of the island. Then came a circle of pleasant flowering myrtle, lover of the babbling banks, forever vowed and dedicated to the divine mother of amorous fires. It was dense and compact, cut and formed into the shape of an enclosing wall a foot and a half high, enclosing in itself the trunks of the upright cypresses whose foliage began to grow two feet above the flat, leveled top of the myrtle. This greenery formed a rampart around the bank of the shore, with convenient pathways passing through suitably spaced gaps. This hedge showed almost no wood, but was covered by its delectable and flowery foliage in which no shoot or leaf exceeded any other. It was cut with extreme evenness, and maintained its height and its circular form.

Within this rampart of myrtle and green shoots, for a distance of about a sixth of a mile from the centre of the island, I could see that the lines drawn from the centre to the surrounding shore made a division of twenty equal parts of one stadium and a fifth. Following the outermost boundary of the myrtle, there was a grove in each division where various plants and trees grew, distributed according to the aspect of the benign sky that each required. The forest of Dodona was nothing to it. This division by twenty can be made by taking a decagon and bisecting

each interval with a line. Make a simple circle and divide it with two diameters intersecting at the central point. Bisect any one of the result- ing radii and mark its centre with a point. From this point, draw a [57'] straight line to the upper end of the other diameter. Then from the radius mark off as much as makes a quarter of the entire diameter. Next, extend a line from the centre, cutting it at the marked place; and this, on the circumference, will give the division of the decagonal figure.

These twenty divisions were marked by excellent fences of diverse trellis-work, made from pierced marble two inches thick and placed in equal sections between neat little pilasters of white marble. The rest was bright red and clothed with a voluptuous variety of climbing plants, each isolated and separate from the others. In the middle of each fence was a gateway of the same size, seven feet wide and nine feet up to the top of its archway. These trellises were beautifully designed in lozenges, squares and other quadrilateral forms. Some of them had honeysuckle winding around them, others jasmine, convolvulus, lupin, wild or black vine, and morning glory with its lily-shaped bells, some half- azure, some all white, others toothed, and all different. Here were Jupiter's wall-flowers, and the bindweed of Smylax who became a flower for love of beautiful Crocus, decked with white blooms smelling of lilies and with fragrant leaves like ivy. There was vitilago, and clema- tis that causes triangular spots with its spotted white seeds, and many other plants winding upwards whose names are unknown.

In the first section, the grove was Daphnic, or laureated with many laurels. I saw here the Delphic variety, the Cyprian, and the kind used for cakes with its large whitish leaves; also the wild laurel, the Cimo- lian, the royal or Bacchic, the yew-like, the sterile, and the dwarf variety. On Mount Parnassus itself there was none more beautiful or more pleasing to Apollo, or a nobler gift sent to the Romans. Brutus did not kiss such laurel-bearing earth; Tiberius would have loved it. Drusilla saw none such in the white fowl's beak, nor were such seen in the villa of the Caesars, planted by order of the augurs to serve (especially the sterile variety) as a triumphal ornament. I also saw the Daphnoid or Pelasgian, or large-leaved laurel, redolent of incense. The evergreen plant made from the daughter of the River Peneus, whose leaves Apollo took to ornament his lyre and quiver, was not so beautiful as this. The airy hills of Sicily gave pride of place to this grove for sweet springs and pleasant situation; and how the handsome son of Mercury would have sported with Diana here! These laurels were untouched by the anger of

294

almighty Jupiter, and would have offered a fine covering for Caesar's baldness. To enhance the place, many arbutus trees were mingled with them.

[s8] I admired another grove whose flat ground bore the lovely oaks, with their tender foliage. Here I saw the broad-leaved variety, the great oak, the Austrian oak, and the small oak that produces the medicinal acorn; the sea-cork oak with its thick bark, many edible oaks, Turkey oaks, cork-oaks, beech-oaks and ilex or smilax, also called aquifolia, whose leaves do not fall and are gathered by the nymphs of the oak-woods.

In another division there followed another pleasant grove, planted in regular order with fragrant wild cypresses: the frankincense tree, buck-thorn, and junipers cut by topiary into manifold figures, with minute and pungent leaves made for the sake of the divine Mother's husband. There were tall cedars, with so many uses, giving cedar-oil from leaves resembling those of the cypress; the wood from which the Ephesians made the statue of Diana, and which is prized for building lofty temples because of its everlasting qualities, immune from the gnawings of age and of insects. The cedar flourishes in great Crete, its home; those of Africa are beautiful, those of Assyria fragrant. The cedars were attractively intermingled with savins, evergreen and noxious to Lucina, in similarly varying shapes.

Next I saw a tall and leafy pine-grove with its cones: here the Tarentine or wild pine, there the urban pine and the aloe pine or sapin, the wild pine and the fir with its lachrymatory resin, all artistically arranged.

In a further enclosure there was a splendid display of many box-trees, planted in round and square marble containers among fragrant and flowery herbs. No such boxes were to be found on Mount Cytorus in Macedonia. They were dense, gradually tapering to a point, diminishing in exact proportion and rising gracefully, interspersed with many other admirable and beautiful shapes. But there was a marvellous one which outdid all the rest. I could see that this specimen had been shaped industriously in the antique manner so as to represent all the virtues of tall Hercules, not omitting innumerable other animals carved in the green and never-falling leaves, and regularly spaced at proportionate intervals on the grassy and flowery lawn.

Another similar grove was planted with a harmonious multitude of trees. There was the hard dogwood, some with blood-red fruits and others still white; and the bitter yew, most welcome and apt for making

Cupid's lethal weapons. Mixed with these I saw the elm, linden and the delicate lime, vines, hornbeams, ash-trees for the flowering lance of Romulus, many medlars and bitter service-berries.

Another grove offered itself with straight-stemmed and lofty silver firs, which, even though they avoid the wide sea and prefer to grow in the mountains, still grew so tall here as to vanish into the sky. Between them, in orderly fashion, were incombustible larches overgrown with fungi and agarics, and similar trees placed in suitable and pleasant arrangements. [s8']

Next came another very admirable grove, in which grew the walnut with its health-giving shade. There was the Persian variety, the royal or soft-shelled, and the Tarentine, keeping company with hazelnut trees. They were far superior to those of Avellano, Praeneste and Pontus. Also accompanying them was the impatient Phyllis, changed into an almond tree, who gave the name of phylla to the leaves, formerly called petals. She appeared all in flower, as if awaiting tardy Demophoon. Her fruit is called the Greek nut, or amygdala, or thasia.

With great pleasure I now admired a little wood of chestnut trees, their fruit armed with a sharp, spiky shell. These excelled those first dis-covered by the Sardes, thanks to whom the Greeks called them Sardian nuts; later the divine Tiberius gave them the name of balani. I sincerely thought the Parthenian chestnut, the easily peeled Tarentine, and the still easier and rounder acorn-chestnut were inferior to these, which also surpassed the pure Salerian chestnut, the much-praised Corellian, the cooking-chestnut, the Tarantine and the Neapolitan. Here was also Spanish broom, tamarisk and gorse.

There was next a grove of noble quince trees; a grove of carob trees such as Cyprus could not produce; and a dense palm grove which offered its tough palms with their useful leaves, pointed like knives. They were resistent and unbending, and their tops were laden with their closely-packed, pulpy fruits. These were not rough and small like Libyan dates, nor like the sweet ones produced in the interior of Syria, but much more excellent, and even larger and sweeter than Arabia and Babylon can offer. There was a charming grove of noble pomegranate trees of every species: sweet, sour, mixed, acid, and vinous. None are to be compared with these, neither Egyptian nor Samian, Cretan, or Cypriot. There were also the seedless, the red-leaved, and the white-leaved variety, laden with fruits and flowers.

Next I saw a lovely little wood containing persimmons or sharp-

296

leaved trees, Syrian beans, cherry-like and apple-like lotuses, with much sweeter fruits than those of Syrtes or Nasamon or any others in all of Africa. There was not lacking a grove of Christ's thorn with its red berries as sweet as wine, finer than the Cyrenaic or the one from inner Africa, or that which grows around the shrine of Ammon. There was a grove of both kinds of mulberry: the one whose fruit recalls a fatal love, and the other which serves as food for our delight.

[II] I also admired a very productive olive grove, and one of figs, with copious crops of every variety. There was a delightful grove of poplars, and a similar one of sour-fruited trees with the Egyptian carob and the weeping African gum-tree, such as was not to be found distilling its ammoniac gum at the oracle of Ammon. These groves were arranged and ordered most cleverly and elegantly, none of them having to strive to see the sky, but each in the best position in accordance with its virtues. Ingenious Nature showed forth all the delights that she has carefully produced and spread throughout the world, as though she had created them with especial care and heaped them all together here. The ground was grassy and flowery, and had springs surging up in shady places, giving forth water as lucid as liquid glass and fresher than the spring of Salmacis. None here suffered the rigorous Arctus or the cloudbearing Notus; the air was health-giving, purged and pure, and transparent to the eyes for a great distance. It was smooth, uniform and invariable. The great amenity of the place and its moderate exposure to the sky never suffered violent change: every cloud dissolved and dispelled, leaving the sky clear. There were no insolent winds such as noisy Eurus and whistling Aquilon; none of the malign violence and din of the raging hurricane, nor any adverse weather. It was subject neither to the tumul-tuous changes of the waters nor to frigid Libra, but everything appeared luminous to the view in an ideal light, glad and growing, as in the month when woolly Aries dries his fleece in the bright and Her-culean sunshine. Nothing faded, but all was perpetually green and filled with a celebration of birdsongs, as the crested lark and the musical nightingale flew together singing through the air.

This third of a mile was entirely taken up with groves (for the cir-cumference of a circular figure is equal to three of its diameters, plus as much that if you divide a diameter into eleven parts, you need to add two of them; thus the diameter of this voluptuous island was a mile, with two elevenths added), bounded toward the centre by a fine circular hedge eight paces high and as many feet thick, of such dense foliage that

one could not see the smallest twig. It had transparent double windows and open, arched doorways let in regularly at suitable places. It was made of closely planted oranges, lemons and citrons, their mature foliage and new leaves splendidly green, ornamented all over with mature leaves and new fronds, fruits both new and ripe, and fragrant flowers. Everything was most delightful and pleasant to the eye, and a spectacle such as is rarely granted to human sight.

In this pleasant and delectable enclosure, between the green myrtle [tɪ'] and this surrounding hedge of flowering orange trees, innumerable animals of many kinds were running and wandering about. Although nature repels dissimilar things, they were roaming tamely and harmlessly in mutual friendship. First there were the goat-born satyrs with their twisted and dangling pendants, two-horned fauns of both sexes; then half-wild stags, mountain goats with their frightened dams, dappled mules, leaping chamois, long-eared hares, timid rabbits, hunting cats, white and yellow ferrets, and the deceptive weasel; restless squirrels and sleepy dormice, ferocious and bearded unicorns, goat-stags, and all the leonine species, but unarmed and playful. There were long-necked giraffes, swift gazelles, and an infinitude of other animals intent on the pleasures of nature.

Beyond this enclosure toward the centre I found a magnificent and extraordinary orchard or delicious plantation, better, I think, than humans could ever design or even imagine, so that one could easily believe it to have been made by the secondary powers, following the First Mover. Moreover, I am certain that no genius, however gifted, could speak adequately of such an excellent work as this sacred place. The hanging gardens built by King Cyrus were not its equal. From this I would judge that this exquisite invention could have been thought up in all its orderliness and fitly executed by none other than the Divine Artificer, for the contemplation of the bountiful Goddess of Nature.

This splendid garden measured 166 ½ paces toward the centre, and was divided into fields by pathways five paces wide, running in the direction of the centre and transversely in a circle. The first fields measured 50 paces along their first line that followed the hedge, and 50 paces along each side, but the fourth line, the one nearest the centre, was smaller. This became the first line of the second field; and the third field was similarly squared. It was the lines leading to the centre that forced both the fields and the paths to narrow, and deformed their squares, while the transverse paths remained constant.

298

These pathways were covered with a pergola, and at each interse-ction there was a hump upon four Ionic columns, whose length was nine times their lowest diameter. And on both sides of the walks or pathways were containers faced in finest marble with handsome linea-ments. One of these columns stood at each of the four angles; and this system of columns and spaces was followed throughout.

[t2] Out of these boxes or containers, beneath the socles of the solid columns, there grew rose-bushes no more than a pace in height, which made a pleasant hedge between one column and another. On either side of each column a rose-stem grew directly upwards, adhering closely to the middle of the column and extending up its interior side to above the noble epistyle, where the roses made the arch of topiary. The epistyle extending above the columns was of reddish stone like brilliant coral, without any admixture. The height of this pergola, with its boxes, columns and straight beam, was five paces. The cupolas of rounded, humped or ball-shaped form, set above the pergola, were covered only with yellow roses, while the longitudinal pergolas were roofed with all varieties of white roses, and the transverse ones with every sort of red, with perennial leaves and a host of flowers exhaling their fragrance. Outside, every species of flower and aromatic herb was growing from the containers.

The first circular pergola was contiguous with the enclosure of orange-trees, which had a window with an arched opening that termi-nated the pergola that ran to the centre. From the ground upwards, this window was a foot shorter than the space between the columns.

Each field had four gateways, each placed in the middle of the space between columns and opening through the containers. These gateways corresponded to each other exactly throughout all the fields.

In the middle of the cultivated and flowery fields, I saw an elegant work of rare design and unusual finesse. To begin with, in the first field I admired the noteworthy structure of a fountain playing beneath a pavilion of cleverly shaped green box. Other, identical ones were to be found throughout the first range or circuit of fields, made as follows:

In the middle of each field, three steps were built in circular form. The diameter of the top one, across its level surface, was two and a half paces. A circular peristyle of eight colonnettes was erected upon it, with their bases and capitals in a ring around the top step. The columns were of Doric proportion, seven of their own lowest diameters in height, and had entasis. On either side were arches, above which ran the

beam, fascia and cornice. Each supporting colonnette had an antique vase perpendicularly above it, these being three feet in diameter at their maximum width. The belly of each vase rested on a point, and swelled gradually from there up to its middle, where it was ornamented with an exquisite border. Above the border it rose with a moderate tapering to the mouth, which had a finely fashioned rim around the edge of its opening. From here to the border was one and half feet; from there down to the base, three feet; and the base was half a foot. There were [t2'] little twisted channels or grooves, at first very shallow then moderately increasing toward the border, and two handles curling in opposite directions from the rim to the end of the slope, in imitation of turned work. Out of the mouths there grew straight stalks of leafy box, of the same thickness as the columns below but without the entasis, with little arcades from one stalk to another and oculi in the spandrels.

Then the stalks rose upwards, sloping from the horizontal circle above their vertical parts for a distance equal to that from the vases to the capitals. They were at first somewhat far apart, but as they rose they incurved gracefully, tapering and diminishing the spaces between them until they met at the top. At the bottom of each leaning pillar, as these are known, an extended branch formed a claw-shape with a ball sus-pended in it, then curved inwards and rose to the height of the inclined columns, making a sinuous form that held at its top an open crown or ring. In addition to all this there were six straight stalks that continued upwards for two-thirds of a pace to form the cap, with arched windows, and then came the rounded dome. Upon this dome stood a rectangle with sides of a pace and a half, pierced with four oval openings, and from the bottom of each angle issued a shoot that hooked upwards. On its inverse curvature sat an eagle making as though to fly, with its beak outwards. This rectangle had a pointed roof which held a conical or cylindrical shape on its peak. From the vases upwards, everything was made from the tight and coherent foliage of the box trees planted in the vases. It was artfully made, extremely dense and finely cut, so that the eye could truly never meet with a more beautiful specimen of artificial topiary.

* * * *
* * *
* *
*

In the middle of the flat, inlaid floor of the peristyle there was a fountain, situated inside a round basin hollowed like a shell. It was supported at its centre by a two-foot high inverted baluster, and the mouth of the bowl was four feet wide. Inside it were three gilded hydras whose tails crept along the bottom, straddled upwards, then entwined themselves tightly in beautiful knots, dividing again at the belly, swelling separately from each other, and knotting at the throats like eels. From their threefold heads they vomited fragrant water into the basin and became the equal supports of an egg-shaped vase, two feet high. At the top of this were fixed eight little golden pipes which sent out fine jets of water, passing through the gaps between the columns of box and watering the whole lawn like dew-drops. The inside of this pavilion was open and transparent, and its stone-work all of fine jasper, red and lucent with a host of little spots of many colours, with elegant and exquisite carving at the appropriate places.

Now in each corner of the quadrangular field, at a proportionate distance from the flower-boxes, was set a square container with four stages. The front of the first stage rose two feet from the ground, and its top was hollowed out for a foot and a half to make empty spaces. Then followed the second stage above it in graduated fashion, the same height as the first one, and similarly the third and fourth. In the first level there grew fragrant herbs, and likewise in the others: there were miniature curled basils, citronellas and chervils, whose leaves were level and did not exceed half the height of the next stage, and this was followed uniformly throughout. The second stage had sweet-smelling miniature thyme that attracts the honeybees. In the third there was the bitter herb used in wine, elecampane or southernwood, such as Sicily cannot offer; and in the top stage was Celtic valerian with its gladdening odour.

301

The same distribution occurred in all the four terraced containers placed in the corners of this first field, which exhibited a garment of flowering periwinkle. The opening of the top stage was a foot across, and in each one was planted a noble and prolific fruit-tree, shaped uniformly by topiary. In the first round they were apples: I saw in one corner the fragrant Appian variety, in the second Claudians, in the third apples of Paradise, and in the fourth Decimians. But in every field of this first order the varieties of apple varied. The fruitful apple branches diffused their scent everywhere, producing such beauty of colour and sweetness of taste as never did the tree of Gaditanian Hercules, nor such trees as Juno commanded to be planted in her gardens. Hence one might call these seedless apples.

They were shaped by topiary into a thick circle like a coronet with its opening facing the pavilion. The risers or sides of this stepped container were of beautiful mirror-like jasper, seeded with golden specks and mingled with spots of yellow, with serpentine blue veins and red transverse veins mixed with undulations of chalcedony, and squared off with graceful wave-mouldings.

After this first range of greenery, which I have described, going toward the centre into the second range, I saw in the middle of a field, in place of the pavilion, a remarkable creation made of box-trees by artificial topiary. There was a stone chest of precious chalcedony, the colour of soapy water; it had the proper lineaments and was three feet high and three paces long, aligned with the transverse pathways. A box-tree in the form of an antique vase was planted one foot away from each end, both of them made equal and remarkably uniform with the pedestal, belly and opening, one pace in height and without handles. Above their mouths was a giant three paces high, standing on them both with his legs apart. He was dressed in a round, belted garment that went down to his knees, and he held his arms up high. His neck, head and chest were carefully formed in proportion to human stature. He wore a hat, and supported two turrets

with his arms, one in each hand. These were four feet wide and six feet high, with bases of two steps, little doors and windows, and showing the courses of masonry. Out of each tower came a short stalk with a ball on it, with a diameter equal to the top of the tower. The trunks came out of the middle of the top of each ball, each issuing at the same angle and bending so as to meet and join, like the arch of a building. The point of this arch was of the same height as one of the towers. Near the inclined trunk, that is, at its place of exit from the ball, another thin, straight stalk rose, supporting a conical finial smaller than the ball beneath. The rounded bottom of this finial was level with the top of the arch. Another ball was attached below the middle of this arch, like the ones on stalks. Above this ball, on the midpoint of the arch, there rose a half-foot long trunk supporting a slightly hollowed shell, a little less across its mouth than the width of the arch. Out of this basin came another trunk like the one beneath the shell, supporting a shape like a lily with its petals curved back all around. Out of the lily's cup came a box-tree divided into eight pillars, bending gradually and tapering toward the summit while still separate from one another. The entire portion from the arch upwards was six feet high, excluding the balls of box. In all this rare topiary there was no sign whatever of wood except in the straight stalks; everything was thickly covered with leaves and smoothly cut with all the care and art of the topiarist.

On the chest at the bottom, between the two vases, could be seen a
box-tree without a stem in the shape of an onion, one pace
wide and two and a half feet high. Out of its middle
rose a pear-shape, four feet high, with its thin end
uppermost. Its tapered end held a flat, circular
shape four feet in diameter. In the middle
of this lenticular form sprouted a few
shoots making an egg-shape,
equal in height to the
pear beneath.

※ ※
※

In the corners of the present field, which was the second toward the centre, the fourfold containers were the same in design, dimensions and location as those in the first field, with the exception of the stone, for these were of black electrum or amber. Not even the daughters of Phaeton, weeping beside the river Eridan, melted into such amber; nor was such to be found in the Electride Isles, or produced by the temple of Ammon. It was polished like a mirror, and when rubbed it attracted straws. These containers were circular in shape.

In the lowest level sweet-smelling cassia was growing; in the second, fragrant nard. In the third was mint, commemorating the fierce hatred of Proserpine for the nymph Mente, and in the fourth marjoram, for the unhappy king Amaracus who died among his perfumes. Cyprus produces none like this.

A fruit-tree was similarly planted in the middle of each uppermost
container, but different from the first range in its fruit and in the form of
its topiary. These four were beautiful spherical figures, producing
four species of pear: first the muscat pear; the second, the
Crustumerian; third, the tender and succulent Syrian;
and last, the Curmundulian. In this second range
of fields, the other fruit-trees differed in their
varieties, all having fine colour, sweet scent
and delicious taste. The ground was
clad with minute, fragrant thyme,
and the containers with
various aromatic
simples.

✳ ✳

✳

Next in order comes the description of the third field toward the centre. In the middle there was a circular container with the usual decorations, three feet high and two paces across its opening, with the decorative lineaments. Out of it flourished a clipped boxtree, shaped by topiary as I shall describe. The container was of fine lapislazuli.

The stem was a foot and a half high, and on it was an onion shape slightly exceeding the circumference of the container. It was voided, with an opening at the top of a pace and a half in diameter. On the rim of this opening stood a circular colonnade of six verdant stems with arches, four feet high, then came a conical roof shaped like the foot of a chalice. Resting on top of this was a perfeċt sphere three feet wide.

Upon the lower edge of this raised roof, perpendicular to each of the columns, was the curled tail of a dragon. Their backs stretched and their bellies bulged out as far as the onion shape below, while their necks adhered to the ball above. With heads ereċt and jaws open, they sprayed perfumed water from hidden pipes concealed in their mouths. They held their feet up toward their heads, their wings were spread, and they were six in number.

Three branches were sprouting from the top of the ball, bending outwards, two feet in height, each of them supporting a rounded pedestal or cylinder, formed with exquisite care and cut smoothly with a little corona above and the proper gullets below. Excluding the lineaments, the height was three feet. On the upper surface rested an antique urn with four handles, three feet tall, from which a boxtree issued in two rounded stages. The lower one exceeded the diameter of the vase beneath, and was raised above the orifice by a footlong stem. The upper one was somewhat separate from it, and somewhat smaller. A little above these was a ball with the same circumference as the vase, and then out of each ball came a straight stalk of the same height. The three stood in triangular relationship, and were joined to one another by three semicircular arches whose bows spanned the distances between the stems.

305

Three elegant stems leaped up from the horns or footings of the arches, making an arched triangle and a delightfully fashioned vault or umbrella-like roof. The vertical stems did not surpass the top of the roof; all three reached an identical height and supported lily-like chalices, on each of which was a conical or rounded shape with its thinner end turned downwards. The delightful beauty of these entertaining inventions was all the more welcome to the senses because the bodies

and configurations were all of bright green leaves. They were so precisely made that no one could have done better topiary in this material, or formed it compactly into such lineaments.

A mixture of flowering plants grew in this field, which was much more beautiful than a painted picture. Again, there were containers in the corners following the plan already described, except that they were triangular and made from golden-yellow chryselectrum. None like this is collected from the virgin Hesperides; when rubbed, it gave off a sweet citric perfume, such as is not given by the amber collected in the German island of Citrum; it was more translucent and clear than the tears of the Meleagrides. In the lowest level there grew sweet Celtic nard; in the second, mountain germander; in the third, ladanum and cisthos; and in the top one, fragrant ambrosia.

The fruit-trees were shaped in a convex hemisphere. In this third range, none exceeded another in height, but all were of a proper stature, various species, and many-fruited. There were pistachios, apricots, every sort of balsam-bearing tree, hypomelides, all the Damascene plums, and many other delicate fruits beyond those that are peculiar to our climate, of manifold species and of unknown and unfamiliar colour, shape and delicious taste.

306

[t6] These trees teemed with fruits, flowers and never-falling leaves, offering the height of pleasure to the senses of the spectator. Their branches did not stick out untidily to the side or tangle each other, but were neatly arranged in different patterns. They were not subject to the phases of the moon nor to bleaching by Phoebus, but remained ever unharmed and in the same state of tender and succulent greenery and abundant fruiting.

 The flowers and sweet-smelling herbs persisted in a similar condition, diffusing an unfamiliar but welcome perfume over all. The roses were all the more pleasing because they were of so many different kinds, including varieties unknown to me. There were prolifically flowering Damascene roses, Praenestine, five-petalled, Campanian, red Milesian, Paestine, Trachinian and Alabandian, and every noble and praiseworthy variety. They remained perennially blooming with their wonderful fragrance, their cheerful colours and lovely flowers among the green fronds: no sooner did one drop than another took its place.

 The containers were made with ingenious craftsmanship. Their edges seemed to reflect the sky, the branches, the abundant flowers and foliage, as if in a mirror.

 Beneath the topiary works and pergolas, the stone paths were the best example of paving that could ever be achieved by human ingenuity and invention.

 Beyond the three equal ranges of fields that I have recorded, there was a great and magnificent border in the form of a rare and admirable peristyle of stout columns with beautiful entasis, which made a closure like a rampart around the perimeter. The wall of this circular colonnade was constructed of a splendid trellis of labyrinthine complexity, with pedestals intercalated and suitably connected at the base, having
[t6'] the corresponding socles, undulating cymas and gullets. The intercolumniation was equal to two columns' width plus a quarter; and where the paths met the peristyle, the latter opened with a width equal to theirs,

making a gap beneath the peristyle and interrupting the continuity of the enclosure. Thereupon a noble gateway was raised, with its bowed arch resting its ends on the columns on either side. These were made uniform with the other columns as to their shaft and position, but differed in thickness in order to match the superstructure. Beyond the curved beam was a gable or frontispiece, with all its appropriate ornaments finely carved. The epistyle, zophorus and cornice continued in a circle above the columns, marvellously fashioned with all the proper mouldings; they had been hollowed out with admirable effort like a chest, and crammed full of soil in which all sorts of attractive flowers grew. Moreover, boxtrees and junipers in topiary work had been planted directly above each column so that a round ball of box, with not a shoot in sight, alternated with a juniper on a foothigh stalk, made with four compressed spheres gradually diminishing upward; and there were flowers in between.

The low walls and entabulature of this admirable peristyle were all of superb alabaster, diaphanous and lucent without having been polished by rubbing with Theban sand or pumice. The columns, however, varied in colour, for the ones that flanked the entrances were of translucent chalcedony, while those on the low wall flanking them were of green hexacontalithos, manycoloured and brilliant. The next pair, [17] one on each side, were of bright hieracitis with its handsome blackness; the next two beyond these, of clear milkstone. Then followed a pair of columns of chrysoprase; and the last ones were of blazing atizoe with its silver sheen and gladdening scent.

These columns alternated thus in a harmonious manner, giving incredible pleasure to the eye. They had the artistic entasis, and were tapered as if on the lathe, with such art as even Theodorus and Tholus

could not achieve in their column-turning atelier. It was a truly sumptu-
ous work, proud, precious and elegant.

The columns were Ionic. Their capitals, their echinuses between
darts, their volutes made like convoluted shells, and likewise the bases
were resplendent with gold, such as was never produced by the aurifer-
ous Tagus in Hesperia, nor by the Po in Latium, the Hebron in
Thrace, the Pactolus in Asia or the Ganges in India. The zophorus was
ornamented with excellent carving of antique foliage winding about
itself. The trellises that formed a circular barrier between the pedestals
were of the best electrum, unrivalled by that which Helen dedicated, in
the form of her breast, in Minerva's temple on the Isle of Lindos.

On top of the low wall, in every interval between one column and
another, there stood a well-made ancient vase, diligently polished all
over and varying in stone and colour. They were of sphragides, chlori-
tis, chalcedony, choaspitis, agate, and many other precious and char-
ming stones, with their surfaces polished so as to reflect every object. I
thought that their lineaments were not of human making. Out of these
came admirable simples and plantlets in various topiary shapes, includ-
ing marjoram, aromatic and curling wormwood, aurotanus, myrtles
and others. Nothing could possibly have offered more delight and con-
tentment to the eye.

This peristyle ran by the edge of a river bank, whose sand was over-
grown on both sides with dewy turf. Charmingly distributed on it were
flowering gladioli, lavenders, oreganos, flea-wort, white oregano and
mint – that nymph who received the beautiful gift from Pluto. Helen's
tears also flourished there, known as helenion, which is good for the face
and attracts the holy Mother's favour. There were innumerable other
well-known plants, aromatic and most welcome in their fragrance,
such as the white, blue and purple hyacinths, the like of which is never
grown in Gaul.

Innumerable small and medium-sized birds were now flying among
[t7'] the tender flowering fronds, decked in their splendid plumage. They
flew nimbly hither and thither, up and down, hopping and twittering
delightfully and making everywhere echo with the sweet music of their
song – which would have aroused pleasure, joy and solace in any heart,
however savage and senseless – as they preened their wings and feathers.
The querulent nightingale Daedalion was there, mourning the death of
her daughter Chione. There were dappled blackbirds, the songful
crested skylark, the rock dove, the solitary swallows, the eloquent parrot

with its many-coloured raiment of green, white, orange, red, and yellow-green. Beside the white turtle-doves there was the fabulous phoenix – unique, but not so in this place; the woodpecker, Pomona's husband, showing signs of Circe's boiling wrath; Idona, weeping for her loved husband Ithilus; Asteria, with her feet shod in pink, and the two kinds of magpie; roof-dwelling Procne and pious Antigone, too beautiful and tongueless; Itys of the dolorous and funereal table; the greedy jaundice-bird; rock-dwelling Tereus, preserving in his plumage his kingly pomp, wearing the military insignia on his crested head, and complaining 'pou, pou!' in his song; and the sleepy shepherd of Syrinx. There were also Palamedes' cranes, the teal, the lascivious partridge and the water-fowl; Periclymene, whose form Jupiter licentiously usurped for his loves; the woodcock or black-head who changes in autumn, and likewise the redstart, beside innumerable others, too many to relate.

✳

This delightful and pleasant island is shown more clearly here. Its circuit measured three miles around, and it was a mile in diameter, which was divided into three parts. Each third contained 333 paces, one foot, two palms and a little more. The distance from the extreme edge of the shore to the orange-tree enclosure was a sixth of the diameter, and thus measured 166 paces, 10 palms. At this point the fields began, proceeding toward the centre and occupying another sixth of the diameter. Thus an entire third of the diameter was taken, leaving another sixth between here and the centre, namely 166 paces, 10 palms. From the peristyle that I have described, some space was eliminated by the contraction of the fields, so as to avoid distorting their squareness. Therefore they ended before completing a third of the diameter. This was deliberate, in order to give the right proportion to the last square formed by the lines drawn to the centre. The space intercalated between

311

the river and the peristyle was all covered with graceful greenery, as has been sufficiently described above.

The space in question ended at the flowery bank of a river, more limpid than the Argyrondes in Aetolia or the Peneus in Thessaly. Its margins were of precious green Spartan stone, green as Augustus's or Tiberius's and fitted tight as a breastplate, so that the entire river was channeled within these marble borders. The banks were not tangled or overgrown by osiers, nor by willow-groves, rushes or reeds, but they channeled the pure and silvery water between surfaces made gladsome and beautiful by many sorts of well-known flowers. The river surged and flowed through openings and subterranean pipes, and bubbled up in various well-chosen places, then ran rapidly along aqueducts of fine stone to irrigate, with a pleasant murmuring, this entire place of happiness and consolation.

Thereafter the water flowed quickly to its terminus at the sea. In this way the clear river emptied its increase through the drains distributed throughout, so that it never overflowed but remained contained and always at the same level. Its width was twelve paces. The surging veins of water outdid every famous spring in splendour, even that of Chabura in Mesopotamia; nor could the virgin Castalia equal it. Like the latter, this spring gave fresh water with a musky but clean odour, shooting sixteen palms high. Hercules' fountain in Gades did not flow with such plentiful and fresh water. These waters were so limpid, pure and subtle that they placed no obstacle or distortion between the sense and the object. Everything that lay on the bottom was perfectly visible, and everything around was reflected in its integrity as in a mirror. The river-bed of gold-bearing sand was level and full of fine pebbles of many bright colours.

The leafy, green and humid banks of the river were adorned with flowering narcissi and with the pungent bulb or sea-onion that grows by water. The hyacinth was not wanting, nor the lilies of the valley, the gladiolus that grows in corn and the Illyrican variety. The marigold flourished there, the equisetum or horsetail, and the dandelion. There was a host of violets: Tusculan, marine, Calatian and autumnal; there was sea-mint, also called cimiadon or trachiotis, and other noble water plants. There were also countless river birds: the kingfisher with his blue plumage and other quick little water-fowl. The long-necked swans were there, dear to augurs, with the dying song that they sing on the waters of Meander.

Upon the handsome banks on each side of the river, orange, citron and lemon trees were distributed in harmonious order, three paces tall from the trunk to the top. The trunks rose for one pace before the branches began to spread out, then the branches met and were cleverly interwoven with each other so as to make an arch that was three paces from the ground to the summit.

The remaining branches vaulted over the river from one bank to the other, intertwining in artificial union and friendly embrace to make an excellent pergola and a pleasant shade.

The vault of the pergola was dense with leaves and elegantly joined, showing a perfect shearing or clipping in which no branch exceeded another, unless for the sake of grace and beauty. It made a peaceful shady place, trembling and airy at the soft breath of Favonius, and full of food, which could be seen through the greenery in its first growth of white flowers and hanging fruits. There were hiding-places suitable for querulous Philomel, ever singing her sweet laments which sounded perfectly clear, precise and without echo, thanks to the grey-eyed daugh-ter of almighty Jupiter, the thunderer. Oh, how readily the wandering eyes were enticed and gently persuaded to gaze on this river! Various boats and skiffs were going to and fro on it, delightfully ornamented with gold and rowed by many maidens with lovely hair interwoven with various scented flowers, wearing filmy, crêpe tunics or shifts of saffron yellow slashed or eyeleted with gold, trimmed and belted over their nymph-like nakedness with lascivious ornaments, and volup-tuously offering their rose-tinted flesh to the unimpeded gaze. So much so, that as the spring breezes lovingly pressed and moulded their gar-ments to the beautiful feminine forms, every part was manifested according to its motions, revealing with voluptuous grace the white breasts shaped like half an apple, as far as the round nipples, elegantly encircled with an embroidery of gems set in gold. There were also many youths of all the warrior clans who were gesturing, tussling and competing in games, and laughingly offering naval battle to any hardy enough to challenge them. The maidens boldly fought them, took away their clothes as spoils, capsized their boats and bore them away, so that the youths were left in the water, mercilessly stripped and despoiled, offering no resistance to their misfortune but making a jest of it. Then the nymphs left them and started teasing one another, starting new skir-mishes among themselves, sinking the stolen skiffs and taking pains to
right them again, then resuming the merry battle with hearty enjoy-

ment. Their graceful, girlish mouths gave out laughter mixed with high shrieks as they gesticulated and capered around.

The water was also teeming with a multitude of fish of various beautiful and striking forms, with golden scales and grey eyes. Since nature had given them nothing to struggle against, they were tame and not scared away. Some were big enough to go butting into mock battle carrying the maidens, who squeezed the soft, scaly bodies, free from fishy slime, with their snowy thighs and dainty feet. They swam gently, going obliquely to right and left, obedient to womanly whim and carry-ing any who wished. Crowding together with them were the white swans with sonorous cry and copious tears for their dear Phaethon; also otters, beavers and other river-dwellers, all playing merrily with volup-tuous delight under the topiary tent without any thought that would disturb their pleasure and solace, and avoiding all conflict. A tacit desire arose again in my own soul: 'I would like to live forever in this happy place with my divine Polia.' Every other vagrant desire was extinguished and repudiated, as without delay I renewed my firm inten-tion of loving only my beloved Polia. Nonetheless, I reckoned that my present delight was without a doubt the most excellent and agreeable that I had ever felt, affording me surpassing pleasure and sweetness.

Similarly in the first circular and wooded enclosure there were people of both sexes, always keeping to their own preserve together with the animals that gave them pleasure.

Looking the other way toward the green fields within the peristyle, I saw innumerable youths and lovely maidens at their leisure, playing instruments, singing, dancing, chatting merrily, enjoying pure and sincere embraces, tending their ornaments and their persons, compos-ing poetry, and the maidens intent and dedicated to their handwork: by which I judged that virtue was more in favour than other salacious pleasures.

Beyond this limpid and entertaining river a grassy meadow contin-ued in a circle, like the one between the river and the peristyle. The river was spanned by symmetrical bridges made alternately from porphyry and serpentine, and shining brightly with the best marble-work. They were aligned with the paths that lead toward the navel-point of this mysterious isle that bloomed with a superfluity of delights.

After the meadow there began seven stairs, each a foot in depth and height and continuing all around, so that together they rose seven feet, and were the same in depth. They were of marble-work, alternately of [112]

314

red-veined triglite and of a black stone resistant to the chisel – blacker and harder than the Paduan stone, brilliant by nature without being ground with the cylinder or polished with emery. The stairs did not obey the rule that each step should be half or three quarters of a foot high, and one and a half or two feet deep, but were made as stated, and all to the same measure.

On the top step of black stone there rose an elegant colonnade in pycnostyle arrangement, which went all the way round except when it was interrupted or broken by gaps of the same width as the bridges, which in turn were as wide as the pathways. These splendid bridges were duly roofed by the uninterrupted pergolas that covered the river, and although the paths led directly to the centre, the unbroken circle of the stairs was not violated by them. For, as I have just said, the columns at the top of the stairs were separated by the same width as the paths. The royal way alone led straight from the port to the marvellous circus without narrowing toward the centre; it alone was equal and uniform in its width, and it traversed the ascent of the stairs with a commodious ramp. The stairs were necessarily discontinuous at that point.

The pycnostyle colonnade had double columns, the plinths of whose bases were aligned with each other on the diagonal, and made mutual contact at the corners with the pair on the right-hand side. One column of each pair was of splendidly shining jasper, and after every seven there was a square column of red, topped with a brilliant ball of gilded bronze. The rest were linked and bound with a small beam, zophorus and cornice resting on the capitals, of the same material and colour as the square column and with the proper lineaments. The chal-cedony columns in between the square ones were six in number, spaced at the proper and companionable distance; one of each pair was of green jasper covered all over with spots.

On top of this delightful pycnostyle I saw innumerable peacocks, white, red and normal-coloured, freely running and perching, some unfurling their tails, while others let their splendid plumage droop. Mingling here and there with them were parrots of every species, adding no small adornment and delight to this structure.

One could see the fronts of the stairs carved marvellously with noble Assyrian knot-work; and the better to show it, the cut-out parts were attractively filled with another substance: in the red steps it was azure, and in the black ones, white.

[u2'] Between this impressive colonnade and the stairs there ran a level

marble surround six feet wide, then immediately another seven stairs began to rise, made like the preceding ones in measure, material and colour. All this was followed exactly in the succeeding ones.

On the top stair a container was excavated, with an opening four feet across. It was sufficiently deep, as were the ones that followed, to contain a hedge of boxwood, whose lovely green shone as bright as glass. And in line with the bridges and the paths I saw a tower of the same greenery, nine feet in height and five wide, with an open doorway six feet high and three wide. And so it was with the following ones.

This first hedge was three feet thick and six high (as were the next ones) and extremely dense in its foliage, which was arranged like feathers made from the tree itself. Between one tower and another I could see a cleverly made triumph with horses drawing a carriage, and several soldiers preceding the hero, armed with swords and triumphal lances, all artfully made. The work was beautifully varied: between another pair of towers was a naval combat; between two others, a sea battle; next, a battle in the field; then a huntingscene and an ancient lovestory, all carefully made and exquisitely cut. Thus it continued all around with changing scenes.

Inside this first enclosure, after a circular path like the lower one between the colonnade and the stairs, a marvellous mosaic offered itself for admiration: it was an excessively pleasing work, fit to exhaust every human wit and sense. At first sight I might easily have thought that decorative carpets had been spread out flat on the ground. It displayed every kind of colour used in making such a work, in the style of a beautiful painting, and showed many and various groupings, figures and signs, all appropriately coloured, and little plants with the distinctness proper to such a work. Some were colourful, some dark, and others midway; some were brighter, with the colours of pistachios and leeks; others pale green, or less pale, with a happy contrast of a dark red colour. The principal figures, which contained multiple variations, were a circle between two rhomboids, and a rhomboid between two circles. These alternated continuously in a ring, except at those places where gaps were left for the paths to cross, which always occurred between two uniform figures.

These configurations were enclosed in a circular frame imitating, as [u3] it were, the shape of the island. First they were encircled by the road that went round next to the box hedge, joined harmoniously by the straight paths leading to the centre. These paths were paved: the middle band,

which occupied three-sevenths of the whole width, with a hard, black, mirror-like stone, unmatched by the Indian touchstone found in the river Oxus, and the bands immediately adjacent on either side of it with a milky white stone, whiter than one ever sees in the milky compound of Murano, hard and translucent. There were two bands, one at either edge, made of a fine stone redder than polished coral, and the tesserae were expertly set in the black band. This attractive arrangement was observed throughout all the enclosures that followed.

The following figures were enclosed by the intersecting paths: inside the lozenges were circles, and inside the circles, lozenges; then came various intricate figures of fertile and graceful invention. At the navel of each circle was planted a tall cypress tree, and in the middle of each lozenge, a straight and well-clad pine. Similarly, the circular borders between the limiting paths on either side displayed a measured distribution of various patterns, oval and semi-oval, at whose midpoint green savins rose up, corresponding to the interspersed cypresses and pines, of equal height and thickly branched; they were used by the divine Mother to dissemble calumny. Next, beautiful flowers of every colour were planted in suitable places, with elegant harmony and redolent fragrance.

These pleasant and beautiful green spaces were frequented by people of both sexes dedicated solely to the works of fertile Nature and contented in her service, working for the conservation of this garden. Even Alcinous, the just king of the Phaeacians, did not show as much diligence in the care of his kitchen gardens as was to be seen here. With marvellous and sedulous attention, everything was placed with its twin, and appeared to be native to that very place. It was decorated with marbles of great splendour, and so were the following circuits.

[u3']

THE SECOND garden enclosure followed immediately after the work just described, then at the end of it another seven stairs began rising toward the centre. On the top step was a variegated hedge whose colours amazed the eye, with towers or pavilions expertly made from orange-trees. Two trunks were planted on either side of the doorway, rose through the wall of the tower past the opening or wings of the door, and extended for three feet above the top of the tower, where they met and joined together as one. Then the thick foliage began, cut like a moderate-sized cypress; and thus it was all round the circle, two paces in height. The hedges between the towers were of various colours and species of tree: between one pair there was juniper, between another, mastic, and then arbutus, privet, rosemary, dogwood, olive and laurel. Their spring greenery was all cut in the same manner, the last replicating the first, making a beautiful specimen of the topiarist's art with not a twig or a dead leaf in sight.

In the middle of the space between two towers an admirable pine-tree rose up, while box-trees sprang out at intervals from the enclosing wall, exquisitely fashioned in the shape of symmetrical crescent moons. They filled out all the space between the towers, and were cut with singular skill with their openings or mouths upwards. In the middle, between the two horns, was a juniper tapering in ten stages and thinning out toward its top, with its pungent leaves as smooth as if it had been turned on a lathe. Its thickest part adjoined the middle of the crescent. One stem rose to a height of one and a half feet beyond the cornice, where there was a well-proportioned ball of box.

Inside this enclosure and between the bordering paths, filling out this whole admirable circuit, were little square gardens of marvellous work, showing arrangements of various edible plants.

The first quadrangle was defined by the paths on either side, which caused it to be an irregular square. It had a four-sided lineament of knot-work three palms wide, very neatly made out of bunches of flowers. The outermost band bent round to make a circle at its mid-point; the bands met as they came from the two corners and circled over one another. The resulting loop was knotted round a second band, four feet inside the first one, and the part of the circle that was above went [u4] below the other band, so that the two bands wove alternately above and below each other. And this second four-sided band made loops at its corners in which the knots were arranged with the bands going alternately over, then under.

The loops of the first band opened out inside the second square to make a circle that filled it. Next came another square, the same distance from the second as that was from the first, and this also made loops at its corners near the angles of the second band, on the diagonal line, inter-

lacing as they turned over and under each other. Inside this last square there was a lozenge shape, whose corners made tight loops knotted around the middle of the sides of the last square.

In the triangular space be-tween the lozenge and the inside square, on the diagonal lines, was a free circle. Inside the lozenge was an unknotted circle that filled it completely; and in the middle of that circle was an eight-petalled rosette. In the centre of this was set a hollow round altar of yellow Numidian stone with three ox-skulls. Between these, carved in deep relief, hung bunches of leaves and fruits swelling toward the middle, with loose ribbons tied around the heads and securing the bunches.

This altar had fine lineaments, both socle and abacus being decorated with a beau-tiful cyma and other ornaments. Out of it there grew a savin in compact cypress-like shape; and the opening of the altar was filled with many chervils.

[u4'] The horticultural design of the square I have described was expressed with the following arrangement of colours: the first band was densely planted with marjoram, the second with aurotano, the third with ground-pine, and the lozenge with mountain thyme. The circle inside the lozenge was planted with germander; the rosette, with amethystine violets; the circle around the rosette and outside it, densely flowered with white violets; the four circles within

319

the last square, in the triangles made by the lozenge and the enclosed square, with gith or Roman coriander; their interior, with yellow violets; all the background of these triangles, with cyclamen. The loops between the first and second squares were entirely filled with rue; those of the third square, with spring-flowering primula. The first border, between the first and second square, had a design of acanthus leaves pointing in alternate directions, planted with mountain hulwort and edged with maidenhair. In the centre of the circles located on the diagonals stood a ball, raised about a foot and a half and identical in height, diameter and position except in the four circles made by the intersection of the inserted square with the diagonals. In those centres there rose stems of mallow, three cubits high and coloured pink, purple and mauve, many-leaved and five-petalled, with a large crop of flowers. In the first was wormwood, in the second, incense-tree. In the centres of the loops formed when the circle was made by the first, external band were balls of hyssop. The size of this and the other squares was determined by the circular pathways and the straight transverse ones leading to the centre, limited by the green enclosure and the stairs.

The square next to this one was very charming, beautiful and admirably constructed, with a marvellous distribution of plants and a splendid knot-design picked out by the colours of various simples. Next to the marble borders of the paths that surrounded this square and distorted it there ran a band a foot and three quarters in width, and all the uniform bands that made up the pattern of this square ran contiguously out of it. It was separated from the next square by the path in between. There were nine little squares placed equidistantly inside the principal square, and joined to one another from corner to corner by intersecting bands that met exactly at their midpoints; and this pattern filled out the square right up to the outermost band. By joining the little squares in this manner, octagons were created surrounding each square. Between the corners of the equal squares, another square was formed with its sides facing the corners of the original ones. Each point of intersection was interwoven in the form of a lozenge, whose angles also met [115] transversely at right angles; and this mutual interference neatly formed another octagon surrounding the first one, harmoniously enclosing nine squares. With all its bands interwoven alternately above and below one another, the whole pattern made an attractive and elegant knot-work of multiple, decorative shapes that filled this entire square. The lines of the pattern were made with bands of white marble fixed in the ground, four

320

and a half inches wide on their surface and bordered on either side with simples. Within the boundaries of this stone enclosure there grew various little herbs, dense and level, in a perfect representation of the pattern; and all of this was repeated in every such artfully constructed square. By Jupiter, it was a wonderful exhibition, giving great delight to the senses!

The picturesque distribution of plants was as follows. Every free square was covered with flowering cyclamen, and their bands were of myrtle. The borders of the other bands that knotted and interwove were of mountain hulwort. The four little squares formed crosswise by the intersecting bands joining the nine squares were all filled with wild thyme. The octagons surrounding the free squares were green with various sorts of herbs:

one of laurentiana, one of tarragon, the third of achillea, the fourth of groundsel, the fifth of idiosmo, the sixth of terrambula, the seventh of hazelwort, the eighth of wild nard and the ninth of golden-hair. These two large squares that I have described were repeated alternately all around this enclosure, filling it magnificently.

To finish with these squares, it remains to say that the one just described had an altar of porphyry at its centre. Attached to its corners, [115'] close to the cornice, were four ram's heads with curly horns, accurately carved, from which hung curved garlands, with all the accessories already described on the round altar. On top there stood an antique amphora with four equidistant handles, made with rare artistry from the best sardonyx beautifully blended with its familiar agate. Out of this there issued a smooth box-tree whose lowest member was a spherical or round shape, one pace in diameter. From the top of this came four foot-high stems, equal and distinct, each bearing a ball of proportionate size. On each ball there rested a peacock, with its tail down and its head

in a plate, which was raised higher than the four balls on a medium-sized stem. Beyond the plate there rose another stem with four branches, each topped with a ball, while the stem continued in their midst and held another ball. From this there grew a flattened circle made by two branches bent round, with a ball on each side and one on the very top. This arrangement was followed in every case, with uniform placing, box-tree, altar, vase and lineaments.

NEXT TO THIS another seven stairs followed. A circle of green myrtle ran above the top one like an enclosing wall, with towers like the cypress wall that I have described, and a fleet carved in the foliage, all excellently made. Similarly, inside this enclosure there were squares with two alternating patterns of plants, as follows: two square bands were interlaced symmetrically with a circle included, in the same way as the first square described. In this circle was a surpassing representation of an eagle with its wings spread, occupying the whole circular space.

Instead of acanthus foliage between the two square bands there were capital letters, which started on the left in the space between the bands and the loops. First there were two letters, A L, then in the next space four, E S. M A. Facing the enclosure, in the first space between the loops there were three letters, G N A, and in the next, four, D I C A. Facing the path, in the same manner and location were four letters, T A. O P, then another three, T I M. On the side facing the stairs, arranged as before in the lettered space, there were two, I O, and next to them another two, V I.

[u6]

The bands, loops and circle were planted densely with rue; the eagle, with wild thyme; the space between the squares, with mountain hulwort; and the surrounding capital letters were of marjoram outlined with ajuga. One of the loops was filled with purple flowers, another with yellow and the third with white, all very prolific in their blossoms, never dropping them but constantly in flower. The herbs, too, were always

322

green and of uniform height, forbidden to follow the destiny of fecund Nature. In each triangle made by the circle and the corners of the inner band there was a ring of plants of the same colour as the enclosing bands, and the background was of myrtle. In the centres of these rings

were planted four spherical balls of dense and regular myrtle, on two-foot stems; and so in all the others.

The other square, with its bands and circle, was as just described, only there were two birds inside the circle: an eagle on one side and a pheasant facing it on the other side, beak to beak. They were standing on the rim of a vase which had a small foot, and raising their wings. Between the loops of the bands, starting from the eagle's side, three letters were formed in the first space, S V P, and three in the next, E R N. In the upper part, three letters in the first space, A E. A, and three in the next, L I T. On the pheasant's side, three letters in the upper space, I S. B, and three in the lower, E N I. Between the two lowest bands, three letters in the first space, G N I, and three in the next, T A S.

Within the circle, around the outlines of the figures, all was planted with mountain hulwort, and the bands with laurentiana. The eagle was of groundsel, and the vase of asaron, with the opening inside its rim of myrtle. The whole length of the outside bands was of periwinkle, and the other band of aquilegia. The circles that fitted in the corners were filled with wild nard, with foxgloves inside and outside them. The letters were of wild thyme, the spaces of golden-hair. The insides of the loops made by the bands were of wormwood. The rings in the triangles had balls at their centres, two of fragrant aurotano and two of lavender, raised a foot and a half on their stems. In the others were alternately a ball of savin and one of juniper, three feet high. All the herbs had beautiful foliage, freshly green and lovely to behold; it was a wondrous work of accuracy, amenity and delight. Tiny pipes in orderly arrangement irrigated it with a spray of fine droplets.

[u6']

FOLLOWING this, seven more stairs rose according to the same rules. On the top step was an admirable circular trellis, all of shining red jasper a sixth of a foot thick, with elegant pierc‑ ing that conformed to its beautiful shapes. This trel‑ lised enclosure and the following one were contin‑ uous and without any opening, because here the straight paths leading to the central island came to an end: one could only continue along the tri‑ umphal way. The following enclosure was similar.

In this voluptuous enclosure I saw a densely shaded wood of rare trees. There were the two female terebinths, resistant to age and of a splendid blackness and heartening fragrance. There was the bdellium with its oak‑like foliage; the Assyrian apple, always bearing fruit; the precious ebony and the pepper‑tree; the cariophyle, the oil‑nut, the three kinds of sandalwood, cinnamon, and the praiseworthy silphium such as is not found in the valley of Jericho, nor in Egyptian Meterea. There was the white costus, such as the Isle of Patale cannot produce, and the fruiting nard with its sharp ears, famed for its seeds and its leaves. There was the aloe‑wood with its indescribable sweetness, such as the source‑ less Nile cannot provide; the storax, the stachys, the incense tree, and myrrh such as does not grow in Sabaea; and an infinitude of other shrubs and aromatic fruit‑trees. The ground was very level, covered all over with the wild spikenard that rivals nard, not to be found in Pontus, in Phrygia or in Illyria. This delicious place was the home and meeting‑ [u7] place of strange and beautiful birds, never before known or seen by the human eye. They were intent on their love‑making, hastening with delightful chirping through the branches that were modestly clad with bright and never‑falling leaves. In this blessed, happy, comfortable and leafy wood were streams of bright water rushing through little channels and winding rivulets, and sacred springs running with a soporific murmur. And here, beneath the cool, interwoven shade of the young

leaves, there echoed many a lively conversation as countless noble nymphs sequestered themselves, together with some of the opposite sex, to enjoy a different pleasure from the others. Fleeing from sweet Cupid, they sang to antique instruments and busied themselves in the dark shadows with rustic pursuits. They wore closed garments made from thin silken crêpe dyed pale saffron; many of the crowd also wore garments of swan-white, yellow and yellow-green, and a few were in violet, shod with sandals and nymphal shoes.

Now all the inhabitants of these voluptuous places, with the exception of those just mentioned, hearing of the triumphant arrival of the archer-lord, immediately presented themselves in reverent and festive fashion, then returned to their several pastimes and their continual recreation.

Lastly, beyond this wood a new stair of seven steps followed without any interval. It had on the topmost stair an impressive colonnaded enclosure, following in its construction and material the earlier one that came after the river. It formed a wall around a spacious site, separate, unimpeded and flat, which was decorated with a marvellous creation of emblematic mosaic. There were interwoven rings, triangular, quadrilateral and conoid figures, basket shapes, semicircles, rhomboids and scalenes, put together beautifully in multiple patterns, polished like a mirror and distinguished by a rare variety and taste in coloration.

The last and central sixth of a mile, between the river and the centre, was proportionately divided. It consisted, as I have said, of 166 ½ paces, 12 of which were taken by the width of the river, and 10 by the field beyond the river. All the stairways occupied 8 paces and 2 feet, in horizontal and also in vertical measurement. The little path was 6 feet wide. The first garden was 33 paces, the second 27 and the third 23, and the wood was 25 paces wide. The area around the theatre was 16 paces, and the theatre contained 16 more from its edge to the centre. And that suffices about the measurement of the island.

AFTER THEY HAD DISEMBARKED FROM THE
BOAT, A HOST OF NYMPHS CAME TO MEET THEM
WITH SUPERBLY DECORATED TROPHIES. POLI-
PHILO TELLS OF THE MYSTERIOUS WAY IN WHICH
THEY OFFERED THE DIVINE ORNAMENTS TO
CUPID, AND OF THE PROCESSION OF HONOUR IN
WHICH CUPID WAS SEATED ON THE TRIUMPHAL
VEHICLE, AND POLIA AND POLIPHILO FOLLOW-
ED, BOUND TOGETHER; AND THEY CAME WITH
GREAT POMP TO THE GATE OF THE MAR-
VELLOUS AMPHITHEATRE. HE DES-
CRIBES FULLY ITS EXTERIOR
AND INTERIOR

OFTLY BLOWING WITH HIS GENTLE
breeze, Zephyrus slightly ruffled the lovely golden
feathers of the divine child, and when his tranquil
breath had carried us to the ebbing shore, we disem-
barked from the fateful boat. A numberless host of
demi-goddesses bearing gifts and noble nymphs of especial beauty
trooped up to the divine winged boy, with a great display of ornaments
and pomp. They were sumptuously dressed with divine pride and more
than regal adornment, exquisitely decked out and devoutly respectful,
and in the tender flower of their age; and they were dancing joyful
Pyrrhic dances with virginal allure. Celestial and noble to look upon,
yet showing the proper humility and reverence of servants, they all pre-
sented themselves with ritual magnificence. First of all came the
hunting pastophores, pyrgophores and the jubilant preluders, with tro-
phies of military decorations mounted on sharp golden lances. There
was the cuirass of furious Mars, with the other arms taken in victory:
a bow hung sideways, holding up the cuirass, with a quiver of
arrows tied to one end and a battle-axe to the other. Below
the cuirass was spread the net, and beneath that a
winged child's head with two faces, and a ball
fixed on the haft of the lance, which passed
through its middle and bore a star-
crested helmet on its point.

* * * * *
* * *
*

A second nymph carried another trophy, on whose point was a laurel-
wreath above a pair of spreading black eagle's wings; beneath these, the
face of a noble child, then two crossed thunderbolts bound together
with flying ribbons woven of gold and silk. Attached horizontally to
the shield was a sceptre on which a superb tunic was hung.

Another nymph bore a trophy of a helmet surmounted by an ox-
skull, and beneath that an antique cuirass with two shields tied on by
the arm-holes. Two bands hung down from this, one on each side,
holding the lion-skin with the knobbed and knotted club.

Following this there came a nymph [118']
bearing an especially well-finished
trophy. The top of the spear tapered up to
a point, from which a cover descended
above an inch-thick roundel; it resem-
bled a platter placed upright, with a
circular form carved in its centre, some-
what like a suppressed pedestal of a vase.
Next beneath it there was a tablet in-
scribed thus in capital letters: WHO
SHALL ESCAPE ? – and under
that a little ball.
Another roundel
followed, which
was similar to the
first one, only smal-
ler. It was flanked
by a pair of wings
and rested upon a
solid vase-stand of
the Massician type.
Below this a longish
baluster descended,
and after that a little
ball.

Another nymph
likewise carried a
spear bearing an
oval figure at its point, all studded around with
bosses. At the centre of it there was a rounded sap-
phire of a similar oval shape, an inch in breadth,
and beneath this was a tablet inscribed with the
single word: NONE. The spear made a kind of
baluster shape as it passed between the two wings,
then below that came a vase-stand, as in the one
previously described.

328

Following on this, another noble trophy was borne in, having at the top of its spear a ball upon a pear-shape, above a moon-like crescent made from two feathers of foliated gold leaf, one leaf superimposed on another like the pages of a book. The rest of the feathers were bent round in a circle so as to make a coronet bound with dentillated ribbons, and the spear passed perpendicularly through the middle, making a narrow baluster form. Beneath the crown was a little ball, then the lower part of a ewer which came down to the place where two wings joined. Below this there was an oval figure with a white ball shining at its centre; and below this was fixed a ball that was grooved like a melon, suitably tied with flying ribbons.

There were too many other trophies to describe here. Some had their shafts of ebony, others of yellow, red and white sandalwood or of whitest ivory; some were gilded, cased with silver, or made from other precious woods. Everything was wrought of the thinnest gold and silver and from light materials; also from silk, of green and every other lovely colour, with charming flowers and abundant gemstones ornamenting them at suitable places. Everything was harmoniously arranged and magnificently made, with hanging pendants or perforated beads of precious stones threaded on fil

aments of gold, and all was painted with colours as charming as one
could wish, sparkling and scintillating. The bearers were wearing
gloves, cleverly woven with many knots and florets of gold and silver
thread and of varicoloured silk, secured like purse⁄strings in a gem⁄
studded border around their pink, fleshy arms, with golden laces
beautifully woven together with different colours of silk.

In front of all these trophy⁄bearers went one bearing the banner that
had been pulled out of the boat, and was now raised on high. Another
followed immediately with a ritual wedding⁄spear that had at its tip a
Cupid, winged and unveiled, bending his bow and treading on a ball.
The latter was on top of a circular laurel⁄wreath made from gold leaves,
resting on the bottom of an inverted ewer and tied at that point, while
the bright ribbons that encircled its joint flew freely outside it. Inside the
circle was a tablet, the spear passing through its thickness and through
two balls attached to the middle of its top and bottom. Similarly, a small
shaft pierced the tablet laterally to left and right, protruding a little bey⁄
ond the wreath. From the ends of this shaft hung two cords of twisted
gold and silk strung with berries of precious stones. On the underside
of the wreath was a ewer with its bottom uppermost and its mouth,
opening like a pomegranate flower, grasping an oval figure;
this had lineaments following its form and two little balls
on the circumference, one in the middle of either
side, and another at the bottom. Lastly came
a golden knot of variegated weave, with
free⁄flying ends. On the two faces of
the tablet was written in Greek
capital letters: ΔΟΡΥ⁄
ΚΤΗΤΟΙ.

Many other trophies passed by in joyful procession, brightly ornamented with divers flowers, leaves and fruits attached to gold and silver plates and enamelled in every colour, infinitely decorative and finished with exquisite elegance. They bore other remarkable and victorious mottoes, and were decorated with arms, spoils and booty taken by the powerful and divine archerboy. The bearers proceeded with some distance between them, with much applause and with sacred dance accompanied by instruments and the throaty cries of the trophybearers.

After these, first his divine wife Psyche presented herself in royal costume, with a foundation of vermilion velvet shot with gold, with a weft of triple gold thread and bright silk unrivalled by that of Malaga and Almeria in Spain. Next came her companions, in silken garments such as our stepmother Nature has forbidden human ingenuity to create: they were dyed in tasteful, particoloured shades, in splendidly novel and unusual styles, richly bejewelled, and in the gentle stirring of the fresh breezes they formed quivering pleats that wrinkled over the delicate and pure bodies and the virginal hips.

Some had closefitting bodices of gold scalework, beautifully and closely ornamented with brilliant gems. Others covered their breasts with silken garments – breasts whiter than the wintry frosts of Capricorn and pleasingly adorned with the first swelling of their bold nipples, resembling highbreasted apples with semiglobes standing out from them. Over these was a smooth bodice of seablue colour with a spiral design of sumptuous Phrygian work, rich in orient pearls; it swelled somewhat as it made a magnificent covering for the whole diaphragm, or the whole part above the belt, with artful rinceaux of rare foliage such as the Phrygian embroiderers never thought of. There

were also Phoenician red bodices with slightly raised shell-forms of small, round emeralds; leek-green ones seeded with glowing rubies; yellow garments dotted with shining sapphires; crimson and bright scarlet ones with brilliant pyramidal diamonds; and amethyst or purple ones with perfect white pearls.

There were still other remarkable and lively colours in this display, such as mallow, rose of Tyre, murex, realgar, sky-blue and pomegran-ate. Some of these silken garments were smooth, others velvet, and some shaggy with three or fourfold threads, excellently embroidered with charming figures of flowers and small beasts. Others were woven with diligent artistry from a silken warp and a gold or silver weft, in every colour and configuration. Yet other garments had alternating stripes: gold, then blue, then green, and after that silver, and the rest of the colours arranged to match, with beautiful weaving and voluptuous contrasts. Some nymphs were dressed in the purple of the sea-snail, some in twice-dyed Tyrian purple, and others in transparent garments such as the Scythians never made from their tree-wool, variously striped and variegated; and yet others were cloaked in thin cotton that veiled their beautiful bellies and clung sportively to them.

The nymphs also wore on their heads ornate hair-bands with a mar-vellous combination of gems in vermiculate patterns, ingeniously made in exquisite networks with gold-threaded ribbons forming lozenges and reticulate shapes. They also wore golden tiaras in which the twisted, twofold threads were quite distinct from one another and joined in threefold union, one gold thread being spun over two threads of silk, with exquisite knots at their junctures. Among them was an orderly variety of resplendent circular gems, matching the variety of the nymphs' garments. Others had their heads divinely encircled by golden diadems.

All of these had little lozenge-shapes, white with roses made from six large pearls, with a heavy conical jewel shining prominently in the middle, of the same kind as on the embroidered ribbons. And there was an ornament on the headband, at the point above their ample foreheads where the thick hair parted and fell in a beautiful shape of gentle curls. Some had elegantly pinned their golden hair to their heads in an attractive bun; some had knotted and twisted their hair in a nymphal chignon, dressing it beautifully in bindings and knots around their shapely necks and interweaving it with threads of silk and gold. Others had tied their fine hair into elaborate knots above their smooth temples,

or had partly concealed their lively brows: they had their hair curled and crisped like bright threads of gold, winding it around in tight ringlets. Some wore their hair in front, framing the rosy forehead, deliciously inconstant in the gentle breezes and floating decoratively around the head and neck. And the ends of the ribbons went back again past the beautiful ears, embroidered with brilliant matching rubies and splendidly fastened with diamonds, green emeralds and blue sapphires, while many lancets of gold and silver foil hung down waving and scintillating, suspended beneath the tresses by a string of orient pearls. The rest of their long hair flowed down freely and copiously in beautiful waves over their delicate shoulders, past their firm, fresh buttocks as far as to their well-rounded calves.

There were some who had lasciviously loosened their washed hair from their gorgeous napes and let it hang down from the crown of the head in equal parts, divided by a gold string that wove in and out above the milk-white neck; then with the utmost smoothness the two tresses wound around themselves and were gathered into a fine spiral that reunited elegantly on top of the head, thinning out at the crown, where a precious bunch of pearls made a most beautiful bond of the pair; then they were masterfully drawn down past the small ears, trained over the smooth temples, and thus simultaneously reached their home and their voluptuous union.

Some nymphs had reddish hair that was splendidly interwoven and bound around the head with a matching garland of spring flowers. Some had hair more yellow than the scales of pure orpiment, splendid in its lustre and colour, made into decoratively twisted whorls and ornamented with nymphal voluptuousness by the pretty addition of various precious stones. Others had hair more coal-black than the feathers of Aesacus, glossy, superbly waved and covered with translucent golden veils secured above the parting by hairpins. Their hair wafted gracefully, splendidly curled in many ringlets, made with an art and artistry that outdid every lascivious design and every nymphal voluptuousness. It was tidily combed and most decoratively arranged, making a veritable snare set with perilous sticky lime to catch amorous hearts! They also had spiral ear-rings of inestimable value hanging from their pierced ears, while their straight snow-white throats were collared and encircled with precious necklaces and braids, and with outrageous collars, sumptuously bejewelled. No one could possibly imagine costlier ornaments or a more shameless exhibition of affected femininity.

In addition, some of them had their little feet shod with purple boots, fastened with golden anklets that ended around the white plump-ness of the calves with a refined woven hem an inch in width, magnificently decorated with precious stones and laced with gold and silk. Some, with voluptuous vanity, had clothed their bare feet with scarlet silk slippers. Many were shod with half-boots of gilded leather embossed with many elegantly executed reliefs. Quite a number wore sandals of pink leather with gilded eyelets, exquisitely adorned with moon-shapes or recurved openings, while from the sole came thongs that made the most novel and amazing ties, tongues and straps that could ever be described, of blue-grey silk and gold filaments, knotted around the plump ankle with such beautiful and graceful entangle-ments as the mind could ever conceive. The thongs, woven of ultramarine and tied in a graceful knot, issued from the narrow sole and embraced the big toe, passed over the others as far as the little toe (all whiter than calcined bone), then rose to make a beautiful union at the swelling of the calf, while a narrow strap of gold vermiculate work dec-orated with bright gems encircled the heel and passed over the instep of the ivory foot.

Some of these nymphs were voluptuously shod with smooth silken cloth of various colours, covered with figures of great artistry and con-trasting with their splendid nymphal garments, handsomely fastened with golden clasps, hooks, buckles and laces. The small, plump feet were kept on their exquisite sandals by elegant gold rings and pearled latchets, and fittingly retained by knotted laces of coloured silk and gold with polished silver ends: decorations fit to dazzle and blind even wild bulls!

Oh, what finesse, what beauty and brilliance, what admirable orna-ment, what rare artefacts! What an extremely skilful and well-planned artifice this was, to allure the gentle beholders with pleasure and to trick them to death!

It was the same with the costumes: beside their proud and delicious design, fully worthy of this happy place, they had artful fringes and little slashes or gaps through which a contrasting colour subtly showed, and marvellous vermiculate enbroidery. And below the tight belt there hung a row of golden fibulas of vermiculate work, some with choice pearls as big as hazelnuts, which instead of being pear-shaped were tapered like an alabaster vase. Likewise, in place of the golden brooches some had a woven golden band or ribbon of vermiculate work, two

inches in breadth from its wavy upper edge to the ambient fringe that was joined to its little indentures. And those with the pear-shaped pearls had conical gems in flat, square settings that made a happy match with the rounded ones and an elegant harmony of the variously arranged colours and shapes, all going together in a beautiful way. I also admired some who had a superb and godlike style, and whose adornments were rare and striking, unbelievably sumptuous and precious beyond compare: they wore a tight tunic of smooth, shiny amethyst silk which descended with moderate curves as far as the last vertebra behind, and to the female parts in front. It had raised embroidery of antique foliage and medium-sized pearls: the tips of the foliage ended with knots upon the breasts, and defined the navel by an open space in which were rosettes and other shapes, wonderfully made from precious stones set in gold and finely ornamented with enamel and smooth vermiculate work. The hem of this tunic ended with wonderful fringes of cloth of gold, at the bottom of which great pearls and golden pear-shapes hung alternately and bounced around playfully. Following this, a skirt of green silk with a weft of gold descended to the knees, beneath which another skirt made of scarlet with a golden weft reached as far as the heels. These many-pleated garments had a fringe an inch and a half in width that ended with a double row of large pearls, and within the embroidery of the first skirt, gems of inestimable price formed lozenges containing sparkling circular gems of the same colouring, placed artistically on a golden field.

Above the lowest edge was a serrated hem with a round stone hanging from every point, while within the indentations little gold darts trembled in the breeze. From this fringe hung a network of gold threads knotted in lozenge-form and secured with little round gems. A gem was placed at every intersection, with a loose golden thread passing transversely through it. Above each gem, another circular one of the same shape and size was attached on the edge of the embroidery, hanging with a golden tassel. The transverse thread passed through a marvellous oval stone in the centre of the lozenge, and a round gem was similarly threaded to either side of it. Every stone was exactly placed and elegantly arranged, with the various colours distributed equally. From the lowest points of this mesh-like configuration there hung priceless square-cut gems with little spherical stones suspended from them, while alternating with these pieces were oblong or oval gems, all of remarkable size. The second fringe beyond the pearls consisted of half-rounded

tablets an inch long and half an inch wide alternating with two circular shapes, then more two oblong ones, with other additions of little stones and other small decorations beautifully inserted to give pleasure and grace and to astonish Nature. They flashed with perpetual lightning, and made a delightful harmony of colours with the beautiful sleeves, the splendid armpieces and the ornate tunic. The armholes and collar had the same kind of beautiful embroidery around them as already

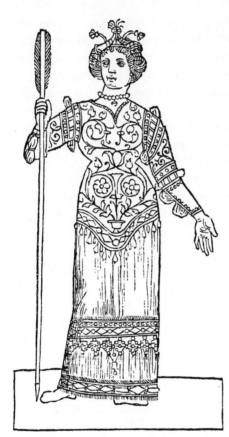

described. The sleeves, made from two parts, were covered with this from the shoulder to the elbow, then from the elbow to the wrist they were all of cloth of gold woven with a fine pattern, ringed with an embroidered hem diligently designed in nymphal style and secured at the elbow with little golden strings or twisted cords. At the joint there was a place for the shining undergarment of thinnest snow-white cotton to emerge elegantly in many little bunchings and compli-cated curves. The openings were bound with double laces of silk threaded through cir-clets or little rings of gold and tipped with pure gold, with hanging knots in exquisite vir-ginal taste. Why ever did desire and lust cohabit there with wisdom, power and will? By Jupiter, it was so pleasurable to my amorous eyes that I desired nothing else than to be able to gaze per-petually at these splendid nymphs — so beautiful, so shapely and so delightful with their lively glances, decked out so sumptuously and las-civiously, with their snow-white garments radiantly shining. With such enticement, a man could give himself up willingly to cruel death. O [x5] infectious artifice! O alluring company! O weapons of war made for

the easy conquest of every heart that is secure, healthy, safe, free and resistant! You are made for its speedy ruin and rapine, laying it low in an instant, catching it unarmed, totally subjugating it and dragging it without any resistance. All continence, be it never so controlled and inflexible, you overturn and shatter. These are the true and infallible accomplices of troublesome Amor, aided by a goodly number of savage executioners to besiege the free and unfettered thoughts, which are prevented by their abject state from prevailing through boldness of heart, and from escaping that seductive and unavoidable sweetness, no matter how hard and skilfully they try. For prolific Nature, with her subtle ingenuity, has invented so beautiful and comely a work as an exquisite trap, as her tool of destruction and as the skilled accomplice of her torments, which, alas, it would be reasonable to use against marble statues, but not against fragile human hearts. For if this noble and divine sex, even when despoiled and naked, can hurl us into such confusion and subject us to such trials, what can it not do when clothed with the pernicious device of these voluptuous adornments? It is simply the case that women think it insufficient for us to die naturally of love, without the addition of these ingenious schemes by which unhappy and feeble lovers are more easily lured to their destruction. These divine objects fill and confuse the heated breast with boiling sighs and ferment the heart to love, so that an unremitting onslaught of incendiary sparks excites the amorous and fervid flickerings to excessive heat. I cannot now explain properly how weakened I felt by an assault so inescapable, well-equipped, insidious and impetuous, even though I had such a firm foundation of love established sincerely in Polia. 'Alas,' I said silently to myself, 'O beautiful Polia, my first love, guard well the prey you have caught! For it is a great trial to pass among these piratical deceivers, these daylight assassins and insidious burglars, who against all justice are commended and praised for their amorous offences, and all the more desired, reverently cherished and sweetly loved by their poor victims.'

Now in her joyous face, beneath two semicircles fine as silken threads and between eyelashes dark as lucent amber, two eyes shot forth their arrows, sparkling more brightly than the radiant stars that shine in the limpid sky. Her complexion was fairer than fresh red roses, and her unrouged cheeks had a charming and natural blush like Decimian [x5'] apples reddening in wine-bearing autumn, and a white more bright than polished ivory, in which the sun appeared even more clearly, perhaps, than Titan appearing to the Achaemenids. The Egyptians

337

showed no greater reverence to the images of Osiris, Isis, or Serapis with his basket and three-headed hound, nor the Persians to Mithras in the sacred cave, than the delicious and divine nymphs showed at the coming of their lord. They made overt signs of veneration and elabo-rate gestures of due submission, endowed as they were with a beauty never seen before, decked with splendid ornaments, outstanding in the integrity of their elegance, and dressed to the last degree of luxurious provocation.

At this point the beautiful Psyche arrived, surrounded by a troop of cheering devotees and preceded by a numerous escort. She received her dear husband with kindly respect, in an unaffected and friendly manner, and with great reverence placed on his head a crown such as Hieron never consecrated. Two nymphs of her honourable company received us: one of them, Imeria, graciously received Polia, and the other, the merry Erototimoride, took me by the hand. Then many others followed us joyfully, three by three, in solemn and orderly proces-sion, with splendid pomp and due reverence, and with vigorous nymphal genuflections.

First came Toxodora: she courte-ously presented the curved and wounding bow, which was tightly strung. She was between two others: one of them, Ennia, held in her plump hands a small inlaid vase with two handles, made from splendid deep-hued sapphire, with its wide mouth carved proportionately. A slightly sloping neck decorated with great finesse with many flowers descended from the mouth to the moderately swelling body. The handles were attached at the point where this rounded body began to diminish: they were diligently made in the form of vipers biting the elegantly gulleted rim. Then came a band around the thickest part of the body, engraved with marvel-lous images and expertly finished; and where the thickness began to diminish to make a graceful and longish container, oblique grooves were carved to a moderate depth. They ended above a somewhat [x6]

338

bulging pommel, thoughtfully placed with a foot beneath it. The vase was filled with many beautiful flowers which Ennia strewed about; and that which Ennia playfully scattered, her companion Phileda collected in her bosom.

Likewise Velode advanced between two other splendidly appareled nymphs, joyously presenting to her lord a wonderful quiver of superb craft and rare design together with two speedy arrows. The point of one was of pure silver, while the other was armed with black, heavy, cold and baleful lead. Cupid fastened these weapons to his tender and divine side, or rather over his winged shoulders. Meanwhile the companions Omonia and Diapraxe were playing merrily with two balls, alternating them. Omonia's was of bright gold, while Diapraxe had one of fragile crystal; and when one of them returned the golden ball, the other threw the crystal, taking care that they did not collide on the way.

Next in order came the beautiful and reverent Typhlote with her two followers, performing the correct religious honours and dignities. She bowed and offered a fine veil for Cupid to blindfold and cover his open eyes. She had with her two wanton maidens, with a shameless air about them: one was called Asynecha, who kept twirling, now to the right, now to the left, and dancing extravagantly like Thimele the entertainer, juggler and famous enchantress.

The other, Aschemosyne, presented herself among all these clothed nymphs fearlessly naked and provocative, just as if she had drunk of the Salmacian spring. In her left hand she held by its centre a sphere made from gold plates, and with her right she seductively prevented her long hair from covering her plump and wriggling buttocks. She was in a truly wanton condition, making obscene tribadic motions and rolling her eyes. With her prurient actions she resembled some shameless Gadi-tanian, crudely gesturing with excessive lust. The filthy Hostius, watching sodomites in concave mirrors, was no worse than she.

Immediately after this, three other nymphs presented themselves as improvident women. Teleste, the first, was dressed in fiery crimson with her hair let down negligently and hanging in little curls over her wrin-kled brow, as she elegantly offered her god a lighted torch. One of her
[x6'] companions, Vrachivia, bore a emerald urn of the most skilful antique manufacture: an audacious work, if indeed it was made by human hands. The neck was fluted around with deepish grooves or channels, slightly increasing with perfect regularity as they ended at the swelling of the vase. Then the attractive belt descended towards the rounded

bottom, where the body thinned out. It was covered with a matchless decoration of parsley-leaves, carved from the solid in high relief. Exquisite foliage, continuous with the rim of the mouth, curled down toward the neck to form two quaintly shaped handles; and there was a

small foot. Sparks were flying out of the wide mouth, glittering as they passed through the air and exploding with an amusing pop; then they went out and fell to earth as glowing ashes.

The other companion, Capnolia, was carrying an earthenware or brick vessel with a narrow orifice, quite elon-gated and diminishing to a point at the bottom. Around its swelling, beneath the handles, thirteen equally-spaced Greek letters were carefully impressed: ΠΑΝΤΑ ΒΑΙΑΒΙΟΥ, with many other decorations and oblique grooves. The part from the letters to the mouth was pierced with many holes, out of which issued a nebulous and fragrant smoke that dissolved to nothing in the air.

Having finally received the mystic offerings, the fateful love-tokens and the appropriate ornaments, the divine child took his seat upon an antique golden chariot or vehicle prepared for his triumph. It was all of gold plates and encircled by an embroidered frieze nine inches wide, on which were inset gems that shone like the sun: they were of inestimable size and price, of imperceptible artifice and rare design. The chariot was divinely invented and perfectly constructed. The two wheels had fellies of gold, and the spokes that came out of the central hub, where the axle was attached, were shaped like longish balusters, made from various precious stones that flashed with colour.

SEATING himself, the triumphant boy gave a nod, and straightway we two, Polia and I, were seized and captured by the noble nymphs Plexaura and Ganoma. Our arms were pulled back and our hands held behind us, then Polia and I were tied and bound like captives with ropes and garlands of roses and other flowers all woven and netted together. Then, gently and willingly, we were attached by the noble nymph Synesia behind the pompous and divine chariot of the triumphant victor and prizewinner.

At this, I began to be somewhat afraid, but soon reassured myself because the nymphs and my renowned Polia were laughing facetiously. Inquisitive Psyche followed immediately behind us, and after her the young maidens who had reverently made the offerings. Psyche wore the customary robe or overgarment of a married woman: an ample cloak or chlamys of cloth of gold, such as Darius never received from Syloson, nor Numa, its first inventor, ever wore. It was fastened in folds on the right shoulder with a brooch made from golden rings, on which, set among massive carbuncles and matchless touchstones of splendid lustre, was a table-cut diamond an inch and a half long and an inch wide. It was stunningly bright, and of a richness and a price exceeding
that which Gyges presented to Pythian Apollo. An intaglio was cunningly engraved upon it, not by the hand of noble Pyrgoteles but by

some divine power, representing Cupid cruelly wounding himself and Psyche rashly handling the arrow with its lethal prick. With her free arm she was holding the speedily flying golden arrow, her fire-spit, and on the other side her cloak was elegantly thrown in graceful folds over her left shoulder, showing its reverse of fine, felted cloth of gold. In that hand she held an ancient lantern of hyacinth, superbly carved, that was lit and gave forth sparks. Her sumptuous cloak, richly fringed with wondrously precious stones, was worn over an exquisite and festive garment of green silk wefted with pure gold, and belted beneath her swelling breast in a divine and delicious manner.

This proud vehicle of Amor's triumph was pulled by two scaly skinks that were larger here than in nature, being raised and fitted for draught and for the sake of this amorous office and mystery. These quadrupeds had long necks and triple tongues that flickered and flamed; their scaly breasts were decorated with a remarkable knot-work of reins and halters woven from cloth of gold, with prominent round studs excellently worked from gold in various relief-patterns, alternating with flashing and radiant gems. The unusual harnesses were attached by golden buckles and decorated with large gemstones. The skinks drew the chariot not at a run, but at the moderate speed of a triumphal procession.

Before this divine triumph and all the triumphal nymphs whom I have described went the reliquary-bearers, then the trophy-bearers, and the torch-bearers with their torches bound with gold; and after these the lamp-bearers with golden lanterns, burning resin or white wax or some other pure substance and giving a clear, lustrous radiance. Next came the perfume-bearers with their golden flasks of a workmanship never seen before, and with golden incense-pans or censers, distributing a marvellous fragrance exceeding even that which was diffused throughout this happy place. Some had golden bottles with tiny mouths through which they constantly shook drops of perfumed liquor over everyone. Several others, in celestial order, were holding musical instruments in their slim hands and playing pleasant symphonies with sweet modulations on their holed flutes and pipes, and on curving trumpets of gold studded with precious gems. Some were singing together in the Lydian mode, making a beautiful harmony and repeating the lovely songs with angelic delivery and an unfamiliar vocal quality. Others played on the tinkling cymbals, or else had noisy, pattering tabors hanging from their left hands and wound onto their chubby arms near [x8]

the wrist with threads of intertwined gold and silk, whilst their slender and nimble fingers alternately opened and closed the holes of the single pipe, such as Mercury never invented. Its sibilant voice received its sonorous spirit from between their crimson lips, which made the cheeks bulge attractively and turned them the colour of apples. Meanwhile with their right hands they struck the tightly-stretched skin with drum-sticks of white ivory in strict and musical rhythm, gently and gracefully matching the muttering of the drum to the whistling of the flute.

Some were playing double flutes such as Marsyas could never have invented, nor the Phrygians; others, the eloquent lyre or the cithara, plucking the slack strings with their tender and delicate fingers or excit-ing the brazen resonance with plectra. There were others playing on noble and extraordinary instruments such as organs, rattling golden sistra to make their high-pitched noise, and striking iron triangles with rings on them that rang out with a cheerful, sweet and high sound; and there were curved horns that made an unheard-of harmony as they played together with the loud trumpets.

These nymphs were crowned with diadems of spring blossoms, with gold leaves interspersed between their various flowers, which were mostly amethystine and sky-blue violets, purple amaranth, goldenrod and cyclamen. There were also wreaths of sweet clover, with yellow and white violets interspersed in measured arrangement, and other flowers that are used for diadems. White pearls and other gems encir-cled and interwove with their ornate hair, in which some wore elegant ribbons. They gave forth to their listeners a caressing harmony such as even Apollo, I dare say, did not make or match when he struck his lyre for the Heliconian Muses. Nor did the Tyrrhenian sailors hear so sweet a sound when Arion, playing the while, made his voyage to Taenarus astride the dolphin. These musicians did not all perform together, but were set out in orderly sequence, each assigned to her proper place in the procession, and thus these numerous squadrons contributed to the great exaltation, the triumphal adoration and the victorious songs of praise.

Touching these divine matters, I am firmly convinced that it would be futile, however eloquent and facile one's tongue, to attempt a com-plete description of the lovely music, the sweet songs, the solemn and the comic dances, the festivities of the divine nymphs and noble maidens, their singular and incomparable beauty, and their rich, illustrious and elegant adornments. It was enough to interrupt and put an end to sweet life itself, and to dissolve and distract every hard and stubborn heart, to

343

see them rejoicing with their various triumphal gestures and advancing in lively motion; to see this sumptuous and superb triumph with its excess of delights and pleasures, its immense profusion of precious [x8'] things and its overwhelming opulence. It seemed to my eyes to be divine rather than natural, yet thanks to Cytherean grace and Cupid's privilege I was able to behold it made manifest, and was supremely blessed by the clear and real sight of it all.

In the last place, immediately before the two draught-serpents, there came two Aegipans: impudent satyrs with the beards and cleft feet of goats. They were merry and frisky, with fillets of flowering satyrion, elecampane and houndscod forming crowns that pressed down the unruly locks above their goatish brows. Each was carrying a monstrous effigy, crudely hewn from wood and gilded, human only from the threefold head down to the diaphragm, while the rest was square, tapering downwards to a basal gullet with a slab. Antique leaves took the place of arms, at the breast was an apple, and in the middle of the square pillar, at its broadest part, there appeared the ithy-phallic symbol.

Immediately in front of these there walked a refined nymph whose cheeks were blushing crimson in her snow-white face. Her brow was circled with ivy leaves and berries, and she wore a flounced mantle that was blown hither and thither by Zephyr's gentle breath, its lappets waving in the breeze. She carried a little golden vase in the shape of a rounded breast, and sprinkled milk out of its narrow orifice.

Two more nymphs likewise advanced, one girt with the leaves of the female mercury plant, the other with the male variety. One of them bore in her right hand the gilded image of a little boy, intact, and in the other an image with its head, arms and neck mutilated. The other nymph, with especial devotion and resolute awe, carried the image of Serapis, venerated by the Egyptians: it consisted of a lion's head out of which protruded the head of a fawning dog on the right, and that of a ravening

wolf on the left; the whole effigy was contained by a dragon that encircled it, and it gave off sharp rays. The dragon had its head turned to the right-hand side of the image, and was expertly gilded.

[Y1] Thus the triumphant lad advanced with his retinue, proportionately spaced in their long and solemn procession, and with Polia and myself festively chained with flowery garlands and rosy withies. The good-natured nymphs acted very kindly and graciously toward us, enticing us with amorous flatteries and comforting us with their cheerful faces, their natural hilarity and their loving solace.

The procession of the archer's retinue and his amorous spoils followed its triumphal and mystic way among fragrant flowers, preceded by the standards of his famous victory, the preluding of the joyful young nymphs, by ceaseless sport and games and the bright, sparkling light of blazing torches. They passed by scented herbs, green and perfumed trees with their odoriferous fruits, sweet-smelling air and a clear and clement sky, along a road edged by every kind of fruit-tree and covered all over with little herbs and green grass. Not a pace was without roses and copious flowers: everything was fragrant in this happy, blessed, delicious and delightful place. The nymphs advanced in their numerous and divine orders, forming troops of every kind with extraordinary pomp and religious progress that was indeed triumphal. Each was placed at a fixed and determined distance from the other, as they passed beneath the pergola with its every kind of rose and its evergreen fronds and leaves, which made gentle rustling noises.

The whole ground here was lavishly covered and hidden under strewn rose-petals, orange flowers, violets of purple, white and yellow, white and crimson buds of pulliphora, jasmine blossoms, lilies, and other bright and sweet-smelling flowers. Shoots of the single-stemmed aristalthea and twigs of flowering myrtle were strewn one by one on the level pavement, which was made from bright marbles compacted with infinite skill, like mosaic. Many nymphs were carrying thyrsi stuffed

345

with flowers; others, branches of olive, laurel, and especially myrtle, together with other celebrated trees on which bold little birds perched tamely, mingling their garrulous song with the sweet harmony of the nymphs' hymns and canticles, accompanied by soft chords on their stringed instruments. Everyone was rejoicing with heavenly approba- tion, cheerful ceremonies and delicate, virginal dancing, whilst some performed the zealous Pyrrhic leaps and loudly extolled the divine Mother and her mighty Son. With these festive displays and in the utmost triumph, the magnificent procession gradually approached an archway containing an open door, conspicuous both for its material and for its workmanship, which led to a marvellous amphitheatre, built very high and filled with ornaments of art and artifice, the like of which was never seen in Atella, nor in any other famous place. It was exquisitely made and perfectly finished, and would take too long to describe since it was almost unimaginable: one might well say that this zenith of archite- ctural ostentation was no human creation, but rather a divine one.

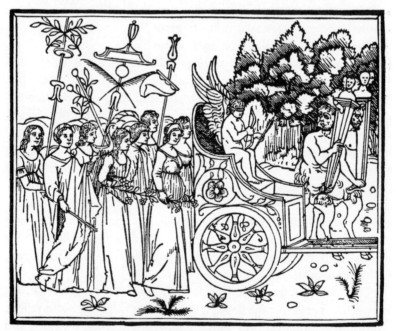

WE ARRIVED with solemn rejoicing, incredible joy and heart- ening delight, while the aspergers sprinkled the processionaries and the whole triumphant host by spraying scented water through fine golden tubes; thus we passed through the triumphal way to the entrance portal.

346

This was a stupendous work; built of oriental lapis-lazuli in which countless flecks were visible, like a powdering of bright gold, and the bases and capitals of the carved columns, together with the beam, zophorus, cornice, pediment, threshold and columns in antis appeared to be of the same stone, which proudly resists hard steel. The reliefs were in antique style, varied, graceful, elegant and admirable in their carving. The structure was extraordinarily grandiose: I thought that it could not have been made by earthlings, for building and finishing such a display would have been required too much costly, patient, long and heavy toil, and no mean skill, care, industry and diligence. The whole archway of the enclosure was of serpentine stone, and the collateral columns on both sides of porphyry; then the subsequent columns were of serpen- tine, then of porphyry, and so on alternately. In the middle storey there were serpentine columns above the two porphyry ones, while the upper storey had squared columns of porphyry, then the contrasting stone, and so forth. The capitals, bases and pedestals also alternated in contrast.

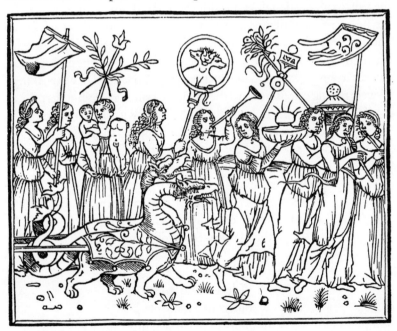

A precious vase stood on either side of the portal, one of sapphire and the other of emerald, intricately decorated with immense skill, putting me in mind of the vases at the temple of Jupiter in Athens.

At this wondrous portal, the archer-lord descended from his tri-

umphal chariot. The amphitheatre was of a structure not to be believed, because its elegant base, its string-courses, its ring of symmetrical col- [y2'] umns with their beams, zophori and cornices were all cast exclusively from bronze, fire-gilded with bright gold. All the rest was of diaph- anous alabaster of lustrous sheen, including the columns in antis with their arches. Marcus Scaurus, when he was aedile, built nothing like it.

The exterior had two equal orders of open arches between the columns. One order was placed above the other, its arc being a semicir- cle plus a fraction. Fluted semi-columns were attached to the solid wall between the openings, corded for a third of their height, with astragals, and the alternate ones were charged with symbols and little images such as were never seen in Ephesus. The columns were supported on suitable pedestals, with the requisite lineaments: two rams' skulls hung at each corner with their corrugated horns curled like shells, and out of their spiraling points came some knotted shoots that held a leafy garland, with pressed leaves and prominent fruits. Within the wave-moulding of the rectangular pedestal, and inside the garland, was a fine carving of a satyrs' sacrifice, showing a little altar bearing a tripod on which an antique pot was boiling, and two naked nymphs blowing at the fire through a pipe. Next to the altar were two little boys, one on each side, each carrying a vase; and two lusty satyrs, who seemed to be speaking, were raising one fist toward the nymphs, holding a coiling serpent.

The nymphs were holding the satyrs' arms with their free hands, while each satyr with his free hand stopped the mouth of a water-pot and kept it from being touched. But the nymphs leaned over to the other side with their pipes, unmoving and intent upon their duty. Some other columns of the same form had spiral cording for two-thirds of their length. Some of them showed children playing above drooping masses of leaves and fruits; others had multiple trophies, excellently sculp- ted, and many had carved heaps of booty. Still others were filled with symbols, with approving goddesses, putti and victories, cornucopias, lettering and other suitable ornaments.

348

Fine capitals
rested upon the
shafts of these
columns, having
artistic abaci or
covers from which
the polished major
voluces extended
downwards. The
entablature of
beam, frieze and
corona ran round
in a circle, with
the projections
exactly aligned to
the perpendicular
of the columns.

Between two
projections in the
order above the
portal, in the
middle of the
zophorus, there
was a nobly
invented and art-
fully executed

design of an ancient vase with its opening filled with antique and
pendant fronds, on either side of which lay a horned bull with its
forefeet extended toward the vase and its head raised. A naked man was
riding it with his right arm aloft, grasping a bundle of sticks with
which he seemed to be striking the bull while his other arm embraced its
dewlapped neck. A naked woman was seated beside him on the bull's
back, with her arm raised toward the solid ground of the relief and
embracing the man around his belly. With her other hand she held a veil
that floated above her garlanded head, then, anchored beneath her seat,
emerged above her embracing arm. A satyr was facing her with his
back to the bull: he was holding its horn with one hand and lifting the
other toward the woman, holding a coiled serpent. There was a second
satyr behind, holding the bull's other horn in one hand and in the other

grasping by its string a pendant garland of leaves which drooped across the lower body of the vase, then with a slight curve met the hand of the satyr on the other side. The bull's hindquarters were transformed as they [y3'] approached the edge into noble rinceaux of antique foliage. The zophorus was beautifully decorated with various sculptures of the same kind.

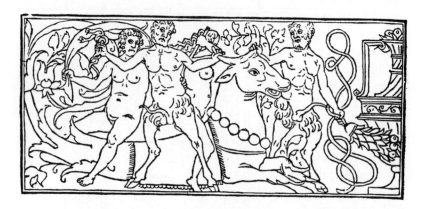

Rising above this first entabulature there followed a similar colonnade, suitably made in every respect and devoid of any irregularity. And although the architectural art requires that the columns above should be shorter than the ones beneath by a quarter, and also that their edge, discounting the pedestal, should be perpendicularly above the centre of the lower ones, and that the third order should be shorter by a fifth, this was not observed in this elegant and symmetrical building. Instead, the first and second orders were of the same height, while the third order of square pilasters did obey the rule; and these had a circular entabulature just like the lower ones, beyond which the squared columns or fluted pilasters stood out from the solid wall by a third part of their width. There was a window between each pair, not rectangular in the fashion of temples, but oblique or arched as secular architecture demands.

The royal cornice that went around at the top above the squared columns did not project, but was equipped with all the ornamentation and requisite lineaments, since it formed the uppermost entablature and encompassed the building with harmonious proportion. Above it ran a smooth and uninterrupted wall of a pace and a half in height.

This famed, illustrious, proud and admirable edifice was all made from the finest Indian alabaster, shining like glass. It was cleverly con

structed, splendidly decorated, and assembled in a remarkable way
without any joints of mortared lime or cement, but stabilized by the
perfect fitting and cohesion of its stones. This shining material could
not be marred by smoke-stains, nor sallowed by spilt oil, nor besmeared
by scarlet wine: every part of it was spotlessly clean, so that it preserved
all its brilliant sheen. The area contained by it was 32 paces in diameter,
and the thickness of the construction, eight paces.

[y4]

The circumference of the surrounding colonnade was divided into
four parts. Within each part were eight equal divisions at which the
columns had been appointed and set up, and from there the building
had proceeded toward the centre. It was traversed by straight and circu-
lar vaults commensurate with the columnar supports below them; and

the openings between the divisions corresponded with those opposite, as did their intervals. The porticos or vaults were artfully roofed and wonderfully arranged with their straight lines converging, while the circular lines crossed them. Their height was moderate, and all the accessories harmonious. The paved floor was inlaid with marvellous inventiveness and conspicuous skill, both the upper and lower galleries being paved [y4'] with beautiful stones of various colours, so smoothly fitted as to resemble a single piece, admirable in its mirror-like sheen and its perfect finish. The expert and tasteful architect had decorated the elegantly-worked ceilings with beautiful mosaic scenes in exquisite hues, all having as their subjects the deeds of Cupid. Next I scrutinized the fine carving in this miraculous building, the remarkable symbolic art and the display of the mosaic-maker's extraordinary skill. The astonishing Temple of Ephesus, the Roman Colosseum, the Theatre of Verona and all the rest must give way before this structure, because its columns, capitals, bases, coronas, inlays, pavements, statues, emblems and every other accessory were of such magnificent and divine workmanship, wondrously assembled, coordinated, perfect in detail, expertly crafted, and deserving of the highest admiration. The great fame and wonder of the statue of Divine Augustus and the four elephants dedicated in the Temple of Concord must pale before it; nor was it equalled by the magnificent statue of Menelaus, or by any other stupendous display.

All these officiating nymphs had to remain outside this marvellous entrance, or rather this central royal portal, while the divine Lord, his beloved Psyche, we two, and the two nymphs who had bound us entered joyously and with extreme contentment. In this adytum alone the spaces between the columns were not open, but walled in and closed by slabs of the noble stone already mentioned. Thither we proceeded beneath the vault to another open doorway, the top of which was contiguous with a pergoletta, as it is called, of the same height.

After this, we passed out of the opening of the vaulted adytum and entered the level arena of the theatre, where we were seized by the highest admiration: I thought at first sight that I was witnessing a most stupendous miracle, because the entire pavement of the arena encircled by the seats of this theatre seemed to consist of a single, solid obsidian stone of extreme blackness and indomitable hardness, so smooth and polished that at the first step I withdrew my right foot, fearing that I was about to fall into an abyss and perish in the midst of all my love and happiness. But its resistance soon brought my scared and shaken spirits

to their senses, by hurting the erring foot. In this clear stone one could see the limpid profundity of the sky perfectly reflected as in a calm and placid sea, and likewise everything around or above it, much better reflected than in the shiniest mirror.

In the middle of this arena, at the very centre, was the sacred and delicious fountain of the divine Mother and mistress of Amor himself, most artistically made. But before I speak of the sacred fount, I will first describe the unheard-of disposition and the wonderful interior of the theatre. Without a doubt, its construction and miraculous precision exceeded the range of our imagination; and it was in the shape (as I have said) of a theatre.

The steps began from the shining stone of the arena – not solid or massive steps, but empty or hollow ones, four of them ascending one above the other like a staircase. The rising benches were made with their seats six palms high and the depth or opening of the steps two and a half feet. All around the circumference were containers filled with divers flowers, which did not exceed half the height of the following box. The fourth and highest step had the edges of its opening on a level with an interposed aisle, five feet wide, which circled round and was covered by a little pergola, a pace and a half in height.

Beyond the rounded vault of this pergola, the next order followed with the same number of steps. The first and lowest one began a little way above the wall or surround that ringed the inner area, so that the curved top of the pergola did not block the front of this first step. Symmetry was observable in the subsequent stairs, such that the fourth was like the second, and the third like the first, with uniform aisles, pergolas and dimensions.

The wall panels, or rather the supports encircling these pergolas, were of black stone polished like a mirror. The first wall, that of the lowest pergola, was made from spartopolias; the second, from hieracitis; the third and highest, from cetionides, which shone so brightly beneath the pergola that it seemed not to be closed, but open to the serene sky that was reflected in them.

This same stone continued upwards beneath the pergola as far as the springing of the vault inside it. Beyond these black panels, as far as the end of the first step, the wall was of the same material as the flower-boxes. All these things were made with careful skill and exquisite knowledge of art, with incomprehensibly assured workmanship and deep understanding, with divine inventiveness and miraculous execu-

tion. They were well worthy of contemplation, for each thing was perfectly distinct and suitably displayed within its limits, not confused and interfering with the rest. From the very top to the bottom one could [y5'] discern everything clearly by following a line drawn directly above the edges of the steps.

The enclosing wall to which the last pergola was attached rose high enough to allow spectators in the arena to see it above the arches of that pergola. A cavity or hollow channel was cleverly made in this wall, which I estimated to be a foot and a half deep and the same in width. This uppermost wall, above the order of windows, was bright and spacious.

The interior ring of the building, namely the hollow steps, was made from the best jasper: heavy, uniform, and of oriental or perhaps Cypriot origin, variegated in colour with many different wavy veins. The rims of the flower-boxes and the socle were beautifully edged all the way around with assayed gold in wave-mouldings and gullets, as were the straight joints that divided the paneling, with workmanship transcending human understanding, made with the ultimate in precision and skill. The luxury of the golden vases of Bassus and of Antonius would perish before it, as would the glory of Nero who gilded the theatre of Pompey, or that of Gorgias Leontinus with his statue. Such excellent gold was never extracted in Scythia, either by ants or by griffins.

The upper cavity or container extended to form a channel which was filled to the top with earth. Cypresses were planted in it, two by two, close to one another but not touching, with three paces between each pair. They were all of exactly the same shape, and their upper parts and tips were bent over and systematically woven together so as make a remarkable union with one another, seeming to be a single tree. The top of each tree joined that of the fourth tree away from it. There were two trees in between, so that the right-hand one of a pair united with the fourth tree to the right, and the left-hand one with the fourth tree to its left. They were connected alternately over and under, with indescribable effect. Beneath each pair of bent or leaning cypresses there was a dense box-tree, cut in the shape of several balls that diminished regularly as they rose, and so well formed, as though with scissors, that not a leaf escaped to mar the surface.

Between the adjacent curved cypresses rose a straight stem of juniper, with its spring foliage cut in an exact sphere that filled the trian-

354

gular space between the cypress arches. The rest of the channel was filled with a variety of exquisite aromatic herbs with abundant, fragrant flowers, as can be seen at the top of the drawing of the theatre.

[y6] The first and lowest pergola was covered with flowering myrtle; it was made from golden rods fitted into the circular cornice and ending in a rounded vault above the arcades of the golden colonnettes. These in turn had their bases resting on the surface of the inner edge of the fourth channel, carved in a circle with exquisite skill.

The ground beneath the first pergola not only stupefied the mind but confounded the senses, for the entire circuit was paved with dusky-coloured, fragrant mastic, condensed with a judicious mixture of amber, musk, storax and benzoin. White pearls had then been elegantly inserted into this fragrant compound so as to make a circular mosaic-like pattern of antique foliage fruited with olives. Between the lobes were flowers, and in their calyxes were little beasts and birds. It was a divine and incomparable work, a pavement fit for the passage of divine feet, such as Zenodorus could never have devised.

The second pergola was opulently strewn with roses, and followed the first in its details. Its level floor was made from a paste of coral which had retained its redness in the grinding, and there flashed forth from it a marvellous design of ancient leaves beautifully fashioned from tiny emeralds and flowers made from sapphires, fitted to perfection.

The third alley was similarly covered with a pergola of small-flowered myrtle and wonderfully paved with a precious composite of crushed lapis lazuli. It was heavy, with its blue colour almost verging to green, while mingled and fixed in it were little fragments or chips of all the jewels that fecund nature could ever produce, as well as flecks of gold. This beautiful pavement was perfectly level, smooth, and shining. Think what incredible pleasure, what joy and solace, what allure all these delights conferred on the human senses, as might make the blessed spirits themselves marvel!

These pergolas were supported in front by golden colonnettes with little arches, beautifully arranged all around like a circular peristyle. The triangular space between one arch and another was coloured like the iris of an eye, filled with bright chalcedonies, agates, jaspers and other precious stones fitted together in a panel without any lineaments. The inside of the pergolas was not arched, but receded in a straight line

[y6'] to the back wall, where it rested on a surrounding cornice with a zophorus and little beam, wonderfully and accurately carved, with the

modillions beneath it joined to the capitals of the colonnettes.

Many cheerful nymphs were to be found down below, constantly dancing; they kept grouping themselves elegantly in the middle arcade of columns, then, all in time, making a reverence to the fountain. After their reverence they all moved to the next arcade and remained there for the same length of time. The two choirs at the ends turned toward the central choir with moderate leaps and elegant twirling, always in the middle arcade. They were accompanied by the superb sound of four golden sackbuts and four mild-sounding shawms: soprano, alto, tenor and bass. These were made on the lathe from red, yellow and white san-dalwood and from black ebony, not lacking many ornaments of gold and gems. With the sweetest homogeneous sound and with very fast rhythms, they played an elaborate symphony that was most delightful, with satisfying cadences and mutual imitations. Meanwhile the choris-ters sang joyfully but without confusion, displaying a remarkable variety of voices and an unheard-of precision of rhythm, tone and harmony. All this pleased my mind exceedingly and held me rapt in its sweetness.

The nymphs in the centre went naked, showing their beautiful white bodies. while the others were exquisitely dressed, adorning their divine little bodies admirably with cotton garments and concealing blouses, making lively, virginal gestures with girlish delight; and an equal number seemed to be present in the mirror made by the black stone of the wall.

Directly opposite the portal by which we entered there was a stair of seven steps made from the same stone as the containers, by which one could ascend to the first pergola; and at the end of the stair, beneath the pergola, a narrow doorway was made in the wall. Passing through it, one could then wander through the interior stairs and corridors, go into the vaults and attics, and have access to every part of the building. And there were similar small doorways beneath the other pergolas, on the same level as the first one, with their golden doors expertly chased.

The first or lowest order of steps had its continuous circuit divided in two by the entrance portal and by the stairway just mentioned. The first step, or lowest container above the arena and between the stair and the portal, was filled with earth from which purple or amethystine violets were growing in perpetual flower, and so it was on the other side. [y7] The containers of the second order abounded in white violets; in the third order they were golden or yellow; and in the fourth, narcissi were

356

blooming, their flowers more plentiful than their leaves, such as were not to be found in the Mountains of Lycia.

Beyond the first pergola, in the first continuous circular container, ivy-coloured cyclamen was growing, with the reverse of its leaves vermilion and its inverted violet flowers plentiful and fragrant. The second step bloomed with blue gladioli, while the third was full of purple chervil flowers and their dense leaves, and the topmost step was crowded with melilot.

On the third level, above the second pergola, the beautiful blue-grey flowers of the herb thora were growing in the first step. On the second were red anemones, and on the third, perfumed cinquefoils with many five-fold leaves. The top step was divided into ten equal parts, each planted with a harmonious selection of various attractive flowers: the first contained primula; the second, marigold; the third, amaranth; the fourth, reddish-white violets; the fifth, purple sparrow-wort; the sixth, opula or the white bulb; the seventh, yellow-white violets; the eighth, lilies-of-the-valley with their inverted bells of white florets hanging down in fragrant clusters; the ninth, many varieties of lilies: Uranian, white Hyraean, hyacinthine, yellow and red; and on the last step there grew aquilegia with its azure, white and russet flowers.

This delicious and rare arrangement of magnificent flowers never succumbed to any change of weather or of seasons; there was nothing like it in Memphis. They were always dewy and fresh, existing in a spring-like condition and never falling.

As I contemplated the majesty of the place, its astonishing beauty, its elegant order and arrangement, its happy harmony of colourful flowers that seemed just touched by the dews of dawn, I was thunderstruck by the miracles I have described and remained utterly dumb; yet my internal and external senses were seized by ineffable pleasure and encompassed by delights. There was, besides, the excessive love that all along had been burning strongly in my wounded heart, and the presence of my Polia's incomparable beauty that was my constant delight, so that I no longer knew in what state of being I was. When we were finally led into this happy place and blessed site, the two nymphs who had tied us up immediately released us from the rough garlands, and Psyche reverently did honour to her beloved husband, returning his

[y7'] golden arrow with a smile. Then she presented us before the sacrosanct Cytherean fount.

POLIPHILO DESCRIBES THE WONDERFUL ARTI-
FICE OF VENUS'S FOUNTAIN IN THE CENTRE OF
THE THEATRE, AND HOW THE CURTAIN WAS TORN
AND HE SAW THE DIVINE MOTHER IN HER MAJ-
ESTY; AND SHE SILENCED THE SINGING NYMPHS,
ASSIGNING THREE OF THEM TO POLIA, AND
THREE TO HIM. THEN CUPID WOUNDED THEM
BOTH, THE GODDESS SPRINKLED THEM WITH THE
WATER OF THE FOUNTAIN, AND POLIPHILO
WAS RECLOTHED. LASTLY, WHEN MARS
ARRIVED THEY WERE GIVEN
LEAVE TO DEPART.

OMING WITH DUE VENERATION AND
great honour to the mysterious fountain of the divine
Mother, the ready-witted Polia and I affectionately
knelt down before it, whereupon I felt an impercepti-
ble sweetness thrilling through me to the point that I
did not know what to do. This incredibly delicious
and pleasant place with its unbelievable decoration of spring greenery,
the birds chattering in the pure air and flying twittering through the
new foliage : all this gave the utmost delight to the external senses; and as
I listened to the lovely nymphs singing melodies together with their
unusual instruments, and watched their sacred actions and modest
movements, I felt ardently impelled to the height of bliss. Moreover, as I
carefully and curiously examined the building that displayed such
nobility of design and such elegant arrangement, and breathed avidly
such fragrance as I had never known before, by immortal Jupiter! I truly
did not know which of my senses I should fix firmly on to my intended
object, distracted as I was by so many different pleasures, by such exces-
sive gratification, and by such voluptuousness; and I know not whether
I was at fault. All these beautiful and charming things that were now
offered to me were all the more lovable and desirable, because I knew
that the celestial Polia was quietly sharing in their enjoyment and
admiring the novelty and excellence of this place, and especially of this
remarkable fountain.

The latter stood right in the middle of this superhuman building, [y8]
divinely constructed and executed as follows. It was made from the
same black stone as formed the entire ground or pavement of the arena

in an unbroken whole, in the middle of a foot-high wall, finely finished with every appropriate ornament, heptagonal in its outward form and round within. It had a surround of cymas, socle, small pedestals and wave-mouldings properly applied to the bases, which were on each of the angles, and above each of these was a column with entasis or swelling, seven in all and exquisitely turned. Two of them flanked the entrance, before which we fell to our knees.

The right-hand one of these turned columns was of finest sapphire and radiantly blue, and the one on the left of green emerald of outstand-ing colour, brighter than the ones placed for eyes in the lion on Lord Hermias's tomb. Ptolemy gave no such emeralds to Lucullus, nor was the gift of the king of Babylon to the king of Egypt so precious. The jewels of the obelisk in the Temple of Jupiter were not worth as much, nor did the statue in the Temple of Hercules in Tyre excite such admi-ration. Next to it there followed a column of turquoise of an intense sky-blue, endowed with its special virtue; and although it was opaque, it shone with no less brightness and lustre. Next to the sapphire column was another opaque precious stone of the pleasant yellow of melilot, as lustrous as the translucent ranunculus flower. Next to this was a column of hyacinth-coloured jasper, and another of refulgently golden topaz. The seventh column alone was hexagonal, and made from limpid Indian beryl the colour of oil, which reflected every object in reverse. It was directly opposite the middle of the two first columns; for every figure with an odd number of angles has an angle opposite the middle of each side. Having drawn a circle, construct an equilateral triangle on its radius, then draw a line from the centre through the middle of the side adjacent to the circumference; and that length gives the sevenfold division of the circular figure.

In the middle of the shaft of the seventh, beryl column, facing the fountain, there was a marvellous carving of the same stone, almost sepa-rate from the column, showing a hermaphrodite child inside a niche.

Similarly, the three transparent columns to the right each showed, in a remarkable way, a male infant within some receptacle, while on the shaft of each column to the left was an infant of the female sex. This mystic work was represented quite naturally in the very centres of the columns, with such sparkling polish such as cannot be achieved by rubbing with carborundum, nor with emery mixed with Tripolean chalk. The bases, the capitals, the beams, frieze and cornice were of purest gold, while the arches, together with the whole solid wall between one column and another, were of the same stone as one of the columns, in the order in which they stood: namely, of sapphire as far as the emerald column, of emerald as far as the turquoise one, and so forth. Thus the entire arcade was wonderfully constructed.

In each angle of the cornice, perpendicularly above the central line of its supporting column, there was a pedestal from which rose an image of a planet with its appropriate attributes. Their height was one third of the columns below them, and they were symmetrically sculpted from pure gold. At the front was scythe-bearing Saturn on the right, and night-shining Cynthia on the left, so that going in sequence from the first one, the circuit ended with Selene. Below them in the circle of the zophorus could be seen the twelve signs of the zodiac, done in relief with exquisite workmanship and elegance, with their symbols and characters above them in the finest of carving.

The summit of this miraculous fountain blazed forth in the form of a proud cupola of the finest unveined crystal, pure and transparent. Xenocrates saw nothing like it, nor was any such found in Cyprus; none such was produced in Asia, nor in Germany. It was free from redness and staining, cloudless and spotless, and no inclusions of salts or capillaries were to be seen in it. Even Nero broke nothing of this kind! It was remarkable for its purity and wholeness. Around the cupola ran a relief-carving with a regular pattern of joined leaves, and, superimposed on it, some little monsters embraced by playful putti. The swelling and rounding of the cupola were excellently done. It tapered toward the summit, where a miraculous ornament was attached: an egg set in gold, made from a carbuncle that flashed in all directions, the shape and size of an ostrich-egg.

On the face of the low wall of black stone, upon which the columns [21] rose in well-proportioned spacing, some ancient Greek letters were perfectly engraved, with their uprights nine times their width. Refined silver in their cavities glowingly spelled these words. Only two letters

were visible on the front, joined with an embellishment elegantly made from gold. Thereafter, the letters went three by three on the other sides, saying: ΩΣΠΕΡΣΠΙΝΘΗΡΚΗΛΗΘΜΟΣ.

Each side was three feet wide, and the height from the golden base to the beam was seven feet. I think that the dignity and reputation of these things, with their miraculous and matchless workmanship, will be more appropriately served by my silence; therefore my description will be poor and meagre.

Between the sapphire and emerald columns there was the most beautiful velvet curtain, hanging in circular folds and attached by knotted cords, such that fruitful Nature could never have thought of producing anything more fair, even for the gods. It was of a material and weave such as I could never describe; but its colour was that of sandalwood, brocaded with lovely flowers, and with four Greek letters subtly embroidered on it in decorative raised work: ΥΜΗΝ. The marvellous curtain sent from the Samians to Delphi would give way before it. It appeared to my Polia as the most precious treasure of all, veiling the majestic and divine presence of the venerable Mother. While Polia and I knelt there on bended knee, the divine lord Cupid gave the golden arrow to the nymph Synesia, and made a courteous sign that she should offer it to Polia, and that she, with this fearful arrow, should tear and rend the noble curtain. But Polia was distressed by the order to tear or damage it, and although she was subject to this divine command, she seemed uneasy with it and hesitated to obey. The Lord, smiling, straightway enjoined the nymph Synesia to give the arrow to the nymph Philedia, and she then presented it to me. And I completed the penetration that the honeysweet and wholesome Polia dared not do, avid as I was to behold the most holy Mother. No sooner had I taken the divine instrument than I was surrounded by a sourceless flame, and with urgent emotion I violently struck the little curtain. As it parted, I saw Polia look almost saddened, and the emerald column made a din as if it were breaking in pieces.

And behold! I saw clearly the divine form of her venerable majesty as she issued from the springing fountain, the delicious source of every beauty. No sooner had the unexpected and divine sight met my eyes than both of us were filled with extreme sweetness, and invaded by the novel pleasure that we had desired daily for so long, so that we both remained as though in an ecstasy of divine awe.

As I came to myself, I began to experience a justifiable fear, thinking

[z1']

of what Aristeo's son saw in the valley of Gargaphia: I felt simultaneously astonishment and terror.

The divine Venus stood naked in the middle of the transparent and limpid waters of the basin, which reached up to her ample and divine waist, reflecting the Cytherean body without making it seem larger, smaller, doubled or refracted; it was visible simple and whole, as perfect as it was in itself. And all around, up to the first step, there was a foam that gave off the scent of musk. The divine body appeared luminous and transparent, displaying its majesty and venerable aspect with exceptional clarity and blazing like a precious and coruscating carbuncle in the rays of the sun; for it was made from a miraculous compound which humans have never conceived of, much less seen.

Oh, how beautiful was her golden hair, delicately arranged on her milk-white forehead and trained into little curls, with errant and restless tips which the curling prevented from straightening! Her rosy shoulders decorously held back the wavelets that cascaded freely downwards. Her face was of roses and snow. The eyes were sky-blue and luminous, with an amorous and holy expression. The cheeks were like crimson apples, and the narrow, coral-red mouth was the nourishing source from which every fragrance was born. The bosom was a treasure-house whiter than snow, with the two swelling breasts defying the force of gravity. The body was of polished ivory that seemed to exhale a fragrance of musky ambrosia. The lovely hair, finer than the most tenuous gold thread, hung down upon the pure water, not submerged but floating in long curls upon the surface.

Her hair rivalled that of Phoebus as he sends out his light-giving rays from bright Olympus. Some of the little curls gathered in dense and twining sprays over her beautiful forehead, wafting in the breeze and making a shade to cover her dainty ears. Two ostentatious pearls hung from these, unrivalled by the union pearl cloven in two that hung from her effigy in the Pantheon of Rome. Nor did Tabrobane Island ever produce pearls of such conspicuous whiteness. Her brow was encinctured with a chaplet of lovely spring roses of vermilion and white, interspersed with sparkling gems.

Moreover, within the surround of the sacred fountain, there grew [22] out of the interstices of the sumptuous steps the flower of Adonis, standing crimson out of the water among its aquatic leaves. On the left side the thelygonon flowered in its pale clusters, and on the right side, the admirable ever-flowering herb arsenogonon. Several white doves

were flying around the goddess, while others obediently ministered to her, dipping their golden beaks in the pure liquid and mysteriously bedewing the Cytherean body. The droplets on the transparent flesh looked like orient pearls attached to it. The nymph Peristeria stood by attentively to perform Venerean services, and to minister to her with bold and ready intelligence.

On the stone arena outside the fountain, three divine girls were standing on the right, like Peristeria, nude and embracing each other. Two of them, Eurydomene and Eurymone, showed their virginal faces to us, while the third, Eurymeduse, turned her white shoulders to us, hiding her buttocks with the long profusion of her blond hair. These girls were gracious handmaids, ready for service of the Mother goddess. The latter held in one divine hand an open shell full of fresh spring roses, and in the other a burning torch.

Now from the top step on which the columns stood, six small steps descended into the fountain. They were of dark agate, so that the flat bottom had a beautiful waving pattern of white veins swelling and spi-ralling, as pleasing to the senses as anything might be. The water of the fountain reached as far as the fourth step, leaving the others dry.

On the top step there lazed a lascivious creature in human form, a nocturnal god who presented himself insolently with the look of a petulant and spoiled girl. His chest was visible as far as the diaphragm, and he had horns on his head, which was wound with a twisted wreath of vine-leaves, ornamented by tendrils and bunches of juicy grapes; and he leaned on two speedy tigers.

Similarly, on the left a handsome matron was comfortably seated, wearing a crown of yellow wheat on the curls above her broad brow. This illustrious personage was supported by two scaly serpents. Both persons held in their laps a round ball of tenuous and soft material, with an ingenious and secret orifice like a nipple, from which at regular inter-vals they distilled into the fountain, drop by drop, a delicately foamy and powerful liquor. They took care not to dip their pretty feet into the [22'] flowing fountain – feet that had the second toe longer than the big toe, and the other toes slightly bending toward the rounded heel and dimin-ishing in pleasing proportion toward the outside of the foot.

With this divine arrangement, then, the sacred majesty of the Goddess resided voluptuously in the centre of the fountain. The part of her body that was above the water shone no more nor less than the spendid rays of the sun in polished crystal.

We remained devoutly kneeling, but my mind was overwhelmed with astonishment. I could not stare steadily at the divinity that radiated all around, nor could I understand by what gift of fate and faith, by what means and merit, I had been granted the clear perception of such mysteries with my own eyes, which were not made for such a sight. In my judgment, it could only have come from the free-will and kindly consent of the immortal gods, and from the faithful prayers of Polia. But above all there was the one disagreable matter: that among so many celestial and divine persons, I should have been the only one contemptible and out of place, standing there in my worn and tattered garments, looking abject and poverty-stricken and unlike them in every way. I would have greatly welcomed any way of concealing my deformity, as Erichthonus hid his serpentine feet. Nevertheless, stupefied by the incredible miracle, I praised in my soul the divine goodness that had allowed an earthly man to contemplate openly the divine works and the treasure of nature in ferment.

Meanwhile the noble nymphs beneath the pergolas were joyfully celebrating, with their dances and songs and sweet harmony, the conquest achieved by bold, feathered Cupid, more sharp-eyed than the lynx or than Argos and always vigorously ready with his weapons. Then for a while the Mother goddess imposed an interval of silence on the celestial playing and singing, and delivered this kindly address to the two of us. She spoke with divine eloquence and amiability, producing from her sacred mouth subtle words that, without a doubt, would have lulled to sleep the vigilant guardian of Colchis's fateful treasure. They would have recalled to his proper form Aglauros, daughter of Cecrops, restored Idaean Daphnis in human form to his beloved flock, and delivered Cadmus and Hermione from their hissing voices and scaly bodies. Thus she spoke to Polia:

'Pretty Polia, my devotee, your holy libations, your devoted services and your religous ministrations have propitiated me and made you [23] worthy of my sweet and fruitful graces. Your sincere supplications, inviolate sacrifices and solemn ceremonies have pleased me, and your devoted heart and observances as a novice incline me with beneficence, favour, munificent liberality and protection toward you. I also wish that your inseparable companion Poliphilo, who is here burning with love for you, be numbered equally among the true and happy lovers. After being cleansed of every plebeian and vulgar stain, and from all unclean impiety into which he may have fallen, he shall be suffused with my

364

dew and purified, and shall give himself in perpetual dedication to you. He shall be ready and willing to please you, and shall refuse you nothing that you desire. And both of you, loving each other equally, shall serve my amorous fires with full consent and everlasting increase, and enjoy blessed and glorious bliss under my safe protection for the rest of your lives.

'Now, Poliphilo, in order that your great love may achieve happiness and success, I wish to consign to you four noble young maidens and endow you with their precious virtues. They will serve very well to enhance your excellent spirit and your generous love, if, with them, you will be steadfast in your conduct and even more devoted to Polia than faithful Pico was toward his Canens.'

Then without delay she summoned the noble nymph Enosina from the pergola, and said to her: 'Take with you the solitary girl Monori, the vigilant Phrontida and their silent sister Critoa, and you shall be inseparable company for our athlete, the loving servant of Polia. And by my fateful decree, let their mutual pleasure be equal.' She lost no time in drawing from the oystershell two rings, each enclosing a precious violetcoloured amethyst, and giving one to Polia and the other to myself, with the affable command that we should always be adorned with these divine gifts. And she added, with serene brow and kindly mien, that, suppressing all reluctance, we must always obey her edict.

She straightway turned and said: 'You, Polia, shall also have four intelligent and shrewd virgins as your perpetual companions, who will treat you with dignity and thus elegantly honour your illustrious love.'

The nymphs who were summoned ceased their singing and playing; and the goddess bestowed on Polia Adiacorista with her three clever sisters, Pistinia, Sophrosyne and Edosia, saying: 'Now do not leave her for a moment, so that she shall live attached by equal decree to her lover Poliphilo in a Herculean knot, adorned by the wisest and fairest love that has ever been celebrated and worthy of remembrance in this century; that she may offer herself as an unyoked victim to that Genius who is kindly and never deceives, with sincere and simple faith in him. If she wavers, may he support her; in worry and care, may she receive blessings; and for her pleasure, may he bind her in the tightest embrace.'

All these divine nymphs now began to obey the command of the supreme goddess, each tightly embracing the one assigned to her and sharing openmouthed kisses, with many nymphal blandishments and attractive graces, merrily mingling and every now and then hugging

and dancing about. They bowed in proper and fitting fashion to the divine Mother, then began diligently to keep company with their wards. The moment the holy words were spoken and the divine speech concluded, the Son was ready: he took aim at me with unaffected presumption, bold and pitilessly severe, not with a Gortinian shaft but with his flying golden arrow; not with a Tyrian bow but with a divine one. No sooner was the arrow impelled by the stretched bowstring than it transfixed my defenceless heart right through the centre. Quickly he drew it out of my inflamed breast, stained and steaming with hot blood and leaving a wound that the fruit of the Cretan thorn would never heal; then he transfixed my blazing-haired Polia in her breast which throbbed with her own immaculate soul. He withdrew the wounding and bloodstained arrow and laid it straightway in his mother's fountain to wash it.

Heavens! I immediately began to feel the honey-sweet burning of a fierce flame inside myself, in my very viscera, which spread like the Lernaean Hydra and possessed my whole being, set me trembling with amorous ardour and made my eyes glaze. Without a pause it tore open my burning breast like a harpy, more mordant than the serpentine toils of the polypus, or like Typhon sucking up water; and there it deposited the precious love and the divine effigy of Polia, never to be erased. It brought about a noble, chaste and delightful condition in which I was prepared and disposed for love, and would ever remain under its rule, with that beautiful and ineradicable image firmly stamped upon me. I burned like a dessicated straw suddenly placed in a fierce fire, or like a torch of inflammable pitch-pine: not a single capillary but was penetrated by the amorous flame, while I seemed to be changing my form accordingly. My mind was so shaken and weakened that it could not understand whether I was undergoing a change like that of Hermaphroditus and Salmacis, when they embraced in the cool and lively fountain and found themselves transformed into the single form of their [z4] promiscuous union. I felt no more nor less than unhappy Biblis, when she felt her tears turning into the liquid spring of the Naiad nymphs. I languished in the sweet flames with my pulse arrested, neither living nor dead, while the open wound allowed my spirit to exhale freely with the utmost sweetness, so that I thought, as I fell on my knees, that I had been struck with a fit of epilepsy.

The merciful Goddess, holding the shell in the hollow of her hand and closing the spaces between her long fingers, quickly sprinkled the

pure salty water over us. She did not do it like indignant Diana, who turned the unfortunate hunter into a beast, to be torn by his own dogs; but by this aspersion she unhesitatingly transmuted us in the other direction, to be congratulated and embraced by the holy nymphs. No sooner had she thus given her blessing by sprinkling and anointing me with sea-dew than I immediately found my mind clarified and my intelligence returning. My singed and cremated members found themselves unexpectedly restored to their pristine state, and I felt myself endowed, if I was not mistaken, with superior qualities. I realized that Jason must have been rejuvenated in a similar way; nor did my return to the blessed light seem any different from that of Hippolytus of Virbius, who was restored to his precious life by the herb glycysides, thanks to the prayers of Diana. Then the dutiful nymphs gently removed my plebeian rags and clothed me afresh in clean, white garments. And now, being calm and secure in our mutually amorous state and consoled by our happy recovery, we were moved by a sudden influx of joy and gladness, so that we kissed, with kisses sweet as wine and with trembling tongues, and tightly hugged each other. Likewise the happy and festive nymphs, receiving us into their sacred college as novices and servants of abundant Nature, all gave us gracious little kisses.

Next the Mother goddess spoke with elegant and pleasing address and queenly gaze, exhaling her natural balsam with her divine breath, and told us things that it is unlawful to divulge to common people, which cannot be spoken here. She gave us daily tasks to strengthen and ferment the love that was kindled in us, to unite our souls and hearts beneath her fruitful and easy laws, and thus to remain in stable and reciprocal magnanimous love. Ever kindly, she conferred her munificent favours on us and generously promised her protection in any troubles that might arise. During this homily, she conferred her grace on us in the mildest and gentlest way.

Now a valiant warrior of divine aspect emerged from beneath the first pergola and descended the steps, striding boldly up to the sacred fountain. His majestic face was ardent, his breast and courage ferocious and formidable; he was broad-shouldered, tall and muscular, with fiercely piercing eyes but an awe-inspiring dignity. His arms were rich, sumptuous and divine: he had an elaborate silver shield, such as Brontes and his companions never made for the exiled Trojans, and on his head was a shining helmet wreathed with fragrant flowers and crested with a prominent golden spike above the crown. He wore a golden breastplate,

[z4']

such as divine Julius never brought from Britain and dedicated to the Mother in her temple; nor did Didymaon ever make such a fine piece. He was belted with a transverse girdle or baldrick studded richly with gold. Besides all the other military adornments, he held a whip firmly in his hand, and was accompanied by Lycaon, his growling wolf.

As soon as he reached the delectable and delicious fountain, he voluptuously divested himself of his armour and entered in with the Goddess unarmed. And there he and she embraced, not with human blandishments and caresses but knotting themselves together with divine gestures and passion. When the nymphs were aware of this they took their leave with humble and reverent words, and I and my lively Polia did likewise. Having spoken our eternal thanks as best we could, we departed. There remained only the divine Mother, with her son and the divinities who always attend at the fountain, and the handsome warrior who had thrown off all his garments for divine solace and pleasure.

✳ ✳ ✳
✳ ✳
✳
✳

POLIPHILO TELLS OF HOW, UPON THE ARRIVAL
OF THE WARRIOR, HE LEFT THE THEATRE TO-
GETHER WITH THE WHOLE COMPANY AND THE
OTHER NYMPHS. THEY CAME TO A SACRED FOUN-
TAIN, WHERE THE NYMPHS TELL OF THE TOMB
OF ADONIS, AND OF HOW THE GODDESS WOULD
COME THERE AT THE ANNIVERSARY TO PERFORM
THE HOLY RITES; AND THEN, CEASING
FROM THEIR SONGS AND DANCES,
PERSUADE POLIA TO TELL OF
HER ORIGINS AND OF
HOW SHE CAME
TO LOVE.

✳

✳

UR TRANSFORMATION NOW BEING
accomplished, I left the sacred fountain together with
my noble Polia and our companions, and exited by
the same gateway as had admitted us. There all the
nymphs were waiting with their sweet music and
songs, and they accompanied us, rejoicing. As for me, I felt my breast
filled to bursting with the fruits of love and every attendant joy: my
former pains had gone, every grievous obstacle had vanished, and every
worrying fear was under control. I had no more doubts about Polia,
who was now the one and only Augustus of my soul, the Silvia of my
heart, and the Ptolemy of my life. She was the Arsacis of my senses, the
Murana of my love, the patron and revered empress of my whole being.
I submitted to her with joy, humility and dedicated contentment. My
love was more intense, sincere, and honorable than that of the pious
Emperor for his dear, fair and divine adulteress. Having this very day
attained her precious love and willing heart, I was an Aristeus in this
amorous battle.

Now the merry band of nymphs returned to their former recreations
and pleasures, with celestial harmonies and angelic symphonies, girlish
games and pleasant sports, showing themselves delighted that we had
achieved and consummated our desires, and dancing around us in a
lively circle. We traversed the holy island through the paths and ways
marked out by the plantings of the fruitful gardens, which were green

369

with perennial spring foliage, walled with hedges of box, in which [25']
every ten paces there was alternately a myrtle or a juniper, five paces
high. Outside this enclosure and two paces higher than it there was an
elegant marble trellis two inches thick, attached to symmetrical square
columns suitably positioned, with everything needful excellently done.
The trellises had openings in the form of rosettes and lozenges, and
were of an attractive colour, red as cinnabar and lustrous. Roses of
many varieties of colour and leaf twined through them like vines.

The nymphs began to lead us through these parts, holding us each
by the hand and merrily persuading Polia that, just as her blond hair
and theirs was encircled with flowery wreaths, so she should gather the
strewn flowers and lovingly make a crown for me. And some of the
divine nymphs, with happy enthusiasm, readily stooped down with my
much-desired Polia and helped her to collect them. She, driven by the
laws of love, immediately put her clever hands to work and found plea-
sure in weaving a rich floral crown out of various fragrant blossoms.
And from her plentiful hair, which tumbled in permanent and charm-
ing waves down her chaste back, she took some long yellow strands
coruscating like threads of pure gold, and passed the time industriously
tying up the gathered flowers with them. With such pleasures and pas-
times to fan the sweet flames we went on joyously and tirelessly, now
through flowery meadows, now through green groves circled by irrigat-
ing canals and tremulous rivulets. Sometimes we passed through the
pleasant shade of arbours paved with flowering periwinkle under a roof
of topiary work. The abundance of the place and the clemency of the
skies, untroubled by frost or heat, attracted us with their voluptuous
invitation, excited and allured us; and so we arrived gaily at a limpid
and sacred spring that bubbled forth plentifully. Its banks were not
overgrown with moss, maidenhair fern, dianthus and spleenwort, but
were edged around and ornamented with a rim of Macedonian marble,
not polished but naturally shiny and many-veined, and shaded by
aquatic plants. These had multiple stems of flowers with a wonderful
and heartening scent, and fresh, dewy fronds.

The flowing waters ran out of the spring in a lovely rivulet, which
passed beneath the leafy rowan-trees with a soft and gentle murmuring.
Beneath the temperate shade of this pleasant place there grew the
immortal laurel, intermingled with copiously red-fruited arbutus trees, [26]
a conical cypress that never re-sprouts, a lofty palm-tree, a poplar, a
resinous and coniferous pine, all placed at equal distances and arranged

in perfect order. Distributed in a circle around this fateful spring, deco-rated with its foliage and flowers, they shaded the rough soil that was carpeted with soft and delicate herbs. From beneath this arbour, whose straight trunks were free from hindering branches for the height of one pace, one could see the open area within the borders.

The sacred spring was hexagonal in shape and twelve paces around. It was four paces from its edge (that is, from the marble rim) to the inside circle of trees; and the circumference of the latter was 36 paces. The trees were all oranges, lemons and citrons, providing a comfortable and calm enclosure or cloister and offering a splendid spectacle to the eye. They were thick with handsome leaves and scented flowers, and shone with fine ripe fruits that went from an attractive russet or minium colour to a pale yellow. Each many-branched tree was separated from its neigh-bours by a uniform and measured distance. They were full of all sorts of singing-birds, especially nightingales, thrushes and solitary blackbirds, whose sweet twitterings gave delightful voice to the amorous urges of spring.

The round space left by these trees was artfully fenced with a trellis, one pace in height and circular in form. It was ingeniously made from a complicated interlacing of reddish sandalwood, into which rose-bushes were woven and threaded. Wandering through the gaps were the hundred-petalled rose, the Grecian, the autumn rose or coroniola with crimson flowers, their leaves never falling, their scent inconceiv-able, and spectacular in their greenery.

I entered in here with awe through a little gate of the same kind of work. Adjoining the entrance there was an arbour as wide as one side of the spring from corner to corner, and of equal height, assigning one pace to the perpendicular part and one to the arch. It was twelve feet in length, covered with noble roses with abundant vermilion flowers and a ravishing scent that were trained over bright golden rods. The shiny floor or pavement was tessellated with vermiculate work of precious stones; and from the sides of the arbour there extended benches of
[26'] jasper, elegantly formed with the proper mouldings, seven inches high and six deep.

The whole enclosed space had a level mosaic floor, while everywhere else was entirely green, with no bare patches, and carpeted with minute, scented wild thyme, mowed so that not one leaf protruded above another. This greenery continued in all its pleasing density and unifor-mity until it touched the periphery of the spring.

371

I saw a venerable object beneath the arbour, to which we and the divine nymphs devoutly paid our respects: it was wondrous and full of mystery, resembling a tomb five feet in length, ten twelfths of that in width and the same in height, excluding the socle and the cornice which measured five inches. This tomb, said the nymphs, was that of Adonis the hunter, slain in this place by the tusked boar; and here, similarly, holy Venus had leaped naked from the spring and torn her divine calf on these rose-bushes, as with indignant looks and anguished soul she hastened to help Adonis, when jealous Mars had beaten him.

This little tale could be seen perfectly carved on one of the long sides of the tomb, together with her son Cupid collecting the crimson blood afterwards in an oyster-shell. The nymphs added that this divine blood had been deposited in the tomb together with the ashes, with all sacred ceremony. On the side of the tomb facing our entrance there was a circle carved within the square and filled with a precious jacinth, transparent vermilion in colour and coruscating with flame-like splendour when the light fell on it, blazing intermittently so that I could scarcely keep my eyes on it.

On the other long side of the tomb I saw Adonis again, pictured as a hunter with some shepherds, shown among the bushes with his hounds and the dead boar, and himself killed by it. And there was Venus bitterly weeping and collapsing in a faint into the kindly arms of three nymphs, who were clothed in delicate material and weeping along with the goddess, while her son wiped the flowing tears from his mother's eyes with a bunch of roses.

Between the male and the female figures, inside a garland of myrtle, I saw this inscription: IMPURA SUAVITAS. Similarly in the other subject there was written in Greek: ΑΔΩΝΙΑ All these things were shown with such exquisite sculpture that I was moved by gentle compassion.

The square opposite that on which the light fell was perpendicularly above the spring. A golden serpent was fixed to it so as to appear to be [z7] creeping out of a hidden cavity in the rock. It was coiled, and large enough to spew a plentiful supply of clear water into the resonant basin. The distinguished artist had cast its coils in a masterful way so as to check the rush of water, which would have sprayed beyond the edge of the basin if it had been channeled unimpeded through a straight pipe.

On the flat top of this tomb was a sculpture of the divine Mother sitting with her child, astonishingly executed in priceless tricoloured

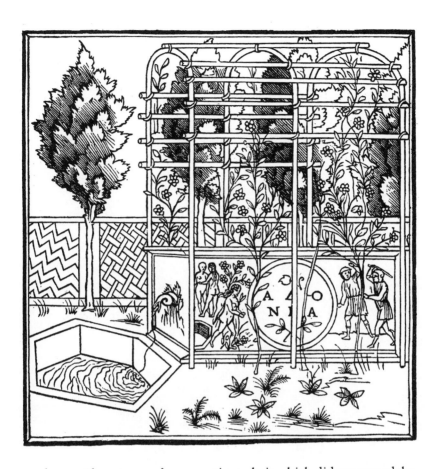

sardonyx. She was seated on an antique chair which did not exceed the vein of sard, whereas the entire Cytherean body was made with incred‐ ible artifice and skill out of the milky vein of onyx. She was almost undressed, for only a veil made from a red vein was left to conceal the secrets of nature, covering part of one hip; then the rest of it fell to the [z7'] floor, wandered up by the left breast, then turned aside, circled the shoulders and hung down to the water, imitating with wonderful skill the outlines of the sacred members. The statue indicated motherly love by showing her embracing and nursing Cupid; and the cheeks of both of them, together with her right nipple, were pleasingly coloured by the reddish vein. Oh, it was a beautiful work, miraculous to look upon, wanting only the breath of life! Her curly hair was parted around the forehead and passed over the smooth temples to the top of the head, where it was tied with a complicated knot; then the free portion

descended like tendrils as far as the seat. The sculptor had hollowed out the locks of hair with supreme skill by means of a drill, keeping them only within the translucent vein of sard, outdoing the ring of fortunate Polycrates which Augustus enclosed in a golden horn and dedicated in the Temple of Concord. The left foot was drawn back against the chair, and the right one extended to the edge or limit of the surface. The nymphs fell on their knees and bowed over this sacred foot, as did we, kissing it with the highest reverence.
Beneath the foot, on the cornice, one
area had been left free from
carving, on which I saw
the following distich
written in small
letters of our
kind:
You suck not milk, cruel child, but bitter tears,
To give back to your mother, for love of dear Adonis.

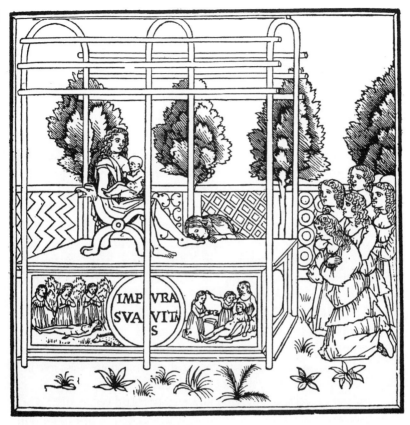

After this honorable and devout ceremony had been completed, we went out of the sacred arbour. The illustrious nymphs said to us with amiable eloquence: 'Know that this is a mysterious place, famous and greatly venerated, and that each year on the anniversary, the day before the Calends of May, the divine Mother comes here with her beloved son for a sacred and stately rite of purification, in which we, her subjects, all join with splendid solemnity, diligently serving her rule of our own free will. She comes here with gentle tears and sighs, then orders us to strip all the roses from the pergola and the trellises, and to scatter them ritually on the alabaster tomb, with loud invocations, until it is heaped over with them. Then we depart in the same order and procession. And on the day after the Calends, the despoiled rose-bushes flower again with the same number of roses as were fallen.

'Moreover, the Goddess returns at the Ides in the same manner and
orders the heap of roses to be removed from the tomb and flung into the

spring with holy acclamations. Then the roses are carried away by the stream that comes out of the spring.

'After the divine Lady has bathed alone in the spring and come out of it, she makes another loving commemoration of her dear and beloved Adonis, beaten by Mars. Wet-eyed, she throws herself on the tomb and embraces it, soaking her rosy cheeks with tears; and we all join in her lamentation with piteous whimpering, because on that day the divine calf, whose foot we kissed, was pricked by the thorns of these roses. Then on the same day the lid of the sacred repository is solemnly unlocked and opened. In this venerable ceremony we all rejoice with exultant song, while the Son receives and bears the oyster-shell with the holy blood; and she, as priestess, glorious in her serene beauty, holds again the bunch of roses with their undiminished bloom.

'No sooner is the precious liquor brought forth than all the white roses are tinged with crimson, as they now appear. Then we circle the spring solemly three times, and the Goddess, who alone is weeping, wipes her wet eyes with the bunch of roses. After the third circuit the sacred objects are put back in their place, and the whole of this famous day is dedicated strictly to pleasures, to choiring, playing and singing. And at such a time it is easy to obtain her grace.'

On the side of the sepulchre facing the spring there were five little steps leading down from the stone edge to the flat bottom, which was not sandy or gravelly, but paved with precious inlaid vermiculate work. The outlet of the stream conveyed its water underground beyond the trellises.

After the friendly nymphs had eloquently told us of such memorable and curious mysteries, they began to make music again. They sang, with great sweetness and delight, a metrical version of the stories they had told and the things that had occurred, and for a long time they danced in a circle about the spring; then they all sat with folded knees on this comfortable ground with its lovely verdure. I, however, felt peculiarly free and exempt from all inhibiting respect, and as I breathed in the unaccustomed scent of my sumptuous Polia, who smelled not only of her own clean and pure fragrance but also retained the dewy balsam that had pervaded her delicate clothing, I fell amorously and incontinently upon her bosom. I kissed ardently her milk-white hands and her snow-white breast that shone like pure ivory; then our kisses became mutual, for it was clear from her looks that she was not unresponsive, but equally possessed by the voluptuous impulses of love. Because of

376

this, the players laid themselves and their melodious instruments down on the pleasant lawn, and the singers shut up their mellifluous voices in their delicious bosoms, and fell silent.

In this happy and voluptuous repose, the nymphs conferred a while among themselves, then appeared very curious to hear about our state and condition. One of them, called Polyorimene, was especially forward, and said engagingly: 'O Polia, you are our companion, and the servant, with us, of our revered Mother. Your fairness of face, your conspicuous and unusually elegant form, your outstanding wisdom and virtue, your remarkable and compliant intelligence, and your extra-ordinary and incomparable beauty: all this makes us understandably keen to learn the cause of your happy loves and the origins of your aris-tocratic and superior ancestry, which we think must have had famous, distinguished and illustrious roots. We have taken account of your probity, your intelligence, and your not inconsiderable erudition in liter-ature; your remarkable accomplishments and your outstanding grace in virginal conduct; your rare and exceedingly beautiful figure and your sweet charm that is your greatest ornament and worthy of the highest honour. Your striking appearance and celestial likeness are so extremely fair and genial that they seem to be not wholly of the earth, but the clear sign of divinity seems evident in them. It would please us beyond measure to hear about the grievous pains of base and impassioned lovers; of their unjust scorn due to discordant and unequal disposi-tions; of their sometimes feigning deafness to the beseeching prayer; how they are ever blind to another's sad and long-ing heart, and so live in a consoling fiction assembled from delectable figments of the imagination, such as they would wish for and very much want, satisfying themselves in vain with sweet sighs and simulated consolation and satisfaction. Although we are intent on such praiseworthy idleness, you will not disturb our calm and pleasant relaxat-ion.'

✳

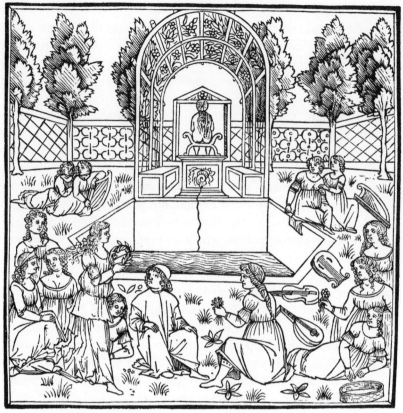

The friendly nymph finished her persuasive and flattering speech, with the approval of her companions, and my tall-haired Polia was quick to oblige. She rose up in all her festive and engaging appearance, with her pink cheeks and red mouth suffused with a frank and modest blush, ready and willing to oblige this worthy request with all the means possible to her virtuous nature. But at the outset she could not conceal a certain reticence, nor keep back a little sigh. This sweet sigh penetrated my inmost parts, indeed my heart, and was reflected there through a concordance such as occurs between two trumpets when they share an identical tuning. But boldly fixing each one of us with her playful and sparkling eyes (which, ah me! would have splintered dia-monds into a thousand fragments), she politely saluted each of the company in a soft and gentle voice and with elegant gestures, then returned to her comfortable seat on the thyme-covered ground. Sitting down there, she paused for a moment, assumed a pose of great elegance, and in a clear and audible voice obliged with the following recital. [z10]

378

THE END OF THE FIRST BOOK OF THE
HYPNEROTOMACHIA
OF POLIPHILO
*
*

POLIPHILO BEGINS THE SECOND BOOK OF HIS
HYPNEROTOMACHIA, IN WHICH POLIA AND HE
TELL ALTERNATELY THE FULL STORY OF HOW
THEY FELL IN LOVE, AND THEIR VARIOUS ADVEN-
TURES.

HERE THE DIVINE POLIA TELLS OF HER NOBLE
AND ANCIENT ORIGINS, AND HOW THE CITY OF
TREVISO WAS BUILT BY HER ANCESTORS; HOW
SHE IS DESCENDED FROM THAT FAMILY OF LELIA;
AND HOW WHILE SHE WAS HEEDLESS AND UN-
AWARE, HER BELOVED POLIPHILO FELL IN LOVE
WITH HER.

 ET MY FEEBLE VOICE BE HEARD
by you, O gracious and divine nymphs,
though it may seem discordant and inharmo-
nious to your benign ears; though it may
resemble the frightful squawk of the cor-
morant who once was Aesachus, rather than
the sweet song of the plaintive Philomela.
Even so, I shall not desist from trying to
satisfy your kind request, with all my feeble intellectual powers and my
other insufficiencies. To do this justice would require an unhesitating
and abundant flow of eloquence, a smooth elegance of speech and a
finely polished delivery; but since these are by no means to be found in
me, I crave your kind indulgence. As for you, blessed nymphs, and also
for me, albeit confused and crudely stammering, the slightest satisfa-
ction will suffice, so long as I shall appear responsive and obedient to
your wishes and desires; better that I act with humble courage and
promptness, than try to describe my earliest ancestry, my ancient race
and my fateful love in clear, smooth and beautiful phrases. Hence, being
already in the sight of your venerable company, and seeing myself
barren and reft of eloquence before such a distinguished and divine
order as yourselves, O nymphs, handmaidens of ardent Cupid; being
moreover in such a mild, delightful and sacred site, wafted with fresh
breezes and the scent of flowers, it is only fitting that I should feel a
respectful courage arising in myself, and my fear of speaking calmed.
Therefore, O beautiful and blessed nymphs, be indulgent above all to

my bleating and to the insignificant knowledge of an earthly female, if at any point I carelessly stray from my intended address. O sacred spring, in which the secrets and the treasure of the celestial Mother are mysteriously contained, filled with perpetual sanctity and quiet awe! I sit now upon your flowery banks in great consolation among these noble demigoddesses, and see reflected in your waters the most excellent and admirable parts of their beautiful bodies, for which you are to be worshipped with constant reverence. But nymphs, do not wonder if you see me trembling all over, and my pious eyes turning to rivers of tears, for my tranquil mind is shaken by the thought of lacerated Dirce, mourning Biblis, envied Galathea, fleeing Arethusa and dolorous Egeria, and my courage does not easily return. What will-power, what exertion, what resolution are required of the untutored tongue for such a story! For my race was unfortunate from the start, considering that some members of it were transformed by just and divine vengeance into surging springs and running rivers. O deplorable metamorphoses! O unhappy fate, bringing dire misfortune and lamentable grief! O unbro-ken chain of disasters! O inevitable and perpetual decree! How could I tell of such a ruinous and thwarted destiny without heavy sighs, a trou-bled voice, and words marred by sobbing? How, without flooding my dry cheeks with tears, as wandering Ulysses wept while he told Alci-nous, king of the Phaeacians, about the miserable destruction of Troy? How can I keep from bursting my breast with my heart's sighs, though they are denied and forbidden to arise in this sanctuary of felicity, this place where the eyes ought rather to be purged of tears, the breast of sighing? They should be remote and alien from such a blessed and kindly audience, especially in view of my precious Poliphilo's sweet and costly victory.

Therefore do not marvel, O fair and heavenly nymphs, if sobs some-times interrupt the long story of my sad parentage and ancestry, and the difficulty of my first love, although my attentive audience does not deserve such delays and hesitations. Without a doubt, my tale contains two extraordinary things: first, an unheard-of and inhuman cruelty, a beastly savagery and a feminine barbarity that beggar belief, turning to such a fortunate and amorous issue as you see before you; and second, the greatest and most unexpected love in the whole wide world. This is their origin and beginnings.

It all began, O divine and Cytherean nymphs, in the time when the green and fruitful palm sprouted miraculously from the woollen head-

band on the brow of the Vestal priestess Ilia Silvia, and shadowed triumphantly the spacious earth and the measureless sea. The noble family [A2] of Lelia had achieved great stature and the dignity of the magistracy, by virtue of their fine deeds and the many victories they had won by their exertions. You are not unaware of why magnanimous men and virtuous acts of any kind were deservedly rewarded in the ancient imperial city.

One scion of this ancient and honored race, named Lelio Syliro, was appointed Consul by the sacred Senate, for reasons too long to explain, and sent to the region and March of Taurisana, named after the high mountain. He came invading a region ruled by a wealthy, magnificent and splendid chieftain named Tito Butanechio, the father of an only daughter, whom he gave to Lelio in solemn, legal and inviolable marriage. Lelio was eager to wed this young and noble girl, who showed prudence, excellent native qualities and a womanly gravity, besides her conspicuous beauty and her affluence in worldly goods. She was upright and good-natured, with many talents, well-read and decorous, and raised amid royal pastimes and parents who aimed to please her. Her name was Trivisia Calardia Pia, and her mother was called Rhoa Pia. Her father gave her a generous dowry, including a large part of the tenth or Venetian region: a flat country enclosed by high and conspicuous mountain peaks and noteworthy for its springs, rivers, waterfalls, and its woods with their abundance of harmless creatures.

Their lawful marriage was celebrated magnificently, the Herculean knot untied and holy Cynthia piously invoked to implement the matrimonial laws. By favour of the divine Zygia Lucina, a noble offspring followed, with many births yielding alternately sons and daughters. The first-born son was Lelio Maurio, named for his swarthy colour. The second was Lelio Halcioneo, the third L. Tipula, the fourth L. Narbonio and the fifth L. Musilistre. Nature, guided by the gods, endowed the girls with beauty and charm to the greatest degree imaginable. The first one was called Murgania, the second one Quintia, the third Septimia, the fourth Alimbrica, the fifth Astorgia and the sixth Melmia. To put it briefly, the parents forgot the fruitful gift of the goddess of birth and, glorying in their elegant brood, averred that it was due to their own virtue. Alas, who can ever come clear and unharmed through the fateful troubles of fickle, deceitful and elusive Fortune? Those who are unworthy of such divine gifts fare no differently than Atalanta and Hippomenes. These, then, sacrilegiously compared themselves to our lady Mother Cypria, parent of our archer Lord, and

thought themselves preferable to her in beauty and dignity. What an evil and unlawful deed! What arrogant presumption! Morgania had scarcely grown out of her childhood when the plebeans, the rude and ignoble mob of common people, thought that she was none other than [A2'] Venus! They built a sanctuary outside the city with an assortment of temples in which the false woman ceremoniously displayed herself, while a great concourse of people came and superstitiously made their annual vows and prayers. Her name survives to this day as the fairy Murgania, and the place has kept its name Murganio in her memory.

Faced with this iniquity, this vile human impiety, this display of arrogance, greed, ambition, pride and abomination, the gods, who do not suffer human offences to go unpunished nor permit any insolence to succeed, grew angry at these usurping earthlings who illegally assimi‑ lated themselves to the almighty gods. The holy Mother of our awful Lord, whom we justly serve today, took vengeance as Juno did upon Antigone, and indignant Eriboea upon Isis: she smote the impious temple with lightning, and with thunder she reduced the royal palace to coals. It was not far from here, where it may even be found, and was always called by the name of Casa Carbona. Murgania was changed into a spring, along with all those who were in that place with her. Like‑ wise her sisters Quintia and Septimia did not escape far from Murgania, but were transformed into flowing springs. Alimbrica, not far off, was turned to ashes by the terrible thunderbolts of mighty Jupiter, and the whole palace with the royal enclave for a great distance around was all turned to coals: hence the place was called Carbuncularia. A little river later ran out from there: it was Astorchia, who fled weeping for these miseries and left her father as a stream, as did Melmia. Their names were given to these places, and their flowing waves embrace their dear father Lelio Siliro. He too suffered a liquid transmutation and, fed by his dear daughters, became a famous river of pure water that can still be seen flowing briskly through this pleasant region and is called by his abbreviated name, Sili. His wife was thunderstruck while mourning their miserable fate, and turned into a famous spring, the Calardia, called after her name. She is close to her dear father Tito Butanichio, who turned to a river as he wept for the cruel fate of his line. And her mother Rhoa flows between her husband and her dear brother Caliano, before all their rivers disgorge into her beloved son Sili.

None of the male children escaped the celestial rage and just revenge. The second‑born, Lelio Musilistre, became the stream of his

name, rejoining his father and irrigating the populous Altinati. The divine wrath was tempered only for the two younger sons, who were still infants without speech, body hair or teeth, so that they were spared metamorphosis. One became the little bird of his name, the halcyon, with its royal and incorruptible plumage, and the youngest became the water-spider. These river-dwellers inhabit their father and never dive, but always stay by him.

[A3] The sole survivor to escape this sad and lamentable event was the first-born Lelio Mauro. While still a child, he had been invited by his relatives, the lords of the Altinati, for a solemn funeral anniversary held before the Mania gate. It was named after the Manes, for the dead bodies from the whole city were buried there, and it still keeps its corrupted name, Alli Mani. The solemn obsequies were over, performed according to ancient rites and patrician custom, but Mauro stayed to roam around with a few other youths. It happened that they found themselves by the seaside, near the watchtower or beacon of Altino called Turricella (which accounts for the name of today's noble town of Turricello, which was founded there), where he was captured, being still a youth, by a band of invading pirates. It so chanced that he entered the ancient family of Brutia, in a famous city now called Teramo, where Theodoro, a noble and eminent man, adopted him on account of his inborn qualities and raised him as a son. After his book-learning was completed, he devoted himself vigorously to military exercises and thus grew to manhood. In the course of time he achieved great things and acquired a bold spirit; he was generous, robust, always successful in his various combats and emerging with all the military honours. As Bellerophon was promoted by Heurie, so Mauro was not longer called Lelio, but because of his high station and great deeds was called Calo Maurio, so as to extinguish with his fine virtues the baleful name.

Because of all this, the holy Roman Senate appointed him military prefect and invested him with the pallium; and thus he came by chance to inhabit the very place where he was born and raised. He served his land by securing and protecting it from the barbarian invasions, and named this place of pleasant shades and breezes, of useful streams and springs, Calo Mario. The advantage of the site was that he could reach it more quickly in between the incursions of the invaders, and enjoy for a while its verdant soil, covered with herbs and flowers. Here, after he was established as guardian of the city, as an eternal monument in pious memory of his beloved mother he founded a great and noble city

around a town called after the hill Taurisana. It was noted for literary and military studies, the home of an ancient cult, and very hospitable to sanctity and religion, situated in a fertile and pleasant location above his swiftly-flowing father, the river Sili. He gave the city the name of his dear mother, Trivisia, and it retains that maternal name to this day.

He governed it as his fortunate foster-child for a long period, and brought it affluence, civil peace, friendly relations with its neighbours, and an ordered and tranquil life. His hereditary successors did likewise for many years. But through inconstant chance and the will of deceptive Fortune, together with faithless Time, it was occupied by various tyrants, until finally, through the aid of Jupiter, greatest and best, made man, it was fortunate to come beneath the just rule of the holy and fierce Lion of the sea. I was born and raised in the surviving line of the ancient Lelia family, and they gave me the famous name of the chaste Roman who killed herself because of proud Tarquin's son. I was brought up most enjoyably in patrician fashion, and came to the flower of my age in the year of human redemption 1462. [A3']

I was standing one day, like any fair adolescent, at the window or balcony of my palace, taking girlish delight in my blond hair which hung down from my ambrosial neck over my white shoulders. It shimmered like threads of gold as I sunned it in Phoebus's rays to dry it, and I was combing and arranging it carefully when Poliphilo chanced to pass by. I dare say that Andromeda's hair looked no more beautiful to Perseus, nor that of Fotis to Lucius, for he stared with intent and piercing gaze, suddenly taking fire with immeasurable and increasing love. As the tough oak splits when struck by the lightning of thundering Jupiter, so his tender and ready heart opened without regard, and on the first pure sight it clove asunder in the midst. Mischievous and vigilant Cupid lost no time in shooting many of his burning flames into it; and thus he was kindled and captured without the slightest defence or resistance. He surrendered as easily as a silly bird lured into a snare by a bit of food, or a fish at the sight of the curved hook. and as the eager spectator of my prettiness and charm, he burned with longing. Many a time, when looking at my clear image in the mirror, I wondered whether the fate of Narcissus would be mine also, when I saw myself clearly in the mirror – as is obvious to you now from my looks. And lest I appear to be boasting, let me recall the following adage: If lying and falsehood is a vice, it is no less to conceal the truth. Thus these first and novel fires in his breast caused him amorous torment, and he henceforth became my

affectionate admirer. Caught in such an amorous snare, he suffered the natural consequences of such a love. Every single day he headed for my palace and looked up at the high and empty windows, for he could not free himself from the desire to see me at least once more. To this end he spent many troubled days and sleepless nights, serenading with instruments and singing poems that he had formed out of sighs; but his urgent solicitude was all in vain. The pain and tedium of this disagreable and [A4] grievous way of life drove him to despair and continual depression. He was afflicted with a constant and bitter heart-ache, because despite all his efforts and vigilance he was unable to see me again. If he did catch the slightest glimpse of me, as rarely happened, he could perceive no more sign or hint of love than in a flint-stone. And if my frigid heart was not averse to him, nonetheless, O glorious nymphs, it was made from a substance very far from susceptible to amorous fires. With my mind totally distant and detached, no suspicion reached me of the intense and amorous anguish which Poliphilo was suffering, cruelly languishing in an excess of love.

POLIA, FALLEN SICK OF THE PLAGUE, VOWED HERSELF TO DIANA, AND DURING HER CONSE-CRATION POLIPHILO CHANCED TO SEE HER AT THE TEMPLE, AND A DAY LATER FOUND HER ALONE AT PRAYER. TELLING HER OF HIS GRIEV-VOUS PAIN AND THE MARTYRDOM HE WAS SUFFERING FOR LOVE OF HER, HE BEGGED HER TO ASSUAGE THEM. SHE, REMAINING PITILESS, SAW HIM PASS FROM LIFE INTO DEATH. THEN AFTER THIS MISDEED SHE RAPIDLY TOOK FLIGHT.

ERY SOON AFTER THIS THERE OCCUR-red a great carnage affecting people of every age and condition. They were infected through the corrupted air by a contagious and deadly plague, and a great multitude died. Dreadful terror and alarm spread over the sickly earth, and people were struck by mortal fear. Everyone sought safety outside the city and took flight to the suburbs and country regions. Such a dreadful mass of people was exterminated that it was suspected that the fetid south wind had brought the plague from humid Egypt, where at the flooding of the turbid Nile the fields are strewn with a mul-

titude of dead animals that putrefy and stink, and that these had infected the air. They wished that the sacrificer of Argos had not lost the cattle that he was to offer to Juno, and that it might turn out as it did at Aegina, with the fulfilment of Eachus's desire; or with Deucalion and Pyrrha, when they threw stones on Mount Parnassus.

Due to my own frail and malignant fate, I found myself afflicted by a tumour in the groin. I besought the highest gods, on the chance that they would grant me recovery, while the spreading infection of the plague in my groin gravely weakened me. Because of this everyone [A4'] deserted me, and I was left behind, except by my nurse, the kindest and best of women, who stayed to care for me and to witness my last breath and the departure of my spirit. Afflicted by the grave malady, raving and wandering, I uttered incoherent words and many a groan and lamentation. But turning inwards I did the best I could, and sincerely invoked the help of divine Diana, because I had as yet no notion of other gods and no religion but of this goddess. So I uttered many a single-minded prayer in my trembling voice, and vowed myself to her cold and sacred chastity, promising in my tormented state that I would be her devotee and ever serve her religiously in her sacred temples, in strict continence, if only she would save me from this deadly contagion and sickness. I was firmly resolved in my mind to persevere in this, the more hopefully since I remembered the benign favour that this goddess had done to Iphigenia. For Agamemnon, warned by Apollo, intended to make a sacrifice of her, but the goddess was touched by the sight of her pious parents bitterly weeping, and she had pity on them. She inter-posed a smoky cloud which hid Iphigenia, then revealed the deer. I hoped that I, in a like situation, might receive her holy aid and prote-ction; and indeed it was not long before I was cured and miraculously restored to my original state of health. Since I was bound by serious and voluntary promises and solemn obligations, I set out to implement them and strictly to fulfill my vows. I intended to do so no less thoroughly than the matrons who at the Thesmophoria sleep on layers of leaves from the agnus castus tree, and to show no less devotion and religion than Cleobis and Biton. And so I entered the holy temple and was received into the isolated company of many other virgin girls in the unstained service of this chaste goddess. With them I began the diligent attendance and humble worship of Diana's altar, where the most beau-tiful portion of my flowering girlhood and my charming youth was used up in chilly continence. Now it happened that my fervid and pre-

sumptuous lover Poliphilo, poor thing, had been in perpetual sorrow and anxiety during all this time, which was a year or more, since he could find no way to see me and my blond hair again. He was as distant from my hard heart as Abila is from Calpe, for my sterile breast was washed and scrubbed absolutely clean of love: he was blotted from my memory, and I never gave him the slightest thought. Just as the walls of the Bona Dea's sanctuary are purged of the names and representations [A5] of male animals, and no living ones are allowed to enter, so every thought of Poliphilo was deleted and wiped from my heart, as though I had already drunk the water of Lethe, son of Phlegethon, and no less than if I had been wearing the good Hebrew's ring, like the amorous Ethiopian woman. But Poliphilo was sorely wounded by love's spurs and blinded by its fire, with his breast speared by Cupid's lance. I do not know how his ready intellect was able to imagine such a thing, or whether Fortune kindly presented her forelock to him, while he was wasting himself with sorrow and pining away from the bitterness of his love, with fierce Cupid intemperately residing in him. However, he found me on the day of my holy dedication, when I was to be conse-crated along with some other young virgins. At such solemn occasions it is usual for a lively young crowd to arrive, eager to see the sacred spectacle. When he saw me plainly, he was altogether lost. His emotions persuaded him that finding me again was the timely and present cure for his inflamed heart, but he did not know what to do, except to stare and stare again with obsessive gaze on the charming head with its decora-tion of yellow tresses to which he had firmly attached himself, and which had become his comfort, his delight, his happy contentment and his fixed idea. But I, since I had retired from the world, had kept my heart true to my vows, and had never or very seldom let myself be seen by any man. I quickly covered my face with a veil, and for a long time took care to remain inconspicuous in the darkest recesses of the sacred temple. Poliphilo, miserable lover that he was, no longer valued sweet life any more than fearful death. He thought of the long year he had waited without seeing me again, spent in anxiety and perplexity but with a constant and steadfast spirit. Like a man who is thrust in fetters into a horrid prison, and is intent only on breaking his bonds and escap-ing, or like an invalid who thinks only of health and recovery, so Poliphilo unwearyingly made a careful and diligent search, exploring and investigating every corner. One day, guided perhaps by winged Amor in his sleepless watches, he came to the temple while I was at

389

prayer alone. He arrived so wound up by an excess of passion and so inflated by hot desire, like an irrational animal that is unthinkingly driven by its appetite, that he was at death's door. But no sooner did I see him before me than I felt polluted; my confused heart froze like the diamond which fire cannot melt, and became hard and rigid as the porphyry stone. My soul was pitiless and wild, all kindness was spurned and deadened, and my mind conceived a great dislike for him. It was crueller and more inhumane than that of Etheocles and Polynices, who [A5'] killed each other with reciprocal wounds, and when the corpses were thrown on the burning pyre they could by no means be cremated until they were separated, giving clear signs even in death of their unbroken hatred. I was more hard-hearted than Isiphyle; nor did Orestes show such severity toward Clytemnestra. And as he gazed adoringly at me, I saw that he was surely half-dead. His flesh, reddened with sorrow, grew pale, and the natural warmth fled from his extremities as death began violently to invade them. He could scarcely find the breath to speak, as with extreme weakness and face discoloured he uttered these halting words with what remained of his broken and trembling voice, not without the accompaniment of sighs and a flood of tears:

'Alas Polia – nymph of the lovely hair – my goddess – my heart – my life – and the sweet executioner of my soul – have pity on me! If, in your divine nature and your unique beauty, that virtue still lives by which my soul, having elected you as its sole ruler in this age and as its first lord, did not hesitate in its joyous offering but abased itself before you, pray be gracious, gentle and benevolent, to assuage my grave sufferings. I am well aware that I have not come hither at a propitious time, yet I have never lost all hope; and I feel myself dying because I can no longer bear this incessant misery. As a last resort, it seems to me better to die now, rather than to live burdened with the absence of your love. Thus I cheerfully expose myself to death, rather than living a miserable and painful life without your longed-for affection: better to perish instantly than to die daily! If perchance some god is afflicting me with inexorable severity, may he at least allow me to die by your hand, if I am not allowed a happy life. For if your angelic presence is removed from my sight, and this one and only solace and pleasure reft from me – a solace which I so much desire and of which I can never have enough – what worse evil or deadly peril could I suffer? I hoped for no other remedy to suit my bitter and unbearable languor than that the kindly heavens should allow me to see you again; otherwise I saw violent ruin

threatening to overwhelm my tedious life. And just as the condemned man leaves off lamenting when he sees the inevitable blow about to descend, I surrendered my miserable life into the hands of the terrible sisters, no less unbalanced and at times maddened by tormenting love than was Attis, or Pentheus by his own sisters and by wretched Agave.

[A6] I saw myself abandoned like Achaemenides left by Ulysses between Scylla and Charybdis. The oppressive heat seething in the confines of my heart afflicted me so much that I had no hope or desire but you alone, Polia, as my instant and healing medicine. I was unknown to you − deprived of you − abandoned by you. The more I dwelt during that absence on your striking figure and celestial beauty, your lovely face and the elegant profusion of your rare virtues, the more bitter and pained I felt at not being able to enjoy them. On this account, miserable lover that I am, I endured so impetuously, so inadvisedly, and so precipitously those horrid affronts, those false blandishments and deceitful caresses of love, whilst hiding the pain and restless agitation which sometimes, nay often seized me in consequence. Yet I have willingly suffered these evil snares with such steadfastness purely for your sake, my sweet lady Polia. Alas, poor me! They have caused me to wait so unreasonably long without seeing you again − you who are all my goods, all my hope, all my consolation, the pleasant prison of my heart − without the sight of the rare and venerable adornment of this beautiful head of yours, without gazing on this lovely face and this splendid and admirable form. Just as the waters of the Lake Ammon in Africa boil violently when the sun is absent, and when it is present at noon, they become freezing cold, even so I am consumed with fire in your absence, my radiant sun Polia. I melt like liquefying wax, but now, in your solar presence, I am taken with a freezing fit. Think about this a little, Polia, my delight and support: how I have spent so long a time in utter deprivation and in fearful peril of my life. This life I have gladly preserved for your love, though it has been in greater danger than the ripe yellow wheat in the broad fields from lightning flashes and thunderclaps, destructive frosts and howling winds. I am like the snaky, variegated ivy that hugs the ancient poplar, which once separated and torn away cannot stand by itself, but can only crawl on the damp ground weakly, feebly and sluggishly. I am like the climbing vine deprived of its pole and prop, lying prostrate without its supporting elm. That is how I am without you, who are my firm column, my pillar, the reliable stake on which I have leaned my life with all the inflexibility of love and obsti-

nacy of intention. Your absence, therefore, is the reason that you find me collapsing and left to die. My fury had increased to the point at which I could no longer feel any pain, indeed was goaded on to greater agitation and spurred by single/minded love, with a ferocity that only increased [A6'] my tolerance. Nonetheless, I invented in my mind many and various fantasies of success, of relief, of comfort and succour, giving them the semblance of reality and generously promising myself wonderful amorous rewards — and found these all to be false hopes and empty imaginations. Lacking your excellent and alluring presence, my sad eyes deprived of your sight, I was shaken to the marrow and began to destroy the foundations of my life; to beat, alas how bitterly! my throb/ bing breast, loudly sighing and gasping with repeated sobs. I found myself empty as a hollow reed or cane, deprived of the soul that lived and dwelt in you alone. Many a time, not knowing in my sorrow what I should do, I wept; and as I groaned to myself, I imagined that you were the enemy of all my repose and blamed you as the cause of all these faults and burdens. Because you had fled my ardent affection, I slan/ dered you as the sweet enemy of my welfare, and, as though driven to mindless madness, I called down the anger of Cupid upon you who were so cruel, so shameless in your contempt for his sacred torches, and, as I thought, the sole cause of my ills.'

I listened patiently thus far to this tirade directed against me, having never heard the like, then I interrupted both his hurtful, displeasing and graceless speech and my own prayers and rose suddenly, indignantly blushing, without answering him or even looking him in the face, and fled, leaving him there with derision and contempt for his vain words. But on the morrow, thinking that he would not persevere in the invasive and molesting behavior of the previous day, I thought nothing of coming to pray in the same place. But behold! here he was again, with a leaden and tragic complexion, and he began to inflict on me the same nuisance as before. With similar sighings he began immediately:

'Alas my beautiful Polia, paragon indeed of all loveliness, have pity on me today and be compassionate toward the pains which afflict me ceaselessly, leaving me no peace by day or by night, and which compel me to come to you. Soften your indecently cruel heart; mollify its hard/ ness a little. Do not be repelled, nor turn a deaf ear to my just desires, caused by a love that your more than mortal beauty has infused through my whole miserable being. Loosen and undo the tangled bonds of your closed mind, and try to assume a merciful disposition so that you can

preserve, with reciprocal love, what little remains of my ebbing and imperilled being that consumes itself with nightly tears and fades away through daily languours. Do not sully your superhuman station through monstrous cruelty toward one who loves you with a sweet ardour, desires you, and worships you. For you are endowed with extreme beauty and every virtue; you are turned out with great elegance and splendour and richly provided for; you are in the flower of your age, and most eligible for the amorous mysteries. Do not, then, hide all these gifts of generous Nature through impious obstinacy that is at variance with the sweet, docile and soft nature of your sex, as you wrongfully showed toward my wretched self yesterday. Ah me, alas! Polia, mistress of my heart, if you feel the slightest particle of this, or, if feeling is too painful and unwelcome, if you can at least imagine my poor little heart, you will understand that these lamenting words proceed from nothing less than its inner torment, mortally wounded with a blow more fatal than Philoctetes'. I suffer dreadfully from this gnawing emotion that wears me down with continuous suffering: more than the moth fretting woollen garments, the thirsty worm sucking the juice from the pale leaves of Minerva, or the borer chewing through a beam beneath hirsute Aries. It is worse than the blight on trees and hollow trunks, the decay of swine's flesh in the heat, the yellowing rust on hardened steel; worse than the hoary sea-spume whose battering demolishes the rocky shores. It ravages me as Antaeus did Libya and the city of Lixus or Tingis, on the promontory of Ampelusa; it wages war on me worse than the cranes on the pygmies. And in this way I am wasting fruitlessly the years of my chaste adolescence, while this cruel love tortures me day after day, so that I am reduced to a worse state than insensible animals, than green plants roasted beneath the torrid sun when it is the sign of the fierce Lion, or with Sirius in the mouth of the fiery Dog. For these revive after the sap-giving night, moistened by the dews of dawn, and come back to life after their soaking as if they had never felt the affliction of the previous day. But I, alas, catch on fire every evening for love of you, Polia; at twilight I am all inflamed; I am burned during the first part of the night; during the second I am consumed; and at cockcrow I feel like ashes. And what does your poor little Poliphilo do then, O my much-desired Polia? Love of you continues to embitter my life, so that in the morning I am shaken with plaintive sighs, and by first light I feel frozen to the bone. When dawn blazes forth, I curse Fortune, my sterile stepmother, but I bless my ardent love, caused by the most elegant and

[A7]

393

beautiful nymph in the world. In the cool morning I begin to warm again, and when the new day comes it finds me already afire. At noon I languish and feel that I am dying, seeing no rescue coming from my unpropitious love, and no consolation in so great a heat. Is there any constancy so firm, any body so strong, that it could survive to escape such tortures? Without a doubt: for if not, my sweet little soul, which makes images only of you and causes me a sweet though false delight and a pleasant fantasy, would have flown free long since – as indeed I [A7'] think it is ready to do at this moment. In such a way I feel my battered heart recovering and respiring a little. But immediately afterwards I find myself totally frustrated and left empty, unprotected and helpless. Thus my days flee away, revolving in this cycle of tribulations. Oh, I have often tried to use my industrious and intelligent mind to extract me from this painful burden, this burning firebrand, this pressing yoke; to liber- ate me from this sweet obsession with you and from this deadly bondage. Alas, Cupid is only the more angry with me, and puts me in a halter to keep me from my evil wanderings; he is all the more vigilant toward my attempts to escape, and binds me the tighter to prevent my flight. O noble nymph, beautiful above all others, may it please the higher powers this very day that hateful death may come to me from your hands! Rather that, than now, when the occasion has arrived, for you to remain deaf to my desperate plight, to my loving and justifiable petition, offered with the affectionate prayers that have been pent up for many a day in my burnt-up heart. That is why, O Polia worthy of ado- ration, I count it a good thing, ever-glorious and most praiseworthy, to die for love of you and for the untoward cruelty of Cupid. He might pardon me if, falling into this madness, I have cursed his cruel and malefic power, which has subjected me forcibly to the tyrannical judg- ment of his false and oppressive laws, and having imprisoned me in this fierce flame, he has flown away again leaving me despoiled, void of all assistance and deprived of all peace. Yet later I repent for a while, taking back those oaths and imprecations, terrified lest his anger should increase toward me and ferment still more pains and sorrows in my breast; also that he might no longer keep aflame my ardent desire for your noble elegance and charm, or else make you more intractable and less kindly than you are even now. Alas, when I inwardly reflect on your lack of kindness yesterday, I feel sure that I have fallen into the mouth of the Calydonian Boar or the dreadful Python, and am being crunched by its gnashing, foamy teeth; or else I am in the lion's fangs, which lacer-

ate my flesh as they devour me. I think I hear the sad murmuring of the souls in Hell, and all the infernal Furies; terrifying Proserpina with her hair of sinuous snakes and three-headed Cerberus; and, further down, Pluto and ill-starred Acheron. I hear the Tartarean ferryman inviting me to cross the Stygian waves of Lethe and Cocytus in his swaying skiff, and come to the dreaded judgment of Minos, Rhadamanthus, Aeacus and Dis. But a poisonous and frightful thought comes to mind that is even more abhorrent than all this: I fear that I will be rejected by you today as I was yesterday. Oh, whatever could be worse than that? Nothing, in truth. Thus I feel altogether lost and fearful, all hope gone. At times I reassure myself, saying: "I cannot be accused of Ixion's bragging lies, nor of the arrogance of Anchises or Salmoneus. I have committed no sacrilege like Brennus or Dionysus of Syracuse. I lack Echo's impudence, Syrinx's immoderate loquacity, and the bold presumption of the Pierides. I do not have the stupid confidence of Arachne the weaver, nor the cruelty of the daughters of Danaus. Why then should Cupid act so plainly as my accuser and harsh oppressor? Why are tender and credulous lovers so deceived, why offered such images of delight that are besmeared with deadly poison and sickly compounds to work their ruin?" I do not know what disaster Fortune intends for me; I cannot know or foresee what calamity, what oppression, what grief and affliction I am entangled in, to what eternal tears I am condemned, unless you, my chief hope, help me out of the plight into which I have fallen and sunk. Considering how disproportionate the effect of love is to its cause, I can in no wise predict the outcome. For this love appeared to me a sweet thing, yet the effect that I feel is as bitter as can be. I do not understand what manner of thing this monstrous love may be, except by supposing that you, Polia, are consenting to this tormenting plight, since I see in your angelic face no sign of kindness and clemency. For this cause alone I feel my soul fleeing, exasperated by your disdain; I can keep here it no longer, for I am losing my chilled spirits, my virtue and my strength. Alas, unhappy lover that I am, oppressed without equal! Most calamitous of all lovers, I see dark death ready and threatening before me; my terror, consternation and seizure at the sight of him are due to you, whom I used to think were the only hope of my life. Deceiving, iniquitous and perfidious woman! You have led me to this point of utter misery! Alas, Polia, my Polia, what am I to do? What other escape, what other help can I find? Whither can I turn? Alas, Polia, help me, for I cannot help my miserable self, and I feel that

[A 8]

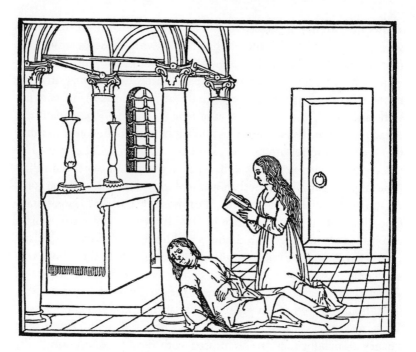

I am dying.' And raising his unhappy voice, choked with tears, with these last words the poor man fell to earth as one dead.

Compassionate nymphs, when a man loses the power of all his members and senses, his loquacious tongue alone remains capable of speech. Poliphilo made long laments, much better than anything I can replicate now, weeping movingly out of the bitterness of his heart much more than poor Ariadne, whose plaint stirred the son of celestial Jupiter. When he had said the last words, I felt an obstinate chill steal [A8'] through my whole being, making me hard and unsympathetic toward him and deaf to his beseechings. I fixed him with an unfriendly and stern expression and wrinkled brow, more unyielding than Daphne and more impious than Medea; more evil than Atreus and Thyestes, more dire than Theseus, more reluctant than Narcissus and much more indifferent than Anaxarete to her lover Iphis. And he was there in his bitter sorrow, his eyes welling with great tears, sighing loudly and lamenting passionately my severity, my beastly hardness of heart and my obstinate silence, imploring me to respond with just one word. But I kept my ears stopped and obdurate to all his pleading. There was not the slightest vestige of pity in me, for my determined will was impris-oned in my cruel and stony breast as surely as the stone in that sacred

tomb, and just as if I had drunk of the river of the Citoni. Then, realiz-ing this, losing all hope and sapped of his natural forces, he was unable to resist any longer or to avoid the approach of death. I watched as a great sorrow come over his face; his pallid and sickly colour increased; his eyes, cast down, were too fatigued and loath to behold the friendly light of day; his hollow cheeks were already soaked with running streams of tears. I saw him fall to the floor: his noisy sighs and groans were silenced, his drooping eyes closed, and there beside me he died.

[B1] I was not moved by this in the slightest. Cruelly resolute, I felt no compassion at seeing him pass away, but thought prudently that I should flee and leave his discovery to others. Efficiently – and with what bestial inhumanity! – I grabbed him by his cold feet and, mustering all my strength, dragged him into a corner of the temple: a criminal act, and one of impiety and pollution. There I abandoned him un-buried and took thought for my secret flight. I looked about me, carefully casting my eyes in every direction, but I saw and heard nothing, and so I escaped from the sacred basilica by a devious route. I felt a great burden weighing on my soul as I contrived to get far away from that place and to hasten home to my palace, more speedily than Hippe and with a bad conscience.

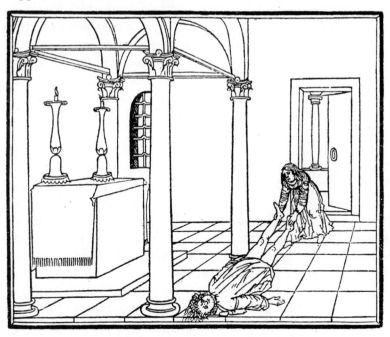

POLIA ENDS BY TELLING SOMETHING OF HER [Bɪ']
UNKINDNESS, AND OF HOW AS SHE FLED SHE WAS
SWEPT UP BY A WHIRLWIND AND CARRIED
WITHOUT WARNING TO A FOREST, WHERE SHE
WITNESSED THE EXECUTION OF TWO MAIDENS.
GREATLY FRIGHTENED BY THIS, SHE RETURNED
HOME. THEN, AS SHE SLEPT, SHE SEEMED TO BE
SEIZED BY TWO EXECUTIONERS. TERRIFIED BY
THIS, SHE STIRRED IN HER SLEEP AND AWOKE HER/
SELF AND HER NURSE, WHO GAVE HER USEFUL
ADVICE ABOUT THIS MATTER.

 ANY TIMES DURING THIS SPEECH
tears filled Polia's loving eyes and bathed her rosy
cheeks; nor could she, upon reaching this point of her
story, control or contain her sighs of sympathy. Like-
wise the nymphs who were gathered round were
moved to compassion for the dolorous lover Poliphilo,
who had perished tragically because of his vehement love and excessive
misery, so that they uttered amorous sighs from the depths of their
tender hearts and turned their kind, moist eyes sympathetically toward
me, as though condemning Polia as guilty. But they were so eager to
hear the end of this unjust case that, after pausing a moment, they asked
her to continue her entertaining talk. Polia complaisantly agreed, and,
taking the fine veil that hung from her white shoulders, wiped her wet
eyes and dried her crimson cheeks. Then, suppressing her hot sighs and
steadying her sweet voice, she continued with ladylike gestures as
follows:

Blessed nymphs, you hear of unkindness so great that I know of no
decent and loving soul that can keep from condemning me. Where was
divine vengeance hiding itself on that day when Poliphilo died shame-
fully through my evil stubbornness and unyielding obstinacy? O
celestial justice, why did you then hold back, who should have put paid
then and there to my wicked and perfidious soul? In fact, it was not long
before I saw the anger of the offended Goddess and her archer-son man-
ifested, prepared for me in case I did not expiate my unfeeling sin and
warm my hard and frozen heart; lest I did not placate this holy divinity
by straightway purging my obstinate imagination of its false beliefs and
vain thoughts, and my mind from its fallacious and deceitful opinions.

However, as I took my solitary flight my heart remained hard and intractable, my mind unyielding, my will harsh and more cruel than that of Phineus and Harpalyce, my icy breast frozen harder than the crystal of the northern Alps or the jet-stone that protects the eagle's egg, or as though I had looked into the frightful mirror of Medusa. I rejected love and spurned all pity for him, who had pleaded with tremulous groans and broken voice, weeping more pious tears than the Hyades; who had tried to move me with a voice more gentle, more anguished and lamentable than that of Britannicus, when he sang to the people of his misfortune; who had humbly implored my help and assistance in his ceaseless pining and tearful woes; had tried his utmost to charm and bend me from my harsh, cruel and unyielding attitude. But I was careless of his sufferings, his sweet supplications, his heartfelt oaths and his amorous prayers, and persisted in indifference to all his pains, spurning and rejecting all humanity, repugning all sympathy, and leaving him not the slightest chance to move or tame this hard and tiger-like breast, implacable and abusive beyond measure. Love could in no way cleave to it or even approach it: his power was spurned and disarmed, though it reigns over human hearts of every kind, just as wax, although malleable, will not stick to wet stone however hard one pushes and compresses it. Oh, how frightful and grievous a case, that I felt no terror, much less emotion! In me, most severe of womankind, it aroused no reaction, no indication of sorrow or sympathy, drew not a tear from my eyes, provoked not a groan. Not a single sigh was to be found in my stony breast that might break the bonds of my imprisoned compassion. Thus, while Phoebus and his follower Vesperugo were already eager to meet the waves of distant Hesperia, judging Poliphilo dead, as I supposed, I concentrated on flight, knowing myself to be the guilty murderess of his loving heart.

On this account I wasted no more time than the aforementioned Phano: finding myself under the most sinister auspices, I briskly hastened my girlish steps. Suddenly and without warning I was seized by a whirlwind and spun around. In a moment I found myself whisked through the air and deposited, without any injury or hurt, in a wild wood planted with shady trees of dense and vast growth and overgrown with horrid thickets of thorn-bushes, making it impassable and impen-
etrable. My heart pounded, for I was frightened beyond belief by the suddenness and unexpectedness of the event. Then I began to hear women's voices loudly yelling 'Woe! Woe!' — as I myself was ready to

do – with sobbings and piteous lamentations exceeding those heard and seen by the nobleman of Ravenna.

A moment later, two doleful and unfortunate maidens staggered by, often stumbling here and there and arousing the deepest pity, for they were harnessed to a fiery vehicle and bound to the yoke with chains of strong, glowing steel that burned fiercely into their tender, white, downy flesh. Their hair was loose, they were naked, and their arms were tied behind their backs. They were weeping miserably, grinding their teeth, and their tears hissed as they flowed over the hot chains. They were being whipped incessantly by a winged youngster mounted on the burning chariot, who was inflamed, furious beyond measure, and implacable. Even the terrible Gorgon's head was not so intolerable and grim to Phineus and his companions as the face of this formidable child, as he used his sinewy and fiery whip to scourge the chained maidens with bestial cruelty and fury. Even Zetus and Amphion did not use such vengeance toward their stepmother Dirce.

Wandering they knew not where, hoping for escape, they were [B3] forced through devious and pathless places and dense thorn-bushes, lacerated by the deadly whip and the heat of the burning chariot, often turning aside only to be scratched by the bushes, torn from head to foot,

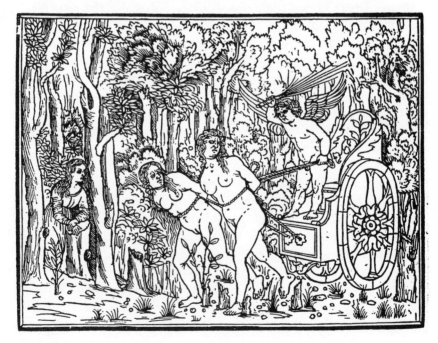

400

with blood raining from their stricken members and lacerated flesh. I could see the steaming, scarlet gore spattered all over the prickly briers and on the ground. A furious rage drove them pell-mell through thick and thorny brambles, now here, now there, as they painfully dragged the heavy, burning carriage. It was cruelly burning their soft and delicate flesh so that it was not only scorched, but burst like blistered leather; and they wailed and shrieked in their wretched affliction, making a greater clamour with their sobs and cries of woe than Orestes pursued by the Furies. The wild and wooded place echoed with their pitiful voices until their jaws seized up, their voices grew hoarse and ceased, and they could bear their sufferings no longer. Soon after this, many fierce creatures approached them; and the brutal and heartless boy, having inflicted long and cruel punishments on these wretched and unfortunate girls like an executioner well practised in his bloody trade, suddenly got down from the burning vehicle. Taking a large, sharp, iron sword, he released them from the painful yoke and the heavy traces that went around their panting breasts, then without the slightest indulgence or pity, but with hard and unmitigated severity, he thrust it through them.

[B3'] At the first stroke a pack of hounds came up, bristling and famished,

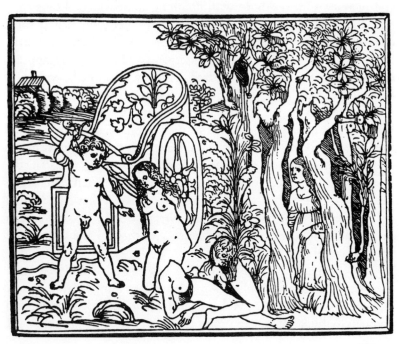

with keen barking and hideous growls, worse than the ones that the king of Albania presented to Alexander the Great. Then came fierce, roaring lions, and howling wolves; and from the air there swooped rapacious eagles, hungry kites and hissing vultures, all eager for the hot blood and the evil feast. After the girls had rendered up their final cries, the boy, devoid of all humanity, struck them and cut them in two. Then slicing open the womanly breasts, he tore out the still beating hearts and threw them to the birds of prey. He gave their steaming innards to the ill-omened eagles, and the rest of their pallid bodies he quartered and threw to the raving beasts. I watched the sharp-fanged lions eagerly devouring them, voraciously fastening their jaws into the human flesh and rending it, while with their curved claws they separated and tore it to shreds. I saw them staining their tawny manes with the crimson blood. The amputated and scattered members of these two maidens of tender age, forced to breathe their last while yet ungrown, finally resem-bled a ghastly butcher's shop. Alas, what a cruel spectacle! What a horrible form of burial! Think, gentle nymphs, of how terrified I was by the sight of such inhuman evil and cruelty, finding myself bare, defenceless and fearful beyond measure. I lay low, hidden in a spiny briar-brake, surrounded by thorny sloe-trees, dog-roses, prickle-bushes and piercing Christ's-thorn with its strong spines. I stood thus con-cealed beneath the dappled shadows of the trees, terrified beyond imagining by this vision, which frightened me more than the horrid image of Clytemnestra, armed with serpents and blazing fire, appear-ing to Orestes the matricide. I feared that the wild animals, with their keen sense of smell, might find me hiding in the thick wood, alone and unarmed, fragile and artless by reason of my sex and my age, and without hope of assistance – and that they would maul me in the same way. I said to myself, trembling: 'Alas! Have I been carried hither by the winds as Iphigenia was to the cruel Tauricians, only to be sacrificed? Alas! What Caucasus, what Hircania, what deepest Libya or Agis-inua suckled such monstrous and bloody beasts? What could equal such incredible cruelty? Alas for my wretched self! No animal can match these fell beasts in rage and violence, as they rip and scatter their prey piecemeal over the ground.

'Oh, what an incredible spectacle of woe and of matchless cruelty! [B4] Oh, what a strange and unheard-of calamity! – a thing horrible to look at, tragic to contemplate, awful and terrifying to behold, repulsive and aborrent to think about. How have I, sad, wretched and hopeless as I

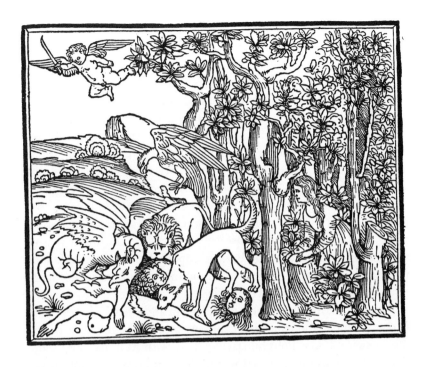

was, come among these deadly perils? Alas, for my grief and affliction! What are these accursed and furious things that I am really and truly seeing?' This filled me with mortal fear, wondering whether my death was imminently sealed and decreed, and I began to weep bitterly, shedding floods of tears, stifling my frequent sighs and soft groans, expecting to be dismembered in the same way. I watched with anxious gaze lest the irate and savage boy, with his menacing weapons and his unyielding cruelty, might spy me hiding in this place. Then I turned my tearful eyes down to my chaste and shining breast, eyes that I believed to be henceforth transformed into dewy tears. Shuddering, I uttered these anxious words interrupted by sobs and panting, my breast swollen with many a groan and inward sigh that I tried to smother; my voice was feeble, my tongue paralyzed, as I softly said: 'O accursed and ill-omened day! O day of terror and horror, to be commemorated my life [B4'] long with mourning and bitter lamentation! How miserable and unfortunate I am, to be caught and ensnared in such a calamity, unable to see why I am in such a state. Has deceptive Fortune ever worn such a malignant and cruel mien? O lady Diana, whom I serve, must my own virginal female flesh be impiously sacrificed and eaten in this way? Must

the flower of my happy youth perish in this wild and thorny wood? Must my sweet life end in such torment and savagery? I feel my feminine virtues ebbing, my dear spirit fleeing from its home.' Moved by this suffering I bitterly cried 'Alas! Alas!' My face was streaked with many rivulets of tears – a special fluid that no doubt was amply prepared in advance – and my breast was soaked with it. I raised my desperate hands to my blond hair in hatred of my own ornament, tousled my locks as I wept and disfigured my beautiful face by scratching it with violent nails. My suffering and affliction were beyond measure, but what added most to my great pain was that I could not give vent to my pent-up cries and groans. In the midst of this torture I could not unlock the doors of my sorrow, which my heart could suffer to contain no longer, and all the more because I could not explain this shattering event. Then without warning I was transported unharmed, and found myself pale, agitated and in tears, but unhurt and unwished-for in the very place from which I had been seized and abducted.

Ah, me, chaste nymphs: the contentment and relief I felt were more than any mind could conceive of, and my mind was detached from the piteous state of poor Poliphilo, which had alarmed it not long before, for that vexatious memory was wiped clean and erased from it. It was concentrated only on the girls who had been wickedly killed and devoured, on their bitter struggles and on their evil executioner. Finding nothing to prevent me from sobbing and frequent sighing, I assuaged my anguished soul in the best way and let the tears, which had been held back in my dire straits, flow freely. At length I came more dead than alive to my safe and cherished home, where I silently reviewed in my heart the atrocity that had occurred.

Burning Phoebus was beginning to show Hesperia the rounded backs of his fleet and winged Pyrois and Aethon. Their golden manes were colouring again in the orange glow, while the serene sky was beginning to wear its ornament of radiant stars. After the long and tiring day, every creature was seeking sweet repose and slumber, and I [B5] did likewise, after this terrible day spent in severe suffering and given up altogether to sighs and tears. I was extremely unsettled as I wondered about the reason for the strange and unheard-of cruelty that I had seen used on these persecuted girls, and about how I had suddenly been arrested in my flight and carried through the air. I diligently considered all these things with constant sobs and sighs – and how they afflicted me! Hear, O happy nymphs, if I did not judge it a portent of anguish,

404

tears, and a life of quandaries and suffering to come, as decreed by Fate! Baffled by this but goaded on by fear, I turned over various ideas in my mind, yet could in no way discern their hidden cause. In view of this, I consumed the whole of this unhappy and inauspicious day in lamenta׳ ble and disagreable silence, in which I would rather have encountered pale Corydon than been overwhelmed with such extraordinary unhap׳ piness. Thus encompassed with bitter sorrows and oppressed with many heavy pains, deprived of all security and not daring to sleep for fear of nocturnal phantasms, in the dark and ambrosial night I sum׳ moned my dear and revered nurse, who was as a parent to me and in whom I had placed and invested all my trust and hope; for all my past had been spent in solitary chastity with my goddess Diana.

It was the hour when white Cynthia has left the Lamian rocks and the dense forests, and made an end to the pleasures of the hunt; the bedroom was closed and locked, and the two of us were finally going to our nightly rest. My pulsing breast was still beating irregularly, scarcely able to contain my frightened and bewildered spirits, as with supreme effort I managed to staunch somewhat the broad stream of great tear׳ drops and begin a painful and uneasy sleep, often interrupted as my fears awoke me.

My shaken body relaxed in its first sleep, which is the best, sweetest and most refreshing; it stretched out and slept in the silent night. But it was as if I had the eumeces stone at my head: I seemed to hear a great noise as though bolts were being shot, locks forced, and burglars break׳ ing the iron bars and violently throwing open the doors on the threshold [B5'] of my bedroom. Then there entered heedlessly, with rapid and hurrying steps, two horrible executioners with bulging and swollen cheeks, coarse clothing, and gross and shocking peasant gestures. They looked wild and angry, with fearful eyes that were more piercing than those of the deadly basilisk: large and round, they rolled in their cavernous sockets beneath bushy eyebrows, dense and bristly with long thick hairs like those of the Sileni. They had huge mouths with pendulous lips, thick, swollen and curling, the colour of putrefaction; the great teeth in their jaws were uneven, rotten and rusty like old iron, destitute of gums and abandoned by the lips, which left them uncovered. They stuck out of their gaping mouths like a boar's tusks, foaming in the chase, and gave off a foul stink. Their faces were hideous and deformed, dusky and leaden in colour, covered in fissures and wrinkles. Their goat׳like hair was greasy and filthy, grizzled with black and grey: it looked like the

405

bark of an old elm-tree. Their broad, calloused hands were bloody and slimy, with stinking fingers and vile nails that they seemed eager to use cruelly against me, a poor maiden. They swore and blasphemed, furrowing their hairy brows and lowering their eyelids above their turgid cheeks. They wore two twisted cords stretched over their muscled shoulders, and hatchets – the lictors' instruments – were stuck in their belts. Their naked bodies were clothed in goatskin, which I suspected to be the costume of bloodthirsty torturers and the most polluted of men. I heard them bellow with ghastly and terrible voices, like a bull roaring in a hollow cave, as with insolent arrogance and presumption they abused me, saying: 'Come on now, you proud and wicked one! Come, come, you rebel, you enemy who opposes the rule of the immortals! Come, come, you silly girl who despises and ignores her own pleasure! You rascal! You rascal! Now you're going to get the divine revenge you deserve, you guilty woman: yesterday you saw two other young criminals just like you torn limb from limb, and in a moment the same will happen to you.' Ah, misery! How terrified I was by these accusations and insults! Gentle nymphs, consider what a state of fear my mind was in, seeing my chamber invaded by these strange, foul and truculent accomplices. I found their arrival even more alarming and disturbing than Pelias, when he was sacrificing and saw the nymph Tiro's son arriving with one unshod foot. The crude and frightening words that they darkly uttered struck more terror into me than those of the unfortunate Polydorus did to pious Aeneas. I was in a worse agony than Andromeda on the seashore; in worse fear than Aristomenes under the table seeing Panthia and Meroe. The strong and vicious arms stretched out toward me in wicked sacrilege. They snarled as their nasty, bloodied hands, beslimed and polluted, disarrayed my blond hair and began to drag me mercilessly, for they had not a drop of pity in them. I suffered greater fear and terror than the chaste Lucretia, when Sextus Tarquinius, naked sword in hand, threatened her with an ignominious death. I lost all heart, stupefied beyond belief by the mixture of wonder and terror that these cruel and bloodthirsty men struck in me, so that every vein leading to my sad and heavy heart was emptied and bloodless; I was as timid as a fawn, startled as the timorous, long-eared hare lurking in the dense bushes and clumps of rushes, surrounded by the barking of the fierce, cruel hounds. I lost not a moment in shouting out with a loud voice, and as they seized me by the hair, I shrieked for help. I tried to prevent their painful dragging as best I could, grabbing their

[B6]

arms and attempting with my weakened and debilitated energy to resist the violent treatment of these furious men; but they were tougher than Scyron, son of Neptune, and crueller than Phineus or Polydectes of Seriphus. No prayer or plea would stop them as they began to drag me from my bed, already wet with tears. I screamed for assistance: 'Help! Help! O God, have mercy!' – struggling with both hands and bare feet, but they grew all the more violent, whipped up to a foaming rage. As they moved, they gave off the stench of their rancid and purulent flesh, which was so foul in my nostrils that I was ready to vomit; it exuded a strange and unbearably nauseous vapour, as these hateful creatures, with their beastly furrowed brows, terrorized me.

Finally, afflicted beyond endurance by anguish and misery, and bereft of speech in this long struggle, I was overcome by bitter tears and lost all heart. Perhaps I was struggling and turning in my virginal bed when my dear nurse, who had been fast asleep, chanced to hear my movements and my incoherent stammerings and immediately rose and woke me, shaking my out of my troubled sleep and my disturbed night. Taking me in her arms, she kept shaking me and arousing me, saying: 'Polia, my pretty girl, Polia my dear soul, Polia my life, my little black [B6'] pudding, whatever's going on with you?' As the wretched, accursed and unhappy sleep vanished from my eyes, and my frightened vision cleared, I could utter nothing but sorrowful sighs: 'Ah me, ah me, alas, alas!' I came to myself in a state of shock and utter prostration; my breast, shaken and defiled, felt the violent throbbing of my nervous and frightened heart, like busy Vulcan hammering out the tremendous bolts of thunder and lightning-wielding Jupiter. My flooding tears had soaked my white linens, my fine shift was adhering damply to my virginal belly, my hair was in disarray, and my soul was lamentably afflicted with this painful torment, obsessed and invaded by the thought of death. I could by no means muster my young and feeble energies; abandoned and ignored by my mortified limbs, I was prostrate, utterly weary, more dead than alive, and lay like a paralytic, finding no joy in life, weak, destitute, and miserable. My kind nurse, seeing me in such straits, calmed and caressed me with gentle urgings and womanly persuasion, and succeeded after a while in getting me to rise and accept comfort and consolation. She did not know what had happened, and was extremely concerned and curious to know what I had experienced, and searched anxiously for what such a fit might mean.

Holding me in her arms against her old bosom, she suffered equally

from my unfortunate and incomprehensible accident and wept bitterly
with me; but after much flattery and urging she drew out my fright and
affliction, and a little life returned to my soul, though I was trembling
with a greater fear than Jupiter's, when the supreme father was turned
by the Giants into a woolly ram. I told her with bleating tones and
shortness of breath about the horrid vision, and also related in all seri-
ousness the strange occurrence of the day before, and what had hap-
pened as I was returning from the desecrated temple, except that I did
not speak at all about the distressing and unjust death of Poliphilo, as I
believed it; but I did say that I had wrongly acted in a foolish and absurd
manner toward Amor. No sooner had I finished my story than she
thought for a moment and then, with the insight of old age, guessed
the cause. She gently revived me with many sweet blandisments, put
my mind somewhat at rest, and calmed me just a little, then revealed
that she could in fact cure my grave and painful state, so long as
I would follow obediently her well-weighed and helpful ad-
vice. Thereupon, freed from every other thought and dis-
tracting idea, I offered myself wholly and exclusively
to her faithful and compassionate advice as an
obedient follower, tame and disciplined to [B7]
a remarkable degree, if only she would
free my mind from such pain, affl-
iction, and prodigious danger,
and my future life from
such chagrin and
sorrow.

✳

POLIA TELLS HOW THE WISE NURSE ADVISED HER TO AVOID THE ANGER OF THE GODS AND TO EVADE THEIR THREATS, USING VARIOUS EXAM/ PLES AND PARABLES SUCH AS THAT OF A LADY MADE DESPERATE BY EXCESSIVE LOVE, WHO KILLED HERSELF. POLIA WAS TO GO WITHOUT DELAY AND CONSULT THE PRIESTESS OF THE HOLY TEMPLE OF LADY VENUS, WHO WOULD TELL HER WHAT TO DO AND WOULD GIVE HER SUITABLE AND EFFECTIVE ADVICE.

 OBLE AND DIVINE NYMPHS, WHEN one's mind is disposed and inclined in one direction, it takes a supreme effort and the expenditure of much energy to turn it in another. Its inflexibility makes great difficulties when it has long been used to some/ thing, and especially when it has found therein some favourite amusement and reward. Wanting to adapt and turn it in a con/ trary and altogether alien direction seems to its faulty judgement altogether too difficult. One should not be surprised in the least if its senses are sometimes depraved, distorted and corrupted, so that things of an agreable nature seem to it unwelcome, uncomfortable, despicable and bitter. Nor is it any wonder, distinguished nymphs, if white appears black and offensive to eyes that are sick, dirty and bleary; if bright red things appear livid to them, while shining and sparkling white ones appear with red spots, covered with mist, soaked in sepia and stained with ink. They reject them, although clearly this is not the fault of the object, but of their diseased sense. It was no different in my case: after I had firmly accustomed and committed my mind and soul to the chills of chaste Diana, and bound and vowed myself to her, it was a grave and extremely difficult matter to make the advent of ardent Amor acceptable to me.

Ignorant of his delights, I repulsed him like a cruel enemy, deter/ minedly contrary to him and disgusted to the point of nausea. Wanting with good intent to introduce this new love into my frozen heart, it was necessary to segregate carefully the repugnant contraries. Now my saga/ cious and experienced nurse wanted very much to remove this hardened [B7'] mass of ice which time and habit had caused to grow and congeal in me. In her pure and sincere judgment, regretting that she had not seen

409

the divine threats, she thought it best to defuse them by flattery. In preparation for this, she said to me lightly:

'We have learned that it's true what they say, Polia my little one, my sweet hope: that he who takes advice can never die by his own fault alone. Think this over well, and ask yourself whether you may have unknowingly offended the higher powers by some simple stubbornness, for their anger is harsh and punishing against those who have not respected their power and have been rebellious. There is no doubt that this anger is great, and all the more so when they postpone their frightful and inevitable vengeance. Considering the foolish and inadvisable levity and the superstitious and unconsidered opinion of some of you girls, it is no wonder that the awful heavenly powers sometimes appear cross and vindictive toward you. We know well what their bitter anger inflicted on Ajax, son of Oileus, because he insulted and cursed the stern gods: he died miserably, struck by heavenly lightning. The hungry companions of Ulysses perished similarly; and there was Hippolytus, who was recalled from darksome death to the blessed light of day through the prayers of the huntress Diana. And many others have fatally and miserably risked their lives through negligence and insufficient fear of the threat of divine punishment: the impudent Propoetides, who scorned holy Venus, were brutally transmuted into solid rocks; Minerva turned the young Lydian weaver into a spider; and beautiful Psyche, for her disobedience, found herself condemned to hard and intolerable labours. There were many other noble girls who acted with uncouth and beastly cruelty to their devoted lovers, and who brought down the vengeance of heaven upon their malevolent hardness of heart: a vengeance that shows itself inexorably in various terrifying fates. Beside this, one should well call to mind how cruel, how pitiless, how impious, how violent and powerful in his tyranny the Son of the divine Mother is, of which we have true and indubitable experience, as well as very clear information (although it is a mystery) that he has not only wounded mortals but also the breasts of the gods, setting them painfully aflame with no respect or pity. Did not Jupiter himself, who gives rain and shine, have difficulty escaping from his amorous and [B8] ardent torches, and did not do so unscathed, for he took on human form for the love of many maidens and, thanks to Cupid, sought delightful unions with them? If we turn now to the other gods and address ourselves to furious and belligerent Mars, always armed with his impenetrable breastplate and with dire and murderous weapons, he

cannot prevail in the least against that archer Cupid, nor protect himself, nor repel or oppose him, much less defend himself against the amorous wounds or resist the stabbing arrows. For Polia, my child and my dear heart, his power is very great. And if he has not spared the high and mighty ones, how can you think that he would spare earthlings, especially those who are fit and apt for his service, and even more those who are foolish enough to try rebellion and resistance, weak, feeble and defenceless as they are? He is much angrier, active and hostile toward those chaste ones who flee, afflicting them with many violent invasions and frightful vexations. And if he could not prevent himself from falling in love with the fair Psyche, how could he be harmless to others? We know for certain that his marvellous quiver contains two different arrows, one made of flashing gold, the other of gray and unlucky lead. The first sets hearts ablaze with a compelling and vehement love that violently irritates them, while the second does the opposite, arousing an intolerable pride and an instant violent dislike, causing deplorable cru/elties. The rogue used them both when he kindled amorous fires of a dire and extreme kind in the breast of Phoebus, but wounded his loved ones with the leaden arrow, because the all/seeing one had boldly brought to light the sacred amours of divine Venus, and had tried to prevent them. Phoebus had a lengthy repentance on account of all the refusals, denials, affairs that turned out badly, and the same happened to all those under him: not one of them prospered.

'Hence the more ardent he grew, the girls he loved became more dis/agreeable, unyielding, austere, rejecting and fleeing from him, and it was the same with his descendants and progeny. Many people, of all conditions, suffered from similar consequences and vengeance for having unadvisedly resisted him and lightly dismissed his swift darts, as you were shown in that dreadful night through fell and abominable images.

'Listen, then, my child, and take my mature, sensible and useful advice. Never wish to oppose something that you cannot resist or match with equal force, nor flee from what cannot be otherwise, and do not reject my well/weighed and mature opinions. For since the great Artifi/cer has created you so beautiful and immaculate of body, intelligent of mind, eloquent of tongue, endowed with unusual and memorable charm and a face of noble and elegant lines, you should consider very carefully that he may have made of you a kind of precognisance, by a unique demonstration of heavenly beauty and a compound without peer. And above all the other noble and incredible beauties that he has

[B8']

411

placed in you are those two amorous and splendid eyes that adorn your distinguished and attractive face. The crown of Ariadne in the limpid heavens is not so well adorned by the three brightest stars among its nine, near the left shoulder of Arctophylax and the shoe of Engonai's right foot, east of Cancer and Leo, and west of Scorpio. Nor does the brow of Taurus appear thus adorned to the Hyades sisters. Because of these worthy features, perhaps the Lady Venus has mysteriously summoned you to her sacred altars, so that such rare and perfect beauty should not be wasted without her amorous fires, as the willow loses its fruits. Your pretty looks indicate that you are destined more for her warm service than for that of cold and fruitless Diana. For it may be that the divine rulers of destiny have a friendly concern for your girlhood, and that the monsters in your nocturnal revelation were evoked by the gods in order to warn you that it could happen to you as it has happened to many others, because those who neglect the preeminent duty of nature in this life show themselves enemies of the gods. Now listen briefly to some examples.

'My dear child, not many years ago in our own town I knew a girl who, like you, was of generous and rare beauty, endowed with noble, famous and distinguished ancestors and born from an illustrious race. She had many virtuous qualities, was delicate, skilful, refined and diligent in all her works, exquisite in her manners, elegant in her dress, studious and painstaking in her feminine adornments, and raised among all the possessions and pleasures of wealth. When she came to the flower of her age that is so pleasing to the great gods, she was much sought after by many young suitors, but especially by one youth who was her equal in elegance and gentility, outstanding in virtue, generous in spirit, and who particularly desired and petitioned her. However, despite his lengthy wooing of her and his importunate pleadings, she would in no wise consent, and continued to pass her springtime years and the most potent and lovely period of her youth in frantic and ostentatious levity. Oh my Polia, she consumed these brief and precious years, never thinking that there is nothing more pleasant and companionable than love reciprocated by one of the same age, and remained alone in this perverse state of mind, in her cold and lonely bed, until she passed her twenty-eighth year. Then Cupid, who does not forget the [C1] insults done to him, became angry and implacable: he took up his mischievous curved bow and wounded her deeply in her proud breast, penetrating that wild and obstinate heart right through with his sharp

412

golden arrow. It reached its goal and settled, burning, in her breast, whereupon powerful Amor with his blind fires began to blaze up again; and the wound was so deep, so dangerous, severe and compound that no healing scab could grow over it. And she, being amorously aroused by the hot urgings, and impatiently vexed by bit, bridle, saddle and spur, began to perish of this longing, craving now the sweet wooing that the noble youth had made in vain; but he appeared to her no more. Now Amor justifiably used his wonted violence toward her, making her grow unthinkably heated and immodest, and making a furnace-fire of her afflicted heart. It was not so much the handsome and elegant youth she wanted: in her state of evil lust she was repelled by nobody, of whatever condition, so that if she could have found satisfaction of her ardent and voluptuous desires and her prurient concupiscence, she would have leaped at the chance without a second thought. I reckon that if an Egyptian, an Ethiopian, or any outcast had offered himself, she would not have refused his demands any more than those of our patricians. In the end, the noble lady languished from an excess of passion: whipped up by these deadly flames, pricked by seductive desires, prurient appetites and immoderate lasciviousness, incredibly agitated and irritated by this importunate lust (as if she had come from Didyma) and unable to stand the pressure, became miserable, sick and infirm, and took to her bed. Now when Antiochus, son of Seleuchus, was excessively enamoured of his stepmother and overcome by mortal languor, the doctor Herasistratus detected the cause of it by feeling his pulse. In the same way, the clever and expert physician understood clearly that this lady had collapsed into this state because of excessive love. When her step-father and mother were consulted about this, they thought that in order to save her from dying, the best remedy would be marriage. Not long passed before a gentleman was found, of good family and rich, but in his declining years and, being wizened, appear-ing even older than he was and approaching the dangerous age. His jowls were somewhat pendulous, his eyes ulcerated, his hands trem-bling, his breath fetid, and he covered his head because it looked like the back of a mangy dog, and the clothing of his chest was covered with slaver. His mind was occupied only with a grasping avarice, and he was
[C1'] obsessed by insatiable greed. Then came the ill-starred wedding day: you would have thought that its dark, funereal and deadly herald was the night-wandering Ascalaphus, monstrous, unlucky and base. This sad marriage-union was celebrated with pomp and the usual feasting,

then came the longed-for night which the overheated woman had long and eagerly awaited. She firmly believed that this would be the hour to quench her burning venereal appetites, no matter what the husband might be, for she was so blinded by excitement and stupefied by her unbridled desire that she thought only of the fruit of this delectable union. Filled to overflowing with her prurient desires and surrendering herself to lust, she lay down beside the frigid and impotent old man, and as she lay in his feeble arms, she was inflamed beyond measure with the desperate and frantic desire to be possessed. Cupid deliberately increased her passion, like a bellows blowing on a little fire, but unfortunately for her, nothing ensued except that her pretty face and crimson mouth were slimed and slavered by his lips, as if a snail had crawled over them. Neither her flatteries nor her venereal and wanton actions, neither her charms nor her caresses could reheat, arouse or stimulate the impotent and sterile dotard, or bring this peevish creature to rut. His breath had the air of a putrid sewer or a fetid bog. His gaping mouth was adorned with pallid, wrinkled lips and a feeble voice, and all that was left of his teeth were two upper ones, chipped and pitted like pumice-stone, and four below, two on each side, which wobbled in their seats. His white beard, coarse as the hair of a long-eared ass, stuck out like wasp-stings. His scarlet eyes were wet and teary, his pug-nose had gaping nostrils, forested, snotty and slimy, and was perpetually snoring, so that all night long it seemed as if a great bellows were blowing. His face was hideous, his head covered with white scabies, his cheeks varicose and his eyes topped with swollen lids. His neck with its wrinkled skin was deformed and veined like that of a bog-turtle. His trembling hands had no strength in them, and the rest of his body was putrid, morbid, sickly and sluggish. When he moved, his garments gave out a stench of stale piss. Now listen to me, my child, and keep what you are hearing in your little memory. The lascivious woman, totally frustrated in her voluptuous desire, tried every means of seduction and every whorish trick, but was unable to arouse the flabby members of excessive and enfeebled age. Thus, as time passed, she came to receive and expect nothing from this obnoxious and tedious old man, who was so idle, inert, slothful and sluggish, yet had become more jealous than Barbarus the decurion – nothing but blows, quarrels, garrulous cries, and a cold and languid boredom, a loathsome tedium and the utter disappointment of her unleashed desires. Turning inward, she [C2] realized that her unhappy fate was the consequence of her obstinate

chastity, and she mourned bitterly not only her fruitless marriage with this disgusting and nauseating old man, but even more because she had uselessly and irrevocably wasted the whole time from her infancy to this moment. She knew that henceforth she had no hope of regaining it, by any means or at any price, and this gave her the greatest cause for sorrow. In addition, her unhappiness was dreadfully increased when she thought of other married couples who were happy and contented, and she would often imagine how they lay together in the sweet embraces of their chosen lovers, and think of their amorous and delightful pleasures and the satisfaction of their appetites and desires, as she thought. Shameless Nature and that celestial rogue Amor urged her on till she was grabbed and torn apart by a burning envy, constantly turning over in her mind the intolerable and tedious complacency of the odious dotard and feeling disgusted with her sad and comfortless life. She took to scratching her face with her nails, and beating her breast violently with her fists, realizing that all hope was lost for her and bursting into tears. Her eyes readily took to weeping, with plaints more bitter than Egeria's, for nothing pleased her, nothing seemed desirable; she lost her taste for everything except ungodly death, and wished for an quick end, like that of Iphis. Out of this there arose a raving fury that turned her into her own cruel and capricious killer. One dismal day, without her husband's knowledge, she secretly took a sharp steel knife, being conscious of her sin but not master of her will; she had lost all faith and become her own mortal enemy. Giving herself over to her furious plan, she took horrible and fearful revenge. Crowned with baleful smylax and leaves of hornbeam, she invoked the infernal and malefic Furies (what an unheard-of deed!) and plunged the fatal blade deep, transfixing the centre of her miserable heart.

'Oh, how wretched and afflicted I should be in my old age (may the Gods save me!) if such a misfortune should befall you in your tender youth as punishment for some similar crime! I would die before my time of sorrow and misery, quickly bringing my life to its close.

'Ah, me! who would then dare to compare my misfortune in kind, in breadth, in weight and in severity to the horrible, unhappy and burning calamity and the miserable ruin of that lady? What encounters with shades, with spooks, spirits and spectres, what nocturnal apparitions, what frightful demons could hurt and horrify me more than if these sad eyes were to see you wronged and damned like her? Polia, my child, my sweet hope, listen to me with all your attention: the inescapable anger of

the gods sooner or later takes its infallible vengeance. This is what Apollo brought on Castalia for her refusal, and likewise the fair [C2'] Medusa was so unfeeling that she resisted and refused her young suitors, and for her beastly hard-heartedness her blond hair was turned by the supernal gods into vile, squirming vipers. Only then did she come to love the amorous crowd, but they were terrified and fled from the snaky head, leaving her even more enraged and agitated by desire because she could not get them back. The divine schemes and orderly causes decree that young persons should fall in love at the proper and predestined time. Silly girls of your own precious age may make light of these decrees, but by naughtily rejecting these mysteries they insult the heavens and beneficent Nature. Thus it is not to be wondered at in the least if sometimes they perish miserably. Alas, my fair Polia, dearer than my own eyes, this season of our life should be valued and appreci- ated above all, more than the renowned treasures of Darius, the riches of Croesus, or the good fortune of Polycrates – more than anything in the world. This life of ours is very short: it runs steadily faster, and flies by more fleetingly, than the race-horses of Phoebus, consuming itself like a fragile and evanescent bubble. This is why we should gladly devote our sweet years to cheerful Amor, when he is opportune and timely, because afterwards, when we come to vexatious old age, we still try to feign our vanished youth: to play the gallant, we carefully remove the white hairs from our hoary head and try to darken and dye it with lye of litharge, quicklime or walnut shells. We want to feign and preserve that which Nature denies, painting our skin and artificially prolonging and con- serving the plumpness and freshness of our flesh. When our hearts are gnawed by continual and incessant pain, we sigh and weep for the time of delight, love and solace that is past, deploring this repulsive old age, hoping greatly for a rare attention, yet barred from the resorts of youth, because that age prefers equality and similarity. Then we remember the loves we have experienced and their tender delights, and our desire to live is fiercer than it was in the flower of our youth, when one thinks nothing of it because the end is so far off. But as death comes nearer, the stronger burns the appetite to live, if possible as long as Nestor, Priam or the Sibyl. Therefore, Polia, my dear treasure, if you value your present life and the lovely flower of your age, beware! It may be that these things are a demonstration from Cupid: he may have showed you in this vision and display that his anger toward you is already aroused and growing. But are you perhaps so vain and superstitious that you think that you

416

[c3] can supplicate and please the high gods? Do take care that it does not happen to you as it did to repudiated Hebe, who served great Jupiter and the other Gods carelessly and fell, her light garments lifting and revealing her obscene and private parts. Although she had no offence in mind, Jupiter was still angry and removed her from the office of cup-bearer, replacing her with Ganymede. Therefore get rid of your cold resolutions and break with them, if any remain in you. Go forthwith to the temple of most holy Venus, alone and of your own free will, and find the sacrificing priestess who is the chief director and interpreter at the divine sacrifices. Tell her what you know to be the cause of these menaces and confess your fault frankly to her, revealing that which may bring you more trouble and harm if you conceal it than if you admit it. And she will kindly and speedily give you suitable advice, necessary aid and helpful understanding, so that you can escape from your doubt and anxiety and all your troubles, and flee from the divine and irrestrainable wrath, if any has been prepared for you on account of your thoughtless rebellion and wicked contempt.'

POLIA, TERRIFIED OF THE DIVINE WRATH BE-
CAUSE OF THE EXAMPLES OF HER PRUDENT
NURSE, OBEDIENTLY BEGAN TO FALL IN LOVE
AND WENT TO THE TEMPLE WHERE POLIPHILO
LAY DEAD. MOURNING AND WEEPING, SHE EM-
BRACED HIM AND HE REVIVED, BUT DIANA'S
NYMPHS CHASED THEM AWAY. POLIA TELLS OF
THE VISION SHE SAW IN HER CHAMBER, AFTER
WHICH SHE WENT TO THE TEMPLE OF VENUS AND
FOUND THE AMOROUS POLIPHILO AGAIN.

FTER MY NURSE HAD SUFFICIENTLY persuaded me that I must consider the nocturnal presage with prudence and insight, that wise old woman made an end of her heartfelt warnings, her good advice and her discourse. The sky had already dispersed the cloudy vapours and driven away the dark of night; the rising sun had gilded the air of the new day and almost dried the morning dew off the grassy meadows. After this opportune warning, my mind was heavy with fearful and grave memories, and I

[c3'] began to sigh inwardly. When she had left the room, I remained alone

417

and carefully reviewed her valuable sayings, her urgent and balanced advice and the clear and terrible examples, dwelling especially on the part that directly condemned me as a stubborn and fierce rebel who deserved dire punishment from the divine wrath. While in my terror I was wishing with all my power to escape and free myself from this anxiety, there came into my mind, led by I know not what heavenly guidance, the loving Poliphilo. I knew that in my impious savagery I had left him in the sacred temple, deprived of his precious life. Cunning Amor found in this first motion a little chink by which to enter, and, together with some warm sighs, gradually began to penetrate the forbidden place and to settle down quietly with his first gentle tapers in my hard and indifferent heart. I could already feel a pleasant heat circulating and expanding around my inexperienced heart and even in its innermost regions, which nourished itself on the stirrings of a sweet and thrilling desire, and on my decision to enter firmly and bravely into the amorous laws of Cupid the Comforter and to offer no check or resistance to his amorous darts. Now that I was thinking clearly, I wondered about certain events and occurrences of various kinds, and of their many outcomes, which were planted by this sweet love alone. My busy and tenacious memory caused to bubble up in my mind the fearful vengeances of Juno, which frightened me greatly; and then I thought of poor Phyllis and her blind love for the tardy Demophoon, and how she saw her delicate flesh covered over with a hard, woody shell. The image of Dido came to my mind, intemperate and enflamed, as she was blinded by the deadly gift of Anchises' son and in a fury did herself to death. Then there was lying Sthenobea, who died for the noble youth Bellerophon; and next came Scylla, daughter of King Niso of Megara, who was carried away by immoderate love of the King of Crete and driven to cut off her father's golden hair, and met with no other result than a miserable death. Likewise there were the two noble Egyptians, whose ardent affections brought nothing more than a darksome death. And what happened to Echo when she loved Cephisus' fruitless son? Alas for my sad and mournful self! What came of the improper love of Byblis, or of tearful Dryope? Or the unlawful lust that weeping Myrrha had for Cinyras? Nyctimene, daughter of Nycteo, who was inflamed with a criminal passion for her own father, found herself turned into a night-bird that hates the precious light and flees from it. Also burning Menthe was transformed into an aromatic herb by Proserpina's father. I saw the unfortunate virgin Smilax who was turned to bindweed on [c4]

418

account of her lover Crocus, and saw the tears of the ill-fated Canens sprinkled on the Tiber's pleasant banks. I thought often of the one whom Poliphemus crushed with a huge rock; and lastly of what fire and massacre was caused by Helen's abduction. Oh wretch that I am, could it be that I, unused to such conflict, must enter all weak and unarmed to fight such a battle? Is not my bashful and inviolate flesh solemnly consecrated to Diana herself? Come, Polia, resist and abandon this first stirring of love, these unaccustomed assaults, this novel expedition and frightening enterprise, and think of her to whom you have made your vows, to whose noviciate you are bound. I vacillated as if demented, fearing something worse than the biting hounds of Actaeon, who furiously tore their own master to pieces; and when I thought of the sad fate of Calisto I began to tremble like the hanging web of bold Arachne in a high wind, or like the thin, whistling rushes shaken by intemperate breezes. As I kept reviewing all these things, thinking especially of my imagined repugnance, I felt in my awkward and tremulous heart a warm and unexpected flame which throbbed gently as little by little it grew, and as it spread by divine impulsion all through me and gradually changed me, separating my deadly distress from this new love and causing an instant and uninterrupted fit of sobbing, as it diffused itself more strongly than the Lernean venom of Nessus the centaur's blood which spread through the robust body of Hercules. And now without warning the provocative and busy Cupid struck a fresh blow to my breast. I deliberately withdrew my idle, wandering mind from its seething, silly thoughts, its frivolous opinions and vain disappointments, and having succeeded at that I filled my whole soul with amorous notions and returned to the dead Poliphilo, desiring him to return to his first state and feeling extremely sad at his death. After many evasions and ambiguities, uncomfortable thoughts and fearful anticipations, I made myself ready and willing to go back and look at him, dead, whom I had been too unkind to want to look at while he was living. Alas, this concern now filled my heart with no small agitation, as I considered in truth that I had acted as the mortal enemy of him who tenderly loved me, and I wanted at all costs to know what had happened to him. But afflicted as I was, how it scared me to think that I might share the fate of Anaxaretes, as cruel and impious as myself, when she went to see the unfortunate Iphis! I almost abandoned [C4'] my plan, but was overcome and prostrated by blind and unfamiliar urgings, and compelled by uncompromising love. However great my

fear, I could not have resisted; and indeed the growth of my love made me spurn all danger, so deeply wounded was I with a passion as inflamed as that of a Pelethronian Lapith. Straightway I hastened my solitary steps and came to the sacred basilica.

I was so eager upon entering that I did not follow my former habit of presenting myself reverently at the holy altars, but without another word or deed I went to the place where, like a wicked undertaker, I had stowed Poliphilo. I found him there with tear-stained face and hollow cheeks, lying absolutely dead, as cold and frigid as hard marble, just as he had lain all night long. His pallid, bloodless and yellowish hue made me go white with terror.

At this point, honourable nymphs, I was bitterly afflicted: my sorrow and misery made my eyes flood with abundant tears, and as I wept, I interrupted my lamentations with loud sighs, wishing that I could share his condition. Like the disconsolate Laodamia throwing herself half-dead on the corpse of Protesilaus, I lay down upon the frozen body, and tightly embracing it, I said:

'O cruel, terrible and untimely death, who devours everything good and inevitably cuts short every sorrow, lose no time in uniting me, here and how, with this faultless and innocent one, who because of me, the most impious, wicked, and shamelessly maleficent woman in the world, has departed the blessed light of day. He loved me to excess, holding me up as his sole and destined treasure. O how iniquitous am I, how fierce, how uncompassionate, how malignant and guilty above all others – more guilty than cruel Phaedra was to the innocent Hippoly-tus. Who now will refuse to give the last quietus to this stormy and hateful life of mine? Cursed be the first light that gladdened my eyes! Cursed be my life's breath for having lasted so long! Ah, odious spirit, still tethered within me, why can you find no way of escape? – for I neither can nor will remain in this sad and burdensome existence. Cursed be the eyes that would not look on him while he lived, yet find him a sweet sight now that he is dead! O tremendous thunderbolts of almighty Jupiter that shake the skies and the earth, are you forever extin-guished? Can you not reduce me as I deserve to coals and dusty ashes? O unlucky day, when the nourishing breast was never taken from my mouth! O evil hour when I came forth from the womb! O midwife Lucina who was then invoked, why did you not abort me? O what a [C5] sad case! What an evil fortune is mine, that I cannot die likewise! Which of us two is now the most pitiful and unhappy: my dead lover

Poliphilo, or myself surviving in such an inconsolable life? Come, then, all you pitiless and horrid Furies, as you came to Orestes, and rightly work your last cruelty upon my soul, for by my malignant and perverse act poor Poliphilo is dead. He loved only me, an undeserving and perfidious savage, and a bitch; and now the poor thing is dead through my evil deed!'

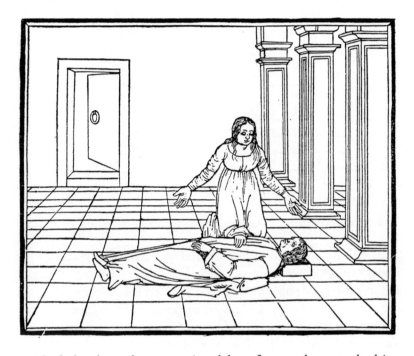

I had already made my eyes into lakes of tears whose steady drips soaked both him and myself, just as the brave and faithful Argia wept upon the body of her beloved Polynices, when I placed my hand on his cold chest and felt therein a tiny, stifled pulse beating. As I hugged him closer and closer, his fleeting spirits began to warm and revive, his heart beat faster as it felt the beloved flesh above it, feeding and invigorating his soul, and with a sigh he awoke and opened his sealed eyelids. And I, panting with eagerness to see him repeat this unhoped-for movement, quickly took his weak and inert arms and gently, with sweet and loving tears and sobs, felt him, rubbed him and frequently kissed him. Then I uncovered my − or rather his − white and apple-shaped breasts and showed them to him with a tender expression and seductive eyes; and in no time at all he regained consciousness in my chaste and delicate arms

[C5']

421

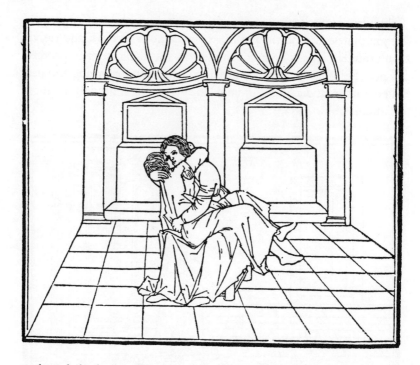

as though he had suffered no hurt and was somewhat regaining his injured strength. He spoke as well as he could with a tremulous and sighing voice, and said quietly: 'Polia, my sweet lady, why do you do me this wrong?' Suddenly, O famous nymphs, I felt my heart ripped through the middle by a kind of amorous sweetness, pity and extreme joy – a sudden new feeling that caused the blood that had been blocked up by sorrow and excessive fear to course through my veins, over-whelming and astonishing me so that I did not know what to say. Instead, I took courage and offered to his still pale lips a lascivious and intoxicating kiss, then we joined and wound ourselves in amorous embraces like the intricately convoluted serpents around Hermes's caduceus, or the entwined rod of the divine physician.

[C6] No sooner had he completely recovered and regained his former energy in my bosom and arms, and his cheeks were reddening a little, than the High Priestess of the sacred temple came toward us with a noisy throng of obedient priestesses and ministers of the sacred service, who perhaps had heard my grievous and tearful lamentations and the shameless sighs that echoed round the resonant temple. As they entered they saw this illicit act, forbidden in this holy and unpolluted place, and were outraged. The High Priestess and her assistants, seething with wrath, fell on us, some wielding rods and others oak branches, and with angry threats and blows put an end to our sweet embrace.

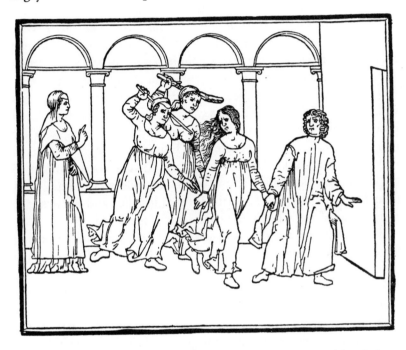

I thought extravagantly that I would suffer like the terrible Medusa, who felt the furious anger of Minerva because she made love to Neptune in the goddess's unpolluted temple. The same happened to Hip-pomenes and greedy, fleet-footed Atalanta, who for illicit coition were turned into lions; and there was also the fury of Juno toward the Proe-tides. We escaped from their hands only with great difficulty, then I fled [C6'] from the hallowed temple, resigning from their chaste company and sis-terhood as a rebel and transgressor, while they banished me with shameful insults. One of them, uttering grave reproaches and upbraid-

ing me disgracefully, dishevelled my hair so that its braids fell loose; she was called Algerea, and had formerly been my best friend in the sacred ministry. I summoned all my depleted forces, and with my feeble efforts just managed to escape from her, leaving behind my light veils in her hands; but as I was driven from the Temple I received many painful lashes on my delicate shoulders. Thus we two fugitives were thrown out and exiled from Diana's sanctuary, but were happy together, not making much of our banishment or of past languours, nor of the reproaches and assaults, seeing that inflamed love was now overflowing, nor did my treatment by the holy priestesses embitter me. And so finally we came hand in hand to the town, where we spoke long about our pitiful fate, then took regretful and amorous leave, with many sweet kisses, loving embraces, and firm and faithful declarations to one another in our great and festive joy. Poliphilo went his way in the height of contentment, and I returned to the welcome of my own home.

I was warmly agitated by love as I returned, with measured steps and with my mind filled with Cupid's works, to the district of my beloved palace, and was as one transformed as I entered, overflowing with joy, into my familiar and private chamber. The image of the goddess Diana no longer presented itself to me, for my imagination was beginning to empty, and the dear effigy of my sweet Poliphilo was entering in. I thought only of him, and actually felt him installed and dominant in every corner of my heart. This was the effect it produced.

Being alone, my mind was content to share in this amorous captivity: it could think of nothing apart from beloved Poliphilo. Turning to my usual sedentary work, I was inspired and incited by Cupid to make a little heart out of red silk, and to embroider on it in sinuous lines whatever Amor was artfully painting upon my own. I decorated the outline with bright pearls, and in the middle I put his beautiful and charming name enlaced together with my own (joining their first letters in Greek, which he favoured), made in Corinthian pearls with all the perfection that the inspiration of Amor could achieve. I also twisted a cord from gold thread, green silk, and my own long hairs, plucked out as a sign of [C7] perfect and fervid love, so that he could hang it around his neck, and sent it to him.

This caused Amor to establish himself firmly in my abstemious and inviolate breast, and to ferment with hourly increasing flame. My mind was occupied inwardly only with these fresh wounds, and indissolubly linked to gracious Poliphilo, who was already the lord of my being,

424

chosen above all others, and the one inheritor of my loving heart, bound tightly to it with an everlasting knot in eternal stability. I gave myself over entirely to sweet reveries, seeking to recapture the lost delights with my recent lover. For love of him I henceforth renounced all hardness and put aside all austerity; I gently tamed my wild and disagreeable soul, and transformed my frigid breast into a furnace of burning love. I reformed my beastly and cruel habits into a compliant disposition, my timidity into magnanimity, my coldness into fervid heat. I transmuted my bashfulness into reckless passion, my disdainful odium into inseparable and longlasting affection, my fleeting and wavering mind to constancy. I became exceedingly desirous of that which I had not experienced, and felt entirely open to the comforting delights of extreme love. I could tell that busy Cupid was increasing hour by hour a tender and blind desire for pleasure, and suffered voluptuously a host of arrows piercing my soul, arising from beloved Poliphilo. My soul could not separate itself from its constant thought of him, for it felt incredible delight in thus being penetrated. These circumstances had already bent me willingly under the strict laws of love, when my wakeful, avid and thievish imagination did something in his absence of which up to then I was incapable and ignorant.

I was sitting alone in my bedroom, enwrapped in these unaccustomed fires, and behold! I was suddenly astonished to see a chariot that passed through the open window, going very fast and making a violent and terrifying noise. It was all of crystalline ice, drawn by two white horned stags, harnessed with chains of grey lead. On the vehicle there sat a furious goddess crowned with a wreath of agnus castus, with an unstrung bow and an empty quiver, who turned a frightful countenance on me, burning with the desire to wreak cruel vengeance. Suddenly another chariot followed behind, pursuing the first one: it was all flashing with fire, harnessed with golden cords to two white swans. On this there sat triumphantly a powerful and divine lady, her starry brow [C7'] crowned with roses, having with her a winged boy with blindfolded eyes: he was holding a flaming torch and chasing away the cold and listless goddess who was menacing me with her hatred. He pursued the cold chariot through the air until it all melted in the heat of his own, then both dissolved and vanished. After watching this whole scene with the courage of love, I discovered my lap and the whole floor of my bedroom strewn all over with fragrant red roses and twigs of flowering green myrtle. I lost all fear and felt justifiably secure because this child

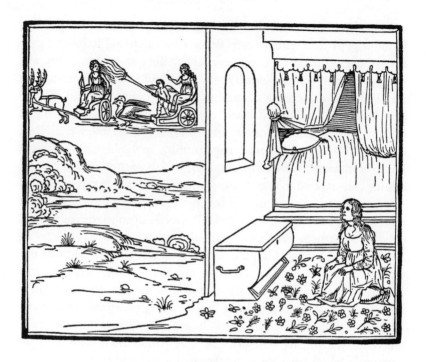

had appeared and come to my aid, supporting my cause, defending me from the furious avenger, and, as my lord, fighting invincibly to protect me. Being brought to such a pass by the love I had banished, and driven by desire, I resolved with firm and determined mind to go forward with this delectable adventure, this sweet campaign, this voluptuous duty.

But before anything else, purging myself of all objections and resigned and determined in everything, I thought over the sincere advice and precepts of my faithful nurse: I would fulfil them to the utmost, and begin by going without fail – spurred on by Cupid – to the venerable altar of the divine Mother, because I was now well aware of the hidden fire that was eating away at me, pricking my heart all over, like a thistle with its sharp, overlapping, hooked needles. I decided to [C8] make ready without delay for its leaping and impatient flames, and to make up for the time that had been fruitlessly and unprofitably wasted. The hour so much desired had now arrived, when I should place my soul inalienably beneath another, like the head-cushion that softens a burden. As I entered excitedly, with undaunted heart, into the sacred threshold, I saw my caring and cared-for Poliphilo, who appeared to be praying that I be restored to him. And while my keen sight went

straight to its expected goal, I did not approach Poliphilo, but first followed the advice of my nurse and presented myself humbly before the holy priestess. I had the greatest faith that she could propitiate and turn away the celestial wrath, and fit my soul for the love it had spurned.

After telling her about all the upsetting and horrible events and the apparitions I had seen by night and by day, I recounted my own inhumanity: how I had been more fierce and cruel than a tigress, more deaf to his lamentations, his heavy sorrows and amorous pains than the ears of an adder immobilized by enchantment, and more displeasing than Dictyna was to Minos. I had made light of his prayers and miserable tears; I had acted toward my Poliphilo with hateful hostility and rage, being slow to mercy, void of kindness, indifferent and alien to human feelings, and unmoved by compassion. The priestess was shocked to hear that I had committed such rebellion, and scolded me severely, while I was repentant and disgusted with myself; but it seemed futile to dwell on the miseries of the past. For I was affected and impelled by a great agitation in my heart, and the heat was spreading through me as I began again to yearn ever more with love for my Poliphilo. As for him, as soon as he had seen me come in, his eager eyes had been fixed on me with unwavering and piercing gaze. Like a celestial arrow sped by the drawn bowstring, it entered my ready and welcoming heart, so that I felt my whole being crackling and seething with amorous delight.

Then, gentle nymphs, I bowed before the reverend presence, begging forgiveness for the past and support in my present struggle, and offering myself with firm faith as a true and undaunted devotee of the venerable lady Mother. I would never rebel, never fail or disobey any command of her mighty Son, nor would I ever refuse any concupiscent desire of my loving lord Poliphilo, but would treat him with goodwill, kindness, obedience and graciousness, and never part from him. I would be quick in the observance of all his amorous wishes, and devoted to him alone, and would live with him in peace and in sincere concord exceeding even that of the Geryons. As soon as my irrevocable vows were made, the holy Priestess summoned Poliphilo into her presence.

PRIESTESS OF HER FORMER IMPIETY AND SAID
THAT SHE WAS NOW ALTOGETHER FILLED WITH
ARDENT LOVE. THE REVEREND LADY, LEARNING
THAT POLIPHILO WAS PRESENT, SUMMONED HIM.
HE PETITIONED HER TO CONFIRM THE TWO
LOVERS IN A WISE RESOLUTION. POLIA, FEELING
IMPATIENT LOVE INCREASING WITHIN HER, INTER⁄
RUPTED THE REPLY.

OLIPHILO APPEARED BEFORE THE VEN⁄
erable Priestess eagerly and without delay and
introduced himself to her with a deep bow, while I
gave forth affectionate and thunderous sighs that
echoed off the temple vault and returned to the caverns
of our ears. My eyes were fixed on him alone; stripped
and disabused now of all my cold⁄heartedness, I had become gentle,
tame and favourable, opening wide to him the gates of my inflamed
heart, while he, with frequent enticing, joyful and attentive glances,
showed me that he had made it his home and his delightful lodging. I
courteously indicated my desire that he would be its worthy, legitimate
and only lord, to join and possess it together with me all my life long,
and to do with me whatever he wished. He now seemed even more
pleasing to me than he had formerly seemed odious and unpleasant, as
he offered himself opportunely as an enjoyable and efficacious remedy
for my ardent love. As mariners upon the roiling sea, beneath the rainy
sky, welcome the bright stars of Castor and his twin to the right of the
Chariot and above Orion, and welcome even more the safety of their
longed⁄for havens, so he appeared as my salvation.

Wounded, then, to the last degree of love, I admired him with
unwavering gaze and gracious looks, which set a little fire deliciously
ablaze in my breast and drove all other concerns out of my mind. He
alone satisfied it; he alone gave it pleasure; he alone offered it comfort.
He was the delectable object of my insatiable and hungry gaze, and I,
suffering no absence, greedily urged on and driven by an immodest
appetite, was captured and possessed by such amorous delight that I
watched him as though beside myself, immoblized in ecstasy. My eyes,
in consequence, were unleashed beyond all measure; yet I had pity and
pardoned them their importunate staring, knowing what new love can

428

be. But Poliphilo, who was feeling blind Cupid's mischief beyond all bearing, was panting as he exerted all his forces toward the desired goal, which was that the reverend Priestess before whom he stood should establish and confirm the two of us in a single, indissoluble and tenacious bond. Encouraged by the sight of me, he made this smoothly eloquent and joyful speech: 'Honourable and holy Lady, if your

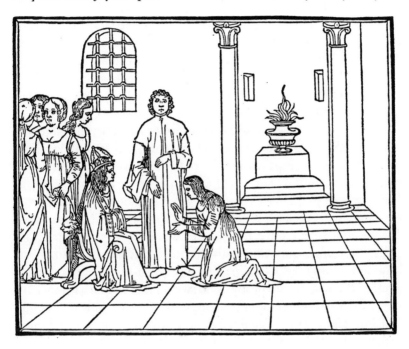

humble and devoted servants, being devout worshippers of the Paphian goddess, merit a hearing within your sacred audience-chamber and tribunal, may my heartfelt prayers and earnest supplications be heard by you today, O most pious Lady, as they are offered in confidence of your favour, O noble Priestess of the Temple. For I believe you to be the last refuge in this amorous enterprise, and the most effective charm, cure, and true remedy for my bitter afflictions. Because you have been received into this place and serve with such reverence and sincerity at the sacrificial altars of the most holy Cytherean, you can mediate her grace to help weak and dissimilar souls, and to unite lovers in one will and one consent. For this have I come hopefully into your majestic presence, because you alone are able to protect unhappy lovers such as myself, who are languishing unrequited under the cruel and punishing wounds.

of her unjust Son. Lift, therefore, our gracious prayers to that Mother and Lady, that she may command her blindfold Son to take up his amorous weapons to a just end, and mercilessly shoot that sharp, pene-trating dart into that stony heart, just as I feel it pitilessly transfixing my own. In this equitable fashion, my sad repinings will be somewhat satis-fied, and all my importunate, urgent sighs and languors will be quieted, which I will bear patiently and willingly, however heavy and painful they may be, if only Polia should feel a little of what it is to love passion-ately, and how sweet and pleasant it is when two hearts are joined in one. Therefore, O merciful Priestess, if this unsatisfying disparity can be balanced, I shall count myself most blest. Do not be astonished, O sublime Mother, at my ardent but reverent daring, and at my attempt to explain its cause.

'For you should know that I am invaded by a love beyond all reason which afflicts me like a battering-ram or a goad, so that, putting all else behind me, I am compelled and driven to this. Nor have I any hope of escaping from my torments, nor of any respite or end to them, except, as I believe, from you, O pious Mediator who can tame this hostile heart of hers and the fierceness that lurks behind her sweet and divine looks. Having tamed them, you can appease them; having appeased them, you can soften their ferocity. She, with her beauty and elegance, is my best help and healing, for I have no little hope that the ministry of those alluring eyes in the midst of my overflowing heart will turn my incredi-ble suffering into voluptuous pleasure, and dampen a little my wanton and ardent fires, if only I could, here and now, unite her will and mind to my own – which, alas, are as far apart as Ossa from Olympus! For I love her so extremely that I am no longer mine, but am hers entirely; thus it is only just that since I am all hers, and her humble servant, she should correspondingly be my venerated lady and possess me totally. For you, O excellent Priestess, are the best and only one who can make the decision and wield the power to unite under this amorous yoke; the one with the high knowledge to control and discipline those who are sworn, with sincere and pure hearts, to this holy and perpetual service of the sacred and mysterious flames. Now that we have come together in this place, if I am not deceived, I do believe that this pure and lovely light, eminent in rare virtues and shining with heavenly splendour, will consent with me to be received and numbered among its servitors.'

The eloquent and inflamed Poliphilo fell silent after his sweet and appropriate speech with its suave and agreable words, and his charming

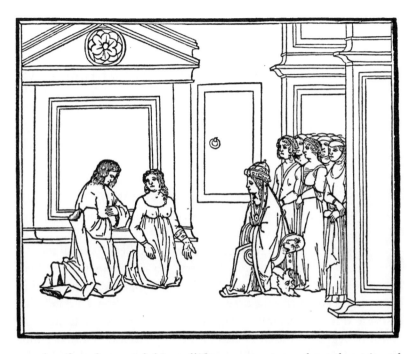

mouth softened my soul; his mellifluous tongue caught and captivated it, so that I no longer felt my spirit inside me, but enjoyed the delicious sensation of it escaping between my rosy lips. His looks fully satisfied my avid eyes, even more than the King of Ephyra's son when he offered himself to wicked Sthenoboea, and I was bound with my full consent and duly prepared to grant his worthy petition. An extreme sweetness spread all through me and forced me, already overflowing with love, to accept it, so that henceforth I would not have to feign pity in order to satisfy him, but was deeply moved to do so. My heart was not forgetful of his miserable life, and as it grew violently warmer within me I could neither suppress nor conceal the importunate and vehement flames. I would doubtless have burst if there had been no opportunity for me somehow to let it out; therefore, interrupting the reply of the Priestess, I fearlessly and incontinently gave full vent to the flying torch within me, and all aflame I spoke thus to my lover Poliphilo.

POLIPHILO HAD SCARCELY FINISHED HIS [D2']
SPEECH WHEN POLIA TOLD HIM OF HER VEHE-
MENT LOVE, WHICH HAD WOUNDED HER IN-
WARDLY AND MADE HER AVID TO LOVE HIM, WITH
VARIOUS EXAMPLES; AND IN ORDER TO SHOW HER
BURNING PASSION, SHE GAVE HIM A DELICIOUS
KISS AS PLEDGE OF HER EXTREME AFFECTION. SHE
TELLS OF WHAT THE VENERABLE PRIESTESS SAID
IN REPLY.

QUABLE COMPENSATION FOR YOUR
cruel injuries, my beloved Poliphilo, can only be ren-
dered by sincere trust, true and ardent love, and the
most tender kindness, for such sufferings equal those of
the Hyades, and deserve no less pious tribute. Your
honest petition moves and stirs me no less than your presence, languish-
ing on my account. As the time passed, I judged without a doubt that
its effect was considerable: it appeared no less gruesome to me than
Hector, dragged through clouds of dust, pouring out his steaming
blood and staining his golden hair, his face besmeared and filthy,
appeared to the weeping eyes of his beloved and wretched Andro-
mache. O my heart! O my only one! O my sweet hope! Your pierced
and tortured heart has suffered through the brutality of my own mis-
guided soul, cruel, dire and impious as it was. For a long time you were
deceived and embittered, dragging out your wearisome life in incessant
tears and groaning, and now you seem to my tear-filled eyes to be fully
laden with love's thorny insults. I want to imitate the grandeur of your
noble and worthy soul, endowed with the fervent excellence of love,
which no longer meets with a deaf and unfeeling audience; hence in a
very few hours you will see a happy end to your sorrows, since it is per-
mitted for the blind desire of your yearning eyes to lodge in my willing
breast. I no longer feel indifferent or empty, but willing to share equally
in your ills. I do not intend to spare my life, which lies under your rule
and will, and the inviolate flower of my maidenhood shall be sacrificed
to your ardent desires and gracious longings. And if I do not act as I
should reasonably have been doing, I may well risk the inescapable
anger of my lord Cupid. Therefore I confirm my solemn faith and my [D3]
firm loyalty, by which I give myself to live amorously with you, so that I
be not condemned of stubborn inhumanity in the sight of the divine

Mother and of the winged god, her inseparable Son. I fear their anger, since they have already warned me with an ominous display of it.

'But since it has pleased you to submit in perpetual vassalage to the furious torches and the heavy servitude of that great Cupid, and since you have inwardly borne such unjust tribulations and painful wounds for my sake, I reckon it as equable and just that I should grant your gracious and deserving wish, and assuage your ardent desire, permitting you to take copious delight of my inviolate and blossoming person. Therefore Poliphilo, my sweet and amorous soul, my one ruler, the triumphal seal on my breast; my safe haven where I take refuge from the present assault of insolent and violent Cupid; my treasure, precious beyond all the jewels of the world – no sooner do I look around and fix my desiring gaze on you, than every hardship dissolves and vanishes, every contradiction is resolved. I am ready to respond with gentle voice and compliance to your precious love, happily consenting with all my soul, with all my heart and with all my strength. For already in the inward parts of my heart, indeed at the foundations of my very life, and in my soul, consumed by fire, I desire to give proper satisfaction to your will and to mine, having reason to believe that the inexorable torments suffered by those maidens whom I beheld as a monstrous warning can find no pretext in myself. I see clearly that Rhodopean Eurydice would not have been bitten by the venomous adder, nor gone down in the three-horsed chariot of Pluto to the infernal realm of Tartarus and the deep Barathrean abyss, if she had acted more complaisantly toward Aristeus; nor, likewise, would Daphne, daughter of Thessalian Peneus, have vainly repented her sprouting leaves when she fled from Phoebus if she had granted his repeated prayers. Similarly, Hesperia would not have felt the fatal bite of the winding serpent if she had been good to Esacus. The nymph Arethusa, washing herself in Alpheus's waves, would not have found her virginal body changed into flowing waters in a subterranean channel if she had shown compliance to Alpheus; and Picus, who also resisted and fled, would not have been clothed with wind-filled feathers if he had returned consenting to Circe. Through such flightiness, many have discovered what it is to refuse and flee from the pleasures of love. And beside this, using all the sharp intelligence of which I am capable, I am certain that the mighty Son of divine Venus wields absolute dominion over the hot and starry heavens, the spacious, fruitful and nurturing earth, and the sounding deeps of the sea, entering wherever he wishes without obstacle or oppo-

[D3']

sition. Nor do I believe that riveted cuirass, nor threefold breastplate, nor helmet of steel, nor armoured shield, however charmed they may be, can resist, repel or withstand the lightning-stroke of his Ithyrean bow and arrow. There is no grim or savage heart, however rigid, however reluctant, however flighty and obstinate, however roughly encrusted, and however independent, that his quick and piercing arrows cannot penetrate.

'I would fear, therefore, that he might be angered and driven to intemperate rage by such an irresolute heart as mine, and shoot his malicious arrows at me while I was all unprotected, being unswayed by tears, sighs or groans. I thought of the cruel vengeance wrought on the elegant youth by the cold spring, who paid no heed to Echo the nymph and was changed into a purple flower; and perhaps Syrinx would not have become a lovely instrument if she had been less hostile and discourteous to amorous Pan. As for me, O most gracious Lady, I am unaccustomed to the duties of love, except that I began to feel a gnawing hunger for this Poliphilo as soon as he showed to my compassionate eyes his sad, bewildered and colourless face, as soon as his gentle words and sweet laments reached my sensitive ears: I was shot through with amorous ardour and my heart was riven in two.

'I offer myself to him no less joyously and graciously than Atalanta to Hippomenes, or the amiable Queen of Carthage when Anchises' son arrived, or the fierce lion to Androcles when he was captive and about to be mauled. Therefore come back to me light-hearted, gay and rejoicing, O Poliphilo my joy, my happiness, my solace, my hope, my refuge and my ardent love! Take your pleasure of me for all days to come, and you will feel comfort and contentment that will make you forget your former torments and past misfortunes: they will dissolve under my caresses and kindnesses just as the mists, rising and thickening from the all-ruling earth, are dispersed by forceful winds and as dust-motes float and vanish in the air. Now take this amorous kiss' (here he embraced me in virginal fashion) 'as the gage of my inflamed heart, conceived from my excessive love.' And as he hugged me tightly, my little round purple mouth mingled its moisture with his, savouring, sucking, and giving the sweetest little bites as our tongues entwined [D4] around each other.

After I had embraced him like a polypus, and he had duly kissed me, the venerable and holy Mother who had seen, heard, and approved everything was moved by our sweet sighs, and the others present mar-

434

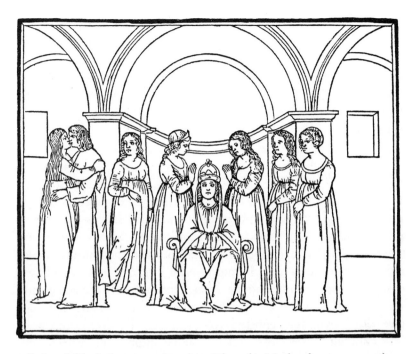

velled and felt their eyes moistening. Then the Mother began to speak:

'Young lovers, I seem to perceive your intention, which is ablaze with mutual love, and since I can see that you are suited to one another and of one mind, it is not necessary for me to intervene in your union. You have arranged it very well between yourselves and have given full satisfaction, so that it seems to me superfluous to add anything further to this pleasant enterprise. Amor, who joins together all similar things, has himself summoned and reconciled you in due season. Now that I have much enjoyed hearing about the conflict and discord of one of you, and you, Poliphilo, have touched on it somewhat, I would be very glad to hear a full and detailed account of how you fell in such extreme love with lady Polia, and how a certain strict rule made her resist so charm-ing a performance, for your speech delights and pleases me greatly.'

[D4'] When the amiable Priestess had finished her grave words, Poliphilo was glad and quick to begin his tale as follows.

435

POLIPHILO PRAISES PERSEVERANCE, OBEDIENT
TO THE PRIESTESS'S COMMAND. OMITTING THE
PART ALREADY TOLD ABOUT HIS FALLING IN
LOVE, HE TELLS HOW HE SAW POLIA AT A SERVICE
IN THE TEMPLE, WHERE, GREATLY AGITATED BY
LOVE, HE REGRETTED AFTERWARDS HAVING LEFT
HER. HENCE HE SHOWED HER HIS SUFFERING BY
SENDING HER A LETTER.

EVEREND AND HOLY PRIESTESS: IT IS
virtuous, when one is suffering arduous and cruel
fatigues, upsetting nuisances and disappointments, to
keep one's wits and one's hope, and to restrain and
temper one's disturbed soul with honour and sanity,
rather than to throw oneself into ruin for lack of patience and fore-
thought. One should continue what is begun with endurance and
perseverance, however hopeless and difficult it may be, and seemingly
give in to the whims and obstacles of chance, to all its pranks and insid-
ious cunning. For victory is not achieved through brute force, but
through virtue and intelligence, as when Bellerophon persevered and
attained to glory. The soldier in action prefers glory to any pay and
prizes. Wishing, therefore, legitimately to claim the honour that is
expected and due in consequence of my amorous battle, I offered myself
firmly and bravely to whatever hardship violent Cupid might impose
on me, despising base inconstancy and thinking that it was foolish and
frivolous to engage battle with a faint heart; and it seemed that there was
no better support than strength of mind. I was persuaded that it is a
base and shameful thing for a warrior, once engaged in battle, to turn
around and show his back, but that he should never give in to despair
and abandon the struggle, once begun, for it is better not to begin at all
than to leave off after one has started. Thus, if I am not mistaken, one
cannot truly call oneself happy if one has never experienced the con-
trary, for that breeds presumption, which generates overconfidence, and
an unhappy conclusion follows, as it did to Polycrates. The perfection
of the paragon is known all the better through its opposite, as one can
see clearly from the example of Battus. Beside this, holy Mother, if this [D5]
noble girl Polia, whose unprecedented beauty could easily seduce the
heavenly spirits, had given in to my desire without difficulty, effort and
bitterness of heart, and without testing my precious life to the limit, by

436

immortal Jupiter! I might similarly have dropped her as casually. But he who meets no resistance, and he who does not persist, earns no palm of glory, because no glory, triumph or any other prize can follow without hard effort. Thus the effort is the cause of the prize, and perseverance its midwife, with their consequences. It is certain that what is won laboriously is more precious than what is easily acquired. Lucius Sicinius Dentatus, for example, would not have been honoured with praise and fame if the scars of his wounds had been visible on his back! It is easy enough for degenerate soldiers to be wounded behind, but only frontal wounds become the strong and resistant ones. For this reason, Amor contaminated, infeᶜted and polluted my heart with his morbid qualities, then invaded me by leaping into it and using it for fires more discomfiting than those of Phoebus's southern steed Ethon, who scorches the fresh flowers and tender plants and herbs, burning more fiercely than the insatiable volcano of Etna. While I was tightly muzzled by his doing, he played mischievously with me and showed me, by means of infinite accidents, various mishaps and many dangers, my evident peril and my pitiless, dereliᶜt and disabled fortune. In obedience to your wish, I shall now tell you briefly about some of these pernicious and deadly cases.

Noble Priestess and illustrious Lady, now that I have relaxed and somewhat quieted my lethal languours, I hasten to satisfy your benign injunᶜtions. Passing over what has already been related, I will use pleasant words rather than tearful sobs as I tell of the origin of that splendid love that embraces me ever more strongly and fervidly. I count myself fortunate to be in your venerable, distinguished and gracious presence, and in that of Polia, and it gives me a certain courage, especially since your kindly face shows that you are not bored by listening to me.

Phoebus had risen to wipe away the fresh tears of weeping Aurora, putting to flight with his renewed rays of gold all the orient stars, illuminating with his Eos the hemisphere marked by our horizon. The [D5'] laborious day supplanted idle repose, and since the heavy earth was clothed with new greenery, every creature went gladly to the work that Nature has assigned to it. I went to the holy temple of chaste Diana, though I never hoped to see her again, and found her there with many other noble and distinguished maidens celebrating the solemn rites and observances, and singing hymns in that holy place. And just as wood that has already been once in the fire lights up when replaced there, more quickly than wood that has never known the flame, as if returning

437

eagerly to its former state, so it was when I saw her again. As I watched her discreetly, I noted that she stood out among all the rest like a goddess among her nymphs, more distinguished and decorative, more charm-ing in her beauty, multiplied by my great desire, and more ornate and elegant as her angelic form became manifest to me. Her eyes were fairer and more lucent than the bright rays of the sun, and made the whole place glitter, and she was richly endowed with every other virtue. Thus, excited with a sweet ardour, I took fire again from head to foot in an incandescent stupor, realizing now that these flames and amorous flares were coming from her serene brow and placid face, and from the renewal of her excellent beauty. Just as generous Ceres first sowed the kindly fruits in the fertile soil, after it had been turned by the curved ploughshare, and just as Melissus, King of the Cretans, began by devoutly sacrificing to the chief gods, so I consecrated and offered up my heart and soul to her before all else. And thus she was the first to sow the amorous fires in my tender heart, ploughed by sharp arrows: a more dangerous and deadly seed than even Jason scattered, and a worse harvest! I was instantly prey to a sudden and extraordinary ravishment, feeling more sensitive than soft, white wax when it is put in the fire to prepare it for the stamping of an image. While the daily and progressive heating of my heart turned it into a flaming furnace, I set my mind to be eternally in love with her whom I now love excessively. I reckoned her fair and honest presence to be my best helper, like heavenly dew and an assuaging remedy for my inflammable and fragile heart, and a safe refuge, and in the meantime looked long and closely, unwearied by the divine service, and fixed my eyes on that elegant and delicate face from which nursling Cupid pelted me with his lightning-bolts. This face seemed to me more splendid than the wide heavens with their transpar-ent, liquid, pure and serene air and their ornament of bright stars, while two of the brightest of these had been turned into two sparkling and radiant eyes, decorated with two delicate, arching black eyebrows, which contained all the food and incitement of love, and the rarest [D6] beauty that Jupiter the Artificer could ever have invented and placed therein. He had likewise made the rest of her form and beautiful figure with the utmost diligence, such as Phianore, whose depiction of Neptune was the very imitation of nature, could never know or emulate. She gave the impression of crimson roses mingled with milk-white lilies. From between her purple lips she breathed a veritable perfumer's shop, a storehouse of wondrous fragrance, a little ivory

438

repository made from tiny teeth in perfect order. Her hair was very blond, unmatched by the ripe straw of Betica and more pleasant to the eye than if she had tasted the river Cratis. Seeing so many splendours manifest in her – to say nothing of the hidden ones – I would have counted myself not only content but the happiest of all lovers if she were to give me her precious affection. With my soul flying toward her I said secretly: 'O great Gods, that I might bend and force her to my inflamed desires, as Acontius tricked Cydippe with the deceptive apple, or through good luck, as proud Achilles conquered gentle Deidamia, or by any other means!'

While I concentrated intently on this immense pleasure and matchless delight, I felt as though I were enjoying a heavenly presence here and now. I beheld her clearly as she smiled and spoke compliantly, and sometimes she turned her wonderful starry eyes toward me, accompanied by two scarlet roses, full of candour and elegance. When she performed the traditional rituals and prescribed services skilfully and neatly, with nymphal gestures, reverent attention and a ladylike seriousness, her voice sometimes reached my ears and aroused me, inviting my soul to flee and to abandon its dear companion; all my spirits were stirred up and I felt overwhelmed and enwrapped in a sweetness never felt before, as if my soul, neglecting its natural home, wanted to die and stay forever in joyous festivity with Madame Polia. Then I knew how violently I had been struck by the amorous fire, which grew even as I contemplated it; nor could I, with all my strength of mind, turn away my insatiable eyes from the sweet allurement of my heart, fascinated as they were by the lovely sight. With a silent sigh, I spoke thus with firm resolve:

'Without a doubt, I belong absolutely to this noble nymph. All my fawning hope rests in her white breast; there I have placed and invested [D6'] all that I have. I revere her as is fitting, honouring and cherishing her above all other, just as the Athenians did honour to their Palladium, the Thebans to cheerful Bacchus, the Indians to Dionysus, the Romans to Liber, the Arabs to Adonis, the Ephesians to Diana, the Paphians to most holy Venus, the Tyrians to Hercules and the Aricinians to fasces-bearing Diana. I will follow her tirelessly, just as Clymene, transformed into a sunflower, always turns to face her beloved Phoebus. Thus I wish to be an amorous devotee of hers, and to remain forever in the same state of mind, unswayed by terror or delight but submitting humbly to her will in affectionate obedience, like the timid partridge in the curved

talons of the fierce eagle. I have no other image, no statue or shrine installed, painted or carved in the chambers of my heart. And I hope through her to recuperate and to live in amorous joy, reckoning this a greater ornament than a king's crown, a general's cloak, a high-priest's headdress or an augur's lituus. When Polia dominates Poliphilo, she shall be my praise, my glory, my honour and my exaltation; thus I offer myself in amorous dedication; thus I am vanquished, thus prostrate, hoping that our souls may become one in the triumphant realms and the delectable state of the divine Cytherean.'

I was now ravished in every way and out of my mind, absorbed in these deliciously fraudulent thoughts and reflexions, and enjoying these images from hour to hour. But strange and invisible wounds gradually appeared in my unprotesting soul, and little by little they grew. Since I had let Cupid in, and he had usurped all jurisdiction, licence and tyranny over me, in all this amorous mystery I desired this alone and above all: 'Ah, that I might open and bare my soul to her and tell her my inmost desires! Following Socrates's idea, I would make a window in my breast and show her where the wound of love had struck. I would tell her of my boundless passion for her, of the tight snare in which my heart was caught, the burning flame in which it was melting, and show her how my amorous life was ebbing away. I would tell her with pitiful and touching words and lamentable groanings about the excesses I was suffering for love of her!' Thus with my mind unhinged, erratic, lost and wandering, I languished in this limitless heat, sometimes sighing, sometimes gay; now placid, tranquil and quiet, now indignant, hope-less, hesitant and discontented, and so I wasted this great and sacred day in these confused and contrary moods, deeming it to be no longer than an atom of time, and over in an instant.

Already the ruddy and beardless sun was in the extreme part of [D7] Hesperia, promising future serenity. The delicate and noble ladies were gathering together before departing from the sacred oracle, making an end to the solemn offices and ritual observances. They did not do this like the Egyptians bewailing Isis and Osiris, nor like the barbarians with a noise of cymbals, drums and flutes, but like the Greeks, with choruses, melodious songs, and maidens bearing consecrated objects with devotion and lively gestures. As soon as my hungry eyes and wavering senses were separated from her precious, superhuman image, I found myself boiling and burning with vehement love, and crackling like salt in a fire. And with eyes stupefied by her outstanding beauty and

440

by the radiance and natural perfection of her elegant form, I frequently saluted her from a distance, saying to myself 'Farewell, farewell, thief and burglar of all my goods!' – and secretly replied again and again 'Farewell!' With what little heart she had allowed me to retain after her departure, I felt my soul seized and abducted by her, while I took my leave overcome with sobbing. Her milk-white breast became the delicious reliquary of myself as her trophy and spoils. I followed her with my desiring eyes, alas, just as the ardent Laodamia sadly watched the departure of her beloved Protesilaus, and then, poor thing, did not see him fall dying on the beach, but cried out for him repeatedly in mortal anguish. Thus in my sorrow I overflowed with sweet tears, raining down in drops, calling Polia, invoking her, recalling her. O Ariadne, did you find yourself thus devoid of all hope when you did not see your perfidious deceiver Theseus? Did you scatter his name in vain, did you vainly call him through the vast caves and hollow rocks of the desert isle of Dia? But nothing appeared to your wet eyes than the eroded crags, the hard heaps of murex shells, the wild ilex groves, and the bitter shore with its curves hollowed by the swelling waves and rushing breakers. Were you like me, left derelict by the love I had rediscovered, by my only treasure and the effective cure for my tearful anguish and bitter torment? Did your love burn even more ferociously, as if your pain did honour to your master? Thus I felt an anguish which I knew could only be relieved by the sight of her. I do not believe that you, unfortunate Io, felt so afflicted when you saw in the clear waters of your father Inachus that your shape had changed, your yellow tresses were now hard and sharp horns, your human voice had turned to lowing, and the green fields had [D7'] become your unwonted food. I was left no less lamenting, disconsolate and dismayed, with my pleasures turned to heavy pains and my weeping eyes deprived and robbed of the sight of that splendid light. I had flung myself before it, thus laying myself wide open to that holy, golden arrow, not resisting in the least but humbly bowing, bending like a supple and pliable wilow-wand, or like an Amerine osier twined into a garland, thinking it great sport and a rare gift of Lord Cupid. I could never describe fully and in detail the pleasure I received and relished from feasting on her incomparable beauty and her other excellent qualities, when I was left without that bright and heavenly torch which I had used to good effect in my dark thoughts. O splendid light of my dull mind! Lady of my life! Mistress of my will! Queen of my heart! Goddess, empress of my soul, which, besieged and surrounded on all

441

sides, began to suffer a grave change in my burning breast. Burning and seething in all its parts, it sent out through my gaping mouth a sweeter lowing, with painful sighs from its dire torment, than the artist and founder Perillus when he was enclosed in the hollow bronze bull by the tyrant of Agrigentum. My soul was just like that, shut up inside my furnace of a breast and consumed with fiery and ardent love. For the happiness that humans get from their enjoyments is less than the sorrow and regret they feel when they are deprived of them. But I did not think it a serious matter to pine and frequently die for such a woman, exposing myself promptly and eagerly to every increasing torment, because I was hoping to see again those beauties from which I was separated, to regain my lost happiness, to restore the interrupted enjoyment of my eyes, to begin afresh this new and supreme love, to keep it, and having kept it, to increase it. But she, alas, fled from me unjustly and unkindly, doing me wrong while my inmost parts were in a painful condition, while a gnawing desire for her alone had been created and established in them. Nonetheless I fought fiercely against this powerful love, feeble wretch that I was and impotent in the face of its great force, blaming Cupid's bow, lamenting that it had not done her the same injury and that it did not appear to be contagious. I invoked heaven against her, saying 'O supernal Fates, make this cruel woman die as she has impiously dealt death to me! And if I die, and she does not suffer the same fate, because of her inhumanity toward me let her plead for death while she lives, and let her not be heard. Let her live in misery, deprived of this glorious [D8] death!' Alas, my reason soon returned to me, and all these absurd curses uttered against my Polia rebounded upon me, saying 'O Poliphilo, how could you have the audacity to blame your treasure, your own soul, your own heart and your hope? How could you assault the sanctuary of all virtue, like Erostratus, with evil curses?' I then damned the amorous madness that had whipped me up to a fury and driven me out of my mind, beseeching the gods to do the opposite to her and to turn my curses into blessings. Caring no more to die than to live thus, I tried to regain a sufficiently able and candid frame of mind to give her an account of my hardships and unbearable languors, and to share my constant thoughts with her. I judged rightly that nothing within the human heart is so hard that the fire of love cannot soften, vanquish and tame it. A round ball remains stationary until given the push that makes it act according to its spherical form. Through such arguments I thought of writing to her and of sounding out the soul of such a noble

and high-born nymph, marvellously compounded of every virtue and excellence, which nevertheless caused me daily struggle, turbid discord and ceaseless pain. Death was my familiar, yet without depriving me of life, and all because I was deprived of something so elegant, so desir- [D8'] able, so lovable. I did not believe that she contained anything but similar qualities, gentle ways and a kindly openness to persuasion. Therefore I had the following letter secretly conveyed to her.

443

VID AND DEEPLY LONGING TO REVEAL
a little of the immoderate flame in my impatient heart,
which has been set fast ablaze by your excellent and
singular love and is pining away, O venerable and
noble nymph, this world's only example of marvel-
lous and perfect beauty: it is not with words but with
the profuse and unstaunched tears that blot this paper that I have taken
courage, not rashly but justly and honestly, being urged beyond belief
by the continual goading, by the constant invasion of a tormenting love,
to speak and declare my incredible passion and the sincere affection that
I have for you, who are my sweet treasure, my sweet hope, the only solace
of my unheard-of sufferings and of languors you cannot imagine.
Hence it is with tender voice, reverent words and humble prayers that I
tell you of my extremity, of my heart wounded by arrows, beseeching
you for help in controlling this rampant fire. O Polia, divine light, my
venerated Goddess, do not be deaf, I pray you, to my timely request and
solicitation. I beg you with bowed head, devoured by burning love; I
call on you, I invoke you, that you may quickly bring to my aid the only
effective comfort and the relief that I need. The rapacious claws of your
starry eyes have torn the heart out of my bosom, which is the reason for
this inept and unpolished letter, written in the confusion that love has
brought upon me. I would already have attempted something of this
kind for several days past, but could never find such a convenient and
secret way; thus I silently repressed and deferred the manifestation of
my agonizing torment. Now, however, I can no longer restrain my
desire, no longer hold it in suspense and in secret, for the violence of my
love demands this, and my ill fortune urges and compels me to adopt the
means I have found with this tender address. O excellent Nymph, the
fairest that ever was, take heed of me, be compassionate, show your
goodness, and be pleased to unite yourself with such benevolence, [E1]
delight and love beyond anything imaginable, this essential salvific
mystery.

In my frustration I have now allowed my blind fire, which was refus-
ing more than ever to remain suppressed and hidden, to vent itself and
come forth, such being the impropriety and presumption of this violent

444

and disagreeable love, which increases from hour to hour until its passion is sufficient to rend my heart, transfix it, and reveal at a stroke my secret martyrdom that I suffer for love of you. Thus my daily and unremitting pains will stay hidden no longer. Since my adoration of you only serves to embitter me, I think that my action is praiseworthy, and shows integrity of mind, believing most firmly that your nature is humane and malleable, noble and magnanimous; that you are upright in your ways, gentle in appearance, clever of mind and urbane in your elegance, generous and liberal, and outstanding in every virtue. These many different gifts bestowed on you by high heaven, together with an inborn capacity to speak with distinction and clarity, a divine appear-ance and attractive looks exceeding the human measure, and your lovely grace, delightful to behold – all these transport my mind, my heart and my life into your white bosom: they transport me as I adore and insa-tiably admire you, then leave me senseless. Afterwards, when I reconsider this more carefully, I satisfy my hope in pursuing my desired goal. Otherwise these uncommon and sublime states would be halluci-nations, which would insult with ingratitude the goodwill of their gracious maker. O beautiful Polia, lend your sympathy now to my first words and anxious writing; read them with untroubled brow, and believe in good faith that I bear a greater and rarer love toward you than ever a lover did in this world. Lend a charitable ear to these just and honest requests by which I ask only your charming and precious love, which would be more than an ornament to my fleeting existence: it would be its solace and salvation, an alleviation and healing salve to my bitter anguish. As long as I live I will certainly not be able to love any but you, to whom I surrender as your reverent servant and subject as though to my sole divine Lord. Your indescribable splendour and beauty have carried me to so perilous a state that I cannot imagine how I am altogether alive in you, and altogether dead in myself, paying no attention to my miserable life.

'To save this life I know of other recourse but the sweet thought of you at every hour of the day and night; and this thinking seems to be the best remedy, more necessary now than ever. Otherwise I will become [E1'] infirm and disabled from resisting the growth of this constant flame, and greedy Fate will make an end of me. In any case, I will receive one of two things from you: either you will desire my salvation and behave kindly and well toward me, in which case you will behold me in perfect happiness, a triumphant victor, crowned by love and in utter content-

445

ment. Or maybe – though I cannot believe it – you will do the opposite, and behold me wretched, miserable and discontent. The one will satisfy us both; the other will make us unhappy with no chance of repentance. O Polia, lovely nymph and my adored one, do not fall into the evil repute of having consented to the death of my soul, for your sublime condition is incompatible and repugnant to such impiety. Nevertheless, here is my soul which I offer as a sacrifice, and my meagre heart: dispose of them both as you will, for you are their ruler, whilst I remain yours in perpetual affection, alive or dead. Farewell.'

I believed, Holy Lady, that the maiden would be moved to give some assent to my amorous speech, just as Corydon, when called by Battus, helped him in his pain; but my writing and my words were as wasted as if I had addressed them to a marble statue, and my speech bore as much fruit as a wind-egg. However, I reasonably considered that the first blow does not fell the tree, and so, with the Herculean courage that Amor inspired in me, and using the same convenient way of writing to her, a [E2] few days later I wrote to her this second letter. With careful attention to my state of health, I said as follows.

'If my torment were less bitter than the cruelty you have shown me,

446

fair nymph Polia, I would have born my long afflictions with honour and virtue, counselling myself to be hopeful and patient. But now I know clearly through my evil and unfortunate stars that your harsh severity and savagery far exceed any burning martyrdom of mine. For what use and value is it for Amor to grow and increase his sweet fire hourly in my already shrivelled heart, if you appear ever more unyielding, and colder than frozen ice? Your bosom is chillier than the springs of Derce and Nome, and colder than the salamander which extinguishes fire by contact, in regard to my humble and servile patience, my declared vows and evident affection, whereas I burn all the more when the contrary opposes me from your displeasure. Nevertheless, I cannot undo the solid and amorous chain that holds me in servitude beneath so soft and pressing a yoke, especially since the more I struggle, the more I am entangled, caught and taken captive in this amorous snare, like a fly tied up inextricably in a spider's web. Thus tightly bound, seized and captured, impotent and unable to escape, I am constrained to grovel weeping before you; for my precious liberty and my every need resides in you alone. Now, my Lady, if you can clearly perceive my sincere and perfect pleasure, my willing subjection, my valiant and troublesome love, why do you not accept all these things that are so freely offered to you, when my whole life hangs on your two delicate hands? Alas, sweet and beautiful little Polia, I beg you to help me, and to allow my words, which are not proud or arrogant but sincere, to penetrate your heart just a little. Feel a little compassion in yourself; receive these hot sighs, hearken to my private and intimate laments. Learn to know goodheartedness; take notice of a faithful and gentle servant, for I am surely dying and consuming myself for excessive love of you. The whole world could not drag me away, for I stand firmer than Milo; it could not move me from my worship, reverence and adoration of you, as one who is precious by far above all else, O image and true likeness of the Goddess. When I behold you in all your splendour and excellence, I see depicted there with complete clarity my whole salvation and the expression of all my peace, delight and contentment.

[E2'] 'Now, my hope, do not deny me, who am all yours and who thus pitifully beseech you to temper with your kindness my oppressive fire; for I know not how to live without you — and even if I did, I would not wish to. I hope firmly for help, some day, from that angelic appearance, those modest and elegant ways, that comely and distinguished countenance. The clearest and surest sign of this is, without a doubt, the fact

that almighty Jupiter has fashioned you with exquisite and supreme care as a miraculous example of every excellent beauty, certainly exceeding those of all the beautiful ladies in the world, for they all unite in you alone. Also I have not the slightest doubt that the same Artificer, who has placed such precious and celestial gifts in you and benignly fashioned you in his own image, has likewise deposited a fragment of clemency in your human heart. He has not created you among the Hyperborean gryphons, nor given you Niobe for a mother or wild and savage Apulo for a father, nor had you born from cruel Diomedes the Thracian, from furious Orestes or wicked Phaedra, but from the kindest of parents – perhaps superhuman ones. It is these things especially that keep me bedewed and moistened in the midst of my fervour; otherwise my heart would turn to coal, and my indignant soul would already have flown from me. Help me, then, succour me and save me! I do not implore you with the insolent desire of a Midas or a Pygmalion: I ask only that in response to my petition your should show your favour, satisfy my needs, act kindly and stay your anger, calm your soul, quieten your mind, soften your heart and accept my amorous affection – offered, Lady, by your faithful slave, who wishes to serve you eternally. Farewell.'

POLIPHILO CONTINUES HIS SAD STORY TELL-
ING HOW, WHEN POLIA WAS UNMOVED BY THE
TWO LETTERS, HE SENT HER A THIRD, AND HOW
SHE STILL PERSISTED IN HER UNKINDNESS. BY
CHANCE, POLIPHILO FOUND HER PRAYING ALONE
IN THE TEMPLE OF DIANA, WHERE HE DIED, AND
LATER REVIVED IN HER SWEET EMBRACES.

Y LADY, HOLY PRIESTESS, DEDICAT-
ed only to the sacraments, if I have not offended your
sacred and benign presence with my sad, rough and
unpolished story, I will now continue briefly to bring
my prolix narrative to an end, and thus presume to
please you. It often happens to a lover that he believes [E3]
perseverance to be appropriate and helpful in persuading her whom he
loves intensely. Seeing that the letters I have quoted neither moved nor
swayed her, any more than Mount Olympus is shaken by the freed and
unleashed winds, I could nevertheless not abandon the struggle once

begun. Therefore I sent her a third epistle in order to search out diligently what was in her mind, and whether her heart was made of flintstone or of human material. Vigilant Amor spurred me ever on, while my confident appetite was whetted and wheedled by the blandishments of hope. This was the tenor of my letter.

'My tongue would fail me, O well-born and noble girl, long before it could express on this blank paper how burdensome, how grave, how grievous is this bitter pain that redoubles day and night and ever increases in my suffering heart, when I see you thus deaf and displeased. I know that you are not only discontented but sated with the recital of my heavy torments, which are now no less, but in fact far greater than those about which I have recently written you two friendly letters. But still deceiving, invincible, cruel and painful Amor joins with my ill luck and adverse star to constrain me to the voluntary servitude and slavery of you, O nymph, whose marvellous beauty surpasses human understanding. You are noted for your conspicuous and elegant breeding, but above all else I dare to say that you are excessively pitiless and cruel, like a wild, untamed beast, and more unmovable and disagreeable than the fierce and hungry lion of Androcles. These circumstances belie your human race and denigrate your gentle and divine appearance, your radiantly beautiful looks, and your rare and heavenly form; bereft of humanity, you are a rebel against the little amorous fires of Cytherea and a spurner of industrious Nature's holy empire. Just reason and hateful experience compel me to tell you of the precious time consumed in vain, which has swiftly fled without affecting you at all. Night and day I have been constricted, detained and busied, and uselessly ruined, enflamed and burnt up by loving you, and you alone, to the point of destroying my life. It is now quite clear to me that the more I love you, the more I harden and turn you to stone. Ah, Polia, can it be that no atom of kindly spirits is to be found in you, and that these little letters that pass between us find in you no willing ear whatsoever? Are you unmoved by the loud sighs and the frequent tears that gush from my wet and misted eyes, which constantly bewail their unfortunate condition and painful state? They might easily have believed, in their simple faith, that your incomparable beauty was joined in indissoluble union with a certain tenderness of heart – these eyes whose hasty desire and wanton ardour were the initial cause of the ruin and captivity of my life. But for all that, I cannot restrain or moderate their extreme desire to gaze again at this radiant sun that has half-blinded them, and to fall back into their

[E3']

449

pernicious hell. Therefore, O celestial spirit and adorable idol of mine, if you are now appeased by my writing but still do not grant me access and audience, perhaps it is because I am absent. Amiable Lady, if you were to see me in your presence consuming myself and pining away, melting in tears and frequent sighs, making every sweet effort to influence your soul, begging your mercy and imploring your goodwill; if you could hear me telling, with all possible reverence and meekness, of the incredible love I bear you, the bitterness of heart I suffer, and my distaste for a life that has become hateful, to which I am miserably and continually exposed because of you – alas, excellent Polia, most beautiful of nymphs, I am certain that they would move you to pity, and that you would see clearly how much I deserve your favour and your prompt assistance. When you persist in stubbornly and unkindly rejecting so fervid and bold a love, I may well conclude that you are telling me to burst and die for you. Now, whatever could be your reason for consenting to such an evil deed? What praise or prize, conquest or contentment could you ever gain from it? No: you would be notorious everywhere for despicable cruelty, and perhaps suffer the inexorable justice of the avenging Gods, which never fails nor allows the guilty and fleeing miscreant to escape. Do not, then, assent to such a reprehensible deed, but show yourself now with your lofty crown: be merciful, gentle and pleasant. You would not find such a thing ungrateful: it would be an ornament of your praiseworthy beauty, a blessing on our brief life, and in a short while the sweet fruits of peace and contentment would arise and grow. For there is no treasure in the whole world more to be prized than two lovers in accord, nor any more damnable and objectionable thing than for you to be loved, and not to love. Therefore, if you do not now become the redeemer of my love and my saviour from my ills, what more do you want me to do with this lamentable life that has become so injurious and painful? I am certain that if in your unmitigated obstinacy and obduracy you remain insensitive, uncouth and senseless, you will force me to depart from this life, and in so doing put an end both to your ill-will and to the enormity of my suffering. Farewell.' [E4]

In this way I attempted to convert and humanize her, to sweetly flatter her, and to temper the rough treatment I had received from my initial arduous and dangerous enterprise. But neither she nor perfidious Amor gave in to my persuasive words. With loud oaths I openly denounced them, wishing that he would fall like me into those sweetest of flames, and that she would love me equally in return. With all my

skill and knowledge I attempted to ignite in her that true, naked, simple and best of affections, that amorous fire in which I continued to live wretchedly and without remedy, like the pyrallis. Beside this, I pretended innumerable times to be having a pleasant conversation with her; I reasoned with her boldly, mingling my discourse with many a painful exclamation, and saying 'O my little nymph with your wild and inhuman heart, though by nature you are a gentle little girl, you are being harder than solid steel or jagged rock, more tenacious than a grappling-hook, more unmoving than a jointed beam, more rending than a clutching talon, and more heart-wrenching than the cruel and ghastly harpies. How can you persist in such hardness and unkindness? You are wickeder than Mithridates, crueller than Alcmaeon, more ungrateful for such affection as Paris to Oenone. Remove, therefore, this iniquitous refusal from your nymphal heart, and answer this letter written in the vulgar tongue with openness to my humble petitions. Allow me, my Lady, to attain the peace I desire; permit me to penetrate your hearing with my tortured sighs, and give your consent to my ardent wooing.' Though I made many insistent complaints similar to this, I was altogether unable to remove the agitation of my continuous pain. It pressed on me, filling my whole viscera and driving its bitter roots deep down into my heart. I know of no way it could have been extirpated than by realization of my greatest hope. But my mournful cries echoed in vain around her splendid palace, for she was more deaf than Icarus to his father's advice, more indifferent than Caunus to desperate Biblis, holding sweet love in abomination, given over to the habitual false opinions which she had conceived in her virginal youth, and which had petrified. It is a hard thing to let go something that was once imprinted on one's soul: it is not easily effaced. This was the origin and cause by which I was simply netted and bound in these enveloping meshes, lured to become the victim of these crafty, vain, uncertain, fleeting and ephemeral nooses and snares of love. Subjugated and made a neophyte under this oppressive tyranny, this condition of miserable servitude, I found my sole happiness and satisfaction in loving her extremely. I did [E4'] not resist the flying arrows of blindfold Cupid, but exposed myself to them with alacrity and humbly submitted to their injustice. I dedicated myself defenselessly as a follower of his turbulent, subtle, searching, perverse and undisciplined laws, resting my hope on that angelic appearance of hers and thinking that her heart was just like it. I thought that the part matched the whole, and the whole harmonized with the

part, and that there could be no discord in such a beautiful, elegant, charming, marvellous and divine composition. I had reason to hope that the archer Cupid, who had painfully and intimately wounded my poor heart, would act with justice as the protector of my baleful and ruinous love, and as the friendly and healing dispeller of the blind errors that beset me; that he would kindly hasten to my aid and temper the excessive heat and burning. Nor did I expect help from any but he, that he might shoot his harsh and cruel bow at her and wound her, just as he had fatefully drawn it against me and injected into my heart that noxious arrow that cannot be retracted. Treating the gaping wound only exacerbated it and increased the sickening and mortal pain. Yet I still had unhesitating trust in him that this great wound could be healed. Since I was his devout subject and slave, his precious prey, his possession, captive, booty, spoil, and rich trophy, I thought that he would follow the maternal example and treat me with the same medicine as his holy Mother, my Lady, gave to Aeneas. Moreover, since I was so devoted to him, he might grant me the same protection as holy Vesta charitably showed to her handmaid and subject Tuccia, when the miracle of the sieve exonerated her from blame and saved her from public infamy and a shameful punishment. Thus it happened, as it frequently does to lovers, that in the desperation of my case, without judge or adversary, I condemned both of them as conspirators against my life. With querulous laments and tears I accused them as criminals and deliberate enemies of all human feeling. When I was happy and gay I revoked my verdict; sometimes, like a raving and impatient hound biting its restraining leash, I wanted to escape and flee the tight knot of my amorous but tiresome bonds, and to free myself. Then I would vainly imagine all manner of pleasant diversions and delights, empty vengeances, bold insults, disturbing perils and fearless death, only to find myself tied all the tighter and solidly imprisoned. Thus my burdensome life wasted away in such altercations and abortive appetites, consuming itself in sighs and bitter sobs. There was no place that I did not explore attentively and with ceaseless care and penetrating vigilance, wandering, prying and searching; not a street or an alleyway, even those with hidden entrances, that I did not explore anxiously and [E5] frequently, peering into every nook and cranny to see if I could find her again. At last it happened that Amor and Fortune, finding themselves in a happy ascendant, were well-disposed and unexpectedly led me without her knowledge to the sacred temple to which she frequently

resorted, but veiled. When I found her there alone, every other desire immediately left my heart, and like a clawed lion leaping on his prey I instantly and ferociously accosted her, gathering and harnessing all my powers; but suddenly, like wax coming close to a fire, I became mindless and confused. Not knowing what to do or say, I began to speak humbly in crude and unpolished terms. All that remained of my strength was a tremulous voice and a little breath that seemed to stick in my throat, while the sadness in my soul paralysed my tongue and made all the members of my body weak and confused. 'Alas, my Polia,' I lamented, 'precious golden column of my life, the only hope for consolation in my affliction, already many a day has passed during which I have not only loved you alone and fervently, but honoured you like a goddess and adored you to the detriment of the other gods. I have offered my heart to you in a holocaust upon the burning flame of love, like the priests sacrificing to Bellona, and have voluntarily consigned my life to your will and command. But oh! you have been undeservedly cruel to poor me; you have angrily rejected my well-being as though you had been hurtfully offended by me, as Juno in great anger persecuted the Trojans. You have been more injurious to me than the stones of Britain to the honey-bees; more hostile, contrary and opposed to my will than Thetis rejecting Vulcan; more burdensome than the waving tail was to Lucius. You are more destructive than scandulaca is to fruits, pounding hail to tender leaves, or burning Phoebus to the verdant flowers and grassy meadows.' Finally, with great tenderness of heart, I tried to soothe, placate and propitiate her by means of pleasing and humble speech, to stir her from her unsympathetic and stubborn position, to divert and reverse her fierce and hostile will, to calm her agitation and her refractory and ill-disposed mind, to incline her to kindness and mercy, to moderate her ferocity, to cure her diseased heart of its cruelty with my tears and sighs, and to heal her dearth and want of pleasure with my ample affection. I flattered her sweetly and gently, weeping many a tear

[E5'] and uttering sighs as I tried to work on her hardened heart, to soften and relax it, just as any tender stalk or osier, no matter how fragile and dry it seems, can be affected by soaking and warming so that it can be bent and woven into a garland with the rest. But no matter how flexible her fragile and tender sex may be, and how inflammable by love, I could do nothing with all my ardent affection or my abundant tears. Bereaved Isis did not weep so anxiously for her beloved Osiris. But my blandishments could never warm, mollify or arouse her to the sweet embrace of

my heartfelt love. I could in no way change or affect her, though I offered my heart in all its purity, sincere and purged of all other love. My radiant affection was no less than that which Tiberius Gracchus showed toward his beloved wife Cornelia, when he believed in the prodigy of the two serpents; greater than that of Queen Alcestes who chose to suffer voluntary death for her dear husband; and incomparably greater than the love shown by her who wept for her husband and proclaimed at his burning pyre that she would swallow the hot coals. It exceeded that which much-loving Panthia bore toward her husband, and the friendly affection of Pylades for his Orestes.

Finally, in my desire to make her tractable, I persevered in my attempt to tame her wild and brutal heart and to instill it with some humanity and tenderness. But it hardened still more, remaining unaffected, untamed, unmoved and rough as stone. She could not have been more a stranger to kindness and devoid of charity if she had been born in Hyrcania, or among the rugged and gnarled oaks and the mighty trees of Ida's dense and darksome forest; or else sprung from the Anthropophagi or the horrible furies of the Cyclopes; or nursed in the hollow cavern of Cacus, or between the Syrtean gulfs.

This inhumanity left me with my constant efforts in a torment of exasperation, and in no feigned sorrow and misery. The raucous sighs arose once more, and more painfully, from out of my burning bosom, worse than the roaring of a hungry or fevered lion in a wide and echoing cave or pit. I realized that my great efforts had been in vain because of her obstinacy, and discovered that a bottomless sorrow is inexhaustible. I was almost broken and made desperate by such an arduous enterprise; my tears kept welling up in my weeping eyes, which seemed to harbour an infinity of them, more painfully than those which Myrrha in her torment distills beneath her hardened bark. Since this unhealthy disease of the affections had begun and grown in me, I found myself, beyond deserving and beyond measure, in a state where my feeble heart suffered ever-increasing and intensifying torment. I felt bereft of all hope in the [E6] face of her persistent hostility which drew from me many tortured tears, laments and complaints, and embittered me beyond belief. And still she remained frozen more stiffly than the Arcadian Styx, totally deprived and void of any kindness, indeed without giving the slightest sign that she had been affected. Then I felt that my genius was fleeing from its unjust wrongs by taking a speedy exit in that very temple and in her presence. And she, with her stubborn mind untroubled and unmoved,

454

watched my young and untimely demise, as gasping for breath I tottered on my joints, praying weakly for mercy, and fell prostrate on the ground, where I lay dead.

Perhaps she was prompted by the gods and warned of her ill-will and her rigid, inhuman perversity, for no one enters upon new things without repenting those that are past. The next morning before day-break she returned to the temple, desecrated by the murder of a soul on the previous day. With many virginal caresses, with sweet anxiety and suppressed groans, with an infinitude of kisses and soft, animal-like murmurs, she embraced me repentantly and bedewed me with the abundant tears that she pityingly shed, and thus gently summoned my soul to return. This soul, no sooner separated from my body, had been carried up and led into the divine presence, before the high throne of the divine Lady Mother. On returning to its accustomed home and its empty little body, it was glad and rejoiced merrily for the victorious grace it had obtained, and spoke eagerly as follows.

POLIPHILO CONTINUES HIS STORY, TELLING HOW HIS SOUL APPEARED UPON RETURNING TO HIM AND SPOKE JOYFULLY, SAYING THAT IT HAD BEEN COMFORTED AND BLESSED IN THE PRESENCE OF THE DIVINE PAPHIAN, AND THAT, HAVING ASKED HER FAVOUR, IT WAS HAPPILY RETURNING TO BRING HIM BACK TO LIFE.

T LAST, O LITTLE BODY OF MINE, MY dear dwelling-place and beloved home, you can rejoice in your love with pleasure and great delight, with calm enjoyment and supreme happiness! You can put behind you every grave trouble, every disquieting sorrow and afflicting desire, for your soul has returned joyfully to its home, and you can confidently expect the delights that follow on the success of your love and the trophies and triumph of your victory. Never has a triumph been adorned with such booty and spoils, such a host of trophies and splendid standards , as this glorious one of ours. Therefore restrain your tearful anguish and your unpleasant lamenting; cut them off altogether, and return from these bonds and this tyrannical servitude into precious liberty, free, unconfined and unimpeded, exchanging harrassments for pleasures. For henceforth no

[E6']

one in the course of the ages shall be found more happy and blessed than you have become, through the graces you have obtained. I have not the least doubt that the high and benevolent gods have taken pity on my amorous case, and have favoured me with their patronage. I have seen that which it would take long to explain, even merely to relate. The lady Venus was doubtless disjunct and far from the cold, torpid and sterile virgin Astraea, distant from vindictive and cloudy Orion, and separated from woolly Aries when I presented myself in a wounded and lamentable state before her lofty and divine throne, in the sight of her grave, sacred and severe majesty. There I lodged my complaint and accusation, as best I could, against her ill-willed and lawless Son, submitting that I had been guiltless, blameless and innocent of any offence when he shot me with his swift, wounding arrows, making more holes in my already riddled heart than there are seeds in a millet-loaf. With feigned pleasure and false delight he has anticipated my destined end, seized me from my dear, lofty citadel and bitterly wrenched me from it, tormented me with the love of a cruel maiden, and made me errant and wandering, fugitive and exiled, faded and knowing no peace.

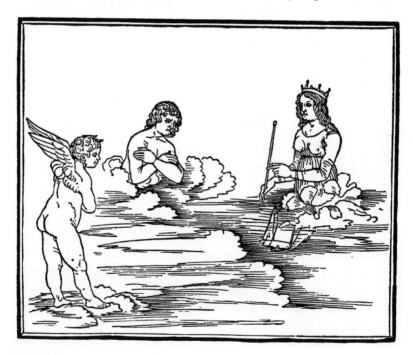

456

[E7] After listening graciously to my lamentable complaints, the glorious goddess and sublime lady immediately called her winged son and asked him what had caused such a wrong. Smiling and jokingly, he said 'Dear Mother, it will not be long before these hostile and discordant souls are attuned and joined together in equal and mutual interchange. No sooner had he said these welcome words than the sweet-talker turned and spoke to me.

'Look carefully at this lovely image. How many are they, and how great they are, who are contented and count themselves happy, blest, and privileged merely to look upon it, not to be loved by it! Such a virgin did not fall to the lot of Thalassus at the rape of the Sabine women.' Here he showed me the true and divine effigy of Polia. 'Look, and as you admire it, appreciate that these especially precious gifts of the Gods should not be spurned, for although we are accustomed to grant them to earthlings, nevertheless many would like to have them and cannot attain them. Such a precious gift I now bestow graciously upon you, and offer to you the first fruits of this glorious compound of virtue and physical beauty.'

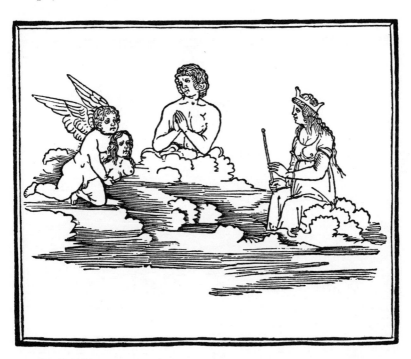

Then he spoke thus to his mother: 'Lady Mother, glorious nurse of [E7']
all burning affections, this is the cause of the evil and heartbreak, the
ruinous exile and sad banishment of this poor, wretched, wandering
and tormented spirit. But in an instant, disconsolate soul, I will cause
your wish to be granted and utterly fulfilled, and send you back unhurt
to the place you have been forced to leave. I want to unite and couple you
closely with your cruel adversary, and to remove and break every barrier
that resists the penetration of my will'. Then, closing his divine lips, he
straightway took his burning, piercing and sharp weapons from their
storehouse in the quiver that hung at his holy side. I could see him
clearly as he bent his curved and tightly strung bow and shot into the
delicate breast of the displayed image an arrow tipped with gold, feath-
ered with sharp spines and decorated with many colours. No sooner
had this blazing arrow wounded and entered her to spread its ferment of
love than this virginal girl became tractable, easy, mild and benevolent.
Joyfully she inclined her head and bowed low, acknowledging herself
vanquished and prostrate with nymphal compliance, just like those
who, feeble and unarmed, cannot struggle against the cruelty and feroc-
ity that are used against them.

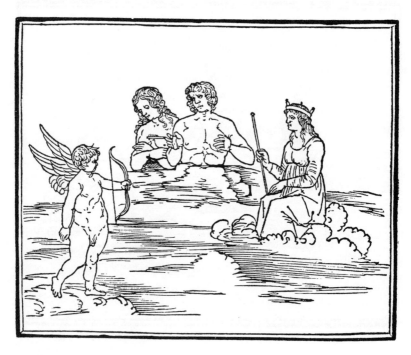

458

Now that I was in the blessed company of three persons, two of
them divine and one little less than celestial, as I rightly judged, I beheld
the open revelation of mysteries and arcane visions that mortal and
material senses are rarely permitted to see. But I, through special grace,
rare indulgence and gracious privilege, was able to find out everything
and to contemplate in detail the divine and generous gift that fire-born
Cupid had wounded and graciously offered to me. I hoped safely and
surely to conquer it with you, and, once obtained, amorously to enjoy it.
I was particularly astonished and amazed that all the elegances and
graceful lines of beauty should be gathered in one small nymphal body,
as I admired the perfection with which it was all assembled, which also
provoked admiration in the divinities who were present. But above all
the other admirable and celestial things were two splendid and
sparkling eyes, brighter than the morning stars, so that one would have
said that a double Phoebus was blazing beneath those lashes, uninter-
ruptedly shooting out golden arrows to me, their willing recipient,
showing the splendour of those outstanding virtues, and forcing me,
like the rays of the blazing sun, to turn away my staring eyes. They were
much more welcome and salutary to me than an approaching shore to
shipwrecked sailors; more than health returning to an invalid; more
than his troublesome riches to Darius, or his victories to Alexander.
They were more than the rising of the water-bringing Nile to the Egypt-
ian fields; more than the cloddy earth to Bacchus, or loose soil to yellow
Ceres. And here the fair nymph added ethereal loveliness to all her
other outstanding beauties as she offered herself lovingly, with her
milk-white bosom where Amor had made his delicious orchard and
garden of delight, the open nursery and token of Jupiter. The golden
plaits of her thick tresses circled her shapely neck with nymphal care,
and fell in shapely waves and bouncing curls without any help from the
hairdresser's art, and some of the waves overflowed upon her gleaming
shoulders. These shone with a snowy whiteness, tinged with rosy
essence, looking more desirable than the sacred gold to wicked Atalanta
or to Myrmex the slave; more than the bracelet to the Tarpeian traitress.
The woven laurel was not more suitable to cover the baldness of Caesar,
nor was the blood of the unfortunate gladiator more effective in curing
lovesick Faustina. To my burning fever, she was as a timely, healing,
efficacious and speedy medicine, far more acceptable than the puddle of
muddy water seemed to Lucius when the bag stuffed with tow caught
fire. Her beauty is so great that I do not believe that it was equalled by

459

that of Deiopea who was promised to Eolus. While I was thus utterly rapt and transported, and stupefied with admiration of the celestial works, the flow of my tears was dried and my sad laments were kindly heard. Then the divine lady Mother spoke, with ineffable majesty and sanctity, and with an extraordinary, venerable, yet sweet voice, such as could calm the cloudy sky, confiscate the dangerous arms of bellicose Mars or the thunderbolts from the hands of far-throwing Jupiter, rejuvenate old Saturn, turn fair Phoebus into an Ethiopian, make the glib Cyllenian stammer and deflower chaste Diana. Mortals have never heard such a voice. She uttered its divine words with divine breath, and with such affable harmony as the divine lips of winged-footed Mercury never drew from the hollow reeds joined in a syrinx, when he played to hundred-eyed Argos. By its sweetness any Libyan flintstone, even the Indian diamond, would become infected and changed to something tender, soft and breakable. [E8']

Speaking like this, she reassured me of my safety, the prospering of my love, and my happy permission to return to you. Then with a charming smile she said to her son: 'And you, now that you have wounded this virgin girl, if ever she turns her back on her amorous duties or makes as though to abandon this soul here, you shall be forfeit.' Therefore, my little body and my opposite, cast off all these bitter griefs and passions and let me enter wholly into you, united with you as I never was before. I return with a famous name impressed upon myself, for whose sake I left you; it is incised and sealed far differently from those of Oenone and Paris that were carved into the rough bark of branching trees. It will never be eroded or erased from there, but will remain as an eternal witness. So now, my beloved host, receive me as your indweller, who, to cure your grave and unbearable tribulations, have passed and penetrated through such floods of tears, such a fire of love and such supreme labours, being carried at last to a place where your kind cannot go. There I was blessed with such divine grace that, as a timely mediator, I bring you perfect health and healing.

I replied to my genius, who had returned and united with me: 'Come, native inhabitant and ruler of the high citadel of my mind, my best rational part. Come, my heart, you house that so readily catches fire. Come, you uttermost part where my arouser Cupid has his residence, and let us celebrate the feast of convalescence, now that you have returned and made us whole.'

POLIPHILO TELLS HOW, AS SOON AS HIS SOUL
FINISHED SPEAKING, HE FOUND HIMSELF ALIVE IN
POLIA'S ARMS. HE ASKS THE PRIESTESS TO JOIN
THEM BOTH IN PERPETUAL LOVE, THEN HE ENDS
AND POLIA CONCLUDES HER NARRATION TO THE
NYMPHS BY TELLING HOW SHE FELL IN LOVE WITH
POLIPHILO, AND HE WITH HER.

ENERABLE AND HOLY MOTHER, NOBLE
and honourable Priestess of this sacred temple, it may
seem incredible and beyond belief that the moment
my soul had made an end of its healing arguments,
and my precious life had returned to me, I suddenly
found myself amid the close and tight embraces and the savorous and
succulent kisses of this nymph, all redolent of the flower of her youth.
And the amorous ferment grew wonderfully within us, in the order of
events that she has charmingly, festively and eloquently described to
you, right up to the present state in which we stand before you, noble
religious and President of this sacrosanct place. If it is in your power to
help us by averting evil, blunting and diverting it, and by favouring
goodness, exalting humble and lowly things, guiding and sustaining
the hesitant, lightening those in darkness, mending and righting those
who err, then make for us, we pray, a mutual and indissoluble bond.
Couple our souls closely in a single concordant will and a single desire;
confirm and strengthen our solidly united love, for we are ready to
submit in perpetuity as obedient servants of the mighty Empire of the
Divine Mother.' Poliphilo then fell silent.

The holy Priestess straightway made us kiss each other amorously,
and said, 'As it has pleased the immortal Gods, so be it, and not other-
wise. It seems to me holy and just that you should graduate from your
first state to a more praiseworthy one. Be therefore blest by me; live in
amorous happiness and visit often this holy Temple, which is your
refuge and the sure protector of your mutual love and equal delight.
And whichever of you shall be the cause of any impediment to this
fated love, let him or her be persecuted by the terrible, noxious arrows
and flying weapons of Cupid, wounding one with the golden arrow,
but piercing the other with dismal lead.'

This, then, O glorious nymphs, was the reason and origin of our
[FI'] love, which burns equally with Cupid's fiery flames, as I have told it at

perhaps tedious length. And with these words Polia, as though tired by her long discourse, came to an end. With her balmy breath modestly enclosed by that choir of orient pearls and made fast by those crimson lips, she fell silent.

POLIPHILO TELLS THAT WHEN POLIA CEASED SHE HAD ALREADY FINISHED THE FLOWERY WREATH, WHICH SHE PLACED ON HIS HEAD, KISSING HIM TENDERLY; AND THE NYMPHS, HAVING LISTENED A WHILE TO THE AMOROUS STORY, TOOK THEIR LEAVE AND RETURNED TO THEIR RECREATIONS. POLIA AND POLIPHILO REMAINED ALONE, AND AS THEY WERE DEVOT, ING THEMSELVES TO LOVE, SHE EMBRACING HIM TIGHTLY, BOTH SHE AND THE DREAM VANISHED.

HAVE NO DOUBT WHATEVER THAT the sympathetic nymphs, who had been so good as to listen intently for a long time, felt not only great plea, sure but also no small admiration for the loves that young Polia had related to them with such clarity and grace. When the long narrative came to an end, they all rose from their quiet seats. At the same time as Polia was telling her story so fluently and straightforwardly, she was weaving fragrant flowers into a circular wreath; and as she finished her suave discourse, she placed it neatly on my head while I knelt affectionately. Then with her two nectar, and cin, namon, scented lips she gave me a dove, like kiss. The nymphs strongly applauded her attractive speech, her rich eloquence, elegant manners and remarkable gestures, which had given such extraordinary beauty to her smooth discourse and made it so elevated and memorable. They were even more delighted to have heard of her noble origin and distin, guished race, her excellent ancestors, her famous, illustrious and ancient family, and of the happy conclusion of her love, all told in sequence.

The nymphs returned straightway to their pastimes, merry and gay, laughing, jesting and full of fun, and began to play their neglected instruments together with their celestial choral songs. They danced in a round by the sacred spring, which poured out its clear waters with a pleasant whispering through the soft, flowery and dewy meadows with their varicoloured blooms, and through the dense shadows of the pleas,

[F2]

ant groves of fruit-trees. Polia and I were also seized with festive enthusiasm and joined awhile in the merry dances, leaping with great alacrity, making delightful gestures and clapping just like the nymphs, to our immense pleasure and enjoyment. After great festivity with much dancing and singing, the nymphs departed in unspeakable delight, taking their leave with sweet and mutual embraces and biting kisses, for they had become extremely fond of both of us.

Now we were left alone in this sacred and charming place, I and my delicate Polia. I was all inflamed with the delectable fires of Venus and the increase of my love; and thus I began to speak: 'Virtuous Polia, my heart's desire and my elegant delight, now that every vulgar thought is banished, every murky suspicion dissolved, you are in every way unique and elect among mortals, preserving the first fruits of your inviolate, blooming and pure person, a nymph adorned with exquisite ornaments, for whose sake I have suffered agonies. My soul, bound and entangled by its love of you, has not enjoyed a moment's peace or relief from its burden of bitterness. You are presently more dear to me than the daylight is to mortals, more agreeable and timely to me than the yearly harvest is for human sustenance. Keep my soul, then, as its amorous custodian in your eternal love. For you are more excessively beautiful, more transcendently lovable than one could ever imagine or divine, filled with a chorus of all virtuous, honest and noble manners, companioned by every sort of beauty; a miraculous image sent by heaven for my contemplation, through which I am bound by profound love in eternal fetters. I have chosen you carefully and wisely out of an infinity of maidens as the mistress of my life and my beloved protectress, the one and only triumphant Empress of my burning and hungry heart, which was flung into the abyss through its amorous ardour. You alone are victorious, you alone deserve to be the proud bearer of the vital spoils and the mighty trophy – you, the sole, adorable Goddess of my soul and of everything I hold dear!' When I had said this, she immediately replied affectionately:

'Poliphilo, my dear, my only joyous consolation, my comfortable solace and delicious delight, the chief and complete satisfaction of my mind; you are the lawful lord of my transfixed and constant little heart. I value you above all the precious treasures, all the rich hoards of jewels in the world. Do not doubt, I pray you, what you have learned openly, clearly and infallibly, nor what you can now know as unfailing and proven: in the divine presence of many nymphs, I vow myself and all

[F2']

463

that is mine strictly to you; I dedicate and give them to you as a sealed and legal gift, and promise you that I will henceforth carry your precious love intimately, as the inmost inhabitant and eternal tenant of my ardent and faithful heart. I am yours absolutely, having never been anyone else's, even if I live longer than the terebinths of Hebron. You are the solid column and pillar of my life, my true and unmoving support, my Philoctetes-in-chief. I see clearly that all my rekindled hope is preserved here, linked and stabilized by adamantine netting and indissoluble chains. Unable to turn or tear my eyes away, I gaze constantly upon it.' Then, winding her immaculate, milk-white arms in an embrace around my neck, she kissed me, gently nibbling me with her coral mouth. And I quickly responded to her swelling tongue, tasting a sugary moisture that brought me to death's door; and I was straightway enveloped in extreme tenderness, and kissed her with a bite sweet as honey. She, more aroused, encircled me like a garland, and as she squeezed me in her amorous embrace, I saw a roseate blush strongly suffusing her naturally snowy cheeks; while on her stretched skin, a mixture of scarlet rose with the calm glow of ivory was shining with the utmost grace and beauty. The extreme pleasure caused tears like transparent crystal to form in her bright eyes, or like pearls finer and rounder than Euriale's, or than those that Aurora distils as morning dew upon the roses. This deified, celestial image then dissolved in the air, like the smoke, perfumed with musk and ambergris, that rises to the ether from a stick of incense, to the great delight of the heavenly spirits as they smell the strangely fragrant fumes. Quickly she vanished from my sight, together with my alluring dream, and in her rapid flight she said: 'Poliphilo, my dear lover, farewell!'

POLIPHILO NOW CONCLUDES HIS HYPNERO⁄
TOMACHIA, REGRETTING THAT HIS DREAM WAS
NOT LONGER, AND THAT THE SUN WAS SO EN⁄
VIOUS AS TO BRING THE DAY.

THIS WAS THE POINT, O GENTLE READERS, at which, alas, I awoke. An inconceivable pleasure was snatched from me as this angelic spirit disappeared before my eyes, and my sweet sleep was stolen from my languid members. I was desolate at the violent theft of this lovely image, this happy presence, this venerable majesty; it trans⁄ ported me from wondrous sweetness into intense bitterness as this glorious dream left my sight, this divine shade was broken up, and this mysterious apparition was shattered and carried off, by which I had been led and raised to such lofty, sublime and penetrating thoughts. Perhaps the sun had become envious of such a blissful dream, and came to plunder the glorious night, being a notorious enemy and slanderer of the divine Mother; he suddenly arrived in all his splendour and, paint⁄ ing white Aurora with the colour of roses, interrupted the courses of the night. And as the day dawned and supplanted them, I was left filled to the brim with a sweet and loquacious illusion. Think how dark and dusky he would have been at this hour if I had really been enjoying the genuine and voluptuous delights of this lovely and divine maiden, this noble nymph! If he was too indignant to allow me a night as long as Alcmene's, I think perhaps this was because it is not permitted with a goddess. Alas, why did he not exchange an atom of his speed for a little sloth in order to preserve my repose, and bend his laws by a fraction? Why was I not given the Stygian sleep from inquisitive Psyche's casket? Then Philomel proclaimed her sorrow before the dawn, hidden in the thorny brambles and in thickets dense with the dark foliage of oaks, entwined with twisting honeysuckle, and telling of the violence of adulterous and perfidious Tereus, saying in her twittering song: Τηρεὺς Τηρεὺς ἐμὲ ἐβιάσατο. I awoke and emerged with a start from my sweet dream, saying with a sigh: 'Farewell, then, Polia.'

At Treviso, while unhappy Poliphilo was engaged in the beauteous bonds of love for Polia.

M.CCCC.LXVII. The Kalends of May.

465

EPITAPH OF POLIA

F elicitous Polia, who buried lives!
C oming to rest after a glorious war,
I Poliphilo guard my own saviour.

EPITAPH IN WHICH POLIA SPEAKS

TRAVELLER, TARRY HERE AWHILE.
THIS IS THE PERFUMERY
OF THE NYMPH POLIA.
WHO IS POLIA, YOU ASK? THE
BEAUTIFUL FLOWER, REDOLENT OF
EVERY VIRTUE,
WHO FOR ALL POLIPHILO'S TEARS
CANNOT REVIVE IN THIS
ARID PLACE.
BUT IF YOU WOULD SEE ME IN FLOWER,
A RARE PICTURE, YOU WOULD BEHOLD
A DISPLAY OF EVERY BEAUTY,
SAYING: PHOEBUS, WHAT YOU HAD LEFT
UNTOUCHED BY FIRE,
HAS FALLEN INTO THE SHADOW.
ALAS, POLIPHILO,
CEASE.
A FLOWER SO DRY
NEVER REVIVES.
FAREWELL.

POLIPHILVSPOLIAE.S.P.D.

OLTE FIATE POLIA COGITANDO CHE gli antichi Auctori ad gli principi & magnanimi homini, alcuni per pretio; altri per fauore, tali per laude, le opere sue aptamente dicauano. Dique per niuna di così facta cagione, se non per la media, questa mia Hypnerotamachia, nó trouádo a chi piu digno pricipe, che ad te mia alta Imperatrice dicare la offerisco. La cui egregia conditione, & incredibile bellecia, & uenerande, & maxime uirtute, & costumi præclarissimi, Sopra qualúque Nympha negli nostri sæcoli principato tenendo, excessiuamente me hano dil tuo insigne Amore infiammato, arso, & comsumpto. Receui dunque di bellecie diffuso splendore, & di omni uenustate decoramento, & di inclyto aspecto conspicua, questo munusculo. Ilquale tu industriosamente, nel amoroso core cum dorate sagitte in quello depincto, & cum la tua angelica effigie insignito & fabricato hai, che singularmente Patrona il possedi. Ilquale dono sotto poscia al tuo solerte & igenioso iudicio (lasciando il principiato stilo, & in questo ad tua instantia traducto) io il commetto. Onde si menda appare, & meno dilla tua elegante dignificatione in alcuna parte sterile & ieiuno trouerai, incusata sarai tu optima operatrice, & unica clauigera dilla mente & dil core mio. Il præmio dunque di magiore taléto & pretio, non altro specialmente æstimo & opto, che il tuo amore gratioso, & ad questo il tuo benigno fauore. Vale.

Translations of Latin and Greek
inscriptions in the illustrations and
the text

p. 33 Dedicated to the ambiguous gods
The horse of misfortune

p. 37 (*Greek*) Toil and talent

p. 39 I would be naked if the beast did not
cover me. Seek and you shall find. Leave me.

p. 40 Whoever you are, take as much of this
treasure as you wish. But I warn you: take the
head without touching the body.

p. 42 (*Greek*) Birth

p. 54 (*Greek*) The god with the aegis

p. 69 (*Greek*) Always hasten slowly

p. 72 (*Greek*) The mother of all

p. 81 (*Greek*) Bath

p. 85 (*Greek*) Trickster

p. 98 Mercury, Venus, Sun, Mars, Jupiter

p. 123 (*Greek*) The wealth of nature

p. 125 (*Greek*) Worldly glory is like a bubble.
(*Greek*) Ineffable

p. 126 (*Greek*) The wolf of the gods is hard-
hearted.

p. 129 (*Greek*) Hard to comprehend

p. 130 (*Greek*) Unspeakable. Inseparable.
Inscrutable.

p. 135 Glory of God. Mother of love. Glory
of the world.

p. 136 Gate of Heaven

p. 169 (*Greek*) You are sweet and bitter to me.

p. 211 (*Greek*) Kulopera [a sanctuary of
Venus on Mt. Hymettus]

p. 246 Sacred to the blessed shades. Cemetery
for the miserable corpses of those maddened
by love.

p. 248 To infernal three-bodied Pluto and his
dear wife Proserpina, and to three-headed
Cerberus.

p. 252 Altar of the infernal gods. Wayfarer,
see here the slain Laodia Publia. Because she
would conceal her age and reject the
commands of love, contrary to the rites of

girlhood, she killed herself with a sword.

p. 253 To the blessed shades. The grieving
parents have placed this for Annira Pucilla,
an incomparable girl, who imitated Dido.

p. 254 To the blessed shades. To my gladiator,
for whom I burned with extreme love and fell
into mortal illness, then, wretchedly polluted
with his blood, alas, I recovered. Divine
Faustina Augusta piously leaves this
monument so that every year, while
sacrificing, they may moisten this sacred tomb
with the blood of doves, and 49 weeping
maidens with burning torches shall perform
the funeral rite. To show their sorrow, they
shall be unveiled and let down their hair, and
scratch their faces and breasts all day long to
propitiate the shades, and they shall repeat this
around the tomb every year in perpetuity. By
her testament she has directed this to be done.

p. 255 Hail, Leria, most beloved of all, and
farewell.

p. 256 To the blessed shades. Wayfarer, turn
your eyes hither, then hear my words. I was
loveless while I lived; loving, alas, I die.
Speak, I pray; I would like to hear it.

I gave myself, dead, to this cemetery,
because I burned with love for a beautiful
youth in the flower of his age.

What, are you mad? So you did love while
you lived.

In fact, I began to love, to my hurt; for the
youth, spurning the gift of love, refused. I
pined away, death took me, and here I am.

What can I do for you?

Pity Nevia Romana, dead for love of cruel
Proculus, and tell it through the whole city
and the world. That is enough. Farewell.

p. 257 (Broken tablet) Hail, viewer, and
weep, I pray. An unhappy queen, madly
loving a wandering guest, alas, with an
unfortunate gift...

(Body of vase) indecipherable

(Base of vase, *Greek*) Nothing is more sure
than death.

p. 258 Hail, wayfarer, and tarry awhile among
the shades summoned here, then read with
many a sigh and kiss the marble, saying: 'Ah,
monster of cruel Fortune! They should have
lived.' The girl Leontia, impelled by the first
intemperance of love for Lollius, a noble

youth, was tormented by her parents and fled. Lollius followed; but while embracing they were captured by pirates and sold to a slave-dealer. We both went on board as captives. When night fell, Lollius suspected that Leontia was being abducted, and seizing a sword he killed all the sailors. A rough sea arose; the ship collided with the rocks close to shore and sank. I climb the rocks. Driven by hunger, I seize Leontia, grasping her elbows: 'Come hither and help us, father Neptune: I commit our fortune to you.' Then with dolphin-like efforts you swim in his arms; but Leontia, while swimming, says: 'Am I a burden to you, my life?' 'Lighter than a water-spider, Leontia my heart.' And she asks repeatedly: 'Is your strength enough, my hope, my soul?' I say: 'You arouse it!' Then embracing his neck she sweetly kisses her bearer, consoles and exhorts him, heartening the swimmer. I am exultant: we have finally reached the shore safely. A roaring lion comes up unexpectedly and we embrace each other; the lion spares us because we look dead. Frightened by this event, we escape by boarding a boat abandoned on the shore, with palms for oars. We row alternately, singing. After wandering for three days and nights, all that surrounds us is the sky. Tormented by mortal hunger and the days of fasting, we fall into each other's arms. 'Leontia,' I say, 'I will always love you. Are you dying from hunger?' 'It is enough to be with you, Loli, for me to feed.' But she sighs: 'My Loli, are you weakening?' 'Not at all in love,' I say, 'only in body.' We fed sweetly with a mutual quivering of tongues and bestowed hard kisses on our open mouths, embracing like ivy. We both died by wasting away, not by the cruel seas. We were borne hither by the breeze, the miserable prey of the air, caught in its embraces, and here we are laid among the Plutonian shades, whom piratical greed has not detained, nor the lion's gluttony devoured, nor the immensity of the sea captured. The narrow space of this little urn contains us both. I wanted you to know of this misfortune. Farewell.

p. 259 To the infernal gods and goddesses. The youth C. Vibius was excited by intemperate love for the beautiful girl Putillia Sexta. Unable to bear her being taken away by another, he knew death through his own bloody sword. He lived 19 years, 2 months, 9 days; none knows the hours.

p. 260 (*Greek*) Protect the noble maiden of Artemis.

To the blessed shades. Lyndia, girl: here am I, Thasius, a boy. Without you, I did not wish to live. I preferred to die. And if you know this, it is enough. Farewell.

p. 261 To the blessed shades. P. Cornelia Anna. Lest I should survive miserably in desolate bereavement, I surrendered myself to be condemned, living, to this tomb with my dead husband, cherished with incomparable love, with whom I lived 22 years without any controversy. We charge our freedmen and freedwomen to sacrifice every year upon our tomb to Pluto and his wife Proserpina, and to all the shades, and to decorate it with roses, and to hold a feast here with what remains. I have given a gift of 10,000 sesterces of my money, and ordered this to be done in my testament. Farewell, life.

p. 263 O reader, come hither to this unhappy monument. It calls you, and then asks you what human pleasure amounts to, as you shall read. Here are the ashes of two lovers, who not long ago were immoderately inflamed with the mutual goading of love. Unbridled in their lawless drive to pleasure, they meet in a deserted place among broken rocks, where were the crumbling walls and jagged ruins of sacred temples. There, as we were both hotly impelled to enjoy the hoped-for gifts of Venus, I, Lopidia, was on my back when I saw a threatening snake descending from above. 'O my Chrysanthes' I say, 'stop what you are doing, get up and flee, for a serpent is about to devour us.' Then I see it about to throw itself from the wall upon him. He looks up, frightened. 'O my Lopidia,' he says, 'I will always love you: flee!' 'You flee!' 'You will die if you attack the dragon without me.' Scarcely have I arisen (alas for my sorrow) than my Chrysanthes, my life, is fatally caught and tightly wound in the snake's coils. Already I see him breathing with difficulty. Suddenly it wounds the throat of my Chrysanthes with its teeth, and I watch him suffocating. 'Oh, I have perished!' – I see my unhappy Chrysanthes dying. With

sudden fury I fall on the serpent, grasping a club to hit it; but the serpent, bending its neck, turns away, and I cannot easily force it from its victim. Dealing a false and careless blow, I killed my Chrysanthes. 'Unhappy one, I am lost. What have I done? What shall such a wretch do? Shall either the serpent or I survive? By no means!' Then snarling with Herculean daring and hellish fury, with the same branch I turn my blow from the fallen body to the entwining beast, strike and kill it. What then was a girl to do, lost and quite dead? Throwing my Chrysanthes and the beast, witnesses to my crime, upon my shoulders, I carry them to the city; and lest I should evade harm, pouring out my sighs and tears upon him I go up to the public forum and make the matter known. A crowd of citizens hastens up to see the cruel and extraordinary sight. They look at it pityingly, accusing Fortune and condemning Venus. I bear witness to my crime and call on the infernal gods. 'Deign, therefore,' I say, 'to punish me together with my Chrysanthes; now I will take all the blame upon myself.' Then desperately, in the sight of all the people, I seized a sword and stabbed my breast, and gave my wretched self to be buried for all eternity with his corpse in this mound. Farewell.

p. 264 To the blessed shades. Whoever should come and read this, if you are in love, beware. And if you do not love, consider, wretch, that he who lives without love misses nothing sweet. For I yearned so for sweetness that I carelessly lost myself, and that was love. When I saw the beautiful virgin girl Dyrvionia, I wanted greatly to oblige her. Leaping down from my horse, my foot was caught in the stirrup, and I was dragged to death.
Hasten at the proper time in your affairs. Farewell.

p. 265 (Greek) Ashes of Queen Artemisia. (Greek) Dishonoured Mausoleum.

p. 266 (Greek) Mirror of Eros.

p. 267 (Greek) Mirror of Eros (Greek) Ashes of Queen Artemisia

p. 269 Behold, wayfarer, the images of Q. Sertullius and my sweet wife C. Rancilia, a virgin; and then read of what wanton destiny may do. In the very flower of her age, when the grievous power of love assailed and captured us both, we were joined with the approval of my father- and mother-in-law in solemn matrimony. But unhappy fate! The first night, as with importunate desire we were about to extinguish the torch and pay our vows to the divine mother Venus, alas, in the very act the marital house collapsed and crushed us, entwined in transports of delight. Consider the mournful sisters, who did not know what to do. We were not fated to spend a longer hour. Dear parents, do not make lamentation or tears over our unhappy shades, nor make things unhappier still, but live your long years for ours; and good reader, live your own.

p. 271 Sacred to the gods Dis and Proserpina. Memorial of the love and piety of V. F. Trebia, daughter of Q. L. S. Trebius. Aulus Fibustius, her husband, lived with her in the most delicious desire for 1 month, 3 days. This my beloved wife has left me wretched, in tears and eternal mourning. Moved by extreme zeal, as she suspected me of lying with another woman, she turned from sweet love to fury, and killed herself by driving a knife through the middle of her breast. 'O wife, why this?' 'My dear husband, you should have spared your lover not just the deed but the suspicion. Fare well and free, while I rest, released from an uncertain, unhappy and agitated life.'
The inevitable law of Stepmother Nature.
The kindly edict of Mother Nature.

p. 323 The great bird, dedicated to almighty Jupiter.

p. 324 The generosity of the supreme bird.

pp. 330,331 (Greek) Captured in war.

p. 340 (Greek) All things in life are short.

p. 361 (Greek) Seduction is like a spark. (Greek) Marriage.

p. 372 Impure sweetness. (Greek) To Adonis.

p. 465 (Greek) Tereus, Tereus has raped me!

APPENDIX 3

Glossary of architectural terms

Note: Colonna's usage is not consistent, nor are his intentions always clear. The following terms are defined according to their apparent meanings in this book.

ABACUS, the upper member of the capital of a column

ADYTUM, entrance-way or portal

ALTAR, term also used for pedestal (Colonna's 'ara')

ANTIS-COLUMNS, columns attached to the jambs of a portal

APOTHESIS, outward swelling at the top of a column, just below the capital

ARCHITRAVE, the chief horizontal beam supported by columns

ARCHIVOLT, band of mouldings decorating an arch

AREOBATE, same as stylobate

AREOSTYLE, disposition of columns in which they are widely spaced

ARULA, squared pedestal beneath a column; a small altar

ASTRAGAL, ankle-bone; ring or moulding of semicircular section

BEAM, a horizontal member, usually straight, resting on columns (Colonna's 'trabs'); an architrave

BINDING, same as astragal (Colonna's 'nextrule')

CABLE, long moulding used to fill the flutings of a column

CHANNEL, same as scotia

COLONNETTE, small column or pilaster

CORDINGS, slender mouldings of half-round section (Colonna's 'cordicule')

CORNICE, the uppermost moulding(s) of an entablature

CORONA, the projecting moulding on top of a wall; same as cornice

CYMA, cyma recta, wave-shaped moulding whose section is a double curve with the concavity uppermost

CYMA REVERSA, reversed cyma, with the convexity uppermost (Colonna's 'cyma resupina')

CYMATIUM, uppermost element of any group of mouldings; same as cyma

CYMBIA, same as torus

DENTIL, rectangular block used in rows between frieze and cornice

ECHINUS, sea-urchin; the rounded element of the Doric capital

ENTASIS, subtle swelling of a column

EPISTYLE, same as architrave or straight beam

FASCIA, flat vertical surface

FILLET, narrow, ribbon-like moulding; cincture

GORGET, crescent-shaped ornament

GULA, gullet, throat-shaped moulding; same as cyma

GULLET, same as gula

HYPOTHESIS, same as apothesis

HYPOTRACHELIA, necking; part of the column below the astragal

IMBRICATED, resembling overlapping tiles or scales

LINEAMENTS, general term for the mouldings and other sculpted decorations of any architectural work

METOPE, panel that alternates with triglyphs in the Doric order; a panel above a door

MUTULE, curved bracket projecting beneath the cornice; a modillion

NEXTRULE (-LI), same as astragal; also used for the edges between the flutes of a column

OCULUS (-LI), circular window or opening

ORBICULO (-LI), same as scotia

ORICHALCUM, a gold-coloured alloy

OVOLO, quarter-round or egg-shaped moulding

PACE, five feet

PALM, three inches

PARADROMIDES, an open promenade

PIER, stout column placed beneath a building (Colonna's 'nana columna', i.e. dwarf column)

PILASTER, engaged column or half-column attached to a wall

PLINTH, rectangular or cubic support for a statue or column (Colonna's 'latastro')

PODIUM, pedestal beneath a column

PRONAOS, porch before a temple

PYCNOSTYLE, disposition of columns in which they are closely spaced

REGLET, narrrow band of moulding; same as fillet

RINCEAUX, decorative spirals of foliage

SCOTIA, circular concave moulding (Colonna's 'orbiculo' and 'trochilo')

SOCLE, block beneath a column or
 other structure; mouldings
 at the base of it
SPANDREL, the triangular shape outside
 an arch
STADIUM (⁄IA), approximately 600 feet
STYLOBATE, footing on which columns
 stand (Colonna's 'areobato')
STYLOPODIUM, column⁄footing, same as
 podium
TESSERA (⁄AE), small piece of stone or glass
 used in mosaic
TORQUE, same as astragal; collar
TORUS, circular convex moulding

TROCHILO, same as scotia
TROCHLEA, same as scotia
VERMICULATE, decorated with winding or
 worm⁄like patterns
VOLUTE, spiral of the Ionic capital
VOUSSOIR, stones comprising an arch,
 especially over a recessed portal
WAVE⁄MOULDING (Colonna's 'undula'),
 1. same as cyma; 2. an undulating
 moulding
XYSTUS, covered colonnade for winter
 exercise
ZOPHORUS, frieze, originally carved
 with animals

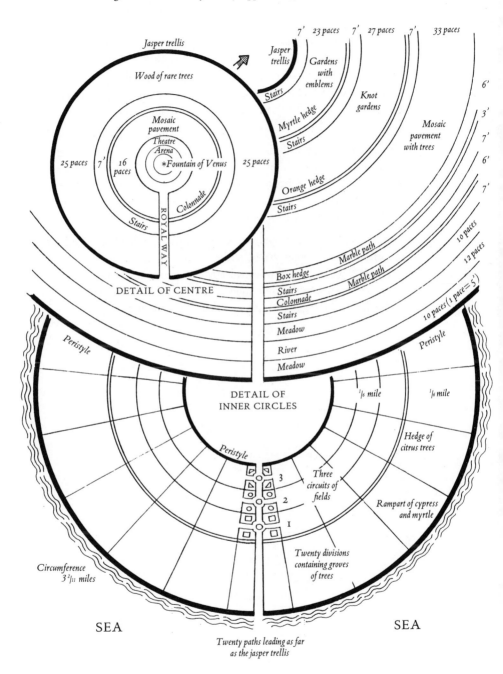

Jasper trellis

Wood of rare trees

Jasper trellis

7' 23 paces 7' 27 paces 7' 33 paces

Gardens with emblems

Knot gardens

6'

3'

Mosaic pavement with trees

7'

6'

7'

Mosaic pavement

Theatre
Arena

*Fountain of Venus

25 paces 7' 16 paces 25 paces

Myrtle hedge

Stairs

Stairs

Orange hedge

Stairs

Colonnade

Stairs

ROYAL WAY

DETAIL OF CENTRE

Marble path

Box hedge

Marble path

Stairs
Colonnade

Stairs

Meadow

River

Meadow

10 paces

12 paces

10 paces (1 pace = 5')

Peristyle

Peristyle

DETAIL OF
INNER CIRCLES

1/6 mile 1/6 mile

Peristyle

3

2

1

Three circuits of fields

Hedge of citrus trees

Rampart of cypress and myrtle

Twenty divisions containing groves of trees

Circumference
3 2/11 miles

SEA

SEA

Twenty paths leading as far
as the jasper trellis

THE FIRST EDITION of this translation was published in 1999 on the five hundredth anniversary of the printing of *Hypnerotomachia Poliphili* by Aldus Manutius in Venice. It followed as closely as possible the page-size and layout of the original edition of 1499 and was issued as one of a series of events, including the exhibition of Rembrandt Self Portraits at the National Gallery, London, and the commissioning and publication of *Vision: 50 Years of British Creativity*, undertaken or sponsored by Thames & Hudson to mark the fiftieth anniversary of its own incorporation.

WALTER NEURATH, THE FOUNDER of Thames & Hudson, always felt a special affinity with the type-face used by Aldus, which had been made available to modern printers by the Monotype Corporation in 1923 under the name of 'Poliphilus'. That typeface became closely associated with the publishing house and its early titles and has been used in its digi-tized version for both editions of this present publication.

IN THIS SECOND EDITION, which save for page-size is all but identical to the first, the opportunity has been taken to correct some textual errors and to restore a woodcut that was inadvertently omitted in the first edition, where on p.170 the facing illustration of four unicorns was repeated instead of the chariot bearing the nymph, now correctly reproduced there.